From Roman to Early Christian Thessalonikē

Studies in Religion and Archaeology

HARVARD THEOLOGICAL STUDIES
64

CAMBRIDGE, MASSACHUSETTS

From Roman to Early Christian Thessalonikē

Studies in Religion and Archaeology

Edited by

Laura Nasrallah, Charalambos Bakirtzis,
and Steven J. Friesen

DISTRIBUTED BY
HARVARD UNIVERSITY PRESS
FOR
HARVARD THEOLOGICAL STUDIES
HARVARD DIVINITY SCHOOL

From Roman to Early Christian Thessalonikē
Studies in Religion and Archaeology

Harvard Theological Studies 64

Series Editors:
François Bovon
Francis Schüssler Fiorenza
Peter B. Machinist

The foreign language fonts (Symbol GreekII, New Jerusalem [Hebrew]) and transliteration fonts (Translit LS) used in this book are available from Linguist's Software, Inc., P.O. Box 580, Edmonds, WA 98020-0580; tel: (425) 775-1130. Website: www.linguistsoftware.com

Library of Congress Cataloging-in-Publication Data

From Roman to Early Christian Thessalonikē : studies in religion and archaeology / edited by Laura Nasrallah, Charalambos Bakirtzis, and Steven J. Friesen
 p. cm. -- (Harvard theological studies .; 64)
 Includes bibliographical references and index.
 ISBN 978-0-674-05322-9 (alk. paper)
 1. Thessalonike (Greece)--Civilization. 2. Thessalonike (Greece)--Church history. 3. Church history--Primitive and early church, ca. 30-600. 4. Bible. N.T. Thessalonians--Criticism, interpretation, etc. 5. Thessalonike (Greece)--Antiquities. 6. Thessalonike (Greece)--Antiquities, Roman. 7. Excavations (Archaeology)--Greece--Thessalonike. 8. Architecture--Greece--Thessalonike. 9. Romans--Greece--Thessalonike. I. Nasrallah, Laura Salah II. Bakirtzis, Ch. (Charalambos) III. Friesen, Steven J.
 DF261.T49F76 2010
 938'.2--dc22
 2010021681

Contents

Acknowledgments

Many hands go into the making of a conference and a coedited volume. For help in sponsoring and planning the conference, we wish to thank then-director of the Center for the Study of World Religions Professor Donald Swearer, Susan Lloyd McGarry, Charles Anderson, and especially our graduate student assistant at the time, the now Dr. Taylor Petrey. We are also grateful to the Ephoreia of Byzantine Antiquities of Thessaloniki for preparing the exhibit that accompanied the conference, and for the generosity of that Ephoreia and the Greek Ministry of Culture for donating the exhibit to Harvard Divinity School.

The volume itself was accepted into this series by Professor François Bovon and funded in part from the office of Dean William Graham at Harvard Divinity School, for which we are grateful. For work on the volume itself, we thank Dr. Margaret Studier, managing editor of Harvard Theological Studies, and members of her staff—copy editors and typesetters Richard Jude Thompson, Eve Feinstein, and Dr. Thomas Wetzel; typesetter Gerhild Klose; proofreaders Dr. Gene McGarry and Keith Stone; and indexer Kip Richardson. At various points in the project, Thomas Christopher Hoklotubbe and the now-Dr. Cavan Concannon were helpful editorial assistants. In the final stages, Michal Beth Dinkler's work in copyediting and proofing was invaluable.

I would especially like to thank my coeditors, Dr. Charalambos Bakirtzis and Professor Steven J. Friesen, for their generous work together on the conference and this volume. It is a precious thing to work with scholars whom one both respects and enjoys. The intellectual imprint of Professor Helmut Koester on this volume should be evident, and it is largely due to his early efforts that such a conference and book were possible at all. For that imprint, we and many generations of his students and colleagues are grateful.

Abbreviations

For abbreviations not included here, see *The SBL Handbook of Style* and the third edition of *The Oxford Classical Dictionary*.

AA	*Archäologischer Anzeiger*
AB	Anchor Bible
AIHV	Association internationale pour l'histoire du verre
AIS	*Archaeology and Italian Society*
AJA	*American Journal of Archaeology*
AM	*Athenische Mitteilungen*
ABD	*The Anchor Bible Dictionary*
AEMΘ	*Αρχαιολογικόν Έργον στη Μακεδονία και θράκη*
ARA	*Annual Review of Anthropology*
ArchDelt	*Αρχαιολογικόν Δελτίον*
ArchEph	*Αρχαιολογική Εφημέρις*
ASMOSIA	*Association for the Study of Marble and Other Stones in Antiquity*

BAR	British Archaeological Reports
BCH	*Bulletin de correspondance hellénique*
BCHSup	BCH supplément
BHTA	British Healthcare Trades Association
BE	*Bulletin épigraphique*
BibInt	*Biblical Interpretation*
BMGS	*Byzantine and Modern Greek Studies*
BoJ	*Bonner Jahrbücher*
BR	*Biblical Research*
BSA	*Bulletin de la société archéologique*
Byzantion	*Byzantion, Revue internationale des études byzantines*

CA	*Cahiers archéologiques*
CBQ	*Catholic Biblical Quarterly*
CH	*Church History*
CFHB	Corpus Fontium Historiae Byzantinae
CIG	*Corpus Inscriptionum Graecarum*
CIL	*Corpus Inscriptionum Latinarum*
CRAI	*Comptes rendus de l'Académie des inscriptions et belles-lettres*

DNP	*Der neue Pauly. Enzyklopädie der Antike*
DOP	*Dumbarton Oaks Papers*
EA	*Epigraphica Anatolica*
EHBS	*Epeteris Hetaireias Byzantinon Spoudon*
EKM	*Επιγραφές κάτω Μακεδονίας*
FAS	Frankfurter althistorische Studien
Gn	*Gnomon*
GOTR	*Greek Orthodox Theological Review*
HR	*History of Religions*
HTR	*Harvard Theological Review*
HTS	Harvard Theological Studies
IG X/2.1	Edson, *Inscriptiones Thessalonicae et viciniae*
ICS	*Illinois Classical Studies*
ILS	*Inscriptiones latinae selectae*
Int	*Interpretation*
JAC	*Jahrbuch für Antike und Christentum*
JBL	*Journal of Biblical Literature*
JECS	*Journal of Early Christian Studies*
JFSR	*Journal of Feminist Studies in Religion*
JGS	*Journal of Glass Studies*
JHN	*Journal of the History of Neurosciences*
JJS	*Journal of Jewish Studies*
JRA	*Journal of Roman Archeology*
JRS	*Journal of Roman Studies*
JSJ	*Journal for the Study of Judaism in the Persian, Hellenistic, and Roman Periods*
JSNT	*Journal for the Study of the New Testament*
JSNTSup	Journal for the Study of the New Testament Supplement Series
JSOT	*Journal for the Study of the Old Testament*
JWCI	*Journal of the Warburg and Courtauld Institutes*

LCL	Loeb Classical Library
LIMC	*Lexicon iconographicum mythologiae classicae*
LRCW	*Late Roman Coarse Wares*
LSJ	Liddell, H. G., R. Scott, and H. S. Jones. *A Greek-English Lexicon*. 9th ed.
MH	*Museum Helveticum*
MMLA	*Bulletin of the Midwest Modern Language Association*
MBC	*Museum of Byzantine Culture*
NA	*Numina Aegaea*
NCB	New Century Bible
NIBC	New International Bible Commentary
NovT	*Novum Testamentum*
NTAbh	Neutestamentliche Abhandlungen
NTS	*New Testament Studies*
OCT	Oxford Classical Texts/Scriptorum classicorum bibliotheca oxoniensis
PAE	*Praktika Archaeologikes Hetaireias*
PG	J. P. Migne, ed. *Patrologia cursus completus. Series Graeca.*
PraktAE	*Praktika tes en Athenais Archaiologikes Hetaireias*
QDAP	*Quarterly of the Department of Antiquities in Palestine*
QR	*Quarterly Review*
RA	*Revue archéologique*
RB	*Revue biblique*
RE	*Realencyklopädie für protestantische Theologie und Kirche*
Rend.	*Rendiconti Classe di Scienze Morali Storiche e Filologiche*
RIDA	*Revue internationale des droits de l'antiquité*
RIG	*Recueil d'inscriptions grecques*
RPh	*Revue de philologie, de littérature et d'histoire anciennes*
RömMitt	*Römische Mitteilungen = Mitteilungen des Deutschen Archäologischen Instituts: Römische Abteilung*

SBL	Society for Biblical Literature
SBLDS	Society of Biblical Literature Dissertation Series
SBLSymS	Society of Biblical Literature Symposium Series
ScrHier	*Scripta hierosolymitana*
SNTSMS	Society for New Testament Studies Monograph Series
SPhilo	*Studia philonica*
SR	*Studies in Religion*
StudRomag	*Studi Romagnoli*
TAPA	*Transactions of the American Philological Association*
ΘΠ	*Θεσσαλονικέων Πόλις*
TM	*Travaux et Mémoires*
TRAC	Theoretical Roman Archaeology Conference
TynBul	*Tyndale Bulletin*
TRE	*Theologische Realenzyklopädie*
WUNT	Wissenschaftliche Untersuchungen zum Neuen Testament
ZNW	*Zeitschrift für die neutestamentliche Wissenschaft und die Kunde der älteren Kirche*
ZPE	*Zeitschrift für Papyrologie und Epigraphie*

Introduction
Laura Nasrallah

This interdisciplinary volume brings together the research of Greek archaeologists and scholars of the New Testament, Early Christianity, and Byzantine Studies. The essays focus on social, political, and religious life in Roman and early Christian Thessalonikē,[1] treating literary and archaeological remains that span from the first century B.C.E. to the seventh century C.E.

Founded by Cassander in 316/5 B.C.E. on the Thermaic Gulf in the Aegean, Thessalonikē was a vibrant and politically significant metropolitan center from its foundation through the Hellenistic, Roman, and early Christian periods and beyond. In the Roman period, the city lay on the Roman Via Egnatia by land and was a diverse center of religious practice. It was home to cults of the Greek pantheon, Roman emperors, the God of Israel, the deities of Egypt, and the Christ of earliest Christianity. By the late third century, Thessalonikē had become one of the imperial capitals of the Roman Empire. The emperor Galerius—known for his persecution of Christians—built a palace complex there, and Constantine—famously the first Christian emperor—expanded its harbor and renovated areas of the palace complex as he considered Thessalonikē for his new capital. Thessalonikē is also one of the most important sites for the study of early Christian art and archaeology, with brilliant mosaics in various churches across the city and some of the earliest evidence of early Christian church structures, in a variety of architectural forms. While Thessalonikē's importance lessened in Late Antiquity as Rome

[1] This volume varies the spelling of the city, as does the Greek. Thus the Roman and early Christian city is spelled Thessalonikē, with an ēta; modern Greek instead uses an iota and the city's name is transliterated Thessaloniki.

and Constantinople gained power, stories of the city's patron St. Demetrios grew, as did his cult and the social services it offered.

This book, which treats that period in the history of Thessalonikē, emerges from a conference held at Harvard Divinity School in 2007. The conference was co-organized and generously sponsored by the Hellenic Ministry of Culture, the Institute for the Study of Antiquity and Christian Origins at the University of Texas at Austin, and the Center for the Study of World Religions at Harvard University. The conference originally was conceived during the collaboration between Charalambos Bakirtzis of the Ephoreia of Byzantine Antiquities of Thessaloniki and Helmut Koester, when he directed the New Testament archaeology project at Harvard Divinity School, and was carried out by this volume's co-editors. A photographic exhibit titled "Studying, Conserving, and Displaying Early Christian Thessalonikē," generously prepared and donated by the Ephoreia of Byzantine Antiquities of Thessaloniki, framed the walls of the room where the conference papers were read and received. For several days, scholars from a range of disciplines met to share findings about social history and religious life in the Roman and early Christian city of Thessalonikē, and to build a common understanding across our disciplinary trainings.

From Roman to Early Christian Thessalonikē: Studies in Religion and Archaeology is also part of the larger interdisciplinary work in Archaeological Resources for New Testament Studies begun by Helmut Koester and currently directed by myself at Harvard Divinity School. This network of scholars has produced volumes on Corinth, Ephesos, and Pergamon.[2]

Standing within this scholarly tradition, the conference and this volume make three major contributions to our knowledge about religion in the ancient world. First, the essays here add new analyses of the city of Thessalonikē in the Roman and early Christian periods. Catalogues of evidence are put to new uses to reveal the complexities of social and religious life in the city (for example, epigraphic evidence in Nigdelis's and Ascough's essays); scattered fragments regarding Egyptian cults in Koester's; typologies of sarcophagi

[2] In order of their publication, these volumes are: *Ephesos, Metropolis of Asia: An Interdisciplinary Approach to its Archaeology, Religion, and Culture* (ed. Helmut Koester; HTS 41; Valley Forge, Pa.: Trinity Press International, 1995); *Pergamon: Citadel of the Gods: Archaeological Record, Literary Description, and Religious Development* (ed. Helmut Koester; HTS 46; Harrisburg, Pa.: Trinity Press International, 1998); *Urban Religion in Roman Corinth: Interdisciplinary Approaches* (ed. Daniel Schowalter and Steven J. Friesen; HTS 53; Cambridge, Mass.: Harvard Divinity School, 2005); *Corinth in Context: Comparative Perspectives on Religion and Society* (ed. Steven J. Friesen, Daniel Schowalter, and James Walters; Leiden: E. J. Brill, 2010).

in Stefanidou-Tiveriou's; ceramic and glass in Papanikola-Bakirtzi's and Antonaras's essays; the urban topography of Christian cities in Ćurčić's. In other essays, detailed case studies allow us to see a piece of literature, a monument, or a methodology in a new light (for example, Johnson-DeBaufre's evaluation of scholarly approaches and ancient evidence; Thomas's study of purity; Friesen's study of 2 Thessalonians; Mentzos's study of the Palace area; my investigation of the hermeneutics of the Moni Latomou mosaic; Bakirtzis's review of evidence regarding St. Demetrios).

Second, our conference and volume contribute to new trends in how archaeological resources are used for the study of the New Testament and early Christianity and how the work of those in religious studies can contribute to the study of Greco-Roman and early Christian archaeology. In the context of the History of Religions School at the turn of the nineteenth to the twentieth centuries, scholars of New Testament shifted from looking at the ruins of the Roman world only for hints of earliest Christianity to an interest in these remains for their own sake. These scholars concluded that "pagan" comparanda, whether literary or archaeological, could serve as a background from which earliest Christian rituals such as baptism or meal practices emerged. More recently, scholars of New Testament and early Christianity who pay attention to archaeological finds have delved into these materials not only to see what ritual and religious parallels they can find for early Christianity but also to understand the social world out of which a variety of religious cults emerged. That is, they seek to understand the emergence of Christianity within a broad context and no longer treat archaeological finds or "pagan" materials as mere background. In addition, archaeologists understand that the approaches of scholars of the New Testament and religious studies more generally could transform their work. What demographic details can we glean about the ancient world? How did the communities emerge in the context of the rise of the Roman Empire? What were the varieties of ethnicities in the Roman period? How was power manifest? What ritual practices occurred and among what sorts of communities? How is religion manifest in everyday objects? This volume addresses such questions, as the authors adduce evidence and offer interpretations of the social and political world in which religious cults are practiced as well as of issues of social life and power within those religious communities.

Finally, this volume models how scholars of multiple disciplines can come together to contribute to a knowledge of the social, political, religious, and everyday life of an ancient city. Too often, scholars of religion and archaeologists and art historians do not communicate about our shared

interests. Scholars of religion are well trained to consider literary texts and even documentary evidence, but often we do not know how to find, much less assess, the archaeological reports or other documentation that could help us to understand the spaces and material world in which religion was practiced. Similarly, archaeologists intensively trained in the science of their field often do not have opportunity to discuss their findings with scholars of religion. Nevertheless, such cross-disciplinary work has occurred through the longstanding seminar "Archaeology of the New Testament World," in which Harvard faculty members Helmut Koester, David Mitten, and myself have taken students to Greece and Turkey to meet with archaeologists and to tour archaeological sites. These seminars gave birth to this volume and others on Corinth, Ephesos, and Pergamon. Moreover, the conference out of which this volume on Thessalonikē emerges was a fruitful convergence of conversations and discussions among scholars of religion and of archaeology. The essays here represent the attempt of various scholars of religion and of archaeology to share our resources and to build together our knowledge about the life of the ancient city of Thessalonikē.

CHAPTER OVERVIEWS

The volume is organized roughly chronologically, with the first part mainly treating literature and archaeological remains from the early Roman Empire (ca. 100 B.C.E.–200 C.E.) and the second part mainly treating literature and archaeological remains from the later Roman Empire and the early Byzantine period (ca. 200–700 C.E.).

The book begins with two essays that focus on Hellenistic and Roman Thessalonikē as a setting for associations of artisans or those who shared common cult practice. Pantelis Nigdelis, author of *Epigraphica Thessalonicensia*, turns his broad knowledge of the inscriptions of the city to ask what they reveal about its social history in the Roman period. He categorizes the forty-four extant inscriptions into four social settings: religious, professional, household, and those for the purpose of entertainment. This chapter provides details regarding the associations' activities and participants, and sets associations in Thessalonikē within a broader regional context. One conclusion that Nigdelis reaches is that voluntary associations were an outlet for those of lower status; they modeled their groups on extant civic structures in order to find new collective identities.

Richard Ascough too uses epigraphic evidence from Roman Thessalonikē to elucidate the concerns expressed about death and about food in Paul's letters and those of his imitators. Voluntary associations often provided funds and a social setting for their members' funerary banquets. This inscriptional evidence puts into a broader context the Thessalonians' concerns for their dead (1 Thessalonians) and the injunction that one should work in order to eat (2 Thessalonians). Ascough demonstrates how multiple communities were concerned with the social practices of eating meals together. Both the literary and epigraphic records show how small communities attempted to regulate the behaviors and meal practices of their members—whether a community in Christ or initiates to Zeus.

Nigdelis and Ascough use epigraphic evidence to show how small groups functioned in Roman Thessalonikē. Melanie Johnson-DeBaufre exposes methodological problems in the study of 1 Thessalonians and the historiography of the ancient world more broadly and shows how women, too, had religious agency and leadership in associations and *ekklēsiai*. Johnson-DeBaufre shows how many scholars (like ancient authors) omit women entirely from their reconstructions of ancient religion or conclude that, because women are absent in the literary record, they must have been nearly invisible. For example, such scholars conclude that women must not have been agents in the earliest communities in Christ in Thessalonikē, since women are nowhere specifically addressed in the epistle, as they are in a text like 1 Corinthians. Those scholars who do recognize the presence of women in Thessalonikē by looking at archaeological remains and the epigraphic record often misuse this information. Recognizing the leadership and agency of "pagan" women, they conclude that such women are sexually loose or otherwise problematic and that 1 Thessalonians implicitly opposes them. Johnson-DeBaufre's chapter embodies a rigorous set of methodological questions that we should bring to ancient materials, whether literary or archaeological, in order to begin to see those whom our sources occlude.

Christine Thomas turns to Paul's language of purity in 1 Thessalonians and other genuine Pauline epistles. She argues that New Testament scholars have misunderstood Greek theological and moral systems, especially the understanding of space and ritual purity in Greek sanctuaries. Even as Paul seeks to construct boundaries between the Gentile community in Christ at Thessalonikē and other Gentiles, he also draws upon a logic that blurs ritual and moral impurities. The different understanding of space and purity that Paul launches, according to Thomas, has to do with his somatization of purity. Instead of locating purity boundaries outside the body, with stelae

and boundaries as in Greek sanctuaries, Paul locates purity boundaries at the surface of the bodies of those in Christ.

In "Egyptian Religions in Thessalonikē," Helmut Koester catalogues the evidence for the worship of Isis, Sarapis, and other Egyptian gods in the city. Ranging in date from the Hellenistic to the Roman period, these materials include buildings, inscriptions, and statuary. Scholars have long seen Egyptian religions as a subset of "foreign" and "mystery" religions that are important comparanda for the introduction of earliest Christianity into the cities of the Greek East. The chapter instead takes the Egyptian materials seriously on their own terms and concludes with a caution that we must balance local and translocal factors in the study of religion in the ancient world, a significant point for the study not only of Egyptian religion but also of Judaism in the diaspora.

Thea Stefanidou-Tiveriou analyzes the typology of locally made Roman sarcophagi in order to discover the social status of those who commissioned such sarcophagi. She asks what influenced buyers' decisions and which styles and iconography were influential in local workshops. Only a small fraction of the population preferred the luxurious and expensive sarcophagi imported from Attica, and, although there was an important Roman community in the city, western influences are very limited in all funerary monuments of Thessalonikē. Stefanidou-Tiveriou observes that, although the owners of the sarcophagi come from different levels of society and have different monetary assets, a high percentage chose locally made products that drew largely from the iconographic and stylistic traditions of Asia Minor. Many families living in Thessalonikē in the Roman period were originally from the cities of the East. She suggests that this demographic reality allows us to interpret the typology of sarcophagi in the context of the reciprocal relations between Asia Minor and Thessalonikē in the Roman period.

The authenticity of 2 Thessalonians has long been debated. Steven Friesen's essay moves beyond the arguments for its deutero-Pauline status and describes the letter as a forgery. He does so to call our attention to the ways in which this short letter provokes important questions about earliest Christian attitudes toward sacred and authoritative texts, about the evolution of orality and writing, and about the aspects of the performance of the relationship between author and audience encoded in letters. Through analysis of the details of 1 and 2 Thessalonians, among other texts, Friesen shows how we are indebted to 2 Thessalonians for laying bare an under-documented period of earliest Christianity: the transition from the period when oral traditions competed with written documents to a time when letters were not items to be debated

in community, but were more weighty and authoritative documents (as Paul, ironically, had always wanted his genuine letters to be).

The second part of the book treats the later Roman Empire and the early Byzantine period. It is important to clarify an issue of nomenclature that differs between disciplines. Material evidence of early Christianity is hard to discern before the third century and even before the fourth. Thus, what many of us trained in religion call the early Christian period (roughly the first to the fourth centuries C.E.) is known to archaeologists as the Roman period. For them, the early Christian period begins only in the third or fourth century with an iconography that is at last legible to us as Christian, and then imperial support for Christianity and the first inklings of major church structures.

The first four chapters of this second part provide an overview of the life of the city from the third to the seventh centuries, as it became a Christian capital. Two chapters focus on the city of Thessalonikē as the empire began to favor Christianity. The Christianization of Thessalonikē was, according to Slobodan Ćurčić, a slow process. His urban overview reveals five large churches woven into the city's fabric: three basilicas and two centralized-domed structures. Ćurčić expands his focus from Thessalonikē to the larger context of early Christian urban iconography. Maps and representations of cities—for example, the famous Madaba map of Jerusalem—show that Christians were self-conscious about how churches fit into the urban fabric. Ćurčić concludes by showing how the two centralized-domed structures of Thessalonikē, which punctuate the city's east-west axis near the city walls, may be a literal manifestation of early Christian urban iconography, symbolizing on either side of the city the earthly and the heavenly Jerusalems.

James Skedros turns us toward the literature of the same period as Ćurčić's architectural survey. Using hagiographical materials, church canons, and letters between imperial and ecclesiastical officials from the fourth through the eighth centuries, Skedros outlines Thessalonikē's changing fortunes in its relations with Rome and Constantinople. He concludes that the cult of St. Demetrios became a key civic marker for Thessalonikē, a way for the ecclesiastical hierarchy and common people of the city to articulate their identity between the new Rome and the old.

The next two chapters move us from ecclesiastical structures and debates to the wider material culture of Late Antiquity, providing data about the use of ceramics and glass in the city. Demetra Papanikola-Bakirtzi brings together ceramic remains of Late Antique Thessalonikē to show something of everyday life in the city. These remains, scattered and difficult to interpret,

nonetheless give a wealth of information: pottery was used as architectural elements (roof tiles and bricks, many with inscriptions), as vessels for the storage and transportation of goods, as cookware, for lamps, and for grave rituals. Her chapter illuminates something not only about the users of such ceramics and the types and decorative detailing they favored, but also about patterns of importing ceramics.

Anastassios Antonaras catalogs the glassware of Thessalonikē from the third to the seventh centuries. From unguentaria to windowpanes to mosaics, glass was used in various ways. Antonaras concludes that glass was common and inexpensive, but warns that we have lost much data due to the fact that it is easily recycled. From his essay, we glimpse glass in its many social settings: the church, graves, and the common household table, to name only a few.

The three final essays provide case studies of Thessalonikē in the late Roman and early Byzantine periods. The palace complex to the south of the Rotunda in Thessalonikē is famously hard to interpret. Aristoteles Mentzos analyzes evidence for the dating and architectural evolution of the nucleus of the palace complex: the octagon, the basilica, and the north court. Mentzos concludes that the palace complex was built in stages and that it was certainly not complete in the reign of Galerius. Instead, it continued to develop during the early Byzantine period. His chapter thus gives us the sense of the evolution of an important set of buildings, in a period crucial for the history of the city, from the third to the seventh centuries and beyond.

My chapter focuses on the mosaic at Hosios David (Moni Latomou). I analyze it alongside literary sources to draw three conclusions. First, representations in the mosaic at Hosios David may tell us about the use and appreciation of texts that we might otherwise conclude were excluded from the canon, such as the Apocalypse of John. Second, juxtaposing the mosaic and a homily of John Chrysostom, I demonstrate that similar midrashic impulses drove each of these early Christian "texts." Third, I hypothesize that 1 Thessalonians may have been an important source for local identity in Thessalonikē, a piece of literature whose imagery of the appearance of Christ in the sky may have influenced the iconography of local early Christian mosaics.

Charalambos Bakirtzis argues that the Church of St. Demetrios functioned not only as a pilgrimage site but also as a hospital and healing center. Drawing from stories of healings in the *Miracles of Saint Demetrios*, Bakirtzis outlines the medical procedures and methods that were possible for people of all social standings to receive at the basilica. He sets these within a wider context of Christian healing centers elsewhere, as well as other traditions of medical care in the ancient world, such as in the cult of Asklepios or in the Sarapeion

in Thessalonikē. Like Asklepios or Sarapis, St. Demetrios came to patients in dreams. Representations of St. Demetrios with children may indicate that the hospital was particularly concerned with pediatric cases. Bakirtzis shows how a similar transition occurred on a literary level, as Christians took over non-Christian theatrical performances and deployed them, only slightly changed, for their own purposes, as is obvious in two mime plays included in hagiographical texts on Thessalonian martyrs. His chapter thus shows the transformation of two important civic institutions—health care and theater—in Late Antique Thessalonikē.

As we learn in each chapter, the historical data that come to us are fragmented: parts of a papyrus, only one side of a correspondence, a ruined basilica, sherds of a pot. Scholars too are fragmented into disciplines: history, New Testament Studies, archaeology, art history. This volume acknowledges that our historical reconstructions are provisional, but also recognizes that they are richer—that we see more and ask better questions—when scholars from various disciplines come together and share the evidence we have from antiquity and the different methodologies of our fields. These chapters show how to bring together a variety of evidence—letters, inscriptions, sarcophagi, buildings, sculptures—to understand better the social world of the Roman and early Christian city of Thessalonikē and its position as a religious crossroads.

The Early Roman Empire

Voluntary Associations in Roman Thessalonikē: In Search of Identity and Support in a Cosmopolitan Society

Pantelis M. Nigdelis

In the last hundred years, many scholars have furthered our understanding of Greco-Roman voluntary associations, including those at Thessalonikē.[1] Nevertheless, there has not yet been a study that takes into account all the available evidence concerning the corporate organization of voluntary associations, including information about their composition, activities, and identity.[2] The publication of the corpus of inscriptions from Thessaloniki has made new inscriptions and improved readings available to scholars, making a comprehensive and up-to-date study of the associations all the more desirable for those who would reconstruct the social history of the city.[3] The aim of this paper is to provide an updated framework for such a study.

[1] On the term "voluntary association," see Kloppenborg, "Collegia and Thiasoi," 17–18. I would like to thank Glen Bowersock, Corrine Bonnet, and Ilias Arnaoutoglou for their comments and suggestions.

[2] Kanatsoulis gives a review of the then-known epigraphic evidence about the associations of Macedonia (those of Thessalonikē included) in "Η Μακεδονική πόλις," 269–80. However, he uses the misleading term "professional union" for the professional associations. Youni and Ascough deal with aspects of the subject within the broader context of Macedonia, without, however, exhausting the subject or taking into account all the epigraphic evidence (Youni, *Provincia Macedonia,* 115–20; Ascough, *Paul's Macedonian Associations*).

[3] For the new epigraphic evidence see Nigdelis, *Επιγραφικά Θεσσαλονίκεια*, 101–211.

Forty-four inscriptions of the imperial era, most of them funerary inscriptions of the second and third centuries C.E., disclose evidence for thirty-nine associations under a variety of titles such as θίασος (religious guild), συνκλίται (companions), (συν)θρησκευταί ([co]-worshipers), συνήθεια (guild), συνήθεις (club), μύσται (initiates), βακχεῖον (Bacchic community), δοῦμος (religious association), σπεῖρα (guild), and κολλήγιον (*collegium*).[4] These associations can be classified in four categories:[5] religious, professional, household,[6] and associations of arena and theater devotees.

THE ASSOCIATIONS OF THESSALONIKĒ

Even a brief overview shows that religious associations are the most numerous at twenty-four. Most of these are Dionysiac associations devoted to different aspects of the god's nature. For example, Dionysos is worshiped as a god of

[4] Contrary to what is sometimes argued about some of the above terms, none of them denotes explicitly the nature of the association as religious or professional. Typical is the case of the term συνήθεια, about which the opinion has been expressed that it denotes professional associations (see the next note). Inscription no. 41, in which the συνήθεια φιλοπαικτόρων (club of jesters or fans of theater shows) is mentioned, amply demonstrates the relative nature of the terminology of the city's associations.

[5] The classification that follows is not the only one possible. Scholars have already stated that some of the associations classified below as religious are actually professional associations under the protection of a particular god that they worshiped. This is true of the associations mentioned in inscription no. 28 (δοῦμος Ἀφροδίτης Ἐπιτευξιδίας; see Voutiras, "Berufs- und Kultverein," 87–96), nos. 15, 16, 25, 29, and 35 (συνήθεις Ἡρακλέους—συνήθεις Περιτιαστῶν; see Poland, *Vereinswesen*, 51–52; Kanatsoulis, "Η Μακεδονική πόλις," 271 n. 9; Iliadou, *Herakles in Makedonien*, 99; and vom Brocke, *Thessaloniki*, 81, who accepts, however, that the association had some kind of cultic function), no. 27 (συνήθεια Ἥρωνος Αὐλωνίτου; see Nigdelis, *Επιγραφικά Θεσσαλονίκεια*, 256, for the relevant views), no. 30 (συνήθεια ἥρωος Αἰνεία; Pandermalis, "Zum römischen Porträt," 161–65). In these cases it cannot be concluded, however, whether the adoration of a revered deity constitutes the basis for the association's existence or simply seals with religious bonds and as an afterthought the common interests of members, as was the case in the professional associations. See Belayche, "Enquête de marqueurs," 16, and the characteristic case of inscription no. 36 (συνήθεια ἐπὶ τοῦ Ποσειδῶνος, where the deceased is a perfume-seller). On the criteria used to classify the professional associations, see Zimmermann, *Handwerkervereine*, 42–43. Although professionals participated in some of the above associations, I prefer to classify them as religious, either because we do not have information about their membership as a whole or because it is not evident from their titles that they consisted purely of workers in the same profession (see, e.g., πορφυροβάφοι and στεφανηπλόκοι). Unless otherwise noted, all references to inscriptions are taken from Nigdelis, *Επιγραφικά Θεσσαλονίκεια*.

[6] On this category of associations see Kloppenberg, "Collegia and Thiasoi," 2–3. In contrast, Ascough doubts the "viability" of such a category (Ascough, *Paul's Macedonian Associations*, 8 n. 39).

nature and fertility by the members of the θίασος Πρινοφόρος, the θίασος Δροιοφόρων,[7] and the Διόνυσος Ὠροφόρος (probably also a θίασος), the latter having been founded by a certain Musaeus.[8] Three interesting Dionysiac associations have in common that their founder(s) originated in Asia Minor: the σπεῖρα (the full title is not given in the inscription),[9] the θίασος Ἀσιανῶν, [10] and the βακχεῖον Ἀσιανῶν.[11] In the case of the σπεῖρα the origin of the founder(s) is presumed by the Phrygian title γάλλαρος, which its officials bear and which reveals syncretism with the worship of Cybele.[12] In some of the above associations, such as the θίασος Πρινοφόρος and the σπεῖρα, certain perceptions about the afterlife can be detected, as the participation of children and certain worship practices suggest.[13] Other Dionysiac associations include the Ἐριφιασταί[14] (initiates of Dionysos Eriphios) and the μύσται Διὸς Διονύσου Γογγύλου (initiates of Zeus Dionysos Gongylos).[15] Although the former were almost certainly

[7] See inscription no. 13. The exact name of the first *thiasos* eludes us. Poland thinks that the *thiasos* worshiped Dionysos under the invocation Πρινοφόρος (*Vereinswesen*, 220), while Edson speaks of Πρινοφόρους (Edson, "Cults," 177); followed by Kanatsoulis, "Η Μακεδονική πόλις," 275; Merkelbach, *Die Hirten des Dionysos*, 117; vom Brocke, *Thessaloniki*, 127; and recently Mitrev, "Dionysiac Thiasoi," 289–97. Regardless of what may be thought, it is evident that in the context of these two *thiasoi* there was δενδροφορία and consequently a worship of nature. Edson also thinks that these two *thiasoi* were official, but the presence of children in θίασος Πρινοφόρου (see below, n. 13) and the relation between those two associations make this conclusion unlikely, in my opinion ("Cults," 177). Edson's argument that the inscription must have been found at the temple of Dionysos has been disputed; see Vitti, *Η πολεοδομική εξέλιξη*, 90–91. On the contrary, the *thiasoi* whose priest (ἱερασάμενος θιάσων Διονύσου) was the councillor Isidoros, son of Sabinus (see Edson, *Inscriptiones Thessalonicae*, [= *IG* X/2.1] no. 506), could be regarded as official; this is why I did not include the inscription in the catalogue of testimonies.

[8] See inscription no. 32; and Nigdelis, *Επιγραφικά Θεσσαλονίκεια*, 129–34.

[9] See inscription no. 31; and Nigdelis, *Επιγραφικά Θεσσαλονίκεια*, 101–28.

[10] See inscription no. 19; and Edson, "Cults," 154–58.

[11] See inscription no. 20; and Nigdelis, *Επιγραφικά Θεσσαλονίκεια*, 135–46. For the meaning of the term Asianoi see below, n. 50.

[12] See Nigdelis, *Επιγραφικά Θεσσαλονίκεια*, 120.

[13] One example is the re-enactment of the myth of the ascension of Dionysos's mother, Semele, from the underworld. See vom Brocke, *Thessaloniki*, 127; and Nigdelis, *Επιγραφικά Θεσσαλονίκεια*, 122, respectively.

[14] The name can be read in a fragmentary inscription. See inscription no. 14. Holtheide recognized in it an association of ναύκληροι (shipowners) because of the οἶκος mentioned in line 14 of the inscription. Holtheide, "Zum privaten Seehandel," 6–7. But every association could have had such a meeting place. For the οἶκος of *hieraphoroi synklitai* (= ἱεραφόροι συνκλίται [society of the bearers of holy objects]), see inscriptions nos. 2 and 75.

[15] See inscription no. 12 with the corrections by Daux, "Quelques inscriptions," 478–87. The same corrections were proposed independently by Peek, "Zu den *Inscriptiones*," 200,

worshipers of Διόνυσος Ἐρίφιος,[16] the identity of the gods worshiped by the latter is not absolutely evident. An inscription discovered in ancient Ioron (today Kentrikon, Prefecture of Kilkis) in the neighboring area of Chrestonia mentions the μύσται Διονύσου Γονγύλων; some statuettes of Bes,[17] the big-bellied Egyptian god of fertility, dance, and magic, were also found. These finds strengthen the older assumption that connects Sarapis to Zeus and Bes to Dionysos Gongylos,[18] and thus it makes sense that this inscription was dedicated in the Sarapeion of Thessalonikē. One view has it that the δοῦμος ταύρου κομπέτου, which appears in a funerary inscription now lost, is connected with the worship of Dionysos as well.[19] The inscription concerns a δοῦμος, an association of Phrygian origin residing at a crossroads of the city, in which both the Great Mother of the Gods/Cybele and the bull-faced Dionysos were objects of worship.[20]

Adherents of the extremely popular Egyptian gods make up the second largest group of religious associations in Thessalonikē. Groups of believers, priests, and/or ministers joined associations that bore names such as συνθρησκευταὶ κλείνης θεοῦ μεγάλου Σαράπιδος (worshipers of the great

203. For the bibliography of this inscription after Daux's study, see Vermaseren, *Cybele and Attis*, 135; Daux, "Notes de lecture," 555–56; Wild, *Water in the Cultic Worship*, 194–95; vom Brocke, *Thessaloniki*, 127–28; Kubińska, "Tiberius Claudius Lycus," 153–60; Mitrev, "Dionysiac Thiasoi," 293–96; Steimle, "Das Heiligtum der ägyptischen Götter," 27–38. Internal indications show that inscription no. 11 is a catalogue of the initiates of the association.

[16] On this cult of Dionysos see Merkelbach, *Die Hirten des Dionysos*, 13–14.

[17] On the inscription from Kentrikon (Museum of Kilkis cat. no. 46), see in the interim Hatzopoulos and Loukopoulou, *Morylos cité de la Chrestonie*, 99 n. 4. On the cult of Bes in the area, see Anagnostopoulou-Chatzipolychroni, "Ἀνασκαφή Παλατιανοῦ 1993," 391 and plate 9; eadem, "Οι αρχαιολογικές έρευνες," 195 and plate 28. On the cult of Bes generally, see Tinh, "Bes," 98–108. The connection of Zeus Dionysos Gongylos to Bes is accepted reluctantly by Wild (*Water in the Cultic Worship*, 193) but rejected by Steimle, who, however, does not take into account the above-mentioned new data (Steimle, "Das Heiligtum der ägyptischen Götter," 34).

[18] André-Jean Festugière, *apud* Daux, expresses this opinion ("Trois inscriptions," 487 n. 1). Festugière also thinks that the office of βησάρτης must be understood as "celui qui lève (soulève) Bès."

[19] See inscription no. 23 with the remarks of Łajtar, "Ein zweiter Beleg," 211–12. The inscription is known only from a copy of Karl Purgold (1885) kept at the Academy of Berlin.

[20] See Marina Polito, who takes into account the original meaning of the word δοῦμος and speaks of a "culto dionisiaco o metroaco" in the context of the above association (Polito, *Il δοῦμος*, 49–51). In contrast, Łajtar thinks that the word ταῦρος is a proper name, i.e., the name of the founder of the association (Łajtar, "Ein zweiter Beleg," 211–12). On the interpretation of the term κόμπετον = *competum* = *compitum*, see ibid., 211–12. On the cult of Dionysos as a bull, see Merkelbach, *Die Hirten des Dionysos*, 13.

god Sarapis),²¹ θρησκευταὶ καὶ σηκοβάται θεοῦ Ἑρμανούβιδος (worshipers and religious officials of the cult of the god Hermanoubis),²² and ἱεραφόροι συνκλίται.²³ In the latter case the members were drawn from the Egyptian cults, as suggested by the office of Ἀνουβοφόρος, which was held by the founder of the association.²⁴

In addition to the associations devoted to Dionysos and the Egyptian gods, there appear associations dedicated to the worship of other traditional Greek gods and demigods. A relatively large number of inscriptions attests to the existence of an association in honor of Herakles, who was popular among the Macedonians (συνήθεις τοῦ Ἡρακλέους or Περιτιασταί).²⁵ Two associations that worshiped Aphrodite are attested: the δοῦμος Ἀφροδίτης Ἐπιτευξιδίας (religious association devoted to Aphrodite Epiteuxidia), which included shipowners and merchants,²⁶ and the θρησκευταὶ Ἀφροδίτης, worshipers of Ἀφροδίτη (Νυμφία).²⁷ The catalogue can be enriched with associations dedicated to Artemis, Asklepios (Ἀσκληπιασταί, worshipers

²¹ See inscription no. 7.

²² See inscriptions nos. 10 and 1. See also Steimle, "Das Heiligtum der ägyptischen Götter," 31–32.

²³ See inscription no. 2. For re-dating of and commentary on the inscription see Voutiras, "Sarapieion de Thessalonique," 286–87; and Steimle, "Das Heiligtum der ägyptischen Götter," 28–29.

²⁴ This office is attested only by the relief of the stele; see commentary by Voutiras, "Sarapieion de Thessalonique," 286.

²⁵ The first name is given by inscriptions nos. 15, 16, 25, and 35, and the second by inscription no. 29. The fact that in inscriptions nos. 15, 16, and 29 the head of the association (ἀρχισυνάγωγος) is the same person leads Hatzopoulos to the conclusion that these inscriptions deal with the same association, whose members bear the name Περιτιασταί from the Macedonian month Περίτιος, which was dedicated to Hercules Phylakos (Hatzopoulos, "Récentes découvertes épigraphiques," 1202–4). Iliadou (*Herakles in Makedonien*, 91) ignores the inscription.

²⁶ See inscription no. 28. The opinion of the first editor (Voutiras), that the δοῦμος consisted exclusively of professionals, is rejected by Polito, who attributes to the term δοῦμος its original (Phrygian) meaning, i.e., a religious association that worships the Magna Mater (here syncretized with Venus = Aphrodite). Correspondingly, Polito doubts that all the members of the association were shipowners or merchants, such as the deceased commemorated in the inscription (Polito, *Il* δοῦμος, 44–49). On the same inscription see also Zimmermann, *Handwerkervereine*, 42.

²⁷ See inscription no. 18; and Voutiras, "Aphrodite Nymphia," 111–13 (with corrections). The latter argues convincingly that the deceased Κλεονίκη ἡ καὶ Κυρίλλα, honored by the θρησκευταί, participated in the rituals of ἱερογαμία in the sense that "während eines Rituals einem Gott (möglicherweise Eros) symbolisch zugeführt wurde, wie etwa die Gattin des Archon Basileus dem Dionysos." In the past, Robert had assumed that the θρησκευταί "semble avoir ici le sens du français 'adorateurs,'" implying that the deceased woman was a hetaera (Robert, *Hellenica* II, 123–42, esp. 133 n. 42; see also n. 93 below).

of Asklepios)[28] and Poseidon (συνήθεια ἡ ἐπὶ τοῦ Ποσειδῶνος, guild of worshipers of Poseidon),[29] the latter being made up of members who engaged in, or were dependent on, maritime commerce. Also found are dedications of the συνήθεις Ἀρτέμιδος Ἀκραίας[30] as well as the συνήθεις τῆς Ἀρτέμιδος Γουρασίας τῆς πρὸς τῇ Ἀχέρδῳ.[31] The former preserves in its official title the Macedonian glossa ἀκραία, known from Hesychius, which indicates that the goddess was worshiped as a patron deity of young girls. The latter association might have been dedicated to a (prehellenic) local deity, who was later identified with Artemis and was probably based in the *territorium* of the city.

Of course, traditional deities did not monopolize the interest of the inhabitants of the city. Thessalonians with monotheistic beliefs considered themselves συνκλίται of Θεὸς Ὕψιστος (the Highest God),[32] while others probably dedicated themselves to the worship of Cybele and Attis.[33] To these can be added worshipers of local heroes such as the Thracian horseman (οἱ περὶ τὸν Ἥρωα);[34] the hero Auloneites, patron deity of narrow passes (ἡ συνήθεια Ἥρωνος Αὐλωνίτου);[35] and Aeneias, the local hero of the neighboring Aeneia (ἡ συνήθεια ἥρωος Αἰνεία).[36] In the last two cases, professionals in transportation and fishing participated, respectively. The fishermen came to the city from neighboring Aeneia, which was already a village of Thessalonikē in the imperial era.

[28] See inscription no. 20.

[29] See inscription no. 36 (the deceased was a perfume-seller); and Nigdelis, *Ἐπιγραφικά Θεσσαλονίκεια*, 163–67.

[30] See inscription no. 34; and Nigdelis, *Ἐπιγραφικά Θεσσαλονίκεια*, 152–59.

[31] See inscription no. 33; and Nigdelis, *Ἐπιγραφικά Θεσσαλονίκεια*, 147–51.

[32] See inscriptions nos. 4, 5, 6, and 37. About this association see the exhaustive discussion of Tsalambouni, *Η Μακεδονία*, 221–56; and Nigdelis, *Ἐπιγραφικά Θεσσαλονίκεια*, 168–78. Recently Campanelli believes that inscription appendix no. 37 proves the existence of the *theoxenia* ritual of Egyptian gods in the Hypsistos cult of Thessalonikē (Campanelli, *"Kline e synklitai,"* 123–33). However, her interpretation is based on a misunderstanding of the inscription, since it is a dedication of a certain Zoilos Θεῷ Ὑψίστῳ καὶ τοῖς συνκλίταις and has nothing to do with συμποσιασταὶ θεοί.

[33] See inscription no. 3 and Robert, who supports there his older opinion that it is an association of Cybele and Attis and not of Dionysos, as other scholars suggested after him (Robert, "Les inscriptions de Thessalonique," 199–205). Pachis connects the association with the cult of Mithras because of a recently discovered relief on which the god is depicted (Pachis, "Cult of Mithraism," 229–55).

[34] See inscription no. 22.

[35] See inscription no. 27. For the different interpretations of this association, see Nigdelis, *Ἐπιγραφικά Θεσσαλονίκεια*, 256.

[36] See inscription no. 30 and Nigdelis, *Ἐπιγραφικά Θεσσαλονίκεια*, 206–11.

As to the purely professional associations of the city, four are documented in an equal number of inscriptions: purple dyers (συνήθεια τῶν πορφυροβάφων τῆς ὀκτωκαιδεκάτης),[37] whose workshops were located in the eighteenth street of the city; the association of muleteers (κολλήγιον μουλιώνων);[38] the association of garland (wreath) makers (συνήθεια στεφανηπλόκων);[39] and the association of the professionals of a gladiatorial school (*collegium ludi centinari*).[40] Owners of merchant ships may have formed an association of shipowners (κερδέμποροι).[41] The third category of associations, those pertaining to the household, is represented only by a fragmentary honorary inscription that the freedmen of Furius Proclus and his wife dedicated to their former masters.[42]

To the last category belong two more clubs—the συνήθια τῆς Νεμέσεος and the συνήθεις φιλοπαικτόρων. The former probably consisted of fans of arena sports,[43] with the latter consisting of fans of theater shows, such as scene athletes or *mimoi*,[44] provided that the term φιλοπαίκτωρ does not merely denote a jester.[45]

[37] See inscription no. 17.

[38] See inscription no. 39; and the interpretation by Nigdelis, *Epigraphica Thessalonicensia*, 184–88.

[39] See inscription no. 40; and Nigdelis, *Επιγραφικά Θεσσαλονίκεια*, 188–91. For another association of garland (wreath) makers, see now French, *IvSinope* (IK 64,1) no. 128 where a σύνοδος ἡ τῶν στεφανηπλόκων is mentioned.

[40] See inscription no. 44; and Nigdelis, *Επιγραφικά Θεσσαλονίκεια*, 238–48. As far as I know, this association is the last attested in the inscriptions of Macedonia. For other associations of gladiators and people of the arena in Macedonia known by inscriptions as well, see recently Bouley, *Jeux Romains*, 229–31.

[41] See inscription no. 26 (the inscription was found at Thasos). The name *kerdemporoi* was proposed for the association by Poland, *Vereinswesen*, 107. For doubts that have been expressed on the existence of such an association as a whole and the relevant discussion, see Nigdelis, *Επιγραφικά Θεσσαλονίκεια*, 452–54.

[42] See inscription no. 8. The possibility cannot be excluded that in such an association not only relatives, freedmen, or slaves participated but also other persons who had a looser relation to the household of Furius, as happens with, e.g., the famous household association of Agripinilla; on the latter see McLean, "Agrippinilla Inscription," 259–69.

[43] See inscription no. 38; and Nigdelis, *Επιγραφικά Θεσσαλονίκεια*, 178–84.

[44] See inscription no. 41; and Nigdelis, *Επιγραφικά Θεσσαλονίκεια*, 191–96.

[45] See Nigdelis, *Επιγραφικά Θεσσαλονίκεια*, 192–94 for discussion of the meaning of the term φιλοπαίκτωρ, which is attested here for the first time. If the interpretation "jester" becomes acceptable, then the association of Thessalonikē should be included in the category of the so-called *Vergnügungsvereine* (recreational associations). This would constitute the first attested instance in mainland Greece and also a parallel of the οἱ ἑξήκοντα, an Athenian association of jokers known by Athenaios. For the *Vergnügungsvereine* and the available evidence see Poland, *Vereinswesen*, 56–57; and Bowersock, "Les Euemerioi," 1242–44.

Finally, there are five associations whose nature cannot be determined on the basis of the epigraphic evidence.[46]

TYPES AND NUMBER OF ASSOCIATIONS: SOME REMARKS

Two general remarks can be made concerning the types and number of associations. First, there are far fewer professional associations than religious ones.[47] This is due to the fact that some religious associations included among their members workers in similar professions. Members of religious associations were thus not exclusive to one category, as was the case with professional associations. Their reasons for choosing to belong to religious rather than professional associations is a matter of speculation. It is possible that in such a framework professionals whose trade was not well developed or depended on similar trades could find more opportunities for cooperation; this may have been the case for the perfume-seller G. Hostius Eros, who joined the association of Poseidon (inscription number 36). The cult associations of Egyptian gods, protector deities of shipping, provided increased opportunities for cooperation at the city port.

Second, the number of associations active in Thessalonikē was high in comparison to other cities in the Roman province of Macedonia. For example, in Beroia, another large urban center in the province, the number of inscriptions is half that of Thessalonikē, but only six inscriptions refer to associations.[48] Even if we assume that the epigraphic record is incomplete, the difference cannot be accidental.[49]

The development of the life of associations in the capital of the Macedonian province is not only explained by the prosperous state of the Roman Empire and the fact that associations are an urban phenomenon. This development is connected, first of all, with the cosmopolitan character of the city, which was the biggest port in the North Aegean Sea and situated on the Via Egnatia,

[46] See inscriptions nos. 9, 21, and 24 (for the various possible ways of completing the text of this damaged inscription, see Nigdelis, *Επιγραφικά Θεσσαλονίκεια*, 63 n. 79), as well as inscriptions nos. 42 and 43.

[47] For the terminology used in this paper in regard to religious or professional associations, see above, n. 5.

[48] See Gounaropoulou and Hatzopoulos, *EKM* I, 22, 26, 28, 122, 371, 372, and 383. The number of associations of Thessalonikē could be compared with that of Pompeii, which had forty-five associations in a population of roughly 15,000–20,000 before the eruption of Vesuvius; see Ausbüttel, *Untersuchungen*, 36–37.

[49] The view of Ascough (*Paul's Macedonian Associations*, 19 n. 22), that the difference is due to the fact that Thessalonikē is better excavated, is incorrect.

next to the estuaries of long, navigable rivers, such as the Axios and the Haliakmon. Cult associations, such as the θίασος of Asianoi, the Dionysiac σπεῖρα, the βακχεῖον of Asianoi, the two δοῦμοι, and the συνήθεια of the purple dyers, were almost certainly founded by immigrants from different regions of Asia Minor.[50] Yet these groups were not closed to locals, as an analysis of personal names of their members suggests. The swift recruitment of citizens of Thessalonikē into these associations would have helped foreigners to overcome possible problems of integration and acceptance by the local community as well as legal challenges, such as buying land for burial or cultic purposes.

Persons of foreign origin also participated in other associations, especially those connected to the Egyptian gods, Theos Hypsistos, and Zeus Dionysios Gongylos. By the end of the first century B.C.E. or the first half of the first century C.E., these foreigners were integrated into the social life of the city. This conclusion is confirmed not so much by ethnic markers in inscriptions, which occur rarely, but by the study of non-imperial *gentilicia*.[51] Such a study deals with the birthplace of Roman citizens and demonstrates that members of associations were often descendants or freedmen of families of Italian origin. It can be argued, for at least some of them, that they settled in Thessalonikē, having come either straight from Italian cities or from southern Greece. Many also came from Delos after its destruction in 55 B.C.E.; others came from cities and regions of Asia Minor, especially in the second and third centuries C.E. We also cannot exclude the possibility of immigration from the Roman colonies of Macedonia.[52]

[50] The term Asianos is interpreted by scholars in two ways: a) a resident of Asia Minor; see Sayar, *IvPerinthos*, 236 n. 206 and b) a resident of the province of Asia; see Frisch and Geissen, "Grabstele für einen Provocator," 194. Edson ("Cults," 155) interprets it as of "Asianic origin." According to Jaccottet, the term denotes not the ethnic origin of Asianoi, but the genuineness of their Dionysiac (= micro-Asiatic) convictions (Jaccottet, *Choisir Dionysos*, 2.53). Regarding this erroneous opinion see Nigdelis, *Επιγραφικά Θεσσαλονίκεια*, 138 n. 116. As for the use of the term σπεῖρα, it is usually attested in inscriptions of Dionysiac associations within and outside Asia Minor; see Nigdelis, *Επιγραφικά Θεσσαλονίκεια* 105–7. For the Phrygian origin of the term δοῦμος see above, nn. 20 and 26.

[51] Ethnic origins are indicated only for the following members: Thalos Eutychou Korinthios (inscription no. 5), Menippos Amiou and Severos Thyateirenos (inscription no. 17), and Athenion Praxitelous Amastrianos (inscription no. 28).

[52] The study of the names of the associations' members and particularly the diffusion of the non-imperial *gentilicia* confirms these conclusions (see below). On the origin of the Italian immigrants of Thessalonikē (including members of its associations), see Salomies, "Contacts between Italy," 118–23; and Rizakis, "L'émigration romaine," 124–30. Especially for the origin of *synklitai theou Hypsistou* who have non-imperial *gentilicia,* see the analysis in Tsalambouni, *Η Μακεδονία,* 241–46; and Nigdelis, *Επιγραφικά Θεσσαλονίκεια,* 172–77;

Roman administration does not seem to have had an impact (adverse or otherwise) on the development of the phenomenon of associations, as one may surmise based on the correspondence of Pliny with Trajan. Securely dated inscriptions prove that in Thessalonikē there were associations functioning before, during, and after the reign of Trajan.[53] One more piece of evidence suggesting the absence of any Roman intervention in associative life is the fact that after 42 B.C.E. the city was a *civitas libera*, a status Trajan asked Pliny to respect with regard to Pontic Amastris's associations.[54]

MEMBERSHIP OF ASSOCIATIONS

The composition of the membership of associations, as far as the sex, legal status, and social status of the 243 known members is concerned, can be reconstructed to some extent through the study of their personal names, since there is some available prosopographical evidence.

Such a study indicates that most of the members were Roman citizens (*cives Romani*), since 145 individuals (approximately 60%) bear imperial or non-imperial *gentilicia*. Of these, 39 *gentilicia* (approximately 15%) are imperial and are borne by naturalized Greeks (*ex peregrini*), while 106 (approximately 45%) are non-imperial and are borne by Italians (*ingenui*) as well as naturalized Greeks.[55] Obviously, this observation has implications for

for the Dionysiac σπεῖρα, see Nigdelis, *Ἐπιγραφικά Θεσσαλονίκεια*, 124–28. On the members of the associations devoted to Egyptian gods, see also the observations of Steimle, "Das Heiligtum der ägyptischen Götter," 36–37.

[53] For securely dated inscriptions, see Nigdelis, *Ἐπιγραφικά Θεσσαλονίκεια*, appendix. This conclusion is true of other regions of the eastern part of the Roman Empire as well, as is shown by Van Nijf, *Professional Associations*, 180; and particularly by Arnaoutoglou, "Roman Law," 27–44. In contrast, Cotter argues for a restrictive policy of emperors on the grounds of Roman legislation, without taking into account the epigraphic evidence at all (Cotter, "Collegia and Roman Law," 84).

[54] For the status of Thessalonikē, see Nigdelis, *Ἐπιγραφικά Θεσσαλονίκεια*, 427. For the case of Amastris, see Pliny, *Epistulae* 10.92, 93; and Arnaoutoglou, "Roman Law," 38–39.

[55] I give here a list indicating the available membership numbers of each Thessalonian association according to the legal status of members (numbers in parentheses denote *cives Romani*, who bring imperial or non-imperial *gentilicia*). Συνθρησκευταὶ Σαράπιδος (inscription no. 7): 3 (3); ἱεραφόροι συνκλίται (inscription no. 2): 14 (8); association of Cybele and Attis (inscription no. 3): 1 (1); συνκλίται of Θεὸς Ὕψιστος (inscriptions nos. 4, 5, 6, 37): 61 (36); association of the household of K. Furius (inscription no. 8): 2 (2); οἱ περὶ Λεύκιον Νόνιον (inscription no. 9): 2 (1); θρησκευταὶ καὶ σηκοβάται θεοῦ Ἑρμανούβιδος (inscription no. 10): 3 (3) *prostates* not included; θίασος Διὸς Διονύσου Γονγύλου (inscriptions nos. 11, 12): 53 = 34+19 (43 = 28+15); θίασος Πρινοφόρος (inscription no. 13): 1 (0); Ἐριφιασταὶ

the question of social composition. Even if we assume that a majority of *ex peregrini* and *ingenui* were freedmen (as were, for example, those carrying the *cognomina* Eros, Felix, Euplous, Agathemeros, Agathopous, Nedymos, etc., and the freedmen of the only household association we know of in the city), we cannot exclude the possibility that there were some wealthy members as well. In fact, among the members of the associations, apart from professionals,[56] we can identify: a) naturalized Greeks with imperial *nomina* and normal *cognomina*, some of whom belong to the local or provincial aristocracy;[57] b) Italians, freedmen or not, whose *gentilicia* associate them with the aristocracy of the city, e.g., Papii (inscription number 2), Salarii (inscription number 2), Avii (inscription number 5), Cerrenii (inscription number 5), Terraeii (inscription number 12), and Rupilii (inscription number 31);[58] and c) individuals who, judging from prosopographical data, belonged to what we today call the "middle class," such as the councillor T. Claudius

(inscription no. 14): 10 (8); συνήθεις τοῦ Ἡρακλέους - Περιτιασταί (inscriptions nos. 15, 16, 25, 29, 35): 12 (7); συνήθεια τῶν πορφυροβάφων τῆς ὀκτωκαιδεκάτης (inscription no. 17): 1 (0); θρησκευταὶ Ἀφροδίτης (inscription no. 18): 1 (0); θίασος Ἀσιανῶν (inscription no. 19): 2 (1); βακχεῖον Ἀσιανῶν – Ἀσκληπιασταί (inscription no. 20): 2 (0); οἱ περὶ Ἐπικράτην (inscription no. 21): 3 (0); οἱ περὶ τὸν Ἥρωα (inscription no. 22): 2 (2); δοῦμος ταύρου κομπέτου (inscription no. 23): 1 (0); κερδέμποροι (inscription no. 26): 2 (0); συνήθεια Ἥρωνος Αὐλωνίτου (inscription no. 27): 3 (1); δοῦμος Ἀφροδίτης Ἐπιτευξιδίας (inscription no. 28): 2 (2); ἡ συνήθεια ἥρωος Αἰνεία (inscription no. 30): 4 (3); Dionysiac σπεῖρα (inscription no. 31): 30 (10 at least); θίασος Διονύσου Ὠροφόρου (inscription no. 32): 2 (1); συνήθεις τῆς Ἀρτέμιδος Γουρασίας τῆς πρὸς τῇ Ἀχέρδῳ (inscription no. 33): 4 (1); συνήθεις οἱ περὶ Δημᾶ – συνήθεις Ἀρτέμιδος Ἀκραίας (inscription no. 34): 2 (0); συνήθεια στεφανηπλόκων (inscription no. 40): 2 (0); συνήθεις φιλοπαικτόρων (inscription no. 41): 2 (2); anonymous association (inscription no. 43): 7 (5). I did not include inscription no. 44, since it is dated to the fourth century C.E.

[56] E.g., the flute player Memnon (inscription no. 20), the ἀρχικερδέμπορος Zoilos (inscription no. 26), the yoke maker Artemon (inscription no. 27), and the perfume seller G. Hostius Eros Insteianus (inscription no. 36).

[57] With regard to the members of local aristocracy that participated especially in associations of Egyptian gods, see inscriptions nos. 7 and 1 and below, n. 113.

[58] For these families and the important role they played in the public life of the city, see Rizakis, "L' émigration romaine," 120–32; and (especially for the family of Rupilii) Nigdelis, *Επιγραφικά Θεσσαλονίκεια*, 127–28.

Lykos of the cult association of Zeus Dionysos Gongylos.[59] Consequently it would be wrong to designate all the associations of the city as *collegia tenuiorum* or common ranks.[60] This conclusion should not raise doubts about the participation of poor Thessalonians or slaves.[61] But any effort at a statistical approach to the evidence from the late second and third centuries C.E. based on onomastics is in vain.

As far as the sex of the members is concerned, it should be noted that women's participation is extremely limited. In our sources, excluding the general references to freedwomen of the only household association (inscription number 8), sixteen women are attested. In some associations, mainly Dionysiac associations of the second and third centuries C.E., women are attested, primarily as cultic officials.[62]

ORGANIZATION AND ADMINISTRATION OF ASSOCIATIONS

Each of the above-mentioned associations consists of a small number of members, usually between twenty and forty.[63] We know little about the procedure of admission. The expression τὰ ἐκ τοῦ γλωσσοκόμου γινόμενα αὐτῷ ("the sum for which he was eligible from the common chest"; see inscription number 27), attested on the funerary stele of the συνήθεια of

[59] For T. Claudius Lykos, see Kubińska, "Tiberius Claudius Lycus," 153–58; and below, n. 114. Participation of well-off Thessalonians in the ἱεραφόροι συνκλίται is attested also by the case of Annius Secundus (inscription nos. 13, 21): the latter offers with his son and his woman earrings for the decoration of a statue of a feminine deity; see Edson, *Inscriptiones Thessalonicae* (= *IG* X/2.1), no. 144. Moreover, Edson ("Cults," 187), on the ground that P. Ailius Nikanor, the *Makedoniarches,* was προστάτης of συνθρησκευταὶ κλείνης θεοῦ μεγάλου Σαράπιδος, concludes: "Here we have an association some at least of whose members belonged to the municipal aristocracy."

[60] For the meaning of the term *tenuiores* (= *humiliores*), see Ausbüttel, who observes that it denotes "die einfache . . . aber keineswegs besitzlose Bevölkerung im Gegensatz zu den *honestiores* oder *divites*" (Ausbüttel, *Untersuchungen*, 24–25).

[61] See inscription no. 39 and Nigdelis, *Επιγραφικά Θεσσαλονίκεια*, 187–88. Roman laws permitted the participation of slaves in collegia *permissu dominis*; see *Dig.* 47, 22, 3, 2 (Marcianus). Ascough, "Of Memories and Meals," 51 (in this volume) considers members of the associations of ἱεραφόροι συνκλίται (inscription no. 2) and συνήθεις of Hercules (inscription no. 15) to be slaves, primarily on the ground of their onomastics.

[62] See inscriptions nos. 8, 11, 31 (where ten names of women are attested), 32, and 34. Equally limited is the participation of women in associations of other cities in Macedonia. See Ascough, *Paul's Macedonian Associations*, 58.

[63] With regard to the number of members in associations of Thessalonikē and other Macedonian cities, see above, n. 55, and Nigdelis, *Επιγραφικά Θεσσαλονίκεια*, 110.

Heros Aulonites (159/60 C.E.), refers to expenses for the funeral of the deceased and is a clear indication that members paid entrance fees and/ or regular dues. However, we do not know whether this was the rule in Thessalonian associations.[64] The fact that funerary stelae mention only the name of the deceased suggests that similar fees were collected by other associations, but we have no other relevant information. In any case, it does not seem that all associations had uniform requirements.[65] Sometimes, when they had the necessary means and available time, Thessalonians participated in more than one association, as was the case with a member of the association of Artemis Akraia.[66]

The internal life of associations replicated the city's institutions, in that it was regulated by laws and decrees. The phrase [ἐν λε]υκώματι κατὰ τὰς δοχὰς ἀ[ναγρα--] ("to be written on a notice board in the room where symposia take place") in a fragmentary law of the third century C.E.[67] referring to the funerals of the members of associations demonstrates that such documents were inscribed and erected in the room of the *symposion* (δοχαί),[68] where associations normally assembled. It is almost certain that these laws regulated not only the funerals of members but the whole range of their activities. With regard to decrees, only one is preserved in honor of an eminent *mystria*, possibly of the association of συνθρησκευταί of Sarapis.[69]

The smooth functioning of an association presupposes adequate finances. I have already referred to the payment of fees or dues, but the income from this source does not seem to have been sufficient. Apart from fines for violation of the constitution, deficits were reduced or eliminated by donations of various magnitudes and purposes. Some donations satisfied urgent needs, such as the purchase of utensils and altars or the repair of statues (e.g.,

[64] Thus we are ignorant of the way these fees or dues were gathered, their amount, and all of the purposes for which they were being used. Although the case of the above-mentioned συνήθεια shows that some of them were intended for the required expenses of members' funerals, it is still not clear what kind of expenses they used to cover the procession, the manufacturing of a stele, and other funeral needs. For cases (including some from Macedonia) similar to that of the συνήθεια ῞Ηρωνος Αὐλωνίτου in the Greek East at that time, see Van Nijf, *Professional Associations*, 49–55.

[65] On the variety of regulations with regard to the burial of associations' members in the cities of the Roman Empire, see Ausbüttel, *Untersuchungen*, 59–66; and Van Nijf, *Professional Associations*, 39–55.

[66] See inscription no. 34; and commentary in Nigdelis, *Επιγραφικά Θεσσαλονίκεια*, 153.

[67] See inscription no. 42.

[68] For the meaning of the term δοχαί, see Nigdelis, *Επιγραφικά Θεσσαλονίκεια*, 198–99.

[69] See inscription no. 1.

the case of the associations of Kybele-Attis and Dionysos Horophorus, in which officials/ministers paid for the making of sacrificial altars),[70] or the renovation of parts of the premises used by the associations (e.g., repairs to the house of the συνκλίται of Theos Hypsistos and the donation of four columns by a priest).[71]

Bequests and testaments were another source of income. Plots of land, usually small, were bequeathed by members who wished to be commemorated and provided much-needed income to the treasury of the association (τὸ κοινόν).[72] The donation of the priestess and εὐία (*mainas*)[73] Euphrosyne provides a characteristic example. She donated to the θίασος of Prinophoros a small vineyard of two *plethra* with ditches around it, on condition that its annual revenue be used to offer a sacrifice and to crown her tomb.[74] The importance of this kind of income should not be overestimated, since donors often expressed the fear that members might not participate in the ritual, possibly because of insufficient income due to bad management of the donated land.[75] As for other pieces of property, we have only brief references to the οἶκος (meeting place) of the association of *Eriphiastai* and the μάγαρον (cult and/or place of sacrifice) of the two Dionysiac associations and of the association of the Great Mother of the Gods.[76]

[70] See inscriptions nos. 3 and 32.

[71] See inscription no. 6. In a recent article, Gutzwiller identifies, primarily on onomastic grounds, the daughter of the aforementioned priest with a Herennia Procla, poetess of an elegiac couplet on the Roman copy of Praxiteles' Eros at Thespiae (Gutzwiller, "Gender and Inscribed Epigram," 388–90). Given the numerous occurrences of the *gentilicium* Herennius in the Greco-Roman East and the lack of any ethnic marker in the name of the poetess herself, I doubt the proposed identification. For the *gens* Herennia in Macedonia see Tataki, *Roman Presence in Macedonia*, 246–50 (65 occurrences, 43 of which are from Thessalonikē).

[72] Mentioned in inscription no. 42 (law of an anonymous association).

[73] For the meaning of the term εὐία (referring to the ritual cry of the *maenads*) and the epigraphic parallels from inscriptions of Macedonia, see recently Bremmer, "Macedonian Maenad in Posidippus," 57–58.

[74] See inscription no. 13; and n. 96, below.

[75] See inscription no. 13.

[76] For οἶκος, see inscription no. 14. With regard to the οἶκος of ἱεραφόροι συνκλίται, Ascough believes that in the expression καταστήσαντι τὸν οἶκον in inscription no. 2 the word refers to their meeting place and that its donation coincides with the foundation of the association (*Paul's Macedonian Associations*, 31–32). However, the word οἶκον can refer to the act of foundation itself and not simply to the location; see Steimle, "Das Heiligtum der ägyptischen Götter," 35. Steimle also speculates that the place of aggregation and cult of the *Zeus Dionysos Gongylos* association was the famous crypt of Thessalonikē's Sarapeieion. For μάγαρον, see inscriptions nos. 31, 32, and 3, respectively. For the functions of the associations that took place in it, see Nigdelis, *Ἐπιγραφικὰ Θεσσαλονίκεια*, 132–33.

The administration of these clubs, like the administration of the city, was handled by a small number of officials. A study of their titles, however, shows great variety, similar to that of the associations themselves; in addition to ἀρχισυνάγωγος (head of association),[77] we find πατὴρ σπηλαίου (father of the grotto), τρικλεινάρχης (director of the feast), and ἀρχικερδέμπορος (president of guild merchants).[78] These particularities are undoubtedly due not only to the different history of each association but also to differences in the composition of their membership. In associations of a clearly religious character, such as the Dionysiac associations, priests and priestesses play an important role, either alone or in conjunction with other officers of the group, such as the head of the initiates (ἀρχιμύσται).[79] Despite this variety on the highest level, there is a tendency among associations dating from the end of the first century C.E. and on to unify their administrative structure.[80] Associations from this period are typically administered by an ἀρχισυνάγωγος (head of association) and a γραμματεύς (secretary) and helped on occasion by an ἐξεταστής (auditor of accounts), a term peculiar to Thessalonikē's associations that indicates an officer with financial duties.[81]

[77] On this office, see inscriptions nos. 15, 16, 35 (συνήθεις of Hercules); 27 (συνήθεια ῞Ηρωνος Αὐλωνίτου); 28 (δοῦμος Ἀφροδίτης Ἐπιτευξιδίας); 30 (συνήθεια ἥρωος Αἰνεία); 33 (συνήθεις τῆς Ἀρτέμιδος Γουρασίας τῆς πρὸς τῇ Ἀχέρδῳ); and Rajak and Noy, "Archisynagogoi," 75–93. Ovadiah, knowing only the ἀρχισυνάγωγος of inscriptions nos. 15, 16, and 27, wonders unjustifiably whether they were officials of associations or heads of synagogue ("Ancient Jewish Communities," 189–90).

[78] See inscriptions nos. 3 (πατὴρ σπηλαίου), 4 and 5 (τρικλεινάρχης = τρικλείναρχος), and 26 (ἀρχικερδέμπορος). For the term προστάτης, see below, n. 112.

[79] For the priests and priestesses of Thessalonikē's associations, see inscriptions nos. 6 (συνκλίται of Θεὸς ῞Υψιστος); 12, 13, 19, 31 (Dionysiac); 27 (συνήθεια ῞Ηρωνος Αὐλωνίτου); 34 (συνήθεις Ἀρτέμιδος Ἀκραίας); and 35 (συνήθεις of Hercules). The second priest mentioned in inscription no. 12, line 33 (*Zeus Dionysos Gongylos*) is a dignitary of Sarapeion. For ἀρχιμύσται, see inscription no. 31 and commentary in Nigdelis, *Ἐπιγραφικά Θεσσαλονίκεια*, 108.

[80] According to Youni, "administration of all sorts of associations was as a rule composed from three-member councils" (Youni, *Macedonia Provincia*, 119). It is more probable that certain associations with small attendance—e.g., φιλοπαίκτορες, and especially those that were self-determined, such as οἱ περὶ τὸν δεῖνα—have no other officials than their head.

[81] For the office of γραμματεύς, see inscriptions nos. 15, 16, 29 (συνήθεις of Hercules, which has two *grammateis*); 28 (δοῦμος Ἀφροδίτης Ἐπιτευξιδίας); 30 (συνήθεια ἥρωος Αἰνεία, where a ὑπογραμματεύς is also attested, for the first time in Thessalonikē); 33 (συνήθεις τῆς Ἀρτέμιδος Γουρασίας); 34 (συνήθεις οἱ περὶ Δημᾶ – συνήθεις Ἀρτέμιδος Ἀκραίας); 37 (συνκλίται of Θεὸς ῞Υψιστος); and 43 (anonymous association). For the office of ἐξεταστής see inscriptions nos. 28 (δοῦμος Ἀφροδίτης Ἐπιτευξιδίας); 33 (συνήθεις τῆς Ἀρτέμιδος Γουρασίας); 34 (συνήθεις οἱ περὶ Δημᾶ – συνήθεις Ἀρτέμιδος Ἀκραίας); and 43 (anonymous association). An *exetastēs* is mentioned also in the fragmentary inscription no. 42 (a law of an anonymous association, where he has—probably financial—duties περὶ

Details regarding the process of election to these offices are not available. For the office of ἀρχισυνάγωγος, there are cases in which the tenure lasted more than a year, as for example in the association of Herakles. The inscriptions of the group of συνήθεις of Herakles provide a parallel that suggests that associations identified as οἱ περὶ τὸν δεῖνα (so-and-so and his associates/attendants) would be administered by an ἀρχισυνάγωγος with a long term in office, perhaps even a life term.[82] It is not known whether this was due to their authority and contributions or to the fact that they were founders.

Inscriptions show that a large number of cult officials existed in addition to the aforementioned officials. On the basis of their duties, these can be divided into regular and extraordinary. The need to guard and care for the premises of the association created offices such as the head temple warden (ἀρχινεωκόρος),[83] while the sacrifices and *symposia* created offices such as (ἀρχι)μαγαρεὺς (ἀθύτου), μαγαρεύς, and μαγάρισσα.[84] The rich rituals of some associations, especially the Dionysiac ones, resulted in the creation of minor ritual offices/ministers, such as (ἀρχι)γάλλαροι (head of the *gallaroi*), (ἀρχι)κρανεάρχαι (head of the *kranearchai*), ναρθηκοφόροι (thyrsus bearers), ἀρχιλαμπαδηφόροι (head of torch bearers), νεβραφόροι (fawnskin bearers), νεβρίναι.[85] Ἐπιμεληταί (curators) should be considered extraordinary officers whose duty, at least as attested so far, was the control of works in the tombs.[86]

τῆς κηδείας). For the financial duties of the *exetastēs*, see already Polito, *Il* δοῦμος, 47 and 93. So far as I know, outside of Macedonia the office of *exetastēs* in associations is attested only once more in the inscription of θρησκευταὶ Σαράπιδος of Maroneia (second century B.C.E.); see Nigdelis, *Ἐπιγραφικὰ Θεσσαλονίκεια*, 199.

[82] See inscriptions nos. 15, 16, and 29. The expression οἱ περὶ τὸν δεῖνα (without any other specification) appears in inscriptions nos. 9, 21, 24, 29, 34, 38, and 41. For its meaning, see Radt, "Οἱ περὶ + acc.," 35–40.

[83] See inscriptions nos. 3 (association of Cybele and Attis) and 11 (Διὸς Διονύσου Γογγύλου). The responsibilities of the officer of συνήθεις τῆς Ἀρτέμιδος Γουρασίας (inscription no. 33), of whose title only the second half, φύλαξ, is preserved, are similar. It is uncertain whether the ἀρχινεωκόρος of inscription no. 10 (θρησκευταὶ καὶ σηκοβάται θεοῦ Ἑρμανούβιδος) is an officer of the association or of Thessalonikē's Sarapeion.

[84] For these offices, which are mentioned in inscriptions no. 3 (association of Kybele and Attis) and 31 (Dionysiac σπεῖρα), see Nigdelis, *Ἐπιγραφικὰ Θεσσαλονίκεια*, 114–17.

[85] This refers to the Dionysiac σπεῖρα (inscription no. 31). For their responsibilities, see the analysis of Nigdelis, *Ἐπιγραφικὰ Θεσσαλονίκεια*, 117–21. With regard to other minor ritual officers or ministers like γαλακτοφόρος and κισταφόρος (inscription no. 3, association of Kybele and Attis), or βοωφόρος and βησάρτης (inscription no. 3, *thiasos* of Zeus Dionysos Gongylos), only their titles are preserved. See also n. 24 for the Ἀνουβοφόρος and n. 108 for the παλεομύστης of the Dionysiac σπεῖρα.

[86] See inscriptions nos. 15 (συνήθεια of Hercules), 28 (δοῦμος of Aphrodite Epiteuxidia), and 43 (anonymous association). For the *epimelētai* see Poland, *Vereinswesen*, 405–6.

ACTIVITIES OF ASSOCIATIONS

Even a cursory look at the epigraphic evidence—mainly funerary stelae on tombs purchased by the association or in conjunction with relatives or friends of the deceased[87]—makes it clear that a major activity of associations was to provide a decent burial. Even if this picture is skewed by the fact that the majority of inscriptions of Thessalonikē are funerary, it nevertheless reflects a reality. The need for a decent burial was probably pressing especially during the economic difficulties of the third century C.E., to which most inscriptions are dated. It is not accidental that a fragmentary law of the third century C.E. (see inscription number 42) seems to provide for lending money to members for burial.[88] It would be a mistake, however, to consider this picture representative of the associations' activity in the city.[89] This would revive the ghost of the *collegia funeraticia*[90] and would contradict the rich and colorful picture provided by the inscriptions.

At the center of associative life are festivities of a different kind. First of all, the rites of the association are connected with the cohesive myth of each association. Titles of cult offices, such as μήτηρ σπείρας (guild mother), and the existence of a *megaron* in the form of a cave (*antron*) imply, in the context of a Dionysiac σπεῖρα, a reenactment of the myth of the ascension of Dionysos's mother Semele from the underworld (see inscription number 31).[91] The cult office of head lamp-bearer/torch-bearer (ἀρχιλαμπαδηφόρος) in the same cult group allows us to conclude that some rituals were performed at night and were associated with the recollection of nocturnal stops in Dionysos's journey from India to Greece. All these look similar to rituals of the Iobakchoi, the well-known Athenian Dionysiac group of the imperial era.[92]

Kanatsulis ("Η Μακεδονική πόλις," 274 n. 2), thinks that they were "the main magistrates of their association," but the evidence does not prove that they held such an important position as that of, e.g., the ἀρχισυνάγωγοι, after whom they are mentioned in some of the relevant inscriptions.

[87] See inscriptions nos. 20, 21, 22, 29, 39, 40, and 44.

[88] See Nigdelis, *Επιγραφικά Θεσσαλονίκεια*, 199–201.

[89] As Voutiras does for the *doumos* of Aphrodite Epiteuxidia (Voutiras, "Berufs- und Kultverein," 95 n. 5).

[90] For this term, which has been justly characterized as a "legal fiction," and its history, see Perry, *Roman Collegia*, 23–60.

[91] For the above interpretation see Nigdelis, *Επιγραφικά Θεσσαλονίκεια*, 121–23.

[92] See *IG* II/2.1368, lines 121–125: μερῶν γενομένων αἱρέτω ... Διόνυσος, Κόρη, Παλαίμων, Ἀφροδείτη, Πρωτεύρυθμος, from which we can conclude that, within the framework of Dionysos's associations, members also played the leading parts in the myths of the Dionysiac circle.

Such activities, nevertheless, were not a prerogative of Dionysiac associations. The reenactment of the sacred marriage (ἱερογαμία) of Aphrodite and Eros in the cult association of the worshipers of Aphrodite (Nymphia; see inscription number 18) demonstrates that such rituals took place in the context of various cult associations.[93] This theatrical performance of myths was accompanied by music, as the presence of a flute player (καλαμαύλης) among the members of the Asklepiastai and the βακχεῖον of the Asianoi also implies.[94] Apart from the grandeur and the authority these performances lent to the group, this practice corresponds to the aesthetic preferences of the ordinary individual of the imperial era, who loved mimes.[95] The performance of similar rituals was part of the attraction a cult group exercised for its members and friends.

Memorial celebrations can also be considered festivities. These celebrations were memorial services for individuals who had left a bequest to their associates with the sole purpose of performing an act of worship over their tomb at a given date. As a rule these ceremonies included sacrifice, crowning, and occasionally a feast. Such celebrations are attested or implied in the cases of the priestess and *mainas* Euphrosyne (see inscription number 13) and Memnon the flute player (see inscription number 20).[96]

An extremely interesting stele of the initiates of Zeus Dionysos Gongylos (inscription number 12) shows that these memorial celebrations played another important role. This stele was erected with the approval of the priest of the Sarapieion in the temple of the Egyptian gods, since, along with Zeus and Dionysos, the initiates of the group worshiped Sarapis and perhaps Bes (see above). The inscription records a double donation. In the first part, one of the association's officers, a certain G. Iulius, donates one third of a five-

[93] For details of these rituals (known by Christian authors) and further proof of their existence in the Greek cities during the imperial period, see Voutiras, "Aphrodite Nymphia," 111–13. Taking into consideration the dead woman's two names (Kleonike and Kyrilla) I can render the guess that she could also be an actress, e.g., *mimas*, similar to Kyrilla of the funerary inscription found in Beroia *EKM* I, 399 (beginning of the third century C.E.).

[94] On the importance of music in the Dionysiac associations, see Jaccottet, *Associations* 1:135, including bibliography.

[95] For the existence of mimes in Thessalonikē, see Korti, "Mimes of Thessalonikē," 621–30 (mime statuettes).

[96] With regard to the bequest, a number of researchers claim that it had to do with the celebration of the *Rosalia*; see Perdrizet, "Inscriptions de Philippes," 323; vom Brocke, *Thessaloniki*, 126; Mitrev, "Dionysiac Thiasoi," 295; and Ascough, *Paul's Macedonian Associations,* 26–28. Although he does not explicitly adopt this view, Edson repeats the false interpretation of Perdrizet (followed by vom Brocke) that the phrase ἀποκέηταί μοι refers to the burning of roses (Edson, "Cults," 169). The connection with the *Rosalia* is rejected by Kokkinia, because on the inscription there is no clear mention of the celebration (but only ἀπόκαυσις and στέφανος ῥόδινος) (Kokkinia, "Rosen für die Toten," 216–17).

plethra vineyard, located in the nearby village of Perdylia,[97] on condition that his associates will use the income to perform three ceremonial feasts annually in the name of some individuals called θρέψαντες (ἡ ἐπὶ τῶν θρεψάντων ἄρτου ἑστίασις).[98] These feasts are to be held on the nineteenth of Dystros (February), the thirteenth of Daisios (May), and the twenty-third of Gorgiaios (August). That these feasts were associated with deceased members of the group can be deduced not only from the use of the past participle (θρέψαντες), but also from the word θρησκήα (i.e., cult, which refers to the dead/θρέψαντες and includes ceremonial feasts described in the upper part of the inscription). Epigraphic evidence from the imperial era attests that the word θρησκεία was used throughout the Greek East to refer to the cult of the dead, including commemorative feasts.[99] This interpretation is corroborated by the fact that at least the first two dates can be identified with well-known Roman festivals for the cult of the dead, that is, the *Parentalia* (in Dystros)[100] and the *Rosalia* (in Daisios);[101] such celebrations are to be

[97] On the village and its possible location on the territory of Thessalonikē, see Daux, "Notes de lecture," 555–56; and Nigdelis, *Επιγραφικά Θεσσαλονίκεια*, 478–79.

[98] The identity of θρέψαντες concerned Daux, who expressed his embarrassment by asking: "sont-ce des vivants, ou les fondateurs (survivants ou morts?) de la communauté? Est-ce en leur présence et sous leur présidence qu'a lieu le banquet, et, dans les deux cas, peut-on parler d'effigies, paintes ou sculptées? S'agirait-il d'une catégorie spéciale, d'un grade parmi les mystes (cf. πάτηρ de mithraisme)?" ("Trois inscriptions," 478–87). Likewise, Vermaseren believes that the collection of bread took place "three times a year in the presence of the educators (θρέψαντες)" (Vermaseren, *Cybele and Attis*, 135). The expression ἐπὶ τῶν θρεψάντων does not necessarily mean "in the presence of" (see LSJ *s.v.* ἐπί A 2 e). See the expression (lines 16–17) ἐπὶ τοῦ θεοῦ on the same inscription and also inscription no. 36 (συνήθεια ἡ ἐπὶ τοῦ Ποσειδῶνος).

[99] For this specific meaning of the word θρησκεία in Greek inscriptions, see Foschia, "Le nome du culte," 15–35. For other evidence from Thessalonikē, see inscription no. 20 in Nigdelis, *Επιγραφικά Θεσσαλονίκεια*, 142–43.

[100] The identity of these celebrations, to the best of my knowledge, has systematically concerned only Mitrev ("Dionysiac Thiasoi," 294–96), who connects these dates with the following Dionysiac celebrations, without, however, justifying their relation to the θρέψαντες: a) the 19th of *Dystros* (February) with the *Anthesteria,* b) the 13th of *Daisios* (May) with the *Rosalia* and c) the 23rd of *Gorgiaios* (August) with the *Vinalia.* In my opinion, the celebration of the 19th of *Dystros* must be the *Parentalia,* which were as much a family celebration as a public celebration in Rome, between the 13th and 21st in memory of deceased parents and relatives. On the *Parentalia,* see Eisenhut, *RE,* 979–82. *Parentalia* are attested in Philippi; see Pilhofer, *Philippi* II, no. 636.

[101] This identification has already been suggested by Mitrev ("Dionysiac Thiasoi," 294–96). On the *Rosalia,* see Nilsson, *RE* 1111–15; and Kokkinia, "Rosen für die Toten," 210–19. In Macedonia, the existence of this celebration is known from inscriptions of the Roman colony of Philippi; see Pilhofer, *Philippi* II, nos. 512, 524, and 529. For more on the possible celebration of the *Rosalia* in Thessalonikē, see also n. 96, above. In support of

expected in an association comprised mainly of Roman citizens of Italian origin.[102] The identity of the dead *threpsantes* is not explained further in the act of donation, but it is obvious that it was known to the initiates, since these celebrations took place in the past and, due to the shortage of regular funds, they were in danger of being interrupted. The wish of the donor that these cultic feasts should take place κατὰ τὸ παραδεδομένον καὶ τὴν δόσιν ("according to the custom and installment of the revenue") confirms this interpretation. It is fair to assume, then, that the donation was not for the memorial service of the donor's parents (adoptive or not)[103] but for individuals whose personal history was closely associated with that of the association: members' parents and relatives, founders (in the sense of educators to the mysteries), or patrons.[104] Thus we can interpret the oath to the god, to the sacred objects of the θίασος (ὄργια),[105] and to the enigmatic τὸ μεσανύκτιον

this identification, we could cite the first ever Latin funerary inscription mentioning *Rosalia* (*CIL* 10, 444; territory of Lucania, during the reign of Domitianus), from which it appears that the celebration was held exactly on the 13th of May. (Other dates for the celebration mentioned on inscriptions are the 11th, the 21st, the 23rd of May, the 20th of June, and the 15th of July.) At this point, I would like to draw attention to the fact that in many of the associations in *Regio* X (Venetia et Histria), members leave bequests for the celebration of both *Parentalia* and *Rosalia*. For examples, see *CIL* 5, 4410, 4416, 4440, and 4871. It is not yet clear to me to which celebration the third date should be linked, although I would not consider it improbable that it should be some anniversary. See, e.g., *CIL* 14 326, a catalogue of an association in Ostia, where are recorded sums bequeathed by some of its members for the annual celebration of their birthday; see also Meiggs, *Roman Ostia*, 327.

[102] It is characteristic that out of the seventeen extant names of members of the association only three were not Roman citizens: Nikandros Nikandrou, Heraklides Koragou, and Antigonos Nikiphorou. Of the remaining members, only two have imperial *nomina*: C. Julius Felix and C. Julius Agathopus (perhaps freedmen of naturalized Greeks). The remaining thirteen members have non-imperial *gentilicia*, which attest to Italian origin, such as Foluius, Avudius, Ombrius, Terraeus, and Olius. Similar *gentilicia* are attested also in inscription no. 11 (a list of members of the association from the second century C.E.). For more on the exact regions of Italy where some of these names originate, see Salomies, "Contacts between Italy," 118–23.

[103] Kubińska argues that it is about the "parents nouriciers" of the donor Julius, a *threptos* himself (Kubińska, "Tiberius Claudius Lycus," 156). This interpretation is based on the reading of line 9, ἡ ἐπὶ τῶν θρεψάντων [α]ὐτοὺς ἑστίασις, proposed by Edson in Edson, *Inscriptiones Thessalonicae* (= *IG* X/2.1), instead of ἡ ἐπὶ τῶν θρεψάντων ἄρτου ἑστίασις, published later by Daux. After having carried out an examination at the Museum of Thessalonikē, I am convinced that the latter is correct.

[104] On the term θρέψαντες in Greek inscriptions, see Ricl and Malay, "Ἄνθρωποι θρεπτικοί," 48–49.

[105] On the term ὄργια, see Merkelbach, *Die Hirten des Dionysos*, 95, who defines it as "heilige Geräte und Gegenstände" that were kept in *cista mystica*.

ἄρτου (midnight bread)[106] as special conditions of the donation owed by both current and prospective initiates. Ceremonies like the one described above aimed to preserve the collective memory of the group.[107] Through a sense of historical continuity, the identity of the members and the firm standing of their collective identity were reenforced.

From the above, it is clear that the common feasts following sacrifices and rituals were a central element in the life of associations. But it would be an unjustifiable generalization to claim that there were no feasts independent of festivals. The important role of feasting is shown by the references to symposia (δοχαί) in the fragmentary regulation mentioned above (see inscription number 42), and by the name "table companions" (συνκλίται) borne by the association of ἱεραφόροι and the association of Theos Hypsistos; their leader was also called the τρικλείναρχος (head of the *triclinium*, or director of the feast). The importance of feasting is also implied by the existence of σωφρονισταί between the Eriphiastai, obviously an office responsible for maintaining order during the association's meetings, like the εὔκοσμος of the Iobakchoi at Athens.[108] What we do not know is whether some of the associations had a custom of holding a feast regularly once a month, as was the rule in the so-called *collegia tenuiorum* in Italy,[109] and as seems to have been the case in the Roman colony of Dion, according to a recently discovered (unpublished) inscription of the association of Zeus Hypsistos dated to 252 C.E.[110] Nevertheless, it is not an exaggeration to claim that such events developed not only the sociability of their members but also their collective identity.

[106] For various speculations on the meaning of the phrase, see Daux, "Trois inscriptions," 484; vom Brocke, *Thessaloniki*, 128; and Vermaseren, *Cybele and Attis*, 134–35.

[107] For this function of the meals, see also Ascough, "Of Memories and Meals," in this volume. As evidence of the importance of collective memory in the associations, we could use also the existence of the παλεομύστης in the Dionysiac σπεῖρα (inscription no. 31), if my interpretation in *Ἐπιγραφικά Θεσσαλονίκεια*, 113 is valid. There I argued that παλεομύστης was an office held by an elder member who knew the association's history and recounted it on some anniversaries of the association.

[108] See inscriptions nos. 2, 4–6. For the office of σωφρονισταί, for the first time attested in an association, see inscription no. 14. Concerning the εὔκοσμος see *IG* II/2.1368, lines 136–39. For rules of associations in the Greek East regulating the appropriate behavior of their members during feasts, see Arnaoutoglou, "Roman Law," 43.

[109] It occurred, with some exceptions, in the famous *collegium cultorum Dianae et Antinoi* (Lanuvium) according to first-century C.E. legislation. For more on this matter, as well as the relevant laws, see the analysis of Ausbüttel, *Untersuchungen*, 22–29.

[110] See Pantermalis, "Ζεὺς Ὕψιστος," 418.

The presentation so far may have created the impression that the world of associations was cut off from public life, that it was an escapist's dream world. This impression would be misleading, since the presence of associations in processions put them firmly in the public domain.[111] However, this presence could take other, more active forms, as suggested by the inscribed base of a statue erected by the συνθρησκευταὶ κλείνης θεοῦ μεγάλου Σαράπιδος to honor the head of the Macedonian *koinon* (Μακεδονιάρχης), Poplius Ailius Nikanor, whom they called their προστάτης (leader or patron) (see inscription number 7).[112] The decision to erect the statue, probably in a public space such as the agora, was made on the basis of a vote taken by raising hands in the assembly of the citizens (χειροτονίᾳ τοῦ ἱερωτάτου δήμου) after a proposal of the council. In other similar texts from Thessalonikē, the expression κατὰ τὸ δόξαν τῇ κρατίστῃ βουλῇ καὶ τῷ ἱερωτάτῳ δήμῳ ("according to the decision made by the most excellent/mighty council and the most sacred assembly") is used regularly to denote a vote by shouting.[113] We do not know why it was thought necessary to mark the process of voting by raising hands, but it may be because of resistance from the political opponents of the honored person, perhaps due to an excessive number of

[111] Due to the presence of an Ἀνουβοφόρος among the ἱεραφόροι συνκλίται (inscription no. 2), Voutiras ("Sarapieion de Thessalonique," 286) supposes justly that the associations of Egyptian gods were taking part in processions in Thessalonikē. That the *collegium of ludus centinari* (inscription no. 44) also made public appearances could be deduced from the position of *vixillarius* (flag bearer), which the dead man of the inscription, a *bestiarius*, held in the association. For more on public appearances of the associations during visits of Roman officials as well as local celebrations, see Van Nijf, *Professional Associations*, 199.

[112] The term προστάτης does not help us to conclude safely whether it means patron, as Ascough reluctantly accepts (Ascough, *Paul's Macedonian Associations*, 51), or merely the head of an association, as, e.g., Kanatsoulis argues (Kanatsoulis, "Η Μακεδονική πόλις," 279). No conclusion is drawn on the subject by Edson ("Cults," 187). With regard to the two προστάτες of the θρησκευταὶ καὶ σηκοβάται Ἑρμανούβιδος (see inscription no. 10), Vidman believes they were head of the associations (Vidman, *Isis und Serapis*, 83 n. 65). The other two inscriptions found in Macedonia that contain the term are: a) the list of 250 C.E. (Cormack, "Zeus Hypsistos at at Pydna," 51–55), where he is mentioned among the officers of the association of the θρησκευταί of Zeus Hypsistos at Pydna, and b) the Latin funerary inscription *SEG* 47 (1997) 954, where he is mentioned along with a *collegium* of gladiators and/or people of the arena from Stoboi. In the first inscription the term characterizes an officer of the association, while in the second one it probably refers to the head of the association. For more on the several interpretations of the term as it applies to religious and professional associations of the Greek East, see Poland, *Vereinswesen*, 363–66; and Zimmermann, *Handwerkervereine*, 46–52.

[113] See, e.g., Edson, *Inscriptiones Thessalonicae* (= *IG* X/2.1) nos. 149 and 150, which are altars of the mid-third century C.E. erected in honor of members of the local aristocracy. On the practice of that time of coming to decisions by acclamation, see Rhodes and Lewis, *Decrees of the Greek States*, 562.

awards by other groups in the city (such as youth groups or the *gerousia*) that would necessitate a counting of votes. What is important, however, is that the group of συνθρησκευταί had the initiative to honor and erect the statue; they had convinced the members of the Council and the πολιτάρχαι (supreme magistrates), who had the exclusive right of *jus agendi cum populo*, to submit the proposal to the popular assembly, and they supported it by means of their strength and reputation during the vote. Therefore, the erection of this statue is a gesture loaded with multiple meanings. Seen from the point of view of the honored, it displays the size of his "clientele" network and its manipulation in the game of city politics,[114] while it also implies financial dependencies. They save him so that he will save them, to rephrase the famous saying *serva me servabo te*: "Save me, and I shall save you."[115] Seen from the point of view of the association, the gesture reveals the collective decision of its members to act as a person in the political arena of the city, cooperating with the magistrates and the council.

CONCLUSION

Living in a city in which political and social life was dominated by a minority of aristocrats, and having few opportunities to play an active role in local politics as individuals, the Thessalonians, especially those from the middle and lower strata of society, sought new collective identities as members of groups, organized on the model of the polis. These identities were built upon common elements linking the members, such as religious convictions, possibilities of professional cooperation, solidarity, or even aesthetic preferences, and were solidified through mechanisms such as celebrations, rituals, and feasts,

[114] The case of Poplius Ailius Nikanor was no exception: in inscription no. 1, another influential family of Thessalonikē, a member of which was also Μακεδονιάρχης, is attested as having participated probably in the same association with Nikanor; see commentary in Nigdelis, *Επιγραφικά Θεσσαλονίκεια*, 211–16. On this occasion it is worth mentioning that sometimes members of associations, like the one of Isis at Pompeii, were asked in grafitti to support the election of their patrons as the city's officers. See Wilson, "Voluntary Associations," 2; and particularly Ausbüttel, *Untersuchungen*, 93–98. Recently Kubińska, "Tiberius Claudius Lycus," 158 considers that the *thiasos* of Zeus of Gongylos "devenu une sorte de club politique où le culte de Zeus Dionysos Gongylos était seulement un élement formel," due to the presence of Tiberius Claudius Lykos, a councillor of the city, among the members of this association (see inscription no. 11). The case of the συνθρησκευταὶ κλείνης θεοῦ μεγάλου Σαράπιδος shows that Tiberius Claudius Lykos could use the association to serve his political agenda, without such a change being necessary.

[115] See Petronius 44, 2.3; and Ausbüttel, *Untersuchungen*, 97.

often memorial feasts. Such organizations, however, did not reflect a will to escape from reality and were not an element in dismembering the city's political and social web. On the contrary, when they joined associations, the Thessalonians—or at least most of them—aimed at being reintegrated into the life of the city as active citizens through a new collective identity, thereby adopting the political behavior of their era, as demonstrated by the case of the συνθρησκευταί of the great god Sarapis.

APPENDIX. VOLUNTARY ASSOCIATIONS OF THESSALONIKĒ: THE EPIGRAPHIC EVIDENCE

No. 1: *IG* X/2.1.16; Nigdelis, *Ἐπιγραφικά Θεσσαλονίκεια*, 211 1st century C.E.

[---]ῳν θεῶν ἐψη||[φίσα --- ἐπειδὴ ἡ δεῖνα nomina διετέλ]ει γένους ἄνωθεν καὶ ἀξιώμα||[τος ---- γυνὴ μὲν ---------]υίου Βάσσου ἀνδρὸς ἱππικοῦ καὶ γυ||[μνασιαρχικοῦ --- τρισί τε ἱππικαῖ]ς στρατείαις κεκοσμημένου, μή||[τηρ δὲ --- υἱοῦ nomina --- ἀρχιερέω]ς τοῦ κοινοῦ Μακεδόνων, ἔτι δὲ καὶ | [--- υἱοῦ nomina --- ἀνδρ]ὸς εὐσεβεστάτης καὶ εὐγενεστάτης θυγατρὸς Κα ||[nomina ------------ γένους τ]ῶν Ἡρακλειδῶν ἀπὸ Τημένου διαδεξαμέ||[νη(ς?) -------------- τοῦ πατρὸς] ἀνδρὸς ἀξιολόγου καὶ ἱεραφόρου καὶ σηκοβά||[του ------------ διαφέροντος ὁμ]οίως τῷ γένει καὶ τῷ ἀξιώματι, ‹ἔ›ζησεν | [----------------------------- φίλανδρο]ς καὶ φιλότεκνος, κεκόσμηκέν τε τὸ ἱε||[ρὸν ---------------, ὥστε φιλοδοξί?]αν μηδεμίαν ἀπολιπεῖν, τήν τε | [------------------ --------------- εὐ]πρεπέστατον ἐν τῷ καλλίστῳ || [τόπῳ τοῦ τεμένους vel ἱεροῦ? --------------------------]υ ὅτε τὸ ἄγαλμα τοῦ Σ[εράπιδος?]. |

No. 2: *IG* X/2.1.58 latter half of the 1st century B.C.E./first half of the 1st century C.E.

Αὔλωι | Παπίωι Χείλωνι | καταστήσαντι τὸν | οἶκον οἱ ἱεραφόροι || συνκλίται | Σκάνιος Φῆλιξ | Σαλάριος Νικηφόρος | Λουκείλιος Βάσσος || Πρίαμος Ἀπολλωνίου | Πρῖμος Ἀρχεπόλε(ως) | Δοσένιος Βάκχιος | Ἰούλιος Σεκοῦνδος || Ἄννιος Σεκοῦνδος | Βιήσιος Φῆλιξ | Σεκοῦνδος Εὐφάντου | Μένανδρος Νικάνδρου.

No. 3: *IG* X/2.1.65 3rd century C.E.

------------ | -------------- | ----- ὁ ἀρχιμαγα|ρεὺς καὶ ἀρχινε||ωκόρος καὶ πατὴρ σπηλαίου | καὶ Αὐρ(ηλία) | Σωσιπάτρα ἡ γαλα|κτηφόρος κισταφο||ρήσασα{ν} ἔτη λ' | τὸν βωμὸν ἐκ τῶν | ἰδίων ἀνέθηκαν. | Εὐτυχῶς.

No. 4: *IG* X/2.1.68 end of the 1st century C.E.

Θεῶι | Ὑψίστωι | ὑπὲρ | Τ. Φλαουίου || Εὐκτιμένου υἱοῦ | Ἀμύ[ν]τα τοῦ | [τρικλει]νάρχου | [οἱ ὑπογε]γραμμένοι || συνκλίται [Τ. Φλαόυιος Εὐ]κτιμένου υἱὸς Ἀμύντας | [--------- Δ]ιοσκουρίδου | [--------------- Νεικ]οπόλεως || [Ζωΐλος Σωσιπάτ?]ρας | Λ[------------]ϛος | Θεοδᾶς › (= Θεοδᾶ) ΕΛ[------- Διο]ϛ κουρίδου|

Θεόδωρος Ἐπειμένους ‖ Λ. Φήσιος Ἄλιμος ǀ Μ. Οὐιούιος Ὀν{ι}ήσιμος ǀ Λ.
Ἀτέλλιος Σεκοῦνδος ǀ Εὐβουλίδης Ὑακύνθου ‖ Τι. Κλαύδιος[Ἀ]γαθόπους ǀ
Μόσχος › (= Μόσχου) ǀ Διονύσιος Κλεοπάτρας ὁ καὶ Γέμινος ǀ Ἀσιατικὸς Φίλας
‖ Γν. Ὀκταούιος Εὐήμερος ǀ Κ. Μινούκιος Ῥοῦφος ὁ καὶ Ἑρμῆς ǀ Μ‹ᾶ›ρκος
Ἑρμέρωτος ǀ Θεοδῆς Πρωτᾶ Θεσσ(αλονικεὺς) ‖ Τι. Κλαύδιος Αἴγ{ι}υπτος
ǀ Ἀντιφάνης Ἐπικράτους ǀ Λ. Τρέβιος Πρειμιγένης ǀ Λ. Πετρώνιος Οὐ‹ά›λης ‖
Φίλιππος Ἐπιγένους ǀ Κ. Πομπώνιος Σωσίβιος‖ Παράμονος › Κερτίμμου ǀ Μ.
Ἑρέννιος Ζώσιμος ‖ Μ. Ἐρέννιος Ῥωμανὸς ǀ Λ. Μεινάτιος Βύβλος ǀ Μ. Ἀντώνιος
Ποτεῖτος ǀ Κάσσανδρος Ἀξιώματος ‖ [Π.] Ποπίλλιος Βάλβος ǀ Γ. Ἰούλιος Ῥῆγλος
ǀ Μ. Σερουίλιος Κρήσκης ǀ Τ. Κλαύδιος Κέρδων ‖‖ Μ. Μουτίλιος Θ‹ύ›ρσος ǀ Τι.
Κλαύδιος Ἀγαθώπους ǀ Α. Ἀούιος Λαῖτος.

No. 5: *IG* X/2.1.69 end of the 1st century C.E.

τοῦ τρικλειǀνάρχου καὶ ǀ ὑπὲρ Τ. Φλαουίου ‖ Ἀμύντα τοῦ ǀ υἱοῦ αὐτοῦ ǀ οἱ
ὑπογεγραμμέǀνοι συνκλίται ‖ Τ. Φλαούιος Διονύσιος ǀΤ. Φλαούιος Ἀμύντας‖
Ζωῖλος Σωσιπάτρας ǀ Θεοδᾶς › (= Θεοδᾶ) ‖ Θεόδωρος Ἐπιμένους ǀ Μ. Οὐιούιος
Ὀνήσιμος ǀ Εὐβουλίδης Ὑακύνθου ǀ Μόσχος ‖ Διονύσιος Κλεοπάτρας ǀ Ἀσιατικὸς
Φίλας ǀ Μᾶρκος Ἑρμέρωτος ǀ Θεοδῆς Πρωτᾶ ‖ Λ. Πετρώνιος Οὐάλ‹η›ς ǀ Φίλιππος
Ἐπιγένους ǀ Κ. Πομπώνιος Σωσίβιος ǀ Μ. Ἐρέννιος Ζώσιμο‹ς› ‖ Λ. Μεινάτιος
Βύβλος ǀ Κάσσανδρος Ἀξιώματος ǀ Γ. Ἰούλιος Ῥῆγλος ǀ Μ. Σερουίλιος Κρήσκης
‖ Τι. Κλαύδιος Κέρδων ǀ Περείτας Δημητρίου ǀ Ἀπελλᾶς Ἀπολονί[ου] ǀ Ξανθίων
Ἀσιατικοῦ ‖ Μ. Μουτίλιος Θύρσος ǀ Τι. Κλαύδιος Ἀγαθόπους ǀ Δημήτριος
Διονυσείου ǀ Λ. Φήσιος Σεύθης ǀǀΑ. Αὗιος Λαῖτος ǀ Θαλλὸς Εὐτύχου Κορίνθιος ǀ
Γ. Σέριος Σεκοῦνδος ǀ Κ. Πομπόνιος Νήδυμος ‖ Γ. Οὐίβιος Πρῖμος ǀ Γ. Μάρκιος
Κεστὸς ǀ Π. Οὐετούριος Σεκοῦνδος ǀ Γ. Ὀκταούιος Φοντεῖος ‖ Γ. Οὐίβιος Ὀπτᾶτος
ǀ ΜΕ--------ΕΥ ǀ Π. Μέμμιος Πωλάρων ǀ Νεικόστρατος Νεικοστράτου Λ. Κομίνιος
Ἀγαθήμερος ǀ Π. Κερρήνιος Ζώσιμος.

No. 6: *IG* X/2.1.70 66–67 C.E.

Ἔτους δισ´ ǀ Ἑρεννία Πρόκλα ǀ τὴν ἐπαγγελίαν ǀ Μ. Ἐρεννίου Πρόκλου ‖ τοῦ
πατρὸς ἑαυτῆς ǀ τοῖς συνκλίταις ἀνέλστησεν κίονας δ ΄ǀ σὺν ἐπικράγ[οις] καὶ ‖
σπείραις [καὶ τ]ὴν ǀφλιάν, ἱερατεύονǀτος Λεω{ι}νίδ[ου τ]οῦ ǀ Λυσανίου.

No. 7: *IG* X/2.1.192 first half of the 3rd century C.E.

Ἀγαθῆι τύχηι, ǀ δόγματι τῆς κρατίστης ǀ βουλῆς κạὶ χειροτονίᾳ τοῦ ἱερωτάτου
δήμου Πόπλιον ǀ Αἴλιον Νεικάνορα ǀ τὸν ἀξιολογώτατον ǀ Μακεδονιάρχην ‖
οἱ συνθρησκευταὶ ǀ κλείνης θεοῦ μεǀγάλου Σαράπιδος ǀ τὸν προστάτην. ‖ Εὐτυ
χεῖτε.

No. 8: *IG* X/2.1.208 2nd or 3rd century C.E.

[--------------]λην, γ̣.υ̣.γ̣[αῖκ]α Κ. Φουρίου ǀ Πρόκλου οἱ ἀπελεύθεǀροι καὶ
ἀπελεύθεραι ǀ Φουρίου Πρόκλου καὶ αὐτῆς ‖ Μαξίμας δι᾿ ἐπιμέλιαν ǀ Οὐαρεινίας
Ἀρετῆς, ǀ γραμματεύοντος Μ. Οὐαρειǀνίου Μακεδόνος.

No. 9: *IG* X/2.1.219 2nd century C.E.

Οἱ περὶ | Λ. Νώνιον | συνήθεις | Βεῖθαν Βείθυ‖ος ἐκ τῶν ἰδίων.

No. 10: *IG* X/2.1.220 3rd century C.E.

[Π]ονπώνιον ῞Ελενον κὲ Κάσσιον | [π]ροστάτες θρησκευτῶν καὶ τῶν σηκοβατῶν | θεοῦ Ἑρμανούβιδος Κλαύδιον Αὔξιμον | τὸν καὶ Πιέριν τὴ‹ν› πρὸς τὸν [[πατ[έ]ρα]] ‖ πατέρα τειμὴν Κλαύδιον Γάϊον τειμῆς χάριν | ἀρχινακοροῦντος Μάρ(κου) Αὐρ(ηλίου) Ἰούστου.

No. 11: *IG* X/2.1.244 second half of the 2nd century C.E.

Col. I ----- | ----- νιος | Ἄρριος Πρόκλος | Σερρουίλιος Ἐπάγαθος | Προτάκιος Πρίσκος βοωφόρος ‖ Γρεκείνιος Σέλευκος | Κάσσιος Εὔτυχος | Φούριος Πριμιγᾶς ἀρχινακόρος | Αἴλιος Εὐελπίδης ‖ Οὐίβιος Μάξιμος | Αἴλιος Ἀσκληπιάδης | Κλαύδιος Λύκος | Ἀβούδιος Θύρσος ‖ Σουλπίκιος Πολύτιμος | Σαβιδιανὸς Μᾶρκος | Ἀλέξανδρος Διονυσίου | Ἀλέξανδρος Ἀλεξάνδρου βησάρτης ‖ Σώσιππος Πρίμου | Σπέδιος Πρόκλος | Καμέριος Καπίτων | Τύριος Ἰοῦστος ‖ Κλαύδιος Εὔπλους.

Col. II ------ | ΗΛ [-------] | Πομπώγι[ος ----] | Κλαύδιος Καιπίῳ[ν] | Σκρειβώνιος Νικηφόρος |Εὔνομος Εὐνόμου | Τ. Φλ(άβιος) Γράνιος Λύκος | Λαρτιδία Ὀπτάτα | Καικιλία Ὀπτάτα ‖ Κλαύδιος Παράμονος | Μ. Οὔλπιος Φῆλιξ | Μ. Οὔλπιος Τρόφιμος | Αἰλιανὸς Σεκοῦνδος | Μ. Αἴλιος Καλάτυος (= Καλάτυ ‹χ›ος).

No. 12: *IG* X/2.1.259; G. Daux, *CRAI* 1972, 478-493; *SEG* 30, 622 1st century C.E.

[Ἀγαθῆ]ι τύχηι. Διὸς | Διονύσου Γογγύλου. | Γ. Ἰούλιος ΒΗΣΑΡΤΗΣ ἀνέθηκεν τῷ θεῷ καὶ | ἔδωκεν ἐν δόσει τοῖς τε νῦν αὐτοῦ καὶ ἐσομένοις | μύσταις, ἕως ἂν συνιστῶνται, ἀμπέλων ἐν τῇ | Περδυλίᾳ ἐν τῷ ἄστυι πλέθρων πέντε τὸ τρίτον | μέρος ἐπὶ τῷδε, ἐφ᾽ ᾧ τὴν καρπήαν ἐχόντων | καθ᾽ ἔτος γείνηται ἡ ἐπὶ τῶν θρεψάντων ‖ ἄρτου ἑστίασις κατὰ τὸ παραδεδομένον | καὶ τὴν δόσιν Δύστρου ιθ΄, Δαισίου ιγ΄, | Γορπιαίου κγ΄ | ὀμνύντων τῶν τε νῦν καὶ | τῶν ἐσομένων μυστῶν τὸν θεὸν καὶ τὰ ὄργια ‖ καὶ τὸ μεσανύκτιον ἄρτου διαφυλάξειν | τὴν ἐπάνō θρησκήαν κατὰ δόσιν. ἀνέθηκαν | δὲ καὶ οἱ ὑπογεγραμμένοι μύσται, ἐφ᾽ ᾧ τῆς καρ|πήας μετέχωσιν τὸν τοῦ ζῆν χρόνον αὐτοὶ ἐπὶ ‖ τοῦ θεοῦ καὶ μεταπαραλαμβάνωσιν οἱ ἐπισι|όντες μύσται τοῦ αὐτοῦ πενταπλέθρου τὰ δύο | μέρη, ἐφ᾽ ᾧ ἄπρατα διηνεκῶς μείνη, ὁμοσάντων κατὰ τὰ αὐτὰ συνδιαφυλάξειν. ‖ Λ. Φουλούιος Φῆλιξ ἱερεύς, Γ. Ἰούλιος Ἀγαθόπους | Ἀβούδιο[ς-------------]ιων | Μ. ῞Ομβριος ῞Ερως Ν. Τερραῖος Φιρμανὸς | Νείκανδρος Νεικάνδρου Μ. Λόλλιος Σαβεῖνος ‖ Ἡρακλείδης Κορράγου Γ. ῏Ωλιος Ζώσιμος | Γ. Ἰούλιος Φῆλιξ Μ. Μάριος Κερεάλις | Μ. ῞Ομβρειος Μακεδὼν Μ. Ἀντώνιος Πρεῖμος | Τ. Σέξτιος vacat ‖ Ν. Τερραῖος Ὑάκυνθος | Ἀντίγονος Νεικηφόρου | Μ. Λόλ λ ιος Ἀττικός, | ἀνετέθη ἐπιτρέψαντος Στράτωνος τοῦ ‖ Ἐπικράτους, φύσει δὲ Διονυσίου ἱερητεύοντος τὸ β΄.

No. 13: *IG* X/2.1.260 3rd century C.E.

Α Εὐφρο[σύ]νη Διοσκο[υ --------------] | Β ἱέρεια οὖσα | Εὐεία Πρινοφόρου κατα‖λίπω εἰς μνί|ας χάριν αἰω|νίας ἀνπέλων | πλέθρα δύο | σὺν τὲς τάφροις,

‖ ὅπως ἀπο|κέηταί μοι ἀπὸ ἀγο|ρᾶς μὴ ἔλα|τον ✕ ε΄, Γ ‹φερέτωσαν δὲ› | καὶ οἱ μύστε μικρὸς μέ|γας ἔκαστος ‖ στέφανον ρό|δινον. ὁ δὲ μὴ ἐ|νένκας μὴ μετε|χέτω μου τῆς ‖ δωρεᾶς. αἰὰν | δὲ μὴ ποιήσω|σιν, εἶνε αὐτὰ τοῦ Δροιοφό|ρων θειάσου ἐ‖πὶ τοῖς αὐτοῖς |προστίμοις. | εἰ δὲ μηδὲ ὁ ἕ|τερος θίασος ‖ ποιῇ, εἶναι αὐ|τὰ τῆς πόλε|ως.

No. 14: *IG* X/2.1.261 (with new readings) 2nd or 3rd century C.E.

[-------------]ΤΛΙ[-------------] | [------------------]ΑΙΝΣ[-------------] | [-----------------] | [---------------]ΛΥ | [------------------] ΣΤΟΥ[---------------] | [...]ΙΟΣ Πετρώνιος Ἰουλιανὸ[ς----------------- ?ἀ]‖[ν]ατολὴν ΑΡΛΦΩΣ.ΤΩ ... ΣΙΛΜ [------------]‖τῶν Ἐριφιαστῶν ΑΝΩ ΑΡΑ [-------------Δι]|ονυσιάδος τῷ μνήματι[------------]‖ νος τῇ έ΄ τοῦ Ξανδικοῦ Ε[-----------------]‖Διονυσιάδος αὐτω[----------------]‖ Εὐπότῳ καὶ Μαικίῳ Σ[-----------------]‖ καὶ Δι...ωνι Τυχικοῦ καὶ [----------------] | Μυησάγδρου καὶ Πετρώνιο[ς---------------] ‖Ἀπολλωνίῳ καὶ Σευηριανῷ [---------------] | ανῷ Βακχίῳ καὶ Οὐαρεινίῳ τοῦ [------------------] | Δομιτίῳ Μοσωνίῳ καὶ τέκ[νοις--------]‖λει ἐπιπέδου ὄντος ἐν τῷ μετοίκω[ν ------------]‖ τοσούτων γε βλεπόντων βοει[----------------] | [.]ου καὶ γεγονότος οἴκου ἑνὸς ΑΠ[---------] | τὸν ὑποκείμενον ὑπερώ‹ο›ις Κλαυδιανο[ῦ -------------τοῦ] | ἐπιβάλλοντος μέρους τοῦ οἴκου τῆς συνη[θείας------------]‖ [..]οὔτε οἴνου τῷ οἴκῳ καὶ ΤΙ [-------------] | [..] μενόντων καὶ προσόντων τὸν [-------------------] | [......] προγεγραμμένα ἅπαντα κῃιγὰ [------ -------] | [......] καὶ βεβαιῶσαι ἀτῷ τὴν ΕΙΣ.ΝΛΓΟ[-------------] ‖ [....]τοῦ οἴκου καὶ τῶν δικαίων αὐτοῦ .ΥΝ [-------------] | [.... δ]ιασχολεῖν [.....]σωφρονισταὶ Σ[-- --------------] | [.....]ΑΝΤΩΝΤΑΑΓΩΙΝΗ ΜΕΣΔΕΙΑΝ[-----------] |ενος [κα]τ[ὰ μηδένα τρόπον [.....]ΕΣ[--------------------] ‖ [..........]Σ.ΑΙΣΙΑΝ..ΣΙΣΛ εἰσιόντων Λ[----------------] ‖[.....]μμένοι [Ἐρι]φιασταὶ τὸν ὑπογεγρα[μμένον [------------- ---] ‖[......]σαι εἴτε δ[ωρ]ίσαι εἴτε καταλιπ[εῖν] [-----------------] ‖[......]ωσαι κατὰ μηδένα τρόπον [-----------------] ‖ [........]ομενον τὸν πάγτα χρόνον. [-----------------] ‖[..........] ΙΝ .. ΚΛΙΛΛΤΟΥΙΟΣ ---------------

No. 15: *IG* X/2.1.288 January 154 C.E.

Οἱ συνήθε[ις] τοῦ Ἡρακλέ|ους Εὐφρά[νορ]ι τῷ συνήθει | μνήμης χά[ριν] ἀρχι συν|αγωγοῦντος Κώτυος ‖ Εἰρήνης, γραματεόντων (!) | Μ. Κασσί[ί]ου Ἕρμωνος | τοῦ καὶ Δημᾶ καὶ Πριμιγᾶ, | ἐπιμελητοῦ Πύθωνος ‖ Λουρκειλίας Θεσσαλονικέος, | ἔτους ἔτι τοῦ ατ΄ μηνὸς Περιτίου ζ΄ .

No. 16: *IG* X/2.1.289 about 154 C.E.

[Οἱ συνήθεις τοῦ Ἡρακλέους | τὸν δεῖνα τοῦ δεῖνος | τὸν συνήθ]εα μνήμης [χάριν] | ἀρχισυνα]γωγοῦντος ‖ [Κώτ]υος ‖ Εἰρήνης, [γραμματ]ευόντων Αὔλου [---------- -------]Λυκαρίωνος | [----------------].

No. 17: *IG* X/2.1.291 end of the 2nd century C.E.

Ἡ συνήθεια τῶ|ν πορφυροβάφ|ων τῆς ὀκτωκαιδεκάτης ‖ Μένιππον Ἀμίου | τὸν καὶ Σεβῆρον | Θυατειρηνὸν μνήμης |χάριν.

No. 18: *IG* X/2.1.299 2nd century C.E.

πολλ‹ά›κι νυφευθῖσ᾽ ἀγ‹ν›οῖς | ἐν ἐμοῖς θαλάμοισι | τ᾽ οὔνομα μέν μοι ἔην Κλεονίκη καὶ Κυρίλ‹λ›α, ‖ ἣν ἐπόθησεν Ἔρως | διὰ τὴν Παφίην Ἀφροδίτην· κεῖμε δ᾽ ἐν τύνβῳ διὰ θρησκευ|τῶν φιλότητα.

No. 19: *IG* X/2.1.309 2nd or 3rd century C.E.

Μακεδόνι | Ἀσιανῶν ὁ θί|ασος τῷ συν|μύστῃ ἱερητεύογ||τος Π. Αἰλίου | Ἀλεξάνδρου.

No. 20: *IG* X/2.1, 480; Nigdelis, *Ἐπιγραφικά Θεσσαλονίκεια*, 146 237/238 C.E.

[Θ]ρησκεία τῶν Ἀσκληπιαστῶν καὶ β[ακ]|χ(ε)ίου Ἀσιανῶν Βειέντορος Μέμν[ονι |τῷ] καλαμαύλῃ μνίας χάριν. | Κασσίᾳ ‖Ἀντιγόνα Μέμνονι [ἔτου]ς επτ᾽

No. 21: *IG* X/2 1.679 about 1st century C.E.

Οἱ συνήθεις οἱ περὶ Ἐπικράτην | [----------------]ον Βίθυος ‹τ›ὸν συνήθη | [----------------]ωρος ὁ ἀπελεύθερος.

No. 22: *IG* X/2.1.821 2nd or 3rd century C.E.

Γ. Κασσίῳ | Φιλήτῳ Γ. | Κάσσιος Νειλᾶς καὶ οἱ πε||ρὶ τὸν Ἥρωα | ἀνέστησαν | μνήμης | ἕνεκεν.

No. 23: *IG* X/2.1.860; A. Łajtar, *ZPE* 94 (1992) 211–12 2nd or 3rd century C.E.

Ταύρου | κομπέτου | δοῦμος Μ|αξίμου μν‖{ν}ήμης χάριν.

No. 24: *IG* X/2.1.933 2nd or 3rd century C.E.

[Ἡ συν]ήθεια | [τῶν] περὶ ΑΛΕ | [----------------]ΟΝΔΙΟΣ | [----------------]ΟΥΑΡ.

No. 25: *IG* X/2.1.982 2nd or 3rd century C.E.

Γ. Δομίτ[ι------------- Ἡ]|ρακλ[----------------]‖ οἱ συνή[θεις]‖ -------------.

No. 26: *IG* X/2.1.1041 about 2nd century C.E.

[Ἀγ]αθῇ τύχ[ῃ], | εὔπλεα τῷ Ἡρα|κλῆ, τῷ εὐτυχῆ |τῷ Θεσσαλονει‖κεῖ, τῷ Ἐπικτή|του καὶ Ζωΐλου. | Ζωΐλῳ ἀρχικερ|δεμπόρῳ εὐτυχῶς.

No. 27: Φώτ. Πέτσας, *Ἀρχ. Δελτ.* 24 (1969)[1970] Χρονικά Β 2 159/160 C.E. = G. Horsley, *New Documents Illustrating Early Christianity* (vol. 4; No. 215; Macquarie University; Grand Rapids: Eerdmans, 1987).

Ἔτους αϙρ´ σεβαστοῦ. | Ἡ συνήθεια Ἥρωνος | Αὐλωνίτου Γ. | Ἰουλίῳ | Κρήσκεν τι οἱ περὶ ἀρχ‹ι›‖συνάγωγον Ἀρτέμωνα | ζυγοποιόν, ἱερῇ | Τρύφωνα τὰ ἐκ τοῦ | γλωσσοκόμου γινόμενα αὐτῷ μνίας χάριν.

No. 28: E. Vutiras, *ZPE* 90 (1992) 87; *SEG* 42, 625 90/91 C.E.

Δοῦμος Ἀφρο|δίτης Ἐπιτευ|ξιδίας ἀρχισυ|ναγωγοῦντος ‖ Γ(αΐου) Αὐτρωνίου Λεί|βερος τοῦ καὶ Γλύ|κωνος, γραμματεύ|οντος Κ(οΐντου) Πουπίου Κάστορος, ‖ ἐξεταστοῦ Ἑρμογένους τοῦ Δι|ογένους, Ἀθηνίωνα Πραξιτέλους Ἀμαστρι|ανὸν ἔξω τελευτήσαντα μνείας ἕνεκεν | δι᾽ ἐπιμελείας τῶν αὐτῶν. ‖ χαῖρε· καὶ σὺ τίς ποτ᾽ εἶ. βκρ´.

No. 29: *SEG* 43, 462 second half of 2nd century C.E.

[Ο]ἱ συνήθεις Περιτιαστῶν | Κασσίῳ Ἀσκληπιάδῃ | περὶ Κότυν Εἰρήνης γραμματευῶντων Βαιβίου ‖ Εὐφρᾶ καὶ Λεωνᾶ Καττία Ἐλπὶς ἡ μήτηρ | καὶ Κόϊντος Ἐρέννιος Σαβεῖνος ὁ πατὴ[ρ] | κατ᾽ εὔνοιαν καὶ Κασσία Ἐρεννία ἡ μ[άμμη] | μνήμης χάριν.

No. 30: Nigdelis, *Ἐπιγραφικά Θεσσαλονίκεια*, 207 125/126 C.E.

Ἔτους ζνρ´ τοῦ καὶ γοσ´ | ἡ συνήθεια ἥρωος Αἰνεία τῶν | περὶ Π(όπλιον) Κωσί διον Κέλσον | ἀρχισυνάγωγον γραμματεύοντος ‖ Τι(βερίου) Κλαυδίου Ζωσίμου ὑπογ[ρ]‖αμματέως Ἐρεννίου Ὀλύ[μπου] | Βάκχυλον Θεοδέους ----------------------- --]‖[-----------------]ον μνήμης χ[άριν].

No. 31: *SEG* 49, 814; Nigdelis, *Ἐπιγραφικά Θεσσαλονίκεια*, 103 first half of the
3rd century C.E.

Col I [------------]ιος Τι(βέριος) Προφάνιος| [------------ἀρχ]ιμύστης Ἀλέξανδρος | [------------ ?-μ]ύστης ἀρχικρανεάρχης | [------------] ἀρχιγάλλαρος ‖ [----------] ἀρχιμαγαρεὺς ἀθύτου | [------------ναρθη]κοφόρος | [------------]ος ἀρχικρανάρχης ‖[------------? κρ]ανεάρχης ‖ [------------]ος ‹γ›άλλαρος ᵛ ᵛ Τερεντία | [------------]ον ἱερεὺς Κλωδία Πῶλ | [------------]ος λα νεβριαφόρος | [------------]ος παλεομύστης‖[- -----------?κρ]ανάρχης | [[------------]] ἀρχιμύστης | [------------Πε?]τρώνιος Ἰοῦστος ἀρχιμύστης | [---------]ος Λούκιος ἀρχιμ(ύστης) ‖ [---------]ανος ἀρχικρανεάρχης Α[------------] | [------------Αὐ]ρ[ή]λιος Σύμφορς μα[γαρεύς?] | [------------]ος------.

Col II Ε[------------] | Πρωφαγ[------------]Νικόπολις μήτηρ σπείρας | καὶ Κουάρ τα ‖ Ῥουπι‹λ›ία Λαιτιλία | Μεστρία ἀρχιλαμπαδηφόρος | Ῥουπιλλία Μαρκία | Ῥουπιλλία Ἀρτεμιδώρα ‖ Διονυσία Πλω‖τιανὴ Θεοδώρα | μαγάρ{γ}ισσα καὶ νεβραφόρος ‖ Φολκιλλία Βενερία μαγάρ(ισσα) | Παραμόνα νεβρίνη καὶ μαγάρισσα | Κυητία ΠΙ[----------].

No. 32: Nigdelis, *Ἐπιγραφικά Θεσσαλονίκεια*, 129 218/219 C.E.

Διονύσῳ ᴹᵒᵘᶜᵃⁱᵒᵘ Ὠροφόρῳ | Ἑλένη Δημητρίου | ἀρχιμαινὰς καὶ Κ(όϊντος?) Δομίτι|ος Φῆλιξ μαγαρεὺς ‖ τὸν βομὸν καὶ τὸ μάγαρον ἐκ τῶν ἰδίων. | ἔτους σνʹ.

No. 33: Nigdelis, *Επιγραφικά Θεσσαλονίκεια*, 147 second half of the 1st
or first half of the 2nd century C.E.

Οἱ περὶ Φλάυιον [----------] | ἀρχισυνάγωγον καὶ | [----------]|φύλακα Γουρασίας
['Ἀρ]τέμιδ[ος] | συνήθεις τῆς πρὸς τῇ Ἀχέ|ρδῳ Κρήσκεντι τε‹λ›ευτήσαντι ἐπὶ
ξένης γραμματεύ|οντος Μάγνου ὑπὲρ τῆς | μητρὸς ἑαυτοῦ Πρίσκας ἐξεταστοῦ
Μουντανοῦ | ---------- .

No. 34: Nigdelis, *Επιγραφικά Θεσσαλονίκεια*, 159 117/118 C.E.

[---------- nomen ---------- Εὐφ]ρόσυνον | [---------- nomen ---------- Εὐφ]ροσύνου ὑὸν
| [συνήθεις περὶ] Δημᾶ Περεί|[τα γραμματ]εύοντος Κοσ||[----------]ου ἐξετασ|[τοῦ
----------]ς Πριμιγᾶ,| [συνήθεια or συνήθεις Ἀρτέ]μιδος Ἀκραίας| [e.g., ἱερεία]ς
οὔσης Τιτιννί|[ας ----------] γραμματεύον|[τος ----------] Ἀράτου, ἐξετα|[στοῦ -----
----ο]ς Μαριανῆς. ἔτους | [θμρ΄ Σεβαστο]ῦ τοῦ καὶ εξ‹σ΄.

No. 35: Nigdelis, *Επιγραφικά Θεσσαλονίκεια*, 162 2nd century C.E.

[Οἱ περὶ Κ]λαύδιον Σε[----------] | [---------- ἀρχ]ισυνάγω[γον | συνήθει]ς Ἥρα
κλέ[ους] | [Ν]έρβα [τ]ῷ ἱερ[εῖ] || ----------.

No. 36: Nigdelis, *Επιγραφικά Θεσσαλονίκεια*, 163 second half of the 2nd
century C.E.

Συνήθεια | ἡ ἐπὶ τοῦ Πο|σειδῶνος | Γ. Ὀστίῳ Ἔρω||τι Ἰνστεϊανῷ | μυροπώλῃ.

No. 37: Nigdelis, *Επιγραφικά Θεσσαλονίκεια*, 168 second half of the 1st
or first half of the 2nd century C.E.

Θεῷ Ὑψίστῳ | καὶ τοῖς συνκλίταις Ἀμύντας | Ζωΐλου γραμματεύσας χειρο| λαβήν,
κατάχυσιν ἐκ τῶν ἰδίων.

No. 38: Nigdelis, *Επιγραφικά Θεσσαλονίκεια*, 178 first half of the 3rd
century C.E.

[Η] συνήθια τῆς | Νεμέσεος | τῶν περὶ Τερμι|νάριν Κοείντῳ || Φαβίῳ Ἀγαθώπω|δι
μνήμης χά[ριν].

No. 39: Nigdelis, *Επιγραφικά Θεσσαλονίκεια*, 184 second half of the 2nd
century C.E.

Χρυσόπαις | Μενεκράτῃ | τῷ τέκνῳ | μουλίωνι || μετὰ τῶν κολ|λήγων μνείας
χάριν.

No. 40: Nidgelis, *Επιγραφικά Θεσσαλονίκεια*, 189 2nd or 3rd century C.E.

Στεφανηπλό[κων] συνήθια ΝΙΚΑ[----------] | Διοσκουρίδ[ου] | μνήμης χάρ[ιν] ||
Εὐρώπ[η ?] | ----------?---------- .

No. 41: Nigdelis, *Επιγραφικά Θεσσαλονίκεια*, 192 2nd century C.E.

Οἱ περὶ Λ(ούκιον) Ῥου|στεικείλιον Ἀγα|θόποδαν συ|νήθεις φιλ[ο]παι||κτόρων Τ(ίτῳ) Εἰο|υλίῳ Προφήτῃ | τῷ κὲ Σεκούνδῳ.

No. 42: Nigdelis, *Επιγραφικά Θεσσαλονίκεια*, 197 first half of the 3rd century C.E.

----------|[----------]απροσπα [----------|----------]νθα ἐκ παντὸς [----------|---------- ἐν λε]υκώματι κατὰ τὰς δοχὰς ἀ[ναγρα ----------|----------]ν κοινὰ γὰρ πάντων τὰ ἀνθρ[ώπινα ----------| ----------]ἀπίῃ ἀδελφῷ ἢ ‹ἀ›δελφῇ ἢ τέκνῳ [----------| ----------] μετὰ τοῦ ἐξεταστοῦ περὶ τῆς κηδεία[ς ----------|----------] Ӿ⟦(δηνάρια) ἑκατόν· ἐὰν δέ τις τῶν ἐκ τῆ[ς συνηθείας? ----------|----------] ἐκ τοῦ κοινοῦ διδόντος αὐτοῦ ἐγγύη[ν ----------||----------]ς τόκου. εὐτυχῶς.

No. 43: Nigdelis, *Επιγραφικά Θεσσαλονίκεια*, 202 234 C.E.

----------?---------- | [----------]Δίωνος | [----------]πυληανῷ | ‹γ›ραμματεύοντος Κ[..]εικίου ἐξεταστοῦ Ἀμαρ‹ά›ντου Θερμείτου || δι᾽ ἐπιμελητῶν Μ(άρκου) Οὐλπίου | Σωτῆρος Κ(οΐντου) Κιτερείου Ὀρβάτου | Κ(οΐντου) Ὠλίου Δόνακος ἔτους εξσ´.| Δείου θ´.

No. 44: Nigdelis, *Επιγραφικά Θεσσαλονίκεια*, 248 first half of the 4th century C.E.

[D(is)] M(anibus) | [*nomen gentis*] Maximus qui vi|[xit an]ṇis · | · cives nat(ione) Iuscil[---] Sirmese, collegiatus || [lud]i centin‹a›ri, vixillarius, | [bes]ṭiaris, pressus ‹a› leopardo | [mors]ụ refugio et mortus | [Thessa]ḷonice munere Domi||[[-------]us et Niko contuber|[nalis fec]ẹrunt.

BIBLIOGRAPHY

Anagnostopoulou-Chatzipolychroni, Elena. "Οι αρχαιολογικές έρευνες στο Παλατιανό" (Archaeological Research at Palatiano). *AEMΘ* 10A (1996) 195–204.

———. "Ανασκαφή Παλατιανού 1993" (Excavation of Palatiano Year 1993). *AEMΘ* 7 (1993) 389–99.

Arnaoutoglou, Ilias N. "Roman Law and Collegia in Asia Minor." *RIDA* 49 (2002) 27–44.

Ascough, Richard S. *Paul's Macedonian Associations: The Social Context of Philippians and 1 Thessalonians.* WUNT 2/161. Tübingen: Mohr Siebeck, 2003.

Ausbüttel, Frank M. *Untersuchungen zu den Vereinen im Westen des römischen Reiches.* FAS 11. Kallmünz: Lassleben, 1982.

Belayche, Nicole. "Enquête de marqueurs des communautés 'religieuses' gréco-romain." Pages 9–20 in *Les communautés religieuses dans le monde Gréco-romain. Essais de définition.* Edited by eadem and Simon C. Mimouni. Bibliothèque de l'École des hautes études. Section des sciences religieuses 117. Turnhout: Brepols, 2003.

Bouley, Elisabeth. *Jeux romains dans les provinces balkano-danubiennes du IIe siècle avant J.-C. à la fin du IIIe siècle après J.-C.* Paris: Press universitaires franc-comtoises, 2001.

Bowersock, Glen. "Les Euemerioi et les confréries joyeuses." *CRAI* (1999) 1242–44.

Bremmer, Jan N. "A Macedonian Maenad in Posidippus (AB 44)." *ZPE* 155 (2006) 57–58.

Brocke, Christoph vom. *Thessaloniki—Stadt des Kassander und Gemeinde des Paulus. Eine frühe christliche Gemeinde in ihrer heidnischen Umwelt.* WUNT 2/125. Tübingen: Mohr Siebeck, 2001.

Campanelli, Sara. "*Kline* e *synklitai* nel culto di *Hypsistos*. Nota su due iscrizioni del Serapeo di Tessalonica." *ZPE* 160 (2007) 123–33.

Cormack, James M. R. "Zeus Hypsistos at Pydna." Pages 51–55 in *Mélanges helléniques offerts à Georges Daux.* Paris: de Boccard, 1974.

Daux, Georges. "Notes de lecture." *BCH* 104 (1980) 555–56.

———. "Quelques inscriptions de Thessalonique d'époque impériale." *BCH* 104 (1980) 531–34.

———. "Trois inscriptions de la Grèce du Nord." *CRAI* (1972) 478–87.

Dessau, Hermannus, ed. *Inscriptiones Latii veteris Latinae. CIL* 14. Berolini: G. Reimerum, 1887.

Edson, Charles, ed. *Inscriptiones Thessalonicae et viciniae* [= *IG* X/2.1]. Berlin: de Gruyter, 1972.

———. "Cults of Thessalonica (Macedonica III)." *HTR* 41 (1948) 153–204.

Eisenhut, Werner. *RE* Supplement 12 (1970) 979–82.

Foschia, Laurence. "Le nome du culte θρησκεία et ses dérivés à l'époque impériale." Pages 15–35 in *L'hellénisme d'époque romaine. Nouveaux documents, nouveaux approches (Ier s.a.C.– IIIe s.p.C.). Actes du Colloque international à la mémoire de Louis Robert, Paris, 7–8 juillet 2000.* Edited by Simone Follet. Paris: de Boccard, 2004.

French, David H. *The Inscriptions of Sinope.* Bonn: Habelt, 2004.

Frisch, Peter and Angelo Geissen. "Grabstele für einen Provocator." *ZPE* 39 (1980) 193–95.

Gounaropoulou, Lucretia and Miltiades B. Hatzopoulos. *Επιγραφές Κάτω Μακεδονίας.* *Τεύχος Α΄. Επιγραφές Βέροιας (Inscriptions of Lower Macedonia. Fascicle A. Inscriptions of Beroia).* Athens: de Boccard, 1999.

Gutzwiller, Katherine. "Gender and Inscribed Epigram: Herennia Procla and the Thespian Eros." *TAPA* 134 (2004) 383–418.

Hatzopoulos, Miltiades B. "Récentes découvertes épigraphiques et glosses macédoniennes d'Hésychius." *CRAI* (1998) 1202–4.

——— and Louisa D. Loukopoulou. *Morylos cité de la Chrestonie.* Meletemata 7. Athens: de Boccard, 1989.

Holtheide, Bernhardt. "Zum privaten Seehandel im östlichen Mittelmeer (1–3 Jh. n. Chr.)." *Münsterische Beiträge zur antiken Handelsgeschichte* 1 (1982) 3–13.

Iliadou, Pinelopi. *Herakles in Makedonien.* Hamburg: Kovač, 1998.

Jaccottet, Anne-Françoise. *Choisir Dionysos. Les associations dionysiaques, ou, la face cachée du dionysisme.* Kilchberg: Akanthus, 2003.

Kanatsoulis, Demetrios. "Η Μακεδονική πόλις από της εμφανίσεως της μέχρι των χρόνων του Μ. Κωνσταντίνου" (The Macedonian City from its Appearance to the Age of Constantine the Great). *Μακεδονικά* 4 (1955–1960) 269–80.

Kloppenborg, John S. "Collegia and *Thiasoi*: Issues in Function, Taxonomy and Membership." Pages 16–30 in *Voluntary Associations in the Graeco-Roman World.* Edited by idem and Stephen G. Wilson. London: Routledge, 1996.

Kokkinia, Christina. "Rosen für die Toten im griechischen Raum und eine neue ῥοδισμός– Inschrift aus Bithynien." *MH* 56 (1999) 204–21.

Korti, Stephē. "Mimes of Thessalonikē." *Ancient Macedonia* 6 (1996) [1999] 621–30.

Kubińska, Jadwiga. "Tiberius Claudius Lycus de Thessalonique et son thiase." *ZPE* 137 (2001) 153–60.

Łajtar, Adam. "Ein zweiter Beleg für δοῦμος in Thessalonike." *ZPE* 94 (1992) 211–12.

McLean, Bradley H. "The Agrippinilla Inscription: Religious Association and Early Church Formation." Pages 239–70 in *Origins and Method: Towards a New Understanding of Judaism and Christianity. Essays in Honor of John C. Hurd.* Edited by Bradley H. McLean. JSNTSup 86. Sheffield: Continuum, 1993.

Meiggs, Russell. *Roman Ostia.* 2d ed. Oxford: Clarendon, 1973.

Merkelbach, Reinhold. *Die Hirten des Dionysos. Die Dionysos-Mysterien der römischen Kaiserzeit und der bukolische Roman des Longus.* Stuttgart: Teubner, 1988.

Mitrev, Georgi. "Dionysiac Thiasoi in the Roman Province of Macedonia: Tradition and Innovations." Pages 289–97 in *Jubilaeus V. Sbornik / čest na Prof. Margarita Tačeva. Studia in honorem Margaritae Tacheva.* Edited by Konstantine Boshnakov and Diljna Boteva. Sofia: Sofia University Press, 2002. [in Bulgarian]

Mommsen, Theodorus, ed. *Inscriptiones Bruttorum, Lucaniae, Campaniae, Sicilae, Sardiniae Latinae.* CIL 10. Berolini: Reimerum, 1883.

———. *Inscriptiones Galliae Cisalpinae Latinae.* CIL 5. Berolini: Reimerum, 1872–1877.

Nigdelis, Pantelis M. *Επιγραφικά Θεσσαλονίκεια. Συμβολή στην πολιτική και κοινωνική ιστορία της αρχαίας Θεσσαλονίκης* (Epigraphica Thessalonicensia. Contribution to the Political and Social History of Ancient Thessalonikē). Thessaloniki: University Studio Press, 2006.

Nilsson, Martin P. *Realencyklopädie für protestantische Theologie und Kirche* I A 1 (1914) 1111–15.

Ovadiah, Asher. "Ancient Jewish Communities in Macedonia and Thrace." Pages 185–98 in *Hellenistic and Jews Arts: Interaction, Tradition and Renewal.* Vol. 1 of *The H. Gildman International Conferences.* Tel Aviv: Tel Aviv University Publishing House, 1998.

Pachis, Panayotis. "The Cult of Mithraism in Thessalonica." Pages 229–55 in *Studies in Mithraism: Papers Associated with the Mithraic Panel Organised on the Occasion of the XVIth Congress of the International Association for the History of Religions.* Edited by John R. Hinnells. Roma: L'erma di Bretschneider, 1994.

Pandermalis, Demetrios. "Ζευς Ὕψιστος και άλλα" (Zeus Hypsistos and Alia). *AEMΘ* 17 (2003) [2005] 418.

———. "Zum römischen Porträt im kaiserzeitlichen Makedonien." *Klio* 65 (1983) 161–65.

Peek, Werner. "Zu den *Inscriptiones Thessalonicae (IG* X/2.1)." *Maia* 25 (1973) 200–3.

Perdrizet, Paul. "Inscriptions de Philippes." *BCH* 24 (1900) 323.

Perry, Jonathan S. *The Roman Collegia: The Modern Evolution of an Ancient Concept.* Mnemosyne Supplement 277. Leiden: Brill, 2006.

Pilhofer, Peter. *Philippi. Band II. Katalog der Inschriften von Philippi.* WUNT 119. Tübingen: Mohr Siebeck, 2000.

Poland, Franz. *Geschichte des griechischen Vereinswesens.* Leipzig: Teubner, 1909. Repr., Leipzig: Zentral-Sntiquariat der DDR, 1967.

Polito, Marina. *Il* δοῦμος. *Un'associazone sacra in zone di contatto.* Napoli: Arte Tipografica, 2004.

Radt, Stephan L. "Οἱ περὶ + acc. nominis proprii bei Strabon." *ZPE* 71 (1988) 35–40.

Rajak, Tessa and David Noy. "Archisynagogoi: Office, Title and Social Status in the Greco-Jewish Synagogue." *JRS* 83 (1993) 75–93.

Rhodes, Peter J. and David M. Lewis. *The Decrees of the Greek States.* Oxford: Clarendon, 1997.

Ricl, Mariana and Hasan Malay. " Ἄνθρωποι θρεπτικοί in a new inscription from Hypaipa." *EA* 38 (2005) 48–49.

Rizakis, Athanasios D. "L'émigration romaine en Macédoine et la communauté marchande de Thessalonique. Perspectives économiques et sociales." Pages 124–30 in *Les Italiens dans le monde Grec. IIᵉ siècle av. J.-C. – Iᵉʳ siècle ap. J.-C. Circulation, Activités, Intégration.* Actes de la table ronde. École normale supérieure Paris, 14–16 mai 1998. Edited by Christer Müller and Claire Hasenohr. BCHSup 41. Athens: de Boccard, 2002.

Robert, Louis. "Les inscriptions de Thessalonique." *RPh* 48 (1974).

———. *Hellenica. Recueil d'épigraphie de numismatique et d'antiquités grecques* II (1946) 133, no. 42.

Salomies, Olli. "Contacts between Italy, Macedonia and Asia Minor during the Principate." Pages 118–23 in *Roman Onomastics in the Greek East: Social and Political Aspects: Proceedings of the International Colloquium on Roman Onomastics.* Athens, 7–9 September 1993. Edited by Athanasios D. Rizakis. Meletemata 21. Athens: de Boccard, 1996.

Sayar, Mustafa H. *Perinthos-Heraklia (Marmara Ereğlisi) und Umgebung. Geschichte, Testimonien, griechische und lateinische Inschriften*. Veröffentlichungen der kleinasiatischen Kommision 9. Vienna: Verlag der Österreichischen Akademie der Wissenschaften, 1998.

Steimle, Christopher. "Das Heiligtum der ägyptischen Götter in Thessaloniki und die Vereine in seinem Umfeld." Pages 27–38 in *Religions orientales—culti misterici. Neue Perspektiven—nouvelles perspectives—prospettive nuove. Im Rahmen des trilateralen Projektes "Les religions orientales dans le monde greco-romain."* Edited by C. Bonnet et al. Potsdamer Altertumswissenschaftliche Beiträge 16. Stuttgart: Steiner, 2006.

Tataki, Argyro. *The Roman Presence in Macedonia: Evidence from Personal Names*. Meletemata 46. Athens: de Boccard, 2006.

Tinh, Tran Tam. "Bes." *LIMC* 3:1 (1986) 98–108.

Tsalambouni, Katerina. *Η Μακεδονία στην εποχή της Καινής Διαθήκης* (Macedonia in the Age of the New Testament). Thessaloniki: Pournaras, 2002.

Van Nijf, Onno. *The Civic World of Professional Associations in the Roman East*. Dutch Monographs on Ancient History and Archaeology. Amsterdam: Gieben, 1997.

Vermaseren, Maarten J. *Cybele and Attis: The Myth and the Cult*. Translated by A. M. H. Lemmers. London: Thames and Hudson, 1977.

Vidman, Ladislav. *Isis und Serapis bei den Griechen und Römern. Epigraphische Studien zur Verbreitung und zu den Trägern des ägyptischen Kultes*. Religionsgeschichtliche, Versuche und Vorarbeiten 29. Berlin: de Gruyter, 1970.

Vitti, Massimo. *Η πολεοδομική εξέλιξη της Θεσσαλονίκης. Από την ίδρυσή της έως τον Γαλέριο* (The Urban Development of Thessalonikē from its Foundation to Galerius). Athens: Bibliotheke tes en Athenais Archaiologikes Hetaireias, 1996.

Voutiras, Emmanuel. "Sanctuaire privé-cult public? Le cas du Sarapieion de Thessalonique." Pages 273–88 in *Ἰδίᾳ καὶ δημοσίᾳ. Les cadres "privés" et "publics" de la region grecque antique. Actes du IXe colloque du CIERGA tenù à Fribourg du 8 au 10 sept. 2003*. Edited by V. Dasen and M. Piérart. Kernos Supplément 15. Liège: CIERGA, 2005.

———. "Aphrodite Nymphia." Pages 111–13 in *Griechenland in der Kaiserzeit. Neue Funde und Forschungen zu Skulptur, Architektur und Topographie. Kolloquium zum 60. Geburtstag von Prof. Dietrich Willers. Bern, 12.–13. Juni*. Edited by Christopher Reusser. Bern: Institut für Klassische Archäologie der Universität, 2001.

———. "Berufs- und Kultverein: ein δοῦμος in Thessalonikē." *ZPE* 90 (1992) 87–96.

Wild, Robert A. *Water in the Cultic Worship of Isis and Serapis*. Leiden: Brill, 1981.

Wilson, Stephen G. "Voluntary Associations: An Overview." Pages 1–15 in *Voluntary Associations in the Graeco-Roman World*. Edited by John S. Kloppenborg and Stephen G. Wilson. London: Routledge, 1996.

Youni, Maria S. *Provincia Macedonia. Θεσμοί ιδιωτικού Δικαίου στη Μακεδονία κατά την Ρωμαιοκρατία* (Institutions of Private Law in Macedonia under the Romans). Athens-Komotini: Ant. Sakkoula, 2000.

Zimmermann, Carola. *Handwerkervereine im griechischen Osten des Imperium Romanum*. Römisch-Germanisches Zentralmuseum. Forschungsinstitut für Vor- und Frühgeschichte. Monographien Bd. 57. Bonn: Habelt, 2002.

Of Memories and Meals: Greco-Roman Associations and the Early Jesus-Group at Thessalonikē*

Richard S. Ascough

In examining the inscriptional evidence from antiquity and the canonical texts of the New Testament, one is struck by the fact that the two things that seem to have preoccupied Greco-Roman voluntary associations—eating and dying—seem also to be predominant preoccupations of early Jesus-believers.[1] The gospel writers, understandably, focus on Jesus' death and resurrection, but there are also frequent references to contexts of eating, particularly in Luke's gospel. Three of the four Gospel writers also include a ritualized meal that Jesus undertook with his closest followers. In 1 Corinthians we find Paul reiterating as a received tradition the ritual formulation of this reputed last meal of Jesus in language similar to that found in Luke (1 Cor 11:23–26; Lk 22:19–20). While Paul often focuses on Jesus' death, references to the death of the followers of Jesus are not absent from his writings (e.g., 1 Cor

* Support for the research and writing of this paper has been provided through a Queen's University Chancellor's Research Award, an Ontario Government Premier's Research Excellence Award, and a Social Sciences and Humanities Research Council of Canada Standard Research Grant. I am grateful to my research assistants, Rachel McRae and David Malone, for their help on this project.

[1] Throughout this essay I avoid the usual designation "Christian" in favor of "Jesus-believer" or "Jesus-group." The term "Christian," although commonly used for groups in the first century, suggests a much more developed theology, community, and trans-local connectedness than the evidence permits, especially for the groups to which Paul writes.

15:12–19, 29; 2 Cor 4:11; 1 Thess 4:13–18; Phil 1:21–23; Eph 5:14). Neither are meals absent from the discussion, as we find references to eating in several of Paul's letters: 1 Cor 8:1–11:1; 11:17–22; Gal 2:11–13; Rom 14:17; and perhaps Rom 13:8–10.[2]

Emphasis on dying and eating should come as no surprise. These actions are basic to human existence—without the one, the other is hastened, but in all cases dying is inevitable. What is striking is how closely death and eating are linked both in Jesus-groups and in various voluntary associations. Admittedly, the link between death and meals is not limited to these two sets of groups. Many other types of groups had similar emphases and linkages. For the sake of this investigation, however, I want to single out these particular taxonomic categories and examine what light the associations might shed on the structure and practices of the Jesus-groups when the two are compared and contrasted.

Associations at Thessalonikē

Within the Roman province of Macedonia voluntary associations are attested by inscriptions found from Kalliani and Stobi, in the south and north of the western part of the province respectively, to Philippi and its surrounding villages in the eastern part of the province. The majority of the inscriptions come from urban areas, with sixty-five of eighty-eight known inscriptions coming from Edessa, Philippi, or Thessalonikē, the latter having forty-four such inscriptions.[3] Most of the associations attested in Macedonia are dedicated to particular deities. There is also some evidence among the inscriptions for workers' associations: a guild of purple-dyers is found at Thessalonikē (*IG* X/2.1.291), as is an association of yoke-makers (*BE* [1972] no. 263). Associations of merchants (Asianoi) are also attested at Thessalonikē (Rhomiopoulou 1981, no. 6; *IG* X/2.1.309, 480), as are an association of donkey-drivers (Nigdelis 2.10) and another of wreath-sellers

[2] Jewett, "Are There Allusions?" 265–78. Elsewhere in the New Testament we find references to the death of believers (2 Pet 1:14) and to meals (Jude 1:12; Jas 2:15–16). Such concerns continue to be manifest in extra-canonical material and even archaeological evidence. On the latter see Snyder, *Ante Pacem,* 64–65.

[3] Ascough, "Voluntary Associations," 297–307. Although not complete, the preliminary database of seventy-five voluntary association inscriptions from Macedonia that appears as an appendix to my 1997 dissertation is certainly representative; see also Nigdelis, *Επιγραφικά Θεσσαλονίκεια,* 101–216. Nigdelis adds another thirteen association inscriptions from Thessalonikē to my database.

(Nigdelis 2.11).[4] Although many inscriptions are simply membership lists (e.g., *IG* X/2.1.244), a good number of inscriptions are dedications or votives to deities.[5] Some inscriptions bestow honor on a founder (e.g., *IG* X/2.1.58) or a patron (e.g., *IG* X/2.1.192, 220).

The membership base of the Macedonian voluntary associations comes predominantly from the lower ranks of society, although in some cases upper-rank or wealthy persons are patrons and/or members. In the Thessalonian associations all social levels are represented.[6] For example, *IG* X/2.1.192 (third century C.E.) attests to the erection of an honorific stele for the patron of the association of Sarapidai, with the consent of the council and the "sacred *dēmos*" of Thessalonikē. Poplius Aelius Nicanor is named as a *Macedoniarch*, which indicates that he is an important official of the Synhedrion, the provincial council.[7] The inscription indicates that at least some of the members belonged to the municipal aristocracy.[8] We have no way, however, of determining whether all the members of this association were of the same status.

Of fourteen persons named in *IG* X/2.1.58, at least six were likely slaves or freedmen, as indicated by their names (Felix, Primus, and Secundus), although at least two Roman citizens were also members. In *IG* X/2.1.288 at least two of the members, Demas and Primitas, were slaves,[9] although both persons served as secretaries within the association alongside a citizen named Marcus Cassius Hermonus. Isidorus, named as the deceased in *IG* X/2.1.506 (209 C.E.), was a modest civic official, a *curialis*, of the civic council. His family was of limited economic means, as indicated by his commemoration by a *bomos* rather than a sarcophagus.[10] The text indicates that he was a priest of at least two *thiasoi*, although it does not indicate whether he held these positions simultaneously or successively. In contrast to most of the inscriptions just mentioned, the inscription of *IG* X/2.1.220

[4] Rhomiopoulou, "New Inscriptions," 299–305. Nigdelis, *Επιγραφικά Θεσσαλονίκεια*, 101–216.

[5] Deities attested in the inscriptions include: Zeus Hypsistos, Theos Hypsistos, Dionysos, Herakles, Sarapis, Isis, Anubis, and Aphrodite.

[6] Nigdelis: "in den Vereinen Thessalonikis alle sozialen Schichten vertreten sind" (*Επιγραφικά Θεσσαλονίκεια*, 507).

[7] Edson, "Cults of Thessalonica," 187.

[8] Ibid.

[9] Bömer, *Untersuchungen über die Religion*, 4:238.

[10] Edson, "Cults of Thessalonica," 160.

is poorly executed, with a semiliterate text, suggesting a membership from the lower ranks of society.[11]

The funerary dedication to a fellow *mystēs* named Makedon was inscribed by the *thiasos* of Asianoi (*IG* X/2.1.309) and names the association's high priest, Publius Aelius Alexander.[12] The priest's name indicates status as a Roman citizen and that he is at least a freedman.[13] This name and the careful work on the monument suggest that the social standing of some of the members was higher than that of laborer.[14] The dedication, however, is to a common person (as is the case with Rhomiopoulou 1981, no. 6), suggesting that the Asianoi at Thessalonikē were a mixed group of higher- and lower-status persons.[15] The name Makedon, used in the same inscription (*IG* X/2.1.309), was a common proper name in Macedonia indicating that this particular person was a Macedonian native. Thus, "the Asiani of Thessalonica did not limit membership in their *thiasos* to persons of Asianic origin."[16] We can conclude that the Asianoi of Thessalonikē were a doubly mixed group which included both higher- and lower-status people and individuals from Asia Minor along with native Macedonians.[17]

THE THESSALONIAN JESUS-GROUP AND THE ASSOCIATIONS

In an earlier article I argued that the Jesus-group at Thessalonikē appeared to outsiders as a voluntary association and functioned internally as such.[18] Paul's concerns and language in 1 Thessalonians are similar to concerns and language found in inscriptions produced by associations. Thus, for example, it is possible to see in his instructions about leaders (5:12–13) a suggestion for a rotating leadership structure among the members. The mention of disruptions and disturbances (ἀτακτοί, 5:13b–14) can be read in the context of religious rites

[11] Ibid., 187.

[12] This may also be the case on the fragmentary *IG* X/2.1.480, where a certain Cassia Antigona Memone is named (Edson, *Inscriptiones Thessalonicae* [= *IG* X/2.1]: no. 480).

[13] Edson, "Cults of Thessalonica," 157.

[14] Ibid.

[15] Ibid.

[16] Ibid., 155. An association of Asianoi at Napoca in Dacia (*CIL* III 870) also admitted natives (ibid., 155 n. 3).

[17] Edson, *Inscriptiones Thessalonicae* (= *IG* X/2.1): no. 480 also suggests that the deceased was a member of both the Asianoi and an association of Asklepiastai.

[18] Ascough, "Thessalonian Christian Community," 311–28; idem, *Paul's Macedonian Associations*, 162–90.

that take place within associations, and his injunction against competition for honor among members (4:11) contrasts with the usual practices among members of associations. Furthermore, vom Brocke argues that the proliferation of Dionysos associations at Thessalonikē provides the appropriate background for understanding Paul's references to nighttime drinking and drunkenness in 1 Thess 5:5b–8. Here Paul is drawing upon the Thessalonians' experiences of Dionysos associations prior to their belief in Jesus as a contrast to the behavior expected of the Thessalonian Jesus-believers—unlike the supporters of Dionysos, the Jesus-believers do not belong to the night and the activities usually associated with nighttime revelries.[19]

While many would agree that Paul's statement that the Thessalonians "turned from idols to God" (1:9) indicates a predominantly Gentile group, I have suggested that a preexisting workers' association turned en masse to worshiping Jesus. This helps make sense of Paul's claim that he and his coworkers labored while recruiting. Thus, I understand 1 Thess 2:9 to indicate that Paul worked at his trade and became friendly with those working with him, eventually convincing members of their social organization (i.e., their professional association) to replace their patron deities with Jesus. More controversial is my suggestion that the Thessalonian Jesus-group was composed at its inception primarily of males, as suggested by, among other things, the ethical injunction to each worker to "control your own member" (σκεῦος κτᾶσθαι, 4:4).[20]

Overall, while there are similarities between the Thessalonian Jesus-group community and the voluntary associations, Paul also reflects a desire for a distinctive community ethos. Yet, in attempting to manufacture this ethos, Paul draws on, and contrasts, the practices and structure of the groups with which the Thessalonians were no doubt familiar—the associations. Although, like so many of the different associations in antiquity, they would have distinguished themselves from all other groups, from a modern perspective they are in appearance and function much more like than unlike such associations. This allows modern scholars to investigate the Thessalonian

[19] "Christen gehörten eben nicht wie die Dionysos Anhänger der Nacht an, sondern dem Tage" (vom Brocke, *Thessaloniki*, 129). Reicke argues that "at times an overly realized eschatology in some of the *agapē*-meals led to Christian forms of the Saturnalia in Thessalonica" (Reicke, *Diakonie*, 244–45; cited in Jewett, "Tenement Churches and Communal Meals," 33). One can see this disorderly meal behavior also in places like Corinth and even in Rome, where Paul notes "carousings and drunkenness" in Romans 13:13 (Jewett, "Gospel and Commensality," 242).

[20] For a well-reasoned challenge to this last argument, see the essay by Melanie Johnson-DeBaufre in this volume.

Jesus-group through the lens of the information available from associations in antiquity, particularly those at Thessalonikē.

This conclusion has led me to focus on both the Thessalonians' concern with the death of some members and Paul's response to them in 1 Thess 4:13–5:11.[21] The extent to which many associations were involved in activities surrounding death is striking. Many types of associations often ensured burial of their members[22] and offered the possibility of an annual commemoration of their death,[23] particularly in the form of banquets[24] (although the taxonomic category of *collegia funeraticia* has rightly been called into question).[25]

Of the forty-four association inscriptions identified as belonging to Thessalonikē, at least eighteen are associated with funerary practices of some sort. Some associations seem to have set up inscriptions in memory of their deceased members, such as the purple-dyers (*IG* X/2.1.291), the donkey-drivers (Nigdelis 2.10), the worshipers of Dionysos (*IG* X/2.1.503), Herakles (*IG* X/2.1.288 and 289), and Nemesis (Nigdelis 2.9), the Asianoi (*SEG* [1992] 625, *IG* X/2.1.309 and 480), and a hero cult (*IG* X/2.1.821). In some cases, an existing association is endowed with a bequest of money or property (i.e., vineyards or land), the income from which is to be used for a memorial at the tomb of the deceased. The remainder of the income goes to the association for its own use, probably for social gatherings and banquets (see *IG* X/2.1.259). An annual commemoration known as the *Rosalia* is indicated by a number of Macedonian association inscriptions, including *IG* X/2.1.260 from Thessalonikē, in which a priestess of a *thiasos* bequeaths two *plethra* (200 ft^2) of grapevines to an association to insure that the *Rosalia* is conducted in her memory.[26] As

[21] Ascough, "Question of Death," 509–30.

[22] Van Nijf, *Civic World,* 31. Van Nijf suggests that about one-third of all inscriptions produced by associations in the Roman East indicate some funerary activity; Ausbüttel, *Untersuchungen*, 59. Ausbüttel indicates that one-fifth of known Italian associations were involved in their members' funerals. For a collection of 298 association inscriptions found among nearly 4000 gravestones and dedicatory inscriptions in the West, see Perry, *Death in the* Familia.

[23] Klauck, *Herrenmahl und hellenistischer Kult*, 83–86.

[24] See Dunbabin, *Roman Banquet*, 127–30.

[25] Perry, *Roman Collegia*, 32; Ausbüttel, *Untersuchungen*, 20, 29; Kloppenborg, "Collegia and *Thiasoi*," 18–23.

[26] On the *Rosalia* see Ascough, *Paul's Macedonian Associations*, 26–28; Pandermalis, "Monuments and Art," 216–17 and fig. 148. A sarcophagus from the western necropolis of Thessalonikē depicts a Dionysiac *thiasos*. Whether these represent a *thiasos* in the sense of "voluntary association" that we are using here or whether they represent simply "a band or company marching through the streets with dance and song, esp. in honor of Bacchus, a band of revelers" as the word is defined by LSJ is unclear. The latter seems more likely

Merkelbach notes, "the lost part of the inscription undoubtedly noted that a time of banqueting was intended."[27]

Funerary reliefs from Thessalonikē are formulaic, both in their iconography and in their inscriptions, although there is some attempt at personalizing the features of those depicted.[28] Heroizing the deceased "was a widely disseminated custom in the imperial period" and in many cases was "made even clearer by the visual representation."[29] Of particular interest are stelae in which the deceased is represented "in heroic roles, participating in a banquet of the dead or in the shape of the 'Thracian horseman' or even of Hermes or Aphrodite."[30] Such hero worship is found elsewhere among Macedonian association inscriptions in places such as Hagios Mamas,[31] the Strymon Valley,[32] Philippi,[33] and Sandanski.[34]

in the case of the Thessalonian sarcophagus, which has a depiction of satyrs and maenads, cupids, and children, along with panthers and goats carved into three of its sides.

[27] Merkelbach, *Die Hirten des Dionysos,* 116; "Auf dem verlorenen Teil der Inschrift hat zweifellos gestanden, dass auch eine Festmahlzeit vorgesehen war" (vom Brocke, *Thessaloniki,* 126).

[28] Pandermalis, "Monuments and Art," 215.

[29] Ibid., 216.

[30] Ibid.

[31] *CIG* 2007–8; Robinson, "Inscriptions from Macedonia," 62–63. Robinson thinks that the hero is more likely to have been the Thracian rider hero but does not give reasons. However, this inscription refers to an *archisynagogos*, as do two second-century inscriptions of the association (συνήθεια) of Herakles from Thessalonikē (Edson, *Inscriptiones Thessalonicae* [= *IG* X/2.1]: no. 288 and 289), suggesting a possible connection with Herakles (Robinson, "Inscriptions from Macedonia," 63).

[32] Papazoglou, "Macedonia under the Romans," 205. A relief from the region of Strymon even represents Dionysos on horseback in the manner of the Thracian horseman; see also Düll, *Die Götterkulte Nordmakedoniens,* 77–85 and fig. 34; see Edson, *Inscriptiones Thessalonicae* [= *IG* X/2.1]: no. 259.

[33] At Philippi archaeological excavation has revealed that the *phialē* of the Octagon church is connected on the east by three compartments. The first compartment was probably used by the Christians to worship a saint, the name of whom is lost to us; see Koukouli-Chrysantaki, "Colonia Iulia Augusta Philippensis," 42–45; White, *Building God's House,* 134–35; Pelekanidis, "Kultproblemeim Apostel-Paulus Octagonon," 2:393–97. This room was taken over from a Hellenistic sanctuary; under the room a vaulted tomb was found containing the sarcophagus of the hero. Often the Christians took over the worship of a hero as the worship of a saint.

[34] See Mihailov, "Deux inscriptions," 259–62. The term νέοι in the inscription is probably not being used in the technical sense of "youth group," although such groups did exist in Macedonia. The inscription appears inside one of two crowns in relief on the stele, which measures 0.43 x 0.65 x 0.06 m. Two of the five lines inside the second crown are almost illegible, but the name Πιερίωνος Ἀπολλωνίου appears on the final three lines.

This wider context sheds light on the issue behind Paul's reassurances in 1 Thess 4:13–18. In talking to others in Thessalonikē, Paul is more likely to have proclaimed that belief in Jesus provides escape from wrath and death rather than promise of eternal life, as suggested by his passing statement, with no explanation, that the Thessalonians await the return of Jesus, who will rescue them "from the wrath that is coming" (1 Thess 1:10). Subsequent to Paul's departure, however, the death of a few members has caused cognitive dissonance among the living, who have become unsure of the status of their dead and whether they are still to be considered part of the community. The issue is sociological, not simply theological, and is framed in terms of the appropriateness of continuing to memorialize the members who have died (presumably not having escaped the consequences against which Paul warned). In his response, Paul explains that the "sleeping" (κοιμάομαι) are still part of the community and that they will be given priority at Jesus' return.[35]

Returning to the associations themselves, clearly the social activities of the group were of more importance than funerary activities; it would not be correct to think that concerns about dying occupied all the energy of the associations.[36] While meals could be linked to funerals, a number of social practices are reflected in the record of the associations at Thessalonikē that have nothing to do with funerary contexts, including drinking parties and attendance at performances in the arena.[37] At Thessalonikē in the first century C.E. an association of *mystai* (initiates) dedicated to Zeus Dionysos Gongulos is endowed with a vineyard measuring one third of five *plethra* (*IG* X/2.1.259).[38] Conditions are given to the "present and future *mystai*," who are the beneficiaries of the largess as long as they remain full members of the association. The first, and seemingly primary, condition is that a banquet (καρπήαν) is to be held when the vineyard produces fruit. Three separate occasions are predetermined "according to what was handed over and

[35] See further Ascough, "Paul's 'Apocalypticism,' " forthcoming.

[36] "Es wäre jedoch falsch zu glauben, dass die Sorge um das Dahinscheiden aus dem Leben die ganze Tatkraft der Vereine aufgesogen habe" (Nigdelis, *Επιγραφικά Θεσσαλονίκεια*, 506).

[37] Nigdelis, *Επιγραφικά Θεσσαλονίκεια*, 506; vom Brocke, *Thessaloniki*, 128. Within the Dionysiac associations, meals were most likely held reflecting general revelry found in Dionysos parties, in which there was eating, dancing, music and, naturally, much wine flowing; see also Merkelbach, *Hirten des Dionysos*, 83.

[38] This association is likely the same as the one indicated in a membership list from the mid-second century C.E. (Edson, *Inscriptiones Thessalonicae* [= *IG* X/2.1]: no. 244) and may also be connected with a third inscription, dated to 155–56 C.E. (*IG* X/2.1.60).

bequested" (κατὰ τὸ παραδεδομένον καὶ τὴν δόσιν).[39] The banquets are to take place in the shrine (οἶκος) dedicated to Dionysos. During each of the banquets the *mystai* participate in rituals (ὄργια) that involve a midnight oath to maintain the shrine, which seems to be located on the vineyard property itself, and a meal, as indicated by the phrase "midnight bread" (μεσανύκτιον ἄρτου).[40]

Another example is seen in an early second-century C.E. inscription recording the establishment of a meeting place (οἶκος) of οἱ ἱεραφόροι συνκλίται, "the table-fellowship of bearers of sacred vessels" (*IG* X/2.1.58). Little else is recorded of this association save a list of thirteen male members who seem to be of lower rank, the last of whom is named as president (ἄρχων) of the association.[41] A similar listing of association members is found in a late first-century inscription dedicated to Theos Hypsistos by the son of a man who is designated as *trikliniarchos* (director of the feast; *IG* X/2.1.68). Although there is no direct link between his functionary title and this association, the lack of other designations regarding when or where he would have served in such a capacity suggests that the office was held within the association itself, in which case they did engage in meals together.

Such commensality has a social dimension that is linked to wider issues of community building. Meals are times of solidifying social bonds, networking, mourning and rejoicing, and establishing the *koinonia* (fellowship) that is to mark the association.[42] They also constitute the locus where boundaries around that *koinonia* are maintained and regulations are implemented to sustain it. It is to this aspect of the associations that we shall next turn when we explore commensality in 2 Thessalonians.

EVIDENCE FOR COMMENSALITY IN 2 THESSALONIANS

Very little has been written about meals, in particular the Eucharist or "Lord's Supper," among the early Pauline Jesus-group(s) at Thessalonikē. What little scholarship there is on this subject draws heavily from the

[39] Compare Paul's use of παραδίδωμι with respect to the institution of the Lord's Supper in 1 Cor 11:23.

[40] Vom Brocke, *Thessaloniki*, 126.

[41] The tutelary deity of the association is Anubis; Edson, "Cults of Thessalonica," 184. Edson finds only one other example in the Aegean of a private association worshiping Anubis not in conjunction with Sarapis and Isis (the *Synanoubiastai* of Smyrna: *RIG* 1223; third century B.C.E.).

[42] On the wider social issues embedded in association life, see Ascough, "Question of Death," 515–20; and idem, "Paul's 'Apocalypticism.'"

practices known to us from Corinth. There is an assumption, explicit or implicit, that Corinth is the paradigm for other Pauline communities. Aside from the obvious methodological flaws in such an assumption, it is ironic in light of Paul's claim in 1 Thessalonians that the Thessalonians themselves "became an example to all the believers in Macedonia and in Achaia" (1:7). Whether or not meal practices are part of the exemplar the Thessalonians provided is difficult to determine—Paul's comment seems to refer to overall behavior rather than to specific practices.

Nevertheless, the two letters ostensibly addressed to the Jesus-group at Thessalonikē do contain some possible hints about meal practices, albeit more so 2 Thessalonians—the authenticity and provenance of which, scholars highly contest. Whatever one decides with respect to authorship, with regard to context I am inclined to agree with scholars who maintain that despite 2 Thessalonians being pseudonymous (written as part of a Pauline "school"), it still must be read in the context of the specific situation at Thessalonikē.[43] Thus, it warrants examination for information regarding the practices of the Jesus-believers at Thessalonikē.

In an earlier work I suggested in a footnote that the cognates of ἄτακτος ("disorderly") in 2 Thess 3:6–12 could be taken to indicate laziness.[44] In making this suggestion, however, my concern was to differentiate the use of ἄτακτος in 1 Thess 5:14 from its usual interpretation as "laziness," which I argued was based on reading the context from 2 Thessalonians into 1 Thessalonians. An alternative approach is to use the evidence from the life of associations to see how and in what contexts they dealt with behavior that might be considered ἀτάκτως ("in a disorderly manner"). I now want to challenge my own assumption—not my understanding of 1 Thess 5:14, but my acceptance that 2 Thess 3:6–16 is referring to laziness.[45] I would suggest that it may rather be a reference to disorderly behavior, and that the setting for such behavior would most likely be meals, which would then

[43] Donfried, *Paul, Thessalonica,* 66; see also 50, 53; so also Malherbe, *I and II Thessalonians,* 373; Still, *Conflict at Thessalonica,* 58.

[44] Ascough, *Paul's Macedonian Associations,* 177–78 n. 63. On the possible renderings of ἄτακτον see Jewett, *Thessalonian Correspondence,* 104. In the New Testament the verb ἀτακτέω only occurs in 2 Thess 3:7 and the adverb ἀτάκτως only in 2 Thess 3:6 and 11.

[45] Gaventa cites *Didache* 12:4–5 in support of the reading of 2 Thess 3:6–12 as referencing the "idle": "No Christian shall live idle in idleness. But if anyone will not do so [i.e., work], that person is making Christ into a cheap trade; watch out for such people" (Gaventa, *First and Second Thessalonians,* 130). However, this text is set within the context of instructions warning against itinerant preachers who would take advantage of those living in urban centers by demanding payment. Such persons are not to receive more than a day's wage and, should they request more, they are "false prophets" (*Didache* 11.1– 21).

allow for the enforcement of Paul's injunction in 2 Thess 3:10: "Let him not eat" (μηδὲ ἐσθιέτω).[46]

Since the predominant theme of the preceding passage in 2 Thessalonians is apocalyptic events (2:1–12), some commentators have proposed that those who are referred to as ἀτάκτως περιπατοῦντος ("persons walking about in a disorderly manner"), usually translated "living in idleness," in 2 Thess 3:6 and 11 have ceased working due to eschatological fervor.[47] The apocalyptic passage, however, is separated from the exhortation against the ἀτάκτως περιπατοῦντος by the rhetoric and structure of the letter.[48] The body of the letter includes the *probatio*, which effectively ends at 2:12 as the writer turns his attention to other matters. This is followed by a *peroratio* (2:13–3:5) that serves to end the preceding section and segue into what will be the *exhortatio* of 3:6–15. The *peroratio* focuses on the primary theme of the letter, God's faithfulness, and includes thanksgiving, a benediction, and a prayer request, all of which serve to distance the apocalyptic *probatio* from the *exhortatio*. The *exhortatio* is framed as a community concern.[49] Paul appeals to his authority to "command" the Thessalonians, and invokes fictive kinship language (ἀδελφοί) to address a community problem—adherents who are ἀτάκτως περιπατοῦντος.[50] The opening recommendation that such persons be avoided is then extended into a punishment to the transgressors themselves: "Anyone unwilling to work should not eat" (3:10). This is, Paul reminds them, a command that was given while he was among them.

[46] Those who understand ἀτάκτως/ἀτακτέω in 2 Thess 3:6–12 as "disorderly" include Rigaux, *Les épîtres aux Thessaloniciens*, 704–5; Bruce, *1 & 2 Thessalonians*, 205; Jewett, *Thessalonian Correspondence*, 104–5; Collins, *Birth of the New Testament*, 94; Menken, *2 Thessalonians*, 130–33; Russell, "Idle in 2 Thess 3.6–12," 107–8; Donfried, "2 Thessalonians," 141–42. Williams uses "idle" and "disorderly" interchangeably (*1 and 2 Thessalonians*, 144). Malherbe maintains that the disorderly "are those who willfully reject the accepted norms by which the church is expected to live" (*Thessalonians*, 450, 456). Few commentators link the disorderly to a meal context.

[47] Jewett, *Thessalonian Correspondence*, 104–5; Bruce, *Thessalonians*, 209; Marshall, *1 and 2 Thessalonians*, 218–19; see also Martin, *1, 2 Thessalonians*, 274.

[48] The same situation applies to 1 Thess 5:14 and the use of τοὺς ἀτάκτους ("the disorderly") there; Ascough, "Thessalonian Christian Community," 319–20.

[49] See Malherbe, who notes, "Paul's interest in this section is not primarily in the economic policy of the church. It is, rather, in mutual responsibility within the church, which some Thessalonians were threatening by being disorderly and meddlesome. His own behavior was exemplary for its orderliness and self-giving concern for others, and constituted the tradition by which they were to conduct themselves" (Malherbe, *Thessalonians*, 457).

[50] On the problematic nature of reading 2 Thess 3:6–12 as a matter of eschatology, see further Nicholl, *From Hope to Despair*, 158–63.

There seem to be two characteristics that demarcate the ἀτάκτως περιπατοῦντος: they refuse to work and instead participate in activities that single them out as "busybodies" (περιεργάζομαι).[51] As a result, they are to be avoided (στέλλεσθαι, 3:6) and not allowed to eat (3:10). The example of Paul and his companions being employed in manual labor while in Thessalonikē is presented as a contrast to those who have ceased working. The text, however, "provides the community with advice and motivation rather than with detailed disciplinary procedures."[52] It is not clear from the text itself how such advice might be put into practice, nor even in what context(s) it might make sense to give such advice.[53] The question becomes how we envision the Thessalonian Jesus-group being able to enforce such an injunction.

A number of inscriptions demonstrate that voluntary associations often struggled with the problem of disorderly behavior at community gatherings, including meals, sacrifices, and processions, to the extent that legislation was introduced to limit it, and fines and corporal punishment were used to enforce the legislation.[54] Such inscriptions give an indication of the type of disturbances that could occur at a meeting (fighting, disruptions of order and ceremony, abuse of others), along with guidance on how to deal with such disturbances (fines and floggings). I have argued elsewhere that Paul's use of ἄτακτοι (disorderly persons) indicates that some persons among the Thessalonian Jesus-believers were disorderly. This was not a challenge to the leadership from a "breakaway" group but rather involved disruptions and disturbances within the context of worship.[55] Paul's injunction in 1 Thess 5:14, "see that none of you repays evil for evil, but always seek to

[51] A number of suggestions have been made as to the reasons the Thessalonian believers might have ceased working, all of them based on the authenticity of 2 Thessalonians: they have become cynic preachers (Malherbe, *Paul and the Thessalonians*, 101); there is unemployment at Thessalonikē (Russell, "Social Problem," 108); disdain for manual labor (Marshall, *Thessalonians*, 223); they are relying on benefaction (Winter, "'If Any Man Does Not Wish to Work . . .'", 312); they are undertaking aggressive evangelism (Barclay, "Conflict in Thessalonica," 522–24).

[52] Richard, *First and Second Thessalonians*, 392.

[53] Winter, *Seek the Welfare*, 57–60. Winter suggests that it concerns the patronage system, where one could rely upon a benefactor to supply a meal and one could move from one benefactor to another in order to insure that one was fed well. Perhaps this is also what is implied when Paul exhorts the Thessalonians to work quietly and not be reliant upon anyone (1 Thess 4:11). This is how Richard takes the critique of those who are acting as busybodies—they are involved in the lives of others where they should not be (*Thessalonians*, 390).

[54] See Ascough, "Thessalonian Christian Community," 318–21; idem, *Paul's Macedonian Associations*, 177–83.

[55] Ascough, "Thessalonian Christian Community," 321.

do good to one another and to all," following his "be patient with them all" (including the ἄτακτοι) indicates that he thinks that verbal admonishing, rather than fines and flogging, should suffice to stem disorderliness. In 2 Thessalonians Paul still does not resort to recommending fines and floggings. He does, however, advocate physical separation from those who are acting disorderly: "Now we command you, beloved, in the name of our Lord Jesus Christ, to keep away from (στέλλεσθαι) believers who are walking about disruptively and not according to the tradition that they received from us" (2 Thess 3:6).

There are few other uses of στέλλω in the New Testament. One use occurs with the prefix ὑπο-, but the word is similar in meaning. Interestingly enough, this use occurs in the context of a meal situation. Paul recounts for the Galatians his confrontation with Cephas, noting that it stemmed from Cephas's decision to withdraw from sharing meals with Gentiles, despite having eaten with them for some time:

> For until certain people came from James, he used to eat with the Gentiles. But after they came, he drew back (ὑπέστελλεν) and kept himself separate (ἀφώριζεν ἑαυτόν) for fear of the circumcision faction. (Gal 2:12)

In this case Paul uses two verbs to describe the action: withdrawal and separation. This raises the interesting notion that it was possible to withdraw (that is, not eat) without separating (that is, leaving the dining facility).

Perhaps in 2 Thess 3:6 Paul is suggesting that those acting in a disruptive manner are to withdraw from sharing in the meal but are allowed to remain in the presence of those eating.[56] They could watch while others ate; thus their punishment for acting disorderly and for not working would be non-participation in the meal—"let them not eat"—which is enforceable so long as they are actually present where the meal is taking place. Paul reiterates the notion of separation at the conclusion of the argument, stating generally: "Take note of those who do not obey what we say in this letter; have nothing to do with him (μὴ συναναμίγνυσθαι αὐτῷ), so that he may be ashamed" (2 Thess 3:14).

The only other uses of συναναμίγνυμι "to associate (with)" in the New Testament are both found in close proximity to one another, in 1 Cor 5:9 and 11:

> I wrote to you in my letter not to associate with (μὴ συναναμίγνυσθαι) sexually immoral persons. ... But now I am writing to you not to

[56] Similarly Best, *First and Second Epistles,* 333–34.

associate with (μὴ συναναμίγνυσθαι) anyone who bears the name of brother or sister who is sexually immoral or greedy, or is an idolater, reviler, drunkard, or robber. Do not even eat with such a one (τῷ τοιούτῳ μηδὲ συνεσθίων).

Paul seeks to clarify what he meant by his command to disassociate from "immoral" persons (as he communicated in an "earlier" letter, 5:9). His instruction "not to associate" really meant not to tolerate immoral persons within the community itself. His clarification of his actual meaning is framed beforehand with a clear directive to expel any immoral person (5:4–5) and afterwards with the more general admonition to drive the wicked from among them (5:13, quoting LXX Deut 17:7).

The writer's use of συναναμίγνυμι in 2 Thess 3:14 is equally ambiguous. Although literally it denotes avoidance, what the writer may intend is the expulsion of the person(s) from communal settings (i.e., meetings and meals). This certainly would fit with the earlier injunction in 3:6 to "withdraw" from the disorderly, and together 3:6 and 3:14–15 frame the passage with references to the separation of some persons from the group. Although 3:6 and 3:14 might mean that those who are not disorderly should actively leave the gathering, a more natural expectation is for the "withdrawal" to take the form of the expulsion of the perpetrators of the trouble from community gatherings. Certainly this would be a way of ensuring that they "do not eat" (2 Thess 3:10): They are not to be present at the table (if at all) during meals.

Support for placing this command in the context of community meals comes from the work of Jewett, who argues that 2 Thess 3:10 reflects "a communal situation of shared resources, involving regularly eating together and relying on the support of members rather than on a patron."[57] He argues that it might "refer to the Lord's Supper, embedded in a practice of communal meals."[58] Drawing on the work of Peter Lampe, Jewett suggests that the most likely setting for the Thessalonian Jesus-group is in tenement buildings, or *insula*, that housed lower-ranking handworkers such as those that seem to have composed the group.[59] These meals, suggests Jewett, are *agapē*-meals, or love feasts.

[57] Jewett, "Tenement Churches and Pauline Love Feasts," 44; ibid., 23–43.

[58] Ibid., 44. We find direct reference to a common meal held within Jesus-groups from evidence spanning the first through fourth centuries. In his examination of such evidence, Reicke argues that there was a "single Christian sacrament of table fellowship" that was demarcated as a love feast (Reicke, *Diakonie, Festfreude, und Zelos*, 14).

[59] See also Jewett, "Tenement Churches and Communal Meals," 23–43. Jewett does not disagree with those who envision Jesus-groups meeting in the houses of patrons and

Jewett finds corroborating evidence for Jesus-believers' commensality in another letter of Paul. Turning his attention to Gal 2:14, Jewett suggests that Paul's rebuke of Cephas concerning the "truth of the gospel" (ἡ ἀλήθεια τοῦ εὐαγγέλιου) had less to do with doctrine than it did with the social dimensions—" 'gospel' in this passage entails a social system requiring 'fellowship,' including cross-cultural eating."[60] Cephas was participating with Gentiles in ordinary meals as well as the sacramental meal, since "the love feast constituted the sacramental meal."[61] Paul was willing to challenge Cephas publicly over his withdrawal because "Paul understood the gospel to be the message that instituted a new form of commensality, in which converted Jews and Gentiles overcame their cultural traditions of separation into distinct and irreconcilable groups in order to participate together in sacramental love feasts."[62] The inability to reconcile the two positions represented by Cephas and Paul led to a "separation into culturally limited love feasts," which Paul understood "as a violation of the gospel."[63]

In a later article Jewett develops his thesis to include the Jesus-groups in Rome, arguing that in Romans we find reference to a system of self-supporting love feasts.[64] He looks in detail at Rom 13:10—"the *agape* does no evil to the neighbor; law's fulfillment is therefore the *agape*"—arguing that the articular use of *agapē* indicates not "love" generally construed but the *agapē*-meal, or "love feast," of the early church.[65] The wider context in Romans suggests to Jewett that ideological and cultural conflicts had led to separation for sacramental meals, a development that Paul aims to correct with these words, along with the admonitions in Rom 14:1 and 15:7.[66] Contrary to earlier scholarly assumptions, then, Romans does, as Jewett suggests, contain a reference to the Jesus-group's meal sacrament.[67]

Smit has also found evidence for meal practices among the early Roman Jesus-groups, in this case from Rom 14:17: "For the kingdom of God is not food and drink but righteousness and peace and joy in the Holy Spirit."

practicing a form of "love-patriarchalism" wherein the patron-patriarch of the household cares for the others, but he thinks that this is only one possible model, more appropriate to some communities, such as those at Corinth, than to others.

[60] Jewett, "Gospel and Commensality," 240.

[61] Ibid., 248.

[62] Ibid., 241.

[63] Ibid., 249.

[64] Jewett, "Allusions to the Love Feast," 265–78.

[65] Ibid., 274.

[66] Ibid., 276–77.

[67] Ibid.

"The association of Rom 14:17 with symposiastic [sic] ideology suggests itself because of the occurrence of terminology central to contemporary symposiastic [sic] thought within the context of a conflict precisely about meal fellowship."[68] Drawing largely upon Greco-Roman philosophical literature, Smit shows how central to the meals were social interactions and the creation of community and that the maintenance of orderly behavior was therefore key: "many writings in the 'meal-centered' first-century Mediterranean world were extremely concerned about having well-ordered and well-organized dinner parties (the early Christians are here no exception), giving them the enjoyment of full κοινωνία."[69] Within the context in which Rom 14:17 falls, one finds three characteristics of the kingdom of God that are also values maintained in the setting of the symposium: righteousness, peace, and joy (δικαιοσύνη, εἰρήνη, and χαρά). The concept of peace is particularly noteworthy, for "the image of the peaceful symposium is the counterpart of war, and *fights and drunkenness at the symposium*."[70] Yet behind all of this is a concern for fellowship. Eating is not the same as a "meal";[71] the latter involves close fellowship.

One can extend this concern about meals to 2 Thessalonians, where the reluctance to contribute to the meal might well be the sign not of "laziness" per se but of an unwillingness to engage in the true fellowship that is to characterize the meal setting among Jesus-believers. As in Rom 14:17, where Paul calls "upon the Romans to preserve meal fellowship, and not to disrupt their community by disrupting the meal fellowship through disapproving of each other's diet,"[72] we suggest that in 2 Thess 3:6–12 the call to contribute goes to the heart of what is *philadelphia* (compare 1 Thess 4:9–12).

According to Jewett, Paul's command to the Thessalonians in 2 Thess 3:10 is a "typical" example of casuistic law in which the nature of the offense is outlined in the first half and the legal remedy or consequence is given in the second. "Since the sanction implies communal discipline rather than some judicial punishment enacted by an official agency, this saying should be classified as a community regulation."[73] That is, for the law to be effective there must be some way for the non-eating of the perpetrator to be enforced.

[68] Smit, "Symposium in Rom. 14:17?" 41.

[69] Ibid., 47.

[70] Ibid., 49 (emphasis mine). Smit cites the helpful but brief article by Slater, "Peace," 205–14.

[71] Smit, "Symposium," 46.

[72] Ibid., 52.

[73] Jewett, "Tenement Churches and Pauline Love Feasts," 52.

It is because the community shares common meals, suggests Jewett, that the law is enforceable in the Jesus-group.

Returning to 2 Thess 3:10, Jewett suggests that the strength of the command—μηδὲ ἐσθιέτω, "let him not eat"—indicates deprivation of food rather than simply exclusion from a particular meal or sacramental celebration.[74] Jewett finds it unlikely that Paul has simply invented this instruction; rather, it is a community rule negotiated within the community itself, about which Paul reminds them, as he did when he was among them (hence the imperfect verbs in 3:10a).[75] Paul's statement in 2 Thess 3:10b "relates to the unwillingness to work, not to the ability or availability of employment,"[76] and as such reflects a situation in which the communal nature of the love feasts was threatened.

To illustrate his point Jewett invokes some general evidence from "Hellenistic guilds," which, he points out, "prescribe penalties of exclusion from the common meal or from the guild itself for certain offenses, although the payment of fines is a more usual punishment."[77] He then conflates this with evidence from Qumran, in which expulsion from the table and/or the community is prescribed for infractions (1QS 6.24–7.24). Yet the Qumran community is much more "communalistic" than the associations insofar as the Qumran group seems to have lived together in relative seclusion from the outside world and thus shared much in common besides meals.[78] It is not the case, as Jewett supposes, that the association inscriptions "reflect settings in which communities are eating their meals together."[79] He is correct, however,

[74] Ibid., 53; Nicholl suggests a meal setting as one of two possible scenarios within which the command to "keep away from" particular people might be relevant, the other setting being temporary excommunication. He maintains that deciding between the two options is "difficult" and "for our purposes unnecessary" (Nicholl, *From Hope to Despair*, 167). I do, however, think it is possible to negotiate some evidence in favor of a meal setting, a setting that Nicholl all but ignores after having raised it as a possibility. Overall, few commentators have favored understanding Paul's command in 2 Thess 3:6 as being set within the wider context of love feasts and/or communion: See Forkman, *Limits of the Religious Community*, 135; Jewett, "Tenement Churches and Communal Meals," 23–43; and idem, "Gospel and Commensality," 240–52.

[75] Jewett, "Tenement Churches and Pauline Love Feasts," 54.

[76] Ibid., 53; Jewett, "Tenement Churches and Communal Meals," 37.

[77] Jewett, "Tenement Churches and Pauline Love Feasts," 52; idem, "Tenement Churches and Communal Meals," 35–36.

[78] Jewett's blending of the association practices with the Qumran practices seems to be a result of his reliance on the very good work of Weinfeld, *Organizational Pattern*, in which he undertakes a comparison of these groups (much more evident in Jewett's 1993 article "Tenement Churches and Communal Meals"). Jewett, however, glosses over some of Weinfeld's nuances.

[79] Jewett, "Tenement Churches and Communal Meals," 36.

that they do "presuppose a communal or familial system of some kind."[80] It is the "of some kind" that is at issue. The association texts to which Jewett alludes reflect communal settings of occasional, prescribed commensality, often grounded in the language of fictive kinship.[81] As such, they do provide an alternative model of community relations to that which Jewett imagines as being grounded in communalism and love.[82] They suggest that it is appropriate to set up sanctions around ritual meals whereby a person is prevented from participation because he or she refuses to adhere to community regulations.

My alternative reading, predicated not on tenement living but on a comparison with association practices,[83] suggests that the injunction μηδὲ ἐσθιέτω ("let him not eat") in 2 Thess 3:10 pertains to a ban of the disorderly from ritualized commensality, the kind of commensality that takes place periodically (perhaps at set times) and provides participants with a means for individual and collective identity.[84] The Pauline prohibition on participation would thus not deprive the offender(s) from ever eating, which would, over time, become a death sentence. If such an extreme sanction were invoked,

[80] Ibid., 36.

[81] See Harland, *Associations, Synagogues, and Congregations,* 30–33; idem, "Familial Dimensions," 491–513; Ascough, *Paul's Macedonian Associations,* 76–77.

[82] Nicholl, *From Hope to Despair,* 173–74. Nicholl notes recent moves to expand love-patriarchalism to "transformative love-patriarchalism" rooted in Christian love, which the poor are abusing by looking to Christian patrons to replace their old patrons now that they have converted.

[83] What is not clear from Jewett's scenario is where such groups would meet or why the inhabitants of an entire tenement building would be inclined toward belonging to a Jesus-group, if indeed this is the location in which the meals took place. Jewett suggests that "a kind of Christian commune or cooperative is required" but does not show how or even why persons in tenement buildings chose to eat together (Jewett, "Tenement Churches and Communal Meals," 38). Apart from some rurally based groups such as the Qumran inhabitants or the *Therapeutai,* we have little evidence for such groups, particularly in urban areas such as Thessalonikē. The exception might be philosophical schools such as those of Plato or Epicurus, but these seem to have been located in Athens in their own day and do not seem to have been exported to other urban areas. As Wilkins and Hill note, "The Urban poor, in Rome at least, lived in tenements without cooking facilities and must of necessity have used the equivalent of fast food from street vendors for a sizeable part of their diet" (Wilkins and Hill, *Food in the Ancient World,* 39); Lampe, "Das korinthische Herrenmahl," 192–96. Lampe argues that participants in community meals would bring their own food, in a scenario akin to a potluck banquet. He finds such practices from earlier times in groups termed ἔρανος ("a meal to which each participant contributed a share"), although these groups are quite early in the classical period and it is rare to find evidence for such bringing of provisions in association inscriptions from the first and second centuries C.E.

[84] Banquets were markers of class and status and provided those invited with a sense of belonging and identity. See Clarke, *Art in the Lives,* 223–27. In general, meals express patterns of social relations. See Douglas, "Deciphering a Meal," 231.

the one punished would more likely find food elsewhere than starve, with the net effect being expulsion from the group (as is the case in 1 Cor 5:2). If understood as a ban on full participation in the ritualized commensality of their group, however, the prohibition is enforceable since it causes the one sanctioned to question his or her identity and whether or not he or she wants to continue to find that identity through membership in the group (and hence continue to be referred to as ἀδελφός [brother]). This identity is not individualized but is rather linked to issues of familial connections (fictive or otherwise),[85] social networking, and communication with the gods (religion). What I am suggesting here is that the meal context of 2 Thess 3:10 is not ordinary meals but ritual commensality, which comes to light for modern interpreters through the examination of commensality in the life of Greco-Roman associations.[86]

CONCLUSION

For the historian of the earliest Jesus-groups, the problem at Thessalonikē is the paucity of archaeological and literary evidence for religious life in the first few centuries C.E.[87] However, as Nigdelis demonstrates in this volume, there is an increasingly rich and abundant body of evidence for associations. Since our data is still limited, the best we can hope for is to make connections and abstractions based on our data in order to construct a picture of the earliest Jesus-group(s) in the city.

[85] The terms "brother" and "brotherly love" in the Thessalonian letters are not communistic terms of endearment, as Jewett seems to suppose, but the mechanism by which fictive kinship was created (Jewett, "Tenement Churches and Communal Meals," 38–40).

[86] On meals in associations generally see Klauck, *Herrenmahl und hellenistischer Kult*, 68–71; Klinghardt, *Gemeinschaftsmahl und Mahlgemeinschaft*, 29–44.

[87] Very little is known about the Jesus-group at Thessalonikē before the fourth century beyond the letter(s) Paul sent, at which point it was a large and important center of Christianity; see Tsitouridou, "Early Christian Art," 230–32; and Spieser, *Thessalonique et ses monuments*. Melito's *Apology* does note that the mid-second-century Emperor Antoninus Pius "had written a letter to the people of Thessalonica, among other places, telling them to take no new steps against the Christians" (Lightfoot, *Biblical Essays*, 267). In the early third century Tertullian mentions both Thessalonikē and Philippi as places "where the letters of the Apostles are read in the original" (ibid., 267–68). Lightfoot also mentions two early bishops Aristarchus and Gaius; Musurillo, *Acts of the Christian Martyrs*, no. 22. In the fourth century there were martyrdoms in Thessalonikē after the edicts of Diocletian, most notably that of Demetrius (whose cult did not develop until after the time of Theodosius), and of three women (and perhaps their companions) who were killed in 304 C.E. for refusing to participate in cult practices, including the eating of sacrificial meat.

In this chapter I have summarized arguments that I have made elsewhere on the makeup of the Thessalonian Jesus-group and the question behind Paul's response to them concerning dead believers (1 Thess 4:13–18), arguments drawn largely from the use of comparative data from Greco-Roman associations. The connection I proposed between this passage and the ritualized memorial of the dead, particularly dead heroes such as Jesus, is suggested by the many connections made in the associations at Thessalonikē and beyond between meals and dead heroes and the interest in the death and eventual return of Jesus among the Jesus-believers. I then pushed the comparison further to suggest that in 2 Thessalonians there are indications that the Jesus-believers shared a ritualized meal. While this has been assumed by many, the assumption is based on evidence from 1 Corinthians. Such geographic dislocation is unnecessary. Evidence from associations at Thessalonikē reveals that they held common meals around which a number of regulatory behaviors were invoked. Comparison with 2 Thess 3:6–14 shows similar concerns, suggesting that the Jesus-group at Thessalonikē was involved in similar meal practices.

BIBLIOGRAPHY

Ascough, Richard S. "Paul's 'Apocalypticism' and the Jesus-Associations at Thessalonica and Corinth." *Redescribing Paul and the Corinthians*. Edited by Ron Cameron and Merrill P. Miller. Vol. 2 of *Redescribing Christian Origins*. SBL Supplement. Atlanta: Scholars, forthcoming.

———. "A Question of Death: Paul's Community Building Language in 1 Thessalonians 4:13–18." *JBL* 123 (2004) 509–30.

———. *Paul's Macedonian Associations: The Social Context of 1 Thessalonians and Philippians*. WUNT 2/161. Tübingen: Mohr Siebeck, 2003.

———. "The Thessalonian Christian Community as a Professional Voluntary Association." *JBL* 119 (2000) 311–28.

———. "Voluntary Associations and Community Formation: Paul's Macedonian Christian Communities in Context." Ph.D. diss., University of St. Michael's College, Toronto School of Theology, 1997.

Ausbüttel, Frank M. *Untersuchungen zu den Vereinen im Westen des römischen Reiches*. Frankfurter althistorische Studien 11. Kallmünz: Michael Lassleben, 1982.

Barclay, John M. G. "Conflict in Thessalonica." *CBQ* 55 (1993) 512–30.

Best, Ernest. *The First and Second Epistles to the Thessalonians*. London: Black, 1972.

Bömer, Franz. *Untersuchungen über die Religion der Sklaven in Griechenland und Rom*. 4 vols. Akademie der Wissenschaften und der Literatur 1, 4, 7, 10. Wiesbaden: Steiner, 1957–1963.

Brocke, Christoph vom. *Thessaloniki—Stadt des Kassander und Gemeinde des Paulus. Eine frühe christliche Gemeinde in ihrer heidnischen Umwelt*. WUNT 2/125. Tübingen: Mohr Siebeck, 2001.

Bruce, Frederick Fyvie. *1 & 2 Thessalonians*. Word Biblical Commentary 45. Waco, Tex.: Word, 1982.

Clarke, John R. *Art in the Lives of Ordinary Romans: Visual Representation and Non-Elite Viewers in Italy, 100 B.C.–A.D. 315*. Berkeley: University of California Press, 2003.

Collins, Raymond F. *The Birth of the New Testament: The Origin and Development of the First Christian Generation*. New York: Crossroad, 1993.

Donfried, Karl P. *Paul, Thessalonica, and Early Christianity*. Grand Rapids, Mich.: Eerdmans, 2002.

———. "2 Thessalonians and the Church of Thessalonica." Pages 128–44 in *Origins and Method: Towards a New Understanding of Judaism and Christianity. Essays in Honour of John C. Hurd*. Edited by Bradley H. McLean. JSNTSup 86. Sheffield, England: JSOT, 1993.

Douglas, Mary. "Deciphering a Meal." Pages 231–51 in *Implicit Meanings: Selected Essays in Anthropology*. Edited by Mary Douglas. 2d edition. London: Routledge, 1999.

Düll, Siegrid. *Die Götterkulte Nordmakedoniens in römischer Zeit*. Münchener archëologische Studien 7. Munich: Fink, 1977.

Dunbabin, Katherine M. D. *The Roman Banquet: Images of Conviviality*. Cambridge, U.K.: Cambridge University Press, 2003.

Edson, Charles, ed. *Inscriptiones Thessalonicae et viciniae* [= *IG* X/2.1]. Berlin: de Gruyter, 1972.

Edson, Charles. "Cults of Thessalonica (Macedonica III)." *HTR* 41 (1948) 153–204.

Forkman, Goran. *The Limits of the Religious Community.* Lund, Sweden: Gleerup, 1972.

Gaventa, Beverly Roberts. *First and Second Thessalonians.* Interpretation. Louisville, Ky.: John Knox, 1998.

Harland, Philip A. "Familial Dimensions of Group Identity: 'Brothers' (AΔΕΛΦΟΙ) in Associations of the Greek East," *JBL* 124 (2005) 491–513.

———. *Associations, Synagogues, and Congregations: Claiming a Place in Ancient Mediterranean Society.* Minneapolis, Minn.: Fortress, 2003.

Jewett, Robert. "Are There Allusions to the Love Feast in Rom 13:8–10?" Pages 265–78 in *Common Life in the Early Church: Essays Honoring Graydon F. Snyder.* Edited by Julian V. Hill et al. Valley Forge, Pa.: Trinity Press International, 1998.

———. "Gospel and Commensality: Social and Theological Implications of Galatians 2.14." Pages 240–52 in *Gospel in Paul: Studies on Corinthians, Galatians and Romans for Richard N. Longenecker.* Edited by L. Ann Jervis and Peter Richardson. JSNTSup 108. Sheffield, England: Sheffield Academic, 1994.

———. "Tenement Churches and Pauline Love Feasts." *QR* 14 (1994) 43–58.

———. "Tenement Churches and Communal Meals in the Early Church: The Implications of a Form-Critical Analysis of 2 Thessalonians 3:10." *BR* 38 (1993) 23–43.

———. *The Thessalonian Correspondence: Pauline Rhetoric and Millenarian Piety.* Philadelphia: Fortress, 1986.

Klauck, Hans-Josef. *Herrenmahl und hellenistischer Kult. Eine religionsgeschichtliche Untersuchung zum ersten Korintherbrief.* NTAbb 15. Münster: Aschendorff, 1982.

Klinghardt, Matthias. *Gemeinschaftsmahl und Mahlgemeinschaft. Soziologie und Liturgie frühchristlicher Mahlfeiern.* Texte und Arbeiten zum neutestamentlichen Zeitalter 13. Basel: Francke, 1996.

Kloppenborg, John S. "Collegia and *Thiasoi*: Issues in Function, Taxonomy and Membership." Pages 18–23 in *Voluntary Associations in the Graeco-Roman World.* Edited by John S. Kloppenborg and Stephen G. Wilson. London: Routledge, 1996.

Koukouli-Chrysantaki, Chaido. "Colonia Iulia Augusta Philippensis." Pages 42–45 in *Philippi at the Time of Paul and after His Death.* Edited by Charalambos Bakirtzis and Helmut Koester. Harrisburg, Pa.: Trinity Press International, 1998.

Lampe, Peter. "Das korinthische Herrenmahl im Schnittpunkt hellenistisch–römischer Mahlpraxis und paulinischen Theologia Crucis (1 Kor 11,17–34)." *ZNW* 82 (1991) 183–213.

Lightfoot, Joseph Barber. *Biblical Essays.* London: Macmillan, 1893. Repr., Peabody, Mass.: Hendrickson, 1994.

Malherbe, Abraham J. *I and II Thessalonians.* AB 32B. Garden City, N.Y.: Doubleday, 2000.

———. *Paul and the Thessalonians: The Philosophic Tradition of Pastoral Care.* Philadelphia: Fortress, 1987.

Marshall, I. Howard. *1 and 2 Thessalonians.* New Century Bible Commentary. Grand Rapids: Eerdmans, 1983.

Martin, D. Michael. *1, 2 Thessalonians.* New American Commentary 33. Nashville: Broadman & Holman, 1995.

Menken, Maarten J. J. *2 Thessalonians.* London: Routledge, 1994.

Merkelbach, Reinhold. *Die Hirten des Dionysos. Die Dionysos-Mysterien der römischen Kaiserzeit und der bukolische Roman des Longus.* Stuttgart: Saur, 1988.

Mihailov, Gorgi. "Deux inscriptions de la province romaine de Macédoine." Pages 259–62 in *Ancient Macedonian Studies in Honor of Charles F. Edson.* Edited by Harry J. Dell. Thessaloniki: Institute for Balkan Studies, 1981.

Musurillo, Herbert Anthony, ed. *The Acts of the Christian Martyrs.* Oxford: Oxford University Press, 1972.

Nicholl, Colin R. *From Hope to Despair in Thessalonica: Situating 1 and 2 Thessalonians.* SNTSMS 126. Cambridge, U.K.: Cambridge University Press, 2004.

Nigdelis, Pantelis M. *Επιγραφικά Θεσσαλονίκεια. Συμβολή στην πολιτική και κοινωνική ιστορία της αρχαίας Θεσσαλονίκης* (Epigraphica Thessalonicensia. Contribution to the Political and Social History of Ancient Thessalonikē). Thessaloniki: University Studio Press, 2006.

Pandermalis, D. "Monuments and Art in the Roman Period." Pages 208–21 in *Macedonia: 4000 Years of Greek History and Civilization.* Edited by M. B. Sakellariou. Athens: Ekdotike Athenon S.A., 1988.

Papazoglou, Fanoula. "Macedonia Under the Romans." Pages 192–207 in *Macedonia: 4000 Years of Greek History and Civilization.* Edited by M. B. Sakellariou. Athens: Ekdotike Athenon S.A., 1988.

Pelekanidis, Stylianos. "Kultproblemeim Apostel-Paulus Octagonon von Philippi im Zusammenhang mit einem älteren Heroenkult." Pages 2:393–97 in *Atti del IX Congresso Internazionale di Archeologia Cristiana, Roma 21–27 Settembre 1975.* Studi di Antichità Cristiana 32. 2 vols. Vatican City: Pontificio Istituto di Archeologia Cristiana, 1978.

Perry, Jonathan Scott. *The Roman Collegia: The Modern Evolution of an Ancient Concept.* Mnemosyne Supplements 277. History and Archaeology of Classical Antiquity. Leiden: Brill, 2006.

———. *A Death in the* Familia*: The Funerary Colleges of the Roman Empire.* Ph.D. diss., University of North Carolina at Chapel Hill, 1999.

Reicke, Bo. *Diakonie, Festfreude, und Zelos in Verbindung mit der altchristlichen Agapenfeier.* Uppsala Universitets Årsskrift 5. Uppsala: Lundequist, 1951.

Rhomiopoulou, Katerina. "New Inscriptions in the Archaeological Museum, Thessaloniki." Pages 299–305 in *Ancient Macedonian Studies in Honor of Charles F. Edson.* Edited by Harry J. Dell. Thessaloniki: Institute for Balkan Studies, 1981.

Richard, Earl J. *First and Second Thessalonians.* Sacra Pagina 11. Collegeville: Liturgical Press, 1995.

Rigaux, Béda. *Saint Paul. Les épîtres aux Thessaloniciens.* Études biblique. Paris: Lecoffre, 1956.

Robinson, David M. "Inscriptions from Macedonia." *TAPA* 69 (1938) 43–76.

Russell, Ronald. "The Idle in 2 Thess 3.6–12: An Eschatological or a Social Problem?" *NTS* 34 (1988) 105–19.

Slater, William J. "Peace, the Symposium and the Poet." *ICS* 6 (1981) 205–14.

Smit, Peter-Ben. "A Symposium in Rom. 14:17? A Note on Paul's Terminology." *NovT* 49 (2007) 40–53.

Snyder, Graydon F. *Ante Pacem: Archaeological Evidence of Church Life Before Constantine.* Macon, Ga.: Mercer University Press, 1985.

Spieser, Jean-Michel. *Thessalonique et ses monuments du IV^e au V^e siècle. Contribution à l'étude d'une ville paléochrétienne.* Bibliothèque des Écoles françaises d'Athènes et de Rome 254. Athens: École française d'Athènes, 1984.

Still, Todd D. *Conflict at Thessalonica: A Pauline Church and its Neighbors.* JSNTSup 183. Sheffield: Sheffield Academic, 1999.

Tsitouridou, Anna. "Political History." Pages 224–32 in *Macedonia: 4000 Years of Greek History and Civilization.* Edited by M. B. Sakellariou. Athens: Ekdotike Athenon S.A., 1988.

Van Nijf, Onno M. *The Civic World of Professional Associations in the Roman East.* Dutch Monographs on Ancient History and Archaeology 17. Amsterdam: Gieben, 1997.

Weinfeld, Moshe. *The Organizational Pattern and the Penal Code of the Qumran Sect: A Comparison with Guilds and Religious Associations of the Hellenistic Period.* Novum Testamentum et Orbis Antiquus 2. Göttingen: Vandenhoeck & Ruprecht, 1986.

White, L. Michael. *Building God's House in the Roman World: Architectural Adaptation among Pagans, Jews and Christians.* Vol. 1 of *The Social Origins of Christian Architecture.* HTS 42. Valley Forge, Pa.: Trinity Press International, 1990.

Wilkins, John M. and Shaun Hill. *Food in the Ancient World.* Oxford: Blackwell, 2006.

Williams, David John. *1 and 2 Thessalonians.* New International Bible Commentary 12. Peabody, Mass.: Hendrickson, 1992.

Winter, Bruce W. *Seek the Welfare of the City: Christians as Benefactors and Citizens.* First-Century Christians in the Graeco-Roman World. Grand Rapids, Mich.: Eerdmans, 1994.

———. " 'If Any Man Does Not Wish to Work . . .' A Cultural and Historical Setting for 2 Thessalonians 3:6–16." *TynBul* 40 (1989) 303–15.

CHAPTER THREE

"Gazing Upon the Invisible": Archaeology, Historiography, and the Elusive Wo/men of 1 Thessalonians[*]

Melanie Johnson-DeBaufre

The responsibility of us all is to gaze upon those rendered invisible and to ensure that the patterns of the past do not continue to be those of the present and the future.[1]

I have taken students to archaeological sites in Greece and Turkey many times. On every single trip, after perusing museums, statuary, funerary reliefs, pottery, mosaics, and innumerable small finds of the ancient everyday, someone has said something like this: "There are so many women here!" It is true. Despite the uneven and accidental nature of ancient remains, archaeology often provides a visible and material confirmation of a basic dictum of feminist historians: *Wo/men were there.*[2] But this statement also

[*] I am very grateful to Charalambos Bakirtzis, Steven Friesen, and Laura Nasrallah for their invitation to participate in this rewarding conference, and to Helmut Koester for introducing me to the study of the material world of Greco-Roman antiquity and the value of on-site visits, a practice I carry on with my own students.

[1] Nobles, "Gazing upon the Invisible," 13.

[2] I write wo/men in this way in order to signal 1) that wo/men are not all the same but are rather located by class, race, sexuality, religion, etc.; and 2) that hierarchical power relations are not only based on sex-gender. Thus the term includes men who also struggle under oppressions based on race, status, sexuality, religion, etc. This approach to writing wo/men has been proposed by Elisabeth Schüssler Fiorenza. For a summary discussion of the term, see Schüssler Fiorenza's *Wisdom Ways*, 108–9.

raises a question: Why are students surprised by this? What is it about our everyday narrative of the past that (still) leads to "eureka"-like discoveries of something obvious?

Compare these revelations with a typical classroom conversation about 1 Thessalonians. I ask the students what they can tell me about the members of the ἐκκλησία of the Thessalonians (1:1) using only the letter as a resource. Predictable observations follow: They are Gentiles (1:9), who work with their hands (4:11), have experienced some kind of suffering or persecution (1:6; 2:14), and are grieving for loved ones (4:13). Invariably, a female student observes that the community must have included men and wo/men because "Paul calls them brothers and sisters." At this point, I call attention to the note in the students' New Revised Standard Version Bibles that says "Greek: brothers," and explain that the NRSV is making a choice for inclusive translation. Two intertwined debates ensue. Students discuss whether or not wo/men were among the audience of 1 Thessalonians and whether or not the NRSV should translate the nineteen references to ἀδελφοί in 1 Thessalonians as "brothers" or "brothers and sisters." Although I am the one who has invited the students into exploring the relationship of rhetoric and reality and the politics of translation, I am often surprised by the serious consideration given to the idea that *wo/men were not there.* What is it about our everyday narrative of the past that (still) leads to matter-of-fact denials of something obvious?

Observing these tensions between material visibility and discursive invisibility opens a valuable space for examining the relationship between archaeological research and early Christian historiography. Does research into the material culture of the ancient world mitigate, exacerbate, or ignore the routine erasure of wo/men's historical presence within the texts and histories of early Christianity?[3] The historical reconstruction of the Thessalonian ἐκκλησία is a particularly interesting context in which to explore this question because 1 Thessalonians itself is a little puzzle, presenting few specific clues to the rhetorical and historical context of the letter. The archaeological finds for first-century-C.E. Thessalonikē are equally sparse and do not provide easy access to the ancient city in the time of the ἐκκλησία.[4] Observing how we fill such textual and material lacunae can be

[3] This is not a new question. Archaeological materials, as well as methodological reflection on their use, have been an important part of the efforts to do ancient wo/men's history for some time. See, for example, the work of Ross Kraemer, Bernadette Brooten, Sarah B. Pomeroy, and Amy Richlin.

[4] For a summary of the situation, see Koester, *Paul and His World,* 56–57.

instructive for practicing critical reflection on the assumptions and procedures of biblical scholarship and early Christian historiography.[5]

Archaeological research has played various roles in the interpretation of the letter, most recently as part of the shift among some New Testament interpreters toward a view of the Thessalonian community as one of poor artisans who, like Paul, envisioned a theo-political alternative to empire. To my knowledge, however, there has been no serious discussion in this work of the challenges to historical reconstruction raised by the unrelenting androcentrism of the text, especially in its frequent use of the masculine collective term ἀδελφοί to address the letter's recipients. Despite a cautious optimism about archaeology's potential to make visible the material presence of wo/men of the past, in this case, wo/men can even become less visible to us than they have been in previous scholarship or in archaeological remains from antiquity more generally.[6] I explore these issues in three parts: 1) a discussion of the nature of the problem of wo/men's visibility and invisibility in 1 Thessalonians and its interpretations; 2) an examination of how three sets of archaeological materials are most commonly used to interpret 1 Thessalonians; and 3) some proposals for approaching the reconstruction of the ἐκκλησία of the Thessalonians with wo/men more fully in view.

"INVISIBLE IN CHRIST": PROBLEMS WITH SEEING THE THESSALONIAN SISTERS

Unlike the other six undisputed Pauline letters, 1 Thessalonians does not name any wo/men ἐκκλησία members or speak of generic wo/men (or "wo/men's issues") in such a way as to bring wo/men members of the letter's audience into the reader's view.[7] Feminist biblical scholars writing

[5] Along with other scholars, I call this practice "critical reflexivity." See Johnson-DeBaufre, *Jesus among Her Children*, 11–17. See also Schüssler Fiorenza, *Rhetoric and Ethic*, 196–97.

[6] Margaret Conkey and Joan Gero point out that "one of archaeology's important contributions is to probe the best means of analyzing the dialectic between human life as socially constructed and the very materiality of human life" ("Programme to Practice," 415). In his work on poverty and the Pauline churches, Justin Meggitt describes the shifts in the field of archaeology away from solely positivist description and cataloging to an increased interest in the ways that "the most unassuming of domestic artifacts is a cultural message carrier." These trends are part of the larger project in academic history writing that he calls "history from below" (*Paul, Poverty, and Survival*, 36).

[7] Rom 16:1–16 names at least eleven wo/men. See also Phil 4:2 (Euodia and Syntyche),

about 1 Thessalonians have considered the implications of these absences.[8] In her brief article in the *Women's Bible Commentary*, Pheme Perkins notes that "there are no clues to indicate the extent to which women participated" in the general activities of the community at Thessalonikē.[9] Lone Fatum has memorably concluded that the Thessalonian wo/men "are invisible in Christ and accordingly, their socio-sexual presence among the brothers is, virtually, a non-presence."[10] Both Perkins and Fatum confirm that, historically speaking, wo/men were there, but each wrestles with how one sees them in and with an androcentric text.

Of course, part of the problem is the nature of the Pauline letters, which, like archaeological remains, are fragmentary[11] and occasional.[12] They also make some people more visible than others. In his discussion of the poor in Pauline communities, Steven Friesen notes that our ancient texts "tend to overlook the poorest saints":[13]

> We could also demonstrate that the texts talk more about local leaders than about other resident members of the assemblies, or that the texts talk more about men than about women. Or consider the case of children: How many children were there in the Pauline assemblies? They may well have comprised half the individuals in the congregations. How many children do we know about from the Pauline congregations? None. The same is certainly true of the poorest members of the Pauline

Phlm 2 (Apphia), 1 Cor 1:11 (Chloe), and 16:19 (Prisca). For generic wo/men members coming into view, see "male and female" in the context of a baptism formula (Gal 3:28), and "sons and daughters" in the context of teaching on mixed marriages (2 Cor 6:18; see also 2 Sam 7:14 and Isa 43:6). In the disputed Pauline letters and pastorals, see Col 4:15 (Nympha), 2 Tim 1:5 (Eunice and Lois), 2 Tim 4:21 (Claudia), "wives, be subject to your husbands as you are to the Lord" (Eph 5:22), "I permit no woman to teach or have authority over a man" (1 Tim 2:12), "women (or wives) likewise must be serious" (1 Tim 3:11), "let a widow be put on the list" (1 Tim 5:9), "tell the older women to be reverent" and "encourage the young women to love their husbands" (Tit 2:3, 4).

[8] See Perkins, "1 Thessalonians," 349–50; Fatum, "1 Thessalonians," 250–62; and eadem, "Brotherhood in Christ," 183–97.

[9] Perkins, "1 Thessalonians," 350.

[10] Fatum, "Brotherhood in Christ," 194.

[11] As the letters present one perspective on a number of multidirectional relationships or one moment in a whole series of communications, certain strains of feminist scholarship have proposed reading the Pauline letters rhetorically and dialogically. See Schüssler Fiorenza, "Rhetoricity of Historical Knowledge," 129–48; and Wire, *Corinthian Women Prophets*.

[12] As Steven J. Friesen points out, except for the controversy over the common meal in 1 Corinthians, "we would have no idea how Paul instructed his assemblies to observe the Lord's Supper" ("Prospects," 361).

[13] Ibid., 358.

assemblies. The poor were present in the congregations, but the texts hardly mention them.[14]

How do we read the silences and biases of the text? Were there no wo/men present because no wo/men are mentioned? Does the lack of attention to (or interest in) wo/men indicate that wo/men are "virtually" not present? What is "virtual non-presence"? Or are these silences largely by chance and bereft of any real value for historical reconstruction? These questions are basic, but, in the case of wo/men in the Pauline ἐκκλησίαι, still need to be asked.[15]

Predictably, what is true of the ancient texts is also true of our scholarly texts: We make some people visible and hide others.[16] A survey of biblical scholarship on 1 Thessalonians tells a more complex story about the purported non-presence of Thessalonian wo/men than one might expect. Rather than a simple progression—inspired by feminist scholarship—from wo/men's invisibility to wo/men's visibility, there is a kind of shifting view somewhat like looking through a camera. Depending on how we move our lens, objects slide back and forth toward the edges or the center or even out of the frame altogether.[17] For example, Thessalonian wo/men are a common

[14] Ibid., 361.

[15] In the process of exploring wo/men's visibility in 1 Thessalonians and its historiographical re-narrations, I make several observations that are quite familiar to feminist scholarship. Thus this essay does not aim to create a new theory for feminist work but rather to further feminist scholarship by attending closely to the discussion of Thessalonian wo/men. Many of the issues raised here concerning androcentric language, the relationship of text and reality, and strategies for making wo/men visible have been articulated in Schüssler Fiorenza's landmark *In Memory of Her* and deliberated in much subsequent feminist work. See also Schüssler Fiorenza, *But She Said*; eadem, *A Feminist Introduction*; Castelli, "Heteroglossia," 73–98; and Matthews, "Thinking of Thecla," 31–55.

[16] Fred W. Burnett provides a convenient summary of the challenges of historiography after the "linguistic turn." Because "one's only access to any past event is through reading and interpreting its textual remains and subsequently writing a narrative about it . . . the direct object of the historian's study is not the 'past itself' but . . . it is any text about the past *and* the history of interpretation of that text." Thus "the ontological question (what actually existed and happened) is now secondary to the epistemological issue (what historians claim to know about what might or might not have existed or happened)" (Burnett, "Historiography," 106, 107, 109).

[17] I have drawn my title and the image of the camera from an essay by Connie H. Nobles about the development and impact of archaeological site reports of a prison complex in Baton Rouge, Louisiana. She shows that public education materials based on archaeological reports make particular aspects of the site's history visible or invisible. In one example, the way in which a photo had been cropped (excluding a female child from the image) was instrumental to creating the (inaccurate) perception that there were no women or children at the prison (Nobles, "Gazing Upon the Invisible," photograph on 12). Nobles also discusses how the presence of everyday finds clearly related to women and children in the site reports were not

topic of discussion in the introductory sections of older and some newer commentaries that debate the historicity of the book of Acts. Because Acts 17:4 says that while in Thessalonikē Paul has success with "a great many of the devout Greeks and not a few of the leading women," these interpreters end up discussing the presence of wo/men in the Pauline churches.[18] Even if these treatments are brief, they render wo/men more visible to readers than discussions of 1 Thessalonians that set aside the Acts account.[19]

On my reading, however, most of the discussion of 1 Thessalonians simply replicates the discursive invisibility of wo/men in 1 Thessalonians by taking up Paul's collective terminology (like "Thessalonians" or "brothers"), and adding some of their own (like "Christians") for referring to Paul's audience. This kind of language raises a question: Could I say, rather, that *all* Thessalonians scholarship and the letter itself refer to wo/men *all* the time—on every page—precisely because they speak with generic language? Are the Thessalonian sisters hidden in plain sight in the constant reference to the community as ἀδελφοί? Or does the gendered nature of Paul's collective kinship language constitute its meaning?[20]

The generic language of scholars can be taken as inclusive, except when it is not. Indeed, gender-specific words like "woman" (or its relatives, "wife" and "prostitute") appear in Thessalonians scholarship at moments when it becomes obvious that wo/men are an exception or a problem.[21] Thus in discussions of Paul's teachings on πορνεία in 1 Thess 4:3–8, "wo/men" words suddenly pop

mentioned in the public booklet. Thus the data we choose to examine or emphasize from the archaeological record renders certain humans visible or invisible (ibid., 9).

[18] For example, F. F. Bruce identifies the converts from the synagogue in Thessalonikē as "several ladies of good family, wives of leading citizens" (*1 & 2 Thessalonians*, xxii). What kind of visibility are we looking for? Like Acts, Bruce sees only high-standing married wo/men.

[19] For example, Harris, *New Testament*, 334–36; and Ehrman, *New Testament*, 276–89.

[20] The translation and interpretation of masculine and/or generic collective language has been under discussion in feminist work for decades with a range of opinions on the issue. Elizabeth Castelli notes that translation is "nuanced and delicate, striving not to obscure the nature of the text while at the same time trying not to construct and reify further sexist expectations and assumptions through the use of language that erases, marginalizes, or trivializes women's lives, agency, and contributions" ("*Les Belles Infidèles*," 191). In their 2006 book on wo/men and early Christianity, Carolyn Osiek and Margaret Y. MacDonald state as the first of their three basic assumptions for the book that "*masculine plural titles should not always presume men to the exclusion of women*" (*Woman's Place*, 6; emphasis in the original). The authors are aware that this should be obvious by now, but they note that "we need to continually remind others and especially ourselves to readjust the mental picture" (ibid., 7).

[21] Schüssler Fiorenza, *In Memory of Her*, 44.

into the scholarly discourse, breaking the flow of generic collective language. Sometimes there is an easy shift from generic talk about Christians, to a discussion of appropriate sexual behavior for a married man toward his wife, and back into generic language without ado or note.[22] In others, there is an effort to explain the shift in terms of Paul correcting an ancient double standard where men had sexual freedom and wo/men did not.[23] Why do scholars discuss wo/men only here in the context of sexual morality and marriage and not throughout their commentaries? How inclusive *are* these collective terms? Does 1 Thessalonians have a similar problem? Paul uses several different collective terms to refer to the community, such as ἐκκλησία, μιμηταί, and τέκνα, but by far his most common term is the vocative masculine plural collective noun ἀδελφοί. The word can be reasonably translated as "brothers and sisters" or "siblings," except when it cannot. 1 Thess 4:1–8 may be such a case. The NRSV translation reads:

> Finally, brothers and sisters (ἀδελφοί), we ask and urge you in the Lord Jesus that, as you learned from us how you ought to live and to please God (as, in fact, you are doing), you should do so now more and more. For you know what instructions we gave you through the Lord Jesus. For this is the will of God, your sanctification: that you abstain from fornication (πορνείας); that each one of you knows how to control your own body (σκεῦος κτᾶσθαι) in holiness and honor, not with lustful passion, like the Gentiles who do not know God; that no one wrong or exploit a brother or sister (ἀδελφόν) in this matter because the Lord is an avenger in all things, just as we have already told you beforehand and solemnly warned you. For God did not call us to impurity but in holiness. Therefore whoever rejects this rejects not human authority but God, who also gives his Holy Spirit to you.

The first problem is the meaning of σκεῦος κτᾶσθαι (literally: to acquire a vessel). Translations vary from "control your own body," which reaches for a gender neutral sense, to "take a wife" and "control your member," which both require a male addressee.[24] And if the teaching is for males, then perhaps ἀδελφός in v. 6 should be translated as "brother." If so, what happens next? Will 4:3–8 stand as an exception in the letter—a place where Paul exposes

[22] E.g., Malherbe, *Letters to the Thessalonians*, 224–41.

[23] Marshall, *1 and 2 Thessalonians*, 106–13. In his discussion of 1 Thess, Marshall explains that Paul "writes in terms of the attitudes of husbands, possibly because they were more liable to temptation; but his instructions can easily be applied to wives" (108). See also Best, *Commentary*, 161–63.

[24] For a discussion of these translation options, see Malherbe, *Thessalonians*, 226–28. Malherbe affirms that there are difficulties with all three, and ultimately chooses "take his own wife." See also Yarbrough, *Not Like the Gentiles*, 65–88.

his own androcentric presuppositions despite his generic-inclusive talk? Or does this male-centered exception expose the rest of Paul's ἀδελφοί language as *really* addressing only the brothers in Thessalonikē?

Pheme Perkins sees 4:3–8 as an exception: "The admonitions to holiness in 4:3–8 are formulated with males in view. They are to discipline unruly sexual urges by an honorable marriage. They are not to defraud their brothers 'in this matter,' an ambiguous expression that could refer either to sexual or to business affairs."[25] Thus at this point in Perkins's text, the wo/men fade from view because she sees them fading from view in Paul's text. However, despite the brevity of her commentary, the Thessalonian wo/men are far more visible in her work than in the book-length commentaries mentioned above. This is because Perkins takes seriously the idea that wo/men are included in Paul's collective terminology. In just two pages, Perkins mentions wo/men handworkers, teachers, and leaders, wo/men who die in childbirth, wo/men patrons, and poor wo/men.[26]

In contrast, Lone Fatum views 1 Thess 4:3–8 as the exception that reveals "how exclusively male Paul's exhortation actually is."[27] Focusing on the letter's pervasive use of kinship language,[28] Fatum argues that Paul strives "to organize the brothers according to the social and moral institution of the *patriarchal family*," thus employing "man-to-man language on a man-to-man stage."[29] This leads her to speculate that the Thessalonian wo/men

[25] Perkins, "1 Thessalonians," 350.

[26] In her discussion of 1 Thess 2:1–12, Perkins notes that Paul pursues what "most people consider slavish trades — leather work and tent making" and that "in some trades, like garment making, we have evidence that women worked along with men" ("1 Thessalonians," 349). She also says that Paul is nervous about what he perceives as Satan's threat to the community and that this anxiety often leads to "authoritarian intervention in the local communities by Paul's emissaries like Timothy. Since the legal codes of the time recognized only males as formal emissaries, we find only males in this role. Their mission would become the basis for later excluding women from teaching or leadership in local churches (see 1 Tim 2:11–12)." She speculates that male members may have died suddenly since "women were too constantly victims of early death in childbirth for their fate to cause much comment." Perkins further notes that "the poverty and largely artisan population of Thessalonica would make it less likely to have had women of sufficient wealth or education to act as patrons such as we find in other Pauline churches (despite Acts 17:4, which assumes their presence)" (ibid., 350).

[27] Fatum, "Brotherhood," 190.

[28] Ἀδελφός is used thirteen times in the vocative masculine plural common form ἀδελφοί (1 Thess 1:4, 2:1, 2:9, 2:14, 2:17, 3:7, 4:1, 4:13, 5:1, 5:4, 5:12, 5:14, 5:25). Other forms refer to the community as a whole (5:26, 5:27), an individual member (4:6), Timothy (3:2), and the communities in Macedonia (4:10). Φιλαδελφία is used for love between members (4:9). Υἱός is used twice (5:5). Paul calls God a father in 1:1, 1:3, 3:11, and 3:13. Paul also calls himself a nurse (2:7) and a father (2:11) to the Thessalonian τέκνα (2:7, 11).

[29] Fatum, "Brotherhood," 189 and 184, respectively.

converts—she does not deny that they were there—"seem to make up a homogenous group, conforming to patriarchal social custom and established gender ideology."[30] She notes that, in Paul's world and worldview, "women are embedded in the lives of men, and women are defined and qualified by their dependence on men. Thus, women are not counted in 1 Thess among the members who, as social agents, constitute the Christian community."[31]

By considering wo/men as a legitimate area of inquiry, both Perkins and Fatum make the Thessalonian wo/men visible in their scholarly texts. Perkins imagines wo/men who work, who face consequences from certain of Paul's proposals, and who struggle with the same kinds of health and financial challenges as their low-status male counterparts—in some cases with more extreme consequences, as in the case of death in childbirth. Fatum's Thessalonian wo/men are "homogenous," "conforming," and "embedded" nonmembers who lack social agency. They nearly slip out of sight as she asks "whether women could in fact be fully Christian according to the androcentric values of Paul's socio-sexual communication. Were the Thessalonian women converts actually among the recipients of 1 Thessalonians?"[32]

Fatum sets out to trace the gender ideology of the text, narrates its patriarchal kinship language, and raises questions about the nature of wo/men's "presence" in the community. She concludes, "The reason women are virtually invisible in 1 Thessalonians may well be that women were not challenging established morality."[33] The Thessalonian wo/men were thus materially there and socially invisible. The masking rhetoric of the androcentric text is taken as an indicator of the social activity of the wo/men themselves. But as Carolyn Osiek and Margaret MacDonald note, "Social invisibility is conceptual; it exists in the minds of those who articulate the ideal and may bear no resemblance to what is really going on." Drawing on the inscriptional evidence of wo/men in business and professions or the arrangement of Greek and Roman houses, they have to assert what should be obvious but is not: "social invisibility is not actual invisibility."[34]

Feminist historiographers have long engaged in this debate over whether and how ancient (and thus modern?) wo/men were historical-social agents and how that "reality" relates to the rhetorical nature of texts.[35] Fatum

[30] Ibid., 193–94.

[31] Ibid., 193.

[32] Ibid., 183.

[33] Ibid., 193.

[34] Osiek and MacDonald, *Woman's Place*, 3.

[35] See Castelli, "Heteroglossia," 73–98; Hollywood, "Agency and Evidence," 234–49. For a helpful analysis of the rhetoric vs. reality debate, Jacobs, "Lion and the Lamb," 95–118.

presses her readers to "come to grips" with "the exclusion of women from the brotherhood of Christians" and to accept the rhetoric of the text as the way things were or the only thing we can say. Her pessimism about the Thessalonian wo/men seems to counter what she sees as an unfounded romanticism in other strains of feminist historiography.[36] Fatum helpfully articulates the gender ideology inscribed in the text but does not explain the theoretical grounds on which she accepts that language as constitutive of the wo/men's reality.

Perhaps the problem is that feminist scholarship often reflects the mood of the wo/men's movement. Osiek and MacDonald note the "greater pessimism" resulting from "a greater awareness of how women are represented in order to further agendas of male authors, . . . [which] leads to a hesitation to draw any conclusions about real women at all."[37] They seek a middle way, as does Shelly Matthews, who argues that "the best feminist historiography pays close attention to representation in texts while still attempting to reconstruct a history of women" and thus rejects "the reduction of literature to a reflection of the world" and "the absorption of history by textuality."[38] Perhaps for 1 Thessalonians we need to work harder to imagine how Perkins's diverse Thessalonian wo/men lived *within* the embedded patriarchal linguistic world described by Fatum. If we accept that "all women and subjected men shape and have shaped culture and religion, even though classic androcentric records do not mention our existence and work,"[39] then the task of feminist historiography is to narrate the complex subtleties of such shaping in various historical contexts while also naming the rhetorical and material obstacles to such activity. This work requires imagining and reconstructing the ways that people in various situations of domination resist, claim, and construct identity, survive, perform transgressions and disruptions, and imagine alternative worlds. Performing an excavation of our own texts is also

[36] This is most obvious in her *Searching the Scriptures* commentary on 1 Thessalonians, which alludes to the work of Elisabeth Schüssler Fiorenza with phrases such as "women-church" and references to "equal members of a democratic discipleship." Fatum discourages "feminist creativity and wishful thinking" and warns that "the ideal of women's liberation may jeopardize critical interpretation and reduce exegesis to feminist or womanist affirmation" (Fatum, "1 Thessalonians," 252). For further discussion of this debate in feminist interpretation and historiography, see Schüssler Fiorenza, "Re-Visioning," 225–50; Beavis, "Christian Origins," 27–49; and Castelli, "*Ekklēsia* of Women," 36–52.

[37] Osiek and MacDonald, *Woman's Place*, 244. See also Clark, "Lady Vanishes," 1–31.

[38] Matthews, "Thinking of Thecla," 54; and citing Spiegel, "History," 77.

[39] Schüssler Fiorenza, "Rhetoricity of Historical Knowledge," 457.

helpful.[40] If we too are producing remains for the future of scholarship, are wo/men visible or invisible in our own texts?

ARCHAEOLOGY AND 1 THESSALONIANS

More recent developments in the study of 1 Thessalonians have moved away from using archaeology as corroborating evidence of the New Testament and have drawn on three areas of archaeological research in order to expand and nuance a reading of the letter in its historical and material context. The first is the religious cults of Thessalonikē, particularly the Dionysos and Kabeiros cults. The second is inscriptions related to voluntary associations. The third is various materials related to the Roman imperial cult.[41] I discuss here the way Thessalonian wo/men can appear and disappear in this research.

Seeing Wo/men in Thessalonian Religion

The 1948 publication of "Cults of Thessalonica" brought several high-standing Thessalonian wo/men into view. Here Charles Edson catalogues priestesses, wives, daughters, and empresses—some with names—without comment and without indication that their presence is either surprising or problematic.[42] Indeed, the Dionysian priestess Euphrosyne receives no fewer than fifteen pages of discussion.[43] As far as I can see, this evidence

[40] Steven J. Friesen performs this kind of archaeology on epigraphic studies of the high priestesses of Asia and concludes that "the seemingly antiseptic sterility of epigraphic interpretation is actually fraught with ideological biases and ethical consequences" ("High Priestesses of Asia," 148).

[41] Vom Brocke's *Thessaloniki—Stadt des Kassander und Gemeinde des Paulus* covers all three of these areas and brings together the literary, epigraphic, and archaeological material related to Thessaloniki. He discusses the city of Thessalonikē in the time of Paul and interprets various details in 1 Thessalonians and Acts 17. Interpretive contributions center on fine-tuning the conclusions of previous commentators (some discussed here). External data do function in the third section to corroborate the historicity of aspects of the Acts account, although the high standing wo/men are not discussed. Vom Brocke's work fits well within the map of scholarship discussed here and does not differ in its effect on either the visibility or invisibility of wo/men in Thessaloniki.

[42] Edson, "Cults of Thessalonica," 153–204. These women are: Artemin, the daughter of Marcus and his wife Isidorus; Junia, the daughter of Isidorus (159); Secunda, ward of Maximus; Euphrosyne, priestess (166–81); Tullia Spendousa (185, 188); priestess Mousa (186); city goddess (190, 191); Julia Domna (191); Julia Paula (191).

[43] Ibid., 166–81. Although Edson rejects the idea, even the possibility of children as μύσται in the Dionysian association is discussed concerning the line μικρὸς μέγας (169) in the Euphrosyne inscription.

of Thessalonian wo/men in *thiasoi* and as priestesses has not played a significant role in the interpretation of 1 Thessalonians.

Edson's catalogue does figure in Karl Donfried's "The Cults of Thessalonica and the Thessalonian Correspondence,"[44] which sets out to read the letter in the context of the city's religious and political life. In the section entitled "The Religious Cults of Thessalonica," there are references to "nocturnal initiations" of Isis, priestesses who honor the fertile phallus,[45] "divine women" who nurse Dionysos, Bacchic frenzies with dancing maidens, and the *hieros gamos* ("sacred marriage").[46] Although Edson's archaeological evidence lends material weight to the analysis, none of these themes appears in the archaeological remains discussed there. This image of pagan orgies and fertility cults serves as a basis for historical reconstruction of the Thessalonian community. Noting that the word πορνεία (1 Thess 4:3) also appears several times in the Corinthian correspondence, Donfried concludes that "Paul is very deliberately dealing with a situation of grave immorality, not too dissimilar to the cultic temptations at Corinth."[47]

Donfried never describes these sacred orgiastic celebrations of the phallus, but his narrative interweaving of archaeology, literary texts, and scholarship invites a series of erotic/exotic wo/men to saunter into the reader's historical imagination. These wo/men stand in comparison to Paul's self-controlled (male?) audience. As a result, these pagan wo/men serve a similar function as "the Gentiles who do not know God" in 1 Thess 4:5. In other words, Donfried's reconstruction of the cults of Thessalonikē in terms of sacred-sexual abandon — represented by the elusive, sensuous, and fertile female pagan — replicates Paul's own rhetoric, which draws a stark line between the Thessalonian ἐκκλησία and their own kin or compatriots (ἰδίων συμφυλετῶν, 2:14) by using essentializing sexual characterization. Predictably, in early Christian literature and its interpretation, sexual wo/men are put to work to mark the border between "us" and "them," as are various barbarians, Jews, and other Others.[48] It is notable that in the second half

[44] First published in *NTS* 31 (1985) 336–56; reprinted in Donfried, *Paul,* 21–48.

[45] Euphrosyne is introduced as evidence of the cult of Dionysos, followed by: "As one looks at the Dionysiac mysteries in general, there are several components which are of particular interest for this study. The hope of a joyous afterlife is central and appears to be symbolized by the phallus" (Donfried, "Cults," 23). Donfried also suggests that the high-standing wo/men of Acts 17 "were familiar with the mysteries of Samothrace, not to mention their acquaintance and possible participation in the other cults of the city" (ibid., 28).

[46] Donfried draws the last two from Lehmann, *Pedimental Sculptures,* 40–42.

[47] Donfried, "Cults," 30. See Lanci's critique and correction of the construct "ritual prostitution" commonly associated with Corinth in "Stones Don't Speak," 205–20.

[48] Knust, "Paul and the Politics," 173. Natalie Boymel Kampen observes a similar

of Donfried's article, which treats the civic cults and "royal theology" of Thessalonikē, the generic language of "Thessalonians" returns and wo/men are not specifically mentioned or discussed.

In his 1986 *The Thessalonian Correspondence: Pauline Rhetoric and Millenarian Piety*, Robert Jewett also reconstructs Thessalonian religious life but to a different effect. Where Donfried links the Pauline instructions on πορνεία to his interpretation of the cults of Thessalonikē, Jewett subordinates 1 Thess 4:1–8 to a larger discussion of the letter's apocalyptic framing (1:6–10; 4:13–5:11) and interprets Thessalonians with a social-scientific model of millenarianism.[49] This religious-political model understands sexual libertinism as social resistance, not as a celebration of sacred sex or a guarantor of fertility. Jewett reconstructs the Thessalonian converts as the (generic) urban poor—skilled and unskilled laborers—who would be particularly drawn to Paul's apocalyptic message of a returning benevolent ruler, a competing messianism to Rome's imperial cult.

Like Donfried, Jewett asserts that all cults of Thessalonikē included orgiastic practices, but they are not described beyond that they offered "sexual fulfillment."[50] The frieze of Dionysian dancing from Samothrake, which is the source of Donfried's dancing maidens, is interpreted by Jewett in terms of an egalitarian movement: "The presence of both male and female participants in this scene indicates an egalitarian emphasis that is consistent with the details Hemburg discovered about the inclusion of slaves and strangers as honored initiates in various Cabiric temples; slaves dedicated their chains or their writs of manumission to Cabirus, indicating that he was the god of the 'suppressed population.'"[51] In this reading, the orgies and phallic

function for some representations of women (in this case, in the Column of Trajan): "Like the barbarians, the female figures do things that the Roman men cannot or would not do, and so they provide the edges against which Roman manliness can be defined" ("Looking at Gender," 64). In some ways, the pagan women can function similarly in Donfried's analysis, with the Roman men being replaced by Christian men. F. F. Bruce's commentary depicts militant Jews and promiscuous pagans at the borders of the Thessalonian community. Interestingly, it is the high-standing Greek women of Acts 17:4 who mark the Christian community as dignified (*1 & 2 Thessalonians*, xxv). Quoting a 1930s commentary, Best transfers the critique of lustful pagans onto foreign converts in the mission fields in the 1930s: "As in the mission field today, when the initial fervour was over, it was only too easy for the converts to slip back into low standards of pagan living" (*Commentary*, 160).

[49] Thus Jewett describes the situation being addressed by 1 Thess 4:1–8 as an "intellectual challenge," within a "libertinistic movement" against traditional ethics, represented by Paul's "Judaic terminology for the marriage contract" (*Thessalonian Correspondence*, 106). This is an intellectual challenge because Paul concedes that they are acting properly in 4:3.

[50] Ibid., 126, 129.

[51] Ibid., 130.

symbols of the cults of Thessalonikē serve to disrupt the status quo—not unlike Carnivale or Mardi Gras—and represent a "violation of traditional mores on the grounds that the new age is present."[52] The sexual activity of these transgressive pagans is imagined using cross-cultural examples of millennialist movements in which "virile prophets show their followers the way," an initiate can "have sexual intercourse with anyone," and "young men and women live in a common house; in the daytime they bathe together and they pass the night in dancing."[53] Although there is no significant gender analysis of millennialist movements (or Paul's rhetoric), this approach to the Dionysian and Kabeiros cults of Thessalonikē brings a different group of wo/men into view. Here we see low status men and women, freed and slave, joining a charismatic movement that expresses their dissatisfaction with and indictment of the social order.

Jewett's reconstruction has been criticized for over-reading a "spotty" archaeological record and inventing a narrative of "pagan millenarianism" against which to read 1 Thessalonians.[54] Ironically, the letters of the Pauline ἐκκλησίαι provide firmer evidence of a coherent millenarian movement in antiquity than the Kabeiros cult. In this regard, cross-cultural comparisons may be useful for interpreting the Pauline texts apart from the Kabeiros data. However, Jewett's efforts to imagine pagan religious practice as fully part of a social-political movement are valuable. But it is Donfried's images of cultic sexual abandon that seem to persist in subsequent Bible dictionaries, rather than the image of an egalitarian social movement. Apparently, pagan promiscuity is easier to imagine (and to juxtapose to Christian morality) than pagan (and Christian) social resistance and disruption.[55]

[52] Ibid., 172.

[53] Ibid., 172–74.

[54] Koester, "Archäologie und Paulus," 393–404; idem, "From Paul's Eschatology," 441–58. Both articles have been reprinted in Koester, *Paul and His World*, 38–54 and 55–69. Koester cites Jewett (*Thessalonian Correspondence*, 127), who draws on Donfried (*Cults*, 338) for the imagery of "Dionysiac sexuality": "Once a model of pagan millenarianism has been invented and has been superimposed upon the Letters to the Thessalonians, all eschatological data of these two letters must be made to fit the same situation" (Koester, "From Paul's Eschatology," 445). Koester concludes that Jewett's reading of the letters as a reaction against a millenarian enthusiasm is no more than pure speculation.

[55] For an exploration of the *basileia*-movement as utopian, see Beavis, *Jesus & Utopia*. Beavis also discusses the way that reconstructions of early Christianity as an egalitarian social movement are mischaracterized and thus discredited as idealist fantasy ("Christian Origins," 27–49).

Seeing Wo/men in Voluntary Associations

Jewett's efforts to see the religious world of the Thessalonians as an integral part of their social-political world resemble a second area of research that draws on epigraphic material in order to compare the Pauline communities to ancient voluntary associations. This work has a similar interest in using social scientific models (as opposed to religious ones) and making Greco-Roman comparisons (in contrast to the too often apologetic juxtaposition to Jewish material) to explain the texts of early Christianity.[56] The primary research of this kind on 1 Thessalonians is from Richard Ascough, who has proposed that a comparison of 1 Thessalonians to voluntary associations suggests that "the Thessalonian Christian community founded by Paul was similar in composition and structure to a professional voluntary association."[57]

As we find in the museums in Greece and Turkey and the 1948 Edson catalogue, all sorts of wo/men appear in the inscriptions related to voluntary associations in antiquity.[58] Ascough helpfully provides an overview of the widespread and diverse presence of wo/men in a section entitled "Gender" in his chapter on "Membership and Its Requirements."[59] He concludes that while male presence in the inscriptions proportionately outweighs female, the known obstacles to female participation in political life suggest that this significant female presence still demonstrates that associations "provided a location in which they could participate more fully in collective life."[60] A brief restatement of wo/men's presence in religious associations, including their roles as leaders, also appears just before Ascough's discussion of Euodia and Syntyche (Phil 4:2) and the evidence that wo/men were leaders in the Philippian community.[61] Although gender analysis is not carried through

[56] These scholars are thus in conversation with Wayne Meeks's work and draw on the theoretical challenges of Jonathan Z. Smith. See Richard S. Ascough's revised 1997 dissertation now published as *Paul's Macedonian Associations*, 1–13.

[57] Ascough, "Thessalonian Christian Community," 311. See also idem, "Translocal Relationships," 223–41.

[58] See also Kloppenborg, ed., *Voluntary Associations*.

[59] Ascough, *Paul's Macedonian Associations*, 54–59. Unfortunately, the gender and social location sections of the chapter are not integrated or interactive in terms of analysis. This means that the discussion of females does not include status analysis and vice versa. Applying the category "wo/men" to the observation that "generally, the social location of the membership of voluntary associations was predominately from the 'urban poor, slaves, and freedmen'" (ibid., 51) suggests that in terms of structures of power, voluntary associations were predominantly organizations of and for wo/men.

[60] Ibid., 58.

[61] Ibid., 134. Ascough supports his conclusion by referring to other wo/men named in the Pauline, deutero-Pauline, and Pastoral Letters (ibid., 135–36 n. 121) and evidence of

the chapter on Philippians,[62] the conclusion of the chapter nonetheless confirms the visibility of the Philippian wo/men leaders: "The Philippian Christian community is clearly a gender inclusive group in which women exercised some leadership capacity. As such, it is like a religious voluntary association."[63]

Thessalonian wo/men do not fare as well. Although Ascough argues that *both* Philippians and 1 Thessalonians have language related to the world of the marketplace and concludes that *both* communities have (generic) members of low status, he does not recount the presence of wo/men in religious voluntary associations in order to fill out the picture of the Thessalonian community, and Paul does not conveniently name wo/men leaders (or any leaders). Rather, the data from the voluntary associations is not brought to bear until it is proposed that the Thessalonians shared the same trade as Paul.[64] This is an important move in the argument, as it will result in a different historical reconstruction of the Philippian and Thessalonian communities.[65]

As with most Thessalonians scholarship, much of Ascough's discussion of the community uses generic terminology like "Thessalonians," and thus we

wo/men's religious activity in Macedonia, especially Philippi (ibid., 136). Secondary support is drawn from later evidence such as Polycarp's *Letter to the Philippians* and Byzantine period grave inscriptions (ibid., 137–38).

[62] See now Marchal, *Hierarchy, Imitation, and Unity*.

[63] Ascough, *Paul's Macedonian Associations*, 160–61.

[64] "Presumably Paul and the Thessalonians worked at the same trade or trades within the same general area, thus facilitating contact between Paul and the Thessalonians. And it was 'while' at work that Paul preached the gospel and presumably made his initial converts. Thus, the core of the Thessalonian community was comprised of hand-workers who shared Paul's trade" (ibid., 174–75). Ascough's "Thessalonian Christian Community" repeats this argument without additions and with similarly tentative language (315).

[65] It appears that this shift is based on reading the participle ἐκηρύξαμεν as "while we preached" (1 Thess 2:9). While this translation is reasonable, it does not follow that this must literally put Paul in the same work space with the Thessalonians while preaching. The participle could refer to not being a burden while preaching. The argument about workshops seems to be part of a larger interest in identifying more convincing models for describing Paul's proselytizing than the synagogue-based Acts narrative (see Ascough, "Thessalonian Christian Community," 311–13). This interest seems to press Ascough's arguments toward using the comparison between the Pauline ἐκκλησία and the voluntary associations for establishing homology and even a sort of genealogy (contra *Paul's Macedonian Associations*, 1–3). It is notable that the confirmed presence of wo/men in the Philippian association does not, conversely, result in an argument for the historicity of the Lydia story (not that it should), and also that when Ascough takes up other issues of interpretation in 1 Thessalonians (such as funerary practices), he does not limit himself to professional association inscriptions nor does he discuss the presence or absence of Thessalonian wo/men. See idem, "Question of Death," 509–30.

could say, as above, that the Thessalonian wo/men are visible everywhere. The return of gendered language, however, casts doubt on this impression:

> Another intriguing possibility arises from the suggestion that the Thessalonian Christian community was formed as a professional association of "handworkers," perhaps tentmakers or leather-workers. If this were the case, we would expect that the group would be composed primarily of males, since women would not be members of an association of artisans in a trade dominated by males even if they worked in the same occupation. Most interpreters do not read 1 Thessalonians in this way, but rather see the group as including both men and women. There are some indications in 1 Thessalonians that the community was composed primarily of men. Clearly, there is no indication of women in the community and no advice is given to women, children, or families.[66]

This last observation takes the text of 1 Thessalonians as descriptive rather than as androcentric or simply occasional. It is followed by a discussion of the popular, but difficult to translate, passage concerning πορνεία (4:3–6). Arguing that σκεῦος κτᾶσθαι exhorts men to self-control[67] and citing Lone Fatum's argument that 4:3–8 "shows how exclusively male" Paul's teaching in the letter really is, Ascough cautiously concludes that "if it is the case that the Thessalonian Christian community was primarily composed of males, then this particular community was atypical among Christian communities known from Paul's letters."[68]

I narrate this argument in detail in order to illustrate how the combination of a very particular set of archaeological materials (professional voluntary associations) and a small selection of details (1 Thess 1:9, 2:9, and 4:4) from 1 Thessalonians can combine to produce a *theory* that wo/men were not actually there.[69] Add the way that one particular feminist approach to the androcentric language of 1 Thessalonians combines with this theory

[66] Ascough, *Paul's Macedonian Associations*, 186–87.

[67] Ascough prefers "control your own member," referring to male genitalia (ibid, 189). He draws on Dale Martin's discussion of the ancient "ideology of sexual hierarchy"(see Martin, *Corinthian Body*, 226–27) to outline how teachings about self-control would be directed toward males (Ascough, *Paul's Macedonian Associations*, 188). Interestingly, rather than imagining that the Thessalonian wo/men might have disagreed with Paul's sexual ethic, as they arguably did in Corinth, Ascough instead quotes Donfried's depiction of the Thessalonian cultic situation as similar to the "grave immorality" in Corinth (ibid.; see Donfried, "Cults of Thessalonica" 341–42).

[68] Ascough, *Paul's Macedonian Associations*, 190.

[69] The repetition of such words as "presumably" and "probably" suggests that Ascough is not entirely convinced of the solidity of the evidence ("Thessalonian Christian Community," 315, 323–24).

and the Thessalonian wo/men are tucked even further out of sight, beyond rhetorical invisibility and effective non-presence to material absence. Although Ascough is tentative about his proposal, he does suggest that ἀδελφοί would best be translated "brothers" and not "brothers and sisters" in 1 Thessalonians.[70] If this suggestion were followed, then the invisibility of the Thessalonian wo/men would be reinscribed in contemporary English texts as well as in (reconstructions of) ancient Greek ones. Despite the striking visibility of wo/men in the epigraphic evidence for voluntary associations, the androcentric (and occasional) nature of 1 Thessalonians is privileged in such a way as to make wo/men's absence from the ἐκκλησία more thinkable. This theory is not being proposed in order to assert wo/men's absence. Rather it is the collateral damage of approaching questions about the origin and identity of the Thessalonian community in a way that privileges certain aspects of the language of 1 Thessalonians.

Seeing Wo/men Under Empire

The situation is different for the third set of archaeological materials used in the interpretation of 1 Thessalonians. Shifting from an interest in the social-scientific makeup and identity of the Pauline communities, this scholarship juxtaposes research on Roman benefaction and imperial cult with an examination of the ideology or political-theology of 1 Thessalonians. Helmut Koester and Holland Hendrix[71] have been instrumental in this work, and because of the recent popularity of empire studies this approach to 1 Thessalonians has begun to receive attention from interpreters interested in New Testament postcolonial criticism.[72] As far as I can see, there is no explicit mention or discussion of Thessalonian wo/men in this material. One reason may be that the usual context for discussions of wo/men, 1 Thess 4:3–6, is of little interest here. Rather, the eschatological teachings in 4:13–5:11, with their political language of παρουσία and peace and security, command

[70] Ibid., 325 n. 66; and *Paul's Macedonian Associations*, 186–87 n. 93.

[71] Hendrix, "Thessalonicans Honor Romans"; idem, "Archaeology and Eschatology at Thessalonica," 107–18. Koester, "From Paul's Eschatology," and "Archäologie und Paulus." See also Donfried, "Imperial Cults of Thessalonica," 215–23 (reprint of the second half of Donfried, "Cults"); Harrison, "Paul and the Imperial Gospel," 71–96; and Oakes, "Re-Mapping the Universe," 301–22.

[72] Smith, "Unmasking the Powers," 47–66; idem, "First and Second Letters," 304–22. Yeo Khiok-khng interprets 1 Thessalonians in the context of the situation of globalization, Western imperialism, and economic depression, thus emphasizing the Roman imperial context of 1 Thessalonians and the Thessalonians' "politically inflammatory" attitude toward the civic cult (Khiok-khng, "1 Thessalonians," 501).

attention. Thus wo/men slide out of the frame altogether. Although wo/men's presence in the community is not explicitly asserted, it seems that they are again generally assumed to be part of the generic congregation that hears Paul's eschatological teaching in light of imperial theology and hierarchically structured civic relationships. This generic visibility can perpetuate an assumption that Thessalonian experiences of imperial rule are uniform and uninflected by status or gender. By not actively discussing wo/men in regard to other aspects of everyday life, we thus miss an opportunity to imagine them variously resisting, surviving, negotiating, and resignifying the kyriarchal ideologies of empire.

Abraham Smith's postcolonial commentary is one exception to the overall inattention to gender. Smith traces the "ineluctable reality of 'empire'" in the history of interpretation of the Thessalonian correspondence, the ways that the eschatology of the letters might represent resistance to imperial theology, and the ways that they reinscribe imperial ideology. This last move is of interest because in this context Smith briefly mentions the πορνεία passage and suggests that the rhetoric of Othering in Paul's letters "included commonplace androcentric critiques against sexual depravity, greed, and lack of discipline." According to Smith, such characterizations "reinscribed the assumptions of empire."[73] He goes on to discuss the gendered nature of the ethic of self-mastery and concludes that "the self-control directives of 1 Thess 4.3–8 seem to be directed at males and not to all the brothers and sisters of the assembly."[74] But, it seems there is more work to be done insofar as imperial ideology and iconography itself is highly gendered as masculine.[75] In fact, while various wo/men appear in the epigraphic record related to voluntary associations, imperial cult artifacts (coins, statuary, and inscriptions) even more predominantly display prominent men. This increased invisibility of wo/men in this data *and* in Paul's discourse on Christ's kingly return is instructive. It calls our attention to the way that imperial ideology *and* apocalyptic Christology both draw our gaze to prominent men and their rule, battles, relations, and honors. It seems appropriate to discuss the re-

[73] Smith, "Thessalonians," 315. By contrast, Neil Elliot claims 1 Thess 4:3–8 for Paul's political resistance: "Against the contours of an abusive culture of male domination, Paul dramatically restricts the 'reign of the phallus' to the bounds of holiness and honor" (Elliot, *Liberating Paul,* 203). Smith draws on Jennifer Knust ("Politics of Virtue and Vice," 155–57), who suggests that Paul is resisting empire while also reinscribing its gendered logic.

[74] Smith, "Thessalonians," 316. Given that the sliding scale of masculinity in antiquity would place all females and low-status men among those incapable of self-control, Smith's statement could be amended to say that Paul addresses only free males.

[75] Lopez, "Before Your Very Eyes," 115–62.

inscription of empire in discourses of gender and sexuality, but gender may also be a site of resistance to empire that goes beyond attempting to rein in the reign of the phallus through marriage. Thus Paul's self-presentation as a handworker (2:9) and as a nurse (2:7) stands in some tension with his depiction of Christ as a victorious returning king (4:16). But even here, wo/men can slide out of the frame as a historical reconstruction of Paul's views of masculinity may not extend to a reconstruction of a movement that inspired and sustained such resistances.[76]

WO/MEN IN FOCUS

The process of putting wo/men back into written history has been underway in global academic contexts in both archaeology and biblical studies since the beginning of the wo/men's movement and various other liberation movements since the 1960s. Indeed, the feminist scholarly recuperation of the wo/men of the past is old news and is often viewed as remedial and theoretically quaint. However, the case of the Thessalonian wo/men suggests that their invisibility is still as much our problem as a problem of the data. Therefore, it is important to continue "gazing upon the invisible." In what follows, I explore examples of three ways that interpreters of Thessalonians can attempt to keep wo/men in focus and thus claim 1 Thessalonians as part of wo/men's history beyond the obvious observation that it occludes them from view.

Wo/men Were There

First, the case that *wo/men were there* should no longer need to be made.[77] It should be a critical presupposition for interpretation. There is no evidence that wo/men were excluded from membership in the first-century ἐκκλησίαι in Christ. If one adjusts for the kyriocentric nature of the texts and materials of antiquity, which ignore or mask the presence of wo/men, then the sheer number of times that wo/men's presence in the ἐκκλησίαι becomes visible — in names, direct address, discussion of "wo/men's issues," and efforts to circumscribe wo/men's speech, clothing, and bodies — should weigh heavily

[76] For further discussion of a Paul-centered focus in postcolonial studies of Paul, see Johnson-DeBaufre and Nasrallah, "Beyond the Heroic Paul."

[77] Osiek and MacDonald go one step beyond this by identifying their third basic assumption as: "Women participated in all the principal activities of the house church" (*Woman's Place*, 6).

against any counterargument. While it is clear that there were homosocial membership groups in the Greco-Roman world, there is no indication that the Christ groups were among them. This wide-ranging evidence should overcome the androcentric silence of any one Pauline text.

Current Pauline studies reasonably focus on analysis of individual letters, attempting to understand each one on its own terms and in its own geographic-historical context. However, in the case of the Thessalonian wo/men, this local, letter-specific focus can become myopic.[78] Both the material *and* textual remains of first-century Thessalonikē are very limited in scope. Going beyond 1 Thessalonians for evidence of wo/men's presence in Christ communities is as defensible as judiciously drawing on inscriptions from other cities or a range of literary texts to reconstruct Thessalonian social and religious life. Helmut Koester's comments about describing local religious practices could be applied to reconstructing the less routinely visible members of local Christ communities: "In all cases, conclusions regarding typical local features of these religions must be very cautious. In most instances, such finds need to be interpreted in the context of other materials from Macedonia, Greece, and Asia Minor as well as from other areas of the Greco-Roman world."[79]

If we want to pursue the idea that Paul first preached to Thessalonian handworkers in his own trade and perhaps even in an all-male professional association, then we could discuss the way that such corporate conversion would markedly change the group. The evidence of household baptism and baptism across population groups in the mission to the nations is well-attested, widespread, and not a point of contention (that is, whether people should baptize households or whether specific individuals can or cannot be baptized based on their social status or gender is not debated in the first century). Beginning with the critical presupposition that wo/men were there means that if we imagine a professional association of Thessalonian leatherworkers, then the process of becoming a distinct community (described

[78] Ascough argues that, "Failure to take seriously local peculiarities of each of Paul's churches and to read each of his letters in the light of the local social situation to which each was addressed will result in a misunderstanding of that particular Christian community" (*Paul's Macedonian Associations*, 111). Certainly this is true, but the warning itself is problematically tautological: A local situation is used to read the letter in order to describe a local situation.

[79] Koester, *Paul and His World*, 54. Ascough seems comfortable going beyond the text of Philippians for corroborating evidence of wo/men's participation in Philippi. Although both letters repeatedly use the masculine plural ἀδελφοί (nine times in Philippians), Ascough privileges this difference between them: That Philippians approves of Euodia and Syntyche and 1 Thessalonians has androcentric thinking about sex. Both details seem accidental and interchangeable.

in 1:9 as "turning" to God from idols) would distinctly change its membership roster. Since this would likely cause some contention in the group, one could, I suppose, read the admonitions to respect "those who labor among you" (τοὺς κοπιῶντας ἐν ὑμῖν; 5:12) as an effort to establish a hierarchy based on the membership of the initial association. Or maybe this is why Paul seems to have left Thessalonikē under tense circumstances (2:17; 3:4). This, however, is as speculative as anything given that there is no other example of such a change in the Christ communities or in the voluntary associations. Apart from the interest in offering an alternative to the origin story of the community in Acts 17:1–8, therefore, what purpose does such a theory serve? Perhaps it is best to conclude about the Thessalonian community what Ascough concludes about the associations in general: "In many cases we simply do not know how an association was formed and propagated."[80]

Rather than privileging the letter's androcentric view, work such as Ascough's can fill out the picture of the Thessalonian community with important evidence of religious associations.[81] Ascough notes that "although there is a paucity of women in professional voluntary associations, this is not the case for the religious associations of antiquity, where women were not only members but played an active role, often serving as leaders."[82] Thus, while Paul does not name them, it is at least thinkable that those who labor and participate in work (κοπιῶντας, ἔργον, 5:12–13) in the community include wo/men, as both words are used inclusively in Romans 16:3 and 12.[83] Or at minimum, one could note that, apart from leadership, among association "members themselves . . . it is not uncommon to find citizens and non-citizens, masters and slaves, and men and women, rich and poor, all meeting together in one association. Professional/trade associations would be the most socially homogenous; other types of associations less so."[84] This view of religious associations coheres with other evidence of Christ associations in the ancient Mediterranean.

[80] Ascough, *Paul's Macedonian Associations*, 28.

[81] See also MacLean, "Agrippinilla Inscription," 212–38; Seesengood, "Rules," 207–16; and Batten, "Moral World," 135–51.

[82] Ascough, *Paul's Macedonian Associations*, 54–55.

[83] Ascough lists these coworkers in his discussion of Philippians (ibid., 135–36 n. 121). Perkins is right that "Since no women are mentioned anywhere, the community's leaders may have been all male" ("1 Thessalonians," 350). The opposite statement is equally true: Although no wo/men are mentioned anywhere, the community's leaders may not all have been male.

[84] Ibid., 59.

Taking Wo/men's Presence Seriously

Second, while many interpreters affirm that, of course, Paul means "brothers and sisters" when he says ἀδελφοί, there is still much to be done *to take wo/men's presence seriously*. Saying that wo/men were present but taking no account of what difference (if any) that makes is the same as imagining that inclusive language equates with actual inclusion and exclusive language equates with actual exclusion. Many seemingly generic topics of Thessalonians might inflect differently when we consider the presence of various kinds of wo/men in the community: suffering, travel, coworkers, work, self-sufficiency, grief/mourning, idleness/disruptiveness, peace and security, contested leadership, prophecy, and testing of spirits, for example. None of these topics is discussed with the methodological presupposition of wo/men in the community. They could be explored in a range of registers, from examining wo/men's activity in funerary practices, to discussing wo/men's prophecy (in Corinthians or the Greco-Roman world), or juxtaposing the themes in 1 Thessalonians to cross-cultural social-political material, such as placing "peace and security" alongside studies of the impact of war on wo/men.[85]

Taking wo/men's presence seriously means clarifying what we mean, both materially and discursively, by wo/men's presence, wo/men's agency, and wo/men's equality. For example, reading 1 Thess 4:3–8 as discursively androcentric (and even phallocentric) does not mean that wo/men were, therefore, not present or had no personal or social agency. Rather than seeking the singular meaning of the intractable phrase σκεῦος κτᾶσθαι, I recommend taking difference among Paul's audience seriously and considering the multiple ways that such a teaching could be heard, regardless of precisely what Paul meant. This requires historiographical work that reconstructs multiple possibilities rather than attempts to reduce them to one.[86]

For example, if we approach 1 Thess 4:1–8 with an interest in imagining a range of readings and responses, then the historical picture becomes both more provisional and, perhaps, more accurately descriptive of human meaning-making.[87] If we begin with male addressees who hear Paul praising

[85] Although Cain Hope Felder replicates the generic invisibility so common in 1 Thessalonians scholarship, he also brings wo/men into view analogically by juxtaposing the eschatological teachings in 4:13–5:11 with a text box on Sojourner Truth's views on the second coming (Felder, "1 Thessalonians," 398).

[86] This requires that historiography become less linear and singular in its vision. See Castelli and Taussig, "Drawing Large and Startling Figures," 3–22.

[87] For an understanding of feminist historiography as supplement, and thus both more provisional and more complete, see Castelli, "Heteroglossia," 92.

(4:1) them for practicing self-control over their genitals (4:4) and strongly encouraging them to consider such extirpation of the passions as setting them apart from other Gentiles (4:5), then several perspectives might come into view. Who are these males? If they are poor artisans or handworkers, then such bodily performance of purity and honor in the community may mitigate their lack of status (and true manliness) on the larger civic map. Paul's words reinforce this expectation. As Fatum observes, community views of marriage, procreation, and intercourse with various partners (wives, male and female slaves, prostitutes) thus are (or become) sites for negotiating the purity and honor of the free/d males in the community, embedding free/d females and male and female slaves into whatever relations maintain the honor and masculinity of those over them. However, those listening to the community reading of the letter who do not recognize their own lived reality in this instruction—such as all females and male slaves—might ignore it,[88] find a way to fit themselves into it, or use it for purposes other than those intended.[89] It is unlikely that this is the first time that they have had to resignify (or find ways to survive) purportedly generic but patronizing social expectations.[90] If there is local energy for border transgression or creating alternative spaces and identities, then the community may opt to write back to Paul expressing its views on the subject of sex.[91]

But let us say they do not. After the reading of Paul's letter, just how the community goes about defining the avoidance of πορνεία and practice of such self-control can have various consequences. If practicing self-control means "taking your own wife," then some in the community might promote limiting intercourse to procreative sex within marriage, reifying the sacrality of the civic (and even imperial) structure while, perhaps, becoming a parody of it as low status males claim to be manly by limiting their sexual prerogatives.[92] For a poor free/d female, marriage to a male who can lay claim (at minimum within the community) to status and manly self-control

[88] Like the slaves who walk out of the white preacher's sermon on Philemon recounted in Martin, "*Haustafeln* (Household Codes)," 206–31.

[89] On the agency of "consumers" in using cultural production in ways other than intended, see de Certeau, *Practice of Everyday Life*, 24–42.

[90] On the agency of subordinates in resignifying meaning in ways that the dominant cannot necessarily understand or even detect, see Scott, *Domination and the Arts of Resistance*.

[91] Of course, 1 Corinthians attests to a lively conversation with Paul on several related issues. See Wire, *Corinthian Women Prophets*.

[92] Does it then become a mockery? See discussions of the agency and resistance of colonial subjects in the work of Homi Bhabha. For a discussion of early Christian interpretations of Paul's letters where πορνεία is interpreted as sex outside of marriage, see Gaca, *Making of Fornication*.

gives her a claim to purity, ideal femininity, and legal provisions that might mitigate her own experience of social inequality.[93] Beyond that, she might imagine that the ideal of reciprocity (4:6), mutuality (4:9), and care of the weak (5:14) articulated by Paul applies to her marital relationship and thus might expect her husband (who is also her brother in Christ) to encourage her to "possess her own vessel" (2 Cor 4:7; 1 Pet 3:7) by abstaining from sex altogether.[94] In such a community context, male and female slaves might claim the value of their own unrecognized partnerships.[95] Or, they might claim that their masters (who are also their brothers and sisters in Christ) should abstain from using them sexually (like Gentile masters who do not know God).[96] A slave owner might benefit from being seen as self-controlled in this way, but his wife might counter that his "morally neutral" use of the slave will guard her own purity and self-control.[97] Upon hearing Paul's teaching, the unmarried may prefer not marrying at all and those married to polluting Gentiles may seek divorce. A female who does not marry may be more dependent economically on the community (as if they were her family) or may need to maintain her connections to her family of origin (who may pressure her to marry or not to divorce). Paul's prayer that God (who is faithful) will somehow sanctify their spirits, souls, and bodies (5:23) does not bypass the communal negotiations by which such sanctification will be attained and by whom.

This process of imagining historical responses to Paul's rhetoric brings Thessalonian wo/men into view by bringing them into our historical narrative.

[93] See Osiek and MacDonald, *Woman's Place*, 17–49, 131–32.

[94] Fatum suggests that "the ideal of eschatological virginity seems not to have been an issue yet" ("1 Thessalonians," 261). We do not really know either way, and thus imagining this view within the community before Paul's letter arrives or after Timothy's visit is reasonable in light of the relatively early evidence for this view in 1 Corinthians 7. In addition, insofar as Paul speaks of imitating him (1:6) and what he has taught them about how to live (4:1–2), it is at least thinkable that some took note of Paul being unmarried.

[95] Martin, "Slave Families," 207–30.

[96] Paul criticizes Gentiles who do not know God in 4:5. For evidence of debates about whether masters in the Christ communities should be different than those outside, see Phlm 16; 1 Tim 6:2. See, however, Glancy, *Slavery in Early Christianity*, 59–63. Glancy's proposal that σκεῦος κτᾶσθαι should be translated literally as "obtain his own vessel" and refers to seeking out morally neutral sexual outlets, such as one's own slaves, is provocative, in a positive way, in that it startles interpreters into "seeing" what it would mean to take seriously that *slaves were there*, struggling with their radically different social reality. While Glancy offers a series of proposals (ibid., 62) for imagining what Paul may or may not have said before this, she does not attempt to imagine how slave wo/men might attempt to resist or resignify such teaching.

[97] Ibid., 21–24.

Rather than concluding from 1 Thess 4:3–8 that women were not actually *there* or not *really Christians*, I suggest that the passage ultimately "proves" only this: that Thessalonian wo/men in Christ experienced and struggled with the conundrums and negotiations of the hierarchically structured world in which they lived. It should be a critical presupposition that they found ways to survive and—in their own ways, not always highly visible or imaginable to us—to create spaces in which to act.

Imagining Wo/men in Multiple and Contested Spaces

In this, the women of the Thessalonian ἐκκλησία were not different from other wo/men in antiquity. The challenge for early Christian historiography is to narrate the complexity of the similarities to and differences from other ways that ancient people organized life, claimed corporate and personal identity, and produced change. Therefore, a third proposal for keeping wo/men in focus in interpretations of 1 Thessalonians is to shift the questions we ask away from origins, difference, and homology to the *creation and contestation of spaces and identities*. Acts narrates the origins of the Thessalonian ἐκκλησία singularly and spatially: It emerges from the synagogue to Jason's house. Of course, a close reading of 1 Thessalonians complicates this picture. However, reading 1 Thessalonians alongside or over and against one space (synagogue, house, workshop), one social model (millenarian movement, patriarchal family), or one set of discourses (pagan religion, imperial propaganda) has a similar effect of bringing some details into focus and pressing others into the background.[98] As I have shown above, these choices have an impact on wo/men's visibility.

First Thessalonians includes language related to several material/discursive spaces: the household, the marketplace or workshop, philosophical schools, and social networks or associations (which includes synagogues). Crossing these spaces, Paul attempts to shape the Thessalonians' self-understanding

[98] "Since models provide cognitive filters that rule out irrelevant information, there is always a danger that such assembling of clues will be foreshortened so that a 'strategic mischoice' is made" (Jewett, *Thessalonian Correspondence*, 135). The preference for one social model has a strong power to naturalize its ways of seeing. While there are many important insights and details in Osiek and MacDonald's book, *Woman's Place*, the privileging of the framework of the household and family as the context of early Christian women's activity has an impact on how (and where) we see them. In her review, Laura Nasrallah asks the following about the positive evaluation of the Ephesians image of the ἐκκλησία as a bride: "How can we square the pure and submissive bride with *ekklēsiai* more broadly represented as places of tussle and struggle in deliberative discourse of Greek cities, and with our knowledge of women's roles as leaders and authoritative benefactors in the public square?" (Nasrallah, Review of *A Woman's Place*, 620; see also 622).

with wide-lensed religious-political narrations of history, geography, and the cosmos intertwined with a tight focus on the everydayness of work, sex, and death. The civic designation of ἐκκλησία resides alongside the household language of kinship. Rather than attempting to pinpoint the letter on a map of ancient urban life and reconstructing the community from there, I suggest placing certain aspects of the letter alongside an understanding of mobile and diverse community members who were not consigned to one space and did not carry a singular identity, but rather moved through the spaces of the ancient city and regularly negotiated multiple identities such as status, wealth, gender, and tribe. From this vantage point, the various discourses in 1 Thessalonians can be interpreted as part of the creation of a certain space (called the ἐκκλησία of the Thessalonians) and one attempt to organize the community members' multiple identities toward a prioritizing of an identity "in Christ."[99]

For example, Paul's positive evaluation of working with your hands (4:11) and being self-sufficient (4:12) looks different from the view of the professional associations and the philosophical schools. A formal declaration of corporate membership in an artisans' association may claim public honor and networks of belonging for male or occasionally female artisans, while the elite and popular promotion of Stoic self-sufficiency serves to shape true masculinity around notions of independence. Paul's teaching can function similarly as creating a sense of belonging among low-status artisans and/or articulating "in Christ" masculinity in terms of self-sufficiency. While these observations are very important, they might miss the fact that both discourses are also part of the way a society masks the informal realities of a domestic and slave economy. If we imagine Paul in an artisan's workshop, do we see the informal domestic economy, the "working" wo/men, that support the artisans? Do we see household slaves at work in the workshop and the rooms in the back or upstairs, doing the myriad of menial, routine, but unrecognized daily jobs? The public advertisement of a gendered professional guild is part of the process by which work itself is gendered, and the informal work of wo/men is not publicly classified as work. If we imagine that Paul's "working with your hands" might have meaning not only to artisans, but also to anyone engaged in "productive activity for household use or exchange,"[100]

[99] For this notion of prioritizing multiple identities in Paul, see Hodge, "Apostle to the Gentiles," 270–88.

[100] For this definition of work, see Pomeroy, "Contribution of Women," 183. Pomeroy also points to the problem of women's economic invisibility (and in this case silence) as a result of both the sources and the scholarship: "Finley and earlier economic historians imposed a veil of silence over women's work. To some extent they were probably influenced by the

then we might see the way that an ἐκκλησία or a group of fictive siblings that values manual labor and promotes self-sufficiency through *communal* interdependence (μηδενὸς χρείαν ἔχητε, 4:12)[101] could function as a space for alternative economic arrangements to both household and workshop. However, for some, the admission of interdependence comes with a cost (or can be misused or taken for an abusive patronage relationship, 2:6) and thus it is not surprising to see Paul advertising his choice of self-sufficiency (2:9) despite his dependence on the work of others (Phil 4:14–16).

We may also be able to keep the Thessalonian wo/men in focus by thinking about the creation of community identity in spatial terms. For example, Acts often makes claims about community identity by dramatizing the community's relationship to civic spaces. In Acts 17:5–7, a mob of Jews and marketplace thugs looking for Paul and Silas attack Jason's house and drag him and some ἀδελφοί out of the house and in front of the politarchs. They then publicly denounce them, saying, "These people who have been turning the world upside down have come here also, and Jason has entertained them as guests. They are all acting contrary to the decrees of the emperor, saying that there is another king named Jesus" (17:6b–7). I am not interested in whether this story is historical; rather I find instructive the way that the story "thinks" spatially. The mob searches in houses and then drags the ἀδελφοί into civic space in order to accuse them as locals who harbor those (outsiders?) who turn the world upside down with their anti-imperial messianism. Thus the story attempts to "out" Jason and the Thessalonian ἀδελφοί as potential enemies of the city and the empire. Taking this spatial concept of "outing" back to 1 Thessalonians might give us some different perspectives on both the kinship and apocalyptic (or eschatological) language in the letter.

The legitimating of imperial rule depended on the repetitive public iconography of the emperor as the quintessential father, benefactor, and ruler of the *oikoumenē*, and the self-presentation of local elites as playing their part (as pious fathers, benefactors, and local rulers) in the emperor's networks of sacred power.[102] Large-scale public representations of this ideology in

ancient sources, which do not draw attention to the work of respectable women" (ibid., 191). It is interesting that the wo/men in Xenophon also become more visible to Pomeroy herself after seeing women weavers during her time in modern Greece in 1988 and studying anthropological reports on the Greek economy and the way "Greek men conceal the work that women in their families perform at home, so that only men appear to be earning cash" (ibid., 182). This contemporary experience helped Pomeroy to "distinguish among realia, idealization, and image" (ibid).

[101] Felder, "1 Thessalonians," 396.

[102] See the now standard Zanker, *Power of Images*; Price, *Rituals and Power*.

imperial cult temples, statuary, civic inscriptions, and processions/festivals are repeated on a portable scale on coinage and in statuary for domestic shrines. Thus the imagery crosses between civic and domestic space both rhetorically and materially. Other spaces are crossed as well. The physically distant rulers nonetheless coexist in each city alongside local divinities. Even the boundaries between the living and the dead (with deified emperors and funerary monuments) and the earth and the heavens (with images of the emperors' apotheosis) are transgressed.

First Thessalonians likewise rhetorically crosses civic and domestic spaces with its language of ἐκκλησία and kinship. It similarly stakes out the heavens as the meeting place between the living and the dead and their returning triumphant Christ. Like the emperor and his statuary, Paul is absent and yet his letters and his self-presentation as father and nurse stand in to legitimate his authority and usefulness. However, 1 Thessalonians also orients its hearers differently to local "spaces," such as those of local *pietas* ("having turned to God from images"; 1:9), local ethno-geographical identity ("you endured the same things from your own countrymen"; 2:14), practices of ideal masculinity ("not like the nations who do not know God"; 4:5), and cosmic history ("and to wait for his Son from heaven"; 1:10; "those who say 'peace and security' then sudden destruction will come"; 5:3).[103] Add to this the repetitive language of fictive siblings with claims on each other apart from each person's place in his or her respective household. If a group publicly claimed and advertised such a space/identity, it may well have "outed" itself as a safe haven for troublemakers. Apparently, however, Paul does not expect the community to go too public with this orientation as he encourages them to live in a way that "commands the respect of outsiders" (4:12), while he, apparently, deals with the hazards of public proclamation (2:2).[104]

Thessalonian wo/men might be imagined *both* as mobile and diverse viewers of the public presentation of structures of honor, piety, and patronage, *and* as private hearers of Paul's letter, insofar as the ἐκκλησία of the Thessalonians likely met in some nondescript house or workshop or apartment out of direct sight of anyone who was not connected to them.[105] It

[103] Oakes discusses how 1 Thessalonians orients its readers differently from the imperial cult ("Re-Mapping the Universe," 301–22).

[104] The book of Acts shows that by the early second century there was anxiety about this question of what went on in those early house churches. One might argue that the author "outs" the Christians in order to show that rumors of insurgency are unfounded (thereby, through historiography, refuting such views of the ἐκκλησίαι among Christians themselves).

[105] I use the terms "public" and "private" in the sense of visibility and invisibility rather than outside and inside, or civic versus domestic space. Davina Lopez describes the way that

is easy to imagine that people in this space could recognize the hierarchical language of kinship, association, and even empire. But is it also imaginable that claiming to belong to a not quite pious club, a not quite family, a not quite tribe, and the not quite (yet) subjects of a victorious king may have created for some a local (and not yet public) space for crossing social boundaries and imagining various ways to resist or resignify the status quo?[106] If so, then, as Mary Ann Beavis notes, "The 'invisibility' of the struggle to realize the vision may be accounted for by its smallness and lack of importance to outsiders, and, as suggested by some scholars, the emergence of egalitarian [and thus also anti-imperial] features *within* traditional household structures."[107] Thus the language of kinship would mark *both* the utopian and the kyriarchal space of the ἐκκλησία of the Thessalonians. From there, if we suspect that Paul has not shown us the whole picture—how could he?—we have to imagine the struggle over who will claim the right to further define this space, how they will do so, and what the opportunities and consequences are for different people of "going public" (or going out, or going home) with such an identity.

Conclusion: Looking Around for Wo/men

In her discussion of the Column of Trajan, Natalie Boymel Kampen notes that through various visual strategies—including the fact that only eight of the 155 friezes contain wo/men—the Forum of Trajan "makes no explicit

public monuments would do their work by being seen by many different people: "Roman imperial emphasis on visual communication also makes the naturalization of ideas about institutions, cultural configurations and hierarchies intelligible to a wider range of people than just literate elites: all who could see and walk past a victory monument [or hold a coin] would probably be able to 'read' it. Public art proclaimed the corporeality, coherence and universality of the Roman state" ("Before Your Very Eyes," 117–18). By contrast, the ἐκκλησία of the Thessalonians may be utterly invisible to an urban population because of its lack of public imagery, distinctive language, public advertisement (in the form of distinctive inscriptions or funerary monuments), and monumental architecture.

[106] For the importance of cordoned-off space out of the public view for cultivating dissident language and practices, see Scott, *Domination*, 108–35.

[107] Beavis, "Christian Origins," 43. Beavis cites Sandnes, "Equality within Patriarchal Structures," 150–65. In his examination of Philemon, Sandnes concludes, "The New Testament writings leave us with a picture of ambiguity, or even tension: egalitarian structures are emerging within patriarchal household structures. . . . Within the context of households an egalitarian brother- and sisterhood is in the making. The new identity of believers, i.e., that they were brothers and sisters on equal footing, involved, however, a modification of household structures" (ibid., 162).

acknowledgement of the public presence and activity of women." She contrasts this view with textual evidence that suggests that elite wo/men "entered virtually all public spaces (even, at times, the Senate chambers)."[108] In addition, she argues that although elite Roman wo/men were officially excluded from military and civil office, they were highly influential through informal avenues of power, such as wealth, marriage, and birth. Thus she disrupts the hegemonic views of elite male power (in text and artifact) with evidence of elite wo/men's presence in public spaces and informal power. In his work on the high priestesses of Asia, Steve Friesen affirms a further kind of feminist inquiry that "challenges us to lower our gaze from the statue, to glance around the base, and to consider those whose labor and lives are implied by the monument but whose voices have been silenced by the dominion of wealth, class, and gender."[109] Feminist New Testament scholars similarly press interpreters to "read" the monuments of kyriarchal inscription, but also to imagine alternative readers and readings. In this discussion of the Thessalonian wo/men, I have tried to show that archaeological remains, ancient texts, and our own historiographies all require such looking around and away, in order to identify what has been rendered visible and invisible.

I do not claim to have found the elusive Thessalonian wo/men. Rather, I hope that the process of "gazing upon the invisible" will have brought into clearer view why it is worth trying. Simply agreeing—as most everyone does—that Phoebe was a deacon or that New Testament generic language should (usually) be translated inclusively in no way means that wo/men in early Christianity are now visible and we all can move on. The questions of how to characterize wo/men's presence, what difference (if any) that presence makes, and how to interpret generic and androcentric discourses persist.

[108] Kampen, "Looking at Gender," 53.
[109] Friesen, "High Priestesses of Asia," 150.

BIBLIOGRAPHY

Ascough, Richard S. "A Question of Death: Paul's Community-Building Language in 1 Thessalonians 4:13–18." *JBL* (2004) 509–30.

———. *Paul's Macedonian Associations: The Social Context of Philippians and 1 Thessalonians*. WUNT 2/161. Tübingen: Mohr Siebeck, 2003.

———. "The Thessalonian Christian Community as a Professional Voluntary Association." *JBL* 119 (2000) 311–28.

———. "Translocal Relationships among Voluntary Associations and Early Christianity." *JECS* 5 (1997) 223–41.

Batten, Alicia. "The Moral World of Greco-Roman Associations." *SR* 36 (2007) 135–51.

Beavis, Mary Ann. "Christian Origins, Egalitarianism, and Utopia." *JFSR* 23 (2007) 27–49.

———. *Jesus & Utopia: Looking for the Kingdom of God in the Roman World*. Minneapolis, Minn.: Fortress, 2006.

Best, Ernst. *A Commentary on the First and Second Epistles to the Thessalonians*. New York: Harper & Row, 1972.

Brocke, Christoph vom. *Thessaloniki—Stadt des Kassander und Gemeinde des Paulus. Eine frühe christliche Gemeinde in ihrer heidnischen Umwelt*. WUNT 2/125. Tübingen: Mohr Siebeck, 2001.

Bruce, Frederick Fyvie. *1 & 2 Thessalonians*. Word Biblical Commentary 45. Waco, Tex.: Word, 1982.

Burnett, Fred W. "Historiography." Pages 106–12 in *The Handbook of Postmodern Biblical Interpretation*. Edited by A. K. M. Adam. St. Louis, Mo.: Chalice, 2000.

Castelli, Elizabeth. "The *Ekklēsia* of Women and/as Utopian Space: Locating the Work of Elisabeth Schüssler Fiorenza in Feminist Utopian Thought." Pages 36–52 in *On the Cutting Edge: The Study of Women in Biblical Worlds; Essays in Honor of Elisabeth Schüssler Fiorenza*. Edited by Jane Schaberg et al. New York: Continuum, 2004.

———. "Heteroglossia, Hermeneutics, and History: A Review Essay of Recent Feminist Studies of Early Christianity." *JFSR* 10 (1994) 73–98.

———. "*Les Belles Infidèles*/Fidelity or Feminism? The Meanings of Feminist Biblical Translation." Pages 189–204 in *A Feminist Introduction*. Vol. 1 of *Searching the Scriptures*. Edited by Elisabeth Schüssler Fiorenza. New York: Crossroad, 1993.

——— and Hal Taussig. "Drawing Large and Startling Figures: Reimagining Christian Origins by Painting Like Picasso." Pages 3–22 in *Reimagining Christian Origins*. Edited by eidem. Valley Forge, Pa.: Trinity Press International, 1996.

Certeau, Michel de. *The Practice of Everyday Life*. Berkeley, Calif.: University of California Press, 1984.

Clark, Elizabeth A. "The Lady Vanishes: Dilemmas of a Feminist Historian after the 'Linguisic Turn.'" *CH* 67 (1998) 1–31.

Conkey, Margaret and Joan Gero. "Programme to Practice: Gender and Feminism in Archaeology." *ARA* 26 (1997) 411–37.

Donfried, Karl Paul. "The Imperial Cults of Thessalonica and Political Conflict in 1 Thessalonians." Pages 215–23 in *Paul and Empire: Religion and Power in Roman Imperial Society*. Edited by Richard A. Horsley. Harrisburg, Pa.: Trinity Press International, 2004. Repr. of the second half of idem, "Cults of Thessalonica."

Donfried, Karl Paul. "The Cults of Thessalonica and the Thessalonian Correspondence." *NTS* 31 (1985) 336–56. Repr., ibid. Pages 21–48 in *Paul, Thessalonica, and Early Christianity*. Grand Rapids, Mich.: Eerdmans, 2002.

Edson, Charles. "Cults of Thessalonica (Macedonia III)." *HTR* 41 (1948) 153–204.

Ehrman, Bart D. *The New Testament: A Historical Introduction to the Early Christian Writings*. 2d ed. New York: Oxford University Press, 2000.

Elliot, Neil. *Liberating Paul: The Justice of God and the Politics of the Apostle*. Sheffield, England: Sheffield Academic Press, 1995.

Fatum, Lone. "Brotherhood in Christ: A Gender Hermeneutical Reading of 1 Thessalonians." Pages 183–97 in *Constructing Early Christian Families*. Edited by Halvor Moxnes. London: Routledge, 1997.

———. "1 Thessalonians." Pages 250–62 in *A Feminist Commentary*. Edited by Elisabeth Schüssler Fiorenza. Vol. 2 of *Searching the Scriptures*. New York: Crossroad, 1994.

Felder, Cain Hope. "1 Thessalonians." Pages 389–400 in *True to Our Native Land: An African American New Testament Commentary*. Edited by Brian Blount. Minneapolis, Minn.: Fortress, 2007.

Friesen, Steven J. "Prospects for a Demography of the Pauline Mission: Corinth among the Churches." Pages 351–70 in *Urban Religion in Roman Corinth: Interdisciplinary Approaches*. Edited by Daniel N. Showalter and Steven J. Friesen. HTS 53. Cambridge, Mass.: Harvard Divinity School, 2005.

———. "High Priestesses of Asia and Emancipatory Interpretation." Pages 136–50 in *Walk in the Ways of Wisdom: Essays in Honor of Elisabeth Schüssler Fiorenza*. Edited by Shelly Matthews, Cynthia Briggs Kittredge, and Melanie Johnson-DeBaufre. Harrisburg, Pa.: Trinity Press International, 2003.

Gaca, Kathy L. *The Making of Fornication: Eros, Ethics, and Political Reform in Greek Philosophy and Early Christianity*. Berkeley: University of California Press, 2003.

Glancy, Jennifer A. *Slavery in Early Christianity*. Oxford: Oxford University Press, 2002.

Harris, Stephen L. *The New Testament: A Student's Introduction*. 5th ed. New York: McGraw-Hill, 2006.

Harrison, James R. "Paul and the Imperial Gospel at Thessaloniki." *JSNT* 25 (2002) 71–96.

Hendrix, Holland Lee. "Archaeology and Eschatology at Thessalonica." Pages 107–18 in *The Future of Early Christianity*. Edited by Birger A. Pearson et al. Minneapolis, Minn.: Fortress, 1991.

———."Thessalonicans Honor Romans." Th.D. diss., Harvard University, 1984.

Hodge, Caroline Johnson. "Apostle to the Gentiles: Constructions of Paul's Identity." *BibInt* 13 (2005) 270–88.

Hollywood, Amy. "Agency and Evidence in Feminist Studies of Religion: A Response to Elizabeth Clark." Pages 234–49 in *The Future of the Study of Religion: Proceedings of Congress 2000*. Edited by Slavica Jakelić and Lori Pearson. Leiden: Brill, 2004.

Jacobs, Andrew S. "The Lion and the Lamb: Reconsidering Jewish-Christian Relations in Antiquity." Pages 95–118 in *The Ways That Never Parted: Jews and Christians in Late Antiquity and the Early Middle Ages*. Edited by Adam H. Becker and Annette Yoshiko Reed. Minneapolis, Minn.: Fortress, 2007.

Jewett, Robert. *The Thessalonian Correspondence: Pauline Rhetoric and Millenarian Piety*. Philadelphia: Fortress, 1986.

Johnson-DeBaufre, Melanie. *Jesus among Her Children: Q, Eschatology, and the Construction of Christian Origins.* HTS 55. Cambridge, Mass.: Harvard Divinity School, 2006.

———— and Laura S. Nasrallah. "Beyond the Heroic Paul: Toward a Feminist and Decolonizing Approach to Paul's Letters." In *Paul and Postcolonial Studies.* Edited by Christopher Stanley. Minneapolis, Minn.: Fortress, forthcoming.

Kampen, Natalie Boymel. "Looking at Gender: The Column of Trajan and Roman Historical Relief." Pages 46–73 in *Feminisms in the Academy.* Edited by Donna C. Stanton and Abigail J. Stewart. Ann Arbor, Mich.: University of Michigan Press, 1995.

Khiok-khng, Yeo. "1 Thessalonians." Pages 500–503 in *Global Bible Commentary.* Edited by Daniel Patte. Nashville: Abingdon, 2004.

Kloppenborg, John S. and Stephen G. Wilson, eds. *Voluntary Associations in the Graeco-Roman World.* London: Routledge, 1996.

Knust, Jennifer. "Paul and the Politics of Virtue and Vice." Pages 155–73 in *Paul and the Roman Imperial Order.* Edited by Richard A. Horsley. Harrisburg, Pa.: Trinity Press International, 2004.

Koester, Helmut. *Paul and His World: Interpreting the New Testament in Its Context.* Minneapolis, Minn.: Fortress, 2007.

————. "Archäologie und Paulus in Thessalonike." Pages 393–404 in *Religious Propaganda and Missionary Competition in the New Testament World.* Edited by Lukas Bormann, Kelly Del Tredici, and Angela Standhartinger. Leiden: Brill, 1994. Repr., pages 38–41 in *Paul and His World: Interpreting the New Testament in Its Context.* By Helmut Koester. Minneapolis, Minn.: Fortress, 2007.

————. "From Paul's Eschatology to the Apocalyptic Schemata of 2 Thessalonians." Pages 441–58 in *The Thessalonian Correspondence.* Edited by Raymond F. Collins. Leuven: Leuven University Press, 1990. Repr., pages 55–69 in *Paul and His World: Interpreting the New Testament in Its Context.* By Helmut Koester. Minneapolis, Minn.: Fortress, 2007.

Lanci, John R. "The Stones Don't Speak and the Texts Tell Lies: Sacred Sex at Corinth." Pages 205–20 in *Urban Religion at Ancient Corinth: Interdisciplinary Approaches.* Edited by Daniel N. Schowalter and Steven J. Friesen. HTS 53. Cambridge, Mass.: Harvard Divinity School, 2005.

Lehmann, Phyllis W. *The Pedimental Sculptures of the Hieron in Samothrace.* Locust Valley, N.Y.: Augustin, 1962.

Lopez, Davina. "Before Your Very Eyes: Roman Imperial Ideology, Gender Constructs, and Paul's Inter-Nationalism." Pages 115–62 in *Mapping Gender in Ancient Religious Discourses.* Edited by Todd Penner and Caroline Vander Stichele. Leiden: Brill, 2006.

MacLean, Bradley H. "The Agrippinilla Inscription: Religious Associations and Early Church Formation." Pages 212–38 in *Origins and Method: Toward a New Understanding of Judaism and Christianity.* Edited by idem. JSNTSup 86; Sheffield: Sheffield University Press, 1993.

Malherbe, Abraham. *The Letters to the Thessalonians.* AB 32B. New York: Doubleday, 2000.

Marchal, Joseph A. *Hierarchy, Unity, and Imitation: A Feminist Rhetorical Analysis of Power Dynamics in Paul's Letter to the Philippians.* Atlanta, Ga.: Society of Biblical Literature, 2006.

Marshall, I. Howard. *1 and 2 Thessalonians*. NCB Commentary. Grand Rapids, Mich.: Eerdmans, 1983.

Martin, Clarice J. "The *Haustafeln* (Household Codes) in African American Biblical Interpretation." Pages 206–31 in *Stony the Road We Trod*. Edited by Cain Hope Felder. Minneapolis, Minn.: Fortress, 1991.

Martin, Dale B. "Slave Families and Slaves in Families." Pages 207–30 in *Early Christian Families in Context*. Edited by David L. Balch and Carolyn Osiek. Grand Rapids, Mich.: Eerdmans, 2003.

————. *The Corinthian Body*. New Haven, Conn.: Yale University Press, 1995.

Matthews, Shelly. "Thinking of Thecla: Issues in Feminist Historiography." *JFSR* 17 (2001) 31–55.

Meggitt, Justin. *Paul, Poverty, and Survival*. Edinburgh: T&T Clark, 1998.

Nasrallah, Laura. Review of Carolyn Osiek and Margaret MacDonald, *A Woman's Place: House Churches in Earliest Christianity*. *JBL* 125 (2006) 617–22.

Nobles, Connie H. "Gazing upon the Invisible: Women and Children at the Old Baton Rouge Penitentiary." *American Antiquity* 65 (2000) 5–14.

Oakes, Peter. "Re-Mapping the Universe: Paul and the Emperor in 1 Thessalonians and Philippians." *JSNT* 27 (2005) 301–22.

Osiek, Carolyn and Margaret Y. MacDonald. *A Woman's Place: House Churches in Earliest Christianity*. Minneapolis, Minn.: Fortress, 2006.

Perkins, Pheme. "1 Thessalonians." Pages 349–50 in *The Women's Bible Commentary*. Edited by Carol A. Newsom and Sharon H. Ringe. London: SPK, 1992.

Pomeroy, Sarah B. "The Contribution of Women to the Greek Domestic Economy: Rereading Xenophon's *Oenonomicus*." Pages 180–95 in *Feminisms in the Academy*. Edited by Domna C. Stanton and Abigail J. Stewart. Ann Arbor, Mich.: University of Michigan Press, 1995.

Price, Simon R. F. *Rituals and Power: Roman Imperial Cult in Asia Minor*. New York: Cambridge University Press, 1984.

Sandnes, Karl Olav. "Equality within Patriarchal Structures: Some New Testament Perspectives on the Christian Fellowship as a Brother- or Sisterhood and a Family." Pages 150–65 in *Constructing Early Christian Families*. Edited by Halvor Moxnes. London: Routledge, 1997.

Schüssler Fiorenza, Elisabeth. "Re-Visioning Christian Origins: *In Memory of Her* Revisited." Pages 225–50 in *Christian Origins: Worship, Belief, and Society*. Edited by Kieran J. O'Mahony. JSNTSup 241. Sheffield, England: Sheffield Academic, 2003.

————. *Wisdom Ways: Introducing Feminist Biblical Interpretation*. Maryknoll, N.Y.: Orbis, 2001.

————. "The Rhetoricity of Historical Knowledge: Pauline Discourse and Its Contextualizations." Pages 129–48 in eadem, *Rhetoric and Ethic: The Politics of Biblical Studies*. Minneapolis, Minn.: Fortress, 1999.

————. *Rhetoric and Ethic: The Politics of Biblical Studies*. Minneapolis, Minn.: Fortress, 1999.

————. *But She Said: Feminist Practices of Biblical Interpretation*. Boston: Beacon, 1992.

————. *In Memory of Her: A Feminist Theological Reconstruction of Christian Origins*. New York: Crossroad, 1983.

Schüssler Fiorenza, Elisabeth, ed. *A Feminist Introduction.* Vol. 1 of *Searching the Scriptures.* New York: Crossroad, 1993.

Scott, James C. *Domination and the Arts of Resistance.* New Haven, Conn.: Yale University Press, 1992.

Seesengood, Robert Paul. "Rules for an Ancient Philadelphian Religious Organization and Early Christian Ethical Teaching." *Stone-Campbell Journal* 5 (2002) 217–34.

Smith, Abraham. "The First and Second Letters to the Thessalonians." Pages 304–22 in *A Postcolonial Commentary on the New Testament Writings.* Edited by Fernando Segovia and R. S. Sugitharajah. London: T&T Clark, 2007.

———. " 'Unmasking the Powers': Toward a Postcolonial Analysis of 1 Thessalonians." Pages 47–66 in *Paul and the Roman Imperial Order.* Edited by Richard A. Horsley. Harrisburg, Pa.: Trinity Press International, 2004.

Spiegel, Gabrielle. "History, Historicism, and the Social Logic of the Text in the Middle Ages." *Spec* 65 (1990) 59–86.

Wire, Antoinette. *The Corinthian Women Prophets: A Reconstruction through Paul's Rhetoric.* Minneapolis, Minn.: Fortress, 1990.

Yarbrough, O. Larry. *Not Like the Gentiles: Marriage Rules in the Letters of Paul.* SBLDS 80. Atlanta, Ga.: Scholars, 1985.

Zanker, Paul. *The Power of Images in the Age of Augustus.* Ann Arbor, Mich.: University of Michigan Press, 1991.

Locating Purity: Temples, Sexual Prohibitions, and "Making a Difference" in Thessalonikē

Christine M. Thomas

This short contribution is a chapter in an ongoing project to develop new models for the integration of evidence from archaeology into the study of early Christianity.[1] The topic, the purity language in Paul's first letter to the Thessalonians, may not initially seem an apt example, but in fact it is. Concepts of purity assume a sacred geography. Basic to most systems of ritual purity is the practice of separating out sacred things from profane. This is an activity that takes place in space, and over the medium of the human body; it is religious work performed physically by individuals in concrete settings, which leaves behind traces in the structures and objects that archaeological excavation produces. Purity language opens a door for imagining Paul's Thessalonian community against its material background.

[1] I would like to thank here the organizers of the conference and editors of this volume, particularly Laura Nasrallah, for their generosity and unstinting encouragement; my discussants at the conference, who opened up new perspectives, particularly Cavan Concannon, Helmut Koester, and Lawrence Wills; also Dennis MacDonald and Sheila Briggs, who heard and discussed an early version of this paper; and most of all my colleague at the University of California at Santa Barbara, the sociologist Roger Friedland, for several typically incisive conversations that measurably improved my analysis.

THE ARCHAEOLOGY OF 1 THESSALONIANS

Previous attempts to integrate archaeological materials into the study of Paul's letter to the Thessalonians have brought much-needed attention to the traditional Mediterranean religions ("Greco-Roman cults") practiced in and around Thessalonikē.[2] This is a particular desideratum for understanding Paul's community at Thessalonikē, since Paul describes them clearly as converts from traditional Greek religions, that is, as Gentiles:[3] "You have turned to God from idols" (ἐπεστρέψατε πρὸς τὸν θεὸν ἀπὸ τῶν εἰδώλων, 1 Thess 1:9).[4] Most previous attempts to work with the archaeological finds, however, have suffered from two limitations.[5] First, New Testament scholars have tended to overestimate the representative value of the evidence. The archaeological record at Thessalonikē is unusually scanty, because the location of the modern city directly over the ancient ruins has limited the ability of archaeologists to conduct extensive and systematic excavations. The finds result from limited rescue excavations, rather than coordinated urban and regional surveys. Thus the extant artifacts cannot provide a clear picture of the major features of religious life in Roman imperial Thessalonikē. The cults of Dionysos or of the Kabeiroi, cited repeatedly in the New Testament scholarship, were prominent features of religious life in Thessalonikē.[6] Yet the piecemeal and unsystematic results of chance excavations cannot demonstrate their relative importance among all the cults practiced at Thessalonikē.[7] They

[2] Donfried, "Cults," 336–56; Jewett, *Correspondence*; Koester, "Eschatology," 441–58; Kloppenborg, "Dioscuri," 265–89; de Vos, *Conflicts*; and vom Brocke, *Stadt*. Specifically on imperial cult: Hendrix, "Thessalonicans Honor Romans"; Hendrix, "Archaeology and Eschatology," 107–18; Donfried, "Imperial," 215–23 (an abridgement of "Cults"); Koester, "Imperial Ideology," 158–66 (an abridgement of "Eschatology"). For Christian reuse of imperial architecture, Nasrallah, "Empire and Apocalypse," 465–508.

[3] Throughout this essay, I wish to take Paul's Jewish rhetoric seriously by describing the adherents of traditional Greek civic religions, "pagans," as they would have appeared to a member of the diaspora Jewish community as "Gentiles."

[4] Εἰδώλων would be better rendered "images [of the gods]," but I have retained the pejorative "idol" because it coheres semantically with the Jewish stereotype of Gentile idolatry and *porneia*, which Paul invokes in this letter. Translations from Greek are the author's, except as noted.

[5] Koester, "Archäologie," 393–404; in English, "Archaeology and Paul" in idem, *Paul and His World*, 38–54; idem, "Eschatology," 441–45.

[6] Summarized by Tzanavari, "Worship of God," esp. 205–16 (for Dionysos), 229–31 (for the Kabeiroi).

[7] Edson, on whose work the majority of New Testament scholars depend for their information on the cults of Thessalonikē, expresses concern that the chance find of a large body of inscriptions concerning the Egyptian gods might obscure their actual role in the

can hardly be used as a basis to argue that these cults, rather than others, are the primary referent of the rhetorical images Paul employs in his letter, or that they particularly influenced Paul's presentation of his eschatology.[8] One would need a more systematic understanding of the range of cults in ancient Thessalonikē to be able to do this. A related problem is the neglect of the chronological distribution of the artifacts, a temptation that always arises in the face of sparse evidence: Isolated remains from the fifth century B.C.E. or the third century C.E. are considered to be directly relevant for an understanding of Paul's period,[9] or a Late Antique Samaritan synagogue inscription[10] is considered evidence of a flourishing Jewish community during Paul's lifetime.[11]

A second limitation of New Testament scholarship on this topic, particularly noted by Helmut Koester, is the recurrent failure to distinguish between characteristics of religious life that are peculiar to Thessalonikē and those that are merely instances of more broadly distributed features of religious life in the Roman Empire.[12] It is questionable that the Dionysiac cult at Thessalonikē was more licentious and prone to sexual misconduct

city of Thessalonikē, on whose coinage they never appear ("Cults," 182). De Vos proves exceptional in emphasizing the full range of cults attested and their similarity to the range of religious expressions found in other free Greek cities (*Conflicts*, 140–43).

[8] Frequent is the assumption that Paul, in his admonitions to be sober, shun *porneia*, and be "children of the light," was alluding to orgiastic, drunken, or nocturnal rites for Dionysos or the Kabeiros (Donfried, "Cults," 30 [pagination from idem, *Paul*]); Jewett, *Correspondence*, 127, 129–31; vom Brocke, *Stadt*, 117–29. Kloppenborg ("Dioscuri") argues that the prominence of the divine twin brothers in Thessalonian iconography demonstrates that Paul was referring to them when he claimed that the Thessalonians were "instructed by (the twin) god(s)" (θεοδίδακτοι) in the practice of fraternal love (φιλαδελφία). Jewett is particularly speculative, arguing that the Kabeiros represented a "laborers' hero," that the cult was co-opted by the upper class, which then left a void in the religious life of the lower classes that was filled by Christ (*Correspondence*, 129–32, 165, 169). For critique, see Koester, "Eschatology," 441–45; "Archäologie," 393–96.

[9] Jewett, *Correspondence*, 130–31.

[10] Lifshitz and Schiby date it to the third to fourth century C.E. on the basis of the name of the donor, which they find attested elsewhere and assume is the same individual ("Synagogue," 368–76); Purvis conducts a detailed analysis of the script and places it between the fourth and sixth centuries C.E. ("Samaritan Inscription," 121–23).

[11] Jewett dates the inscription to the third century B.C.E. (*Correspondence*, 120), erroneously citing Lifschitz and Schiby ("Synagogue," 368–76); Donfried ("Cults," 44) also cites the "newest supporting evidence" by vom Brocke (*Stadt*) for a first-century synagogue in Thessalonikē (*Paul*, xxxiii). Vom Brocke does not present new evidence but merely claims that Thessalonikē must have had a synagogue in the first century because it was the largest city in Macedonia, and Philo claims that Jews had settled in Macedonia.

[12] "Auf der einen Seite ist es wichtig, regionale Unterschiede ernst zu nehmen; auf der anderen Seite darf man solche Unterschiede nicht zu hoch veranschlagen. . . . In Bezug auf

than it was at other places in the Roman Empire, and yet it has been cited a number of times as the reason for Paul's emphasis on shunning πορνεία (*porneia*)[13] in this letter.[14]

A potential way forward, which I will pursue in this essay, would be to address Greek traditional religion as an integrated and meaningful system, rather than parceling it up into an analysis of the individual cults of specific deities. Organizing the analysis around the cults of specific gods, rather than around particular aspects of human religious activity, is a reflection of the theological orientation of New Testament studies, which tends to define religion primarily as doctrines about the divinity, rather than as ritual practices and habitual behaviors of human worshipers. The monotheist tendencies of the field are similarly evident in the reluctance to see multiple gods acting together as a symbolic system. Their worshipers, however, approached them as a network of divinities, in which several gods could be approached for the same sorts of needs, such as healing. The gods were part of a global economy of honor and reciprocity, which included human beings; and the gods also formed a kinship system, with family relationships among themselves.

In order to begin a more sustained investigation into the import of archaeological materials for the interpretation of 1 Thessalonians, I will focus on an aspect of Greek religion that is systematic and broadly attested, but seldom cited as a relevant background for Paul's discussion of sanctification and purity:[15] the "sacred laws," a body of inscriptions[16] that described the

archäologische Funde muß man daher fragen, ob sie einem spezifischen regionalen Phänomen angehören oder sich auf allgemein gültig Erscheinungen beziehen" ("Archäologie," 398).

[13] The word does not have an exact English equivalent, so I will refer to it in Greek transliteration throughout this article. The root meaning is sexual intercourse with a πορνή (female prostitute) or πορνός (male prostitute). Gaca investigates the term from Plato into early Christianity, and sees a significant discontinuity in the manner in which the term is defined over time (*Fornication*); Rousselle focuses on its use in early Christianity (*Porneia*).

[14] Vom Brocke, *Stadt*, 121, 128–29; Donfried even suggests that the Dionysiac cult influences Paul's discussion of the Thessalonians' control of their σκεῦος (1 Thess 4:4), which he interprets as referring to the male genitalia ("Cults," 30–31). See below for discussion of this term.

[15] An exception is Regev, who, though not citing the sacred laws directly ("Moral Impurity"), invokes them through the work of Parker (*Miasma*). David Horrell, though not citing the epigraphic evidence, at least describes Gentile sexual morality in its own terms by citing Greek and Roman literary sources (*Solidarity*, 153–63).

[16] The classic source is the work of Sokolowski, *Lois sacrées de l'Asie Mineure*; idem, *Lois sacrées des cités grecques*; idem, *Lois sacrées des cités grecques. Supplement*. See for new sources Lupu, *Law*. Lupu provides an extensive overview of the sacred laws, treating

purity requirements for entrance to the sanctuaries of individual Greek gods and the procedures for performing worship there. Though the evidence is not specifically Thessalonian, it is broadly distributed and well-enough attested throughout the Hellenistic and Roman period that one can view these prescriptions as representative of Greek attitudes during this period.[17] This evidence is particularly germane to an analysis of sacred space, since the inscriptions were placed in specific locations that functioned as physical boundaries between the sacred and the profane: They were engraved on steles that stood at the entrances of sanctuaries to inform worshipers of proper behavior before they entered to visit the gods.

There is an apparent lack of coherence in this comparison, however, because in treating the religion of the Christians in the first two centuries, we have almost no material evidence, but only literary sources. Early Christians during this period seem to have had almost no distinct material culture; it was generally not used in a uniform fashion to mark their religious identity. One way around the problem of the absence of data pertaining directly to a "New Testament archaeology" is to recognize, with Henri Lefebvre, that the social construction of space includes both spatial practices and spatial discourses. The first, spatial practice, includes production and reproduction of items in physical space and the ways that people live and move in space. The second, spatial discourse, is all the things that people say, think, and imagine about space. The two are involved in a reciprocal and dynamic relationship, in which practice and discourse influence and change one other.[18]

What early Christian texts tell us about spaces and spatial practices is important evidence about how the earliest Christians interacted with their material context, a milieu that they shared with worshipers of other gods. To examine their spatial discourse reverses the usual direction of inference between texts and archaeology in the field of early Christian studies. Usually archaeological finds are employed as individual units to illustrate the text of the New Testament. In cases in which the archaeological data are considered systematically, they are often reconstructed as a sort of economic or social "background" into which to place the text, which is

them thematically under the categories of sacred space, officials, cult performance, and religious events such as festivals (9–112).

[17] "Alongside distinctly local documents there exist, however, a great number of sacred laws dealing with issues common to most sanctuaries which are met time and time again, usually with only minor differences" (Lupu, *Law*, 14).

[18] Lefebvre, *Production of Space*, 1–67, esp. 33, 38–39. Though I find Soja's postmodern rereading of Lefebvre to be intriguing (*Thirdspace*), I find it less useful for the ancient spaces reconstructed from lacunose artifacts than the original work of Lefebvre.

always foregrounded as the thing to be discussed and understood. The text itself can, however, be used to illustrate some aspects of the lived spatial experience of early Christians, because Paul and other early Christian writers did use spatial categories. Purity language is one example of this, because it assumes a separation of the sacred from the profane within a specific cognitive geography.

PURITY AND GROUP BOUNDARIES IN THESSALONIKĒ

The language of purity and sanctification in Paul's first letter to the Thessalonians is overwhelming in its density.[19] The letter is rife with the language of consecration, holiness, blamelessness, and purity. These terms do not all denote the same thing, but they all do belong to the general language of ritual purity. Moreover, the vocabulary for these terms is unusual for Paul. The first mention of "holiness" (ἁγιωσύνη, 3:13) appears just before the lengthy and explicit discussion of *porneia*. Ἁγιωσύνη is a somewhat unusual word for Paul. It appears, outside this letter, once in the epistle to the Romans (1:4) and twice in the second epistle to the Corinthians (1:12; 7:1). In the subsequent discussion of *porneia*, the word ἁγιασμός (sanctification) appears three times, again rather unusual in Paul (4:3, 4, 7). Outside these three occurrences in a single short letter, the word appears twice in Romans (6:19, 22) and nowhere else in the genuine Pauline letters.

The concern for purity stands in relationship to the formation of a strong group identity.[20] Paul persistently uses the language of boundary definition in 1 Thessalonians. Not only is the language of purity ubiquitous, but Paul's anthropology is dualistic. The Christ believers are described as "children of light and children of the day," and the surrounding society is "of the night and of darkness" (5:5). The text makes an explicit distinction between those in the community and those "outside" (τοὺς ἔξω, 4:12).

Purity language typically appears when group boundaries are threatened. One of the primary functions of purity systems is to draw a distinction between

[19] Horrell, *Solidarity*, 134.

[20] De Vos describes in detail the means by which Paul strives to strengthen group boundaries and contextualizes this within the sociocultural situation of the Thessalonian community (*Conflicts*, 173–77). Another aspect of the project of community formation is establishing an identity constituted in allegiance to Paul and his authority. Paul stresses his close relationship with the community in a time of difficulties, using affectionate, but authoritarian and hierarchical images, such as father and nurse (Malherbe, "Gentle as a Nurse," 203–17).

the group that holds to the purity restrictions and the rest of humanity, the "impure." Additionally, communities concerned to maintain their social boundaries against an outside threat of assimilation often express a desire to patrol the bodies of their members.[21] Paul's prescriptions to limit sexual behavior (4:3–8) and the advice about how to conduct manual labor (4:11–12) would fit in well here.

Part of the difficulty of forming a clear boundary for the Thessalonian community would have been their similarity in background, experience, and ethnicity to the fellow inhabitants of their city. The letter emphasizes that the chief difference in their change of religious identity was that they "turned to god from idols, to serve a living and true god, and to wait for his son from heaven" (1:9–10). This suggests that the Thessalonian community was drawn exclusively from the worshipers of the traditional civic gods of Thessalonikē, that is, from among the Gentiles. There is no evidence for a Jewish community in the city of Thessalonikē during the Pauline period.[22] The note that they were being persecuted by their συμφυλετῶν ("fellow tribesmen," singular συμφυλέτης)[23] suggests that Paul's converts had citizen rights in Thessalonikē.[24] Archaeological evidence shows that Paul's term referred to something concrete: Several such "tribes" are epigraphically attested at Thessalonikē, which were established at the foundation of Thessalonikē in the Hellenistic period and were active late into the Roman period.[25] Presumably they functioned like similar organizations

[21] Douglas, *Natural Symbols*; *Purity and Danger*, 114–39. Klawans provides an excellent evaluation of her arguments and their reception in the field of Biblical studies (*Impurity*, 7–10).

[22] Koester, "Eschatology," 442–43; de Vos, *Conflicts*, 130–32; Ascough, "Community," 312–13. Vom Brocke argues both that Paul's converts were Gentiles and that their persecutors could not have been Jews (*Stadt*, 162–65). Ascough provides a full and accurate treatment of the literary and archaeological evidence (*Macedonian*, 191–202). Only the influence of the account in Acts can explain the persistence of the assumption that Jews in Thessalonikē played any role in the religious experience of Paul's converts there.

[23] I take 1 Thess 2:14–16 to be genuine and not an interpolation. See below.

[24] Donfried considers the συμφυλετῶν to include a reference to Jews, which is highly unlikely given the lack of attestation of a Jewish community at Thessalonikē and the usual political meaning of the word φυλή; the motivation seems to be to harmonize Paul's letter with the account in Acts 17 in which the Jews are said to have instigated civic uproar against Paul and Silas ("Paul and Judaism," 242–53). Vom Brocke concludes from the mention of συμφυλετῶν that Paul's converts were Gentiles and not Jews, who were generally not accorded citizen rights in Greek cities (*Stadt*, 162–64); similarly de Vos, *Conflicts*, 146.

[25] Some of their names are attested: the *phylē* Dionysias (*IG X/2* no. 185) the *phylē* Antigonis (*IThess* no. 184), and the *phylē* Askelpias (*IThess* nos. 183, 265). The first three are attested on monuments dating to the Severan period; the date of the fourth is probably

in other cities, such as the "brotherhoods" (*phratries*) at Athens and the "tribes" and *chiliasties* at Ephesos. At Athens, boys would be introduced to the brotherhood at birth and formally enrolled upon attainment of majority, thereby achieving full citizen rights in the city.[26] If the Thessalonian converts belonged to such tribes, this would have been a significant social connection, since it would have been the primary body that guaranteed citizen rights for each free male in the city. Membership in a tribe would have overlapped with membership in the Pauline community in ways that might have been difficult for individual converts to resolve.[27] Such groups met regularly to inscribe new members, at which time sacrifices would be made to the patron god—precisely the "idol" worship from which Paul claimed they had turned.[28]

The indistinguishability of the Thessalonian converts from their non-Christian counterparts, and their rejection of traditional "idol" religion, which would have rendered problematic their membership in traditional social groups,[29] explains Paul's emphasis on group boundaries and his focus on conflict. He dwells on the difficulties the converts face and emphasizes that he predicted the present situation of persecution, thereby legitimating it as a direct and ineluctable result of their conversion (3:4). Directly after this passage, Paul begins his ethical advice with the injunction to be "spotless in holiness" (ἀμέμπτους ἐν ἁγιωσύνῃ, 3:13). The first specific behavior Paul

early imperial (Edson, *Inscriptiones Thessalonicae* [= *IG* X/2.1]). All are cited in Edson, "Cults," 160.

[26] Lambert, *Phratries of Attica*. The terms φυλή and *chiliasty* (χιλιαστύς) are well attested at Ephesos. Knibbe discusses their role in assigning Ephesian citizenship, in this case to a foreigner, in an inscription from the Hellenistic period, as well as the attestation of the term χιλιαστύς at Samos and Cos (*Staatsmarkt*, 13–14, no. A2).

[27] Donfried argues that the persecution of the Thessalonians resulted from the establishment of the cult of Roma in Thessalonikē and may have ended with the martyrdom of some of the Thessalonians ("Cults," 38–46; repr., Donfried, "Imperial," 215–23). One does not need to go so far afield to find a reason for persecution. The expectation of loyal participation in the usual cults of the city would have been problematic enough for the Thessalonian converts. De Vos argues that, as a free city that sided with Anthony, Thessalonikē may have been particularly careful about honoring Rome and discouraging displays of disrespect to the gods, yet he finds no compelling evidence for martyrdom (*Conflicts*, 156–60).

[28] Vom Brocke, *Stadt*, 152–62. Ascough argues that the primary social context of the Thessalonians would have been an all-male trade association, though much of the language and considerations that he cites would apply equally well to the traditional tribes into which (male) citizens were divided at Thessalonikē ("Community," 311–28; *Macedonian*, 176–90). He holds 1 Thess 2:14–16 to be an interpolation, however, which prevents him from using it as evidence (*Macedonian*, 163–64).

[29] Donfried notes Paul's conscious co-optation of the language of Thessalonian religion and politics ("Assembly," 390–408).

advocates to his Gentile community is to abstain from *porneia*.[30] The two are conjoined throughout the letter: The passages in which Paul discusses sexual immorality are also those in which the highest density of purity and sanctification language occurs.[31]

IDOLATRY, *PORNEIA*, AND JEWISH CONSTRUCTIONS OF IDENTITY

Paul's discussion of sexual purity in the context of a rejection of idolatry may seem an unexpected move, but in ancient Jewish rhetoric, idolatry, sexual immorality, and the concept of sanctification were frequently conjoined. It was a trope in Jewish anti-Gentile discourse that Gentiles were sexually immoral and idolaters;[32] the pure and holy people of Israel stood in juxtaposition to them. Gentile *porneia* was, moreover, sometimes considered a direct result of their idolatry.[33] The conjunction of idolatry and *porneia* also had deeper theological resonances in the Hebrew Bible, since prophetic literature describes idolatrous behavior on the part of Israel as adulterous, as a sexual betrayal of their true spouse, the God of Israel.[34] As Jennifer Knust has pointed out, sexual slander such as this fulfills the function of drawing boundaries between social groups. One's antagonists are characterized as having loose morals and engaging in derelict practices. Such a discursive strategy is not so much about sex as it is about power[35] and group identity: We are the people who would not do such a thing. In 1 Thessalonians, both appear together as identity markers for Paul's community, who have turned away from idols and are told to shun *porneia*.

Paul's discursive strategy was, then, common in various forms of Judaism and functioned to draw a sharp boundary between Jews and Gentiles along the lines of sexual practices. But Paul's audience in Thessalonikē was largely

[30] It is important to note that the only people for whom sexual liberty existed in the ancient world were free males. Slaves were inert objects who could be used by their owners at will in any way, including for sex. Paul's assumption that his audience had control over their sexual behavior strongly suggests that they were free and not slaves, and predominantly male, agreeing with the general lines of Ascough's argument ("Community," 311–28).

[31] Klawans, *Impurity*, 152.

[32] Carras, "Jewish Ethics," 306–15; Horrell, *Solidarity*, 136–37; Knust, *Lust*, 54–63, 66.

[33] Wis 14:12: ἀρχὴ γὰρ πορνείας ἐπίνοια εἰδώλων.

[34] Gaca, *Fornication*, 160–79. In the book of Jubilees (second century B.C.E.), the sexual union of a Gentile and an Israelite was itself designated as πορνεία (Knust, *Lust*, 57; Hayes, *Gentile Impurities*, 73–81).

[35] Noted by Knust on the first page of her book, citing the Clinton impeachment trial.

Gentile, so the discourse functioned very differently than it would have among Jews. In imposing this rhetoric of self-definition on Gentiles, rather than on Jews, Paul is making a symbolic inversion: His Gentile converts have taken up the position of the Jews vis-à-vis the symbolic complex of idolatry and *porneia*. They are the righteous, over against the rest of their kinsmen and countrymen. As John Barclay has written, "Paul's success in winning Gentile converts does not cause him to redraw his conceptual map of the world, simply to move the chosen few among the Gentiles into the territory traditionally ascribed to Jews."[36]

This leaves out of consideration, however, the perspective of Paul's audience—concrete individuals with whom Paul was in conscious dialogue, with whose conceptual world he would have been familiar. The tendency to view Paul as the sole agent in his correspondence has resulted in a focus on Jewish purity prescriptions as the primary cultural background for the examination of purity language in his letters.[37] Yet the members of Paul's community in Thessalonikē had been formed by a deeply conservative education in the moral traditions of their city. They did not stand before Paul as a *tabula rasa* to be inscribed with a new Christian morality, but were adults with many years of previous experience in the practice of ethics and morality.[38] A tacit assumption seems to reign within New Testament scholarship that Gentiles possessed no independent system of moral values.[39] The assumption of Gentile impurity is necessary if Paul's rhetoric is to function for modern

[36] Barclay, *Jews in the Mediterranean Diaspora*, 388; Horrell, *Solidarity*, 139–40, 143. Carras writes that Paul applied Jewish ethics to his Gentile converts "with little creative reflection of his own" and that this served the social function of distinguishing the converts from their fellow Gentiles in the same way these ethical standards marked off Jews from Gentiles ("Jewish Ethics," 311–15).

[37] Part of this results from the otherwise positive development that recent treatments of purity in Paul have been undertaken by scholars whose primary focus is the Jewish purity system from the Hebrew Bible onward (Klawans, *Impurity*; Hayes, *Gentile Impurities*). That they include treatments of Paul and other early Christian figures can only be lauded, since they thereby overcome the unfortunate and inexplicable tendency to treat Jesus and Paul as somehow not Jewish and instead view them as evidence for Jewish attitudes during this period. Horrell does turn to the significant issue of whether Paul's ethical teaching was really distinct from Greek and Roman moral philosophy (*Solidarity*, 153–63; see below for fuller discussion), after a long examination of purity language in ancient Judaism, but Gentile conceptions of purity do not really inform his specific treatment of purity language in the letters of Paul.

[38] Ascough provides an interesting exception in viewing Paul's statements about resurrection of the dead in 1 Thessalonians in the context of traditional concepts of death and burial ("A Question of Death," 509–30).

[39] Donfried, "Cults," 30; Jewett, *Correspondence*, 127, 129–31; vom Brocke, *Stadt*, 117–29.

readers in an unproblematic way; the immoral Gentiles are the required foil for Paul's description of his life's purpose. The standard anti-Gentile tropes employed by Paul are consequently taken at face value as a description of actual Gentile behavior.

PURITY AND MORAL BEHAVIOR AMONG THE GENTILES

Gentiles had their own deeply complex system of purity and impurity; it was a basic cognitive structure in their indigenous religious traditions. These were categories that they employed to describe manifestations of the divine, various types of sacrifices,[40] and the conditions necessary for humans to approach the gods in their sanctuaries. Long lists of "sacred laws" described in detail the conditions that rendered worshipers impure and the specific means for restoring purity.[41] Very typical were prescriptions to enter a sanctuary in white clothes, with no clothing or shoes made of animal skins, along with interdictions against jewelry, weapons, or other metal utensils or anything with a knot. But the most typical causes of impurity were birth, abortion or miscarriage, sexual intercourse of any sort, masturbation or seminal emissions, contact with the dead, and murder.[42] The subtypes of these conditions resulted in varying degrees of impurity. A *lex sacra* from Selinos in the fifth century B.C.E. lists types of murder in ascending degrees of impurity, with unintentional manslaughter being the least impure, followed by intentional murder, and then the murder of a blood relative or host as the most impure offense.[43]

Similarly, not all types of sex produced the same degree of impurity. Sex with a wife or concubine affected one's purity to a lesser degree than sex with a prostitute, whether male or female, or sex with someone else's wife.

[40] This extended as far as rendering "pure" and "impure" sacrifices to the same gods. In the case of the local Seluntine gods the *Tritopatores*, the pure and impure forms of these gods had two distinct sanctuaries, but shared an altar. Though both "pure" and "impure" sacrifices took place on the same altar, it was reanointed between the two sacrifices (Clinton, "Lex Sacra," 170–72; providing extended and corrective commentary on Jameson et al., *Lex Sacra from Selinous*).

[41] See the various volumes by Sokolowski, as well as Lupu, *Law*.

[42] See Lupu, *Law*, 15–17.

[43] Clinton, "Lex Sacra," 179.

Being a male prostitute represented the most impure state, and could result in loss of citizenship and access to civic temples.[44]

The sexual prohibitions expressed in these purity regulations have much the same content as those in use among the Jews. The classes of sexual activity that were prohibited in contemporaneous Judaism included, for men, masturbation, sex with the wife or concubine of another man, sex with prostitutes, and sex with other men.[45] Ancient Jews regularly contrasted their sexual ethics with stereotypical Gentiles, who were accused of *porneia*, lust, adultery, incest, homoerotic sex, and bestiality.[46] Yet, as we have seen, all these behaviors appear among the Greek sacred laws as practices that would render a worshiper impure. Thus, ironically, the ideals of sexual morality so critical to Paul as a boundary marker for his community did not differ significantly between Jews and Gentiles. Both groups negatively sanctioned the same sexual practices. Using a different body of evidence—the ancient Greek and Latin philosophical texts discussing sexual ethics—David Horrell has also identified this ironic similarity in Jewish and Gentile moral codes, which appears in the context of Jewish claims of difference and superiority.[47] The convergence of the two bodies of evidence—the literary evidence cited by Horrell, and the epigraphic evidence brought forth here—is a striking confirmation of the general lines of my argument.

Where then are the differences, the critical distinctions that would lead to the construction of a strong group boundary? A purity system that marks a social group must differ significantly from the system(s) used in the societies with which it comes into contact. As Jonathan Klawans writes, "If purity systems of distinct societies were not significantly different, no boundaries would be demarcated. Impurity systems, in order to perform their function, ought to be rather distinct."[48] If Paul primarily advocated a Jewish purity system and used purity language repeatedly, the purity system(s) against which he positioned himself must have been quite different.

Horrell, citing the borderlands theory of Frederik Barth,[49] concludes that the content of the moral instruction itself would not mark the community as much as its discursive context. Horrell argues that it is the Christian theological context in which Paul enunciates these ethical practices, or the relatively

[44] Parker provides a systematic treatment of these and other categories of pollution in ancient Greek religion (*Miasma*). For sexual purity, see Cole, *Landscapes*, 130–36.

[45] Gaca, *Fornication*, 119–59.

[46] Knust, *Lust*, 54–63, 66.

[47] Horrell, *Solidarity*, 155–56.

[48] Klawans, *Impurity*, 19.

[49] Barth, "Introduction," 9–38; idem, "Boundaries and Connections," 17–36.

higher standards of the Christian community in actually carrying out these ideals, that would have made the difference.[50] I am not entirely convinced, however, by Horrell's contention that simply placing these moral practices in a different philosophical setting—that of Christian theology—would be enough to draw the strong distinctions between groups that Paul seemed to be envisioning in the purity language he employed. The true difference between these two moral universes comes to the fore much more clearly, I would argue, in the archaeological evidence of the *lex sacra* inscriptions than it does in the literary texts of moral philosophy cited by Horrell.

CONTESTED TOPOGRAPHIES OF THE SACRED

Recent scholarship has emphasized that texts do not exist as disembodied content, but appear on specific physical objects—scrolls, codices, or steles —that have locations in space and that express the agency of the person(s) who produced them.[51] New Testament scholarship has long been aware of the rhetorical nature of Paul's epistles and their use as quite concrete missives once sent from Paul to his recipients. Similar attention must be given to the strategic and rhetorical contexts of Gentile religious texts. The Greek sacred laws, as similar as their content might have been to Jewish or Christian ethical conceptualizations, appeared in a very different physical context: on steles marking the entrance to the sacred enclosures of the gods and providing instruction about the requirements to enter that space. They were quite literally boundary markers, objects that defined sacred and profane space in the concrete topography of a civic landscape. They would have also formed a boundary between Paul's Thessalonian community and the inhabitants of Thessalonikē in terms of their respective ritual practices. As Richard DeMaris has recently argued, modern approaches to Pauline texts often privilege theological and ethical readings to the point that their fundamental ritual orientation vanishes from the analysis. Purity categories are ritual in nature, evoking practices that were enacted by worshipers in concrete spaces.[52]

For worshipers of the traditional Greek gods, purity came into focus primarily on a map of concrete space, when one moved from the realm of everyday life into a sacred place. In a culture dominated by the discourse of

[50] Horrell, *Solidarity*, 161–63. In Barth's words, at issue is "the . . . boundary that defines the group, not the cultural stuff that it encloses" ("Introduction," 15).

[51] Moreland, *Archaeology and Text*, 77–97.

[52] Maris, *Ritual World*, 80, 89.

honor and shame, becoming pure before approaching the gods was an act of respect toward them; coming into their presence in a state of impurity showed disrespect. The quotidian condition of the human being was not a pure state; people were either polluted or acceptably profane (ὅσιος, suitable for daily use).[53] Since one would inevitably become impure in the course of daily living, the system also prescribed procedures by which one could be restored to purity. Impurity caused by sexual intercourse was usually effaced by the passage of time. An interval of time anywhere from a night to three days would render one pure again.[54] If there was a need to approach a sanctuary before the requisite time, bathing in a holy spring could also restore purity. Lustral basins, *perirrhanteria*, were ubiquitous at the entrances of traditional Greek sanctuaries, where people would generally sprinkle themselves with water upon entering, just as they still do in Catholic churches.[55]

PAUL IN THE SACRED SPACE OF THE GENTILES

Paul's system of the sacred was not organized around fixed locations in this fashion. He typically translocated sacred spaces or transposed them into the heavenly realm. In 1 Thessalonians, God's primary location is in heaven. When Paul contrasts the images of the gods from whom the Thessalonians have turned away, he states that the son of the true God is in heaven and will appear at some future time (1 Thess 1:9–10). The divine son of God appears in both temporal and spatial suspension: He is not here, and he is not now.[56] When describing the resurrection of the dead members of the Thessalonian community at the end of time, Paul tells them that they will be caught up in the clouds to meet the Lord in the air (1 Thess 4:17). That is where God is.

Where, then, is the sacred on earth, according to the letter to the Thessalonians? The only physical locations for purity or holiness mentioned in the

[53] Parker, *Miasma*, 11.

[54] Lupu, *Law*, 35.

[55] Parker, *Miasma*, 19; Cole, *Landscapes*, 139–42.

[56] I am not arguing here that Paul's rhetoric is anti-temple. Klawans is correct that spiritualizing treatments of the temple, such as Paul employs here, are not necessarily anti-temple tropes, but tend rather to substantiate the tremendously positive symbolic value that the temple possessed for Jews. That it becomes so often for Paul a symbol, an entity lost in the clouds, does, however, underscore the irrelevance of the temple as a real and concrete location of worship for Jews living far from it. As Klawans writes, for Jews in the diaspora, "rejecting all sacrifice but the Jerusalem cult is little different from rejecting all sacrifice whatsoever" (*Purity, Sacrifice, and the Temple*, 218–21, quotation from 221).

letter are "you," or "each of you," or specifically "the σκεῦος of yourself" (1 Thess 4:4). Σκεῦος can mean "inanimate object," "gear," "baggage," "tool." The metaphorical meaning, "the physical body," is the most likely here.[57] Paul uses the same word in 2 Cor 4:7, where he writes, "But we have this treasure in clay σκεύεσιν," meaning the treasure of divinity within earth-bound human bodies, a standard trope in middle Platonism. He ends the letter to the Thessalonians with the clear wish that "God may sanctify you completely and keep your spirit, soul and body blameless" (1 Thess 5:23, ἀμέμπτως). The individual, or her physical body, is where the holy is located in the first epistle to the Thessalonians.[58] Paul did not understand purity as a spatial practice, as would his Gentile audience, but rather as a bodily practice. Paul *somatized* the language of ritual purity.

Throughout 1 Thessalonians, Paul employs language from his own tradition that has cultic overtones. Instead of using the common Greek term for "pure," καθαρός, or "purity," ἁγνεία, Paul uses a word that is ubiquitous in the Septuagint, but not frequent in non-Jewish texts, ἁγιασμός. This is not simply purity, but "consecration," and was used of items that were holy because they were dedicated to a god, like the furnishings of a temple, and not free for profane use. But Paul did not want a temple with its utensils; he wanted the bodies of his followers.[59]

[57] The σκεῦος can also mean the male genitalia, though attestation for this is quite late (third century C.E., in Aelian, *NA* 17.11). Most interpreters reject this meaning and conclude that it refers to the body in general (vom Brocke, *Stadt*, 130–31; Borschel, *Die Konstruktion einer christlichen Identität*, 244–46). Ascough interprets it as referring to the male genitalia and uses it as evidence to further his thesis that 1 Thessalonians was addressed to members of an all-male trade association ("Community," 325–27; *Macedonian*, 187–89). The tradition of translating the term in this passage to mean one's wife (as an extended understanding of possessions or chattel) appears only very late in the history of interpretation, originating with John Chrysostom. This coheres well with later Christian ideology in which the control of women was critical to the control of society.

[58] These observations are generally true in the Pauline epistles, though one could argue that God is also present in his community in some fashion, which seems to be presupposed in the concept of the (corporate) "body of Christ." Donfried similarly emphasizes that the phrase "in Christ" signifies the separation of Paul's community from the world and that Paul uses it to establish a group boundary against those in the community who follow practices and beliefs Paul condemns ("Assembly," 151–56 [pagination from idem, *Paul*]). But this still evades the question of the physical location of the holy on earth; a physical human body is localized in a much more concrete fashion than a group of individuals who represents a (symbolic) "body of Christ." Økland's treatment of ἐκκλησία space emphasizes that it is not a fixed location, but a space created by ritual action (Økland, *Women in Their Place*, 131–67).

[59] His directive to offer one's body as a "living sacrifice" (Rom 12:1) uses the temple rhetoric, but in a ritual rather than spatial fashion.

The language of bodily purity does not sound strange today, but it differed sharply from most ancient conceptions of the sacred. The idea that individuals should maintain a complete and constant state of purity was not commonplace.[60] In the logic of ancient Greek piety, purity was not really an absolute value but was related to access to sacred places, or participation in sacred times such as festivals. What is strange here is not Paul's connection of purity and sexual prohibitions, which was commonplace in all the "sacred laws," but rather his advice that one should remain in a constant state of purity.

The somatization of purity language also appears in 1 Cor 6:19, which forms a close parallel to the Thessalonian text. In both these texts, Paul equates purity and sexual behavior.[61] In 1 Thess 4:3–4, he writes, "Your sanctification (ὁ ἁγιασμὸς ὑμῶν) is the will of God, (which is) to keep away from *porneia*, which is for each of you to know how to keep the vessel of himself in holiness and honor" (τὸ ἑαυτοῦ σκεῦος κτᾶσθαι ἐν ἁγιασμῷ καὶ τιμῇ). The Corinthian text describes the body (σῶμα) as a temple (ναός) of the Holy Spirit and similarly warns the Corinthian converts against *porneia*.

Moral Impurity and Contagion

In the Corinthian passage, however, we see some of the consequences of Paul's rejection of external locations of the sacred. It reverses the usual direction of purity. There is no sacred space on earth that the body needs to be pure to enter. So, the emphasis then turns from what the body can enter to what can enter the body. Since the body is the temple, it must be kept free from impurity, as a sanctuary is protected from defilement and pollution. The implications of this are drawn out vividly in 1 Cor 6:12–20, where any sexual contact with a πορνή (female prostitute) or πορνός (male prostitute) defiles the body of the convert and thus also Christ, who dwells

[60] Paul's ethical instruction would make the Christian convert into something like a cult official in traditional Greek religion, who is a sort of walking shrine. He or she possessed inviolability and avoided precisely those categories of people who could not enter a temple. This was, however, a limited state, since most priests served not for life, but only for the term of a year (Parker, *Miasma*, 175; Cole, *Landscapes*, 136–38).

[61] Martin provides an important contribution to the understanding of Paul's sexual ethics (*Sex and the Single Savior*, 37–90); Ellis responds to Martin's characterization of sexual desire in Paul (*Paul and Ancient Views of Sexual Desire*).

in the body of the convert. The human body becomes subject to pollution by the entry of the impure just as the sanctuary of a god can be defiled.[62]

Christine Hayes has shown that Paul's sexual ethics stood in continuity with a growing Jewish concern about the dangers of intermarriage with Gentiles. During the Second Temple period, some Jewish communities began to forbid intermarriage between Jews and Gentiles out of a fear of defiling the holy seed of Israel. This represented a "democratization" of the priestly prohibition of intermarriage with Gentiles within the Levitical line; Ezra in particular broadened this prohibition to apply to all of Israel.[63] Paul similarly prohibited sexual traffic with "Gentiles" outside the community of his converts. In contrast to the Second Temple literature, Paul did not conceive of this as an improper commingling of seeds, but rather of the generally prohibited contact of the holy with the impure, that is, the holy body of the believer with the impure body of the unbeliever.[64] Hayes designates Paul's new conception of impurity as "carnal impurity." It would not have been unusual for Paul to view *porneia* as a practice that rendered the body of a Gentile impure; what was new in Paul was the conviction that this impurity could be transferred physically to the believer through sexual contact.[65]

This may be a point at which Paul was influenced by conceptions of purity common among his Gentile audience. As Jonathan Klawans has demonstrated, from the book of Leviticus onward, Jewish conceptions of purity generally drew a clear distinction between ritual and moral impurity. Ritual impurity was temporary and highly contagious, was often the result of unavoidable natural processes, and could be removed by purification. Moral impurity was brought by grave sin (usually murder, idolatry, and incest), was not contagious, could not be purified, and could be eradicated only by exile

[62] Martin sees this passage in the context of rival ancient theories of disease, with Paul here being concerned to guard the *pneuma* from potential disease through contagion with the impure (*Corinthian Body*, 168–74); I would stress instead the concepts of ritual purity native to Paul as a Jew. Both approaches, however, emphasize Paul's concern to establish and patrol the boundaries of his community.

[63] Hayes, *Gentile Impurities*, 24–33; 58–59; 68–91.

[64] Hayes recognizes that 1 Cor 7:12–14 represents a special case, in which the unbelieving spouse is sanctified through the believing spouse, as well as any resultant children, in the case of a marriage contracted before conversion. It tends to confirm her point, since Paul concedes that ordinarily the children would be impure; the unbelieving spouse is given permission to leave. She explains Paul's concession as a positive case of his underlying understanding of sexual union as producing one flesh and of purity and impurity as being physically transferrable (ibid., 94–96).

[65] Ibid., 92–98, esp. 96.

and death because it rendered the land impure.[66] Ritual impurity, on the other hand, was not considered to be sinful or problematic except that it barred access to the temple for an individual until corrected.[67]

Sexual immorality was generally assigned to the category of moral impurity, rather than ritual impurity. Paul, however, seemed not to have made a clear distinction between ritual and moral impurity. Like other Jews, he considered sexual immorality as an instance of moral impurity that created a more or less permanent defilement, which could bring judgment upon the community if the offender was not exiled (1 Corinthians 5).[68] But for Paul, moral impurity possessed features that usually pertained to *ritual* impurity. First, it created consequences for access to the sacred, such as the communal eating of the Eucharist (1 Cor 5:9–11; 11:27–30). Second, moral impurity affected not only the community, from which the miscreant should be expelled, but also the individual, who could remedy the situation by repentance.[69] Third, and most significantly, moral impurity could be transferred as a contagion. Thus, not only did immoral behavior render the believer impure; the immoral behavior of others could pollute the believer by the contagion of sexual contact, since the physical body itself became a ritual object, a "temple," subject to potential pollution.

Traditional Mediterranean piety as practiced in Greek-speaking cities seemed similarly to have lacked a clear demarcation between moral and ritual purity. Unlike the prevailing conceptions of purity in Judaism as Klawans has described them, moral offenses, especially sexual offenses, resulted primarily in *ritual* impurity in Gentile practice, that is, in the inability to approach the gods in their sanctuaries.[70] Moreover, the *miasma* caused by moral offenses, particularly murder, was often viewed as being contagious,[71]

[66] Klawans, *Impurity*, esp. 158–62.

[67] Regev, "Moral Impurity," 388.

[68] Klawans notes that exclusion from the community was common in cases of *moral* impurity and that Paul's teaching was in line with Jewish precedents (*Impurity*, 153). He does not address satisfactorily the issue that Paul seems also to have presupposed that the individual body, and not merely the community, could be defiled by the contagion of moral impurity. This is somewhat different from his point that Jesus and John the Baptist diverged from most strands of Judaism in believing that individual Jewish sinners needed to repent, and that their sin defiled them as individuals (*Impurity*, 138–50). In requiring the exclusion of the morally impure from the community, Paul was actually closer to the traditional understanding than were Jesus and John (*Impurity*, 157).

[69] In his concern with the individual ramifications of moral impurity, Paul is similar to some strands of the "Qumran community" (Regev, "Moral Impurity," 395–96).

[70] Parker, *Miasma*, 322–24; Regev, "Moral Impurity," 393–94.

[71] Stukey, "Purity."

a characteristic only accorded to ritual impurity in Jewish texts. Moral actions that rendered individuals impure did not result in a permanently defiled state in Greek piety, but generally represented a temporary condition, more similar to Jewish conceptions of *ritual* impurity. Even in the case of the more impure types of sex, one could regain a state of purity by mere passage of time after engaging in them. Men who engaged in sex with male prostitutes were not rendered permanently impure but merely had to wait longer to enter a sanctuary than after engaging in other kinds of sex.[72] Grave sins, similarly, did not generally result in full exile but rather in disbarment from civic sanctuaries. Confirmed adulteresses and those guilty of incest were sometimes deprived of their citizenship and of access to their city's gods.[73] Murderers were forbidden to take the Eleusinian initiations. Yet even the most heinous sins, such as murder of a family member, could be purified through ritual means.[74] In extreme cases where impurity was suspected as the cause of widespread disease in a community, traveling ritual specialists offered to diagnose the cause of the problem and prescribe rituals to address it successfully.[75] Thus, Gentiles did not typically draw a distinction between moral and ritual impurity. Both types of impurity were on the same continuum and could be addressed by the same means.

THE SOMATIZATION OF THE SACRED: MAKING A DIFFERENCE IN THESSALONIKĒ

Where Paul differed most seriously from the piety practiced in Greek cities was in his rejection of civic sacred space. In 1 Thessalonians, Paul was attempting to form a new group not determined by ethnicity, which, in antiquity, was largely established by geographic origin, as was true even for ancient Jews.[76]

[72] Greek sexual codes reflected the assumption that the restraint of a private physical function in the presence of a divinity was a show of respect. Sexual purity was required to go certain places, touch certain objects, and see certain things (Parker, *Miasma*, 92).

[73] Parker, *Miasma*, 94–100.

[74] This is clearly envisaged in literary sources such as Aeschylus's *Eumenides*, in which Orestes is successfully purified from matricide (Sidwell, "Purification and Pollution," 44–57). The *lex sacra* from Selinos outlines the process of purification for a murderer: Until he was purified, he could not speak or be addressed and could not take food to feed himself. A host was required to feed him and provide for him the purificatory rituals, after which he became pure, was freed from exile, could speak and be addressed by others, and could take food for himself (Clinton, "Lex Sacra," 174–78).

[75] Neta Ronen, "Who Practiced Purification?" 273–86.

[76] See the helpful discussion in Cohen, *Beginnings of Jewishness*, 69–106.

By drawing out Gentiles into a community that was not ethnically Jewish, that is, not defined by relationship to a territorial Judaism still centered on the temple in Jerusalem, Paul was making a *tertium quid* that fell into neither camp. The ethnic indistinguishability of the Thessalonian community is evident where Paul mentions that the Thessalonians were suffering at the hands of the people in their own tribe (τῶν ἰδίων συμφυλετῶν, 2:14).[77] Since the question of ethnicity, based on location, is at stake in this passage, it would be much better to translate Ἰουδαῖοι here as "Judeans," so that v. 14 would read, "You became imitators of the churches of God in Christ Jesus in Judea, for you suffered the same things from your own fellow tribe members as they did from the Judeans."[78] The problem in both cases, for the converts at Thessalonikē and in Judea, was that their new community did not define itself in relationship to a territory and needed to find other ways to "make a difference."[79]

The turn toward the body and toward constant bodily purity was not a predictable move on the part of Paul or his early converts, though it did solve the problem of finding a sacred, pure location within a world that quite concretely did not have room for them. Like his fellow Jews in the diaspora, Paul lived in an urban environment studded with shrines containing impure images of the gods. Paul's followers after their conversion also entered into a similarly problematic situation, but with important differences: Paul as a Jew had only a symbolic relationship with his temple in Jerusalem, whereas his converts had grown up physically frequenting the temples of their cities, and Paul was advocating not a replacement of their temples with the one in Jerusalem, but a replacement of their temples with their bodies. This was a radical solution to the problem of finding sacrality in a newly construed space, in which the strategy was to make a difference between their map of the sacred and that of everyone else. And this rejection of civic space was not only an argument against traditional conceptions of sacred space, but also in favor of the sacralization of the boundaries of the body.

[77] I find no reason to reject the authenticity of this passage as does Pearson ("1 Thess 2:13–16," 79–94). Broer thoroughly examines the textual and stylistic arguments both for and against, and concludes that Paul's statements stem from his use of deuteronomistic rhetoric from the LXX ("Zorn," 137–59). Schlueter investigates the passage and claims that it is an example of hyperbolic rhetoric such as one finds elsewhere in Paul (*Filling Up the Measure*).

[78] Vom Brocke notes that the use of μιμηταί in this passage echoes Paul's use of it at 1:6, a further argument for the integrity of the passage (*Stadt*, 153).

[79] Carras, "Jewish Ethics," 313–14.

Mary Douglas has written persuasively about the manner in which the body can function as a symbol of society in general. Attempts to control bodies and patrol their boundaries are attempts to maintain social order and community coherence. Pollution beliefs are powerful forms of social control and flourish precisely when more effective and direct means of control are impossible or undesirable.[80] Paul and early Christian leaders seem to have had little access to effective political strategies for managing their communities; they also did not have the political or economic means to impose their own map of the sacred onto civic space. By concentrating on the bodily practice of purity, their spatial discourse aligned itself with the slim resources that they had at their disposal. This alternative spatial dynamic provided a complex of religious signification around the one thing that everyone in the community possessed: a body. This is particularly true if the letter was addressed to free laborers who worked with their bodies, which seems to be assumed in Paul's advice to work with one's hands (4:11–12).[81] The early Christian lack of concern for traditional spatial conceptions of ritual purity did not necessarily result from a particular focus on the individual, or from the interiorization of ritual purity as moral purity. I have tried here to argue that the opposite may be the case: Christians became focused on the individual body because they needed to find a location for the sacred, and the rest of the world was already full.

[80] Douglas, *Purity and Danger*.

[81] So Ascough, "Community," 311–28; idem, *Macedonian*, 165–73. De Vos also sketches a city with little ethnic integration between Romans and Greeks, in which evidence even for patron-client relationships is sparse (*Conflicts*, 129–38); within this, the Thessalonian community seems to be composed of poor citizens who work for a living, artisans of various sorts (ibid., 147–54).

BIBLIOGRAPHY

Ascough, Richard S. "A Question of Death: Paul's Community-Building Language in 1 Thessalonians 4:13–18." JBL 123 (2004) 509–30.

———. *Paul's Macedonian Associations: The Social Context of Philippians and 1 Thessalonians.* WUNT 2/161. Tübingen: Mohr Siebeck, 2003.

———. "The Thessalonian Christian Community as a Professional Voluntary Association." *JBL* 119 (2000) 311–28.

Barclay, John M. G. *Jews in the Mediterranean Diaspora: From Alexander to Trajan.* Berkeley, Calif.: University of California Press, 1996.

Barth, Frederik. "Boundaries and Connections." Pages 17–36 in *Signifying Identities: Anthropological Perspectives on Boundaries and Contested Values.* Edited by Anthony P. Cohen. London: Routledge, 2000.

———. "Introduction." Pages 9–38 in *Ethnic Groups and Boundaries: The Social Organization of Culture Difference.* Boston, Mass.: Little, Brown, 1969. Repr., Long Grove, Ill.: Waveland, 1998.

Borschel, Regina. *Die Konstruktion einer christlichen Identität. Paulus und die Gemeinde von Thessalonike in ihrer hellenistisch-römischen Umwelt.* Berlin: Philo, 2001.

Brocke, Christoph vom. *Thessaloniki—Stadt des Kassander und Gemeinde des Paulus. Eine frühe christliche Gemeinde in ihrer heidnischen Umwelt.* WUNT 2/125. Tübingen: Mohr Siebeck, 2001.

Broer, Ingo. " 'Der ganze Zorn ist schon über sie gekommen': Bemerkungen zur Interpolationshypothese und zur Interpretation von 1 Thess 2, 14–16." Pages 137–59 in *The Thessalonian Correspondence.* Edited by Raymond F. Collins. Louvain: Leuven University Press, 1990.

Carras, G. P. "Jewish Ethics and Gentile Converts: Remarks on 1 Thess 4:3–8." Pages 306–15 in *The Thessalonian Correspondence.* Edited by Raymond F. Collins. Louvain: Leuven University Press, 1990.

Clinton, Kevin. "Review Article: A New Lex Sacra from Selinus: Kindly Zeuses, Eumenides, Impure and Pure Tritopatores, and Elasteroi." *CP* 91 (1996) 159–79.

Cohen, Shaye. *The Beginnings of Jewishness: Boundaries, Varieties, Uncertainties.* Berkeley, Calif.: University of California Press, 1999.

Cole, Susan Guettel. *Landscapes, Gender, and Ritual Space: The Ancient Greek Experience.* Berkeley, Calif.: University of California Press, 2004.

Collins, Raymond F., ed. *The Thessalonian Correspondence.* Louvain: Leuven University Press, 1990.

DeMaris, Richard E. *The New Testament in Its Ritual World.* London: Routledge, 2008.

Donfried, Karl P. *Paul, Thessalonica, and Early Christianity.* Grand Rapids, Mich.: Eerdmans, 2002.

———. "The Imperial Cults of Thessalonica and Political Conflict in 1 Thessalonians." Pages 215–23 in *Paul and Empire: Religion and Power in Roman Imperial Society.* Edited by Richard Horsley. Harrisburg, Pa.: Trinity Press International, 1997.

———. "The Assembly of the Thessalonians: Reflections on the Ecclesiology of the Earliest Christian Letter." Pages 390–408 in *Ekklesiologie des Neuen Testaments. Festschrift Karl Kertelge.* Edited by Rainer Kampling et al. Freiburg: Herder, 1996.

Donfried, Karl P. "The Cults of Thessalonica and the Thessalonian Correspondence." *NTS* (1985) 336–56.

———. "Paul and Judaism: 1 Thessalonians 2:13–16 as a Test Case." *Int* 38 (1984) 242–53.

Douglas, Mary. *Natural Symbols: Explorations in Cosmology*. London: Cresset, 1970.

———. *Purity and Danger: An Analysis of the Concepts of Pollution and Taboo*. New York: Praeger, 1966. Repr., London: Routledge, 1994.

Edson, Charles, ed. *Inscriptiones Thessalonicae et viciniae* [= *IG* X/2.1]. Berlin: de Gruyter, 1972.

———. "Cults of Thessalonica [Macedonica III]." *HTR* 41 (1948) 153–204.

Ellis, J. Edward. *Paul and Ancient Views of Sexual Desire: Paul's Sexual Ethics in 1 Thessalonians 4, 1 Corinthians 7, and Romans 1*. London: T&T Clark, 2007.

Gaca, Kathy. *The Making of Fornication: Eros, Ethics, and Political Reform in Greek Philosophy and Early Christianity*. Berkeley, Calif.: University of California, 2003.

Hayes, Christine. *Gentile Impurities and Jewish Identities: Intermarriage and Conversion from the Bible to the Talmud*. Oxford: Oxford University, 2002.

Hendrix, Holland. "Archaeology and Eschatology at Thessalonica." Pages 107–18 in *The Future of Early Christianity: Essays in Honor of Helmut Koester*. Edited by Birger A. Pearson. Minneapolis, Minn.: Fortress, 1991.

———. "Thessalonicans Honor Romans." Th.D. Diss., Harvard Divinity School, 1984.

Horrell, David. *Solidarity and Difference: A Contemporary Reading of Paul's Ethics*. New York: T&T Clark, 2005.

Jameson, Michael H., David R. Jordan, and Roy D. Kotansky. *A Lex Sacra from Selinous*. Durham, N.C.: Duke University, 1993.

Jewett, Robert. *The Thessalonian Correspondence: Pauline Rhetoric and Millenarian Piety*. Philadelphia, Pa.: Fortress, 1986.

Klawans, Jonathan. *Purity, Sacrifice, and the Temple: Symbolism and Supersessionism in the Study of Ancient Judaism*. Oxford: Oxford University, 2006.

———. *Impurity and Sin in Ancient Judaism*. Oxford: Oxford University, 2000.

Kloppenborg, John S. "Philadelphia, Theodidaktos and the Dioscuri: Rhetorical Engagement in 1 Thessalonians 4:9–12." *NTS* 39 (1993) 265–89.

Knibbe, Dieter. *Der Staatsmarkt. Die Inschriften des Prytaneions. Die Kureteninschriften und sonstige religiöse Texte*. Vienna: Österreichische Akademie der Wissenschaften, 1981.

Knust, Jennifer. *Abandoned to Lust: Sexual Slander and Ancient Christianity*. New York: Columbia University Press, 2006.

Koester, Helmut. "Archaeology and Paul in Thessalonike." Pages 38–54 in idem, *Paul and His World: Interpreting the New Testament in Its Context*. Minneapolis, Minn.: Fortress, 2007.

———. "Imperial Ideology and Paul's Eschatology in 1 Thessalonians." Pages 158–66 in *Paul and Empire: Religion and Power in Roman Imperial Society*. Edited by Richard Horsley. Harrisburg, Pa.: Trinity Press International, 1997.

———. "Archäologie und Paulus in Thessalonike." Pages 393–404 in *Religious Propaganda and Missionary Competition in the New Testament World: Festschrift Dieter Georgi*. Edited by Lukas Bormann et al. Leiden: Brill, 1994.

———. "From Paul's Eschatology to the Apocalyptic Schemata of 2 Thessalonians." Pages 441–58 in *The Thessalonian Correspondence*. Edited by Raymond F. Collins. Louvain: Leuven University, 1990.

Lambert, S. D. *The Phratries of Attica*. Ann Arbor, Mich.: University of Michigan, 1993.

Lefebvre, Henri. *The Production of Space*. Malden, Mass.: Blackwell, 1991.

Lifshitz, Baruch and Jacques Schiby. "Une synagogue samaritaine à Thessalonique." *RB* 75 (1968) 368–76.

Lupu, Eran. *Greek Sacred Law: A Collection of New Documents*. Leiden: Brill, 2005.

Malherbe, Abraham. "Gentle as a Nurse: The Cynic Background to 1 Thess 2." *NovT* (1970) 203–17.

Martin, Dale. *Sex and the Single Savior: Gender and Sexuality in Biblical Interpretation*. Louisville, Ky.: Westminster John Knox, 2006.

———. *The Corinthian Body*. New Haven, Conn.: Yale University, 1995.

Moreland, John. *Archaeology and Text*. London: Duckworth, 2001.

Nasrallah, Laura S. "Empire and Apocalypse in Thessaloniki: Interpreting the Early Christian Rotunda." *JECS* 13 (2005) 465–508.

Økland, Jorunn. *Women in Their Place: Paul and the Corinthian Discourse of Gender and Sanctuary Space*. London: T&T Clark, 2004.

Parker, Robert. *Miasma: Pollution and Purification in Early Greek Religion*. Oxford: Clarendon, 1983.

Pearson, Birger. "1 Thessalonians 2:13–16: A Deutero-Pauline Interpolation." *HTR* 64 (1971) 79–94.

Purvis, James. "The Paleography of the Samaritan Inscription from Thessalonica." *BASOR* (1976) 121–23.

Regev, Eyal. "Moral Impurity and the Temple in Early Christianity in Light of Ancient Greek Practice and Qumranic Ideology." *HTR* 97 (2004) 383–411.

Ronen, Neta. "Who Practiced Purification in Archaic Greece? A Cultural Profile." Pages 273–86 in *Transformations of the Inner Self in Ancient Religions*. Edited by Jan Assmann and Guy G. Stroumsa. Leiden: Brill, 1999.

Rousselle, Aline. *Porneia. De la maîtrise du corps à la privation sensorielle. IIᵉ–IVᵉ siècles de l'ère chrétienne*. Paris: Presses universitaires de France, 1983.

Schlueter, Carol. *Filling Up the Measure: Polemical Hyperbole in 1 Thessalonians 2:14–16*. Sheffield: JSOT, 1994.

Sidwell, Keith. "Purification and Pollution in Aeschylus' Eumenides." *CQ* 46 (1996) 44–57.

Soja, Edward. *Thirdspace: Journeys to Los Angeles and Other Real-and-Imagined Places*. Cambridge, Mass.: Blackwell, 1996.

Sokolowski, Franciszek. *Lois sacrées des cités grecques*. Paris: de Boccard, 1969.

———. *Lois sacrées des cités grecques: Supplément*. Paris: de Boccard, 1962.

———. *Lois sacrées de l'Asie Mineure*. Paris: de Boccard, 1955.

Stukey, Harold J. "Purity in Fifth and Fourth Century Religion." *TAPA* 67 (1936) 286–95.

Tzanavari, Katerina. "The Worship of Gods and Heroes in Thessaloniki." Pages 177–262 in *Roman Thessaloniki*. Edited by D. V. Grammenos. Translated by David Hardy. Thessaloniki: Archaeological Museum of Thessaloniki, 2003.

Vos, Craig de. *Church and Community Conflicts: The Relationships of the Thessalonian, Corinthian, and Philippian Churches with Their Wider Civic Communities*. Atlanta, Ga.: Scholars, 1999.

Egyptian Religion in Thessalonikē: Regulation for the Cult

Helmut Koester

With respect to the religions of Thessalonikē, the Egyptian religion is the only one attested by finds from several centuries. The only possible exception is the worship of Dionysos, which was popular in Macedonia and especially in Thessalonikē in both the Hellenistic and Roman imperial periods.[1] A total of sixty-nine inscriptions found in Thessaloniki refer to the worship of the Egyptian deities.[2] Most of these were not yet available or published at the time of the publication of Charles Edson's valuable essay on the "Cults of Thessalonica" of 1948,[3] and most are also still missing from the *Sylloge inscriptionum religionis Isiacae et Sarapiacae* of Ladislav Vidman in 1969.[4] They became fully accessible only in Charles Edson's publication in 1972.[5] I have not yet worked through all these materials carefully and can therefore only comment on a small, and, I hope, characteristic selection. A comprehensive interpretation of all these materials will be a major task for future scholarship.[6]

[1] Tzanavari, "Worship of Gods," 205–16.

[2] Edson, *Inscriptiones Thessalonicae* (= *IG* X/2.1): nos. 3, 5, 16, 37, 51, 53, 59, 75–123, 221, 222, 254–59.

[3] Edson, "Cults of Thessalonica," 153–204.

[4] Vidman, *Sylloge*.

[5] Edson, *Inscriptiones Thessalonicae* (= *IG* X/2.1).

[6] For the following discussion of the Egyptian religion in Thessalonikē, I owe much to Daniel Fraikin's publication about the excavation of the Sarapis temple in *Numina Aegaea*

The worship of the Egyptian gods must have been introduced to Thessalonikē before the year 200 B.C.E. This fact is attested in an inscription that records a letter of King Philip V of Macedonia, dated to the year 187 B.C.E.[7] The inscription shows that at this time the cult of the Egyptian gods was regulated by the state. Among other regulations, Philip's letter prohibits the use of the Sarapeion's funds for extracultic purposes and declares specific penalties for contraventions of the regulations. This inscription is the only tangible evidence for the existence of this cult in Thessalonikē during the early Hellenistic period.

The arrival of the Egyptian religion in Macedonia around 200 B.C.E. is attested also in an inscription to Sarapis found in Amphipolis, dated to the third or early second century B.C.E.[8] Other Hellenistic evidence, however, is rare. Most of the surviving inscriptional evidence from Macedonia (Philippi, Beroia, Anthemos) must be dated to the Roman imperial period.

THE SARAPEION

At the end of World War I, the Greek scholar Professor Pelekides found a small temple, parts of a stoa, and ruinous remains of some other structures in the eastern part of Thessaloniki during excavations in the middle of a street.[9] In the beginning of the year 1939 other structures were found a few meters away from the site when the ground was excavated for a new building. Charalambos Makaronas reported these later finds in an article published in the first volume of the journal *Makedonika* in the year 1940.[10] But the fact that this publication appeared just at the beginning of World War II and was, moreover, written in Greek had the result that it was barely noticed in the scholarly world. In the following report, I describe some of the more important finds.[11]

and to Holland Hendrix's descriptions of various finds in "Thessalonike," in Koester, *Cities of Paul*. My thanks also go to Dr. Katerina Romiopoulou, then director of the Archaeological Museum in Thessaloniki, who helpfully granted access to the relevant materials in the early seventies when all finds had just been transferred from the old museum and were still housed in the basement of the new museum.

[7] Edson, "Cults of Thessalonica," no. 3.

[8] Vidman, *Sylloge*, no. 113.

[9] Edson, "Cults of Thessalonica," 181–88. These findings were reported in Edson, "Chroniques," 540–41.

[10] Makaronas, "Excavations at the Serapeion," 464–65.

[11] I am mostly following here Fraikin, "Note on the Egyptian Gods," 1–6. For this and other items of the Egyptian gods discussed in the following, see Koester, *Cities of Paul*.

Fig. 1. The Model of the Sarapeion. Photo: Helmut Koester.

The most significant part of the 1939 discovery was a small temple-like structure, measuring approximately 11 x 8 m, with a crypt under its entrance hall (fig. 1). The crypt, in particular, yielded a number of significant artifacts, which leave no doubt that this structure belonged to the cult of the Egyptian gods. Because it is not known to which Egyptian god the temple was dedicated, it is simply a matter of convenience to call it a Sarapeion. I quote here an English translation of parts of the description of that temple-like structure from the article of Makaronas:

> The building consists of a small fore-hall (πρόδομος) or narthex, and a hall (αἴθουσα) ending to the north with a small niche (κόγχη). The walls, of simple Roman construction, were made of rough stones and lime-mortar interrupted by successive horizontal belts of three layers

of baked brick. The floor was decorated with a marble pavement made of small irregular pieces of multicolored plaques forming a decoration of simple geometric design. Inside and in front of the niche, which was filled to a height of about two meters, stood a stone bench, which probably served as a sacred table.

The crypt, which seems to have been a place for a mystery cult, consisted of an elongated vaulted room lying exactly under and along the length of the fore-hall of this aedicula and of a tunnel-like corridor about 1 m wide and 10 m long. This corridor communicated with the vaulted room by an arched opening at the western extremity of the north wall of the room. The corridor ran parallel to the west wall of the building above and terminated in an exit staircase located beside the niche. The vaulted room, that is, the crypt proper, measured about 4 m by 1.60 m. In the middle of the east side, on the wall, was a niche, in which a small herm of a bearded god stood on a marble base. The floor of the crypt had no special covering. . . . The difference of construction technique between the crypt proper (simple mortar without lime) and the rest offers clear evidence that the temple and the corridor are of a later date. It seems, that is, that at an earlier period only the crypt existed and that later on the temple was built on top of it along with an exit corridor.[12]

As the entrance to the crypt had been sealed in Late Antiquity with marble slabs, the inscriptions and various statues and statue fragments hidden in the underground structure were found in relatively good condition. The latter have been reported in various publications. Of all sixty-nine inscriptions relating to the Egyptian cult in Thessaloniki, thirty-five were found in the context of the excavations described above and are now published.[13]

The interpretation of this small apsed temple is fraught with difficulties. Until recently the only available evidence was the brief report of the Greek excavator Charalambros Makaronas. The site is no longer accessible because a street and houses have been erected over the site of the 1939 excavation. A small plaster replica of the temple has been made and is now in the Archaeological Museum of Thessaloniki, but it is not known when, where, and on what basis it was made. New information has come to light more recently through an article of Christopher Steimle, however, which is based on the discovery of the archives of the Deutsche Archäologische Institut (DAI) of a hitherto unknown diary of the German archaeologist Hans von

[12] The translation is by Fraikin, "Note on the Egyptian Gods," 2–4.

[13] Edson, *Inscriptiones Thessalonicae* (= *IG* X/2.1).

Schoenebeck, who died in action in 1944. He was present in 1939 at the time of the excavation of this temple.[14]

Von Schoenebeck reports that when he arrived on site, the excavator S. Pelekides had just ordered that the temple be destroyed because he thought that it was a worthless post-Theodosian house.[15] But von Schoenebeck was able to examine the wall's masonry, which consisted of courses of bricks alternating with courses of rubble and lime mortar. He compared these with the masonry of the Rotunda and Palace of Galerius, which he had studied in detail, and came to the conclusion that the apsed temple must have been constructed also in the time of Galerius, that is, at the turn of the third century C.E. (297–303).[16] Moreover, Steimle notes that in an excavation at the same site by Pelekides in the year 1920 another foundation had been found a few meters to the northwest of the apsed temple. This was a foundation of orthostatic limestones of definite Hellenistic date for a small prostyle or ante temple,[17] although the remnants above the foundations seem to have been of Roman date. The inscription of Philip V of Macedon regulating the Egyptian cult[18] was apparently found in the neighborhood of this latter temple, but it is not possible to ascertain whether it was in fact related to it.[19]

Important is also von Schoenebeck's (and Makaronas's) observation that the crypt under the narthex of the apsed temple must be dated to a period earlier than the temple itself, based on the study of the "simple mortar without lime" used in the construction of the crypt.[20] The underground passageway leading from the side of the apse to the crypt was constructed only at the time of the construction of the apsed temple. Thus those who constructed the apsed temple intended to include the purpose of the earlier crypt into the cultic activities related to the Egyptian religion.

To be sure, a statue of a god must have been standing in the niche at the end of the building. We have evidence, however, that a second statue had been placed in the temple. Steimle reports on the basis of von Schoenebeck's diary the following:

> "Reused altar with a later dedicatory inscription for Isis in the interior."
> This brief note in the diary of von Schoenebeck is so far the only evi-

[14] Steimle, "Neue Erkenntnisse," 291–304.

[15] Ibid., 298, 304.

[16] Ibid., 294, 296, 304.

[17] Ibid., 294–95. Exact measurements are not given, but according to the site plan it must have been slightly smaller than the apsis temple that measured ca. 8 x 11 m.

[18] See above.

[19] Steimle, "Neue Erkenntnisse," 296.

[20] Ibid., 297–98.

dence for a movable discovery in the interior of the apsed temple. That
von Schoenebeck is talking of the interior of the cella, and not about
the pronaos, is suggested by a map of the building preserved in the
Archaeological Museum of Thessaloniki, in which in the southeastern
wall—that is, on the right-hand side as seen from the entrance—two
semicircular forms are indicated. Apart from any indication of the mea-
surements, these are not specifically marked, but one of these might
have been made for the placement of an altar. Fortunately, this altar
can be identified among the known finds; it is most certainly the round
altar preserved in the Archaeological Museum of Thessaloniki Inv. no.
MΘ 986[21] that was originally dedicated in the year 35 B.C.E.[22] In the
course of the second century C.E. the altar experienced a renovation,
which was related to its reuse as a statue base. Its new inscription,
carved on the back of the altar, is a dedication of the priest Γ. Φολουί-
νιος Οὖῆρος to Isis Orgia.[23] The naming of the goddess demonstrates
that the image (now lost) standing on the base must have been a rep-
resentation of Isis. Considering the measurements of the base, it was
an almost life-size statue.[24]

Since it is certain that a statue of a deity was standing in the niche of the
apsed temple, a second deity was housed in the temple. But it cannot be
known whether both were images of Isis or whether the statue of the niche
represented Sarapis. Both alternatives are possible.[25]

Although two statues of deities were eventually standing in the apsed
temple—one in the niche of the apse, the other on the right-hand side of
the nave—the construction of the apsed temple is significant not only
because of the underground crypt, which gives rise to speculations about
secret initiation rites celebrated there, but also because this structure is not
a "temple" in the traditional form, that is, a house for the gods. Rather, it is
a small assembly hall in which the place for the deity has been moved into
a niche at the northern end of the room, leaving space for the assembly of
a worshiping congregation. This construction parallels, on a smaller scale,
the Sarapis temples in western Asia Minor. While the Egyptian sanctuaries
in Miletos, Pergamon,[26] and Ephesos[27] are much larger, the form of all these

[21] Despinis, *Κατάλογος γλυπτῶν,* no. 47, with pictures 121–24.

[22] Edson, *Inscriptiones Thessalonicae* (= *IG* X/2.1), 84: Πόπλιος Σαλάριος Πάμφιλιος
καὶ Μάνιος Σαλάριος θεοῖς ἐντεμενίοις.

[23] Steimle, "Neue Erkenntnisse," 303 and n. 58, shows that the designation of Isis as
Orgia is without parallel.

[24] Ibid., 302 (translation mine).

[25] Ibid., 303.

[26] See Koester, "Pergamon: Red Hall," 168–76.

[27] See Koester, "Ephesus: Sarapeion," in idem, *Cities of Paul.*

"temples" is clearly different from the traditional form of the Greek temple as the house of the god. In all instances they are spaces for the assembly of people, whether for small groups or larger crowds. Accordingly, the place for the image of the deity is then a special district or niche at the far end of the building. The Egyptian religious structures, as well as the building of Jewish sacred places (commonly and appropriately called "synagogues"), thus appear as predecessors for the later Christian churches. Interior sacred space, no longer the exclusive dwelling of the deity, had now become the place of the worshipers.

This small building has been conveniently designated as a Sarapeion, although it is not known to which Egyptian deity it is dedicated. Indeed, a head of Sarapis was found in this context. Sarapis also appears in inscriptions from Thessaloniki. An inscription from the later imperial period mentions the fellow worshipers (συνθρησκευταί) of the great God Sarapis,[28] while a dedication from the first century B.C.E. mentions Sarapis and Isis together.[29] This small temple, however, could not possibly be *the* main Temple of Sarapis or Isis. Parallels from Asia Minor, as well as the large quantity of inscriptions of the Egyptian cult from Thessaloniki, leave no doubt that larger and more important structures must have been devoted to the worship of Sarapis and Isis, probably in the close vicinity of the small structure shown here. This small structure may have served a special purpose, for example, as a healing shrine, as Charalambos Bakirtzis suggests in a paper in this volume.[30] I shall return to this question later in this paper.

THE HERM FROM THE CRYPT OF THE SARAPEION[31]

The architectural distinctiveness of the Sarapeion's crypt may indicate that it served some particular function. It was not accessible directly from the temple, but only after traversing a long tunnel. We do not know whether the tunnel and the crypt were the setting of mysteries associated with the cult or were simply a sacred underground space.

A small herm of Dionysos was discovered standing on the altar of the crypt (fig. 2). This may indicate that this popular Macedonian deity was somehow involved in the mystery celebrations of the Egyptian cult. It is also possible

[28] Vidman, *Sylloge*, no. 111.

[29] Ibid., no. 111a.

[30] Bakirtzis, "Late Antiquity and Christianity," in this volume.

[31] See Koester, "Thessalonike: Egyptian Cult," in idem, *Cities of Paul*.

Fig. 2. Herm of Dionysos. Photo: Holland Hendrix.

that Dionysos was identified with the Egyptian god Osiris, an identification that was already known to Herodotus.[32] Some mythical traditions tell that Dionysos, like Osiris, suffered dismemberment. One can hardly argue, however, that the absence of the phallus in the statue of the herm would suggest a ritually enacted restitution, symbolizing the god's powers of renewal and regeneration.[33] But the phallus may have been sculpted as a separate piece, so that it could be removed and be carried in a procession.[34]

VOTIVE RELIEF OF DEMETRIOS FOR OSIRIS

An inscribed relief, executed in thoroughly Hellenistic style, has been dated to the late second century B.C.E. (fig. 3). According to the inscription, it was given by one Demetrios, who stands behind the altar, to his father Alexander, who stands on the right of the altar pouring a libation, and his mother Nikaia, who stands on the left.[35] The money purse, hanging from the father's wrist, designates him as a benefactor of the sanctuary.

The inscription reads as follows:

Ὀσείριδι μύστει Ἀλέξανδρον Δημητρίου καὶ Νικαίαν
Χαριξένου Δημήτριος τοὺς αὐτοῦ γονεῖς.

To Osiris initiate, Demetrios, for his parents Alexander, son of Demetrios, and Nikaia, Daughter of Charixenos.

The relief and its inscription are clear evidence that mystery initiations were associated with the Thessalonikan Egyptian cult. It is striking that it is not Demetrios, the devotee, who is called "initiate" but rather the god Osiris. Holland Hendrix explains this as follows: "If Demetrios' dedication was intended to honor his deceased parents, as seems likely, the implication of the inscribed relief is that Osiris as 'initiate' oversees the continuing devotions of his deceased followers."[36]

[32] *Histories* 2.145.
[33] Donfried, "Cults," 338.
[34] This possibility was suggested to me by Charalambos Bakirtzis.
[35] Edson, *Inscriptiones Thessalonicae* (= *IG* X/2.1): no. 107.
[36] Hendrix, "Thessalonike," in *Cities of Paul*.

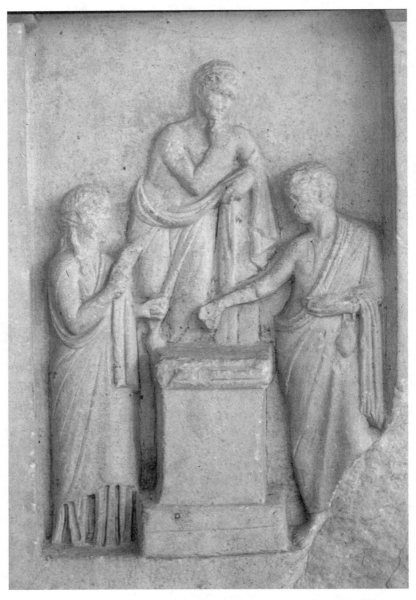

Fig. 3. Votive Relief of Demetrios for Osiris. Photo: Daniel Fraikin.

INTRODUCTION OF SARAPIS TO OPUS

An inscription found in the Sarapeion excavations contains a well-preserved text that describes the introduction of Sarapis and Isis to the city of Opus. It is a fragment of a larger inscription that seems to have recorded several deeds of the god Sarapis,[37] thus functioning as an aretalogy. I quote the translation by Daniel Fraikin, revised by Philip Sellew, of a part of the inscription:

> Xenainetos . . . thought that Sarapis stood beside him while asleep and ordered that on his return to Opus he should tell Euronymos, son of Teimasitheos, to receive both him and his sister Isis and to deliver to him the letter which was under his pillow. When he woke up he marveled at the dream and was uncertain as to what should be done, because there was political rivalry between him and Euronymos. But when he fell asleep again he saw the same things, and when he awoke he found the letter under his pillow, just as had been indicated to him. On his return he delivered the letter to Euronymos and reported what the god had prescribed. But Euronymos was perplexed for a time after taking the letter and hearing the things said by Xenainetos to him because, as was explained above, there was political opposition between them. But when he had read the letter and had seen that the things written agreed with what had been said by Xenainetos, he received Sarapis and Isis.[38]

That this story was found copied in an inscription from the first century C.E. is rather remarkable. The dialect of the inscription is not Macedonian or Attic but belongs to the Greek Koine spoken in the area of the Aetolian league, including Lokris and its city Opus. Moreover, according to linguistic evidence, the story must have been produced in the third or second century B.C.E. It has probably been preserved in Thessaloniki because Xenainetos received this dream vision in the Sarapeion.

The story is a typical example of the missionary style of the Egyptian religion where the god himself initiates the movement of his cult to new areas. Such dream vision reports, however, can also be found in Christian propaganda.[39]

[37] Edson, *Inscriptiones Thessalonicae* (= *IG* X/2.1): no. 225; Koester, "Thessalonike: Egyptian Cult," in *Cities of Paul*.

[38] Translation by Philip Sellew, "Religious Propaganda in Antiquity: A Case from the Sarapeum at Thessalonike," *Numina Aegaea* 3 (1980) 15–20.

[39] See Peter's vision in the Book of Acts of the unclean animals that moves him to bring the gospel to a new city (Acts 10).

Phouphikia to Isis with Relief of Ears

An inscription dated to the second or third century C.E. (fig. 4) reads as follows:

Κατ᾿ εὐχὴν Φουφικία Ἴσιδι ἀκοήν.
According to a vow, Phouphikia to Isis for hearing.[40]

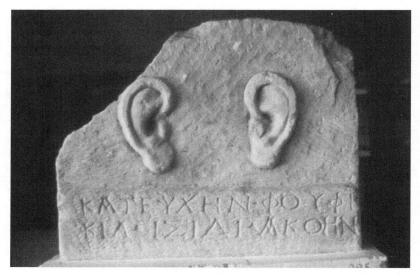

Fig. 4. Phouphikia to Isis with Relief of Ears. Photo: Daniel Fraikin.

In the *ex voto*, a woman thanks the goddess for hearing her prayer. The inscription is thus a testimony that healing activities were connected with the Egyptian sanctuary in Thessalonikē. This does not come as a surprise as healing activity is in evidence at other sites of the Egyptian cult. One can also observe how a new healing cult can replace an older, well-established healing sanctuary in the course of time. Financial records from the island of Delos demonstrate this. On Delos, the Egyptian cult began in the third century B.C.E. as a small house sanctuary (Sarapeion A). In time it grew; in the second century B.C.E., this small house sanctuary resulted in the establishment of a large sanctuary on the terrace of the foreign gods, fully equipped with a long *dromos* for processions and a temple court surrounded by several sanctuaries and additional structures. The healing activities here

[40] Edson, *Inscriptiones Thessalonicae* (= *IG* X/2.1): no. 100.

became more popular than those of the older sanctuary of Asklepios on the island. Financial records show that the income of the sanctuary of Asklepios declined dramatically as the income of the major Egyptian sanctuary on the island (Sarapeion C) increased sharply.[41] It was not a question of better advertisements as evidenced by the public display of inscriptions narrating miraculous cures. Rather, one must assume that the Egyptian sanctuary had the better health care facilities of a new religion, which rendered older healing cults obsolete. That the primary activities of such healing facilities were not the production of healing miracles but general medical services is clearly shown by the famous Sanctuary of Asklepios at Pergamon, seat of the famous physician Galen. The small Temple of Sarapis in Thessalonikē—certainly not the main sanctuary of Sarapis or Isis—might have served as a hospital. But it eventually lost its significance because of the better health care in the sanctuary of St. Demetrios.

Votive Inscription with Feet

A plaque, measuring 0.58 x 0.68 m, bears the inscription "Venetia Prima (dedicated this) according to a decree of the god" (Βενετία Πρεῖμα κατ᾽ ἐπιταγήν, fig. 5).[42] It dates to the same time as the Phouphikia inscription, which was just discussed, and may also be evidence for healing activities at the Egyptian cult center. The name of this female devotee, Venetia Prima, is Latin. The feet, probably those of Isis, indicate that the goddess had been present in the sanctuary.

Dining Association Stele with Relief of Anubis

A small stele with a relief of the Egyptian god Anubis, measuring 0.89 x 0.25 m, was found in the Eliades district of Thessaloniki (fig. 6). It is dated no later than the first half of the second century C.E. Whether this stele was ever connected with the Sarapis temple is unclear. Anubis appears in the relief but is not mentioned in the inscription. Dedications to Anubis alone,

[41] Mark Kurtz, "The Cult of Asclepius on Delos," Seminar Paper at Harvard Divinity School, 1997. Kurtz, a doctoral candidate at the time, demonstrated on the basis of inscriptional evidence that the income of the Sanctuary of Asclepius drastically diminished while the income of the Egyptian Sanctuary increased significantly after the building of Sarapeion C.

[42] Edson, *Inscriptiones Thessalonicae* (=*IG* X/2.1), no. 120.

Fig. 5. Votive Inscription with Feet. Photo: Daniel Fraikin.

that is, without Sarapis and Isis, are extremely rare. A guild of Anubiasts is attested only in Smyrna in an inscription that can be dated as early as the third century B.C.E. The Smyrna inscription is dedicated to Anubis on behalf of queen Stratonike, daughter of Demetrios Poliorketes and wife of Seleukos I Nikator.[43] The dedication is followed by as many as twenty-five lines listing the names of the rather numerous members of this guild.[44] In the case of the stele from Thessaloniki, the appearance of Anubis in the relief does not necessarily indicate that this association was exclusively dedicated to the service and protection of the god Anubis. As "bearers of holy objects" (ἱεραφόροι), they may have served the Egyptian cult in general and are thus not a separate private society, but functionaries who serve the official Egyptian cult and have chosen to create their own dining club.[45]

Anubis appears in one other inscription from Thessaloniki in the Greek form Ἑρμάνουβις.[46] The inscription from the late imperial period mentions two leaders of the worshipers and the *sēkobatai* (θρησκευταὶ καὶ σηκοβαταί)

[43] Seleukos I later ceded Stratonike to his son Antiochos I. The Stratonike named in this inscription has also been identified with the wife of Eumenes II of Pergamon, which would date the inscription to the second century B.C.E. On this question, see the note in Vidman, *Sylloge*, no. 305.

[44] Vidman, *Sylloge*, no. 305.

[45] Edson, "Cults of Thessalonica," 186–87.

[46] Vidman, *Sylloge*, no. 110.

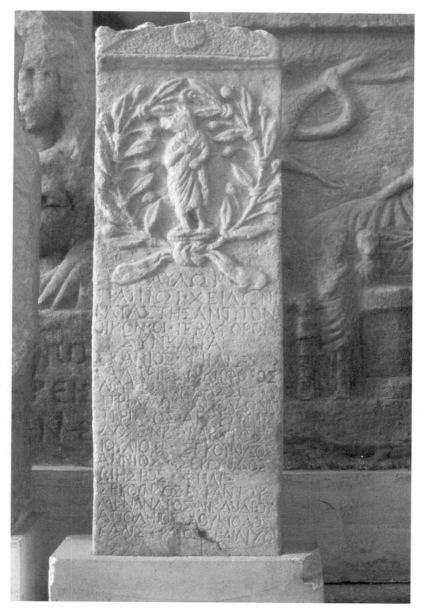

Fig. 6. Dining Association Stele with Relief of Anubis. Photo: Daniel Fraikin.

of the god Hermanoubis. The term σηκοβάτης is not attested anywhere else; it probably designates some kind of cultic official. The inscription was executed under the chief temple warden (ἀρχινακόρος) Marcus Aurelius Justus. All the names occurring in this inscription—Pomponius, Cassius, Claudius, Claudius Gaius, and the chief temple warden Marcus Aurelius Justus—are Roman. Nothing else is known about this association.

The dedicators of our Anubis stele call themselves "the bearers of holy objects (ἱεραφόροι) and table companions (συγκλίται)." While the meaning of ἱεραφόροι συγκλίται is perfectly clear, a dining association of "bearers of holy objects" is not attested elsewhere. Indeed the term ἱεραφόροι occurs in the Egyptian religion only in an inscription of the first century C.E. from Pergamon. It was found near the Armenian Church in the lower city and tells that Euphemos and Tullia Spendousa, the ἱεραφόροι, gave to the gods a number of statues as the goddess had commanded: "Sarapis, Isis, Harpokrates, Osiris, Apis, Helios on a horse, . . . Ares, and the Dioskouroi."[47] Although this group includes a number of deities, Isis is the goddess who gives the command and for whom a special painted linen is part of the dedication.

In his discussion of the stele, Edson[48] points to Plutarch,[49] who speaks of Isis as the one who discloses

> the divine mysteries (τὰ θεῖα) to those who truly and justly have the name ἱεραφόροι and ἱεροστόλοι. These are they who within their own soul . . . bear the sacred writings about the gods clear of all superstition and pedantry; and they cloak them with secrecy, thus giving intimations, some dark and shadowy, some clear and bright, of their concepts about the gods, intimations of the same sort as are clearly evidenced in the wearing of the sacred garb.

[47] Max Fränkel, *Die Inschriften von Pergamon* (Berlin: W. Spemann, 1890–1895) 248, no. 336; Vidman, *Sylloge*, no. 313:

Π. Εὔφημος [κ]αὶ [Τ]υλλία Σ[π]ένδο[υ]σ[α] οἱ ἱεραφόροι καθιέρωσαν τοὺς θεοὺς, ὃν ὁ θεὸς
ἐκέλευσε, Σάραπιν. Εἶσιν, Ἄνουβιν, Ἀρφοκράτην, Ὄσειριν, Ἄπιν, Ἥλιον ἐφ' ἵππῳ καὶ ἱκέτην παρὰ
τῷ ἵππῳ, Ἄρη, Διοωκούρους, σίνδονα, ἐν ᾗ ἐζωγράφηται ἡ θεὸς καὶ περὶ τὴν θεὸν πάντα, ἄλλας
σίνδονους λαμπρὰς τρεῖς, πέταλα χρυσέα ὀγδοήκοντα. Ἐπεσκεύασεν δὲ καὶ τὰ ἀκρόχειρα τῶν
ἀγαλμάτων, συνδάλια, χαλκεῖα καὶ περιρραντήριον πρὸ τοῦ πυλῶνος.

[48] Edson, "Cults of Thessalonica," 184–85.

[49] Plutarch, *De Iside et Osiride*, 3.352 B.

More than a dozen names follow the dedication of the Anubis stele from Thessaloniki. At the end of the inscription stands the name of Kallistratos, the leader (ἄρχων) of the dining association. Nine of the fourteen persons seem to be Roman citizens, many of them perhaps freedmen.[50] Dining associations of special groups—distinguished by rank, function, knowledge of mysteries, or social status—are not rare within the context of a Hellenistic religion, while this would have been unthinkable in the beginnings of Christianity. Here the community meal, the Eucharist, was always understood as the documentation of the unity of all believers (see 1 Cor 11:20–22) and the divine mysteries were disclosed to all (1 Cor 2:6–16).

In all cases we must be cautious with conclusions regarding typical local features of these religions. In most instances such finds need to be interpreted in the context of other materials from Macedonia, Greece, and Asia Minor as well as from other areas of the Greco-Roman world. This judgment must be valid for archaeological finds from the world of early Christianity in general. Both geographically and chronologically, such finds need to be considered within a larger context. To be sure, occasionally special features of such discoveries from a limited area may yield information about religious circumstances of a particular time and place. A careful examination of the materials must therefore also take account of the peculiarities of a particular city or a limited area. But the relationship to culture and religion of the larger areas, such as Palestine/Syria, the realm of the Aegean, Rome and the West, or Egypt, must be taken into account. At the same time, one must face the possibility that early Christian writings, too, are not directed to a special local situation but that their terminology and vision is dependent upon more universally valid conventions, ideologies, and languages. I would argue that the language and vision of Paul's genuine letter to the Thessalonians, for instance, is not directly influenced by local Thessalonikan conventions but by his universal eschatological message. Influenced by the language of Jewish apocalyptic writers, that message confronts the new community of the people of God in which equality and mutual responsibility and loving care are constitutive in comparison to the empire of Rome and its hierarchical organization and patronage system.

[50] Ibid., 184.

BIBLIOGRAPHY

Despinis, Giorgios, Theodosia Stephanidou-Tiveriou, and Emmanouil Voutiras. *Κατάλογος γλυπτών του Αρχαιολογικού Μουσείου Θεσσαλονίκης* (Catalogue of Sculpture in the Archaeological Museum of Thessaloniki). Thessaloniki: Morphōtiko Hidryma Ethnikēs Trapezēs, 1997.

Donfried, Karl Paul. "The Cults of Thessalonica and the Thessalonian Correspondence." *NTS* 31 (1985) 336–56.

Edson, Charles, ed. *Inscriptiones Thessalonicae et viciniae [IG* X/2.1]. Berlin: de Gruyter, 1972.

———. "Cults of Thessalonica (Macedonia III)." *HTR* 41 (1948) 153–204.

———. "Chroniques des fouilles et découvertes archéologiques dans l'Orient hellénique." *BCH* 45 (1921) 540–41.

Fraikin, Daniel. "Note on the Egyptian Gods in Thessaloniki." *Numina Aegaea* 1 (1974) 1–6.

Fränkel, Max. *Die Inschriften von Pergamon*. Berlin: W. Spemann, 1890–1895.

Hendrix, Holland. "Thessalonikē." In *Cities of Paul: Images and Interpretations from the Harvard New Testament Archaeology Project* [CD-ROM]. Edited by Helmut Koester. Minneapolis, Minn.: Fortress, 2005.

Koester, Helmut. "The Red Hall in Pergamon." Pages 168–76 in idem, *Paul and His World: Interpreting the New Testament in its Context*. Minneapolis, Minn.: Fortress, 2007.

———, ed. *Cities of Paul: Images and Interpretations from the Harvard New Testament Archaeology Project* [CD-ROM]. Minneapolis, Minn.: Fortress, 2005.

———. "Ephesus: Sarapeion." In *Cities of Paul: Images and Interpretations from the Harvard New Testament Archaeology Project* [CD-ROM]. Edited by Helmut Koester. Minneapolis, Minn.: Fortress, 2005.

———. "Thessalonikē: Egyptian Cult." In *Cities of Paul: Images and Interpretations from the Harvard New Testament Archaeology Project* [CD-ROM]. Edited by Helmut Koester. Minneapolis, Minn.: Fortress, 2005.

Kurtz, Mark. "The Cult of Asclepius on Delos." Seminar Paper at Harvard Divinity School, 1997.

Makaronas, Charalambos. "Excavations at the Serapeion." *Makedonika* 1 (1940) 464–65. [in Greek]

Sellew, Philip. "Religious Propaganda in Antiquity: A Case from the Sarapeum at Thessalonike." *Numina Aegaea* 3 (1980) 15–20.

Steimle, Christopher. "Neue Erkenntnisse zum Heiligtum der ägyptischen Götter in Thessaloniki. Ein unveröffentlichtes Tagebuch des Archäologen Hans von Schoenebeck." *AEMΘ* 16 (2002) 291–304.

Tzanavari, Katerina. "The Worship of Gods and Heroes in Thessaloniki." Pages 177–262 in *Roman Thessaloniki*. Edited by D. V. Grammenos. Translated by David Hardy. Thessaloniki: Archaeological Museum of Thessaloniki, 2003.

Vidman, Ladislav. *Sylloge inscriptionum religionis Isiacae et Sarapiacae*. Religionsgeschichtliche Versuche und Vorarbeiten 28. Berlin: de Gruyter, 1969.

Social Status and Family Origin in the Sarcophagi of Thessalonikē*

Thea Stefanidou-Tiveriou

The marble sarcophagi of Thessalonikē have attracted the attention of scholars since the early nineteenth century.[1] The number and size of the sarcophagi impressed the visitors to the city, who encountered them outside the walls (fig. 1), at the entrances to the city, or scattered about houses and streets of the city where the inhabitants had used them as fountains (fig. 2). As shown by the great number of surviving examples, which approaches 290, the sarcophagi occupied a prominent place among the various categories of grave monuments in the cemeteries of ancient Thessalonikē during the

*The corpus of Thessalonikē's locally produced sarcophagi will be published shortly in the Sarkophag-Studien series (7) of the German Archaeological Institute in Berlin by the author in collaboration with Pantelis Nigdelis, who is responsible for the study of the inscriptions on these monuments. This research was approved by the Greek Ministry of Culture on the recommendation of the 16th Ephorate of Prehistoric and Classical Antiquities, and I warmly thank the former directors Dēmētrios Grammenos and Eleni Trakosopoulou-Salakidou for their support. I also want to thank my colleague Pantelis Nigdelis for giving me useful information and discussing with me various issues I dealt with in this paper. I particularly want to thank Professor Guntram Koch, who suggested the topic of the local sarcophagi of Thessalonikē and helped me in every possible way. Dr. Stefanie Kennell translated this text into English.

[1] See Clarke, *Travels in Various Countries*, 2:3, 361. See also Leake, *Travels in Northern Greece*, 3:246.

Fig. 1. Sarcophagus in the East Cemetery of Thessalonikē (today the cemetery of the Protestants). Photo: Archive of Aristotelis Zachos, Neohellenic Architecture Archives. Athens, Benaki Museum.

second and third centuries C.E.[2] Thus, we can appreciate the passage in Ioannēs Kameniates, who informs us that Petronas, the governor of the city, sank monolithic carved "tombs" (τύμβοι, i.e., sarcophagi) into the sea in order to keep enemy ships from approaching land during the Arab siege of Thessalonikē in 904 C.E.[3]

Concerning the cemeteries and the city's funerary customs, we can draw relatively limited information by studying the sarcophagi. Because of the roles that the monuments played in later history, we have little information about the original location of the sarcophagi (figs. 1, 3), the way in which they were set up, or the remains that they contained. We can fill out the fragmentary picture to some extent with information from the cemeteries and monuments of Asia Minor at, for example, Chalcedon,[4] and especially at Thasos. Sarcophagi occupied the preeminent position among grave

[2] To the 241 locally-made sarcophagi of Thessalonikē included in the forthcoming corpus should be added the imported sarcophagi, mainly from Attica and Assos, which yield a total of 290 funerary monuments.

[3] Böhlig, *Ioannis Caminiatae,* 17:6–7.

[4] See Asgari and Firatli, "Die Nekropole von Kalchedon."

Fig. 2. Sarcophagus used as fountain in Thessaloniki. Photo comes from a postcard from the beginning of the twentieth century.

monuments in the cemeteries of ancient Thasos and Thessalonikē in northern Greece. In two cases, we know from literary descriptions that they stood in the open air arranged outside the gates and along the major roads to a fair distance outside the city.[5] In a few cases, they stood inside grave monuments called ἡρῷα in the inscriptions (ἡρῷον, "temple or chapel of a hero").[6] Large sarcophagi usually served as family tombs (in the broader sense of family), secured with clamps and opened at every new interment. Inscriptions on the

[5] For Thasos, see, e.g., the information supplied by Conze, *Reise auf den Inseln,* 17–18.
[6] See Edson, *Inscriptiones Thessalonicae* (= *IG* X/2.1): nos. 563, 579, and 608.

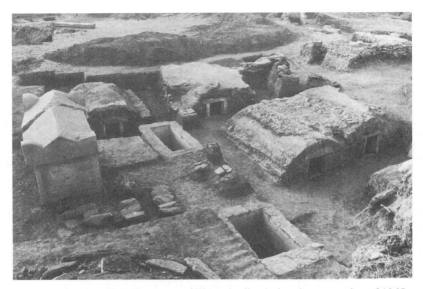

Fig. 3. View of the East Cemetery of Thessalonikē during the excavation of 1965.
Photo: *Θεσσαλονίκη,* 69, fig. 40.

sarcophagi themselves and the scant information gained from excavations confirm this observation. In certain cases, two or more sarcophagi, made for different members of the same family, stood within a grave precinct or in a funerary edifice.[7]

A peculiarity of Thessalonikē's sarcophagi—as also of its funerary altars—is the presence of inscriptions, often precisely dated, which are carved into approximately 70 percent of these monuments. These inscriptions, an overwhelming majority of them in Greek, offer us a wealth of information regarding the social history of Thessalonikē. My colleague, Pantelis Nigdelis, has studied them as part of our joint publication of the monuments.[8] From these inscriptions we can draw information regarding the legal and social positions and, indirectly, the origins of their owners.

The study of the typology of these sarcophagi also offers abundant information about the sarcophagus market in Thessalonikē and the special preferences of the buyers. Given the large number of surviving monuments,[9] we can pose two questions. First, what criteria determined the buyers'

[7] More particulars about all the relevant issues will be given in forthcoming Sarkophag-Studien 7.

[8] See forthcoming Sarkophag-Studien 7.

[9] See n. 2, above.

selection of particular types of sarcophagi in Thessalonikē? Second, which models influenced the types of sarcophagi produced in Thessalonikē? The latter question can provide us with relevant evidence concerning the origin of the buyers. I shall thus attempt to analyze the sarcophagi, on the one hand, as indications of the manner in which their owners promoted themselves and their social status and, on the other, as probable indications of the origin of the individuals who commissioned them.

IMPORTED SARCOPHAGI IN THESSALONIKĒ

A considerable proportion of Thessalonikē's sarcophagi (13 percent) was imported from Athens.[10] These lavish sarcophagi included reliefs, which frequently depicted mythological scenes (fig. 4). As products of the famous Attic workshops, they were highly sought after throughout the Mediterranean in the second and third centuries. However, these imported works exerted a limited influence on local production of Thessalonikē.[11] Notwithstanding their imitation of the Attic style, certain sarcophagi have individual elements that we can recognize as being of local origin.[12]

Other groups of sarcophagi from Asia Minor had a wide distribution in the Roman Empire but were aimed at a less wealthy and discerning public; these are less common in Thessalonikē than Attic sarcophagi. Ten of these, which belong to the Assos group from the Troad (fig. 5), were made of reddish volcanic stone (andesite) and decorated with unfinished garlands.[13] Six specimens have inscriptions inside *tabulae ansatae* (handled tablets) that were carved for use at Thessalonikē. Two or three other sarcophagi are imports from Proconnesus (fig. 6).[14] A great number of sarcophagi produced in these Marmara Island marble quarries and destined for export in an unfinished state

[10] For imported Attic sarcophagi in Thessalonikē, see Koch and Sichtermann, *Römische Sarkophage*, 350. Of the approximately 38 surviving examples, a fair number—mainly the best-preserved ones—have been published in the context of the *Sarkophagcorpus* and the *Κατάλογος γλυπτών του Αρχαιολογικού Μουσείου Θεσσαλονίκης* 1 and 2 (see Papagianni, "Αττικές σαρκοφάγοι στη Θεσσαλονίκη"). To these should be added the sarcophagi now located outside of Greece, in Istanbul (Archaeological Museum) and Paris (Louvre).

[11] Koch and Sichtermann, *Römische Sarkophage*, 461–70.

[12] See Papagianni in *Akten des Symposiums,* 187–92; eadem, "Αττικές σαρκοφάγοι στη Θεσσαλονίκη."

[13] For this category, see Koch and Sichtermann, *Römische Sarkophage,* 515–19. See also Koch, *Sarkophage der römischen Kaiserzeit,* 171–73.

[14] For an example see Koch and Sichtermann, *Römische Sarkophage,* 350–51 with n. 62.

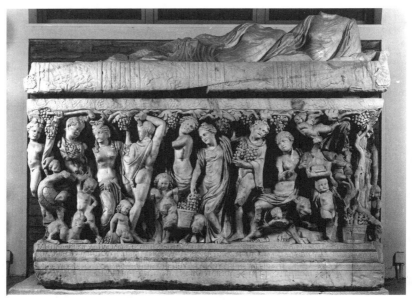

Fig. 4. Attic sarcophagus, Archaeological Museum of Thessaloniki, inv. 1247.
Photo: Valtin von Eickstedt. Photoarchive ΑΓΜΕ: Museum of Casts of the
University of Thessaloniki, no.1062 A.

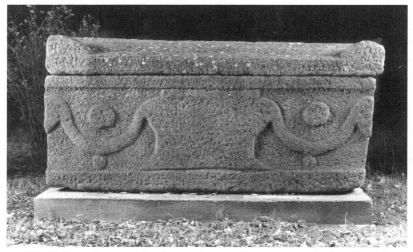

Fig. 5. Sarcophagus made of volcanic stone (Assos group), Archaeological
Museum of Thessaloniki, inv. 5691. Photo: Valtin von Eickstedt. Archive of the
"Sarkophagcorpus," Marburg.

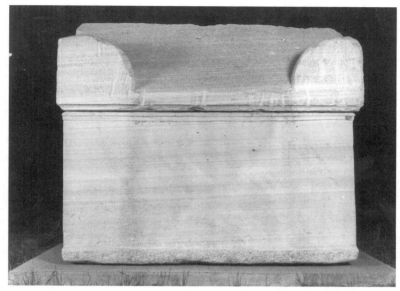

Fig. 6. Sarcophagus made of Proconnesian marble, Archaeological Museum of Thessaloniki, inv. 5698. Photo: Valtin von Eickstedt. Archive of the "Sarkophagcorpus," Marburg.

would then be completed in local workshops.[15] This practice may also have occurred in the case of Thessalonikē.

LOCALLY-PRODUCED SARCOPHAGI

The majority of surviving sarcophagi were manufactured in workshops at Thessalonikē proper from roughly-dressed products (*Rohlinge*) quarried on the island of Thasos (fig. 10); we have 241 examples of these.[16] After sarcophagi from Attica, these sarcophagi produced from the local workshops comprise the second largest group in this category of monuments within the territory of Greece proper. In contrast to the wide demand for Attic sarcophagi, the demand for these local products was limited exclusively to the city of Thessalonikē.

[15] See Asgari, "Objets de marbre finis."

[16] Until the volume of Thessalonikē's sarcophagi is published, see Koch and Sichtermann, *Römische Sarkophage*, 350–57; Stefanidou-Tiveriou, "Kleinasiatische Einflüsse"; eadem, "Thasian Marble."

All the locally produced sarcophagi of Thessalonikē, with only one exception, have gabled lids and can be distinguished by the shape of the chest into three main types: framed type sarcophagi with framing moldings, plain sarcophagi, and garland sarcophagi. Smaller (children's) sarcophagi conform to the same basic types, as do the funerary urns, which are much less common than sarcophagi.[17]

The framed type constitutes the most common and most characteristic type of Thessalonikē-made sarcophagi and comprises 45 percent of the local production (figs. 1, 3, 7, 29, 30). Its moldings adorn three (rarely four) sides, usually the front panel and the two shorter ends of the chest. I have divided the framed sarcophagi into two distinct types: those without a base (which are more common) and those with an integrated base. An inscription constitutes the principal decorative element and frequently takes up all the available space on the front of the chest. Less often, the inscription is placed in a *tabula ansata* (fig. 30). In both cases the inscription serves as the vehicle of self-presentation for the owner of the sarcophagus and his family. Occasionally, small reliefs appear without any specific scheme of composition (fig. 29). Distant models for this framed sarcophagus type appear in Augustan Rome and more generally in the territory of Italy, where moldings are characteristic of other types of monuments as well, such as, for example, altars of the Lares.[18] The framed sarcophagi of Thessalonikē thus have a close relationship, in terms of shape and time period, with the sarcophagi manufactured in northern Italy, which used roughly quarried products from Proconnesus in the second and third centuries C.E.[19]

Despite these general similarities between the two groups, however, Thessalonikē's production was not directly linked to that of northern Italy, although they share a common denominator: The models for both are found in the East. Framed sarcophagi were in fact made on Proconnesus and carved from roughed-out Proconnesian chests and lids, as certain examples from the territory of Asia Minor (e.g., Chalcedon) attest.[20] Framing moldings are also found on sarcophagi from other regions of Asia Minor. Most closely related to those of Thessalonikē, however, are the sarcophagi of Nicaea in Bithynia (fig. 8). The

[17] Cinerary urns constitute 11–12 percent of the total number of locally produced monuments.

[18] For framed sarcophagi in Italy, see Koch and Sichtermann, *Römische Sarkophage*, 37–38; Koch, *Sarkophage der römischen Kaiserzeit*, 63–64 with n. 294. For framing moldings on other types of monuments, see Gabelmann, "Zur Tektonik oberitalischer Sarkophage."

[19] Rebecchi, "Cronologia." Koch and Sichtermann, *Römische Sarkophage*, 281–88; Koch, *Sarkophage der römischen Kaiserzeit*, 125–28 with n. 506.

[20] Asgari and Firatli, "Die Nekropole von Kalchedon," 44, 72, sarcophagus SR.2, figs. 20–23, 26.

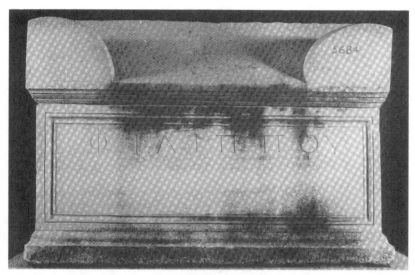

Fig. 7. Sarcophagus, Archaeological Museum of Thessaloniki, inv. 5684. Photo: Valtin von Eickstedt. Archive of the "Sarkophagcorpus," Marburg.

chest of the Nicaean sarcophagi is formed into a unified field with the help of the framing, as at Thessalonikē, or is divided into three smaller fields; it is also raised up on an integrated base.[21] Thus we should seek the models for the workshops of Thessalonikē in Bithynia and, more generally, in the region of northwestern Asia Minor with which Thessalonikē had close relations.[22] Both the city's funerary reliefs and its altars correspond to types from this territory, as we shall see later on.[23] With the exception of the sarcophagi of Assos, however, few imported products in Thessalonikē come indisputably from Asia Minor, and the marble used in Thessalonikē comes from the quarries of Thasos, obviously for reasons of economy.[24] The adoption of the framed sarcophagus type thus could have occurred indirectly through craftsmen, who came mainly from the region of Bithynia in Asia Minor.

The plain type of chest, which in a few cases is also raised up on an integrated base, occurs in a less widespread area at Thessalonikē (figs. 9, 10). The inscription on the front, frequently within a *tabula ansata* and

[21] See for example Koch and Sichtermann, *Römische Sarkophage*, 510–11, fig. 19, plate 494; Koch, *Sarkophage der römischen Kaiserzeit*, 169–70, figs. 98, 1–2.

[22] Framed sarcophagi in Greek territory also appear at Philippi and on Thasos. They do not, however, constitute the preeminent type in these regions, as they do at Thessalonikē.

[23] See below p. 172 with n. 52 and p. 175 with n. 61.

[24] Stefanidou-Tiveriou, "Thasian Marble," 19–29.

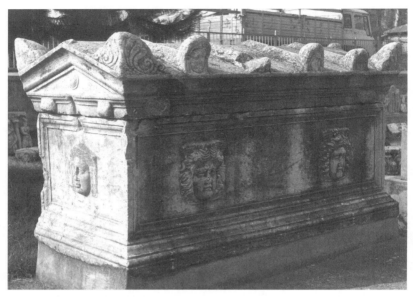

Fig. 8. Sarcophagus, Iznik inv. 685. Photo: Guntram Koch. Archive of the
"Sarkophagcorpus," Marburg.

sometimes in combination with a relief, constitutes the preeminent decorative
element also in this type of sarcophagi. Many of these sarcophagi were used
in a roughly worked state (fig. 10) sometimes after an inscription had been
carved or a small relief sculpted. Similar semi-finished sarcophagi are also
known from the quarries and the cemeteries of Proconnesus[25] and enjoyed
a large distribution in the wider region of the Propontis and Thrace and
throughout the Mediterranean, the Adriatic, and the Black Sea.[26] They had
a noteworthy influence on local workshops, which manufactured imitations
of these plain type from locally quarried stone. The quarries of Thasos, from
which the workshops of Thessalonikē drew their material, produced this type
in significant numbers (fig. 11).[27] This plain type of chest appears in other
Macedonian cities as well, such as Beroia and Philippi,[28] and in a group of
Hellenistic-period sarcophagi on the island of Paros that were reused into the

[25] Asgari, "Objets de marbre," 107–17, esp. 111–13, figs. 3–4.

[26] Ward-Perkins, "Dalmatia and the Marble Trade," 111.

[27] Stefanidou-Tiveriou, "Thasian Marble," 19–29.

[28] For sarcophagi in Beroia, see Stefanidou-Tiveriou, "Kleinasiatische Einflüsse," 117
with n. 27. For Philippi, see Koch and Sichtermann, *Römische Sarkophage*, 350 n. 50.

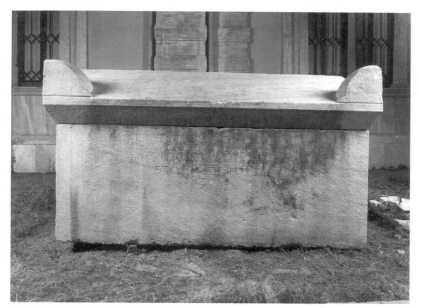

Fig. 9. Sarcophagus, Archaeological Museum of Thessaloniki, inv. 1832. Photo: Valtin von Eickstedt. Archive of the "Sarkophagcorpus," Marburg.

imperial period.[29] Although direct imports from Proconnesus to Thessalonikē appear rare, sarcophagi from Proconnesus likely inspired the plain chest in Thessalonikē and in Macedonian territory in the second century C.E. due to their early appearance and widespread distribution through trade during the imperial period.[30] All the same we cannot rule out the possibility that craftsmen from the region of the Propontis or Thrace might have influenced Macedonian production.

The garland sarcophagi give an initial impression of great variety (figs. 12, 13, 15, 18, 19). Despite this impression they comprise specific typological groups, which show their dependence on prototypes mainly from Asia Minor. Although made of Thasian marble, the most significant group of these Thessalonikē sarcophagi nevertheless displays features showing that its models were finished sarcophagi made from roughly-worked Proconnesian products (fig. 14) as indicated by the garland with three swags on the front,

[29] For the Paros group, see Mercky, *Römische Grabreliefs,* 37–41.

[30] Certain of these are dated to the end of the first century C.E.; see Asgari and Firatli, "Die Nekropole von Kalchedon," 49 with n. 145; Koch, *Sarkophage der römischen Kaiserzeit,* 345; see Asgari, "Objets de marbre," 111 with n. 185.

Fig. 10. Sarcophagus, Archaeological Museum of Thessaloniki, inv. 19705. Photo: Valtin von Eickstedt. Archive of the "Sarkophagcorpus," Marburg.

the figures supporting them, and the ancillary motifs (figs. 12, 13).[31] The molding on the upper edge of the chest, a requisite element of Proconnesian products, does not occur on the examples from Thessaloniki; this absence and the plain back of the chest constitute a local characteristic. An exceptional fragment from Thessaloniki, now at Istanbul, bears a molding along its upper edge and may therefore have been made from an unfinished chest from Proconnesus.[32] Parallels for this garland type appear at Thasos.[33] No unfinished sarcophagus from Proconnesus, however, has yet been found anywhere in Macedonia. In other cases I have established that Thessalonikē's production depends on Proconnesian models but have observed divergences from these models, for example, in the number of swags the garland has (only two) or in the figures that form their supports.[34] In any case, the stimulus

[31] For unfinished Proconnesian garland sarcophagi, see Asgari, "Die Halbfabrikate kleinasiatischer Girlandensarkophage"; Asgari and Firatli, "Die Nekropole von Kalchedon," 107–15, fig. 3(E); see also Koch, *Sarkophage der römischen Kaiserzeit*, 162–65.

[32] Edson, *Inscriptiones Thessalonicae* (= *IG* X/2.1): no. 848; Stefanidou-Tiveriou, "Kleinasiatische Einflüsse," 119 with n. 50, plates 29, 2.

[33] Stefanidou-Tiveriou, "Thasian Marble."

[34] See for example Koch and Sichtermann, *Römische Sarkophage*, figs. 391–92.

Fig. 11. Sarcophagus from the cemetery of Thasos, Archaeological Ephorate
Thasos. Photo: Thea Stefanidou-Tiveriou.

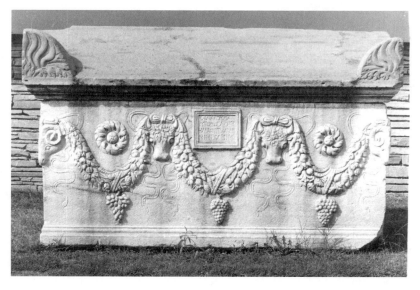

Fig. 12. Sarcophagus, Archaeological Museum of Thessaloniki, inv. 5685. Photo:
Guntram Koch. Archive of the "Sarkophagcorpus," Marburg.

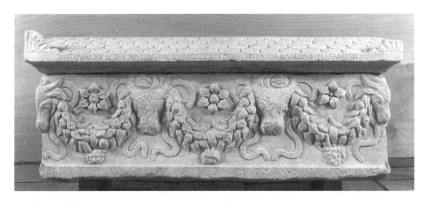

Fig. 13. Sarcophagus, Archaeological Museum of Thessaloniki, inv. 12545. Photo: Valtin von Eickstedt. Archive of the "Sarkophagcorpus," Marburg.

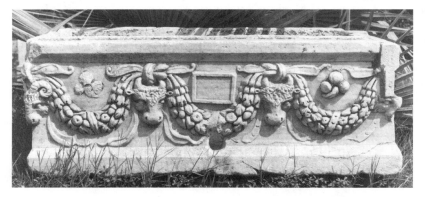

Fig. 14. Sarcophagus, Adana, Archaeological Museum. Photo: Guntram Koch. Archive of the "Sarkophagcorpus," Marburg.

for the production of the garland sarcophagi at Thessalonikē probably came from the Proconnesian type.

A few sarcophagi of Thessalonikē combine garlands with architectural elements and place two columns with a garland stretching above a horizontal architrave instead of the usual central swag. A similar mix of elements that derive from columnar and garland sarcophagi occurred at Aphrodisias without which it would be exceptionally difficult to understand the examples from Thessalonikē.[35] This circumstance becomes especially interesting if we take into account that one of the Thessalonikē examples is dated to 131–132 C.E.

[35] Stefanidou-Tiveriou, "Girlandensarkophage."

and consequently constitutes indirect evidence for the dating of the prototypes for this group.[36]

Another noteworthy group of garland sarcophagi from Thessaloniki (fig. 15) shows influences from the so-called "main group" of Asia Minor sarcophagi, as does an example from Beroia (fig. 16).[37] In the products from Asia Minor, the decorative scheme comprises a garland with three swags (fig. 17), while the local Macedonian manufactures have only two, perhaps because of Attic influence. As in the sarcophagi of Asia Minor, however, the garlands are especially heavy and supported at the corners by Victories and in the middle by an Eros. Above the swags are large *gorgoneia* or rosettes. Despite the simplifications in the Macedonian products, their relationship with the "main group" of sarcophagi from Asia Minor appears obvious. I have also noted that these works reveal the adoption of models from Asia Minor but that no examples of directly imported work have turned up in Thessalonikē or in any other location in Macedonia until now. If imports of this type in fact existed, they would belong in the second quarter of the second century,[38] and the local imitations that have survived should not be dated much later.

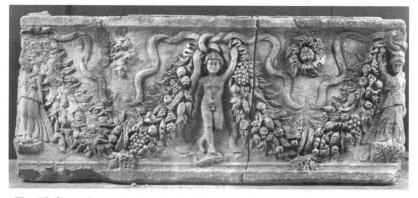

Fig. 15. Sarcophagus, Archaeological Museum of Thessaloniki, inv. P 74. Photo: Valtin von Eickstedt. Archive of the "Sarkophagcorpus," Marburg.

[36] Ibid., 713–14, fig. 3.

[37] The Asia Minor sarcophagi, which come from Aphrodisias, are not dated, whereas one of the Thessaloniki examples is dated to 131–132 C.E. and offers us a *terminus ante quem* for the Asia Minor group. See Stefanidou-Tiveriou, "Kleinasiatische Einflüsse," 119–21, plate 29,3 and plate 30.

[38] According to Waelkens, the examples with *nikai* treading on acanthuses and *erotes* on dolphins do not occur after the middle of the second century C.E. (*Dokimeion*, 12).

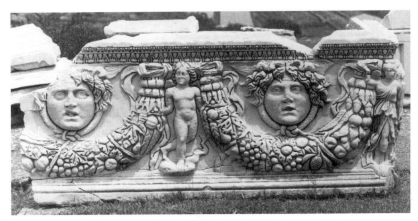

Fig. 16. Sarcophagus, Archaeological Museum Beroia, inv. 485. Photo: Guntram
Koch. Archive of the "Sarkophagcorpus," Marburg.

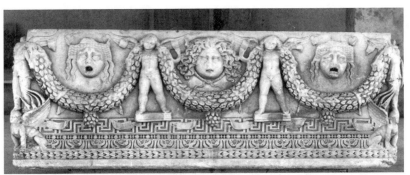

Fig. 17. Sarcophagus, Archaeological Museum Antalya inv. A 16. Photo: Guntram
Koch. Archive of the "Sarkophagcorpus," Marburg.

The garland cinerary urns of Thessalonikē comprise a separate group, all of
which derive from Ephesian models. We classify this group of urns into two
separate categories: one with garlands of fruits (fig. 18) and the other with
garlands of leaves (fig. 19).[39] As in the case of the Ephesian products (figs. 20,
21), all the examples from Thessaloniki have a molding along the lower edge
of the chest and share the same decorative scheme. The garland cinerary urns
of the first category bear a two-swag garland on the front (fig. 18), and one
of the short sides which are supported at the ends by rams' heads and in the
middle by an ox head. The absence of feet on the corners of the container

[39] Cinerary urns from Ephesos: Thomas and Içten, "Ephesian Ossuaries"; Koch,
"Kaiserzeitliche Sarkophage in Ephesos," 558–59.

Fig. 18. Cinerary urn, Archaeological Museum of Thessaloniki, inv. 10757. Photo: Valtin von Eickstedt. Archive of the "Sarkophagcorpus," Marburg.

Fig. 19. Cinerary urn, Archaeological Museum of Thessaloniki, inv. 2194 and 6118. Photo: Valtin von Eickstedt. Archive of the "Sarkophagcorpus," Marburg.

Fig. 20. Cinerary urn, Archaeological Museum Selçuk, inv. 455. Photo: Guntram
Koch. Archive of the "Sarkophagcorpus," Marburg.

Fig. 21. Cinerary urn, Archaeological Museum Selçuk. Photo: Guntram Koch.
Archive of the "Sarkophagcorpus," Marburg.

and the long ends of the ribbons provide evidence of local production. The second category of cinerary urns has a single swag of laurel leaves (fig. 19) on each side that is carried by two rams' heads. Although the urns of Ephesos had a wide distribution in the Roman Empire,[40] we have no examples of imports in Thessalonikē at all. Despite this lack, the urns of Ephesos exerted an obvious influence on Thessalonikē's production. It is noteworthy that local production at Thessalonikē continued into the first half of the third century C.E., longer than that of Ephesos.

In contrast to all of the sarcophagus types just discussed, which imitate mainly eastern, Asia Minor models, we have found one isolated example of a western prototype (fig. 22).[41] Although the insertion of a garland within a rectangular frame has parallels both in the West and in the East, this example most closely resembles a cinerary urn in the Museo Nazionale in Rome, which dates to the end of the first century C.E.[42] The sarcophagus in question constitutes a distinct case in Thessalonikē, since it is superior to most local monuments and carved of good quality white Thasian marble rather than the gray, large-grained stone usually used. It may have been a special order by a purchaser with a connection to Italy.

From this survey we can conclude that sarcophagi from Thessalonikē lack significant western influence but that these locally produced sarcophagi,

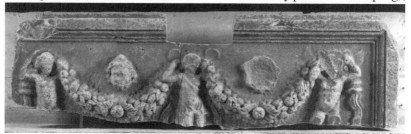

Fig. 22. Sarcophagus, Archaeological Museum of Thessaloniki, inv. P 103. Photo: Valtin von Eickstedt. Archive of the "Sarkophagcorpus," Marburg.

by contrast, have close links to Asia Minor production. Indeed, production of sarcophagi in the city's workshops probably began by following models from Asia Minor. The limited presence of genuine imported products from Asia Minor in Thessalonikē, however, should be attributed to the supply of abundant

[40] Koch, *Sarkophage der römischen Kaiserzeit*, 155; Koch, "Kaiserzeitliche Sarkophage in Ephesos," 559 nn. 36, 37.

[41] Thessaloniki, Archaeological Museum, inv. P 103 (unpublished).

[42] See recently Kammerer-Grothaus, "Ollaria," 391, fig. 10.

and affordable material from nearby Thasos. We now turn to Thessalonikē's other types of funerary monuments and inquire into their connections to Asia Minor and to Italy from the late Hellenistic period to around the middle of the third century C.E.

OTHER TYPES OF FUNERARY MONUMENTS IN THESSALONIKĒ

Free-standing grave stelae with traditional images, such as those of the deceased and his family, or with motifs of heroization, such as the funeral banquet (fig. 23) or the horseman, are widespread in the Hellenistic world. In ancient Thessalonikē these grave stelae persist throughout the late Hellenistic period and the Roman Empire.[43] In the early imperial period, a new category of grave relief makes its appearance for the first time: reliefs within medallions. These reliefs are sometimes incorporated into a structure and sometimes set up independently on a tall pillar.[44] Inside a circular frame, members of a family are depicted frontally as busts (fig. 24). For the origin of this type, some scholars have suggested the area of northern Italy (Altinum), because similar, though not exact, parallels have been found there.[45] Recently Elisabeth Walde rejected this theory and drew attention to the fact that Greece had an older (Hellenistic) tradition of depicting portraits in tondo (*imago clipeata*). For this reason she connects the Macedonian grave reliefs within circular frames with the older, local, Hellenistic type.[46]

In time, rectangular reliefs gained ground (fig. 25) and became frequently incorporated into the altar-like structures in Thessalonikē.[47] In these monuments the traditional depictions of the funeral banquet and the horseman coexist with family portraits like those of the medallion reliefs.[48] According to the prevailing view, the depiction of partial figures, widespread in the funerary

[43] For the grave reliefs of Macedonia, see e.g., Lagogianni-Georgakarakos, *Die Grab-denkmäler*.

[44] See Ioakimidou in *Κατάλογος γλυπτών*, nos. 309, 310–12, 314–15, 322–25. See also recently Ioakimidou-Kontsé, "Die Grabmedaillons," 121–26.

[45] See Gabelmann, "Die Typen der römischen Grabstelen," 93 n. 88.

[46] Walde, "Bemerkungen."

[47] Stefanidou-Tiveriou, "Εντοιχισμένα ταφικά ανάγλυφα," which also includes references to related finds.

[48] See Lagogianni-Georgakarakos, *Grabdenkmäler*, nos. 3, 78, 86, 96, 109, and 137; Voutiras, in *Κατάλογος γλυπτών*, nos. 123, 126.

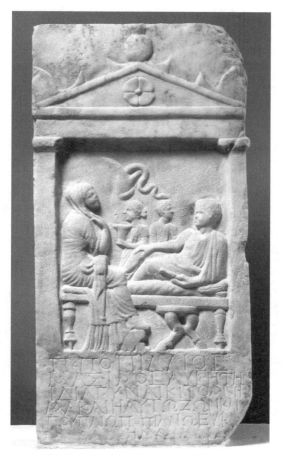

Fig. 23. Grave stele, Archaeological Museum of
Thessaloniki, inv. 11037. Photo: Makis Skiadaressis.
Photoarchive ΑΓΜΕ: Museum of Casts of the
University of Thessaloniki, no. 39.

reliefs of the West, passed from the West to Macedonia[49] and Asia Minor.[50]
Korkut has recently stressed, however, that the frontal depiction of a partial
figure has older roots in the territory of Asia Minor and that this artistic
tradition passed gradually from Hellenistic reliefs to those of the imperial

[49] See Spiliopoulou-Donderer, *Kaiserzeitliche Grabaltäre Niedermakedoniens*, 32.
[50] See Cremer, *Mysien*, 93.

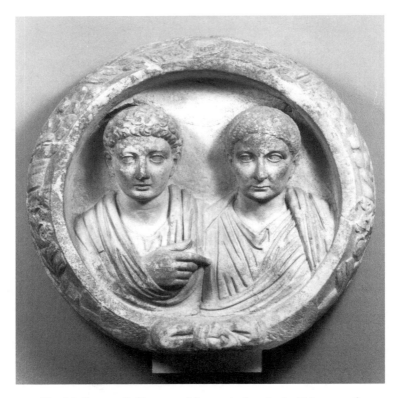

Fig. 24. Grave relief in a round frame, Archaeological Museum of
Thessaloniki, inv. 60. Photo: Makis Skiadaressis. Photoarchive ΑΓΜΕ:
Museum of Casts of the University of Thessaloniki, no. 109.

age.[51] Setting aside the question of the origin of these depictions, I note that
in reliefs from Macedonia, the partial figures coexist with Hellenistic motifs
of heroization (funeral banquet, horseman). This observation holds true
of the reliefs from northwestern Asia Minor, which often have a similar
arrangement within superimposed fields.[52]

Reliefs that occur in monumental size composed of several slabs with
complete standing or seated figures (fig. 26) have raised a similar set of
issues. In the scholarship on late Hellenistic and early imperial funerary
monuments in Macedonia, this relief type has often been compared to
the grave monuments of freedmen at Rome, which are similar in form

[51] Korkut, "Überlegungen." See Stefanidou-Tiveriou, "Ioanna Spiliopoulou-Donderer," 634.

[52] Cremer, *Mysien,* 27–28, 93–101, 107–12; eadem, *Bithynien,* 15–35.

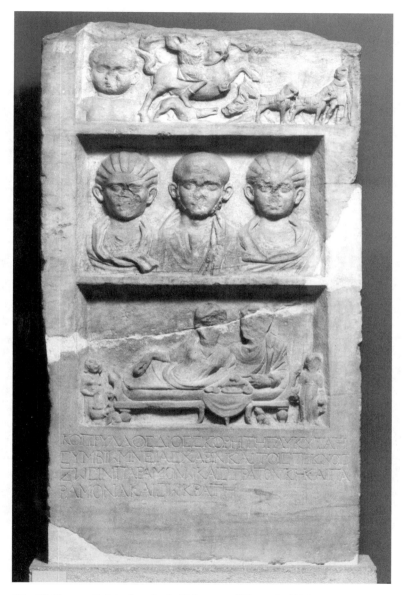

Fig. 25. Grave relief, Archaeological Museum of Thessaloniki, inv. 1523. Photo: Makis Skiadaressis. Photoarchive ΑΓΜΕ: Museum of Casts of the University of Thessaloniki, no. 85.

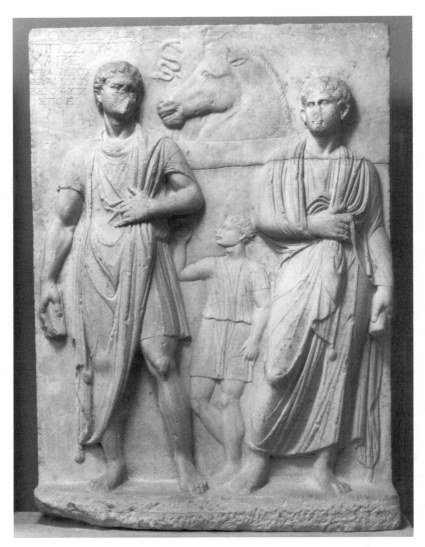

Fig. 26. Relief slab from a grave monument, Archaeological Museum of
Thessaloniki, inv. 1935 B. Photo: Makis Skiadaressis. Photoarchive ΑΓΜΕ:
Museum of Casts of the University of Thessaloniki, no. 80.

and appear in the first century B.C.E.[53] Doubts regarding this comparison have been expressed, however, because of the early date of certain of the Macedonian examples.[54] Moreover, the types of figures depicted stand firmly in the Hellenistic tradition and do not constitute evidence for any sort of Roman influence.

One particularly significant monument, now in Istanbul but originally from Thessaloniki (fig. 27), also stands in this tradition and belongs to the category.[55] Although this monument was published long ago, contemporary scholarship has not recognized its importance.[56] This 3.05 meter-long relief contains a composition with the hero-horseman as its central figure, which constitutes a common theme in the Balkans and Asia Minor.[57] We do not know what sort of monumental construction would have held these relief slabs but consider as a possibility the altar-shaped constructions which are very common in the cemeteries of Thessalonikē; in certain cases they are as long as 4 m.[58] Such constructions have as far as we know no relationship to western models.

The so-called "Macedonian altars" (fig. 28) appear in Thessalonikē around 130 C.E., contemporary with the sarcophagi, and form another category of funerary monuments.[59] As in other cities of Macedonia, altars and sarcophagi are among the most common types of funerary monuments in the second and third centuries. Spiliopoulou-Donderer recently asserted that the Macedonian altars corresponded to monuments in northern Italy dating to the first century C.E.[60] More convincing, however, is the argument that these Macedonian monuments—which, unlike the Italian ones, are monolithic—have a much closer typological kinship with altars from Asia Minor,[61] for example, from Bithynia. Their relief depictions, which have nothing in common with those of their supposed western parallels but instead reproduce customary motifs

[53] See Voutiras in *Κατάλογος γλυπτών*, no. 54 with n. 2.

[54] Allamane and Tzanavare, "Τα υστεροελληνιστικά εργαστήρια," 56 with n. 47.

[55] Mendel, *Musées Impériaux Ottomans*, 2, no. 492; Budde, "Istanbuler Reiterrelief," with figs. 1–13.

[56] See Koukouli-Chysanthaki, "Heros Equitans," 1053 no. 469, 1071, which adheres to Bernard Holzmann's view that this slab is a dedicatory relief.

[57] See Koukouli-Chysanthaki, *Lexicon Iconographicum Mythologiae Classicae*.

[58] See Stefanidou-Tiveriou, "Εντοιχισμένα ταφικά ανάγλυφα," 394.

[59] Spiliopoulou-Donderer, *Kaiserzeitliche Grabaltäre Niedermakedoniens*, 32; Adam-Velenē, *Μακεδονικοί βωμοί*, 57–58 with n. 242.

[60] See Spiliopoulou-Donderer, *Kaiserzeitliche Grabaltäre Niedermakedoniens*, 20–22.

[61] See Adam-Velenē, *Μακεδονικοί βωμοί*, 57–58 with n. 242. For a discussion of this issue, see Stefanidou-Tiveriou, "Ioanna Spiliopoulou-Donderer," 632–33 n. 3.

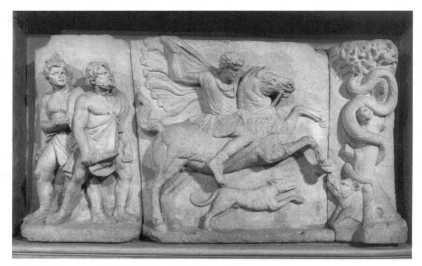

Fig. 27. Large relief from Thessaloniki now in Istanbul, Archaeological Museum, Mendel no. 492. Photo: D. Johannes. DAI Istanbul Neg. Nr. R 30.457.

known from earlier and contemporary funerary monuments of Macedonia and Asia Minor, further support the argument for an eastern origin.

Nevertheless, the appearance of a preeminently western phenomenon among the depictions on the funerary monuments of Thessalonikē and of Macedonia should not pass without comment. The so-called "deifications" — or better, theomorphic representations — present the deceased in the guise of a god or hero, such as Aphrodite, Artemis (fig. 29), Hermes, or Herakles. Deifications of this sort, influenced by corresponding depictions of the imperial house, appear in monuments of private individuals in the West from the time of Nero.[62] In the eastern provinces of the Roman Empire, this practice did not find fertile ground in the private sector, except in Macedonia where it appears from the beginning of the second century C.E. and occurs in all categories of funerary monuments.[63] This deification phenomenon constitutes a distinctive element of Romanization in the funerary monuments of Macedonia.

In sum, the continuation of the Hellenistic tradition is evident in the funerary monuments of Thessalonikē but, at the same time, so is their

[62] For a detailed study of this phenomenon see Wrede, *Consecratio in formam deorum*. The most recent survey of the subject is by Karanastassi in *Thesaurus cultus*, 2:203–4. For the term theomorphic representation see Bergmann, *Strahlen*, 38–39.

[63] Voutiras in "Aphrodite Nymphia" also discusses the meaning of the term "deification."

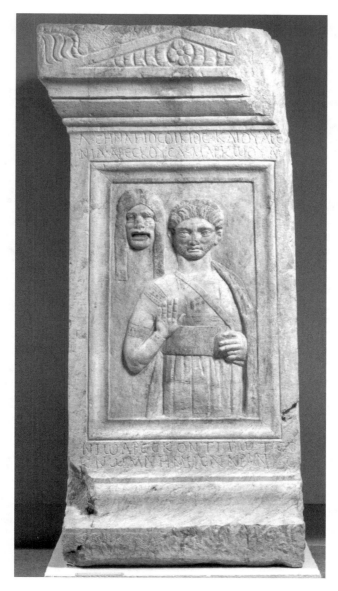

Fig. 28. Grave altar, Archaeological Museum of Thessaloniki, inv. 9815. Photo: Makis Skiadaressis. Photoarchive ΑΓΜΕ: Museum of Casts of the University of Thessaloniki, no. 7A.

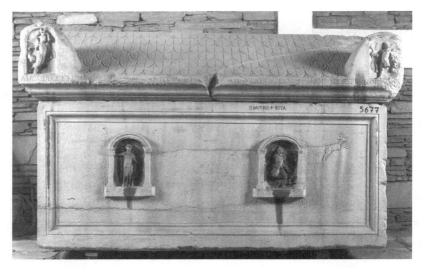

Fig. 29. Sarcophagus, Archaeological Museum of Thessaloniki, inv. 5677. Photo:
Valtin von Eickstedt. Archive of the "Sarkophagcorpus," Marburg.

relationship to the contemporary monuments of Asia Minor. The latter represent the closest typological parallels for most of the categories of Macedonian funerary monuments and particularly for sarcophagi. I cannot explain the clear orientation toward the types of monuments found in Asia Minor in purely commercial/economic terms, but look instead for a deeper cause, which I seek among those persons who possessed and commissioned the sarcophagi and the city's funerary monuments.

SOCIAL STATUS OF THE SARCOPHAGI OWNERS

We should therefore pose the question about the particular preferences shown by the buyers of sarcophagi in Thessalonikē. Some of them paid considerable sums to acquire imported Attic products (fig. 4) during the entire period of their manufacture from the age of Hadrian to around 260 C.E. The financial resources of these buyers, which allowed them to advertise themselves and their families by means of exceptionally lavish monuments, were a prerequisite for their selections. Most likely, however, the inclination to display wealth by means of these Attic monuments and their high artistic value was not the only factor that led people to order them. Were this the case, less affluent buyers would have wanted to acquire local imitations of the genuine Attic

article at lower prices, as happened in other places.[64] The ordering of an Attic sarcophagus, at least in a Greek city of the Roman Empire, presupposed not only financial resources but also the buyer's interest in and understanding of the mythological and allegorical depictions. This presupposition would hold true also in the case of subjects rare or even unique among Attic sarcophagi, for example, in the depiction of Iphigenia among the Taurians, which until now is known only in one example from Thessaloniki.[65] The buyers could specify in advance the subject that would adorn their monument. They must, then, have attained an education in Greek culture and have come either from the local elite or from the circle of upper-level Roman government officials. Thus the great Dionysiac sarcophagus at Thessaloniki (fig. 4) belonged to Poplia Antia Demokratia, daughter of the provincial governor of Thrace, according to the inscription carved on the molding of its base.[66]

The social strata of the population that had resources for purchasing sarcophagi, however, preferred local products.[67] One such locally produced sarcophagus from the early third century interred one of the age's most famous and wealthy residents of Thessalonikē, T. Aelius Geminius, who once served as president of the Attic Panhellenion.[68] Mariniane Pantonike and Philippos both were buried in similar sarcophagi (fig. 7). They probably belonged to the same Mariniani family, which was an important one among the local urban elite and in the province of Macedonia.[69] Local officials were likewise interred in locally made monuments; the politarch (municipal magistrate) Aristarchos had a garland sarcophagus, and the councilor Claudius Lycus had a simple sarcophagus, which bore a depiction of a funeral banquet.[70] Annia Tryphaina, a prominent woman of Thessalonikē and perhaps

[64] For this phenomenon more generally, see Koch and Sichtermann, *Römische Sarkophage*, 470–75. See also recently Papagianni, "Der Sarkophag in Preveza." This phenomenon has in fact been observed at Thessalonikē as well, but on an extremely limited scale. See n. 12, above.

[65] See Stefanidou-Tiveriou, "Iphigenie in Aulis."

[66] For the inscription, see Castritius,"Die Sockelinschrift." For the sarcophagus see Matz, *Die dionysischen Sarkophage*, 112–16, no. 11.

[67] For this subject, see Nigdelis in the forthcoming volume of Sarkophag-Studien 7.

[68] Edson, *Inscriptiones Thessalonicae* (= *IG* X/2.1): no. 628 plate 14.

[69] For Mariniane Pantonike, see Koch and Sichtermann, *Römische Sarkophage*, 352, fig. 386. For the family of the Mareinianoi (Mariniani), see most recently Nigdelis, *Επιγραφικά Θεσσαλονίκεια*, 274–76 no. 2; for Philippos: Edson, *Inscriptiones Thessalonicae* (= *IG* X/2.1): no. 549; Koch, *Sarkophage der römischen Kaiserzeit*, 352 n. 73, 356 with n. 144, fig. 387; Stefanidou-Tiveriou, "Kleinasiatische Einflüsse," 119 with n. 42, 122, plate 27,4.

[70] Aristarchos: Edson, *Inscriptiones Thessalonicae* (= *IG* X/2.1): no. 848; Stefanidou-Tiveriou, "Kleinasiatische Einflüsse," 119 with n. 50, plate 29,2; for Claudius Lykos, see Themelis, "Η σαρκοφάγος του Τιβερίου," plates 1–4.

a priestess of Isis, ordered a locally made sarcophagus for herself and her family with an unusual depiction based on the iconographical tradition of the hero-horseman.[71] The owner herself is duly displayed and depicted frontally in the middle of the composition.

The majority of sarcophagi, however, belonged to persons lower in the social hierarchy, who belonged to the *plebs urbana*. By this expression I mean professionals, merchants, Roman government functionaries, army officers, and simple soldiers, as well as persons connected with public spectacles. A fair number of these monuments belonged to freedmen,[72] although the owners' names do not always allow us to distinguish their legal status. Rarely, slaves owned sarcophagi when their paid employment provided them with the funds to order the costly monuments.[73]

The majority of those who ordered sarcophagi preferred the framed type of sarcophagus, one of which carries its own characterization in its inscription as "a simple tomb" (λειτὸς τάφος).[74] These monuments, indeed simple but at the same time also imposing, suited the monumental inscriptions by means of which their owners could advertise themselves.[75] The great *tabula* created by the frame of the sarcophagus or the plain surface of the simpler type of chest gave the sarcophagus the potential to record something about the deceased, even if the sarcophagus did not stand together with other monuments in some enclosure or funerary edifice. Small reliefs, sometimes added to the inscription, can bear messages, which complement the inscription; for example, they can refer to the profession of the deceased.

Garland sarcophagi appealed to a significant number of buyers but (with the exception of those with *tabulae*) did not offer the option of recording information. Their popularity derived from their broader symbolism, long recognized in the Hellenistic world, connected to religious practice and the cult of the dead, and easily grasped by the general public.[76] In these cases the

[71] For this sarcophagus, see Lagogianni-Georgakarakos, *Grabdenkmäler*, no. 66.; a detailed recent treatment is presented by Stefanidou-Tiveriou, "Der Annia Tryphaina Sarkophag."

[72] Edson, *Inscriptiones Thessalonicae* (= *IG* X/2.1): no. 839.

[73] Nigdelis, *Ἐπιγραφικά Θεσσαλονίκεια*, 224–30 no. 2; he also makes reference to the ability of slaves to acquire funerary monuments.

[74] Nigdelis, *Ἐπιγραφικά Θεσσαλονίκεια*, 374–75 no. 6.

[75] Stefanidou-Tiveriou, "Kleinasiatische Einflüsse," 122 with n. 75; this article also discusses comparable monuments from northwestern Asia Minor.

[76] For the meaning of garlands in the ancient world generally and especially in the cult of the dead, see Turcan, "Les guirlandes." See Herdejürgen, *Stadtrömische und italische Girlandensarkophage*, 1:25 n. 89.

owner would have recorded the necessary family information on some other monument within the grave enclosure or in the family ἡρῷον.[77]

ORIGIN OF THE SARCOPHAGUS OWNERS

The owners of locally made sarcophagi came from different levels of society with varying monetary assets. What common denominator among them led to their shared preference for their city's simple monuments when the wealthy among them could have afforded more elaborate ones? The fact that an overwhelming majority of sarcophagus owners (approximately 80 percent) came from the class of *cives Romani* (Roman citizens)[78] cannot suffice as a common denominator. That the buyers showed no interest in western products, such as sarcophagi from the metropolitan workshops of Rome, however, does constitute one common element. This element of absence of Roman products parallels the rarity of the use of the Latin language in funerary inscriptions. Even so, we know that Italians had emigrated to Thessalonikē already in the second century B.C.E. Because of the city's importance, a large and active Italian community of *negotiatores* (businessmen) migrated there.[79] We should therefore expect to see influences if not imports as well from Italy. Although scholars still debate this issue, we could connect the medallion relief type mentioned earlier (fig. 24) with Italian families from northern Italy.[80] We note at least that the appearance of this type in the first century C.E. coincides with the period of greatest growth of Thessalonikē's Roman community.[81]

I suggest yet another explanation for the common preference of the Thessalonians for locally produced sarcophagi. By studying Roman onomastics in the inscriptions of Macedonia from the imperial period, Salomies tied more than 200 *nomina* in the province of Macedonia to corresponding names found in the province of Asia.[82] Among them he found a large number

[77] In addition, a fair number of framed sarcophagi have no inscriptions, so that we must envision them functioning within a broader semantic context. It is not impossible that these sarcophagi once had painted inscriptions (suggested by Nigel M. Kennell, personal communication, April 2007).

[78] An onomastic study has shown this fact; see Nigdelis in the forthcoming volume of Sarkophag-Studien 7.

[79] See Rizakis, "Η κοινότητα"; idem, "L'émigration romaine," esp. 118, 125 (for Thessaloniki).

[80] For Roman *nomina* in Macedonia which likely originated in northern Italy, see Salomies, "Contacts," esp. 121–24.

[81] Rizakis, "Η κοινότητα," 517.

[82] Salomies, "Contacts," 111–27.

of uncommon *nomina*, and that fact confirms this connection. Names in Macedonian cities thus match names in the Asia Minor cities of Thyatira, Pergamon, Smyrna, Ephesos, Cyme, Amastris, Abydus, Lampsacus, and Nicomedia. As the largest and most flourishing city in northwestern Asia Minor, Cyzicus receives particular mention from Salomies.[83] Of all the cities, Cyzicus presents the most names that parallel those in Macedonia.

A high percentage of the owners of Thessalonikē's sarcophagi are of Greek origin,[84] and their names confirm this observation. Both those with imperial *nomina* and those with non-imperial *nomina* come mostly from various areas of the eastern part of the Empire and especially from Asia Minor.[85] The inscriptions rarely refer to the origin of individuals, and the case of Demas son of Euktemon, who characterizes himself as Νεικομηδεύς (fig. 30), proves unusual.[86] *Gentilicia* (names indicating affiliation with a particular *gens*, "clan") such as Atellii, Calvinii, Carvilii, Castricii, Elvii, and Marinianii, however, show ties with cities in Asia Minor.[87] I could not pretend that in every single case we should search for a direct link between the type of sarcophagus or cinerary urn and its owner's place of origin. Yet the fact that Castricia Epigone used an Ephesian type of urn for her son and her siblings (fig. 19) does not appear accidental, since most of the persons of the Castricii of the East appear in inscriptions from Ephesos. That the Castricii of Thessalonikē emigrated to that city from Ephesos or at least had relatives there appears reasonable.[88] A

[83] Ibid., 125–27; Rizakis, "L'émigration," 129–30, 132.

[84] See Nigdelis in the forthcoming volume of the Sarkophag-Studien 7.

[85] For individuals and families represented on Thessaloniki's funerary monuments who were from the cities of the East, see Nigdelis, *Επιγραφικά Θεσσαλονίκεια*, 249–53 no. 7; 274–76 no. 2; 287–89 no. 6; 302–8 no. 11; 328–31 no. 18.

[86] Edson, *Inscriptiones Thessalonicae* (= *IG* X/2.1): no. 826; Koch and Sichtermann, *Römische Sarkophage*, 352 with nn. 74; 78; 83; 355 with n. 126; 356 with n. 150, figs. 380–81. On another sarcophagus *IG* X/2.1.565 plate 14, now lost, the *cognomen* of Ioulia Bithynia likely alludes to some connection with Bithynia. On the probable relationship of the family of the Rouvvii, known from a funerary stele from Thessaloniki, with Nicomedia, see Nigdelis, *Επιγραφικά Θεσσαλονίκεια*, 287–89 no. 6.

[87] The above mentioned *gentilicia* are found in the inscriptions of the sarcophagi: Archaeological Museum Thessaloniki inv. nos. P 72 (*IG* X/2.1.544); 5679 (*IG* X/2.1.538); now lost (*IG* X/2.1.580); 2194 (and 6118) (Nigdelis, *Επιγραφικά Θεσσαλονίκεια*, 302 no. 11); now lost (Feissel and Sève, *Inscriptions de Macédoine*, 460 no. 16); 5707 (Nigdelis, *Επιγραφικά Θεσσαλονίκεια*, 274 no. 2).

[88] For the Ephesian-type cinerary urn of Castricia Epigone, see Nigdelis, *Επιγραφικά Θεσσαλονίκεια*, 302–8 no. 11, who mentions Ephesos as one of the more likely places from which the Castricii may have come.

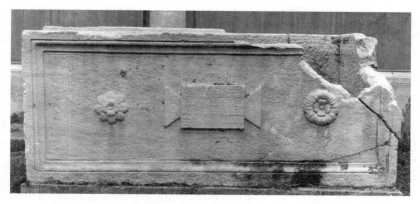

Fig. 30. Sarcophagus, Archaeological Museum of Thessaloniki, inv. 1833. Photo: Guntram Koch. Archive of the "Sarkophagcorpus," Marburg.

family of Italians from Salona of the *gens Valeria*, however, also made use of a framed sarcophagus with a large inscription.[89]

The abundant presence of families from the cities of the East created a favorable context at Thessalonikē—and throughout Macedonia—for the adoption of eastern-style sarcophagi. This becomes obvious from the moment the workshops began to produce this category of funerary monuments in the latter part of the reign of Hadrian around 130 C.E. It seems likely that among the foreign immigrants, specialized craftsmen, who had contributed to the development of these types in the city's workshops, arrived in response to the demand. Accordingly, it is not accidental that the dominant type of sarcophagus at Thessaloniki, namely the sarcophagus with a frame and monumental inscription, which responds to the demands of a large number of Thessalonikē's residents, shows an exceptional similarity in its general appearance to analogous monuments in Asia Minor and especially to those of the city of Cyzicus (fig. 31). In fact Cyzicus is the city whose *nomina* provide more parallels to those of Macedonia than any other.[90]

It is obvious that the archaeological data that emerge from studies of the sarcophagi and the other marble funerary monuments in Thessalonikē are in agreement with the information provided by the study of the names in the inscriptions.

[89] Edson, *Inscriptiones Thessalonicae* (= *IG* X/2.1): no. 554. Edson and Daux, "*IG* X/2.1," 533, fig. 3; 549.

[90] The sarcophagi of Cyzicus are insufficiently studied: for some examples see Stefanidou-Tiveriou, "Kleinasiatische Einflüsse," 122 with n. 75; for names common to Cyzicus and Macedonia, see Salomies, "Contacts," 126–27. See Nigdelis, *Ἐπιγραφικά Θεσσαλονίκεια*, 330–31.

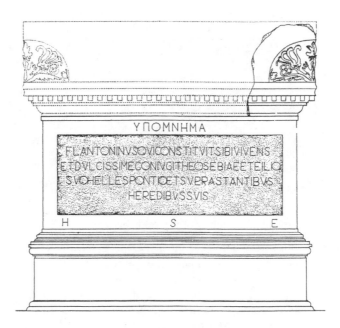

Fig. 31. Sarcophagus from Cyzicus. Stefanidou-Tiveriou,
"Kleinasiatische Einflüsse," fig. 32.

CONCLUSION

The funerary monuments of ancient Thessalonikē thus suggest, on the one
hand, that a large and economically strong section of the city's population
came from Asia Minor. This population, moreover, maintained familial and
cultic relations between the cities of Macedonia and those of Asia Minor.[91]
The Italians of Thessalonikē, on the other hand, adapted on a large scale
to local conditions and did not import significant western elements. This
adaptation of the Romans to eastern models holds true even more from the
second century C.E. onward when the communities of Roman citizens in
the Greek-speaking East disappeared. The Roman *negotiatores*, who had
remained in Thessalonikē on a permanent basis, apparently assimilated into
the city's eastern-style public and private life.[92]

[91] Rizakis, "L'émigration," 130 n. 104.
[92] Rizakis, "κοινότητα," 516–24.

BIBLIOGRAPHY

Adam-Velenē, Polixenē. *Μακεδονικοί βωμοί* (Macedonian Altars). Athens: Tameio Archaiologikōn Porōn kai Apallotriōseōn, Dieuthynsē, Dēmosieumatōn, 2002.

Allamane, Victoria and Katerina Tzanavare. "Τα υστεροελληνιστικά εργαστήρια της Βέροιας" (The Late Hellenistic Workshops in Beroia). Pages 45–75 in *Ancient Macedonia: Sixth International Symposium held in Thessaloniki, October 15–19, 1996.* 2 vols. Thessaloniki: Institute for Balkan Studies, 1999.

Asgari, Nuşin. "Objets de marbre finis, semi-finis et inachevés du Proconnèse." Pages 107–26 in *Pierre éternelle du Nil au Rhin. Carrières et préfabrication.* Edited by Marc Waelkens. Brussels: Crédit communal, 1990.

———. "Die Halbfabrikate kleinasiatischer Girlandensarkophage und ihre Herkunft." *AA* (1977) 329–79.

Asgari, Nuşin and Nezih Firatli. "Die Nekropole von Kalchedon." Pages 1–92 in *Studien zur Religion und Kultur Kleinasiens. Festschrift für Friedrich Karl Dörner zum 65. Geburtstag am 28. Februar 1976.* Leiden: Brill, 1978.

Bergmann, Marianne. *Die Strahlen der Herrscher. Theomorphes Herrscherbild und politische Symbolik im Hellenismus und in der römischen Kaiserzeit.* Mainz: von Zabern, 1998.

Böhlig, Gertrud. *Ioannis Caminiatae de expugnatione Thessalonicae.* Berlin: de Gruyter, 1973.

Budde, Ludwig. "Istanbuler Reiterrelief." *Belleten* 17 (1953) 475–82.

Castritius, Helmut. "Die Sockelinschrift eines attischen Sarkophags." *AA* (1970) 97–98.

Clarke, Edward Daniel. *Travels in Various Countries of Europe, Asia and Africa.* 4th ed. 8 vols. London: Cadell and Davies, 1817–1824.

Conze, Alexander. *Reise auf den Inseln des Thrakischen Meeres.* Hannover: Ruempler, 1860. Repr., Amsterdam: Hakkert, 1986.

Cremer, Marielouise. *Mysien.* Vol. 1 of *Hellenistisch-römische Grabstelen im nordwestlichen Kleinasien.* Asia Minor Studien 4. Bonn: Habelt, 1991.

———. *Bithynien.* Vol. 2 of *Hellenistisch-römische Grabstelen im nordwestlichen Kleinasien.* Asia Minor Studien 4. Bonn: Habelt, 1991.

Edson, Charles, ed. *Inscriptiones Thessalonicae et viciniae* [= *IG* X/2.1]. Berlin: De Gruyter, 1972.

——— and George Daux. "*IG* X,2.1 Prolegomena, epilegomena." *BCH* 98 (1974) 521–52.

Feissel, Denis and Michèle Sève. "Inscriptions de Macédoine." *BCH* 112 (1988) 449–66.

Friesinger, Herwig and Fritz Krinzinger, eds. "Kaiserzeitliche Sarkophage in Ephesos." Pages 555–63 in *100 Jahre österreichische Forschungen in Ephesos. Akten des Symposions Wien 1995.* Archäologische Forschungen 1. Vienna: Österreichische Akademie der Wissenschaften, 1999.

Gabelmann, Hans. "Zur Tektonik oberitalischer Sarkophage, Altäre und Stelen." *BoJ* 177 (1977) 215–44.

———. "Die Typen der römischen Grabstelen am Rhein." *BoJ* 172 (1972) 65–140.

Herdejürgen, Helga. *Stadtrömische und italische Girlandensarkophage.* Die antiken Sarkophagreliefs 6.2.1. Berlin: Mann, 1996.

Ioakimidou, Chrissoula. Nos. 309, 310–12, 314–15, 322–25 in *Κατάλογος γλυπτών του Αρχαιολογικού Μουσείου Θεσσαλονίκης* (Catalogue of Sculpture in the Archaeological Museum of Thessaloniki). Vol. 2. Edited by Giorgios Despinis, Theodosia Stefanidou-Tiveriou, and Emmanouil Voutiras. Thessaloniki: National Bank Cultural Foundation, 2003.

Ioakimidou-Kontsé, Chrissoula. "Die Grabmedaillons der römischen Kaiserzeit aus Ostmakedonien." *Spartacus* 2 (2002) 121–26.

Kammerer-Grothaus, Helke. "Ollaria. Eine stadtrömische Bestattungsform der frühen Kaiserzeit." *RömMitt* 112 (2005–2006) 385–97.

Karanastassi, Paulina. "Zur Ikonographie der römischen Apotheose." Pages 2:199–204 in *Thesaurus cultus et rituum antiquorum*. 5 vols. Los Angeles: Getty Museum; Basel: Fondation pour le *LIMC*, 2004.

Koch, Guntram. *Sarkophage der römischen Kaiserzeit*. Darmstadt: Wissenschaftliche Buchgesellschaft, 1993.

——— and Hellmut Sichtermann. *Römische Sarkophage*. Handbuch der Archäologie 34. Munich: Beck, 1982.

Korkut, Taner. "Überlegungen zum Aufkommen der Halbfiguren auf kleinasiatischen Grabstelen vom Hellenismus bis zur römischen Kaiserzeit." *Adalya* 4 (1999–2000) 181–88.

Koukouli-Chysanthaki, Haido. "Heros Equitans." Pages 6:1019–81 in *LIMC*. 9 vols. Zürich: Artemis, 1992.

Lagogianni-Georgakarakos, Maria. *Die Grabdenkmäler mit Porträts aus Makedonien*. Corpus signorum imperii Romani, Griechenland 3,1. Athens: Akademie von Athen, 1998.

Leake, William Martin. *Travels in Northern Greece*. 4 vols. London: Rodwell, 1835. Repr., Amsterdam: Hakkert, 1967.

Matz, Friedrich. *Die dionysischen Sarkophage*. Die antiken Sarkophagreliefs 4.1. Berlin: Mann, 1968.

Mendel, Gustave. *Musées impériaux Ottomans. Catalogue des sculptures grecques, romaines et byzantines*. 3 vols. Constantinople: Musée impérial, 1912–1914.

Mercky, Annette. *Römische Grabreliefs und Sarkophage auf den Kykladen*. Europäische Hochschulschriften. Reihe 38; Archäologie 55. Frankfurt: Lang, 1995.

Nigdelis, Pantelis M. *Επιγραφικά Θεσσαλονίκεια. Συμβολή στην Πολιτική και Κοινωνική Ιστορία της Αρχαίας Θεσσαλονίκης* (Epigraphica Thessalonicensia. Contribution to the Political and Social History of Ancient Thessalonikē). Thessaloniki: University Studio Press, 2006.

Papagianni, Eleni. "Der Sarkophag in Preveza. Nachahmungen attischer Sarkophage in Nikopolis." Forthcoming in *Colloque international. Les sarcophages romaines. Centre et périphéries, 3–5 novembre 2005*. Edited by François Barratte and Guntram Koch.

———."Der Eroten-Sarkophag Inv. 1284 des Archäologischen Museums in Thessaloniki." Pages 187–92 in *Akten des Symposiums des Sarkophagcorpus, 2.–7. Juli 2001*. Edited by Guntram Koch. Mainz: von Zabern, 2007.

———."Αττικές σαρκοφάγοι στη Θεσσαλονίκη: οι πρώιμες εισαγωγές και οι επιδράσεις στην τοπική παραγωγή" (Attic Sarcophagi in Thessalonikē: Early Imports and Influences on Regional Production). *Εγνατία* 12 (2008) 179–93.

Rebecchi, Fernando. "Cronologia e fasi di fabbricazione dei sarcofagi pagani dell' officina di Ravenna." *StudRomag* 29 (1978) 249–66.

Rizakis, Athanasios D. "L'émigration romaine en Macédoine et la communauté marchande de Thessalonique." Pages 109–32 in *Les Italiens dans le monde grec. Actes de la table ronde, Paris 14–16 Mai 1998*. Edited by Christel Muller and C. Hasenohr. BCHSup 41. Paris: École française d'Athènes, 2002.

————. "Η κοινότητα των «συμπραγματευομένων Ρωμαίων» της Θεσσαλονίκης" (The Community of the "Roman *negotiatores*" in Thessaloniki). Pages 511–24 in *Ancient Macedonia, Fourth International Symposium held in Thessaloniki, September 21–25, 1983*. Thessaloniki: Institute for Balkan Studies, 1986.

Salomies, Olli. "Contacts between Italy, Macedonia and Asia Minor during the Principate." Pages 111–27 in *Roman Onomastics in the Greek East: Social and Political Aspects, Proceedings of the International Colloquium organized by the Finnish Institute and the Center for Greek and Roman Antiquity, Athens 7–9 September 1993*. Edited by Athanasios D. Rizakis. Meletimata 21. Athens: Kentron Hellēnikēs kai Rōmaikēs Archaiotētos, Ethnikon Hidryma Ereunōn. Paris: de Boccard, 1996.

Spiliopoulou-Donderer, Ioanna. *Kaiserzeitliche Grabaltäre Niedermakedoniens*. Peleus 15. Mannheim: Bibliopolis, 2002.

Stefanidou-Tiveriou, Theodosia. "Der Annia Tryphaina Sarkophag. Heroisierung und Selbstdarstellung." In *Symposium des Sarkophag-Corpus, Marburg, 3.–8. Juli 2006*. Edited by Guntram Koch. Mainz: von Zabern, forthcoming.

————. "Εντοιχισμένα ταφικά ανάγλυφα στη Θεσσαλονίκη" (Intramural Grave Structures in Thessalonikē). Pages 387–403 in *Κερμάτια φιλίας. Τιμητικός τόμος για τον Ιωάννη Τουράτσογλου (Tokens of Friendship: A Volume in Honour of Ioannis Touratsoglou)*. Edited by Stella Drougou et al. Athens: Numismatic Museum, 2009.

————. "Thasian Marble: A Connection Between Thasos and Thessaloniki." Pages 19–29 in *Asmosia VII: 7th International Conference, Thassos, Greece, 15–20 September 2003*. Edited by Yiannis Maniatis. BCHSup 51. Paris: École française d'Athènes, 2009.

————. "Ioanna Spiliopoulou-Donderer, Kaiserzeitliche Grabaltäre Niedermakedoniens." *Gn* 78 (2006) 631–36.

————. "Girlandensarkophage nach aphrodisiasischen Vorbildern in Thessaloniki." Pages 711–18 in *Anadolúda Doğdu. Festschrift für Fahri Işik zum 60. Geburtstag*. Edited by Taner Korkut. Istanbul: Ege Yayınları, 2004.

————. "Kleinasiatische Einflüsse bei römischen Sarkophagen in Makedonien." Pages 115–23 in *Griechenland in der Kaiserzeit: Neue Funde und Forschungen zu Skulptur, Architektur und Topographie. Kolloquium zum sechzigsten Geburtstag von Prof. Dietrich Willers Bern, 12.–13. Juni 1998*. Edited by Christoph Reusser. Hefte des archäologischen Seminars der Universität Bern. Beiheft 4. Bern: Institut für Klassische Archäologie der Universität Bern, 2001.

————. "Iphigenie in Aulis. Ein neuer Mythos im Repertoire der attischen Sarkophage." Pages 216–39 in *Akten des Symposiums "125 Jahre Sarkophag-Corpus," Marburg, 4.–7. Oktober 1995*. Edited by Guntram Koch. Mainz: von Zabern, 1998.

———— with epigraphic contribution by Pantelis Nigdelis. *Local Sarcophagi of Thessaloniki*. Sarkophag-Studien 7; German Archaeological Institute in Berlin. Mainz: von Zabern, forthcoming.

Themelis, Petros G. "Η σαρκοφάγος του Τιβερίου Κλαυδίου Λύκου βουλευτού" (The Sarcophagus of Councillor Tiberius Claudius Lycus). *Makedonika* 5 (1961/63) 438–47.

Θεσσαλονίκη. *Από τα προϊστορικά μέχρι τα χριστιανικά χρόνια* (Thessalonikē. From the Prehistoric until the Christian Age). Athens: Tameio Archaiologikōn Porōn kai Apallotriōseōn, 1986.

Thomas, Christine M. and Cengiz Içten. "The Ephesian Ossuaries and Roman Influence on the Production of Burial Containers." Pages 549–54 in *100 Jahre österreichische Forschungen in Ephesos. Akten des Symposions Wien 1995*. Edited by Herwig Friesinger and Fritz Krinzinger. Archäologische Forschungen 1. Vienna: Österreichische Akademie der Wissenschaften, 1999.

Turcan, Robert. "Les guirlandes dans l'antiquité classique." *JAC* 14 (1971) 92–139.

Voutiras, Emmanuel. "Aphrodite Nymphia." Pages 107–8 in *Griechenland in der Kaiserzeit. Kolloquium zum sechzigsten Geburtstag von Prof. Dietrich Willers Bern, 12.–13. Juni 1998*. Edited by Christoph Reusser. Hefte des archäologischen Seminars der Universität Bern. Beiheft 4. Bern: Institut für Klassische Archäologie der Universität Bern, 2001.

———. Nos. 123, 126 in *Κατάλογος γλυπτών του Αρχαιολογικού Μουσείου Θεσσαλονίκης* (Catalogue of Sculpture in the Archaeological Museum of Thessaloniki). Vol. 1. Edited by Giorgios Despinis, Theodosia Stefanidou-Tiveriou, and Emmanouil Voutiras. Thessaloniki: National Bank Cultural Foundation, 1997.

Waelkens, Marc. *Dokimeion. Die Werkstatt der repräsentativen kleinasiatischen Sarkophage. Chronologie und Typologie ihrer Produktion*. Archäologische Forschungen 11. Berlin: Mann, 1982.

Walde, Elisabeth. "Bemerkungen zu den freistehenden Grabmedaillons in Noricum." Pages 131–39 in *The Proceedings of the 8th International Colloquium on Problems of Roman Provincial Art, Zagreb 5.–8.5.2003*. Zagreb: Golden Marketing tehnička knjiga, 2005.

Ward-Perkins, John Bryan. "Dalmatia and the Marble Trade." *Disputationes Salonitanae* 1970 (1975) 38–44.

Wrede, Henning. *Consecratio in formam deorum. Vergöttlichte Privatpersonen in der römischen Kaiserzeit*. Mainz: von Zabern, 1981.

Second Thessalonians, the Ideology of Epistles, and the Construction of Authority: Our Debt to the Forger

Steven J. Friesen

Approximately 200 years ago, Johannes E. C. Schmidt first proposed that 2 Thessalonians was not written by Paul.[1] His argument has been supported by some scholars and denounced by others. In this paper I accept the accumulated evidence against Pauline authorship and go on to examine some of the implications of this evidence for our understanding of the authority of epistles in the early churches. I argue that 2 Thessalonians is distinctive among the alleged Pauline writings and is best described as a forgery. The author's efforts to make 2 Thessalonians appear to be Pauline illuminate the process by which written traditions came to dominate oral traditions as sources of authority in the early churches as the churches shifted from a mainstream ideology of letters to a sectarian ideology of letters.[2] I defend this position first by adapting for my own purposes a theoretical framework proposed by Martin Jaffee. Next, I survey the issues of oral and written authority in an analogous collection of texts: 1 and 2 Corinthians and *3 Corinthians*. Finally, I return to 2 Thessalonians to examine its particular mode of appropriating Pauline literary characteristics.

[1] Schmidt, "Vermuthungen," 380–86; cited in Hughes, "Thessalonians," 111–16.

[2] Merz, "Fictitious Self-Exposition of Paul," esp. 130–32. In this sense, I pursue Merz's challenge to take fictitious authorship seriously and to explore the open situation of debate in the churches at the time when these texts were written.

ORALITY AND SCRIPTED PERFORMANCE

In his book, *Torah in the Mouth: Writing and Oral Tradition in Palestinian Judaism, 200 BCE – 400 CE*, Martin Jaffee analyzes the way oral Torah in the early rabbinic traditions changed from a relatively unconscious practice into an ideologically charged concept. In the process he makes two observations that inform my paper. One observation is simply the difference between the performance of oral tradition and the ideology of oral tradition. Ideology is the value placed on the performance of oral tradition by a community. The ideological formations around oral traditions—and around written records of oral traditions—"constitute part of the rationale for sustaining the particular life of the community."[3] Ideology is defined here rather simply as the importance of particular traditions for constructing a group's identity and for creating boundaries that distinguish it from other groups.

The second observation is that alienation creeps in when an oral tradition is inscribed into a written text.

> The oral-performative tradition, once it is imitated in writing, is in some sense alienated from itself, the written text reconstructing the oral tradition as an objective cultural presence now discernible to its audience in a way never seen so clearly before. . . . Henceforward . . . even as the written version itself pursues its literary career as an orally performed and aurally experienced cultural possession, the oral tradition is never the same. It has become a commodity, an element of exchange, in the shaping of culture, more or less valuable in the shifting constellation of a given society's literary universe.[4]

These observations provide tools for thinking about the development of pseudepigrapha in the early churches. When Paul could not be present with the churches he had founded, he sometimes adopted a typical strategy for his time: He composed letters. In doing so he adopted a mainstream ideology of letters. The letter was a substitute for his presence with the community.[5] While these letters approximated personal presence, they also introduced a form of

[3] Jaffee, *Torah in the Mouth*, 7–10. The content (the "oral-literary tradition") simply denotes the information that is conveyed, while the performance (the "oral-performative tradition") describes the production and transmission of the content, the strategies by which the content "is summoned from memory and delivered in diverse public settings" (ibid., 8, 10).

[4] Ibid., 6. Jaffee discusses alienation as his understanding of Franz Bäuml's concept of fictionalization. Bäuml describes the process of writing an oral tradition as fictionalization. In such cases the oral tradition is transformed into a character that plays its role within the context of written tradition (ibid., 5–6).

[5] The mainstream ideology of letters is described in the next section.

alienation. The letter was both a substitute for Paul's presence and an ersatz Pauline presence.[6] In place of Paul's actual personal performance, the letter offered a scripted performance—Paul's words delivered orally by someone else who read what Paul's scribe had written. In this scripted performance, Paul became a character in his own literary creation. The letter made the apostle "discernable to its audience in a way never seen so clearly before."[7] Now Paul could be copied and passed around to other congregations, who could then engage in discussions about the textualized, unresponsive apostle. This was a step in the direction of a sectarian ideology of epistles, in which the inscribed Paul inscribed the boundaries of group identity.

We can propose a model for this development of Pauline pseudepigrapha in five stages: 1) personal presence; 2) oral traditions surviving in the community after Paul's departure; 3) a letter that substitutes for Paul's personal presence; 4) competition between letter and oral tradition; and finally 5) the epistle as authoritative document.[8] The first two stages are by definition unavailable to us unless they have been written into a letter. The third stage—a Pauline letter substituting for Paul's presence—initiated a process of alienation that eventually allowed the letter to take on a certain authority of its own.[9] This led to a fourth stage at which the oral and written traditions vied for supremacy, and eventually to stage 5, when the letter became dominant.[10]

[6] Kafka, *Letters to Milena*, 229; quoted in Klauck, *Ancient Letters*, 3. It is perhaps this sort of alienation to which Kafka refers in one of his letters: "The easy possibility of letter-writing must—seen merely theoretically—have brought into the world a terrible disintegration of souls. It is, in fact, an intercourse with ghosts, and not only with the ghost of the recipient but also with one's own ghost which develops between the lines of the letter one is writing and even more so in a series of letters where one letter corroborates the other and can refer to it as a witness. How on earth did anyone get the idea that people can communicate with one another by letter! Of a distant person one can think, and of a person who is near one can catch hold—all else goes beyond human strength."

[7] Jaffee, *Torah in the Mouth*, 6.

[8] This is an abstract model meant to be tested against textual data. It is based on the fact that Paul's physical presence in the communities came to an end while his letters became authoritative documents. The model hypothesizes probable stages for this transition and provides a starting point for analysis of that historical process. In other words, the model is suggestive, not prescriptive. Also, stage 5 does not imply that oral traditions have come to an end, but rather that the written tradition takes precedence over them.

[9] There must have already been a kind of characterization of Paul in the oral tradition (my stage 2). But the character "Paul" was much less flexible once he was written into a letter, and so I think it is justified to speak of stage 3 as the beginning of this alienation.

[10] Phillip Sellew suggested to me that a sixth stage would be appropriate: the collected Pauline letters. I agree that this would be helpful but it is beyond the scope of this study.

In this process the Pauline epistle underwent an ideological shift. At stage 3, Paul's letters conformed to the epistolary ideology of mainstream society — the letters were simply a way of communicating long-distance. By stage 5, Paul's letters were suspended within a new ideological formation. They no longer contributed to the life of the community as a vehicle of personal communication. Instead, the written letters constituted an authoritative source for community practice and thinking, a source increasingly independent of oral tradition. In this way the ideology of epistles shifted from a mainstream perspective to a sectarian perspective.

The rest of this paper will flesh out stages 3–5 by looking briefly at issues of orality and literacy in the Corinthian correspondence and then in the Thessalonian correspondence. I conclude that 1–2 Corinthians illuminate stage 3, while *3 Corinthians* illustrates stage 5. The peculiar contribution of the forgery known as 2 Thessalonians is that it takes us into stage 4, where the relative value of oral and written traditions is contested.

ORAL AND WRITTEN AUTHORITY IN THE CORINTHIAN CORRESPONDENCE

What little we can discern about the ideology of epistolary practice of dominant society in the first century C.E. indicates a fairly pragmatic perspective. Letters were primarily for personal communication when personal presence was not possible.[11] In the extant *progymnasmata* of the Hellenistic and Roman imperial period, letters were undertheorized,[12] suggesting that intellectuals did not consider letters to be as important to community life as other forms of rhetoric or writing. The earliest surviving discussion of epistolary theory comes from a certain Demetrius (probably mid-second century B.C.E.), who considered letters to be related to the genre of dialogue, representing one phase in the give-and-take of a spontaneous conversation.[13] Demetrius

[11] White, *Light from Ancient Letters*, 190–91.

[12] The rhetorical handbooks that survive from antiquity provide surprisingly little guidance on letter-writing and even less on the social significance of the genre. See Kennedy, *New History of Classical Rhetoric*, 45–46.

[13] For brief commentaries on this work, see Klauck, *Ancient Letters*, 184–88; and Trapp, *Letters*, 180–83 (text with translation) and 317–20. Demetrius focused more on the style than on the significance of letters, but his categories give us some direction. According to Demetrius the goal of a letter is to communicate warm friendship and conventional wisdom, which makes it more frank than a judicial speech and gives it a tone that is inappropriate for logic or natural science. Demetrius partially agreed with Artemon, an earlier theorist

maintained, however, that letters should be somewhat more formal than dialogue because they are premeditated rather than spontaneous and because they have the character of a gift to the recipient (§ 224). Above all, a letter communicates warm feelings of friendship (§ 231–32) and conveys an image of the author's soul (§ 227). This ideology of friendship, gift, and self-disclosure perhaps reflects the thinking of intellectual elites, while letters from further down the social hierarchy tend to deal more with household affairs — family relationships, possessions, crops, business, legal requirements, etc.[14] Overall, however, we see that letters were a relatively transparent medium for personal communication in the early Roman imperial period, with a social function in the realm of family and friendship.[15]

In the undisputed Pauline letters of 1–2 Corinthians we see this sort of mainstream ideology of epistles at work.[16] Paul's letters are primarily a vehicle for communicating when absent and for developing his relationship with the house churches in the Roman colony of Corinth. A self-conscious example of this comes in 2 Corinthians 13 where, following a series of exhortations, Paul alludes to the way the letter allows him to intervene from a distance in the life of the Corinthian churches: "So I write these things while I am away from you, so that when I come, I may not have to be severe in using the authority that the Lord has given me for building up and not for tearing down" (2 Cor 13:10). A particularly poignant example of the letter's function as a substitute for personal presence comes from 2 Cor 2:1–11, where we see a complicated interplay of personal visitation and letter-writing. After his original visit, Paul made a painful visit to Corinth, where he was humiliated by someone in the church, and so he later wrote a harsh letter to the churches there:

> So I made up my mind not to make you another painful visit. For if I cause you pain, who is there to make me glad but the one whom I have pained? And I wrote as I did, so that when I came, I might not

whose work is lost beyond this reference. Artemon categorized letters as a form of dialogue, except that only one side of the discussion is recorded. Demetrius stipulated, however, that the letter is somewhat more formal than dialogue.

[14] Stowers, *Letter Writing in Greco-Roman Antiquity*, 27–31, 71–73.

[15] For a concise summary of the function of letters in antiquity, see Malherbe, *Ancient Epistolary Theorists*, 12.

[16] I begin with the Corinthian correspondence because it is the only other existing example of multiple letters that claim to be Pauline and are directed toward churches in one city. Also, these documents frame 2 Thessalonians by illustrating stages 3 and 5, the stages before and after 2 Thessalonians in my heuristic reconstruction. The Corinthian material is especially instructive for comparative purposes because there are no doubts that 1–2 Corinthians contain genuine Pauline materials and that *3 Corinthians* is pseudonymous.

> suffer pain from those who should have made me rejoice; for I am
> confident about all of you, that my joy would be the joy of all of you.
> For I wrote you out of much distress and anguish of heart and with
> many tears, not to cause you pain, but to let you know the abundant
> love that I have for you. (2 Cor 2:1–4)[17]

We later learn that the letter led to reconciliation in the relationship between
Paul and the congregations, and Paul recommends that they forgive the one
who offended him (2:5–11 and 7:5–12).

The undisputed letters also record an exchange of letters between Paul and
the Corinthian believers that developed their two-way relationship from a
distance. Even though much of this correspondence is lost, we can reconstruct
some of the contacts. In 1 Corinthians 5 Paul refers to a letter of his, now lost
to us, that preceded the one we now call 1 Corinthians. A good deal of the
last half of 1 Corinthians is a response to questions contained in a lost letter
to Paul from the Corinthian believers. The questions included such topics
as sexuality and marriage (1 Corinthians 7), food sacrificed to other deities
(1 Corinthians 8–10), worship and spiritual gifts (1 Corinthians 12–14), and
the collection for the poor among the believers in Jerusalem (1 Cor 16:1–4).
In the earlier, lost letter, Paul instructed the Corinthians not to associate with
sexually immoral people. The Corinthians apparently misinterpreted this and
so Paul clarifies:

> I wrote to you in my letter not to associate with sexually immoral
> persons—not at all meaning the immoral of this world, or the greedy
> and robbers, or idolaters, since you would then need to go out of the
> world. But now I am writing to you not to associate with anyone who
> bears the name of brother or sister who is sexually immoral or greedy,
> or is an idolater, reviler, drunkard, or robber. Do not even eat with such
> a one. For what have I to do with judging those outside? Is it not those
> who are inside that you are to judge? God will judge those outside.
> "Drive out the wicked person from among you." (1 Cor 5:9–13)

Looking more broadly at references to writing in 1–2 Corinthians, we see
that these letters do not express any sense that they are authoritative because
of their author. On the contrary, half of the references are citation formulas
("as it is written") that invoke Jewish scripture in order to authorize Paul's
viewpoint.[18] In places where Paul might have claimed authority for his
writing, he does not do so because he claims that the Corinthians themselves
are the validation of his authority (2 Cor 1:12–14), or because he expects the

[17] Quotations are from the NRSV unless otherwise noted.

[18] In 1–2 Corinthians, 14 of 28 uses of the verb γράφω refer to scripture.

recipients to judge for themselves whether the content of his letter has divine authority (1 Cor 14:37).[19] In all these instances, whatever authority the letter might have comes not from Pauline authorship, but rather from scripture, from the effectiveness of Paul's gospel, or from the audience's discernment.

One fascinating confluence of these themes is found in 2 Cor 10:7–11. Many scholars currently regard 2 Corinthians as a patchwork of several Pauline letters. If this the case, then 2 Corinthians 10–13 may actually be the painful letter mentioned in 2 Corinthians 2.[20] Whether this is the precise explanation for these chapters or not, the middle section of 2 Corinthians 10 reflects a competition between Paul and other apostles regarding authority in the churches. Paul wrote,

> Look at what is before your eyes. If you are confident that you belong to Christ, remind yourself of this, that just as you belong to Christ, so also do we. Now, even if I boast a little too much of our authority, which the Lord gave for building you up and not for tearing you down, I will not be ashamed of it. I do not want to seem as though I am trying to frighten you with my letters. For they say, "His letters are weighty and strong, but his bodily presence is weak, and his speech contemptible." Let such people understand that what we say by letter when absent, we will also do when present. (2 Cor 10:7–11)

This text raises many significant issues, but I limit myself to two observations. First, letters are compared to personal presence. In this polemical setting in which his letters are recognized as powerful, Paul insists that his claim to authority is validated by his personal presence and not by the letters that mediate his presence from a distance. Second, the passage notes the difference between Paul's scripted epistolary performance (strong written rhetoric) and his oral performance in person ("weak and contemptible," according to detractors).[21] Even when other apostles appeared to be winning influence over his churches (2 Cor 10:16), Paul refused to claim authority for his letter based solely on his own status as apostle.

Once we move from the undisputed Pauline letters of 1–2 Corinthians to *3 Corinthians*, the claims for authority are completely different. The precise origin of *3 Corinthians* is not clear. The letter was incorporated into the larger *Acts of Paul*, which is usually dated to the late second century C.E.,

[19] See also Rom 15:14–19, where Paul writes to churches he has never visited and grounds his authority not in his personal status in the churches nor in the propositional truth of his writing, but in the results that God has accomplished among the gentiles through him.

[20] See discussion above. Mitchell, "Paul's Letters to Corinth," 307–38.

[21] Paul is replying here to charges from other apostles. For a discussion of the character of this exchange, see Harrill, *Slaves in the New Testament,* 53–57.

so most scholars place *3 Corinthians* somewhere in the early to mid-second century.[22]

In the *Acts of Paul, 3 Corinthians* is introduced by a fictional letter from five presbyters in Corinth who ask for advice about two men who promulgate questionable teachings.

> They say that we must not use the prophets and that God is not Almighty, and that there shall be no resurrection of the flesh, and that man has not been made by God, and that Christ came not down in the flesh, neither was born of Mary, and that the world is not of God but of angels. (*3 Cor* 1:10–15)[23]

"Paul" then replies with a string of "orthodox" theological statements and two scriptural arguments that revolve mostly around the themes of the creation of the material world by God and the resurrection of the physical body.

For several reasons, no one today claims that *3 Corinthians* comes from Paul. One reason is that the theological issues are much later than the time of Paul. Moreover, no effort is made in *3 Corinthians* to replicate the standard Pauline greeting, nor is the language similar to Paul's in either vocabulary or style. The author of this pseudepigraphic piece made no effort to replicate the appearance of a Pauline letter, for the attribution of the letter to the apostle was apparently sufficient to gain a hearing. *Third Corinthians* simply appropriates the name of Paul as an authoritative voice in a letter designed to combat ideas that arose after Paul's time with which the later author disagreed.

Nor did the author of *3 Corinthians* attempt to develop the relationship between the apostle and the congregations.[24] There are no references in *3 Corinthians* to specific details about earlier visits, except for the formulaic reference, "For I delivered to you first of all what I received from the apostles before me." Here the pseudepigrapher draws on 1 Cor 15:3 but adds the

[22] Klijn, "Apocryphal Correspondence," 2–23; Thomason, "Corinthians," 1:1154. Recently, however, Hovhannessian has argued that the incorporation of *3 Corinthians* into the *Acts of Paul* may have taken place later (*Third Corinthians*).

[23] Translation from James, *Apocryphal New Testament*, 289.

[24] All of this means that there was no integral connection between *3 Corinthians* and the churches in Corinth. Then why did the author address the work to the Corinthian believers? The answer is apparently that there is a thematic literary connection between 1 Corinthians and *3 Corinthians*. 1 Corinthians is the letter which allows the author to connect his later theological issues with the Pauline tradition. One point of contact is the extended argument about physical resurrection in 1 Corinthians 15. Another point of contact is the allusion to lost letters in 1 Corinthians, one from Paul and one from the Corinthians. The author of *3 Corinthians* took this possibility of lost letters as an opportunity to fill in the gap, and then built a new letter for a later audience with the name of Paul attached.

phrase "from the apostles" to add their authority to that of Paul. The author then goes on to introduce a set of teachings that "Paul" allegedly taught to the Corinthians. These teachings no doubt reflect the written and oral traditions of the author's historical context, but this "letter" did not function according to the mainstream epistolary ideology of personal communication from a distance. Rather, *3 Corinthians* was a sectarian attempt to define its communities by drawing on the authority of the textualized apostle.

By examining the extended series of letters connecting the name of Paul with Corinth, we get a sense of the larger shift in the ideology of epistles. In 1–2 Corinthians, written by Paul in the mid-first century C.E., we see a standard appraisal of the authority of letters in the community. When written, they were primarily a means of communication between separated parties, which is what I call phase 3 in the evolution of Pauline pseudepigraphy. By the time that *3 Corinthians* was written we see what I call phase 5. The letter was no longer a means of communication, but rather an attempt to invoke the authority of the venerated apostle for a set of ideas that came from a later time. This invocation of authority, however, was not simply about ideas. It was also an ideological statement, setting boundaries that established the membership of the community. These ideas were connected to foundational truths and sources of authority that were not shared by the dominant society and therefore comprised a sectarian ideology.

A Peculiar Imitation: Second and First Thessalonians

Many specialists have discussed the reasons for concluding that Paul did not write 2 Thessalonians, so we need not rehearse the details of the debate. Edgar Krenz published a fine summary of the arguments against Pauline authorship in 1992 that focused on such issues as vocabulary, literary style, personal tone, and uncharacteristic theological positions.[25] While international scholarship now gravitates toward this position, there are also significant examples of specialists who maintain Pauline authorship of 2 Thessalonians, such as Robert Jewett[26] and Abraham Malherbe.[27] I find the case against

[25] Krentz, "Thessalonians," esp. 520–22. For a longer exposition of the arguments, see Trilling, *Untersuchungen zum 2. Thessalonicherbrief.*

[26] Jewett, *Thessalonian Correspondence,* 3–18. Jewett recognizes the ambiguous nature of some of the evidence but concludes that Pauline authorship is more likely. He goes on to argue for a historical scenario that would explain the ambiguous evidence.

[27] Malherbe, *Letters to the Thessalonians*, esp. 349–75. Another recent commentary that accepts Pauline authorship is Witherington, *1 and 2 Thessalonians.*

Pauline authorship convincing and take pseudonymity as a starting point for my analysis. But the peculiar character of the relationship between 2 Thessalonians and 1 Thessalonians requires clarification. The literary dependence of 2 Thessalonians on 1 Thessalonians is widely recognized. The places where 2 Thessalonians quotes from 1 Thessalonians provide a starting point for a discussion of the precise character of the relationship. The following chart reproduces some examples.

Fig. 1. Examples of quotations and parallel expressions.[28]
Bold indicates quotations from 1 Thessalonians; italics indicate similar words and/or differing word order.

2 Thessalonians	1 Thessalonians	
1:1–2 **Παῦλος καὶ Σιλουανὸς καὶ Τιμόθεος τῇ ἐκκλησίᾳ Θεσσαλονικέων ἐν θεῷ πατρὶ** ἡμῶν **καὶ κυρίῳ Ἰησοῦ Χριστῷ, χάρις ὑμῖν καὶ εἰρήνη** ἀπὸ θεοῦ πατρὸς ἡμῶν καὶ κυρίου Ἰησοῦ Χριστοῦ	**Παῦλος καὶ Σιλουανὸς καὶ Τιμόθεος τῇ ἐκκλησίᾳ Θεσσαλονικέων ἐν θεῷ πατρὶ καὶ κυρίῳ Ἰησοῦ Χριστῷ, χάρις ὑμῖν καὶ εἰρήνη.**	1:1
2:16–17 *Αὐτὸς δὲ ὁ κύριος ἡμῶν* **Ἰησοῦς Χριστὸς καὶ ὁ θεὸς ὁ πατὴρ ἡμῶν** *ὁ ἀγαπήσας ἡμᾶς καὶ δοὺς παράκλησιν αἰωνίαν καὶ ἐλπίδα ἀγαθὴν ἐν χάριτι, παρακαλέσαι* ὑμῶν *τὰς καρδίας* καὶ *στηρίξαι* ἐν παντὶ ἔργῳ καὶ λόγῳ ἀγαθῷ.	**Αὐτὸς δὲ ὁ θεὸς καὶ πατὴρ ἡμῶν καὶ ὁ κύριος ἡμῶν Ἰησοῦς** κατευθύναι τὴν ὁδὸν ἡμῶν πρὸς ὑμᾶς· ὑμᾶς δὲ ὁ κύριος πλεονάσαι καὶ περισσεύσαι *τῇ ἀγάπῃ* εἰς ἀλλήλους καὶ εἰς πάντας καθάπερ καὶ ἡμεῖς εἰς ὑμᾶς, *εἰς τὸ στηρίξαι ὑμῶν τὰς καρδίας*	3:11–13a

[28] Based on Bailey, "Who Wrote II Thessalonians?" 133–34; and Leppä, "2 Thessalonians," 176–95.

3:6	Παραγγέλλομεν δὲ ὑμῖν, ἀδελφοί, ἐν ὀνόματι τοῦ κυρίου ἡμῶν Ἰησοῦ Χριστοῦ στέλλεσθαι ὑμᾶς ἀπὸ παντὸς ἀδελφοῦ ἀτάκτως περιπατοῦντος καὶ μὴ κατὰ τὴν παράδοσιν ἣν παρελάβοσαν παρ' ἡμῶν.	Παρακαλοῦμεν δὲ ὑμᾶς, ἀδελφοί, νουθετεῖτε τοὺς ἀτάκτους, παραμυθεῖσθε τοὺς ὀλιγοψύχους, ἀντέχεσθε τῶν ἀσθενῶν, μακροθυμεῖτε πρὸς πάντας.	5:14
3:8	οὐδὲ δωρεὰν ἄρτον ἐφάγομεν παρά τινος, ἀλλ' ἐν κόπῳ καὶ μόχθῳ νυκτὸς καὶ ἡμέρας ἐργαζόμενοι πρὸς τὸ μὴ ἐπιβαρῆσαί τινα ὑμῶν·	Μνημονεύετε γάρ, ἀδελφοί, τὸν κόπον ἡμῶν καὶ τὸν μόχθον· νυκτὸς καὶ ἡμέρας ἐργαζόμενοι πρὸς τὸ μὴ ἐπιβαρῆσαί τινα ὑμῶν ἐκηρύξαμεν εἰς ὑμᾶς τὸ εὐαγγέλιον τοῦ θεοῦ.	2:9
3:10a	καὶ γὰρ ὅτε ἦμεν πρὸς ὑμᾶς	καὶ γὰρ ὅτε πρὸς ὑμᾶς ἦμεν	3:4a
3:12	τοῖς δὲ τοιούτοις παραγγέλλομεν καὶ παρακαλοῦμεν ἐν κυρίῳ Ἰησοῦ Χριστῷ, ἵνα μετὰ ἡσυχίας ἐργαζόμενοι τὸν ἑαυτῶν ἄρτον ἐσθίωσιν.	καὶ φιλοτιμεῖσθαι ἡσυχάζειν καὶ πράσσειν τὰ ἴδια καὶ ἐργάζεσθαι ταῖς ἰδίαις χερσὶν ὑμῶν, καθὼς ὑμῖν παρηγγείλαμεν	4:11
3:18	Η χάρις τοῦ κυρίου ἡμῶν Ἰησοῦ Χριστοῦ μετὰ πάντων ὑμῶν	Η χάρις τοῦ κυρίου ἡμῶν Ἰησοῦ Χριστοῦ μεθ' ὑμῶν.	5:28

Outi Leppä takes the analysis of verbal similarities between 2 Thessalonians and 1 Thessalonians further, expanding the discussion to the reuse of other Pauline texts in 2 Thessalonians. She concludes that 2 Thessalonians is almost certainly literarily dependent on 1 Thessalonians, and probably on 1 Corinthians as well. Romans and Galatians might also have been known to the author of 2 Thessalonians, but here the evidence is too limited to reach a conclusion (two verbal similarities to Romans and one to Galatians).[29]

[29] Leppä, "2 Thessalonians," esp. 183–94.

Leppä also compares these observations on 2 Thessalonians to observations regarding the influence of Pauline texts on Colossians and Ephesians. The comparisons lead to two important observations regarding the particular character of pseudepigraphic practice by the author of 2 Thessalonians. One is that 2 Thessalonians tends to avoid verbal agreements with Pauline texts of more than three words, except for long agreements with 1 Thessalonians. This is especially striking when compared to Colossians, in which Leppä finds 22 such verbal agreements. A second observation is that Colossians and Ephesians have a strong tendency to conflate earlier texts as they imitate them, while 2 Thessalonians does not.[30] Thus it is clear that the author of 2 Thessalonians was familiar with other Pauline texts, but worked with them in a way that differed from other pseudepigraphers.[31]

In addition to the verbal similarities between 2 and 1 Thessalonians, there are also structural similarities that are unparalleled in Pauline literature. Both Thessalonian letters have the same five parts, which is not unusual. There are, however, two unusual features in the body of 1 Thessalonians that are found also in 2 Thessalonians: the awkward second prayer of thanksgiving (2 Thess 2:13–14//1 Thess 2:13) and the benediction that closes the body (2 Thess 2:16–17//1 Thess 3:11–13). Neither of these structural elements is found in the other undisputed letters of Paul, suggesting that the author of 2 Thessalonians mimicked even relatively unimportant formal features of 1 Thessalonians.

The dependence of 2 Thessalonians on 1 Thessalonians, however, extends beyond verbal similarities and structural elements to crucial themes. The pattern of the dependence is as follows: The three important topics in 2 Thessalonians—revenge, eschatology, and employment—are all based on smaller statements found in 1 Thessalonians. The first topic is introduced in

[30] Ibid., 191–93. Leppä emphasizes that 2 Thessalonians, Colossians, and Ephesians are similar in that they all exhibit literary dependence on earlier texts. My purpose here is to build on her work by showing that 2 Thessalonians expresses its literary dependence in an unusual fashion.

[31] The only similar replication is the use of Colossians in Ephesians, in which 73 of the 155 verses have parallels in Colossians in addition to scattered parallels to four other Pauline letters (Duling, *New Testament,* 272–74). There are, however, two major differences between Ephesians and 2 Thessalonians with respect to their handling of earlier letters. First, Ephesians makes almost no effort to relate itself to a specific congregation. Even the opening reference to Ephesos (1:1) is missing from the oldest manuscripts, and there is only one reference to an individual in Ephesians (Tychicus in 6:21–22). Second, Ephesians seems to be an extension of its original, perhaps even a summary of its ideas. In contrast, 2 Thessalonians does not summarize 1 Thessalonians. Rather, the author of 2 Thessalonians attempted to correct some of the original's ideas by setting up a different eschatological framework.

the prayer of thanksgiving. In 1 Thessalonians the prayer emphasizes the faith, love, hope, and joy of the Thessalonian believers, even in the face of great opposition (ἐν θλίψει πολλῇ, 1 Thess 1:6), and ends with the statement that they are awaiting the return of "Jesus, who rescues us from the wrath that is coming" (1:10b). The author of 2 Thessalonians took the idea of escape from the coming wrath and reworked it into a prayer of thanksgiving asserting that God would ultimately annihilate their enemies (2 Thess 1:3–12). In other words, this prayer section shifts from thanksgiving for rescue to thanksgiving for revenge.[32]

The second and third developments both have their origins in the exhortation section of 1 Thessalonians. The author of 2 Thessalonians borrowed the idea of the return of Christ from the exhortation section of 1 Thessalonians and transformed it into the body of his or her letter. The new content of this teaching about the *parousia* need not detain us here. What is important is that one topic from the exhortation of 1 Thessalonians became the entire body of 2 Thessalonians. The same is true of the exhortation section of 2 Thessalonians, which is devoted almost entirely to warnings about believers who are not willing to work for a living. Again, the author picked up a small theme from the exhortation of 1 Thess 4:11–12 and developed it into the extended exhortation of 2 Thess 3:6–15.

Thus, in addition to copying some phrases and the format of 1 Thessalonians, the author developed much of the content of 2 Thessalonians by expanding and changing three selected ideas from 1 Thessalonians. First Thessalonians provided the language, the structure, and the three main topics for 2 Thessalonians. But even these similarities, and many others covered in the secondary literature,[33] are not sufficient to conclude that 2 Thessalonians is a forgery. For that, we need to examine the relative importance of oral and written authorities in the text.

COMPETITION BETWEEN ORAL AND WRITTEN SOURCES: SECOND THESSALONIANS AS FORGERY

I have argued that *3 Corinthians* embodies a sectarian ideology of letters in which the authority of Paul's written word is unchallenged by oral traditions, which I call stage 5 in the development of pseudepigrapha. In this section I argue that 2 Thessalonians presents a more complicated situation—a situation that I characterize as stage 4, with written and oral traditions vying

[32] Roose, "2 Thessalonians," esp. 141–51.

[33] The classic statement of these issues is found in Wrede, *Die Echtheit des zweiten Thessalonicherbriefs*.

for supremacy—and that these considerations lead to the conclusion that 2 Thessalonians is a forgery.

The first order of business is to define "forgery." Timothy Barnes notes the difficulties in applying such terminology to ancient texts, in which writers claim various identities for various reasons. One traditional solution in German historiography has been to define *Fälschung* as a general, technical term meaning "a source that is not what it purports to be," without regard for process, motivation, or consequence. But this definition is so general as to be of little use in distinguishing a deliberate deception from an educational exercise in stylistic reproduction or a creative homage to an admired personage.[34]

For the purposes of this study, I work with a simple distinction between two terms: imitation and forgery. I use "imitation" to cover a range of pseudepigraphic practices in which the real author's identity is disguised in some way. These might include the pastimes of highly educated writers: pseudonyms and pen names, *livres à clef*, creative imitations or extensions, pastiches and parodies, and imaginary authors.[35] By "forgery" I mean a work that misleads the audience about the identity of the real author because the deception is fundamental to the rhetorical aims of the text. So I would not consider the Pastoral Epistles or even Ephesians to be forgeries because the rhetorical goals of these letters do not strictly require Pauline authorship. With 2 Thessalonians, however, the situation is different.

A consideration of 1 Thessalonians is an instructive starting point. Paul's rehearsal of the relationship between the apostle and his churches permeates 1 Thessalonians in a way that is not matched even in 1–2 Corinthians. A list of Paul's references in 1 Thessalonians to encounters with the church is perhaps the most efficient way to demonstrate this.

1:5	How we behaved while among you.
1:6–10	How you responded and the results.
2:1–2	Our coming to you not in vain, even after embarrassment at Philippi.
2:5–7a	We did not flatter, did not seek money or praise.
2:7b–8	We were gentle like a nurse with you.

[34] Barnes, "*Fälschung*," 497–500.

[35] These categories come from Barnes ("*Fälschung*," 500), who cites the chapter headings of Picard's *Artifices et mystifications littéraires* as one possible typology for pseudepigraphic practices.

2:9	We worked night and day not to be a burden.
2:10	Our conduct was pure and blameless.
2:11–12	Encouraged you like a father.
2:13	You received word from us as divine message.
2:17–3:5	Separation from you like being an orphan; sent Timothy.
3:6–9	News from Timothy's return encouraged us.
3:10	We pray night and day to see you again.
4:1–2	You learned from us how to live.
4:11–12	We directed you how to behave properly.

This rehearsal is not a transcript of their relationship but rather an artful creation. Through the rhetoric of his letter, Paul scripted a performance. In the reading of 1 Thessalonians at Thessalonikē, both author and audience became characters in a drama, with Paul as father and wet-nurse to the Thessalonian children, the Thessalonians as role models for believers in Macedonia and Achaia, the Thessalonians as victims of persecution, and so on. In Jaffee's terms, we see here a subtle alienation introduced into the relationship through the writing of 1 Thessalonians, a slippage in which Paul and the church become characters visible to themselves—and distinguishable from themselves—in a new way through the new performative reading of a written communication.

Nevertheless, in 1 Thessalonians the authority of the apostle remains fairly close to the situation of actual personal contact, as in 1–2 Corinthians. Paul does not assume that his letter has automatic authority. In fact, at the end of 1 Thessalonians he feels the need to put the recipients under oath to ensure full distribution of his letter: "I adjure you by the Lord that this letter be read to all the brothers!"[36] In writing 1 Thessalonians, then, the apostle could not assume that his letter would not be suppressed. By the time of 2 Thessalonians, however, the ideology of writing had changed considerably but not to the extent of the change in ideology reflected in *3 Corinthians*. In 2 Thessalonians, we see a complex interplay of oral and written authority as the author works to gain a hearing for this text.

The author of 2 Thessalonians uses three main strategies for legitimating this written message. The first strategy is to create fictional oral traditions

[36] 1 Thessalonians 5:27 (translation mine). The NRSV obscures the idea of putting the readers under an oath to comply: "I solemnly command you by the Lord that this letter be read to all of them."

about Paul's visits to Thessalonikē in order to enhance the authority of this new written letter. The most blatant example of this comes in 2 Thess 2:5. The author has just contradicted the Pauline eschatology of 1 Thessalonians by asserting that the day of the Lord will not come until there is a great apostasy and the man of lawlessness is revealed. How can the author support such a statement? In 2:5 he or she writes, "Do you not remember that I told you these things when I was still with you?" In this way, the fiction of Pauline authorship allows the author to insert new content into the traditions about Paul's personal presence in Thessalonikē.[37] Another example is found in 2 Thess 3:10, where the author quotes several words from 1 Thess 3:4a and then creates a new command that Paul supposedly gave the Thessalonians while in Thessalonikē: "For even when we were with you, we gave you this command: Anyone unwilling to work should not eat." This new written command is supported by the fiction that it was first delivered orally. In other words, the author creates an oral tradition to support this new written tradition.[38]

The author's second strategy for validating 2 Thessalonians is to assert equal authority for letters and for oral traditions. We see this, for example, in 2 Thess 2:15. The author has just finished laying out an eschatology that contradicts the eschatology of 1 Thessalonians and then concludes the section by imitating the second prayer of thanksgiving from 1 Thess 3:11–13. Next the author moves into an exhortation about holding to the traditions. But the author is careful to stipulate that the authority of this letter is equal to that of earlier oral and written traditions: "So then, brothers and sisters, stand firm and hold fast to the traditions that you were taught by us, either by word of mouth or by our letter" (εἴτε διὰ λόγου εἴτε δι' ἐπιστολῆς ἡμῶν, 2 Thess 2:15).

The author makes a similar claim later, giving this letter authority equal to that of other earlier traditions:

Εἰ δέ τις οὐχ ὑπακούει τῷ λόγῳ ἡμῶν διὰ τῆς ἐπιστολῆς, τοῦτον σημειοῦσθε μὴ συναναμίγνυσθαι αὐτῷ, ἵνα ἐντραπῇ·

[37] This causes me to question whether 2 Thessalonians can be explained simply as "reading instruction" for 1 Thessalonians (Roose, "Reading Instruction"). At certain points the author does not simply revise or reinterpret 1 Thessalonians but rather undermines the earlier letter.

[38] 2 Thess 3:10 does not contradict Paul (as in the case of eschatological issues), but merely goes beyond Paul: Instead of exhorting the Thessalonians to admonish those who are idle (1 Thess 5:14), the new letter orders them not to help anyone who does not work (2 Thess 3:10).

> Take note of those who do not obey what we say in this letter; Have
> nothing to do with them, so that they may be ashamed. (2 Thess 3:14)

Here the letter is not simply another medium for Paul's message. The letter
is an authority to be obeyed, and those believers who do not obey are to be
ostracized.[39]

These first two strategies created a problem for the author of 2 Thessalonians.
The author had raised the value of this particular letter by attaching Paul's
name to it and by alluding to fictional visits and had raised the value of
Pauline letters in general in comparison to the value of oral traditions.
But this new letter also contradicted elements of Pauline thought, and
so genuine Pauline letters like 1 Thessalonians were in some ways direct
competitors. By raising the value of written tradition, the author also created
the possibility of this letter being overshadowed by other letters.

Thus the third strategy is to question the authority of other Pauline letters.
This strategy comes to the fore as the author introduces the subject on which
he or she disagrees most strongly with 1 Thessalonians: eschatological
timetables.

> As to the coming of our Lord Jesus Christ and our being gathered
> together to him, we beg you, brothers and sisters, not to be quickly
> shaken in mind or alarmed, either by spirit or by word or by letter,
> as though from us (μήτε διὰ πνεύματος μήτε διὰ λόγου μήτε δι'
> ἐπιστολῆς ὡς δι' ἡμῶν), to the effect that the day of the Lord is already
> here. (2 Thess 2:1–2)

Again we see the author suggesting that oral traditions and written letters are
equivalent sources of authority and even including charismatic inspiration
as a third possible medium of authority. The author, however, also inserts a
phrase that undermines the credibility of any letter with Paul's name attached
by raising the issue of pseudonymity: δι' ἐπιστολῆς ὡς δι' ἡμῶν ("by letter,
as though from us," 2 Thess 2:2).[40] While writing a letter in Paul's name the
author warns against letters written in Paul's name!

[39] This ideology of letters goes far beyond what we find in the undisputed Pauline letters.
There are no references to letters in Philemon, Galatians, or Philippians, and Romans only
uses ἐπιστολή when the scribe Tertius describes himself as the one who wrote the letter
down (Rom 16:22). In the Corinthian correspondence Paul corrects a misunderstanding
of a previous letter (1 Cor 5:9), discusses a harsh letter that provoked repentance (2 Cor
2:3–4 and 7:8–12), and mentions letters of recommendation (1 Cor 16:3; 2 Cor 3:1–3). In
1 Thessalonians Paul uses the rhetorical trope, "You have no need for anyone to write you
about X" as a prelude to writing about X (1 Thess 4:9; 5:1), and he commands the recipients
to read the letter to the whole assembly (1 Thess 5:27).

[40] Roose is correct that this phrase is grammatically ambiguous and could theoretically

The danger for the author is obvious. Would this not cause the audience also to question the authority of 2 Thessalonians? This possibility created the need for another facet to this third strategy. At the end of the letter, the author creates a new marker of authenticity for judging most other Pauline letters as inferior to this letter. "I, Paul, write this greeting with my own hand. This is the mark in every letter of mine; it is the way I write" (2 Thess 3:17). We know this is not true. Paul did not write greetings in his own hand at the end of every letter.[41] This exact phrase — Ὁ ἀσπασμὸς τῇ ἐμῇ χειρὶ Παύλου ("the greeting of Paul in my own hand") — is found, however, in 1 Corinthians 16:21, where Paul did write a greeting in his own hand, and in Colossians 4:18, where a follower of Paul also used the phrase. The important point to note is that the author of 2 Thessalonians copied this phrase[42] and transformed it into an official signature that set this letter above other letters attributed to Paul, including 1 Thessalonians.

These strategies by the author of 2 Thessalonians comprise a complicated gambit. The author claims authority for written letters, but does so by appealing to fictitious oral traditions. The author also relies on the growing authority of Pauline texts to contradict some aspects of Pauline texts.[43] Perhaps most surprising of all, the author warns against letters falsely attributed to Paul in a letter falsely attributed to Paul. It is a risky and brazen project that should be labeled not simply an imitation, but rather a very successful forgery. The letter was eventually included in the Christian canon, and it took 1700 years

refer to a letter "truly from us" ("Roose, "Letter as by Us," 108). In context, however, the grammatical ambiguity is overcome; it must be a reference to letters written in Paul's name. It is not clear what it would mean for either Paul or a pseudepigrapher to instruct the Thessalonians to ignore genuine Pauline letters that say that the day of the Lord has already come.

[41] Malherbe suggests that Paul did indeed write the last few lines of each letter in his own hand, but without always calling attention to his own handwriting. Once the letters were copied and circulated to other churches, Paul's practice of "signing" the letters in this way would have disappeared (Malherbe, *Letters to the Thessalonians*, 463). There are two problems with this argument. First, it is an argument from silence that suggests special pleading to maintain Pauline authorship. Second, since there are no greetings from Paul at the end of 1 Thessalonians, Philemon, 2 Corinthians, or Romans, the statement in 2 Thess 3:17 cannot be construed to reflect Paul's practice. 2 Thess 3:17 refers specifically to a greeting in Paul's hand, not to general writing in Paul's hand.

[42] Leppä, "2 Thessalonians," 189. Leppä concludes that the author of Colossians probably made use of 1 Cor 16:21 independently.

[43] I do not think that 2 Thessalonians was sent specifically to the Thessalonian assembly. The author knew of more than one Pauline letter (Leppä, "2 Thessalonians") and assumed the audience's familiarity at least with 1 Thessalonians (Roose, "A Letter as by Us"), so he or she probably intended 2 Thessalonians to be added to the growing number of letters circulating under Paul's name among the churches.

for serious doubts to be raised about its Pauline authorship. Even today specialists disagree, although the majority now conclude that 2 Thessalonians is indeed a pseudepigraphical work. Most specialists will not go so far as to call 2 Thessalonians a forgery, but I have insisted on that label. I think that we do the letter and the author an injustice if we do not recognize this accomplishment.

THANKS TO THE FORGER

There are at least three ways in which we are indebted to the author of 2 Thessalonians for his or her forgery. This study has been concerned primarily with showing the way that our author gives us access to an under-documented period in the earliest churches, the period during which the churches were beginning to develop authoritative writings of their own. The fact that this process occurred is obvious, but the stages by which it occurred are not so clear. Precisely because our author attempted to forge a Pauline letter, he or she wrestled with the ways in which a written document could be presented as authoritative. The forger had to take into account the strength of oral tradition and the competition from other Pauline literature. The result is a letter that attempts to place written documents and oral tradition on equal footing, an important step toward the dominance of writing as a source of authority in the churches. One part of this process was a shift in the ideology of letters from a mainstream view of letters as communication to a sectarian view of letters as authoritative statements of divine truth. Second Thessalonians emerged right in the middle of this transition. So we should thank the forger for helping us document the process by which the churches shifted their bases of authority.

Second, we should also be grateful to the forger for his or her attention to the details of Pauline style and structure, for there is a sense in which the disguised author of 2 Thessalonians was the first New Testament scholar, the first specialist in Pauline studies. Anthony Grafton has argued more broadly that forgers have been responsible for some of the most important developments in modern western literary criticism because they forced scholars to hone their craft and to develop more nuanced measurements of language and genre.[44] The same can be said of the individual who wrote 2 Thessalonians. This forger has forced us to new understandings about Paul and his churches that might have been impossible without the challenge of

[44] Grafton, *Forgers and Critics*.

this text. As the most successful Pauline pseudepigrapher known to us, we owe him or her a great debt. But it is still possible that he or she was not the best imitator of Pauline style. For, as Aviva Briefel and others have noted, the very best forgers are, by definition, the ones whose work has not yet been detected, whose work is still mistakenly considered genuine.[45]

Finally, there is one more debt we owe the forger: He or she reminds us that imitation, gullibility, and dishonesty are all part of what we study in the study of religion. New Testament scholarship has always struggled with the boundary between analysis and apologetics, and I suspect that scholars hesitate to call 2 Thessalonians a forgery at least in part because it is in the Christian Bible. But is it our role to function as apologists? Why should we hesitate to recognize a forgery if it is in the New Testament canon? Such recognition would certainly result in repercussions from some quarters, and perhaps in a political squall or an ecclesiastical tempest. But it could also have a salutary effect. It might help us develop a more balanced appraisal of the texts and institutions of early Christianity. So let us thank the forger for providing us with an opportunity to explore the ways in which church life from the very beginning has involved imitation and deception in the construction of authority.

[45] Briefel, *Deceivers*, 18.

BIBLIOGRAPHY

Bailey, John A. "Who Wrote II Thessalonians?" *NTS* 25 (1978) 133–34.

Barnes, Timothy D. " '*Fälschung*' and 'Forgery.' " *Historia* 44 (1995) 497–500.

Briefel, Aviva. *The Deceivers: Art Forgery and Identity in the Nineteenth Century*. Ithaca, N.Y.: Cornell University Press, 2006.

Brodie, Thomas L., Dennis R. MacDonald, and Stanley E. Porter, eds. *The Intertextuality of the Epistles: Explorations of Theory and Practice*. Sheffield, U.K.: Sheffield Phoenix, 2006.

Duling, Dennis C. *The New Testament: History, Literature, and Social Context*. 4th ed. Belmont, Calif.: Thompson Wadsworth, 2003.

Grafton, Anthony. *Forgers and Critics: Creativity and Duplicity in Western Scholarship*. Princeton, N.J.: Princeton University Press, 1990.

Harrill, J. Albert. *Slaves in the New Testament: Literary, Social, and Moral Dimensions*. Minneapolis, Minn.: Fortress, 2006.

Hovhannessian, Vahan. *Third Corinthians: Reclaiming Paul for Christian Orthodoxy*. New York: Peter Lang, 2000.

Hughes, F. W. "Thessalonians, First and Second Letters to the." Pages 111–16 in *New Testament: History of Interpretation; Excerpted from the Dictionary of Biblical Interpretation*. Edited by John H. Hayes. Nashville: Abingdon, 2004.

Jaffee, Martin S. *Torah in the Mouth: Writing and Oral Tradition in Palestinian Judaism, 200 BCE–400 CE*. New York: Oxford University Press, 2001.

James, M. R. *The Apocryphal New Testament*. Oxford: Clarendon, 1924.

Jewett, Robert. *The Thessalonian Correspondence: Pauline Rhetoric and Millenarian Piety*. Philadelphia: Fortress, 1986.

Kafka, Franz. *Letters to Milena*. Edited by Willy Haas. Translated by Tania and James Stern. New York: Schocken, 1953.

Kennedy, George A. *A New History of Classical Rhetoric*. Princeton, N.J.: Princeton University Press, 1994.

Klauck, Hans-Josef and Daniel P. Bailey. *Ancient Letters and the New Testament: A Guide to Context and Exegesis*. Waco, Tex.: Baylor University Press, 2006.

Klijn, Albertus Frederik Johannes. "The Apocryphal Correspondence between Paul and the Corinthians." *VC* 17 (1963) 2–23.

Krentz, Edgar M. "Thessalonians, First and Second Epistles to the." *ABD* 6:515–23.

Leppä, Outi. "2 Thessalonians among the Pauline Letters: Tracing the Literary Links Between 2 Thessalonians and Other Pauline Epistles." Pages 176–95 in *The Intertextuality of the Epistles: Explorations of Theory and Practice*. Edited by Thomas L. Brodie, Dennis R. MacDonald, and Stanley E. Porter. Sheffield, U.K.: Sheffield Phoenix, 2006.

Malherbe, Abraham J. *The Letters to the Thessalonians*. AB 32B. New York: Doubleday, 2000.

———. *Ancient Epistolary Theorists*. Atlanta, Ga.: Scholars Press, 1988.

Merz, Annette. "The Fictitious Self-Exposition of Paul: How Might Intertextual Theory Suggest a Reformulation of the Hermeneutics of Pseudepigraphy?" Pages 113–32 in *The Intertextuality of the Epistles: Explorations of Theory and Practice*. Edited by Thomas L. Brodie, Dennis R. MacDonald, and Stanley E. Porter. Sheffield, U.K.: Sheffield Phoenix, 2006.

Mitchell, Margaret M. "Paul's Letters to Corinth: The Interpretive Intertwining of Literary and Historical Reconstruction." Pages 307–38 in *Urban Religion in Roman Corinth: Interdisciplinary Approaches*. Edited by Daniel N. Schowalter and Steven J. Friesen. HTS 53. Cambridge, Mass.: Harvard Divinity School, 2005.

Picard, Roger. *Artifices et mystifications littéraires*. Montreal: Dussault et Péladeau, 1945.

Roose, Hanna. " 'A Letter as by Us': Intentional Ambiguity in 2 Thessalonians 2:2." *JSNT* 29 (2006) 107–24.

———. "2 Thessalonians as Pseudepigraphic 'Reading Instruction' for 1 Thessalonians: Methodological Implications and Exemplary Illustration of an Intertextual Concept." Pages 134–51 in *The Intertextuality of the Epistles: Explorations of Theory and Practice*. Edited by Thomas L. Brodie, Dennis R. MacDonald, and Stanley E. Porter. Sheffield, U.K.: Sheffield Phoenix, 2006.

Schmidt, Johannes Ernst Christian. "Vermuthungen über die beyden Briefe an die Thessalonicher." Pages 380–86 in *Bibliothek für Kritik und Exegese des Neuen Testaments und ältesten Christengeschichte 2,3*. Herborn; Hadamar: Neuen Gelehrtenbuchhandlung, 1797–1803.

Stowers, Stanley K. *Letter Writing in Greco-Roman Antiquity*. Philadelphia: Westminster, 1986.

Thomason, Dana Andrew. "Corinthians, Third Epistle to the." *ABD* 1:1154.

Trapp, Michael, ed. *Greek and Latin Letters: An Anthology with Translation*. Cambridge, U.K.: Cambridge University Press, 2003.

Trilling, Wolfgang. *Untersuchungen zum 2. Thessalonicherbrief*. Erfurter theologische Studien 27. Leipzig: St. Benno, 1972.

White, John L. *Light from Ancient Letters*. Philadelphia: Fortress, 1986.

Witherington, Ben, III. *1 and 2 Thessalonians: A Socio-Rhetorical Commentary*. Grand Rapids, Mich.: Eerdmans, 2006.

Wrede, William. *Die Echtheit des zweiten Thessalonicherbriefs*. Leipzig: J. C. Hinrichs, 1903.

*The Later Roman Empire and the
Early Byzantine Period*

Christianization of Thessalonikē: The Making of Christian "Urban Iconography"

Slobodan Ćurčić

The city of Thessalonikē is renowned for a number of important early Christian monuments preserved in reasonably good condition. In fact, as such, it may have a unique status among all Late Antique urban centers. Yet paradoxically we know little about the process of Christianization of the city, how and when it may have begun, what conditions the authorities involved in that process may have had to confront, and, indeed, who the individuals involved in that process may have been. Therefore, before going any further, it is necessary to review some of the known facts.

THESSALONIKĒ AS A TETRARCHIC CAPITAL UNDER CONSTANTINE

During the last quarter of the third century, Thessalonikē, a long-since established Roman city on Greek soil, emerged as a major imperial center thanks to Emperor Galerius, whose activities as Diocletian's co-ruler within the so-called Tetrarchy are the subject of a paper in this volume by Aristotle Mentzos. In accordance with the Tetrarchic reforms and the new concept of governance, it was under Galerius that Thessalonikē became one of the four new capital cities of the Roman Empire: Milan, Trier, and Antioch were the

other three.[1] The relatively rapid emergence of Thessalonikē in this new role—within just over a decade—left a lasting urban and architectural imprint. These elements are still highly visible within the fabric of the modern city.

As is the case in several other urbanized ancient cities, the Christianization of Thessalonikē was a relatively slow process. The role of Emperor Constantine in Thessalonikē following the death of Galerius, as well as the crucial shift in imperial policy toward Christianity, is not well documented and has become a subject of some debate. In his push to establish himself as the only Roman Emperor, Constantine spent the years 318–324 C.E. almost exclusively in the Balkans. Preparing himself for the eventual decisive confrontation with his brother-in-law Licinius, Constantine spent time in Thessalonikē in 322–323 C.E. At that time, among his various projects he also undertook the construction of a new harbor in the city.[2] Recent investigation of the remains of the great Octagon within Galerius's Palace, apparently left unfinished at the time of Galerius's death in 311 C.E., suggests that Constantine may have actually completed it.[3]

In a lecture delivered in Thessaloniki in 1999 and subsequently published, I argued that the great Rotunda itself, begun under his command as his mausoleum, may have been one of Constantine's undertakings in Thessalonikē (fig. 1).[4] Constantine apparently left the Rotunda unfinished, as his focus abruptly shifted toward Constantinople in the wake of his victory over Licinius in 324 C.E. I presented my ideas regarding the Rotunda and its association with Constantine strictly as a hypothesis. The more commonly accepted viewpoints that Galerius built the Rotunda either as the mausoleum or, alternatively, as a pagan temple dedicated either to Jupiter or to the Kabeiroi, however, do not rest on firm ground based on the weight of evidence. The proposed hypothesis that the Rotunda may have been built as a temple, in my opinion, can be safely laid aside.[5] The mausoleum hypothesis can also be challenged in part because neither Galerius nor Constantine was actually buried in Thessalonikē. Historical facts regarding their actual places of burial are now well established and cannot be disputed: Constantine was buried

[1] Vitti, *Η πολεοδομική εξέλιξη*. See Vitti regarding Thessalonikē in Roman times; Adam-Velenē, "Thessaloniki: History and Town Planning," 121–76.

[2] Macmullen, *Constantine*, 123–38. See Macmullen for Constantine's eastward push; see ibid., 134–35 for the harbor in Thessalonikē.

[3] Athanasiou et al. "Νέα στοιχεία," esp. 176.

[4] Ćurčić, *Some Observations*.

[5] With the exception of the Pantheon in Rome no other comparable Roman temple, either in general conception or in details, is known. Other known circular Roman temples invariably feature external colonnades, and none has windows in the exterior walls of its *cella*.

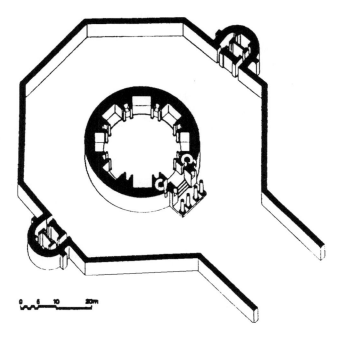

Fig. 1. Thessalonikē, Rotunda, ca. 330; axonometric drawing: Slobodan Ćurčić.

in Constantinople in the Church of the Holy Apostles, built by him as his own mausoleum toward the end of his life, while Galerius was buried at the complex known as Romuliana, which he built in the memory of his mother Romula. Romuliana lies in the northern Balkans at a location presently known as Gamzigrad in Serbia.[6] Consequently, if the Rotunda was intended as an imperial mausoleum for either of the two emperors, it never served its intended purpose, and for that very reason may initially have been left unfinished. This, of course, leaves the following question of its origins in doubt: Which of these two Emperors may have changed his mind regarding his planned place of burial, and why? Regardless of the ultimate answer to this question, by ca. 320 C.E., Thessalonikē displayed a vast complex of monumental imperial buildings, which included the Rotunda. These were

[6] Srejovic, ed., *Roman Imperial Towns*, esp. 31–53; Srejović and Vasić, *Imperial Mausolea*; and the still invaluable Ćanak-Medić, *Gamzigrad*, are the most valuable among several works published on Romuliana within recent years.

organized in a deliberate manner, and their grouping in an urban context has been interpreted as an example of late Roman imperial "iconography."[7]

Constantine's documented and postulated building involvements in Thessalonikē leave little room for further discussion of what—if anything— may have been specifically Christian in his building program, if the notion of a "program" is appropriate at all in that context. Nor does determining the nature of the specifically Christian building activity in Thessalonikē become easier during the six or seven decades following Constantine. To a considerable degree the problem appears exacerbated by the fact that we can securely date none of the early surviving churches in Thessalonikē, and that we do not know even their dedications in most cases.

THE CONVERSION OF THE ROTUNDA INTO A CHURCH

This brings us back again to the Rotunda, whose history scholars have ceaselessly debated and whose eventual completion appears no less problematic than the question of its origins.[8] The next critical stage in its history occurs with its conversion into a church, which, according to a number of scholars including myself, probably took place late in the reign of Emperor Theodosius I (379–395 C.E.). The conversion involved much more than a functional change of the building; it also profoundly affected the building's appearance. A large apse, with a square bay preceding it, was added to the east side of the freestanding Rotunda (figs. 2 and 3). To accomplish this, one of the great niches and a corresponding window above it had to be removed, and the original arched openings had to be widened. At the same time, the outer walls of the remaining ground-floor niches were opened, transforming them into large passageways related to a spacious ambulatory that was wrapped around the entire building, more than doubling its interior floor area.[9]

The most impressive intervention within the converted Rotunda, without a doubt, was the finishing of its dome and the decorating of its underside

[7] Frazer, "Iconography," esp. 386–88. Frazer provides references to Thessalonikē.

[8] Torp, "Quelques remarques," 489–98. The opinions concerning the date of this conversion are sharply divided, ranging from the late fourth to the sixth century. Although not the first, Torp has been the most persistent promoter of the late fourth-century dating. See also idem, "Date of the Conversion," 13–28. Vickers argued for a mid-fifth-century date ("Date of the Mosaics," 183–87). Spieser proposed an early sixth-century dating (*Thessalonique et ses monuments*).

[9] At a later time in the history of the building, these openings were again closed, while the spacious ambulatory was eliminated; see Ćurčić, "Some Observations," 22.

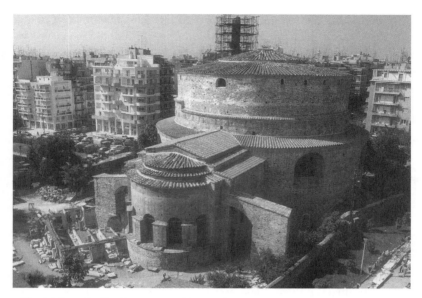

Fig. 2. Thessalonikē, Rotunda; aerial view from N.E. Photo: Soteris Haidamenos, Ninth Ephoreia for Byzantine Antiquities, Thessaloniki.

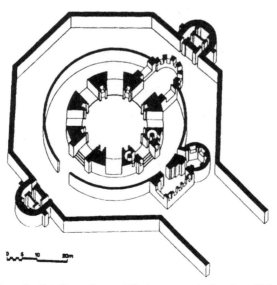

Fig. 3. Thessalonikē, Rotunda, ca. 400. Axonometric drawing: Slobodan Ćurčić.

with one of the first, largest, and finest of monumental Christian mosaic programs that has been preserved anywhere (fig. 4).[10] The program consisted of eight enormous panels (only seven are actually preserved), depicting pairs of standing male figures in prayer (fig. 5). These, in all likelihood, represent martyred saints shown against a background of fantastic architecture, although the general meaning has sparked various interpretations.[11] The elaborate architectural displays, recalling Roman theater *scaenae frons* and, therefore, also imaginary palaces, has been interpreted as an allusion to the heavenly Jerusalem.[12] The "heavenly" nature of these buildings is reinforced by the inclusion of peacocks and other birds and by the fact that many of the columns on their façades are depicted as studded with gems (fig. 6).

The elaborate scenes, including the frontal male figures in prayer, should be considered together with the pictorial representation at the apex of the dome (fig. 7). Although badly damaged, the dome mosaic included a full standing figure of Christ victorious within a wreathed medallion, symbolically carried by four angels with widespread wings. While this theme clearly depicts an early version of Christ's ascension, its iconographic makeup unmistakably links it to imperial themes and notably to the apotheosis. Hypothetically speaking, we may postulate that, along with the real architecture, which accommodates it, the entire composition owes its debt to Roman imperial art at its best. We may go one step further and propose that what is depicted here, in a distinctly Christian context, is a scene of an imperial *salutatio*

[10] This grand mosaic program underwent long, thorough restoration in the aftermath of the 1979 earthquake that had partially damaged the Rotunda and endangered all of the mosaics in the building. The process of conservation and cleaning has recently been completed, but a thorough study of the dome mosaics remains a major desideratum.

[11] Grabar, "A propos des mosaïques," 59–68; Kleinbauer, "Iconography and the Date," 27–107. Kleinbauer still has the most detailed study of the dome mosaics to date. Both authors accept the date of ca. 450 and see the program as depicting the second coming of Christ. Ten years later Kleinbauer returned to the subject of the program, offering a new interpretation that has not been accepted: idem, "Orants in the Mosaic," 25–45. The imperial sources of the program's central theme, curiously, have not been stressed extensively. Even one of the main proponents of the imperial origins of early Christian art, Grabar (*Christian Iconography*), does not discuss it in his main work on Christian iconography. The subject is also not dealt with by Elsner (*Imperial Rome*), who writes a single sentence that refers to Thessalonikē in conjunction with Galerius, while it is completely ignored by Mathews (*Clash of Gods*), whose book has failed in its central objective—to prove the lack of links between early Christian and Roman imperial art. Most recently, Laura Nasrallah offers a balanced interpretation of the dome program with an extensive up-to-date listing of relevant literature ("Empire and Apocalypse," 465–508).

[12] Lidov, "Heavenly Jerusalem," 341–53; see also Torp, "Dogmatic Themes," 11–32; see idem, "Les mosaïques de la Rotonde," 3–20. Torp discusses the architectural setting of the scenes and its meaning.

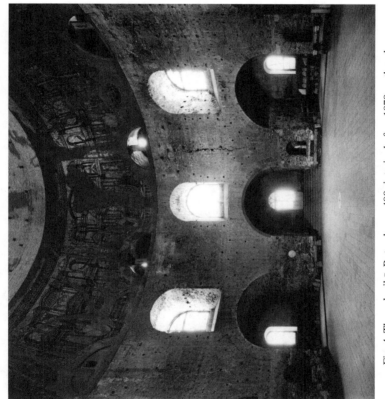

Fig. 4. Thessalonikē, Rotunda, ca. 400; interior before 1979 earthquake.
Photo: Max Hirmer.

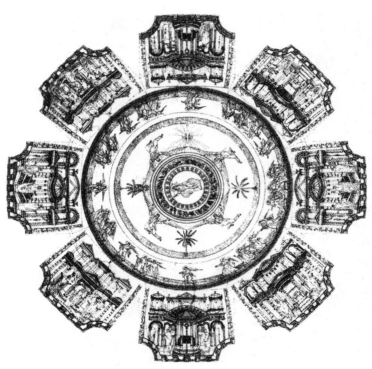

Fig. 5. Thessalonikē, Rotunda, dome mosaic program; reconstruction. Drawing: Manolis Korres, Ninth Ephoreia for Byzantine Antiquities, Thessaloniki.

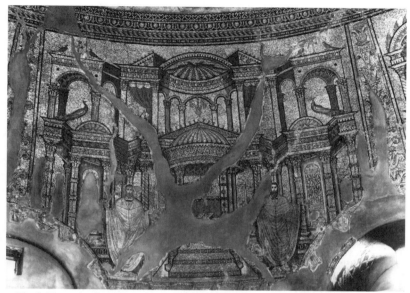

Fig 6. Thessalonikē, Rotunda, dome mosaic program; one of the seven surviving panels. Photo: Max Hirmer.

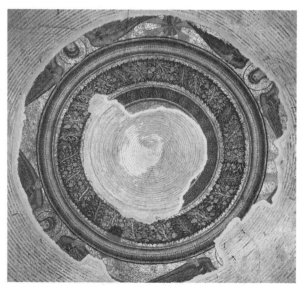

Fig. 7. Thessalonikē, Rotunda, dome mosaic; preserved apex portion. Ninth Ephoreia for Byzantine Antiquities, Thessaloniki.

shown in a manner resembling an actual event that would have taken place in a *vestibulum* or a *salutatorium* of an imperial palace and in the presence of invited dignitaries.[13] The "emperor," in this context, is Christ himself; the "invited dignitaries," martyr saints; and the palatine setting, the heavenly Jerusalem.

The ad hoc creation of this grand scheme, as far as we know, has no precedent and no following in early Christian art. The choice of the subject matter would have ideally suited the city chosen by Emperor Theodosius as a stage for the affirmation of his stringent policies and particularly his efforts at making Christianity the exclusive religion of the Empire.[14] By converting an unfinished older structure and giving it a new Christian use, the emperor would have given a palpable form to the notion of Christian triumph. The conversion of the Rotunda in Thessalonikē may well have been the first major instance of an older, pagan monumental structure in the Balkans being specifically converted to Christian use.

Thessalonikē in the Fifth Century

The conversion of the Rotunda at the very end of the fourth century ushered in a large-scale building program, which transformed Thessalonikē into a Christian city par excellence (fig. 8).[15] Despite the fact that we lack documentary evidence for most of the surviving or excavated buildings, beyond any doubt the momentum for the building of major Christian churches lasted through the fifth century but subsequently declined in the course of the sixth. The number, the size, and the character of Thessalonikē's several intramural buildings, especially churches, reveal the city's real economic strength and the creative powers of its patrons, planners, and builders during the fifth century. At the same time, this pattern of construction signals a steady, deliberate transformation of the former tetrarchic capital into a major Christian metropolis with its own distinctive urban characteristics.

A number of cemetery churches, among them a large basilica, were built outside the city walls in a manner characteristic of all large Christian urban centers of this period. This chapter focuses instead on several major church

[13] Alföldi, "Die Ausgestaltung," 1–118; this text is still a basic work. Smith, *Architectural Symbolism*, esp. 130–51, for the architectural setting of the ceremonies in question.

[14] Williams and Friell, *Theodosius*, esp. 67ff., for Theodosius's interventions in Thessalonikē, notably the massacre in the Hippodrome in 390.

[15] Torp, "Thessalonique paléochrétienne," 113–32. See Torp for a fine overview of early Christian Thessalonikē.

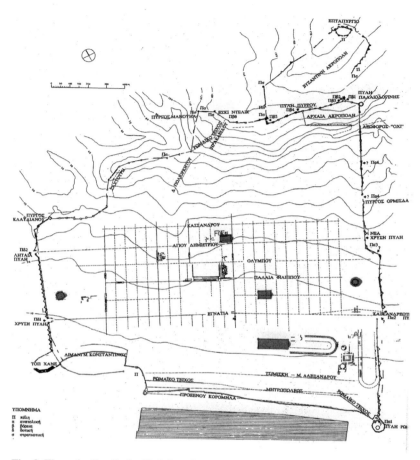

Fig. 8. Thessalonikē, Early Christian city; plan showing the main churches. Based on Georgios Velenēs.

buildings that were constructed within the city walls. These include the well-known and still preserved churches of Hagios Demetrios and Acheiropoietos, as well as two other large churches known only from excavated remains. Built within six to seven decades, this group of buildings, strategically placed within the preexisting urban fabric, unequivocally demonstrates Christian triumph within the city. Needless to say, their incorporation into the preexisting urban constellation of the tetrarchic capital fundamentally altered its meaning, albeit without obliterating the underlying logic of its planning.

We shall start our discussion of these churches by turning first to the excavated remains of foundations belonging to a large octagonal church near the original Golden Gate in the western part of the city (fig. 9). Possibly associated with the cult of St. Nestor, St. Demetrius's companion saint martyred near the Golden Gate, the church in all probability had a dome and resembled the converted Rotunda at the opposite side of town by virtue of its size as well as its form.[16] Measuring 54 x 59 m, the building matched closely in size the converted Rotunda with its diameter of 57 m. Two smaller, centralized buildings accompanied the octagonal church: a baptistery to its northwest and possibly a *martyrium* to its southeast. The main part of the church consisted of a domed octagon (22 m in diameter) open only on the east and the west sides, with six semicircular niches cut into the remaining six sides of its massive octagonal parameter wall. On the east side, resembling the layout of the converted Rotunda, this octagonal space opened into a spacious, apsed sanctuary, while on the west side it was linked to a large, oblong narthex measuring 7 x 40 m. An ambulatory, possibly subdivided by a row of columns (and piers?) supporting an arcade and the vaulting above (fig. 10), circumvented the octagonal core. The hypothetical reconstruction of its plan has no direct parallels in Thessalonikē or elsewhere, although it may have a conceptual link to the converted Rotunda.[17] Although large domed buildings featuring massive exterior walls in the older Roman tradition continued to appear in the course of the fifth century in Constantinople, generally speaking, they seem to have gone out of fashion shortly after 400 C.E.[18] Thus, we should probably think of our building as dating to the early fifth century and perhaps associated with the climate of aggressive Christianization initiated by Theodosius I. As such, it may be considered a true ideological pendant to the converted Rotunda: Both originally stood within the city walls near the principal city gates marking the west and the

[16] Markē, " Ἔνας ἄγνωστος ὀκταγωνικός ναός," 117–32. The association with St. Nestor is completely hypothetical, based essentially on the proximity of this church to the site of the "Golden Gate" and on the fact that the building shares some general characteristics with the early *martyria*.

[17] See also comments by Torp, "Thessalonique paléochrétienne," 127–28.

[18] The most remarkable of the late buildings constituting the progeny of the Pantheon in Rome is the so-called Myrelaion Rotunda in Constantinople. Its foundations survive and attest to the fact that centralized domed buildings of conservative design and even larger than the Rotunda in Thessalonikē were being built after ca. 400 in Constantinople; see Ćurčić, "Design and Structural Innovation," 16–38, esp. 25; MacDonald, *Pantheon*. MacDonald devotes ch. 5 to discussing the "progeny" of the Pantheon but surprisingly does not mention either the Rotunda in Thessalonikē or the Myrelaion Rotunda in Constantinople.

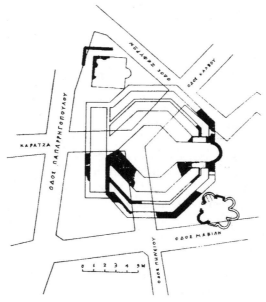

Fig. 9. Thessalonikē, Octagonal Church near the Golden Gate; plan of excavated remains. After Euterpē Markē.

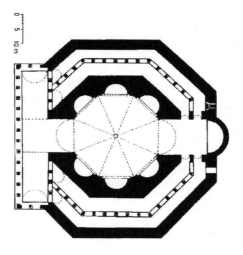

Fig. 10. Thessalonikē, Octagonal Church near the Golden Gate; plan, hypothetical reconstruction. After Evangelia Hadjitryphonos.

east terminal points of the Via Egnatia.[19] Save for some of its architectural sculptural elements, nothing of the octagonal church survived. These and other building characteristics unmistakably confirm the early fifth century as the probable date of its construction.

The largest and probably the most important church built within the walls of Thessalonikē in the course of the fifth century was a giant basilica, whose foundations were uncovered under the present church of Hagia Sophia (fig. 11).[20] Constructed over the remains of an older, possibly fourth-century building, the remains of this church, the second basilica on the site, are far more comprehensible than those of its predecessor. This may have been the largest church in the Balkans, measuring 94 x 53 m and covering a floor area of 0.5 ha. It should be pointed out that, generally speaking, five-aisled basilicas were exceptional buildings; rare comparable giant structures include the well-known basilicas of Old St. Peter and San Paolo fuori le Mura in Rome. The church in Thessalonikē, whose dedication remains unknown, had a nave 19.45 m wide terminating in a spacious apse, which was semicircular internally and externally. One entered the church through an oblong narthex as wide as the church itself. In front of the building was a huge atrium, measuring approximately 53 x 55 m. By virtue of its size and its central location in the city, the church, in all likelihood, functioned as the city's cathedral. The great church had a correspondingly large baptistery on its south side that may have already been built for the earlier church that existed on the site. The baptistery survives in ruins. Known today as the Hagiasma of Hagios Ioannis, it lies separated by a modern street to the south of the church of Hagia Sophia.[21]

Whether the giant church may have also been adjoined by a bishop's palace, as became customary for cathedral churches of this period, cannot be said with certainty. The discovery of a bath to the southwest from this area may be linked to such a complex in the general area.[22] It is also worth noting that, in addition to the great basilica under Hagia Sophia, other large urban churches, such as Hagios Demetrios and Acheiropoietos, were also built in

[19] Markē, "Ἕνας ἄγνωστος ὀκταγωνικός ναός," 117–32. The juxtaposition of the two centralized domed churches near the two main city gates of Thessalonikē was observed already by Markē, but she saw their role in that context as an apotropaic one: Both buildings supposedly served as repositories of important relics and had important roles in defending the city.

[20] Theocharidou, *Architecture of Hagia Sophia,* 10–13.

[21] Hadjitryphonos, "Η εικόνα, το περιεχόμενο," 106–9; Markē, "Η Αγία Σοφία," 54–61.

[22] Hattersley-Smith, *Byzantine Public Architecture,* 142–44. Hattersley-Smith discusses the great basilica; ibid., esp. 142, for the baths.

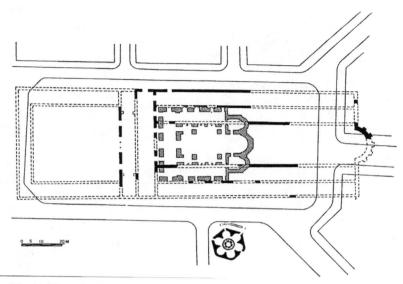

Fig. 11. Thessalonikē, Basilica below Hagia Sophia; plan based on excavations including the baptistery (?). After Evangelia Hadjitryphonos.

relationship to preexisting bathing establishments. Built within the older city fabric, most of these large churches must occupy sites previously occupied either by public buildings originally owned by the state or by sumptuous private residences donated to the Church by their owners. In either case, in the course of the fifth century, real estate ownership within Thessalonikē by various means was increasingly passing into the hands of the Church.

Two other well-known basilicas built in the course of the fifth century—Hagios Demetrios and Acheiropoietos—survive, albeit substantially altered. We shall devote to them a limited amount of space in this context. The church of Hagios Demetrios, despite many unresolved problems, remains certainly the most important fifth-century monument to have survived in Thessalonikē (fig. 12).[23] Its present form is a result of a massive reconstruction carried out after the great fire of 1917, which severely damaged the church along with a large section of the city that was utterly destroyed. Without going into detailed clarifications, I shall accept the point of view that the basilica

[23] Bakirtzis, *Basilica of St. Demetrios.* Bakirtzis provides a useful summation of the extensive literature on the Hagios Demetrios basilica, and issues related to its archaeology and dating are much contested. Some of the general conclusions expressed by Georgios and Maria Georgiou Soteriou are now widely rejected, but the book nonetheless remains the most thorough and therefore unavoidable study of the building. Soteriou, *Η Βασιληκή.*

Fig. 12. Thessalonikē, Hagios Demetrios, aerial view from the southwest. Photo:
Soteris Haidemenos, Ninth Ephoreia of Byzantine Antiquities, Thessaloniki.

of Hagios Demetrios was initially built during the second half of the fifth
century. Although considerably smaller than the giant cathedral church that
we have already discussed, Hagios Demetrios was nonetheless a sizable
building, measuring 33 x 44 m. It, too, was a five-aisled basilica: It had a large
transept, slightly narrower and slightly lower than the main nave. The church
had galleries over its side aisles and the narthex and an original large open
atrium now preserved in the form of an open plaza fronting the church.

The other surviving fifth-century basilica in Thessalonikē, the Acheiropoietos
("Not made by [human] hands"), has preserved much of its original form (fig.
13). Despite the fact that we do not know the exact dates of its construction
and that it also underwent a number of repairs throughout its long history,
scholarly opinion agrees that the construction of the building took place
within a decade or two after 450 C.E. The Acheiropoietos is a three-aisled
basilica somewhat smaller in size than Hagios Demetrios.

The two basilicas share a number of architectural features characteristic
of fifth-century architecture that, according to Richard Krautheimer, had

Fig. 13. Thessalonikē, Acheiropoiētos Basilica; interior looking east. Photo: Nikolaos Bakirtzis.

undergone a process of standardization.[24] Particularly notable among these are the newly devised columnar orders that constitute one of the hallmarks of church architecture of this period (fig. 14). Based on the classical orders,

Fig. 14. Composite capital with impost block, from Hagios Demetrios, Thessalonikē. Photo: Max Hirmer.

these are unmistakably Christian in their conception. The difference is not only one of style, although the composite capitals used at this time are also distinctive in those terms. Rather, the classical understanding of orders is now supplemented by the addition of an entirely new element: the so-called impost block placed atop each of the column capitals. Analyzed by historians in the past, these impost blocks have erroneously been ascribed a structural role.[25] Their sole function seems to have been symbolic. Almost invariably, impost blocks feature on their primary faces crosses that visually appear to stand atop the columns to which they are related. A cross, atop a single column, must be viewed as a Christian version of an honorific column, commemorating in this case Christian victory. Collectively, these columns allude unequivocally

[24] "The inventiveness and experimentation of the Constantinian age gives way to the establishment of norms, and distinct building types, which had gradually evolved for different liturgical functions, rapidly becoming standardized." Krautheimer, *Early Christian*, 68; repr., 94. The quotation remains unchanged in the fourth revised edition.

[25] Jackson, *Byzantine and Romanesque*, 1:51–52. Jackson uses the terms *pulvino* and *dosseret*, instead of impost. See Ćurčić for a critique of the structural rationalization regarding the invention of the impost block ("Justinian Impost Capitals," 53–54).

to the final victory of Christianity over paganism. Impost blocks, almost universally present in fifth-century Byzantine church architecture, disappear in the course of the sixth century. By ca. 500 C.E., they appear to have fulfilled their symbolic role. This phenomenon unmistakably suggests that the role of the impost block was not related to structural issues; otherwise its disappearance in the sixth century would be difficult to understand.

Individual columns topped by a cross evidently stood in many Late Antique cities. One is recorded on a mosaic depiction in the sixth-century Church of the Lions at Kastron Mefaa, present-day Umm al-Rassas in Jordan (fig. 15).[26] The column is shown in an area fronting the main city gate and on axis with it. It depicts the column on a stepped base and with a cross on top of its capital. Unmistakably, this Christian victory symbol was intended to greet all those arriving at the gate of Kastron Mefaa.

THE CHRISTIAN TOPOGRAPHY OF THESSALONIKĒ

The topography of the churches in Thessalonikē that we have discussed is also revealing and must be taken into account. As already mentioned, the Rotunda and its counterpart, the octagonal church on the west side of the city, relate to the main east-west axis of the city. The three large basilicas, although not absolutely lined up, substantially define a transversal, north-south axis. None of the churches involved occupied the city center. The area of the excavated ancient agora contained no church buildings, and the same appears to have been the case in a large area directly south of the agora, identified as the "lower agora."[27] By virtue of their location, the monumental churches appear to have "ringed" the city center, the presumed heart of the ancient, pagan Thessalonikē, deliberately positioned in demonstration of the Christian "conquest" of the pagan urban domain.

Such urban planning strategies are known from other contexts.[28] In the eastern sphere, perhaps the most impressive example is that of Philippi, where by the early sixth century, the ancient city forum was surrounded by large Christian churches: the Octagonal cathedral to the east, Basilica A to the north, Basilica B to the south, Basilica G to northwest, and yet another unexcavated

[26] Saradi, *Byzantine City*, 128–29 and fig. 12; Bowersock, *Mosaics as History*, 66–67; and Bertelli, "Visual Images," 127–46, esp. 133–36.

[27] Hattersley-Smith, *Byzantine Public Architecture*, 120–27, for a useful summary.

[28] Krautheimer, *Rome*. The case of the city of Rome is the most revealing and the best studied; see ch. 1 ("Rome and Constantine") and ch. 2 ("The Christianization of Rome and the Romanization of Christianity").

Fig. 15. Um-al-Rassas (Kastron Meffa), Church of the Lions, floor mosaic.
Photo: Hélène Saradi (detail).

church apparently stood directly west of the forum area (fig. 16).[29] At Philippi, the Christian "containment" of the main pagan public space was the most dramatic. The case of Apamea in Syria, although less emphatic, recalls the approach that we saw in Thessalonikē. Its *decumanus* was defined by two large centralized buildings: the Rotunda, just west of the *cardo*, and the tetraconch cathedral close to the city's eastern gate. The north-south axis of the city was dominated by a basilica to the north and by the so-called Atrium Church to the south (fig. 17).[30]

The disposition of monumental church architecture in Thessalonikē, Philippi, and Apamea brings two additional points into focus. The first point involves the typology of churches in question. In all three cities, we see a relatively balanced use of centralized domed and basilican churches. Examination of church typology once used to dominate the study of Byzantine architecture, so much so that its rejection in the past two decades has left a glaring void in current scholarship on this issue.[31] I consider this methodological flip regrettable, not because I believe that we need to resuscitate typological investigations and to give them the disproportionally large role they once held, but because certain typological choices made during the times that concern us certainly do not appear to have been accidental. Typology, as a method of study, has many shortcomings, yet some of the typological observations can prove useful. Early scholarship believed that centralized churches were predominantly *martyria*, a notion that has long since been demonstrated as wrong, but present scholarship has not yet adequately resolved the question why some churches were indeed centralized, while others were not. We can hardly consider the issue itself irrelevant.

Our topographical observations regarding the Christianization of cities bring into focus a second point concerning the iconography of architecture. Richard Krautheimer introduced the subject as such in a seminal study sixty-five years ago.[32] Largely misunderstood and erroneously employed in several instances, the iconography of Byzantine architecture has also become

[29] Bakirtzis and Koester, eds., *Philippi*, 37–48; see also Koukouli-Chrysanthaki and Bakirtzis, *Philippi*.

[30] Saradi, *The Byzantine City,* esp. 273–74 and 398; Balty, *Guide d'Apameé.*

[31] The phenomenon has taken place virtually by fiat, without significant scholarly debate, during the past two decades or so. While the typological approach to the study of buildings still flourishes in certain places (e.g., Greece, Eastern Europe), it has essentially been abandoned in the U.S.

[32] Krautheimer, "Introduction," 115–50. In a postscript Krautheimer expresses certain methodological reservations.

Fig. 16. Philippi, Early Christian city, plan. Based on Hélène Saradi.

Fig. 17. Apamea, Early Christian city, plan. Based on Hélène Saradi.

a substantially ignored topic in recent times.[33] As in the case of typology, I would like to argue for a greater sensitivity to the implicit issues. Although a search for such a thing as an "iconographic guide" may be a futile task and even a false expectation, "iconographic statements" may have been employed

[33] In some ways related to the typological method, "iconography of architecture" has retained a degree of respectability perhaps because of its general intellectual associations with the subject of the iconography of Christian art. Unlike the iconography of art, which enjoys a high level of popularity, topics dealing with the iconography of architecture are discussed relatively rarely.

by Late Antique patrons and builders not only in the context of individual buildings, but even on the scale of urban planning.

THE MAKING OF CHRISTIAN "URBAN ICONOGRAPHY"

We may pursue the latter point further in the context of the present study. As already noted, the Christianization of Thessalonikē was a long process, whose ultimate success received a palpable expression in the reconfiguration of its urban fabric through the building of major public churches in the course of the fifth century. This process ultimately resulted in the suppression of the pagan triumphal urban iconography that formed the backbone of the tetrarchic capital and the introduction of a new, Christian triumphal urban iconography in its place.[34] The chief elements of this Christian urban iconography consist of five large church buildings: two centralized domed structures and three basilicas. The juxtaposition of the two domed buildings, the Rotunda and the octagonal church, as monumental framing points of the city's east-west axis, may have had the primary symbolic significance. Our lack of information as to the exact function of either of these two buildings compromises our ability to penetrate into this issue with greater conviction. If we accept the possibility of the octagonal church having been dedicated to St. Nestor, however, we may think of it as a "martyrium-memoria" marking the location of Nestor's martyrdom, and, therefore, as in association with Christ's own and the manner of its memorialization in the Anastasis Rotunda in Jerusalem. We could further link this hypothetical analogy with the Rotunda in Thessaloniki at the opposite end of the city as a symbolic embodiment of the Heavenly Jerusalem, a notion reinforced, as already noted, by its mosaic program. Different means—from the placement of the cross within the context of the columnar orders, to various depictions in art, to the topographical placement of buildings within the urban structure of established cities, and ultimately to the typological choice of individual churches—could and apparently did memorialize the celebration of Christian triumph.

The notion of "Christian urban iconography" to which I have just alluded has its equally significant parallels in contemporaneous art. Late Antique art is known for its conscious development of a new iconography of Christian

[34] Nasrallah ("Empire and Apocalypse") discusses links and contrasts between triumphal Christian iconography in the Rotunda and the triumphal imperial iconography on the Arch of Galerius.

cities.[35] Floor mosaics excavated in large numbers, notably in the territory of Jordan, prove especially significant for the understanding of this phenomenon. A few critical examples illustrate the point. The partially preserved floor mosaics in the church of St. John the Baptist at Gerasa, present-day Jerash, include representations of three cities, one of them labeled Alexandria (fig. 18).[36] The schematic representation, customary in all of the related

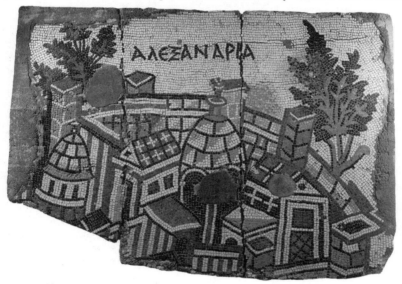

Fig. 18. Alexandria; mosaic representation; floor mosaic from Church of St. John the Baptist in Gerasa. Photo: Michele Piccirillo.

mosaics, in all likelihood also highlights some of the distinctive features of Alexandria's urban topography. Within the walled city, one recognizes two domed buildings, presumably churches, as well as two basilicas. The mosaic offers a synoptic image of Alexandria as it must have appeared around 531 C.E., when the mosaic was made. Clearly the mosaic selectively highlights the essential features of Christian Alexandria: its city walls and its churches, which included two domed buildings and two basilicas. Similar in conception is a representation of Memphis on a floor mosaic at Khirbet es-Samra, also

[35] Saradi, *The Byzantine City*, 119–44 (ch. 5, "The City as a Visual Motif in Early Byzantine Art").

[36] Duval, "L'iconografia architettonica," 151–56, and 220 (cat. no. 2).

in Jordan, dated a century earlier (fig. 19).[37] Here the walled enclosure is more regularized: The seven towers are symmetrically arranged around an

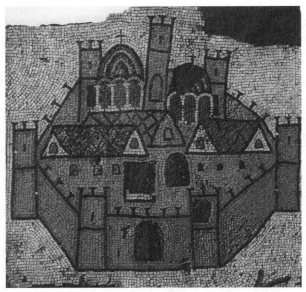

Fig. 19. Memphis; mosaic representation; floor mosaic from Khirbet es-Samra.
Photo: M. Piccirilo.

interior that contains two domed and three basilican churches. The clichéd rendition appears as an abstract echo of the situation that we encountered in Thessalonikē with its two domed and three basilican churches within a walled enclosure. I remain conscious of the necessity to resist hastily drawn assumptions from such visual comparisons. Yet, in my opinion, the collective evidence does suggest the emergence of a Christian urban iconography. Distinctive developments in urban practice of the fifth century produced a coded visual version of the notion of Christian triumph as expressed in the "compressed iconography" of what may be referred to as "city icons." Significantly, these city icons seem to have made their appearance a century or so after the "conquest" of major urban centers through the deliberate placement of major public churches within the urban framework of their respective cities.[38]

[37] Ibid., 221 (cat. no. 6).

[38] Duval and Popović, "Urbanisme et topographie," 541–79; see also Lavas, "Οι πόλεις," 581–623. At the time of their publication the two articles were pioneering contributions to the

As the last image in the context of this analysis, we shall consider the well-known early Christian apse mosaic from the Church of Saint Pudenziana in Rome (fig. 20).[39] Made ca. 400 C.E., this is the oldest monumental early Christian wall mosaic to have survived in Rome, despite its extensive subsequent restorations. It depicts an enthroned Christ surrounded by the twelve apostles (only ten remain) against an elaborate architectural setting. It shows Peter and Paul additionally as crowned by the personifications of the *ecclesia ex circumcisione* (Jews) and the *ecclesia ex gentibus* (pagans). Behind the enthroned Christ, the hill of Golgotha topped by a huge gem-studded cross dominates a cityscape seen against a sky within which appear the four apocalyptic beasts symbolizing the four evangelists. The imperial pose of Christ seated on a gem-studded throne is axially aligned with the huge cross in a scheme that clearly alludes to the Christian triumph. If this indeed was the central theme, its appearance around 400 C.E. in Rome would have reflected the relatively slow progress of Christianization in the main stronghold of paganism. As such, the mosaic from St. Pudenziana and the conversion of the Rotunda in Thessalonikē may represent contemporary achievements with a similar symbolic message delivered within two major urban centers. The iconographic details of the mosaic at St. Pudenziana have been a subject of considerable interest and debate. The urban skyline depicted in the background includes two centralized buildings symmetrically framing Christ. The one on our left clearly depicts a domed rotunda, while the one on our right, although more problematic, may depict an octagonal structure with a low pyramidal roof, possibly featuring an opening (*oppaion*) at its apex. Earlier scholarship associated the two buildings with the Anastasis Rotunda in Jerusalem and the Church of the Nativity in Bethlehem. In the light of our analysis, we could propose that the two centralized buildings may allude symbolically to the earthly and heavenly Jerusalem, juxtaposed

study of Christian urban topography in the Balkans, although neither referred to the concept as "urban iconography." Lavas essentially reiterates the same points made in his 1984 article by emphasizing the transformations in Byzantine "urban planning" not as a result of a "decline" but as manifestations of a shift to "theocratic" (in contrast to "rational") ordering of space that had prevailed in antiquity before the rise of Christianity ("Town Planning," 29–39).

[39] Oakeshott, *Mosaics of Rome*, 65–67. Oakeshott presents basic older literature; see also Krautheimer, *Rome: Profile*, 40–41; Brenk, "Imperial Heritage," 46–47; and Elsner, *Imperial Rome and Christian Triumph*, 232. Oakeshott, Krautheimer, and Elsner are among a group of scholars who stress the imperial component in the context of Christian triumph as depicted in this mosaic; Mathews, *Clash of Gods*, ch. 4, esp. 95–103. The subject is approached very differently by Mathews, who introduces the concept of "democratization of worship" and attempts to debunk what he defines as the "Emperor Mystique" in ch. 4, "Larger-than-Life." This approach has met with little approval.

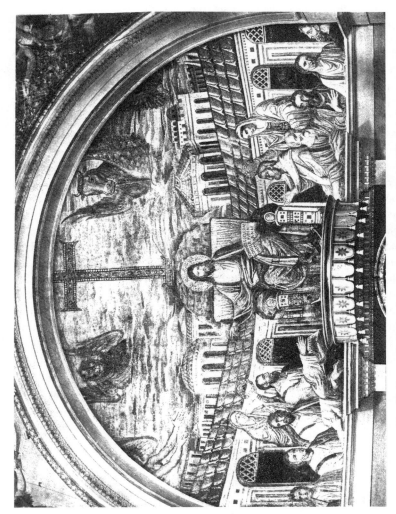

Fig. 20. Rome, St. Pudenziana; apse mosaic. Photo: Richard Krautheimer.

within a general symbolic portrayal of Christian triumph. The iconography of the St. Pudenziana mosaic, then, could relate to the phenomena of urban iconography of fifth-century Thessalonikē, which this chapter has analyzed. The pictorial iconography in the case of the St. Pudenziana mosaic draws heavily on imperial, pagan heritage, thus signaling at once a strong dependence of fledgling Christian iconography on past models. At the same time, it reveals a growing strength and a sense of confidence within the Church, which could now stand on its own feet in proclaiming a definitive Christian victory over the pagan past. Paganism, once a dreaded adversary, no longer posed any significant threat, and visual appropriations of its imagery became not only possible, but useful and even normative. The story of the transformation of Thessalonikē in the course of the fifth century had the same message to deliver, reliant as it was on the same language of Christian triumph expressed in the vocabulary of distinctively new Christian urban topography. The "reality" of Christian triumph, broadly coalescing as it did around the turn of the fifth century, became palpable in these new urban planning schemes with characteristic topographical solutions. The ultimate developments along these lines closely followed chronologically and yielded new images of Christianized cities whose own codified vocabulary can best be described as the new, Christian urban iconography.

BIBLIOGRAPHY

Adam-Velenē, Polyxenē. "Thessaloniki: History and Town Planning." Pages 121–76 in *Roman Thessaloniki*. Edited by D. V. Grammenos. Translated by David Hardy. Thessaloniki: Archaeological Museum of Thessaloniki, 2003.

Alföldi, Andreas. "Die Ausgestaltung des monarchischen Zeremoniells am römischen Kaiserhofe." *RömMitt* 49 (1934) 1–118.

Athanasiou, Fanē et al. "Νέα στοιχεία για το Οκτάγωνο του Γαλεριανού συγκροτήματος" (New Finds in the Octagon of Galerius's Complex). *AEMΘ* 8 (1994) 169–79.

Bakirtzis, Charalambos. *The Basilica of St. Demetrios*. Thessaloniki: Institute for Balkan Studies, 1988.

———— and Helmut Koester, eds. *Philippi at the Time of Paul and after His Death*. Harrisburg, Pa.: Trinity Press International, 1998.

Balty, Jean C. *Guide d'Apameé*. Bruxelles: Centre Belge de Recherches Archéologiques à Apamée de Syrie; de Boccard, 1981.

Bertelli, Carlo. "Visual Images of the Town in Late Antiquity and the Early Middle Ages." Pages 127–46 in *The Idea and Ideal of the Town between Late Antiquity and the Middle Ages*. The Transformation of the Roman World 4. Edited by Gian Pietro Brogiolo and Bryan Ward-Perkins. Leiden: Brill, 1999.

Bowersock, Glen W. *Mosaics as History: The Near East from Late Antiquity to Islam*. Revealing Antiquity 16. Cambridge, Mass.: Belknap Press of Harvard University Press, 2006.

Brenk, Beat. "The Imperial Heritage of Early Christian Art." Pages 39–52 in *Age of Spirituality: A Symposium*. Edited by Kurt Weitzmann and Hans Georg Beck. Princeton, N.J.: Princeton University Press, 1980.

Čanak-Medić, Milka. *Gamzigrad. Kasnoantička palata. arhitektura i prostorni sklop*. Saopštenja 11. Belgrade: Republički zavod za zaštitu spomenika kulture SR Srbije, 1978.

Ćurčić, Slobodan. *Some Observations and Questions Regarding Early Christian Architecture in Thessaloniki*. Thessaloniki: Hypourgeio Politismou. Ephoreia Vyzantinōn Archaiotētōn Thessalonikēs, 2000.

————. "Design and Structural Innovation before Hagia Sophia." Pages 16–38 in *Hagia Sophia from the Age of Justinian to the Present*. Edited by Robert Mark and A. S. Çakmak. Cambridge, U.K.: Cambridge University Press, 1992.

————. "Justinianic Impost Capitals: Some Questions Regarding Their Origins and Meaning." *Abstracts of Papers, Byzantine Studies Conference* 18 (1992) 53–54.

Duval, Noel. "L'iconografia architettonica nei mosaici di Giordania." Pages 151–56 in *I mosaici di Giordania*. Edited by Michele Piccirillo. Rome: Quasar, 1986.

———— and Vladislav Popović, "Urbanisme et topographie chrétienne dans les provinces septentrionales de l'Illyricum." Pages 541–79 in *Actes du Xᵉ Congrès international d'archéologie chrétienne*. Vol. 1. Vatican City: Pontificio Istituto di archeologia cristiana, 1984.

Elsner, Jaś. *Imperial Rome and Christian Triumph*. Oxford: Oxford University Press, 1998.

Frazer, Alfred. "The Iconography of the Emperor Maxentius' Buildings in Via Appia." *Art Bulletin* 48 (1966) 385–92.

Grabar, André. *Christian Iconography: A Study of its Origins*. Princeton, N.J.: Princeton University Press, 1968.

Grabar, André. "A propos des mosaïques de la coupole de Saint-George à Salonique." *CA* 17 (1967) 59–68.

Hadjitryphonos, Evangelia. "Η εικόνα, το περιεχόμενο και οι επεμβάσεις στο χώρο γύρω απο την Αγία Σοφία Θεσσαλονίκης" (The Space around the Church of Hagia Sofia in Thessalonikē: Image, Content, and Interventions). *Μνημείο και περιβάλλον* 5 (1998–1999) 95–132.

Hattersley-Smith, Kara M. *Byzantine Public Architecture between the Fourth and Early Eleventh Centuries AD, with Special Reference to the Towns of Byzantine Macedonia.* Thessaloniki: Society for Macedonian Studies, 1996.

Jackson, Thomas G. *Byzantine and Romanesque Architecture.* Vol. 1. Cambridge, U.K.: Cambridge University Press, 1913.

Kleinbauer, W. Eugene. "The Orants in the Mosaic Decoration of the Rotunda at Thessaloniki: Martyr Saints or Donors?" *CA* 30 (1982) 25–45.

———. "The Iconography and the Date of the Mosaics of the Rotunda of Hagios Georgios, Thessaloniki." *Viator* 3 (1972) 27–107.

Koukouli-Chrysanthaki, Chaidō and Charalambos Bakirtzis. *Philippi.* 2d ed. Athens: Ministry of Culture Archaeological Receipts Fund, 1995.

Krautheimer, Richard. *Early Christian and Byzantine Architecture.* Baltimore, Md.: Penguin, 1965. Repr., 4th ed. New Haven, Conn.: Yale University Press, 1986.

———. *Rome: Profile of a City, 312–1308.* Princeton, N.J.: Princeton University Press, 1980.

———. *Studies in Early Christian, Medieval, and Renaissance Art.* New York: New York University Press, 1969.

———. "Introduction to an 'Iconography of Medieval Architecture.'" *JWCI* 5 (1942) 1–33.

Lavas, Georgios. "Town Planning in Byzantium." Pages 29–39 in *Everyday Life in Byzantium.* Edited by Demetra Papanikola-Bakirtzi. Athens: Hellenic Ministry of Culture, 2002.

———. "Οι πόλεις των Χριστιανικών Βασιλικών: μία συμβολή στην πολεοδομία του ανατολικού Ιλλυρικού" (Cities of Christian Basilicas: A Study in the Urban Planning of Eastern Illyricum). Pages 581–623 in *Actes du X^e Congrès international d'archéologie chrétienne.* Vol. 1. Vatican City: Pontificio Istituto di archeologia cristiana, 1984.

Lidov, Alexei. "Heavenly Jerusalem: The Byzantine Approach." Pages 341–53 in *The Real and Ideal Jerusalem in Jewish, Christian and Islamic Art.* Jewish Art 23–24. Edited by Aliza Cohen-Mushlin and Bianca Kühnel. Jerusalem: The Hebrew University of Jerusalem, 1997–1998.

MacDonald, William L. *The Pantheon: Design, Meaning, and Progeny.* Cambridge, Mass.: Harvard University Press, 1976.

Macmullen, Ramsey. *Constantine.* London: Weidenfeld and Nicolson, 1987.

Markē, Euterpē. "Η Αγία Σοφία και τα προσκτίσματά της μέσα από τα αρχαιολογικά δεδομένα" (Hagia Sophia and the Surrounding Buildings on the Basis of the Archaeological Data). *ΘΠ* 1 (1997) 54–61.

———. "Ένας αγνωστος οκταγωνικός ναός στη Θεσσαλονίκη" (An Unknown Octagonal Church in Thessaloniki). *Μακεδονικά* 23 (1983) 117–32.

Mathews, Thomas. *The Clash of Gods: A Reinterpretation of Early Christian Art.* Princeton, N.J.: Princeton University Press, 1993.

Nasrallah, Laura. "Empire and Apocalypse in Thessaloniki: Interpreting the Early Christian Rotunda." *JECS* 13 (2005) 465–508.

Oakeshott, Walter. *The Mosaics of Rome, from the Third to the Fourteenth Centuries.* Greenwich, Conn.: New York Graphic Society, 1967.

Saradi, Hélène G. *The Byzantine City in the Sixth Century: Literary Images and Historical Reality.* Athens: Society of Messenian Archaeological Studies, 2006.

Smith, E. Baldwin. *Architectural Symbolism of Imperial Rome and the Middle Ages.* Princeton Monographs in Art and Archaeology 30. Princeton, N.J.: Princeton University Press, 1956.

Soteriou, Georgios and Maria Georgiou Soteriou. *Η Βασιλική του Αγίου Δημητρίου της Θεσσαλονίκης* (The Basilica of St. Demetrios of Thessalonikē). Bibliothēkē tēs en Athēnais Archaiologikēs Hetaireias 34. Athens: Hē en Athēnais Archaiologikē Hetaireia, 1952.

Spieser, Jean-Michel. *Thessalonique et ses monuments du IVᵉ au VIᵉ siècle. Contribution a l'étude d'une ville paléochrétienne.* Bibliothèque des Écoles françaises d'Athènes et de Rome 254. Athens: École française d'Athènes; Paris: de Boccard, 1984.

Srejović, Dragoslav and Čedomir Vasić. *Imperial Mausolea and Consecration Memorials in Felix Romuliana (Gamzigrad, East Serbia).* Belgrade: Centre for Archaeological Research, Faculty of Philosophy, University of Belgrade, 1994.

———, ed., *Roman Imperial Towns and Palaces in Serbia.* Gallery of the Serbian Academy of Sciences and Arts 73. Belgrade: Serbian Academy of Sciences and Arts, 1993.

Theocharidou, Kalliopi. *The Architecture of Hagia Sophia, Thessaloniki, from its Erection up to the Turkish Conquest.* BAR International Series 399. Oxford: British Archaeological Reports, 1988.

Torp, Hjalmar. "Dogmatic Themes in the Mosaics of the Rotunda at Thessaloniki." *Arte Medievale*, n.s. 1 (2002) 11–32.

———. "Les mosaïques de la Rotonde de Thessalonique: l'arrière-fond conceptual des images d'architecture." *CA* 50 (2002) 3–20.

———. "Thessalonique paléochrétienne. Une esquisse." Pages 113–32 in *Aspects of Late Antiquity and Early Byzantium.* Edited by Lennart Rydén and Jan Olof Rosenqvist. Stockholm: Swedish Research Institute, 1993.

———. "The Date of the Conversion of the Rotunda at Thessaloniki into a Church." Pages 13–28 in *The Norwegian Institute at Athens. The First Five Lectures.* Edited by Øivind Andersen and Helène Whittaker. Athens: Norwegian Institute at Athens, 1991.

———. "Quelques remarques sur les mosaïques de l'église Saint-Georges à Thessalonique." Pages 489–98 in *Actes du IXᵉ Congrès International des Études Byzantines.* Vol. 1. Athens, 1955.

Vickers, Michael. "The Date of the Mosaics of the Rotunda in Thessaloniki." *Papers of the British School at Rome* 38 (1970) 183–87.

Vitti, Massimo. *Η πολεοδομική εξέλιξη της Θεσσαλονίκης. Από την ίδρυσή της έως τον Γαλέριο* (The Urban Development of Thessalonikē from its Foundation to Galerius). Bibliothēkē tēs en Athēnais Archalologikēs Hetaireias 160. Athens: Hē en Athēnais Archalologikē Hetaireia, 1996.

Williams, Stephen and John Gerard Paul Friell. *Theodosius: The Empire at Bay.* New Haven, Conn. and London: Batsford, 1994.

Civic and Ecclesiastical Identity in Christian Thessalonikē

James Skedros

During the first quarter of the seventh century, John, archbishop of Thessalonikē, penned a lengthy panegyric to the Thessalonikan martyr Demetrios. John opens his *enkomion* by claiming that he does not need to state the name of the city's patron, since Demetrios is so well known among its citizens. John begins:

> Surely, we know many martyrs of Christ, and there exist protectors of various cities and of this our god-protected homeland, but none of those do we consider as our chief protector except the all-holy martyr of the Lord, Demetrios. How, then, can anyone offer an *enkomion* to him for the assistance and trustworthy forethought he offers to our homeland? How can I speak of the bonds of love and the concord he offers the city? How can I neglect his invisible assistance in wars and his compassionate patriotism?[1]

In these opening lines John weaves a close connection between the city and the early Christian martyr. The archbishop develops the association more fully in his collection of miracles related to the saint's interventions in the life of the city and its citizens.[2] John's justification for his promotion of the cult of St. Demetrios is found in the cult itself: The saint is an integral part of the religious and civic life of the city and is therefore worthy of such

[1] Philippidis-Braat, "L'enkômion de saint Démétrius," 406, lines 10–36.

[2] Lemerle, *Les plus anciens recueils.*

documentation and sponsorship. The saint is a marker of civic identity. In the following pages, I shall argue that the development of ecclesiastical and civic identities in Thessalonikē during the Late Antique period contributed to the elevation of the cult of St. Demetrios as a civic marker.

Situated along the Via Egnatia, the most important east-west road of the later Roman Empire, Thessalonikē was geographically positioned between the two imperial capitals of Rome and Constantinople. In addition, its strategic and economic importance was enhanced by its role as the major port city in the Thermaic Gulf. Like other major economic, ecclesiastical, and political centers, Thessalonikē took part in a larger context of changing civic identities during the key centuries of transition from the late Roman to the medieval world. In this transition, local civic identities became established and articulated in relation to neighboring cities and larger ecclesiastical and imperial networks. This articulation is also a story of Christianization. The trajectory of civic identity during the three centuries following the toleration of Christianity is a narrative of civic pride and developing identities between cities and their elites who, for the most part, are responsible for the creation of these identities.[3]

The decline of the city in the Mediterranean world of Late Antiquity has become a truism of modern scholarship.[4] Even with the political and economic crisis of the third century C.E., cities of the Roman Empire rebounded during the following century. Throughout the fourth through the sixth centuries, cities remained relatively wealthy and contained, at least visually, many of the markers of their classical and Roman past: baths, fountains, porticos, squares, gymnasia, and other public buildings.[5] The functioning of pagan temples during the fourth century is less certain. By the seventh century, however, for many cities in the Greek East, many of these civic spaces had ceased to operate. The exceptions prove the rule: the great imperial city of Constantinople and a handful of large port cities such as Antioch, Alexandria, Ephesos, and Thessalonikē. The demise of a vibrant, classically-oriented urban lifestyle is usually taken as one indication of the shift from Late Antiquity to medieval society.

Along with this demise came, of course, the ascendancy of Christianity and its influence upon the cultural, political, and religious landscape. The

[3] The establishment of Constantinople as the imperial capital of the East in 330 C.E. is one of the clearest examples of how elites (in this case, imperial) altered the identity of a city. See Limberis, *Divine Heiress*.

[4] For a lucid discussion of the issue, see Spieser, "City in Late Antiquity," 1–14.

[5] Spieser, "La christianisation de la ville," 49.

Christianization of urban centers correlates with the disappearance of traditional civic markers of imperial Rome, most often seen in the eventual disappearance of the curial class and its civic liturgies along with the loss of local city councils. Perhaps the most glaring loss involves the almost total absence of speeches regarding the glories of new constructions or of cities themselves.[6] Does the disappearance of the traditional city panegyric suggest the evaporation of civic pride? Is the bureaucratic centralization of the late Roman Empire, with Constantinople as its focal point, to blame? Do local elites continue to identify with their respective cities, or has an association with the heavenly Jerusalem become the true mark of civic identity? With regard to Thessalonikē, what are the markers of civic identity for its citizens from the end of the Constantinian period through the middle of the seventh century? I shall look at one marker of this identity: episcopal leadership and its relationship to the imperial and ecclesiastical centers of Constantinople and Rome. In particular, I shall suggest that one contributing factor to the conscious elevation of St. Demetrios as a civic marker for Thessalonikē is the need to distinguish the city from its two most influential ecclesiastical neighbors, old and new Rome. Before I do this, I discuss the material landscape of Christian Thessalonikē as background for the distinctively Christian civic identity of this late Roman city.

THE MATERIAL LANDSCAPE

Unlike other cities of the eastern Mediterranean during the period under consideration, the topographical landscape of Thessalonikē remained relatively consistent throughout the Hellenistic, late Roman, and Byzantine periods. With the exception of the city's acropolis, Thessalonikē's circuit of walls followed the lines of its Hellenistic predecessor. City planning in late Roman Thessalonikē did not significantly alter street alignments or the traditional boundaries of the city walls even during the reconstruction of the latter in the mid-fifth century. The agora or forum continued to function at least through the sixth century.[7] The theater was most likely still in use at the

[6] For the period from the fourth to tenth centuries C.E., the majority of references to the civic identity of Thessalonikē come from hagiographical texts. See Kaltsogianni, *Thessaloniki in Byzantine Literature*, 87–114. On the decline in the production of inscriptions in Thessalonikē in Late Antiquity, see Antonopoulou, "Quantitative Survey," 1:169–78. See also Bakirtzis, "Imports, Exports and Autarky," 2:89–116.

[7] Bakirtzis, "Περὶ τοῦ συγκροτήματος," 257–69.

end of the same century.[8] Aristotle Mentzos has suggested that the tetrarchic palace complex retained its imperial ownership and perhaps continued to be used as an imperial residence up to the early eleventh century.[9]

The boundaries within which Thessalonikē was contained and the grid upon which the city lay remained intact. At the beginning of the seventh century, by which time Thessalonikē was essentially Christian in its identity, the topographical organization of the city had changed little from its Roman imprint. This does not mean that the identity of the city had not changed. It most certainly had. A visitor to Thessalonikē today looks in vain (as have archaeologists for decades) for monuments from the city's pagan past. Although imperial monuments remain—the Arch of Galerius, the Rotunda, and Galerius's palace—as one walks the city today, the Christian monuments provide the lasting impressions. Unlike Athens, no equivalent temple of Athena imposes itself upon the city. Rather, in the seventh century, as today, the impressive basilicas of Acheiropoietos, St. Demetrios, the converted Rotunda, and the episcopal church (replaced in the ninth century by the current Hagia Sophia) not only formed the cityscape but informed and molded civic identity. Episcopal involvement in the creation of these monuments is documented for some and assumed for others. In this regard, Thessaloniki is no different from other cities of the eastern Mediterranean; it is unique only in that these monuments still stand and provide an impressive visual picture of what constituted the material landscape of a Late Antique Christian city.

The Ecclesiastical and Political Landscape

The Christian landscape of Thessalonikē as depicted in its monumental churches developed alongside the civic role of its bishop. In response to a request of Bishop Anastasius of Thessalonikē for specific ecclesiastical privileges, Leo, bishop of Rome from 440 to 461, in a letter dated 12 January 444, writes,

> We consent to grant you authority over Illyricum in our place for the preservation of discipline, such as was granted to your predecessors. And we urge you by our admonition to allow no carelessness, no negligence, to occur in the governing of the churches situated throughout

[8] Spieser, "La ville en Grèce," 318.

[9] See in this volume, Aristotle Mentzos, "Reflections on the Architectural History of the Tetrarchic Palace Complex at Thessaloniki," 333–59.

> Illyricum, which we are entrusting to you in our stead, following the
> example of Siricius of blessed memory.[10]

In this letter, Leo agrees to the granting of certain ecclesiastical privileges
based upon precedence by suggesting that Pope Siricius (384–399) was first
to approve special privileges for the bishop of Thessalonikē. In fact, some
thirty years earlier, another of Leo's predecessors, Innocent (401–412), had
sent a similar letter to Bishop Anysius of Thessalonikē. In this letter and
in one written by the same pope to Anysius's successor, Rufus, Innocent
mentions the jurisdictional responsibility of the bishop of Thessalonikē
over the provinces of Macedonia and Dacia. He notes specifically that the
precedence for such authority goes back to the papacy of Damasus in the
second half of the fourth century.[11]

The exact date and nature of these episcopal privileges, usually referred
to as the vicariate of Thessalonikē, evades us. Many have dated their origins
to the pontificate of Damasus (366–384) while others to that of Innocent I
(402–418). Further, the nature of the vicariate has often been understood
in the context of a rivalry between Rome and Constantinople, as they vied
for ecclesiastical influence over the prefecture of Illyricum. Unfortunately,
we have no extant archives of the church of Thessalonikē, and thus we
are left trying to understand the ecclesiastical landscape of this important
metropolitan see from the outside.[12] Yet, from the evidence that does survive,
we know that the nature and prerogatives of the vicariate fluctuated during
a period of nearly four centuries, from the end of the fourth century to the
third decade of the eighth, when Thessalonikē and eastern Illyricum were
formally placed under the ecclesiastical authority of Constantinople by the
Byzantine Emperor Leo III. Imperial political considerations often curtailed
the extent of Rome's influence over the metropolitan of Thessalonikē
during this period.

[10] Leo I, *Letters*, 6.

[11] Macdonald, "Who Instituted the Papal Vicariate?" 478. For a detailed discussion of the
history of the papal vicariate of Thessalonikē during the fifth and sixth centuries, see Pietri,
"La géographie de l'Illyricum," 21–62. See also Pallas, "L'Illyricum Oriental," 62–76.

[12] Evidence for the papal vicariate of Thessalonikē comes almost exclusively from two
collections of papal letters and imperial texts. The first consists of texts of the fourth and fifth
centuries and was compiled in 531. Known as the *collectio Thessalonicensis*, it was edited
by Tarouca, *Epistularum Romanorum*. Initial questions of the authenticity of this collection
were settled by Duchesne, *Églises séparées*, 229–77. The second collection, the *collectio
Avellana*, is a compilation of 243 papal and imperial letters dating from Pope Damasus (366)
to Pope Vigilius (553); see Günther, *Epistulae imperatorum pontificum*.

Developments in the ecclesiastical organization of the civil dioceses of Macedonia and Dacia and the role played by Thessalonikē in its administration need to be considered in relation to the ever-changing political organization of Illyricum. With the final division of the empire into its eastern and western halves in 395, most of the Balkan provinces came under the imperial control of Constantinople. As early as 379, however, eastern Illyricum had been placed under the administrative care of the East when Gratian ceded the two civil dioceses of Macedonia and Dacia to Theodosius I. Some scholars have dated the creation of the papal vicariate to this date, which falls during the papacy of Damasus. According to this view, Rome reacted to Theodosius's move by creating a new office of a papal vicar for the metropolitan of Thessalonikē.[13] With the loss of eastern Illyricum (the provinces of Dacia and Macedonia) to the political jurisdiction of Constantinople, Rome wanted to keep its connections with this area and instituted the papal vicariate of Thessalonikē.[14] With the exception of the diocese of Pannonia, the two Balkan dioceses of Dacia and Macedonia were firmly within the eastern imperial administration. Further, the political division of the empire into East and West resulted in the geographical stabilization of the office of the praetorian prefect. By the early fifth century, there were four such prefects for the entire empire. The Balkan provinces were placed within the prefecture of Illyricum with the residence of the prefecture at Thessalonikē (however, without the provinces of Pannonia or western and Latin-speaking Illyricum). The prefect was the most senior imperial official who had the authority to appoint the local governors. He represented the will and person of the emperor, acted as the chief judge of appeal, recruited and supplied the army, and was the primary individual responsible for the post and public works.[15] With the prefect's residency firmly established at Thessalonikē by 441 C.E., the city could now claim the two most important civil and ecclesiastical offices of the Balkan peninsula.

Although we do not know for certain what prompted and justified the establishment of the papal vicariate of Thessalonikē, we can, from several surviving letters of popes for the period from Damasus in about 380 to Leo I around 450, sketch the general history and nature of the vicariate. Pope Damasus requested that Acholios, bishop of Thessalonikē, use his influence at Constantinople to argue against the candidacy of Maximus the Philosopher

[13] Dvornik, *Idea of Apostolicity,* 25. However from the period between 379 to the final split of the empire in 395, the two dioceses shifted back and forth between eastern and western political rule. During this period of flux, Rome seems to have given the title of vicar to the bishop of Thessalonikē.

[14] Ibid., 27–28.

[15] Jones, *Later Roman Empire,* 370–71.

and Gregory of Nazianzus for the episcopal see of the imperial city.[16] In a letter from Pope Siricius (384–399) to bishop Anysius of Thessalonikē, the pope requests that Anysius personally supervise the appointment of all bishops in Illyricum or delegate the responsibility to another bishop.[17] Not until the papacy of Innocent I (402–418) do we find language used by Rome to refer to Thessalonikē as a vicariate. Two of Innocent's letters written to bishops of Thessalonikē survive. In the first, the bishop of Rome writes to Anysius of Thessalonikē acknowledging the special relationship between Rome and Thessalonikē created during the period of the pope's immediate predecessors: Damasus, Siricius, and Anastasius. It is this relationship that Innocent wants to continue.[18]

A second letter was written to Rufus, Anysius's successor, and dated 17 June 412. After specifically noting that the bishop of Thessalonikē functions as a vicar of the pope, Innocent goes on to name the provinces over which Rufus has jurisdiction. These provinces constituted the two dioceses of Macedonia and Dacia. The rights enumerated by Innocent in his letter to Rufus are considerable: Rufus was to confirm the election of all bishops and to consecrate them, to preside over the local synod of bishops for both provinces, and to adjudicate controversies arising among his bishops. When serious issues arose, cases of appeal or assistance could be heard in Rome.[19]

The rights and prerogatives of the bishop of Thessalonikē delineated by Innocent are more expansive than those of the traditional metropolitan bishop. The metropolitan system of church organization was well established by the end of the fourth century. What is different in the case of the metropolitan of Thessalonikē is that his authority extends beyond the province of which his city is the provincial capital. The Councils of Nicaea in 325 and Constantinople in 381 enacted legislation confirming the metropolitan system in which the bishop of the metropolis of a given province served as a lead bishop in gathering the bishops of his province to address local issues. There were three noteworthy exceptions where a metropolitan held jurisdiction over dioceses outside of the civil diocese of his metropolitan see: Alexandria, Antioch, and Rome.[20] These supra-metropolitan prerogatives were maintained throughout the fourth century and afterward. With the rise in importance of the bishop of Constantinople during the fourth and fifth centuries, Constantinople

[16] *Collectio Thessalonicensis*, I–II.

[17] Ibid., III.

[18] Ibid., IV.

[19] Ibid., V.

[20] Canon 6 of the Council of Nicaea (325) and canon 2 of the Council of Constantinople (381).

would gain supra-metropolitan status. The bishops gathered at the Council of Constantinople in 381 seemingly were aware of the desire for a supra-metropolitan status of Constantinople and attempted to curtail this. Canon 3 of this council gives the bishop of Constantinople "prerogatives of honor" (τά πρεσβεῖα τῆς τιμῆς) after the bishop of Rome, since he was "bishop of new Rome." The full text of the canon reads: "Because it is new Rome, the bishop of Constantinople is to have the prerogatives of honor after the bishop of Rome."[21] The canon is conspicuously silent in delineating the extension of jurisdictional authority over specific civil provinces.

Over the course of the following decades, the ecclesiastical authority of Constantinople increased. Several factors influenced this, including the loss of imperial territory in the western empire, the sack of Rome in 410, and the overall centralization of imperial administration in Constantinople that had been developing in the course of the fourth and first half of the fifth centuries. This growing ecclesiastical authority is reflected in canon 28 of the Council of Chalcedon (451), which gave the bishop of Constantinople the authority to ordain the metropolitans of the dioceses of Thrace, Pontus, and Asia, although it allowed the bishops of these dioceses to retain the right of ordaining their own bishops. This canon is all the more interesting given that twenty years earlier bishops at the Council of Ephesos (431) had thwarted a similar attempt by Antioch to extend its ecclesiastical influence over Cyprus. In canon 8 issued at Ephesos, which acknowledged Cyprus's independent status, the bishops stressed that "the same thing will also be observed in the other dioceses and everywhere in the provinces, so that none of the bishops beloved of God shall take over another province that, in former times and from the beginning, has not been under his authority or that of his predecessors."[22] For the imperial capital, however, exceptions could be made.

Constantinople's acquisition of supra-metropolitan status is best understood in the context of ecclesiastical organization around 450. The three ancient and apostolic sees of Rome, Alexandria, and Antioch all had supra-metropolitan status. In addition, immediately to the west of the imperial city, the see of Thessalonikē had also acquired supra-metropolitan status, although the extension of the authority of the bishop of Thessalonikē was based most likely upon his status as vicar of Rome and thus, technically, it was Rome's supra-metropolitan status that was being extended into the dioceses of eastern Illyricum. Constantinople, an imperial capital, the home of the Senate, and a

[21] For the Greek text, see Tanner, *Decrees of the Ecumenical Councils*, 1:32.

[22] Quoted in L'Huillier, *Church of the Ancient Councils,* 163–64.

city enjoying equal civic status with old Rome, was not a supra-metropolitan see. The Council of Chalcedon in 451 changed all of this.

Did Thessalonikē play any role in Constantinople's push to create for itself a supra-metropolitan structure? Was Thessalonikē such an important episcopal see that its position might have challenged the status of Constantinople? The ecclesiastical importance of Thessalonikē is evidenced by the place that its bishop occupied in the signing of the acts and decisions of various regional and universal councils. At the Council of Chalcedon in 451, Quintillus, the legate representing the absent bishop Anastasios of Thessalonikē, appears in the seventh rank of signatories.[23] He was preceded only by the names of the three Roman legates representing the pope and the bishops of Constantinople and Antioch. Among the bishops of the eastern half of the empire, Thessalonikē could claim, in the absence of Alexandria, the rank of the third most important episcopal see. This, coupled with the fact that Constantinople and Ephesos were two major eastern cities without supra-metropolitan status, most likely led Constantinople to exert its authority through the promulgation of canon 28 of Chalcedon, which gave the bishop of Constantinople jurisdiction over the civil dioceses of Thrace, Pontus, and Asia. With this canon, the organization of the church in the East took one step closer to the eventual patriarchal organizational structure that would dominate later Byzantine ecclesiastical polity.[24]

The period following the Council of Chalcedon is filled with controversy over the christological definition of the council. The political landscape in the West continued to deteriorate with the eventual demise of the western empire by the end of the fifth century. In the East, turmoil over the christological definition of Chalcedon drew various responses, and it resulted in an ecclesiastical schism between Rome and Constantinople from 484 to 519. The schism is known as the Acacian schism, named after the bishop of Constantinople, Acacius, who supported the imperial edict issued by Zeno that rejected the language of the Chalcedonian christological formulation. Thessalonikē, fully within the civil administrative orbit of the eastern Roman

[23] Pietri, "La géographie de l'Illyricum," 61.

[24] The discussion and approval of canon 28 at the council reflects the ambiguity of the see of Thessalonikē. Canon 28 had been presented at an ad hoc meeting of some 185 bishops all of whom agreed to accept the canon. Both the papal legates and Quintillus were absent from this meeting. Although the legates and Quintillus were present the following day at the sixteenth session of the Council during which this canon was once again presented, neither gave their approval of the canon. The acts of the sixteenth session record the verbal disagreement and rejection of the canon by one of the papal legates; however, Quintillus, although present, remained silent; see Schwartz, *Concilium universale chalcedonense*, 1.86–99.

empire, acquiesced to the religious policies of Zeno and the papal vicariate, for the time being, ceased to function.[25]

With the accession of Justin, a native of Latin-speaking Illyricum, to the imperial throne in Constantinople in 518, immediate attempts were made to bring an end to the Acacian schism. A Roman delegation dispatched with letters from Pope Horsmidas traveled through Illyricum in order to gain support for the reunification of Rome and Constantinople. The delegation visited Thessalonikē, where the metropolitan of the city, Dorotheos, agreed in principle with the reconciliation but postponed formal acceptance until he could gather all of his suffragan bishops together for synodal approval. The delegation continued on to Constantinople and the union of the two churches was proclaimed in March of 519. In September of the same year, one of the members of the Roman delegation, an Italian bishop named John, accompanied by the Greek priest Epiphanius, was dispatched to Thessalonikē in order to obtain the region's acceptance of the reunification of the churches. Things did not go well, however, and local opposition to the reunion swelled, fueled no doubt by Dorotheos. A riot ensued resulting in the murder of the legates' slaves as well as a local layman, who had welcomed the Roman delegation. The Italian bishop John was seriously injured and sought refuge in the baptistery of the episcopal cathedral. The intervention of civil authorities representing the *magister militum per Illyricum* prevented further bloodshed.[26] Dorotheos's motives for his opposition to the union were not stated. He and his provincial bishops eventually agreed to the union.

The healing of the Acacian schism was part of a larger plan of Justin and his young nephew Justinian, the future emperor, to reclaim western lands lost to the Gothic invasions of the previous century. With Justinian's accession to the imperial throne in 527, military operations in North Africa and Italy were soon launched. Ecclesiastical unity with Rome and the acknowledgement of Roman papal authority over Illyricum soon followed. An episode involving a contested episcopal election in the city of Larissa in the province of Thessaly gives evidence for a return of the vicariate status to the bishop of Thessalonikē. A certain Stephen had been elected and consecrated bishop of Larissa around 529. Constantinople contested the appointment. Stephen appealed to Pope Boniface II and sent one of his suffragan bishops, Theodosius, to plead his case before the Roman bishop. At a Roman synod in December 531, Theodosius argued that the pope had jurisdictional authority

[25] Pietri, "La géographie de l'Illyricum," 35, argues that the vicariate was suspended in 457 under the newly appointed bishop of Thessalonikē, Exitheus.

[26] Blaudeau, "Stereotype of the Roman History," 205–10.

over all the churches of the prefecture of Illyricum, and therefore Rome's authority superseded that of Constantinople. To support his claim, Theodosius produced a dossier of twenty-six letters of popes covering a period of about 100 years.[27] Theodosius must have obtained these letters from the archives of Thessalonikē, since they were all letters directed either specifically to the bishop of Thessalonikē or to all the bishops of eastern Illyricum. The letters come from the pontificates of Damasus, Siricius, Innocent, Boniface, Sixtus, and Leo. The council found in favor of Stephen. What is interesting about the collection of letters is the justification for the vicariate of Thessalonikē. None of the letters recognizes the important civil status of Thessalonikē nor its apostolic foundation as the basis of its prestige in eastern Illyricum. Rather, Thessalonikē's position simply as a vicariate of the Roman see justifies her position in relation to the other bishoprics of Macedonia and Dacia.

A second incident during the reign of Justinian involves an ecclesiastical and political realignment attempted by the emperor. In 535 Justinian issued a rescript elevating the bishop of Justiniana Prima, the town of his birth, to the rank of archbishop and to a status of independence from the jurisdiction of the bishop of Thessalonikē. Additionally, Justinian intended to move the seat of the praetorian prefect from Thessalonikē to Justiniana Prima. In the rescript, Justinian traces briefly the history of the prefecture stating that, when it finally arrived in Thessalonikē, the "city became the seat of the prefecture as well as episcopal authority. The bishop of Thessalonica, however, did not thereby obtain any prerogatives over the other bishops merely through the exercise of his own authority, but acquired supremacy by being in the shadow of the prefecture."[28] Justinian clearly supports the ecclesiastical authority of Thessalonikē based on the policy of civic accommodation. Thessalonikē's ecclesiastical prominence is due to her civil status and not based upon her position as an apostolic see nor as a vicariate of Rome.

A New Civic Identity

The important role of the bishop in the civic affairs of towns and cities in the Late Antique Mediterranean world is well known. The bishop of Thessalonikē was certainly no exception. Yet upon what basis was the bishop of the capital of the Macedonian province to justify his particular authority: on its apostolic foundation by Paul, on his status as a papal vicar, or because the city was the

[27] This dossier is known as the *collectio Thessalonicensis*; see n. 12 above.
[28] *Corpus Juris Civilis*, Novel 11, in Scott, *Civil Law*, 68–69.

residence of the praetorian prefect? Evidence suggests that at times each of these claims to authority was used. For example, in the same panegyric to St. Demetrios with which this paper opened, John, archbishop of Thessalonikē, asserts that the apostles Paul and Andrew planted the church in Thessalonikē and thus gives the city its apostolic roots.[29] Some fifty years later, the bishop of Thessalonikē, also named John, signed the decisions of the Council of Constantinople in 680 as "vicar of the apostolic throne of Rome."[30]

As for the idea of political accommodation, that is, the notion that episcopal rank and extension of authority is dependent upon the civil rank of a particular city, the anonymous *Life of St. David of Thessalonikē* provides an engaging example. Written around 718, the text recounts the activities of the holy recluse David, who lived in an almond tree outside the walls of Thessalonikē during the early years of the emperor Justinian's reign. The *Life* contains an episode related to the transfer by Justinian of the prefect of Illyricum to Justiniana Prima. According to the *Life*, the prefect of Illyricum currently residing in Thessalonikē appealed to the bishop of Thessalonikē, Aristides, to intercede on his behalf to the emperor in order to have the seat of the prefecture remain in Thessalonikē. The bishop chose the holy man David to lead the delegation to the imperial city. The *Life* describes in vivid detail the encounter between David and the imperial court and especially the meeting with the empress Theodora. In the end, the embassy was successful, for the administrative seat of the prefecture of Illyricum was returned to Thessalonikē after a short duration at Justiniana Prima.[31]

The bishop of Thessalonikē, however, had another means by which he could enhance his authority as well as promote the civic identity of Thessalonikē: the cult of the martyr Demetrios. Regardless of the origins of the cult in the city, by the first quarter of the sixth century, the monumental basilica dedicated to the martyr, which currently stands near the center of the city, had become a focal point in the religious life and cultural identity of the city.[32] The prestige of the basilica and that of the saint was enhanced by the efforts of the archbishop of the city, John, whom we have already encountered several times. John, archbishop during the first half of the seventh century, authored a collection of fifteen miracle stories of varying length related to St. Demetrios. In the collection of miracles, John portrays St.

[29] Philippidis-Braat, "L'enkômion," 407, lines 27–30.

[30] Η Ἰωάννης ἐλέει θεοῦ ἐπίσκοπος Θεσσαλονίκης καὶ βικάριο τοῦ ἀποστολικοῦ θρόνου Ῥώμης καὶ ληγατάριος (John, by the mercy of God, Bishop of Thessalonikē and vicar of the apostolic throne of Rome and legate). *Acta Conciliorum Oecumenicorum*, 2.778.

[31] Vasiliev, "Life of David of Thessalonica," 115–47.

[32] Skedros, *St. Demetrios of Thessaloniki*, 42–48.

Demetrios as one concerned for the welfare of individuals and the citizens of Thessalonikē. In particular, John relates the miraculous intervention of the saint during the Slavic raids on the city in 586. Yet perhaps the most telling expression of the civic concern of the saint is contained in a miracle associated with civil unrest in the city. John describes quite vividly this strife:

> [People were] drunk in the public squares on the blood of their neighbors, and they attacked each other in their homes and pitilessly murdered those within, so that they who lived in the upper stories were flung down to the earth—women and children, the old and the young, who because of their weakness could not escape by flight—and citizens, like the rough barbarians, plundered friends and relations and burned down their buildings.[33]

John continues the story by telling how, during this time of turmoil, an unnamed yet trustworthy relative of the prefect of Illyricum, who was visiting Thessalonikē for the first time, had a dream in which St. Demetrios appeared in his ciborium located in the middle of his basilica. In the dream, Demetrios sits on a golden throne inside the ciborium, and next to him on a silver throne sits "a dignified and discreet woman, dressed nobly yet modestly and staring intently at the martyr." As the visitor observes the scene, the woman begins to rise from her chair, but St. Demetrios grabs her hand and exclaims, "For God's sake, do not leave from here, nor depart from the city, for you are always needed here, especially at the present time."[34] The prefect's relative learns the identity of the lady: She is the lady Eutaxia who, the text claims, is always present with the saint. The significance of the miracles lies in the interpretation of the Lady Eutaxia. The name literally means "good order." In the miracle she acts as the female personification of civil order, and St. Demetrios keeps her—that is, civil order—close at hand. The city is thus assured that even during this trying time of civil unrest, the great martyr Demetrios provides protection.

The miracle of the Lady Eutaxia, along with several others, reflects archbishop John's attempt to connect St. Demetrios with the city over which he is ecclesiastically responsible. In other miracles recounted by John, the archbishop calls the saint the "city-loving" martyr (φιλόπολις), "protector of the homeland" (σωσίπατρις), "an unshakeable wall" (τεῖχος ἄσειστον νοητόν), and an "unconquerable wall" (τεῖχος ἀκαταμάχητον).[35] These

[33] Lemerle, *Les plus anciens recueils,* 1:112.15–113.6; Hoddinott, *Early Byzantine Churches,* 148–49.

[34] Lemerle, *Miracles de saint Démétrius,* 1:115.26–27.

[35] Skedros, *St. Demetrios of Thessaloniki,* 125.

epithets, along with the intensely local character of the fifteen miracle stories, suggest that archbishop John is concerned with connecting the identity of the city of Thessalonikē with the growing cult of St. Demetrios. John's conscious elevation of the cult of St. Demetrios provides the city with a new civic marker.

Conclusion

By the beginning of the seventh century, the cult of St. Demetrios has become a key civic marker for Thessalonikē. The civic identity and status of the city is forged with the authority of the city's patronal saint. St. Demetrios becomes an integral civic marker of the ecclesiastical elite, the pious faithful, and by extension, the civic administration in three ways: by attributing the successful defense of the city to St. Demetrios; by providing a place of pilgrimage, healing, and access to divine power; and by connecting the saint with the power and figure of the Virgin. Bishop John's efforts are primary, and his texts serve as panegyrics to the city. They are sources of civic pride and serve as venues for the creation of civic identity—an identity that is more and more associated with the martyr Demetrios. The process was not completed until much later, but it is well underway in John's time. An interesting example of this is a seventh-century lead seal of a civil servant from Thessalonikē that bears an image of St. Demetrios dressed in his traditional senatorial clothing.[36] The cult of St. Demetrios, like other provincial cults throughout the empire, provided an additional venue through which the local ecclesiastical hierarchy could buttress its authority and importance. The regional authority of the see of Thessalonikē had traditionally been based upon its position as papal vicariate of Illyricum or as the residence of the praetorian prefect. As we have seen, neither of these claims was permanent. Although the vicariate continued into the early eighth century, its viability had diminished dramatically. Similarly, the office of the praetorian prefect had all but disappeared by the second half of the seventh century. Thus, at the time when the two traditional sources of power claimed by the archbishop of Thessalonikē were on the decline, the cult of St. Demetrios was elevated, perhaps not coincidentally, by the local ecclesiastical hierarchy as a symbol of civic, and therefore ecclesiastical, identity. As Thessalonikē and its civic elites worked their way through the vicissitudes of the ecclesiastical and civic networks that made up the world of Late Antiquity, the cult of St. Demetrios provided a means of civic identity

[36] Cotsonis, "Contribution of Byzantine Lead Seals," 462.

that no other ecclesiastical or civil center could claim. In fact, Thessalonikē would work hard to keep for itself the claim to St. Demetrios and the unique civic identity that the saint offered to the city.[37]

[37] Skedros, *St. Demetrios of Thessaloniki*, 85–88.

BIBLIOGRAPHY

Acta Conciliorum Oecumenicorum. 2d series. Berlin: de Gruyter, 1992.

Antonopoulou, Theodora. "A Quantitative Survey of the Christian-Byzantine Inscriptions of Ephesus and Thessaloniki." Pages 1:169–78 in *100 Jahre österreichische Forschungen in Ephesos. Akten des Symposions Wien 1995.* Edited by Herwig Friesinger and Fritz Krinzinger. 3 vols. Vienna: Österreichischen Akademie der Wissenschaften, 1999.

Bakirtzis, Charalambos. "Imports, Exports and Autarky in Byzantine Thessaloniki from the Seventh to the Tenth Century." Pages 2:89–116 in *Post-Roman Towns, Trade and Settlement in Europe and Byzantium.* Edited by Joachim Henning. 2 vols. Berlin: de Gruyter, 2007.

————. "Περὶ τοῦ συγκροτήματος τῆς Ἀγορᾶς τῆς Θεσσαλονίκης" (The Building Complex of the Agora of Thessalonikē). Pages 257–69 in *Ancient Macedonia II: Papers Read at the Second International Symposium.* Thessaloniki: Institute for Balkan Studies, 1977.

Blaudeau, Philippe. "A Stereotype of the Roman History of Monophysitism? About the Violent Episode of Thessalonica (September 519)." *Hortus Artium Medievalium* 10 (2004) 205–10.

Cotsonis, John. "The Contribution of Byzantine Lead Seals to the Study of the Cult of the Saints (Sixth–Twelfth Century)." *Byzantion* 75 (2005) 383–497.

Duchesne, Louis. *Églises séparées.* Paris: Albert Fontemoing, 1905.

Dvornik, Francis. *The Idea of Apostolicity in Byzantium and the Legend of the Apostle Andrew.* Cambridge, Mass.: Harvard University Press, 1958.

Günther, Otto, ed. *Epistulae imperatorum pontificum aliorum inde ab. a. CCCLXVII usque ad a. DLIII datae Avellana quae dicitur collectio.* 2 vols. Corpus Scriptorum Ecclesiasticorum Latinorum 35. Vienna: F. Tempsky, 1895–1898. [*collectio Avellana* 2]

Hoddinott, Ralph. *Early Byzantine Churches in Macedonia and Southern Serbia: A Study of the Origins and the Initial Development of East Christian Art.* New York: St. Martin's, 1963.

Jones, A. H. M. *The Later Roman Empire, 284–602: A Social, Economic and Administrative Survey.* Oxford: Blackwell, 1964.

Kaltsogianni, Eleni, Sophia Kotzabasi, and Eliana Paraskevopoulou. *Thessaloniki in Byzantine Literature: Rhetorical and Hagiographical Texts.* Byzantine Texts and Studies 32. Thessaloniki: Kentron Vyzantinon Ereunon, 2002. [in Greek]

L'Huillier, Peter. *The Church of the Ancient Councils: The Disciplinary Work of the First Four Ecumenical Councils.* Crestwood, N.Y.: St. Vladimir's Seminary, 1996.

Lemerle, Paul. *Les plus anciens recueils des miracles de saint Démétrius. I. Le texte.* 2 vols. Le monde byzantin. Paris: Éditions du Centre National de la Recherche Scientifique, 1979.

Leo I, Pope, *Letters. Saint Leo the Great.* Translated by Edmund Hunt. The Fathers of the Church 34. Washington, D.C.: Catholic University Press, 1963.

Limberis, Vasiliki. *Divine Heiress: The Virgin Mary and the Creation of Christian Constantinople.* London: Routledge, 1994.

MacDonald, James. "Who Instituted the Papal Vicariate of Thessalonica?" *Studia Patristica* (1961) 478.

Pallas, Demetrios I. "L'Illyricum Oriental. Aperçu historique. La problématique de son archéologie chrétienne." *Theologia* 51 (1980) 62–76.

Philippidis-Braat, Anna. "L'enkômion de saint Démétrius par Jean de Thessalonique." *TM* 8 (1981) 406, lines 10–36.

Pietri, Charles. "La géographie de l'Illyricum ecclesiastique et ses relations avec l'église de Rome (Vᵉ–VIᵉ siècles)." Pages 21–62 in *Villes et peuplement dans l'Illyricum protobyzantin. Actes du colloque organisé par l'École française de Rome*. Rome: L'École française de Rome, 1984.

Schwartz, Edward, ed. *Concilium universale chalcedonense*. Vol. 2 of *Acta Conciliorum Oecumenicorum*. 6 vols. Berlin: de Gruyter, 1935.

———, ed. *Versiones particulares. Pars 1. Collectio Novariensis de re Eutychis ; pars 2. Rerum Chalcedonensium collectio Vaticana. Canones et symbolum*. Vol. 2 of *Acta Conciliorum Oecumenicorum*. 2d series. 6 vols. Berlin: de Gruyter, 1992.

Scott, Samuel P., trans. *The Civil Law*. Vol. 16. Cincinnati, Ohio: Central Trust Company, 1932.

Skedros, James. *St. Demetrios of Thessaloniki: Civic Patron and Divine Protector, 4ᵗʰ–7ᵗʰ Centuries CE*. HTS 47. Harrisburg, Pa: Trinity Press International, 1999.

Spieser, Jean-Michel. "The City in Late Antiquity: A Re-Evaluation." Pages 1–14 in *Urban and Religious Spaces in Late Antiquity and Early Byzantium*. Edited by idem. Aldershot, U.K.: Ashgate, 2001.

———. "La christianisation de la ville dans l'antiquité tardive." *Ktema* 11 (1986) 49.

———. "La ville en Grèce du IIIᵉ au VIIᵉ siècle." Pages 315-40 in *Villes et peuplement dans l'Illyricum protobyzantin. Actes du colloque organisé par l'École française de Rome*. Rome: L'École française de Rome, 1984.

Tanner, Norman, ed. *Decrees of the Ecumenical Councils*. 2 vols. London: Sheed & Ward, 1990.

Tarouca, Carlos da Silva, ed. *Epistularum Romanorum Pontificium ad vicarios per Illyricum aliosque episcopos collectio Thessalonicensis*. Rome: Apud aedes Pont. Universitatis Gregorianae, 1937. [*collectio Thessalonicensis I–V*]

Vasiliev, Alexander. "Life of David of Thessalonica." *Traditio* 4 (1946) 115–47.

Ceramics in Late Antique Thessalonikē

Demetra Papanikola-Bakirtzi

In the series of conferences held by the Harvard Divinity School and devoted to important cities of the New Testament world, the question of material culture has arisen only occasionally. This paper proposes to contribute to this field with regard to Thessalonikē through the examination of archaeological data. More specifically, this essay will attempt to use the study of pottery to shed light on some aspects of everyday life in Late Antique Thessalonikē.

A chapter on ceramics in a volume treating the topic of religion prompts me to begin with a story that demonstrates the importance of ceramics in daily life and in addition points to the "sacred" nature of the material. According to the *Life of St. Spyridon*, Bishop of Trimithous on Cyprus and a participant in the First Ecumenical Council at Nicaea in 325, the saint demonstrated the threefold, indivisible, homoousian nature of the Holy Trinity by taking hold of a roof tile: "He squeezed it and fire went up, while water flowed down, and the earth remained in his hands, revealing the mystery of the Holy Trinity" (fig. 1).[1]

Earth, water, and fire: These are the three elements that determine the nature of any ceramic object. Earth and water are the constituents of the clay, while fire transforms that malleable, soluble substance into a ceramic body with an immutable form and a strength and durability far

[1] Lagges, Ὁ Μέγας Συναξαριστής, 347–49. For the iconography of this incident, see Walter, "Icons," 217–18, fig. 13; the recorded icon is referred to as number 707 in the collections of the Byzantine and Christian Museum of Athens. Today the icon is kept in the Museum of Byzantine Culture in Thessaloniki (inv. no. B. Ετ. 740).

Fig. 1. "The Miracle of the Roof Tile." St. Spyridon demonstrating the threefold indivisible homoousian nature of the Holy Trinity. Museum of Byzantine Culture, Thessaloniki.

greater than those of the glass and the apparently invulnerable metal objects that can, as a rule, be recycled. Ceramics, by contrast, even when broken, continue stubbornly to make their presence felt. It is precisely this attribute of ceramics and the abundance of pottery in archaeological finds that we are going to examine in an effort to address aspects of daily life in Late Antique Thessalonikē.

However, I must point out that the ceramics of Late Antique Thessalonikē have only appeared sporadically as excavated finds or as isolated, fragmentary entries in exhibition catalogues. An exception to this scholarly pattern is a small number of recent studies of finds from the Ancient Agora and of funerary finds from the burial grounds of Thessalonikē.[2] This essay is a preliminary effort to present the available archaeological material and to discuss it in the context of the Late Antique city. Ceramics have played an important part in Thessalonikē's economy and daily life, used in many forms and for many purposes: building materials, trade and transport vessels, household utensils like table and cooking wares, lighting devices, and grave ceramics. I will address these categories of ceramics in an effort to shed light on some aspects of the city's material culture.

BUILDING CERAMICS

A huge proportion of building materials—such as roof-tiles, bricks, floor tiles, pipes, and guttering—are still made from clay and belong in the category of ceramics. It goes without saying that a metropolis as large and important as Late Antique Thessalonikē would have manufactured ceramic building materials locally.[3] And it should be noted here that excavations outside the city's west walls have brought to light remains connected with the manufacture of building materials. An excavation on Monasteriou Street, outside the west city walls, yielded remnants of a kiln, specifically the support for the grate and the fire-pit. These finds have been identified as part of a workshop manufacturing bricks and roof-tiles and have been dated to the early Christian period.[4] It has been suggested that the area outside the city's west walls was the Κεραμήσιος κάμπος, the "ceramics plain" mentioned in

[2] On the Agora, see Adam-Velenē et al. "Στρωματογραφία," 501–31; Karagianni, "Κινητά ευρήματα," 147–58. On the funerary finds: Nalpantis, *Ανασκαφή*.

[3] On the production of ceramic building materials in the Byzantine world, see Theocharidou, "Συμβολή," 97–112; Ousterhout, *Master Builders*, esp. 128–32; Kiourtzian, "Enépigraphos Plinthos," 385–87. More recently, see Bardill, *Brickstamps*, esp. vol. 1, part I.

[4] Makropoulou, "Οδός Μοναστηρίου 93," 379–80.

the fifth miracle in the second book of the Miracles of St. Demetrios,[5] because of the workshops manufacturing ceramic building materials that have been located there.[6] The same area supplied the city's workshops with clay until recently. The area near the eastern walls seems to have been another region where building materials were manufactured. Excavations there have found remains of kilns and also of discarded products that were spoiled during the manufacturing process.[7] The location of kilns near the walls, *extra* or *intra muros*, must be due to legal regulations regarding how brick and tile works should operate and how far they had to be from residential areas.[8]

Archaeological finds suggest that bricks and tiles were generally made in wooden molds and fired in rectangular kilns with very strong supports under the grates.[9] The roof-tiles as well as other kinds of tiles and bricks of the Late Antique period often bear "finger-marks" that helped the mortar to adhere to them (fig. 2a–c). Tiles have also been found marked with Christian symbols, like crosses, or bearing inscriptions.[10] Bricks bearing a variety of markings have been found in the masonry of various early Christian monuments in Thessaloniki, such as Acheiropoietos, the basilica of St. Demetrios, Hagia Sophia, and the city walls (fig. 2).[11] The variety and nature of these markings is interesting and needs to be studied carefully. In some cases these markings, which can be symbols or inscriptions, are in very low relief, and are made

[5] Lemerle, *Les plus anciens recueils*. Scholars have tried to locate the *kerameisios kampos* at a number of sites. See relevant bibliography in Gregoriou-Ioannidou, "Το επεισόδιο του Κούβερ," 67–87. More recently, see Bakirtzis, *Αγίου Δημητρίου Θαύματα*, 280, 427; idem, "Imports, Exports and Autarky," 89–118.

[6] A site on Koloniari Street within this area yielded remains of two pottery kilns, which very possibly manufactured bricks and tiles and date to the early Christian period. See Nalpantis, "Οδοί Κολωνιάρη," 405–6; Eleutheriadou et al., "Σωστικές ανασκαφές Θεσσαλονίκης," 274.

[7] *Σωστικές ανασκαφές 2002*, 11; Bakirtzis, "Imports, Exports and Autarky," 108, fig. 4.

[8] Armenopoulos, *Πρόχειρον Νόμων ή Εξάβιβλος*, § 15 (S 5–6); Pitsakis, "Πόλεις και περιβάλλον," 107–8; Tourptsoglou-Stephanidou, *Περίγραμμα*, 126–28.

[9] Theocharidou, "Συμβολή," 100–8; Ousterhout, *Master Builders*, 130; Bardill, *Brickstamps*, 1:5–7.

[10] Mango, "Brickstamps," 19–27; Bardill, *Brickstamps*, 1:169–403.

[11] As early as 1746, J.-B. Germain transcribed a number of brick inscriptions from the Rotunda, which were published later: see Omont, "Inscriptions grecques de Salonique," 1:196–214. In 1864 Texier and Pullan published some more examples from Thessaloniki (Texier and Pullan, *Byzantine Architecture*, 134, 150). Tafrali gave a significant number of examples of brick inscriptions (45) from various sites and monuments in Thessaloniki (Tafrali, *Topographie de Thessalonique*, 76–77, 151–54). More recently, see Vickers, "Brickstamps," 285–94, which includes charts with brick stamps and an extensive discussion of previous bibliography and publications. See also Raptis, "Παρατηρήσεις," 219–26.

Fig. 2. Brick marks from the monuments of Thessaloniki.
Museum of Byzantine Culture, Thessaloniki.

by cutting their reverse impression in wooden molds with a bottom. This practice is similar to examples from Pieria, in northern Greece, in the area of Dyrrachion, and in the region of Serdica.[12] In contrast it seems that the molds used in Constantinople were without a bottom. Letters and symbols were stamped on bricks with the use of a terracotta or wooden die while the brick surface was still damp.[13] This is a key distinction that calls for a more accurate use of terminology regarding markings on bricks, since the broadly used term "brick stamps" is too narrow and specific to represent adequately the rich variety of marking techniques, including the use of molds. For example, the term "brick marks" can cover a wider variety of applications that certainly includes brick stamps.[14]

The presence of bricks with similar marks in different monuments, as well as the presence of bricks with different marks in the same construction phase, are among the unsolved problems relating to the manufacture, use, and dating of building materials in the period under discussion. Inscriptions on brick surfaces are of great importance for the dating of buildings.[15] They are also important for the study of the economic parameters of brick production and marketing. For the purposes of this study I will not dwell further on brick production issues. Questions such as whether bricks were manufactured for specific building projects or were reused are of great interest but are outside the scope of this chapter.

In an age of intensive building activity such as the period of Late Antiquity, Thessalonikē's brick and tile works must have played an important part not only in the building industry, but also in the city's economic life, providing employment for a host of artisans and craftsmen. In the ancient sources these artisans and craftsmen are generally referred to as κεραμεῖς (ceramists) and more specifically as πλινθουργοί and πλινθευταί (brickmakers),[16] ὀστρακάριοι (ceramic workers) or κεραμοποιοί

[12] Theocharidou, "Συμβολή," 108; Mentzos, "Σφραγίσματα σε πλίνθους," 197; Raptis, "Παρατηρήσεις," 220.

[13] Mango, "Brickstamps," 19; Bardill, *Brickstamps*, 5–7.

[14] A large number of brick inscriptions found in Thessaloniki consist of combinations of the letters EN or ENT between crosses, which scholars have taken to be an abbreviation of the word ἐντικτίονος (indiction); while any other letters with them, such as A, Θ, or I, are interpreted as indiction years (fig. 2f, i, k, l, o, p). Vickers, "Brickstamps," which contains related previous bibliography; Theocharidou, "Συμβολή," 110; Raptis, "Παρατηρήσεις," 220–26. Other groups of bricks bear various types of crosses alone or together with single letters (fig. 2d, e, g, h, j, m, n).

[15] Mango, "Brickstamps," 22–26; Vickers, "Brickstamps"; Bardill, *Brickstamps*, 1:45–53.

[16] For examples from the Late Antique period, see πλινθουργός, πλινθουλκός, in Pollux, *Onomasticon*, vol. 9, part 1, § 163, line 2; πλινθουργοί καὶ τέκτονες, in Galen, *Thasybulus*,

(tilemakers).[17] The edict of Diocletian (301 c.e.)[18] and *The Book of the Eparch*, which dates to the tenth century, make no mention of a guild of potters. The potters who specialized in building materials must have belonged to the large guild of the ἐργολάβοι (construction workers), λεπτουργοί (carpenters or wood carvers), γυψοπλάσται (plasterers), μαρμαράριοι (marble workers), ἀσκοθυράριοι (key makers?), ζωγράφοι (painters), and λοιποί (others).[19] Potters would have been in the category of "others."

Trade and Transport Vessels[20]

Finds from rescue excavations throughout the city and surprise "catches" by fishermen in the Thermaic Gulf have given us some idea about the amphorae that were used in Late Antique Thessalonikē and have allowed us to investigate the city's mercantile relations.

A considerable number of the amphorae found are of the type known as Carthage LRA1 (Late Roman Amphora 1) (fig. 3a).[21] This well-known amphora type was widespread throughout the Mediterranean, especially

(14) 5, 890, 14–15; οἱ κεραμεῖς τὰς πλίνθους ἔπλαττον, in Pollux, *Onomasticon*, vol. 9, part 1, § 185, line 3.

[17] Mango and Scott, *Chronicle of Theophanes Confessor*, 440.17–22. According to the ninth-century Chronicle of the Theophanes, in 766/7 five hundred ὀστρακάριοι from Greece and the Islands and two hundred κεραμοποίοι from Thrace were transported to Constantinople to assist the reconstruction of the Aqueduct of Valens. Dictionaries translate ὀστρακάριος as κεραμέας (ceramist). Mentzou, *Συμβολαί*, 93. Mentzou, however, is right when she claims that ὀστρακάριοι were professionals who used ὄστρακα (= broken ceramic shards) and hydraulic plaster to cover the surfaces of cisterns and aqueducts, thus rendering them waterproof. This practice continues to this day in the Aegean islands. This justifies the origin of the ὀστρακάριοι of Theophanes (islands), as well as the origin (Thrace) of the κεραμοποιοί (ceramicists). In Madytos (Μάδυτος) in Thrace, a great number of brick and tile making factories existed until recently.

[18] Lauffert, *Diokletian's Preisedikt*.

[19] Koder, *Das Eparchenbuch Leons des Weisen*, 22 (t).

[20] I wish to thank Professor Andrei Opaiţ who kindly read the amphorae segments and gave me the benefit of his expertise. He is in no way responsible for any remaining errors.

[21] We are following here the widely used amphorae classification and nomenclature suggested by Riley, *Carthage*, 85–124. For LRA1, see also idem, "Berenice," 91–467; Papadopoulos, "Amphorae," 67–103; idem, "Pottery," 547–68; for a discussion of the amphorae found at Torone, a site geographically close to Thessaloniki, specifically for LRA1, see type II, 555–58. Chrisostomou, "Ἐμπορικές ανταλλαγές," 1:593–619, specifically for LRA1, see type 2, 597–99. Also see Opaiţ, *Ceramics of Scythia*, for a recent discussion of shape, spread, and contents, as well as the extensive literature regarding the usage of amphorae. For the production centers, see Piéri, "Centres de production," 611–25.

Fig. 3. Amphorae types found in Thessaloniki.
Museum of Byzantine Culture, Thessaloniki.

in the regions of the east Mediterranean and the Black Sea. It has a hard, "sandy," pale-brown to pinkish fabric. The cylindrical body is globular, with wheel ribbing that is denser at the top and bottom and more widely spaced in the middle section. It has a comparatively long neck. Its handles extend from the neck to the projecting shoulder and are not always positioned symmetrically.

A recent study distinguishes six subtypes of LRA1 with minor variations, dating the type's appearance to the third century and tracing its development to the seventh century.[22] LRA1 and LRA2 were the two largest groups of amphorae in the cargo of the ship that went down off Yassi Ada in southwestern Asia Minor in circa 625 c.e.[23] At Torone in Chalkidiki

[22] Opaiţ, *Ceramics of Scythia*, 8–10.
[23] Bass and Doorninck, *Yassi Ada*, 155–65. See also Alfen, "New Light," 189–213.

they comprise the second most common type.[24] Current archaeological data indicate that LRA1 originated on the Syrian coast (more specifically the area of Antioch) and the area of Cilicia spanning to Rhodes in the west;[25] there is also a variant from Cyprus.[26] An amphora fragment found in Histria bears a stamp that has been deciphered as *Korykos*. This was initially interpreted as a name, but more recently it has been understood to be the name of a city in Cilicia, further supporting the conclusion that this type of amphora was produced in that area.[27] This interpretation is bolstered by numerous references to κεραμεῖς (ceramists) on funerary inscriptions found in Korykos of Cilicia.[28] A considerable number of these amphorae from Thessaloniki have Greek inscriptions, written in red color and with a sloppy hand, a common feature of LRA1. They have different groups of *dipinti* situated both on the neck and on the amphora shoulder. Scholars have concluded that LRA1 were mainly used to transport wine, since a number of them were coated with pitch inside; dry goods (grain, dry fruits, salted fish, etc.) are other products which might have been stored or transported in LRA1 amphorae.[29]

Another type of amphora commonly found in Thessaloniki is Carthage LRA2 (Late Roman Amphora 2, fig. 3b), which was also common throughout the Mediterranean and the Black Sea.[30] Together with LRA1 they are the most common amphorae types in Thessaloniki. LRA2 is the most common type at Torone. Its presence is recorded on almost all the sites in the Aegean, which is where most researchers locate the first appearance of the type. In fact its appearance is dated to as early as the first or even the second century B.C.E., with its shape evolving from ovoid to spherical as the dense ribbing around the shoulder area was reduced.[31] The Late Antique type dates from the fourth to early seventh centuries. LRA2 has a hard, pale, brownish-red, brown-beige fabric, broad-bellied body with wide shoulder, short tapering

[24] Papadopoulos, "Pottery," 555.

[25] Empereur and Picon, "Production of Aegean Amphorae," 33 and 35, fig. 21; Hayes, *Saraçhane*, [type 5], 63–64.

[26] Demesticha and Michaelides, "Excavation," 289–96; Demesticha, "Amphora Production," 469–76; Piéri, "Centres de production," 614–16.

[27] Opaiţ, "Eastern Mediterranean Amphorae," 5:295.

[28] Mentzou, Συμβολαί, 90.

[29] Rothchild–Boros, "Determination of Amphora Contents," esp. 86; Hayes, *Saraçhane*, 64.

[30] For LRA2, see Riley, *Carthage*, 122; idem, "Berenice," 217–19; Zimmermann-Munn, "Late Roman Kiln Site," 342–43; Hayes, *Saraçhane*, [type 9], 66; Papadopoulos, "Amphorae," [type I], 83–87; idem, "Pottery," [type I], 551–55; Chrisostomou, "Εμπορικές ανταλλαγές," [type 1], 597. Also see Opaiţ, *Ceramics of Scythia*, 10–12.

[31] Opaiţ, "From DR 24 to LR2," 627–44.

neck, and rounded base with a central knob. The mouth is conical and there are two strong handles from neck to shoulders. Excavations have recently uncovered possible kiln sites where this type of amphora was produced in the region of the Argolid, more specifically at Kounoupi,[32] on Chios,[33] and in Knidos in Asia Minor.[34] Scholars believe that this vessel was used primarily for the transportation of oil. Its frequent presence in the area of the lower Danube has been connected to the olive oil distribution to the garrisons of the frontier provinces through the *annona militaris* system.[35]

One more amphora type frequently found in excavations in Thessaloniki is Carthage LRA3 (Late Roman Amphora 3, fig. 3c), which is believed to originate in Asia Minor, probably Aphrodisias or the area between Ephesos and Sardis, especially the Hermos or Meander valleys.[36] These amphorae are made of dark, red-brown, soapy fabric verging on dark brown and rich in mica. They have a spindle-shaped body with widely spaced shallow ribbing and a hollow conic toe (knob). The neck, like the mouth, is narrow. One small handle on the earlier examples and two on the later are affixed to the neck. The LRA3 type enjoyed a long period of development from the first to the seventh centuries. The presence of resin in the interior of these amphorae suggested that they contained wine, which gives their place of origin. The Hermos and Meander valleys were known for their fine wines. LRA3 found in Thessaloniki often have a hole made later in the neck, indicating that they were used for drawing water from wells: The hole served for ventilation and made it easier to fill and empty the vessel. Fragments of such amphorae are frequently found in excavated wells in many places.[37]

Amphorae with a long cylindrical body, comparatively wide mouth, no neck, and loop handles are known as Carthage LRA4 (Late Roman Amphora 4) or "Gaza" amphorae (fig. 3d), generally thought to come from southern Palestine and more specifically from the area of Gaza.[38] They represent a well-known type of amphora, which spread through the Mediterranean as far as

[32] Riley, *Carthage*, 118; idem, "Berenice," 229–30.

[33] Tsaravopoulos, "City of Khios," 124–44.

[34] Tuna et al., "Rapport préliminaire," 49.

[35] Karagiorgou, "LR2," 129–66; Opaiț, *Ceramics of Scythia*, 107.

[36] For LRA3, see Robinson, *Athenian Agora*, 17, pl. 41; Papadopoulos, "Amphorae," [type V], 93–95; idem, "Pottery," [type V], 562–64. Also, see Opaiț, *Ceramics of Scythia*, 13–14; Hayes, *Saraçhane*, [type 3], 63.

[37] Robinson, *Athenian Agora*, 17; Papadopoulos, "Pottery," 562.

[38] For LRA4, see Riley, *Carthage*, 120; idem, "Berenice," 219–23; Papadopoulos, "Amphorae," [type IV], 92–93; idem, "Pottery," [type IV], 561–62; Chrisostomou, "Commercial Exchanges," [type 3], 599–600. Also, see Hayes, *Saraçhane* [type 6], 64–66; Opaiț, *Ceramics of Scythia*, 20–22.

Britain and the Crimea and dates from the fourth to the sixth centuries. These amphorae are made of brown to brownish-red fabric and the body has dense ribbing in the shoulder area and in the lower part. If the proposed hypothesis that they were used for the transportation of the splendid wines of the Gaza area is correct, their discovery in Thessaloniki reflects market demand and shows that the city's market was supplied with select products.

Among the finds from Thessaloniki are also examples of Cretan amphorae. The amphora on fig. 3e comes from an excavation of the northern part of the East Cemetery of Thessaloniki.[39] It is of pinkish to buff color and rather fine fabric. It has an ovoid wheel-ridged body, a short cylindrical neck, a rounded rim, and two loop-shaped handles. A similar amphora was found in the excavations in the East Cemetery but also further south in the area of the Aristotle University Campus.[40] These amphorae have a Cretan origin, being the fourth-century subtype of a well-known Cretan wine amphora that started its evolution in the first century C.E.[41]

Σπάθειον (*spatheion*, sword) is the conventional name of an amphora with a long cylindrical body (fig. 3f), a wide cylindrical neck in a continuous line with the body, smooth walls, and two small handles affixed to the neck.[42] Products of the North African workshops, such amphorae have a whitish-cream surface and must have been used for transporting wine, for a considerable number of them were found to be coated with pitch inside, although they may also have contained a fish sauce. They were widespread and are found in many places in both the east and the west Mediterranean, and they date from the fifth to the seventh centuries. The Thessaloniki finds include a good number of mostly medium-sized examples. Owing to their tubular shape, *spatheia* were frequently used as waste pipes, by breaking off the bottom and fitting them together. Such a waste pipe was found under the cardo of Hagia Sophia Street during excavations for Thessaloniki's new water supply pipeline, when a two-kilometer trench was dug along Agiou Dimitriou Street.[43] A similar waste pipe with *spatheia* was found in an excavation at Olympiados Street, where Theramenous Street meets Lazou

[39] Pelekanidou, "Ανασκαφή," 528.

[40] Petsas, "Ανασκαφή Πανεπιστημιου," 335, pl. 349c.

[41] Robinson, *Athenian Agora,* pl. 15; Riley "Berenice," 180–83; Marangou-Lerat, *Le vin et les amphores de Créte*, [type AC1 variant D, 73], 66–77, figs. 44–46; Yangaki, *La céramique*, [type MRC2, variant MRC2a], 185–88.

[42] Bonifay, *Études sur la céramique*, 125–29, for a lengthy discussion of the name, the size, and the other characteristics of these amphorae.

[43] *Σωστική ανασκαφή*, 330–31, pl. 107.

Exarchi Street, and is now in the permanent exhibition of the Museum of Byzantine Culture.[44]

Outside of the above types, which are the most common finds of amphorae in the archaeological ceramic material in Thessaloniki, amphorae of other types like the Pontic Sinopean[45] and the North African Africana II "Grande"[46] are also recorded among the finds from Late Antique Thessalonikē.[47]

HOUSEHOLD UTENSILS

Until quite recently, household utensils—tableware, cooking ware, and storage vessels—were mostly made of clay. The cellars of a Late Antique house contained amphorae full of oil and wine, while larger quantities of commodities, including dry goods like grain, were stored in large jars that were kept in basement areas, half embedded in the ground to keep the contents cool.

An excavation in Thessaloniki's East Cemetery in 1994 uncovered two twin graves.[48] Both are frescoed, barrel-vaulted tombs. The wall paintings survive in very good condition and appear to represent views of the cellar of a house (fig. 4). A wide range of contemporary delicacies is depicted around the walls of the tombs: game, such as hare and deer, hams and sausages, and even a liver hanging on the wall. Amphorae of various types are depicted lying on the walls. They represent the known types of amphorae we saw earlier. At least we can recognize here ceramics of LRA2 (fig. 3b), which was used for the transportation of oil, and a one-handled version of LRA3 (fig. 3c), which was used for transporting wine. This suggests that specific amphorae used for specific foodstuffs—mainly oil, wine, and possibly salted fish, of renowned provenance and famously superb quality—were available in the market of ancient Thessalonikē. It is likely that such commodities were depicted in a grave fresco to indicate a belief in the Elysian Fields and the Isles of the Blessed, where the dead were able to enjoy all the things they had not been able to enjoy during their life on earth.[49]

[44] Toska, "Οδός Ολυμπιάδος," 535–37, esp. 537.

[45] Opaiţ, *Ceramics of Scythia*, 31–32; idem, *Amphorae*, 301–2.

[46] Bonifay, *Études sur la céramique*, 107–17; Papadopoulos, "Amphorae," [type VI], 95–98; idem, "Pottery," [type VI and related], 564–66.

[47] Collections of Museum of Byzantine Culture in Thessaloniki.

[48] Pelekanidou, "Τοιχογραφημένοι τάφοι," 192–201; Markē, *Η νεκρόπολη*, 162–69.

[49] Lucian, *Dialogi mortuorum*, 1.5–8; Kourkoutidou-Nikolaidou, "From the Elysian Fields," 130.

Fig. 4. Wall painting depicting amphorae in a cellar from a tomb in the East
Cemetery of Thessaloniki. Museum of Byzantine Culture, Thessaloniki.

Tablewares

The finds from Thessaloniki confirm that types of Roman slipped wares
continue to serve as table vessels through the Late Antique period. Most
of the finds are rather large plates or dishes, a fact that suggests that they
were used for dry or solid food (fig. 5). Smaller bowls with a shape similar
to that of a "skyphos" must have been used for drinking water or wine.
Closed vessels shaped like jugs must also have been connected with drinking
(fig. 6). The ware, which appears to be the standard fine ware in Late
Antique Thessalonikē and other Aegean sites from 150–250 C.E., is called
Çandarli ware.[50] Finds from this period in Thessaloniki and in Torone show
that Çandarli ware was the predominant fine ware import. Çandarli ware
belongs to the class of eastern sigillata and is a product of the workshops
in the region of Pergamon, where the 1911 excavation at the site of ancient
Pitanē (Çandarli) produced evidence of the manufacture of this fine ware.[51]
Çandarli ware has rather thick walls and a characteristic low, heavy foot.

[50] Hayes, *Late Roman Pottery*, 316–22; Papadopoulos, "Pottery," 530–31.
[51] Loeschcke, "Sigillata-Töpfereien in Tschandarli," 344–407.

The early products have a fine-grained orange body with a lustrous orange, orange-red gloss. Later, the body became red-brown and even darker. The gloss over it has a similar shade and is of good quality.

Another fine ware that appears frequently among the Late Antique finds from Thessaloniki is the Phocaean Red Slip ware, known earlier as late Roman C ware.[52] It is a common ware throughout the eastern Mediterranean from the late fourth to seventh centuries. The Phocaean Red Slip ceramics found in Thessaloniki are dishes and bowls and have the characteristic features of this ware: a fine-grained, hard-fired, brownish-red to purplish-red ceramic fabric; a red-brownish and rather dull slip; roulette and stamped decoration. The outer surface of their rim is usually discolored due to partial reduction as a result of the practice of firing the vessels in stacks, where the outer edge of the rim was directly exposed to the kiln. John Hayes recorded among the finds from Thessaloniki forms 1, 2, 3 (fig. 7, group a).

Dishes, bowls, and mugs produced by the North African workshops are among the finds from fourth- to sixth-century Thessalonikē.[53] The wares are of characteristic fairly coarse orange-red to brick-red fabric. The body is usually coated with a slip of the same or slightly darker color. Sometimes, the wares bear stamped and engraved decoration. The ceramics from North African workshops, specifically Tunisian, are diffused throughout the Mediterranean. Among the excavation finds from Thessaloniki, John Hayes mentions examples of forms 50, 71, 91, 132, and 172 (fig. 7, group b).

The so-called Macedonian T. S. Grise ware[54] (fig. 7, group d) appears prominently among finds from Late Antique excavations in Thessaloniki.[55] It is of characteristic fine-grained gray clay coated with a thin layer of slip of the same color as the body clay, which gives a satiny metallic appearance to the surface. Among the finds from Thessaloniki are flat-rimmed dishes and deep bowls. The scalloped or notched rim is a fairly common feature, as well as the stamped decoration. The ware has a rather regional Macedonian distribution and dates from late fourth to early sixth centuries. Excavations at Stobi gave numerous examples of the ware dated in this period. In comparison

[52] Hayes, *Late Roman Pottery*, 323–70; idem, *Supplementum to Late Roman Pottery*, 525–27; idem, *Saraçhane*, 7–8; Papadopoulos, "Pottery," 531–36.

[53] Hayes, *Late Roman Pottery*, 13–305; idem, *Supplementum to Late Roman Pottery*, 481–524; idem, *Saraçhane*, 5–7; Papadopoulos, "Pottery," 534–36; Bonifay, *Études sur la céramique*, 155–210.

[54] Hayes, *Late Roman Pottery*, 405–7; idem, *Supplementum to Late Roman Pottery*, 534; Papadopoulos, "Pottery," 536–38; Stojanović, "Stobi," 61–72.

[55] Petsas, "Ανασκαφή Πανεπιστήμιου," pl. 355d, mentioned as terra nigra; Kambanis, in *Everyday Life in Byzantium*, cat. no. 340.

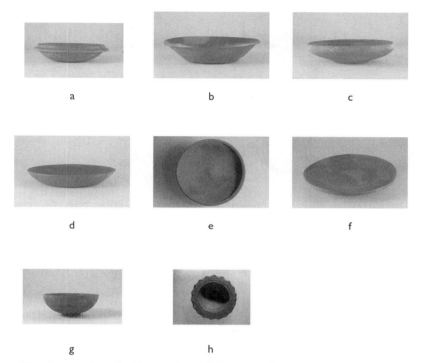

Fig. 5. Examples of tableware found in Thessaloniki. Museum of Byzantine Culture, Thessaloniki.

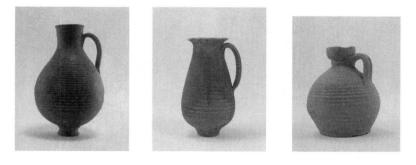

Fig. 6. Jugs (oinochoes) from Thessaloniki. Museum of Byzantine Culture, Thessaloniki.

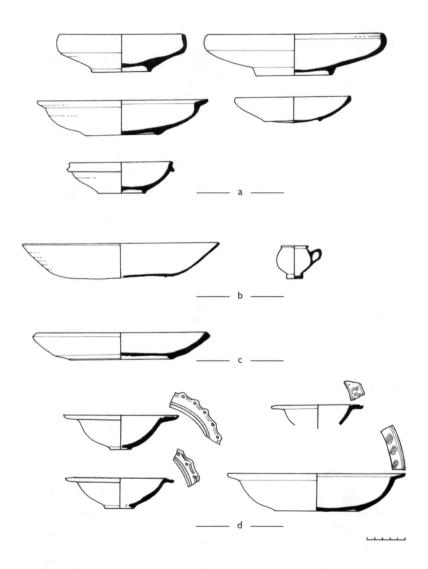

Fig. 7. Forms of tableware from Thessaloniki. Museum of Byzantine Culture, Thessaloniki.

with Thessaloniki it is worth noting the scarcity of the ware in Torone. Among the excavated material from Thessaloniki, Asia Minor light-colored ware is also well represented.[56] There is also very little evidence of tableware from Cypriot workshops (fig. 7c).[57]

Only a few household utensils are decorated; most of those that are decorated, naturally enough, are tableware. According to the finds, tableware vessels in Thessaloniki were decorated with relief, stamped (fig. 8), and painted decoration.[58] The spread of Christianity does not seem to have brought about serious modifications of shape or form, probably because dietary habits did not change dramatically. Preference for large vessels may have been connected with the rise of Christianity and the adoption of communal eating.[59] However, as far as decoration is concerned, there were significant differences and a new thematic repertory. Christian symbols, mainly crosses, appear among the decorative subjects (fig. 8, group a).[60] These Christian motifs do not necessarily indicate that the utensils concerned were used for exclusively religious purposes. Such religious symbols reflect the early Christians' need to invoke divine presence and protection for the household, and this seems to apply as much to pottery as to luxury metal utensils.[61] As for the form of the decoration, the pottery decoration imitates that of luxury utensils, such as repoussé and embossed work.[62]

To this day, scholars have not yet attributed tableware-specific ceramics to local Thessalonikan workshops. Although this essay can cover only a small portion of the ceramic production of Thessalonikē, it can be safely suggested that the city's production followed the general patterns of the world of Late Antiquity: that already in the fifth century, imports began to decline, and local workshops supplied the needs of the local market in table/kitchen vessels and other ceramic objects.

Cooking utensils

As one would expect, cooking utensils were among the most common excavation finds from Thessaloniki (fig. 9). As with tableware, cooking

[56] Hayes, *Late Roman Pottery*, 408–10; Papadopoulos, "Pottery," 538–41.

[57] Hayes, *Late Roman Pottery*, 371–86, esp. 373–74 (fig. 80, form 1–2), 385; idem, *Supplementum to Late Roman Pottery*, 528–29.

[58] Petsas, "Ανασκαφή Πανεπιστήμιου," pl. 355c, d; pl. 350c; Karagianni, "Κινητά ευρήματα," 152, fig. 12.

[59] Hawthorne, "Post Processual Economics," 29–37.

[60] Hayes, *Late Roman Pottery*, 272–73, 276, 280, 364.

[61] Maguire et al., *Art and Holy Powers*, 16–33.

[62] Hayes, *Late Roman Pottery*, 211–14 and 283–87.

Fig. 8. Examples of stamped (group a) and relief (group b) decoration on ceramics from Thessaloniki. Museum of Byzantine Culture, Thessaloniki.

vessels have not been attributed to local workshops. The ergonomic shape of cooking ware, with its spherical belly, wide mouth, and out-turned rim, frequently shaped to receive a fitted lid, continued in the Late Antique period. The soft ribbing done on the wheel around the body of quite a number of cooking pots made the vessels easier to grip and are a common feature on pots of this period.[63] Apart from the main type of deep, closed cooking utensil, among the finds are vessels of a smaller size that very possibly were used for cooking small quantities of food or for boiling water (fig. 9d).

CERAMIC LAMPS

The mold-made clay lamp of the Roman period was still the main lighting device in the Late Antique period, until the seventh century when production slowed and eventually ceased. As one might expect, excavations in Thessaloniki, both in residential areas and in cemeteries, have yielded a large number of lamps (figs. 10, 11).[64] They represent or resemble well-known types of the period, like those with a round shape, short nozzle, and projecting solid handle, which are related to the Attic workshops and were widely distributed during the late third and the fourth centuries.[65] Others belong to the "North African" type, and are either "genuine"—that is, they come from North African workshops mainly from northern or central Tunisia—or imitations of the products of the noted North African workshops.[66] They have a round body, a long nozzle, and a disc linked to the nozzle by a channel. Numerous groups of lamps with a characteristic fabric shape and frequently with granulation on the body are known as the "Asia Minor" type. The bulk of this type's production was probably manufactured at a number of sites on the coast of Asia Minor.[67] It is worth noting here that the numerous "Asia Minor" lamps found in Thessaloniki confirm that sites in northern Greece imported significant quantities of Asia Minor products during the Late Antique period.[68]

[63] Bakirtzis, "Περί χύτρας," 111–16.

[64] Adam-Velenē et al., "Στρωματογραφία," 501–31; Karagianni, "Κινητά ευρήματα," 147–58; Pelekanidou, "Ευαγγελίστρια," 528, pl. 158.

[65] Perlzweig, *Athenian Agora*, 17–69; Karivieri, *Athenian Lamp Industry*.

[66] Broneer, *Terracotta Lamps*; Hayes, *Late Roman Pottery*, 310–15; Bonifay, *Études sur la céramique*, 358–416; idem, "Observations," 34–37.

[67] Perlzweig, *Athenian Agora*, 65–99; Poulou-Papadimitriou, "Lampes paléochrétienne de Samos," 586.

[68] Sodini, "Productions and échanges," 188, 194; Petridis, "Relations," 43–54.

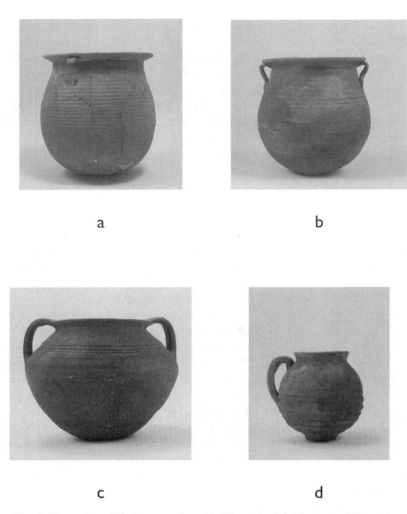

a

b

c

d

Fig. 9. Examples of kitchenware found in Thessaloniki. Museum of Byzantine Culture, Thessaloniki.

In Thessaloniki, sites like the Ancient Agora have yielded ceramic molds for lamps.[69] The discovery of molds shows that the city had workshops that produced mold-made lamps. The distribution of molds is a subject of lively scholarly debate, which focuses on such questions as how they were

[69] Adam-Velenē et al., "Στρωματογραφία," 509.

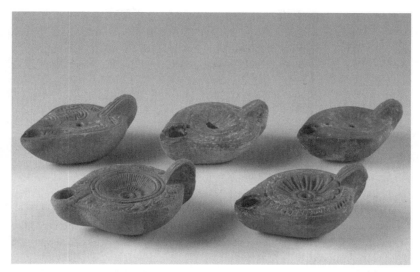

Fig. 10. Examples of clay lamps found in Thessaloniki. Museum of Byzantine Culture, Thessaloniki.

Fig. 11. Examples of clay lamps found in Thessaloniki. Museum of Byzantine Culture, Thessaloniki.

copied and the minor differences that appeared with each new mold.[70] This debate constitutes such a large chapter in the study of mold-made lamps that we cannot go into it in detail. Molds were also found in excavations in the East Cemetery (fig. 12), raising the question of pottery workshops near cemeteries.[71]

GRAVE CERAMICS

Ceramics have always played an important part in burial customs and burial ritual. Excavations in the cemeteries to the east and west of Thessaloniki's walls have uncovered hundreds of graves, a Late Antique phenomenon that continues the long habit of burying the dead outside the city walls. Studying these burials has made it possible to collect information about the typology of the graves, burial practices, burial offerings, and the ways in which the dead were honored.[72]

Regarding the use of ceramics in this context, let us start by commenting on the use of roof-tiles and bricks, which we looked at earlier as construction materials for public and private buildings. Identical tiles and bricks were used to build tombs. Such materials were also used to make humble sepulchral structures known as tile-graves, which took the form of a brick-lined pit with a pedimented roof of tiles.[73] Very often the bricks and tiles used for the construction of the tombs were spolia.

The excavation of Thessaloniki's Late Antique cemeteries yielded an abundance of ceramic vessels in a variety of uses. Among them were a significant number of urn burials. In this type of burial, amphorae, small jars, and other large vessels were used for burying the remains of young children and infants (fig. 13).[74] Of a totally different use were vessels found inside the graves, most of them medium-sized jugs resembling oinochoes (fig. 14).[75] The next most commonly found vessels are unguentaria, which typically

[70] Petridis, "Échanges et imitations," 241–50.

[71] Petsas, "Ανασκαφή Πανεπιστήμιου," 338–39 and pl. 356a, c, e.

[72] Nalpantis, *Ανασκαφή*; Markē, *Η νεκρόπολη*; Makropoulou, "Δυτικό νεκροταφείο Θεσσαλονίκης," 257–70; eadem, "Grave Finds."

[73] Nalpantis, *Ανασκαφή*, 102.

[74] For example, see Petsas, "Ανασκαφή Πανεπιστήμιου," 335, pl. 348a, 349a–d; Pelekanidou, *Everyday Life in Byzantium*, cat. no. 735.

[75] Nalpantis, *Ανασκαφή*, 119–23.

Fig. 12. Clay mold for lamps from the excavations in the West Cemetery of Thessaloniki. Museum of Byzantine Culture, Thessaloniki.

are small in size and have a spherical or ovoid body and a long neck.[76] They were used for perfume oils and unguents (fig. 15).

Jugs and unguentaria were found inside the graves, usually near the corpse's feet, together with the bones of previous burials. The ancient tradition for burial offerings, that is, objects placed in the graves for the deceased to use in the afterlife, seems to have languished from the first and second centuries onwards. The number of vessels found in the graves became appreciably smaller. The prevalence of Christianity and its concepts of a posthumous life with no material needs must have played a part in this. Of the examples of vessels found in burials, jugs and unguentaria were generally used in the burial ritual and in customs practiced to honor the dead, such as libations and funeral banquets.

In the wall paintings of the fourth-century "Tomb of Eustorgios" in the West Cemetery of Thessaloniki, a family—father, mother, and two sons—offers libations to the dead, very possibly to the "mother of all, Aurelia Procla," according to the inscription.[77] Aurelia Procla is depicted on the wall opposite the rest of the family, and her presence in the scene indicates that

[76] Ibid., 123–24; Markē, *Η νεκρόπολη*, 239.
[77] Pelekanidis, *Gli affreschi Paleocristiani*, 8–12, fig. 1.

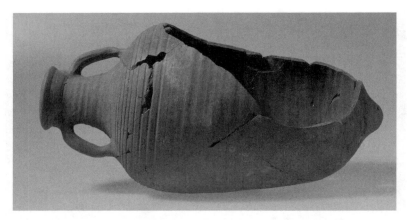

Fig. 13. Clay burial amphora found in the East Cemetery of Thessaloniki.
Museum of Byzantine Culture, Thessaloniki.

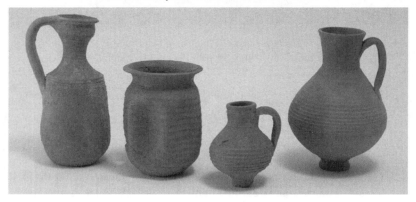

Fig. 14. Grave ceramics from Thessaloniki. Museum of Byzantine Culture,
Thessaloniki.

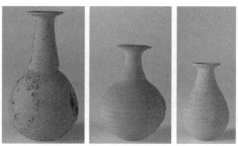

Fig. 15. Unguentaria found in Thessaloniki.
Museum of Byzantine Culture, Thessaloniki.

she is part of the burial ritual.[78] In the depiction the two boys hold a vessel, gray in color, which must have contained milk or wine. Together with honey, these were the main substances used for libations (fig. 16). We do not know what this particular vessel was made of; it may be silver or a ceramic vessel of the gray clay of the Macedonian T. S. Grise ware mentioned earlier.[79]

The discovery of a clay stove from an excavation in the West Cemetery (fig. 17) indicates a different practice.[80] It must have been used to cook food for the funeral banquet and to heat the water used to dilute the wine. Cooking pots as well as plates and dishes frequently found in cemetery excavations must also have been used for funeral banquets.[81] Such a funeral banquet is depicted on a wall-painting of a grave dated to the fourth century (fig. 18).[82] There is a plate in the center. We do not know what it is made of, but in shape and color it resembles a clay plate.

Lamps similar to those found in residential sites are a common find when graves are excavated. The custom of keeping some kind of light burning on a grave continues to the present day.[83] This practice was recorded in the depiction of a double lamp on a wall painting of a grave dated to the fourth century (fig. 19).[84]

The discovery of pottery kilns on burial sites indicates that, in obedience to the age-old dictates of commerce, light industrial units operated where there was a demand for their products. This is still the case today; marble workshops and shops selling candles and flowers are located near cemeteries.

CONCLUSIONS

We may conclude this brief examination of ceramics from Late Antique Thessalonikē by noting that the material published to date does not allow us to discuss further or analyze in detail differences in terms of number, quantity, and quality during the period under discussion. Yet, it is safe to claim that, thanks to the archaeological evidence, we can examine ceramics used in a

[78] Markē, *H νεκρόπολη*, 138–39.

[79] See above, nn. 54, 55.

[80] Makropoulou, in *Everyday Life in Byzantium*, cat. no. 149.

[81] Markē, *H νεκρόπολη*, 209–10, 240.

[82] Ibid., 140–41, fig. 155.

[83] Sorochan, "Light for Life," 111–17.

[84] Markē, *H νεκρόπολη*, 171–72.

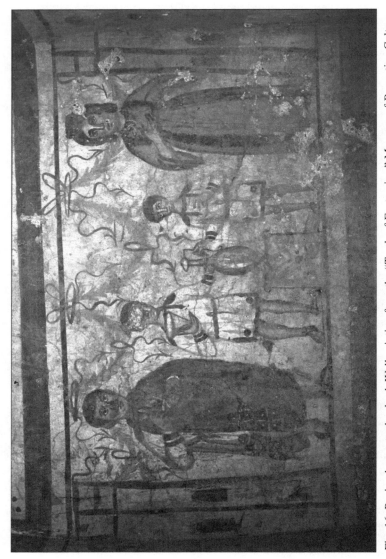

Fig. 16. Paying honor to the dead. Wall painting from the "Tomb of Eustorgios." Museum of Byzantine Culture, Thessaloniki.

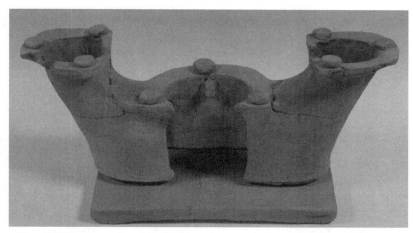

Fig. 17. Clay stove found in the West Cemetery of Thessaloniki. Museum of
Byzantine Culture, Thessaloniki.

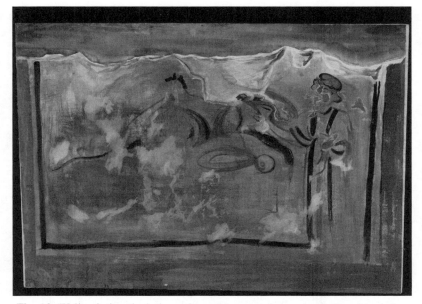

Fig. 18. Wall painting depicting a funeral banquet from a tomb found in Agiou
Dimitriou Street, Thessaloniki. Museum of Byzantine Culture, Thessaloniki.

Fig. 19. Drawing of a wall painting depicting a double lamp from a tomb found in Thessaloniki. Museum of Byzantine Culture, Thessaloniki.

number of aspects of daily life in Late Antique Thessalonikē. They were objects that assisted life in the households of the city, sustained the city's economy, and were vital components of its built environment. Further study and systematic analysis of the archaeological record is necessary in order to address issues of local production and to refine the typology of ceramics in Late Antique Thessalonikē.

Returning to the tradition of the roof-tile used by St. Spyridon to display the nature of the Holy Trinity, we may note that this particular demonstration during the Ecumenical Council of Nicaea in 325 C.E. displays the significance of ceramics in all aspects of daily life. The archaeological evidence from Late Antique Thessalonikē mirrors this reality and demonstrates the diverse role and meaning of ceramics in Byzantine life. Ceramic tiles and bricks gave form to the built environment of the city, pottery vessels and utensils

accommodated the various needs of the Late Antique household, amphorae were indispensable in the economy, utilized for storage and transportation, and, finally, ceramic containers and other objects were used in burial customs and to receive the remains of the deceased for posterity. As a result, Byzantines were familiar with this humble material, made from the very essence of this earth. This familiarity rendered the unprivileged clay and its products "sacred" in the mysteries and the tussles of everyday life.

Bibliography

Adam-Velenē, Polyxenē et al. "Αρχαία Αγορά Θεσσαλονίκης: Η στρωματογραφία και τα κινητά ευρήματα" (The Ancient Agora of Thessalonikē: Stratigraphy and Small Finds). *AEMΘ* 10B (1996) 501–31.

Alfen, Peter G. van. "New Light on the 7th-c. Yassi Ada Shipwreck: Capacities and Standard Sizes of LRA1 Amphoras." *JRA* 9 (1996) 189–213.

Armenopoulos, Konstantinos. *Πρόχειρον Νόμων ή Εξάβιβλος* (Drafts of the Laws or the Six Books). Edited by Konstantinos G. Pitsakis. Athens: Dodoni, 1971.

Bakirtzis, Charalambos. "Imports, Exports and Autarky in Byzantine Thessalonikē from the Seventh to the Tenth Century." Pages 89–118 in *Byzantium, Pliska, and the Balkans.* Vol. 2 of *Post-Roman Towns, Trade and Settlement in Europe and Byzantium.* Edited by Joachim Henning. 2 vols. Berlin: de Gruyter, 2007.

———. "Περί χύτρας" (Cooking Pots). Pages 111–16 in *Food and Cooking in Byzantium: Proceedings of the Symposium "On Food in Byzantium." Thessaloniki Museum of Byzantine Culture 4 November 2001.* Edited by Demetra Papanikola-Bakirtzi. Athens: Archaeological Receipt Fund, 2005.

———. *Αγίου Δημητρίου Θαύματα. Οι Συλλογές Ιωάννου και Ανωνύμου. Ο βίος, τα Θαύματα και η Θεσσαλονίκη* (The Miracles of St. Demetrios: The Reflections of John and of the Anonymous. The Life, the Miracles, and Thessalonikē). Athens: Agra, 1997.

Bardill, Jonathan. *Brickstamps of Constantinople.* 2 vols. Oxford: Oxford University Press, 2004.

Bass, George Fletcher and Frederick H. Van Doorninck, Jr. *Yassi Ada, Volume I: A Seventh-Century Byzantine Shipwreck.* The Nautical Archaeology Series 1. College Station, Tex.: Texas A&M University Press, 1982.

Bonifay, Michel. "Observations sur la typologie des lampes africaines (II^e–VII^e siècle)." Pages 31–38 in *Lychnological Acts 1. Actes du 1er Congrès international d'études sur le luminaire antique (Nyon-Genève, 29.IX – 4.X.2003).* Edited by Laurent Chrzanovski. Monographies Instrumentum 31. Montagnac: Éditions Monique Mergoil, 2005.

———. *Études sur la céramique romaine tardive d'Afrique.* BAR International Series 1301. Oxford: British Archaeological Reports, 2004.

Broneer, Oscar. *Terracotta Lamps.* Corinth: American School of Classical Studies 4.2. Cambridge, Mass: Harvard University Press, 1930.

Chrisostomou, Anastasia. "Εμπορικές ανταλλαγές της Έδεσσας μέσα από τους αμφορείς των παλαιοχριστιανικών χρόνων" (The Commercial Exchange of Edessa through the Study of Early Christian Amphorae). Pages 1:593–619 in *Ancient Macedonia V: Fifth International Symposium.* Thessaloniki: Institute for Balkan Studies, 1993.

Demesticha, Stella. "Amphora production on Cyprus during the Late Roman Period." Pages 469–76 in *VII^e Congrès International sur la Céramique Médiévale en Méditerranée, Thessaloniki, 11–16 Octobre 1999, Actes.* Edited by Charalambos Bakirtzis. Athens: Hellenic Ministry of Culture; Archaeological Receipts Fund, 2003.

——— and Demetrios Michaelides. "The Excavation of a Late Roman 1 Amphora Kiln in Paphos." Pages 289–96 in *La céramique byzantine et proto-islamique en Syrie-Jordanie. Actes du Colloque tenu à Amman, 3–5 décembre 1994.* Edited by Estelle Villeneuve and Pamela Watson. Bibliothèque archéologique et historique 159. Beirut: Institut français d'archéologie du Proche-Orient, 2001.

Eleutheriadou, Kiriaki, Ioannis Kanonidis, Despina Makropoulou, and Dimitris Nalpantis. "Σωστικές ανασκαφές Θεσσαλονίκης" (Rescue Excavations in Thessaloniki). *AEMΘ* 2 (1988) [1991] 271–82.

Empereur, Jean-Yves and Maurice Picon. "The Production of Aegean Amphorae: Field and Laboratory Studies." Pages 223-48 in *New Aspects of Archaeological Science in Greece. Proceedings of a Meeting Held at the British School at Athens, January 1987.* Edited by Richard E. Jones and Hector W. Catling. Fitch Laboratory Occasional Paper 3. Athens: British School at Athens, 1988.

Galen. *Claudii Galeni Pergameni scripta minora. Galenus Med. Thrasybulus sive utrum medicinae sit an gymnasticae hygiene.* Edited by Georg Helmreich, Johann Marquardt, and Iwan Müller. 3 vols. Leipzig: Teubner, 1893. Repr., Amsterdam: Hakkert, 1967.

Gregoriou-Ioannidou, Martha. "Το επεισόδιο του Κούβερ στα Θαύματα του Αγίου Δημητρίου" (Kouver's Incident in the Miracles of St. Demetrios). *Βυζαντιακά* 1 (1981) 67–87.

Hawthorne, John. "Post Processual Economics: The Role of African Red Slip Ware Vessel Volume in Mediterranean Demography." Pages 29–37 in *TRAC 96: Proceedings of the Sixth Annual Theoretical Roman Archaeology Conference, Sheffield 1996.* Edited by Karen Meadows, Chris Lemke, and Jo Heron. Oxford: Oxbow Books, 1997.

Hayes, John W. *Excavations at Saraçhane in Istanbul II: The Pottery.* Oxford: Princeton University Press/Dumbarton Oaks, 1992.

———. *Supplementum to Late Roman Pottery.* London: The British School at Rome, 1980.

———. *Late Roman Pottery.* London: The British School at Rome, 1972.

Kambanis, Panagiotis. *Everyday Life in Byzantium.* Edited by Demetra Papanikola-Bakirtzi. Athens: Hellenic Ministry of Culture, 2002.

Karagianni, Flora. "Κινητά ευρήματα πρώτης ανασκαφικής περιόδου: το δείγμα των ετών 1970–1973" (The Small Finds of the First Excavation Period: 1970–1973). Pages 147–58 in *Αρχαία Αγορά Θεσσαλονίκης* 1, *Πρακτικά Διημερίδας για τις εργασίες των ετών* 1989–1999 (The Ancient Agora of Thessalonike 1, Proceedings of a Two-Day Symposium on the Archaeological Work of 1989–1999). Edited by Polyxenē Adam-Velenē. Thessaloniki: University Studio Press, 2001.

Karagiorgou, Olga. "LR2: A Container for the Military annona on the Danubian Border?" Page 129–66 in *Economy and Exchange in the East Mediterranean during Late Antiquity: Proceedings of a Conference at Somerville College, Oxford 29th May 1999.* Edited by Sean Kingsley and Michael Decker. Oxford: Oxbow, 2001.

Karivieri, Arja. *The Athenian Lamp Industry in Late Antiquity.* Papers and Monographs of the Finnish Institute at Athens 5. Athens: Finnish Institute at Athens, 1996.

Kiourtzian, Georges. "Enépigraphos Plinthos." *TM* 15 (2005) 381–400.

Koder, Johannes. *Das Eparchenbuch Leons des Weisen.* CFHB. Series Vindobonensis 33. Vienna: Österreichische Akademie der Wissenschaften, 1991.

Kourkoutidou-Nikolaidou, Eutychia. "From the Elysian Fields to the Christian Paradise." Pages 128-42 in *The Transformation of the Roman World. AD 400–900.* Edited by Leslie Webster and Michelle Brown. London: British Museum Press, 1997.

Lagges, Matthew, ed. *Ὁ Μέγας Συναξαριστὴς τῆς Ὀρθοδόξου Ἐκκλησίας* (The Great Synaxarion of the Orthodox Church). Vol. 12. 5th ed. Athens: Matthew Lagges, 1977.

Lauffert, Siegfried. *Diokletian's Preisedikt. Texte und Kommentare* 5. Berlin: de Gruyter, 1971.

Lemerle, Paul. *Les plus anciens recueils des miracles de saint Démétrius et la pénétration des Slaves dans les Balkans*. 2 vols. Paris: Éditions du Centre national de la recherche scientifique, 1978–1980.

Loeschcke, Siegfried. "Sigillata-Töpfereien in Tschandarli." *AM* 37 (1912) 344–407.

Lucian of Samosata. *Works: English and Greek: Dialogi mortuorum*. Translated by Matthew D. Macleod. Vol. 7 of 8 vols. LCL. Cambridge, Mass.: Harvard University Press, 1961.

Maguire Dauterman, Eunice, Henry Maguire, and Maggie J. Duncan-Flowers. *Art and Holy Powers in the Early Christian House*. Illinois Byzantine Studies 2. Urbana, Ill.: University of Illinois Press, 1989.

Makropoulou, Despina. "Grave Finds and Burial Practices in Thessaloniki (4th–15th c.)." *Proceedings of the 21st International Congress of Byzantine Studies, London, 2006*. Online: http://www.byzantinecongress.org.uk/paper/II/II.4_Makropoulou.pdf).

——. "Δυτικό νεκροταφείο Θεσσαλονίκης: αρχαιολογικές έρευνες στην οδό Λαγκαδά" (The Western Cemetery of Thessaloniki. Archaeological Research on Langadha Street in 1991). *AEMΘ* 5 (1991) 257–70.

——. "Οδός Μοναστηρίου 93. Καμίνι πλίνθων και κεράμων. 9η ΕΒΑ" (93 Monasteriou Street. A Kiln for the Production of Bricks and Roof-Tiles, 9th Ephoreia of Byzantine Antiquities). *ArchDelt* 43 (1988) [1993] Β′2, *Chronika*, 379–80.

Mango, Cyril. "Byzantine Brickstamps." *AJA* 54 (1950) 19–27.

—— and Robert Scott. *The Chronicle of Theophanes Confessor: Byzantine and Near Eastern History, AD 284–813*. Oxford: Clarendon Press, 1997.

Marangou-Lerat, Antigone. *Le vin et les amphores de Créte. De l'époque classique à l'époque impériale*. Études crétoises 30. Athens: Ecole française d'Athènes; Thessaloniki: Fondation Fany Boutari, 1995.

Markē, Euterpē. *Η νεκρόπολη της Θεσσαλονίκης στους υστερορωμαϊκούς και παλαιοχριστιανικούς χρόνους (μέσα του 3ου έως μέσα του 8ου αι. μ.Χ.)* (The Necropolis of Thessalonikē during the Late Roman and Early Christian Period [mid 3rd–mid 8th century]). Dēmosieumata tou Archaiologikou deltiou 95. Athens: Hellenic Ministry of Culture; Archaeological Receipts Fund, 2006.

Mentzos, Aristoteles. "Σφραγίσματα σε πλίνθους από το Δίον και τη Θεσσαλονίκη" (Brickstamps from Dion and Thessaloniki). *Ιστορικογεωγραφικά* 2 (1988) 196–97.

Mentzou, Konstantina. *Συμβολαί εις την μελέτην του οικονομικού και κοινωνικού βίου της πρώιμου βυζαντινής περιόδου (Η προσφορά των εκ Μ. Ασίας και Συρίας επιγραφών και αγιολογικών κειμένων)* (Contribution to the Study of Economical and Social Life of Early Christian Period). Bibliothēkē Sophias N. Saripolou 31. Athens: Ethnikon kai Kapodistriakon Panepistēmion Athēnōn, Philosophikē Scholē, 1975.

Nalpantis, Dimitris. *Ανασκαφή στο οικόπεδο του Μουσείου Βυζαντινού Πολιτισμού. Ταφές και ευρήματα* (The Excavation in the Grounds of the Museum of Byzantine Culture in Thessaloniki). Athens: Archaeological Receipts Fund, 2003.

——. "Οδοί Κολωνιάρη – Γαλανάκη – Παπαθανασίου. 9η ΕΒΑ" (Koloniari – Galanaki – Papathanasiou Streets, 9th Ephoreia of Byzantine Antiquities). *ArchDelt* 42 (1987) [1992], Β′2, *Chronika*, 403–6.

Omont, Henri. "Inscriptions grecques de Salonique, recueillies au XVIII siècle par J.-B. Germain." *RA* 3rd series 24 (1894) i. 196–214.

Opaiț, Andrei. "From DR 24 to LR2." Pages 2:627–44 in *LRCW2: Late Roman Coarse Wares, Cooking Wares and Amphorae in the Mediterranean*. Archaeology and Archaeometry. Edited by Michel Bonifay and Jean-Christophe Tréglia. 2 vols. BAR International Series 1662. Oxford: British Archaeological Reports, 2007.

———. "The Eastern Mediterranean Amphorae in the Province of Scythia." Pages 293–308 in *Acts of the International Colloquium at the Danish Institute at Athens, September 26–29, 2002*. Edited by Jonas Eiring and John Lund. Monographs of the Danish Institute at Athens 5. Athens: The Danish Institute at Athens, 2006.

———. *Local and Imported Ceramics in the Roman Province of Scythia*. BAR International Series 1274. Oxford: British Archaeological Reports, 2004.

Ousterhout, Robert. *Master Builders of Byzantium*. Princeton, N.J.: Princeton University Press, 1997.

Papadopoulos, John K. "Pottery of the Roman Period." Pages 547–68 in *Torone 1: The Excavations of 1975, 1976 and 1978*. 3 vols. Vol. 1: *Text: Part 1*. Vol. 2: *Text: Part 2*. Vol. 3: *Illustrations*. Edited by Alexander Cambitoglou, John K. Papadopoulos, and Olwen T. Jones. Bibliothēkē tēs en Athēnais Archaiologikēs Hetaireias 206–208. Athens: Archaeological Society at Athens, 2001.

———. "Roman Amphorae from the Excavations at Torone." *ArchEph* 128 (1989) [1991] 67–103.

Pelekanidis, Stylianos. *Gli affreschi Paleocristiani ed i più antichi mosaici parietali di Salonicco*. Universita' degli Studi di Bologna. Istituto di Antichità Ravennati e Bizantine, Quaderno N.2. Ravenna: Edizione "Dante" di A. Longo, 1963.

Pelekanidou, Elli. "Τοιχογραφημένοι τάφοι στην περιοχή του Τελλογλείου Ιδρύματος Τεχνών" (Painted Tombs near the Telloglion Foundation for the Arts). Pages 191–205 in *Πρακτικά Η΄ Διεθνούς Επιστημονικού Συμποσίου, Χριστιανική Θεσσαλονίκη. Ταφές και κοιμητήρια, Ιερά Μονή Βλατάδων, 6–8 Οκτωβρίου 1994* (Proceedings of the International Symposium, Christian Thessalonikē: Burials and Cemeteries, Vlatadon Monastery, 6–8 October 1994). Thessaloniki: University Studio Press, 2005.

———. *Everyday Life in Byzantium*. Edited by Demetra Papanikola-Bakirtzi. Athens: Hellenic Ministry of Culture, 2002.

———. "Ανασκαφή βόρεια του κοιμητηρίου της Ευαγγελίστριας (Ανατολικό νεκροταφείο)" (The Excavation North of the Evangelistria Cemetery [Eastern Cemetery]). *ArchDelt* 49 (1994) Β΄2, *Chronika*, 528.

Perlzweig, Judith. *Lamps of the Roman Period*. Athenian Agora 7. Princeton, N.J.: Princeton University Press, 1961.

Petridis, Platon. "Relations between Pottery Workshops on the Greek Mainland during the Early Byzantine Period." Pages 43–54 in *Çanak: Late Antique and Medieval Pottery and Tiles in Mediterranean Archaeological Contexts, Proceedings of the First International Symposium on Late Antique, Byzantine, Seljuk, and Ottoman Pottery and Tiles in Archaeological Context (Çanakkale, 1–3 June 2005)*. Edited by Beate Böhlendorf-Arslan, Ali Osman Uysal, and Johanna Witte. Byzas 7. Istanbul: Deutsches Archäologisches Institut; Abteilung Istanbul: Ege Yayınları, 2007.

Petridis, Platon. "Échanges et imitations dans la production des lampes romaines et paléochrétiennes en Grèce Centrale." Pages 241–50 in *L'artisanat en Grèce ancienne. Les productions, les diffusions. Actes du colloque de Lyon, 10–11 décembre 1998*. Edited by Francine Blondé and Arthur Muller. Lille: Villeneuve d'Ascq: Université Charles de Gaulle, 2001.

Petsas, Fōtios. "Ανασκαφή Πανεπιστημιουπόλεως Θεσσαλονίκης" (Excavation of the University Campus of Thessaloniki). *ArchDelt* 21 (1966) B´2, *Chronika*, 334–39.

Piéri, Dominique. "Les centres de production d'amphores en Méditerranée orientale durant l'antiquité tardive: quelque remarques." Pages 611–26 in *LRCW2. Late Roman Coarse Wares, Cooking Wares and Amphorae in the Mediterranean: Archaeology and Archaeometry*. Edited by Michel Bonifay and Jean-Christophe Tréglia. BAR International Series 1662. Oxford: British Archaeological Reports, 2007.

Pitsakis, Konstantinos G. "Πόλεις και περιβάλλον στα βυζαντινά νομικά κείμενα" (Urban Centers and Environment in Byzantine Law Texts). Pages 63–162 in *Φυσικό και δομημένο περιβάλλον στις βυζαντινές νομικές πηγές* (The Natural and Structural Environment in the Byzantine Legal Sources). Edited by Spyros N. Troianos and Konstantinos G. Pitsakis. Athens: Goulandri-Horn Foundation, 1998.

Pollux, Julius. *Pollucis onomasticon*. Edited by Ericus Bethe. 2 vols. Lexicographi Graeci 9.1–9.2. Leipzig: Teubner, 1900, 1931. Repr., Amsterdam: Hakkert, 1967.

Poulou-Papadimitriou, Natalia. "Lampes paléochrétiennes de Samos." *BCH* 110 (1986) 583–610.

Raptis, Konstantinos Th. "Παρατηρήσεις επί ορισμένων δομικών στοιχείων της Αχειροποιήτου" (Remarks on Some Structural Elements of Acheiropoietos Church). *ΑΕΜΘ* 13 (1999) 219–37.

Riley, John A. "The Coarse Pottery from Berenice." Pages 91–467 in *Excavations at Sidi Khrebish, Benghazi (Berenice)*. Edited by Graeme Barker, Anthony Bonnano, and John A. Riley. Vol. 2 of Supplements to Lybia Antiqua 5. Edited by J. A. Lloyd. Tripoli: Department of Antiquities, Secretariat of Education, [1979] 1982.

———. "The Pottery from Cisterns 1977. 1, 1977. 2 and 1977. 3." Pages 85–124 in *Excavation at Carthage 1977, conducted by the University of Michigan*. 7 vols. Edited by John H. Humphrey. Ann Arbor, Mich.: University of Michigan Press, 1981.

Robinson, Henry S. *Pottery of the Roman Period: Chronology*. Athenian Agora 5. Princeton, N.J.: American School of Classical Studies at Athens, 1959.

Rothchild-Boros, Monica C. "The Determination of Amphora Contents." *AIS* 19 (1981) 79–89.

Sodini, Jean-Pierre. "Productions and échanges dans le monde protobyzantin (IV^e–VII^e siècles): le cas de la céramique." Pages 182–208 in *Byzanz als Raum. Zu Methoden und Inhalten der historischen Geographie des östlichen Mittelmeerraumes*. Edited by Klaus Belke, Friedrich Hild, Johannes Koder, and Peter Soustal. Veröffentlichungen der Kommission für die Tabula Imperii Byzantini 7. Vienna: Verlag der Österreichische Akademie der Wissenschaften, 2000.

Sorochan, Sergey. "Light for Life and Death in Early Byzantine Empire." Pages 111–19 in *Fire, Light and Light Equipment in the Graeco-Roman World*. Edited by Denis Zhuravlev. BAR International Series 1019. Oxford: British Archaeological Reports, 2002.

Stojanović-Anderson, Virginia R. "Stobi. The Hellenistic and Roman Pottery." Pages 1:61–72 in *Studies in the Antiquities of Stobi*. Edited by James Wiseman. Princeton, N.J.: Princeton University Press, 1999.

Σωστικές ανασκαφές 2002 (τεύχος πινακίδων) (Rescue Excavations 2002 [Booklet of Posters]). Thessaloniki: 9th Ephorate of Byzantine Antiquities, 2002.

Σωστική ανασκαφή αγωγού ύδρευσης Θεσσαλονίκης 2 (2000–2002) (Rescue Excavations for Thessaloniki's Water Supply Pipeline 2 [2000–2002]). *Τετράδια Αρχαιολογίας* 3 [DVD]. Thessaloniki: Hellenic Ministry of Culture; 9th Ephorate of Byzantine Antiquities, 2006.

Tafrali, Oreste. *Topographie de Thessalonique*. Paris: Librairie Paul Geuthner, 1913.

Texier, Charles Félix Marie and Richard Popplewell Pullan. *Byzantine Architecture*. London: Day and Son, 1864.

Theocharidou, Kalliopi. "Συμβολή στη μελέτη της παραγωγής οικοδομικών κεραμικών προϊόντων στα βυζαντινά και μεταβυζαντινά χρόνια" (A Contribution to the Study of Brick and Tile Production in the Byzantine and Post-Byzantine Period). *ΔΧΑΕ* 13 (1985–1986) 97–112.

Toska, Leda. "Οδός Ολυμπιάδος, Λ. Εξάρχη και Θηραμένους" (Olympiados, L. Exarhi, and Thiramenus Street). *ArchDelt* 50 (1995) Β′2, *Chronika*, 535–37.

Tourptsoglou-Stephanidou, Vasiliki. *Περίγραμμα βυζαντινών οικοδομικών περιορισμών (από τον Ιουστινιανό στον Αρμενόπουλο και η προβολή τους στη νομοθεσία του Νεοελληνικού Κράτους)* (An Outline of Building Regulations in Byzantium [from Justinian to Armenopoulos and Their Influence in the Legislation of Modern Greek State]). Epistēmonikai Pragmateiai. Seira Nomikē kai Oikonomikē 6. Thessaloniki: Hetaireia Makedonikōn Spoudōn, 1998.

Tsaravopoulos, Aris. "The City of Khios. A contribution to the topography of the city from the results of rescue excavations." *Horos* 6 (1986) 124–44.

Tuna, Numan et al. "Rapport préliminaire de la prospection archéologique turco-française des ateliers d'amphores de Resadiye-Kiliseyani sur la Péninsule de Datça." *Anatolia Antiqua* 2 (1987) 48–49.

Vickers, Michael. "Fifth Century Brickstamps from Thessaloniki." *BSA* 68 (1973) 285–94.

Walter, Christopher. "Icons of the First Council of Nicaea." *Deltion tēs christianikēs archaiologikēs hetaireias* 16 (1991–1992) 209–18.

Yangaki, Anastasia. *La céramique des IVᵉ – VIIIᵉ siècles ap. J.-C. d' Eleutherna. Sa place en Créte et dans le basin égéen*. Athens: University of Crete, 2005.

Zimmermann-Munn, Mary Lou. "A Late Roman Kiln Site in the Hermionid, Greece." *AJA* 89 (1985) 342–43.

Glassware in Late Antique Thessalonikē (Third to Seventh Centuries C.E.)

Anastassios C. Antonaras

The invention of glass is widely known through what Pliny claims in his *Natural History*. Even if his story has been proven technically impossible, Pliny connects the invention of glass with the Phoenician coast and natron merchandisers, who sailed from Egypt.[1] Today it is believed that glass—along with faience, the first artificial, human-made substance—was probably invented in Mesopotamia around 2200 B.C.E.[2] Colored glass was already widely used in Egypt in the second half of the second millennium B.C.E.[3] For many centuries after its invention, glass remained an extremely expensive material, used only as semiprecious stone and later for production of special vessels found only in palaces and temples.[4] From the classical Greek period onwards, small glass unguentaria became more widely available than earlier but were still products for the highest social strata.[5] The invention of glass blowing, a technological revolution that took place around the early first century B.C.E. somewhere on the Levantine coast, led to a gradual fall

[1] Pliny, *Nat.* 36.190–192.

[2] Oppenheim et al., *Glass and Glassmaking*, 4–101.

[3] Stern and Schlick-Nolte, *Early Glass*, 20, with exhaustive bibliography.

[4] Ibid., 27–37, 44–53.

[5] Grose, *Early Ancient Glass*, 110–25. Stern and Schlick-Nolte, *Early Glass*, 37–44.

in the price of glass vessels by the mid-first century C.E. and made possible their use by wider social strata in the eastern Mediterranean.[6]

Although glass vessels had functions similar to pottery ones, glass needs to be treated quite differently from ceramics, and any researcher should keep in mind a few basic differences while studying comparatively these two groups of finds.[7] During the entire period under consideration, glass was thoroughly recycled. Glassblowers' kilns melted all evidence of the true quantitative distribution and the diversity of original forms. Also, it should be kept in mind that all didactic parts of vessels, like rims, handles, and bases, weigh the most and therefore were collected and recycled most consistently, leaving mainly smaller, noncharacteristic fragments on site.[8] Thus archaeological finds do not reflect the everyday life of the period or area under consideration. Rather, they reflect the consistency of recycling. The only exceptions come from undisturbed strata of abruptly destroyed and/or abandoned sites, which unfortunately are not the case with the finds from Thessalonikē. Grave goods do offer an undisturbed picture of the past, but unfortunately reflect only the burial habits of society and not necessarily everyday life. In addition, because the vast majority of excavations conducted in Thessalonikē are salvage operations, we glimpse the always already obscure past through a deforming prism created by the fragmented and circumstantial character of the excavated finds. Furthermore, we must also stress that glass objects were found almost exclusively in graves; therefore they only represent part of the repertoire of the vessels and objects used in burial and memorial rituals and as grave goods.

GLASS WORKSHOPS

Remains of the local glass working activity have been spotted in three parts of Thessalonikē: outside the eastern city walls in a building (which probably was also used as a workshop for clay lamps), in the city's abandoned public Forum, and in the abandoned ruins of the Roman public bathhouse where the basilica Acheiropoietos was erected in the mid-fifth century (fig. 1). All finds are generally dated between the fourth and sixth centuries C.E. Only the

[6] Israeli, "Invention of Blowing," 46–55; eadem, "What did Jerusalem's First-Century B.C.E. Glass Workshop Produce?" 446–47.

[7] On that matter, see also Antonaras, "Ὑάλινα και κεραμικά αγγεία," forthcoming.

[8] Trowbridge, *Philological*, 106–7; Stern, "Roman Glassblowing," 451. It appears that recycling of glass shards was widely introduced only during the Flavian period (69–96), along with the spread of the free-blowing technique.

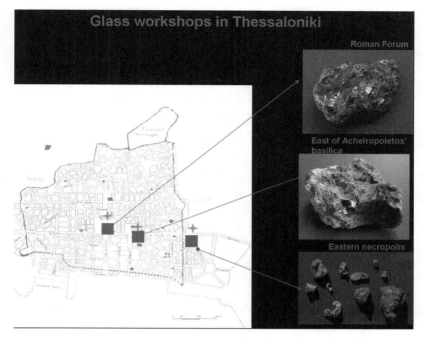

Fig. 1. Glass Workshops in Thessaloniki. Town Plan and Remains.

workshop from the eastern necropolis yielded relatively secure information about its products, which probably consisted of several types of lamps.[9]

Raw material, according to its appearance, color, and quality, might have been partly imported from Syro-Palestinian primary workshops and partly was acquired from recycling of broken objects, which must have been collected quite thoroughly.

A. Glass Vessels

In the period under examination, the forms and uses of glass vessels in Thessalonikē according to the excavated material could be summarized as follows.[10]

[9] Antonaras, "Ενδείξεις δραστηριότητας," 247–53; idem, "Υαλοποιία και υαλουργία," forthcoming.

[10] For a thorough and analytical study of glass vessels from Thessalonikē's region, see Antonaras, *Ρωμαϊκή και παλαιοχριστιανική υαλουργία*. For a version of the same study in English, see idem, "Glass Vessels," forthcoming.

After the middle of the second and during the third century, Thessalonikē flourished, but, as far as glass finds are concerned, the number of preserved examples diminished considerably, as did the number of forms in use (fig. 2). Mainly tableware is preserved: arybaloid jugs, biconical bottles with

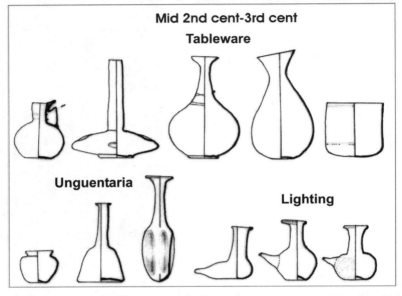

Fig. 2. Drawings of mid-second- and third-century glass vessels. Drawings by Anastassios C. Antonaras.

indentations, and pear-shaped flasks. Also, large, jar-like unguentaria are found, possibly of western origin. Finally, during this period, if not a bit later, spouted vessels appear with an inherent spout. These vessels are known as baby-feeders but were probably used as lamp fillers. These vessels were produced both in the West and the East, although their handleless variants, which appear in Thessalonikē, seem to be an eastern product. They continue to be used and produced in the fourth century, mainly with an applied spout, as well.

Around the end of the second and during the third centuries, the following new forms appeared in Thessalonikē: bulbous flasks; cylindrical, engraved beakers; as well as indented, ovoid, and conical unguentaria with horizontal shoulders, which were western products.

In the second half of the third century a new period of development started in Thessalonikē. In general this was a prosperous period for the city,

as is evident from the erection of new monumental buildings. Its prosperity was a result of its strategic position on the Via Egnatia and its position on the sea; both of these elements, which made Thessalonikē important for the

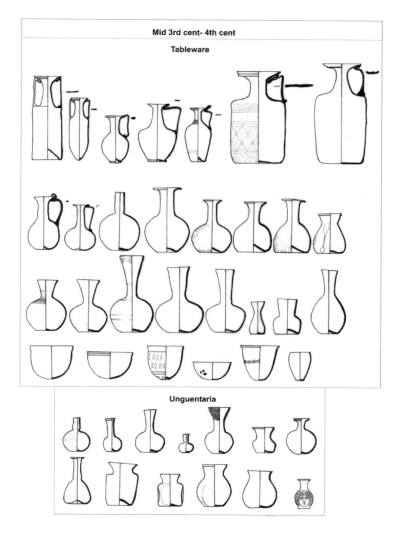

Fig. 3. Drawings of mid-third- and fourth-century glass vessels. Drawings by Anastassios C. Antonaras.

constant military events of this period, led Galerius to choose the city as his imperial capital.

After the middle of the third century, the use of glass in Thessalonikē was more widespread (fig. 3). Glass was now mostly produced as large-sized vessels, amforisks, jugs, and bottles; these forms, equally widespread in eastern and western provinces, seem to have lasted until the beginning of the fifth century. The following tall tableware vessels appear in large numbers: jugs in new shapes, known both from East and West; pointed and flat-bottomed amforisks; spherical bottles with cut-off rim and constriction at the base of their neck; spherical and pear-shaped bottles with outsplayed rim or funnel mouth, ribbed and plain ones. The aforementioned forms were widely used and produced both in the West and the East, but probably a large number of them were produced locally. Also, flasks appear in many forms: pear-shaped, squat or slender; spherical ones with short or long neck; ovular and cylindrical ones, some of which were locally produced. The prevailing form of drinking vessels consists of hemispherical bowls often bearing engraved or applied decoration, while ovular beakers appear only sporadically.

Unguentaria too appear among the finds from Thessalonikē. These, which are miniature versions of tableware vessels, are spherical with cut-off or outsplayed rims or funnel-mouthed. They include pear-shaped ones with outsplayed rims, wide and cylindrical ones, bulbous ones, and jar-like ones with vertical ribs. At the same time cubical and double-faced mold-blown unguentaria appeared. All these forms survived throughout the fourth century. They seem to have originated in the West or even in the Balkans, while only a few appear to be of oriental origin.

Wide use of glass vessels in Thessalonikē continued in the fourth century (fig. 4). Vessels are mainly Syro-Palestinian or imitate Syro-Palestinian forms. Vessels for serving liquids appear in a variety of forms, namely jugs and flasks. Drinking vessels consist of bowls, both shallow and deeper ones, and tall conical beakers without bases, which were probably used also as lamps. The following bowls appear: free-blown hemispherical ones, and mold-blown ones with a honeycomb pattern. Present also are calyx-shaped bowls and short cylindrical ones with scalloped rims.

Unguentaria appear in a great diversity of sizes and forms: as small amphorae, craters, and jugs; as handleless and biconical, squat and spherical, pear-shaped, cylindrical with short and tall neck; as square bodied with tall or short neck; and as jar-like (fig. 5). Glass was also used for the production of lamps, like the three-handled hemispherical and calyx-shaped bowls

4th cent.- early 5th cent.

Tableware

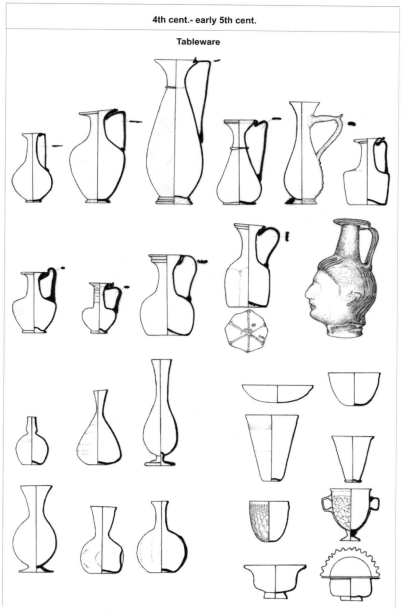

Fig. 4. Drawings of fourth- and early fifth-century glass tableware. Drawings by Anastassios C. Antonaras.

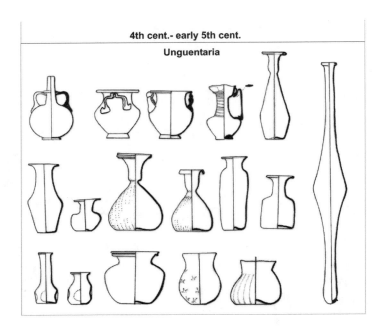

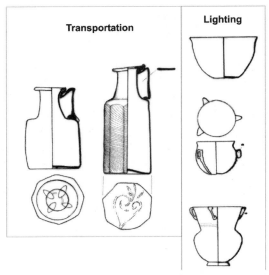

Fig. 5. Drawings of fourth- and early fifth-century glass vessels. Drawings by Anastassios C. Antonaras.

(fig. 5).[11] A special group consists of octagonal jugs, plain and with oblique ribbing, which appear to be local products of the late fourth to fifth centuries (fig. 5).[12]

At the end of the fourth and during the early fifth centuries, tall conical beakers with ring bases, indented bowls, and tall cylindrical flasks appear in Thessalonikē (fig. 6). These may have originated in the northwestern provinces.

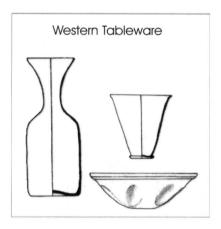

Fig. 6. Drawings of late fourth-century western glass vessels. Drawings by Anastassios C. Antonaras.

In Thessalonikē during the fifth and sixth centuries, quite possibly several forms of the fourth-century tableware, such as jugs, bottles, and drinking vessels, survived (fig. 7). The latter were also used as lamps. The well-known form of stemmed beakers prevails. The other forms of glass lamps known from the area of Thessalonikē are equally well documented all over the Mediterranean region (i.e., three-handled stemmed beakers, hemispherical or calyx-shaped stemmed lamps, and pointed cylindrical vessels with a smaller or larger knob forming the base).[13]

Examples of vessels found throughout the inhabited areas of Thessalonikē are few and date to the second half of the fourth and to the fifth centuries. Vessels for carrying liquids—such as jugs, deep and shallow bowls, and others for drinking—prevail. Some bear engraved decorations, indicating

[11] Antonaras, "Glass Lamps," forthcoming.

[12] Idem, "New Glass Finds," 2:413–20.

[13] Idem, "Glass Lamps," forthcoming.

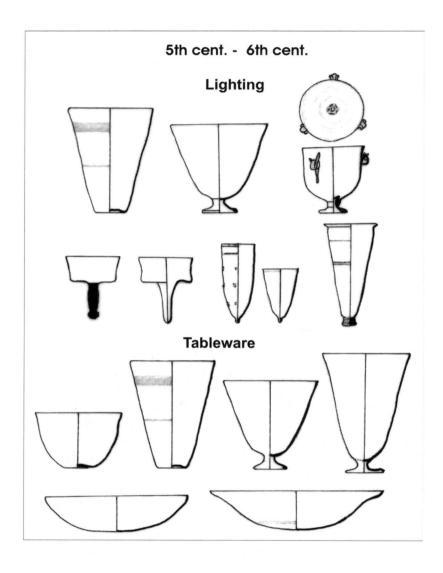

Fig. 7. Drawings of fifth- and sixth-century glass vessels. Drawings by Anastassios C. Antonaras.

their use by the wealthier people. These engraved vessels, which are probably mainly of Italian origin, also show Thessalonikē's relationship to Rome and the Italian peninsula in general. Although pagan themes occur, mainly Christian or nonreligious, geometrical themes prevail. The most interesting fragments are the following:

Depicted on a fourth-century spherical bottle is a hunting scene with a female, most likely Diana, with a bow, hunting two deer assisted by dogs (fig. 8.1).[14] The scene takes place among bushes and trees, and the deer are running toward a stretched net. Above the scene a partly preserved inscription reads: ΥΣΥΧΙ ΠΙΕ . . . ΗΣ ΜΕΤΑ . . . /ΩΝ ΠΙΕ Ζ . . . Σ. Although it has been published with the lacunae filled with Christian words, like ΑΓΙΟΝ, etc., I find this reconstruction quite, if not highly, inappropriate, given the pagan scene covering the vessel's body.[15] So, it seems more probable that the text with the wish for this certain Ὑσύχι(‹ο›ς), owner of the bottle, could be filled with the words ΤΩΝ ΣΩΝ, or ΤΩΝ ΟΙΚΕΙΩΝ, or ΤΩΝ ΣΩΝ ΟΙΚΕΙΩΝ ΠΑΝΤΩΝ, or, given the size of the vessel's missing part, even with the names of these ΟΙΚΕΙΟΙ — a pattern well known from other similar finds.[16] Therefore, the inscription might be reconstructed as follows: Ὑσύχι, πίε ζήσῃς μετὰ τῶν σῶν οἰκείων πάντων. Πίε ζήσῃς. "Hesychios, drink; may you live with all your intimates. Drink; may you live!" All other decorated vessels (shallow bowls and plates) are open-shaped.[17]

[14] Archaeological Museum of Thessalonikē, reg. no. ΜΘ 7224. For the vessel's form see Isings, *Roman Glass*, 122–23, form 103; Antonaras, *Ρωμαϊκή καὶ παλαιοχριστιανική υαλουργία*, 322–24, form 145. For Diana's representations on glass vessels, see Whitehouse, *Roman Glass*, 1:268–69, no. 457; Loeschcke and Willers, *Beschreibung römischer Altertümer*, vol. 2, plate 28; Fremersdorf, *Die Römischen Gläser*, 2:165–66, plate 218. Extremely similar is the entire hunting scene depicted on a second-century B.C.E. faience calanthus found in a grave at Neapolis, Thessalonikē, where the hunter is also identified as Diana: Daffa-Nikonanou, "Δύο εμείσακτα αγγεία," 269–75, fig. 3, plate 56.

[15] Petsas, "Ανασκαφή πανεπιστημιουπόλεως Θεσσαλονίκης," 391, plates 296ε and 298, fig. 12ε; Pallas, *Les Monuments paléochrétiens de Grèce*, 75. Pallas sees [Ε]ΥΣΥΧΙ ΠΙΕ [. . . .]ΗΣ ΜΕΤΑ [. . .]/[. . .] ΩΝ ΠΙΕ Ζ[. . .]Σ and reads it as: [Ε]ΥΨΥΧΕΙ. ΠΙΕ [ΖΗΣ]ΗΣ ΜΕΤΑ/ [ΤΩΝ/ ΑΓΙ]ΩΝ. ΠΙΕ Ζ[ΗΣΗΣ] (75 n. 163). Feissel reads it as ΥΣΥΧΙ ΠΙΕ [ΖΗΣ]ΗΣ ΜΕΤΑ [ΤΩΝ]/ [ΑΓΙ]ΩΝ ΠΙΕ Ζ[ΗΣΗ]Σ and suggests the fourth century as a possible date. Idem, *Recueil des inscriptions chrétiennes*, no. 127.

[16] Cabrol and Leclerq, "Pie zeses," col. 1023–31; Auth, "Drink may you live!" 103–12, where exhaustive bibliography on that issue can be found; Fremersdorf, *Die Römischen Gläser mit Schliff*, 189–91, plate 214; 271–73.

[17] Isings, *Roman Glass*, 144–45, form 116; Antonaras, *Ρωμαϊκή καὶ παλαιοχριστιαμική υαλουργία*, 131–33, form 16.

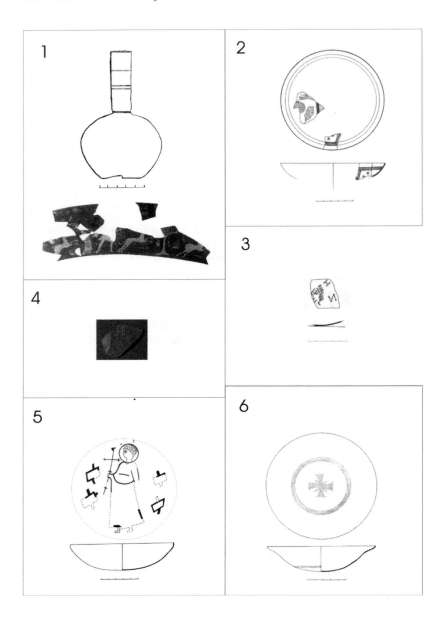

Fig. 8. Engraved glass vessels. Drawings by Anastassios C. Antonaras.

On a plate[18] a standing figure is preserved, holding a plant in the right hand that looks like a poppy (?) and showing what would appear to be the seed pod (fig. 8.2). Perhaps also from the same vessel is a herringbone band preserved around the rim and parts of what once were eight-pointed stars.[19]

From another plate[20] a male, beardless head in profile is preserved (fig. 8.3), over which letters "ZH" can be read; these are part of an inscription, probably a salutation in the form of πίε ζήσης, which was equally used in pagan, Jewish, and Christian scenes.[21] The plate seems to be a product of a Roman workshop from the second half of the fourth century.[22]

We find yet another fragment of a plate,[23] on which the letter "H" can be read, along with an uncertain motif (fig. 8.4). The decoration on the fragment could be the leg of a throne or of a cathedra.

The best-preserved sample presents a young, beardless, standing figure with a nimbus and holding a long staff with his right hand, which ends up in a chrism (fig. 8.5).[24] Around the nimbus can be seen the letter "M," and possibly a second one, hardly visible today. The figure is flanked by two *tabulae ansatae* (tablets with handles), possibly standards, placed perpendicularly at each side. This plate is likely the product of a Roman workshop at the end of the fourth to the early fifth centuries. This workshop is known from several pieces that share the same Christian themes in their detailing, themes similar to that of the aforementioned plate.[25]

Identifying the figure is not an easy task, and only a few suggestions on that matter will be made. This kind of staff can be seen held by Christ or St. Peter, less often by St. Paul or St. John the Forerunner.[26] Also, saints highly venerated locally are given this *insignium*, such as St. Laurent in Galla

[18] Archaeological Museum of Thessalonikē, reg. no. MΘ 21960.

[19] For similar plants on rock crystal vessels, see Fremersdorf, *Antikes, Islamisches und Mittelalterliches Glas*, 117 nos. 1047–48, 1061–62, plate 82. For parallels in glass: Paolocci, *I vetri incisi*, 150–51, 164–65; Ružić, *Rimsko staklo u Srbiji*, 57 no. 1195, plate 43:14.

[20] Archaeological Museum of Thessalonikē, reg. no. MΘ 21978.

[21] Cabrol and Leclerq, "Pie zeses," col. 1023–31; Auth, "Drink may you live!" 103–12, where exhaustive bibliography on that matter can be found.

[22] On this workshop see Paolucci, *I vetri incisi*, 57–62. For a thorough study of the workshops active in Rome during the late fourth and early fifth century, see Saguì, "Un piatto di vetro," 337–58.

[23] Archaeological Museum of Thessalonikē, yet unregistered, presented in Antonaras, *Ρωμαϊκή και παλαιοχριστιανική υαλουργία*, as vessel no. ΠΑΜ 36.

[24] Museum of Byzantine Culture, Thessalonikē, reg. no. BY 327/1.

[25] Paolucci, *L'arte del vetro inciso*, 27–28; also, Saguì, "Un piatto," 337–58.

[26] Schäfer, "Die Heilige," 33.

Placidia's mausoleum and in a glass bowl from Ostia.[27] Finally, if indeed the letter "M" above his head is an indication of his name, then possibly he could be identified with the Archangel Michael or some other saint with an "M" in his name. *Tabulae ansatae*, or possibly standards, which are presented around the figure, have also been observed in association with other archangels and lead to the identification of the admittedly wingless figure with the archangel Michael.[28]

Among the nonfigurative themes, we distinguish a Greek cross inscribed in a round medallion (fig. 8.6),[29] while all the others are just dots, facets, and bands engraved solely or in combinations that sometimes create more elaborate patterns.

Regarding the decorative techniques present in our material and their overall distribution in Thessalonikē, we could summarize our remarks as follows. Almost exclusively free-blown, plain, undecorated vessels were used. Few forms of fully mold-blown, or more usually, dip mold-blown occur; these are concentrated mainly in the fourth to fifth centuries. Dip mold-blowing offered an easy and inexpensive way of decorating vessels with ribbing, usually oblique or occasionally vertical. From the late third to fifth centuries, few vessels are incised, mainly with simple bands, while only a handful bear more complicated figurative decoration. An even smaller number of vessels bears applied decorations, mainly consisting of simple threads or dots, alone or in clusters of contrasting colors, while only a couple of vessels are adorned with pinching.

Figure nine summarizes the above data and visualizes in charts the spread of different groups of vessels by century. Results of my research on glass finds from Thessalonikē dating from the first century B.C.E. to the sixth century C.E. will be used.[30] From this chart, we can observe that in the second and the beginning of the third centuries the total number of forms and vessels, compared to that of the first century, diminishes significantly — representing 7.5 percent of the total number of forms and just 3 percent of vessels. While tableware still prevails, the number of vessels for serving liquids increases and the number of unguentaria drastically diminishes. Additionally, spouted

[27] Paolucci, *I vetri incisi*, 52, fig. 18.

[28] I would like to thank Dr. Charalambos Bakirtzis for suggesting to me this interpretation of the indeterminable motifs of the *tabulae ansatae*/standards. Rectangular standards on tall shafts can be seen held by archangels in the mosaics of S. Apollinare in Classe.

[29] For parallels see Barag, *Glass Vessels*, plate 52/5; Iliffe, "Tomb at El Bassa," 81–91; from a grave of the last decade of the fourth century, represented in Paolucci, *I vetri incisi*, 72–73, fig. 36.

[30] Antonaras, *Ρωμαϊκή και παλαιοχριστιανική υαλουργία.*

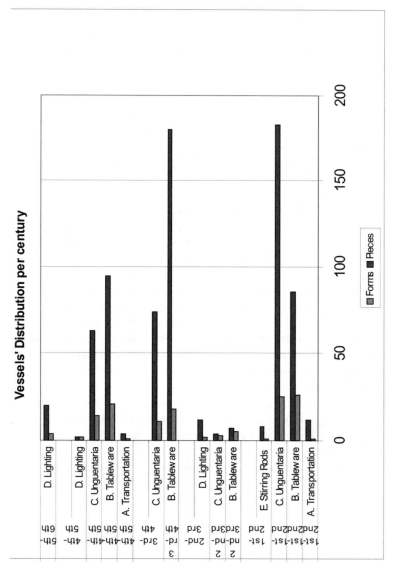

Fig. 9. Distribution Chart of Glass Vessels.

vessels and possibly lamp fillers appear for the first time. Among the vessels of this period those whose origin can be traced appear to be western products. From the middle of the third until the early fifth century, the spread of glass vessels recovers in Thessalonikē. A large number of unguentaria appears, although tableware nevertheless prevails even for carrying liquids. A few transporting vessels and some lamps are also present. Vessels of this period represent fifty percent of the total number of forms and fifty percent of the total number of vessels discussed here. It seems that imports from the East prevail, especially from Syro-Palestine, while at the same time the total number of local products also rises considerably. Later, during the fifth and sixth centuries, lamps dominate among the indeed quite scarce number of finds. Lamps, representing three percent of the total number of forms and 2.7 percent of the number of vessels studied, demonstrate one of the main needs that glass objects fulfilled throughout the Byzantine era. No securely dated seventh-century finds have yet been unearthed or published.

As has already been mentioned, the majority of the extant material was found in cemeteries (fig. 10). Therefore, the surviving samples elucidate the general repertoire of vessels used during burials as grave goods and during the memorials (i.e., *mnēmosyna*).

Spouted vessels, pseudobiberons, or rather lamp fillers, as well as examples of the entire repertoire of glass lamps have been found in large quantities at the *necropoleis* of Thessalonikē. These finds witness to the well-attested custom of letting a lamp burn over the grave for the first forty days after the burial and additionally on special occasions and fixed dates during the year.[31] Several graves were equipped with a special rectangular niche (*lucernarium*) where the lamp was placed.[32]

The presence of unguentaria and partly of larger, close-shaped tableware vessels (e.g., jugs, flasks, and bottles) is connected with the equally pagan and Christian custom of anointing the dead—equal to the extent that the fathers of the Christian church castigated it.[33] Also, the vessels must have held oil used in the symbolic act performed by the priest when he poured

[31] Koukoules, *Βυζαντινῶν βίος*, 4:208–14. For an early reference on the continuous burning of a lamp on a grave, see *Egeria's Travels*, 123–24, § 47.3.

[32] Markē, *Η νεκρόπολη*, 115–16, 208, where local examples are cited; Makropoulou, "Grave Finds," 5–6. For representations of burning lamps and candelabra in wall paintings from tombs in Thessalonikē, see Markē, *Η νεκρόπολη*, 167–68, figs. 113–15, plate 15β; 171, fig. 123, plate 17β.

[33] Koukoules, "Βυζαντινῶν νεκρικὰ ἔθιμα," 3–80, esp. 8–9, 13. All the information from this article with new thoughts on that matter can be found in English in Kyriakakis, "Byzantine Burial Customs," 37–72.

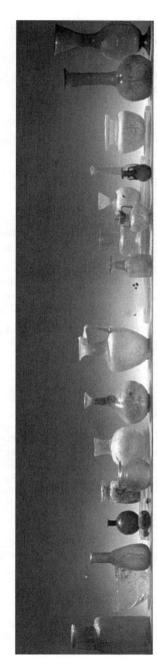

Fig. 10. Glass Vessels used as grave goods, third–fifth centuries. Museum of Byzantine Culture, Thessaloniki

it crosswise over the corpse at a funeral in order to show that the deceased lived and died in accordance with the sacred canons.[34] Additionally, this custom was connected with an attempt by the deceased's loved ones to render the frequently luxurious burial garments useless and thus to discourage the desecration of the grave.[35]

Tableware fragments, found in and around the graves or scattered around at the *necropoleis*, are connected with the memorial ceremonies and the meals (*makaries*) that Christians offered above the graves.[36] All aforementioned vessels, used for the burial or in the cemetery, were not supposed to be brought back to the deceased one's house, as they were not considered clean anymore.[37] This belief could partly explain the fact that vessels found in the graves are usually completely new, bearing no traces of use, even if they are sometimes found broken.[38] It seems that these vessels were bought to be placed in the graves. To some extent, this practice explains their often lower quality or evidence of a few faults, such as body deformations or poor balance, that might have excluded them from the normal market.

Also, one must keep in mind that such vessels had other uses, for example, in medicine or alchemy. Although these uses were once quite common, they are scarcely traced in archaeological finds. For evidence of such uses, we must rely on the scant and circumstantial finds supported by the information preserved in pictorial and written sources.

[34] Kallinikou, *Ὁ χριστιανικὸς ναός*, 560–61; Koukoules, "Βυζαντινῶν νεκρικὰ ἔθιμα," 43–44; Loucatos, "Λαογραφικαὶ," 47.

[35] Kyriakakis, "Byzantine Burial Customs," 51; Antonaras, "Early Christian Gold-Embroidered Silks," 45–47; idem, "Late Antique Gold-Embroidered Silks," 18–19.

[36] For that reason several wealthy graves, found in both necropoleis of Thessalonikē, had atop of their barrel-vaulted ceiling a flat surface, where memorial banquets could take place (Markē, *Ἡ νεκρόπολη*, 114, 209). For relevant finds from other Greek sites see Laskaris, *Monuments funéraires paléochrétiens*, 268. Memorial meals were well attested in Macedonia during the Roman period, possibly connected with the Italian colonists, in the form of *parentalia* and *Rosalia*, which also involved meals in the cemeteries (see Ascough, "A Question of Death," 513–14, with relevant references). For Thessalonian associations and their importance on burials and memorials, see Nigdelis, *Ἐπιγραφικά Θεσσαλονίκεια*, 101–211. For presentations of memorial banquets in Thessalonikē's tombs, see Markē, *Ἡ νεκρόπολη*, 140–41, figs. 74–75, plates 5β–γ. On representations of burial banquets on pagan altars, see Adam-Velenē, *Μακεδονικοί Βωμοί*, 86–91, where examples from Thessalonikē and ancient Macedonia in general are discussed in detail.

[37] Loucatos, "Λαογραφικαί," 75–79.

[38] For relevant archaeological evidence from Thessalonikē's necropoleis, see Makropoulou, "Ταφικά ευρήματα," 266–67; eadem, "Grave Finds and Burial Practices in Thessaloniki (fourth–fifteenth century)."

In conclusion, we should note that glass vessels covered just a small part of the uses and needs that were mainly served by clay vessels. Glass was utilized by the wealthier social strata or, in special instances, by multiple lower-strata users who ordinarily met their needs with clay and wooden vessels. Applying our limited knowledge about the price of glass in the beginning of the fourth century,[39] we can calculate that a glass bottle would cost ten times the price of a similar ceramic vessel, around five to ten denarii, equal to the price of a worker's meal or one-fifth to one-third of his daily wages.[40] Glass vessels, or at least the plain ones, were sold by the pound, just like glass tesserae and window panes. Thus, the workmanship of the glass-worker offered no added value to the product.[41]

Also, it is quite easy to conclude that glass was favored for some uses like unguentaria and medicine receptacles. In contrast, they were only exceptionally used as storage vessels or as vessels for long-distance trade. Finally, in the case of tableware, glass, clay, and metal vessels were used side-by-side in banquets or were interchanged according to what was socially dictated or requested for every instance.

B. Window Panes

Use of glass window panes is well attested from the first century C.E.[42] In Thessalonikē, though, unlike other Macedonian sites like Philippi,[43] few finds of this kind are published (fig. 11). These finds date to around the fourth century.[44] Due to the small size of the preserved fragments, their manufacturing technique is difficult to determine. Nevertheless, it is

[39] On Diocletian's edict of 301 C.E., see Giacchero, *Edictum Diocletiani*. On prices of glass objects, see Barag, "Recent Important Epigraphic Discoveries," 113–16; and Stern, "Roman Glassblowing," 466.

[40] The average bottle or jug widely used in Late Antique Thessalonikē weighs ca. 80–150 g. So if a pound (327.45 g) costs twenty or thirty denarii, depending on the quality of glass, a vessel of that kind would cost five to ten denarii.

[41] Barag, "Recent Important Epigraphic Discoveries," 113–16; Stern, "Roman Glassblowing," 466.

[42] For the latest and most up-to-date information about glass window panes in the Mediterranean world, see discussions in *De Transparentes speculations*, 15–52.

[43] Pelekanidis, "Ἡ ἔξω τῶν τειχῶν," 114–79; repr., idem, *Studien zur Frühchristlichen*, 360–61, fig. 19; Kourkoutidou-Nikolaidou, "Vitraux paléochrétiens à Philippes," 277–96; Antonaras, "Early Christian Glass Finds," 49–51, fig. 2.

[44] Romiopoulou, "Νοσοκομείο ΑΧΕΠΑ," 241–42, plate 194a, where considerable quantities of window glass were found in the debris of a third-century bath house, possibly part of a Roman villa. Similar material, still unpublished, has been unearthed in the Roman villa under Galerius's palace, dated to the second half of the third century. I express my thanks to the excavator of the site, Mrs. Marianna Karaberi, for sharing this information with me.

Fig. 11. Window Panes from Museum Basilica, Philippi, sixth century. Museum of Byzantine Culture, Thessaloniki.

quite certain that muff-process or cylinder's technique prevailed, as no fragments are found with the characteristics of the bull's-eye technique or of production in a mold. Besides, in Late Antiquity the muff-process was almost exclusively used to make windowpanes. Before closing this chapter, I should stress that the paucity of finds does not reflect the extent of the use of glass window panes because recycling was commonplace at the time. As is only logical — but also supported by archaeological finds — broken window panes were meticulously collected after the abandonment or the ruining of a building. The fragments were re-melted, as their mass equaled that of several costly glass vessels.

C. Jewelry

Glass was used early as a substitute for colorful semiprecious stones in ancient Mesopotamia and pharaonic Egypt and may have even been invented for this purpose. During the early imperial period, fancy, colorful gems were created, developing the Hellenistic tradition of the originally colorless gems and representing objets d'art per se. Buyers in Late Antiquity would not pay the same prices for glass jewelry as for the crafted gems' natural prototypes, as consumers were well aware of the relatively cheap and easy methods that the production of glass jewelry involved. Thus, products had to be cheap. Plain artifacts were created often as inexpensive and massively produced substitutes and handy solutions of adornment addressed to the wider, less wealthy social strata.

The greatest portion of jewelry finds from Thessalonikē can be dated to the late third to sixth centuries (figs. 12–13).[45] It appears that Thessalonians, just like other eastern Mediterranean peoples, used larger beads and pendants as central pieces for necklaces. Pendants were looped and dark colored with trails or specks in contrasting colors. At least three to four variants of these pendants exist: jar pendants,[46] sometimes in an elongated[47] or simplified version;[48] juglet pendants;[49] and the popular disk pendants with stamped

[45] Makropoulou, "Κοσμήματα," 56–69; idem, "Παλαιοχριστιανικά κοσμήματα," 61–62.

[46] Spaer, *Ancient Glass*, 177 nn. 332–38; Makropoulou, "Κοσμήματα," 64, plate 2, end of third to early fourth century.

[47] Bead no. BYM 21/12, in the permanent exhibition of the Museum of Byzantine Culture, Thessalonikē.

[48] Spaer, *Ancient Glass*, 185 nn. 409–13, late fourth to sixth centuries.

[49] Bead no. BYM 21/6, in the permanent exhibition of the Museum of Byzantine Culture, dated to the fourth to early fifth century.

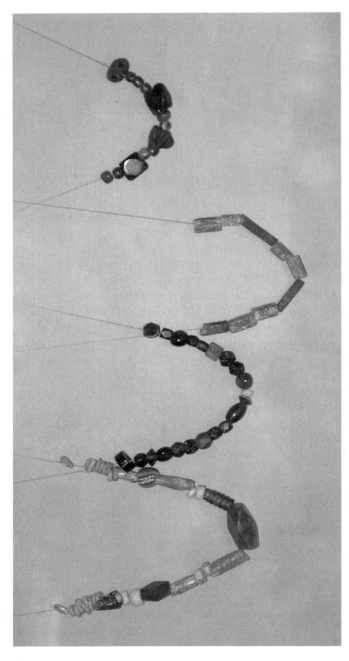

Fig. 12. Glass Jewelry, third–fourth centuries. Museum of Byzantine Culture, Thessaloniki.

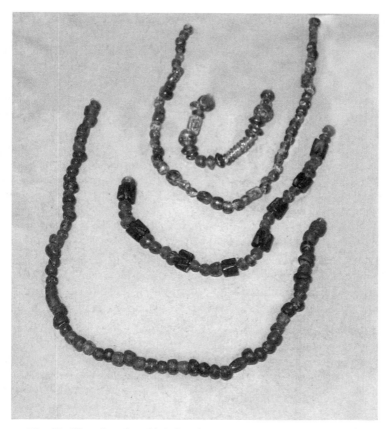

Fig. 13. Glass Jewelry, third–fourth century. Museum of Byzantine Culture, Thessaloniki.

motifs.[50] Also, pendants in the form of simplified glass droplets occur.[51] Large-sized beads are also found frequently. Most were probably used as central pieces or pendants and are characterized by their biconical or globular shape

[50] Nalpantis, *Ανασκαφή στο οικόπεδο*, 63, fig. 32, ca. mid-fourth-century flat, looped discs with impressed motifs on the one side. No Christian or Jewish motif survives in Thessalonikē, only a lion beneath a crescent and the sun or *sol/luna*, which is the most popular motif on these pendants. The lion represents the celestial protective power while the *sol/luna* motif over its head, which was used throughout the Byzantine period, denotes that God was the ruler of time. For analogous finds, see also Philippe, *Le monde Byzantine*, 37–38; and Spaer, *Ancient Glass*, 179–84, plates 29–30.

[51] These are later, degenerated, and simplified versions of earlier, more elaborate beads in the form of glass droplets dated in the late fourth, fifth and sixth centuries (see Spaer, *Ancient Glass*, 185 nn. 414–22).

and a dark-colored body usually decorated with white trails[52] or specks.[53] Also, sometimes large-sized beads are long and cylindrical, occasionally even looped,[54] segmented, and patterned by the segmenting mold, gilded,[55] or just plain, long, smooth, or spirally-ribbed pieces. Ribbed spacers—roughly circular plano-convex objects with two parallel perforations, an apparently North Balkan or Central European import—present glass imitations of jet prototypes.[56] Bright but simple glass beads in striking colors were occasionally used in earrings as stone substitutes.[57]

All methods of bead forming known from other sites are also present among finds from Thessalonikē (e.g., winding, folding, molding, segmentation, drawing, etc.). Generally, these finds indicate their obvious connections with eastern Mediterranean production centers. Beads of the following shapes appear: smooth and ribbed (melon-like) globular,[58] ovoid, pear-shaped shapes;[59] smooth, ribbed, and patterned cylindrical, cubical, hexahedron-like,[60] hexagonal, and multifaceted[61] shapes.

Often, necklaces consist of a few beads, eight to fifteen, probably arranged immovably in predefined distances on the string. Also, beads are used in great numbers, combined with a few stones—bone or amber ones—to achieve especially tasteful creations. In some cases almost the entire

[52] Ibid., 102, fig. 47; 113 nn. 170–72.

[53] Ibid., 127, 129, third to fifth centuries.

[54] Ibid., 103, 113 nn. 173–74. On the grave's dating, see Nalpantis, *Ανασκαφή*, 63, ca. mid-fourth century. Rod-formed, wound, looped bead, inspired by the looped pendants, all of which were imitations of precious, metal amulets, like the golden one from Thessalonikē. See *Θεσσαλονίκη*, 49, fig. 10:9; 50, no. 10:9.

[55] Spaer, *Ancient Glass*, 132–33 nn. 237–38. See an identical example from Romano-Byzantine necropolis at Castra, see ibid., 132, fig. 58, second row from bottom. These long, cylindrical beads, segmented and patterned by the segmenting mold, ended in collars, with granular pattern on their body, imitating granulation of their metal prototypes.

[56] Ibid., 66, 76 nn. 56, 57, fourth century, possible eastern European or Pannonian product.

[57] For examples dated from the third to seventh centuries, see Ross, *Jewelry, Enamels, and Art*, 138, no. 179P, plate 99; Kypraiou, *Greek Jewelry*, 156, no. 157; Papanikola-Bakirtzi, *Everyday Life in Byzantium*, 424 nn. 542, 558, no. 768.

[58] An interesting multicolored bead decorated with drawn-trailing, made possibly in the first century was used later in a composite necklace. For parallels, see Spaer, *Ancient Glass*, 108, 117 nn. 198–99.

[59] Folded, pear-shaped or cylindrical beads, similar in technique, but not in colors, with Egyptian "date" beads, of the second century (see ibid., 11 nn. 160a–c).

[60] Beads nos. BYM 10/6 and BYM 21/8 in the permanent exhibition of the Museum of Byzantine Culture, Thessalonikē.

[61] Nalpantis, *Ανασκαφή*, 133, plate 45, dated to the first quarter of the third century; also, Spaer, *Ancient Glass*, 74 nn. 48–49.

necklace consists of small, identical beads, interrupted by a few larger, more elaborate ones. In other cases almost every bead is unique, both in size and color, forming a dazzling product.[62]

Bracelets

Glass bangles of the earlier *La Tène* period do not occur in Thessalonikē or ancient Macedonia in general.[63] They appear for the first time around the third century C.E. and are of dark-colored glass usually called "black," although the color is in fact purple or dark green, only appearing black due to the thickness.[64] They appear in circular, semicircular, and flat, band-like cross-sections. They were made by two techniques: There are seamed examples, made from drawn out canes of glass, and seamless ones, made with the perforation and centrifugal rotation of a hot mass of glass.[65] The majority are plain, while a few examples bear pressed, geometrical decorations in the form of oblique ribbing. They were usually quite wide, ca. 6–7 cm, but whether they were worn around wrists or at the upper part of the arm is not attested archaeologically. They had been substitutes for more expensive jewelry, most probably imitating jet prototypes, which were in fashion during the fourth century.[66]

Glass rings

Early imperial glass rings known in the western part of the empire are not present in Thessalonikē.[67] In Late Antique sites of central Macedonia, a couple of glass rings were unearthed, supporting the supposition that they must have been sold in Thessalonikē's market as well. What do occur in Thessalonikē are glass gems, used in many cases as substitutes for semiprecious stones in

[62] For color photos of necklaces, see Antonaras, *2003–Glass*, illustrations of forty-eighth to fiftieth weeks.

[63] Haevernick, *Die Glasarmringe*. Venclová, *Prehistoric Glass in Bohemia*, 142–45. Spaer, *Ancient Glass,* 193, 198.

[64] *Θεσσαλονίκη*, 123, 132, photo 133. Kypraiou, *Greek Jewelry*, 150, no. 149. Makropoulou, "Κοσμήματα," 65, plate 3, examples dated to the second half of the fourth century.

[65] Spaer, *Ancient Glass*, 193. Antonaras, "Use of Glass," 331–34. Especially for later examples, see Antonaras, "Υάλινα μεσοβυζαντινά βραχιόλια," 423–34.

[66] Nalpantis, *Ανασκαφή*, 35, 133, fig. 10, plate 45, jet bracelet from a grave dating from the first half of the fourth century.

[67] Stern, *Roman, Byzantine and Early Medieval Glass*, 371 no. 204, with exhaustive bibliography.

rings, both in cheaper creations[68] and in elaborate golden examples as well.[69] Of course it should be kept in mind that the same gems were also used for the embellishment of other minor luxury objects.

In Late Antiquity, unlike the early imperial period, glass ring gems usually are plain with no intaglios or other decoration except for their vivid color. They are small, lenticular, or plano-convex pieces, occasionally in the shape of a pyramid, sometimes found in graves with no metal remains of their original setting. They are identical to the ancient Greek and early Roman gaming pieces, which are not found in Late Antique graves or strata.

Some larger, elongated pieces found in several sites at the vicinity of Thessalonikē, testify to the use of *hyelia* for the decoration of larger metal objects, furniture, book binding, or other luxury-type objects.

Enamel

Another form in which glass was used in Late Antique Thessalonikē is enamel. This technique, already fully developed in classical antiquity,[70] has been sporadically traced among our finds. For example, we can find enamels among early third-century jewelry in the form of micromosaics[71] and later as a single layer of glass that covered a greater area, as on golden earrings with emerald-green inlays.[72]

Our jewelry finds come almost exclusively from graves, as they were well-looked-after valuables in people's everyday lives. A few of the excavated graves, however, have yielded some jewelry. This rather small number of finds might be connected to a pragmatic approach by the family of the deceased—that something valuable should not be buried in the ground and be lost for future generations. This paucity of jewelry finds could also be connected with Christian beliefs. Generally speaking, it appears that Christian folk indeed respected and followed patristic regulations about burying their beloved ones without special adornments rather than burying them in luxurious vestments.[73]

[68] Papanikola-Bakirtzi, *Everyday Life,* 425, no. 544, a seventh-century copper alloy example.

[69] Nalpantis, *Ανασκαφή*, 34, plate 46, BKo 215/2, double, golden ring with green glass gem, from the first half of the fourth century. Also, Makropoulou, "Κοσμήματα," plate 4.

[70] Mikou-Karachaliou, *Greek Jewelry,* 28–29, 65, fig. 11; 74, fig. 26.

[71] Copper alloy brooches covered with enameling, nos. BKo 87/15 and BKo 244/214, in the permanent exhibition of the Museum of Byzantine Culture, Thessaloniki.

[72] Golden earrings, no. BKo 214/5, in the permanent exhibition of the Museum of Byzantine Culture, Thessaloniki.

[73] Patristic texts focus mainly on the use of luxurious vestments and placing of money

In conclusion, in Thessalonikē's glass jewelry we recognize imports and prototypes deriving from the Levantine coast, which is something natural and already noted in glass vessels. We see quite clearly a different aesthetical approach among Thessalonians: a tendency towards polychromy with the use of several different, smaller beads, sometimes in large numbers, which was not so usual in the East and could be connected to local or western traditions. We may assume that our finds were mainly local products, as it was easy to produce glass beads and bracelets in simple, open kilns or even braziers, and/or as sidelines of the glass workshops, which were active in the city at that period. We also see connections with the northern and central parts of the Balkans.

D. Mosaics

Glass was also used in Late Antique Thessalonikē in the form of tiny tesserae, which were used to form mural mosaics. Wide use of wall mosaics, as attested in Thessalonikē's early Christian churches, demanded huge amounts of glass. Today, mosaics survive on the walls of the Rotunda, Acheiropoietos, St. Demetrios, and the Latomou monastery. An average tessera weighs ca. 1–1.5 gm and covers 0.7–0.9 sq. cm. If we add the seam around each one of them, we see that they covered ca. 1 sq cm with ca. 1.2 gm of glass. So, for every square meter of mosaic, approximately 12 kgs of glass were needed. The Rotunda's wall mosaics originally would have covered ca. 1414 sq m. If we multiply this figure by twelve, then we see that for Rotunda's decoration alone some seventeen tons of tesserae were needed out of which roughly thirteen tons would have been made out of glass. Tesserae were often cut on-site from large glass cakes.[74] It is not known whether such cakes were formed in the city or imported from elsewhere. In the case of Thessalonikē, *musivarii* were probably working with cakes made with imported raw glass, which possibly were locally shaped. Supporting this hypothesis is the fact that the shaping of the cakes is a simple process, which did not require any special technical skills. In contrast, the work of coloring is difficult; it needs to be done skillfully and in great quantities in order to produce homogeneous coloring in large enough batches to cover entire commissions.[75] The only

in the graves (John Chrysostom, *PG* 55.231, 59.465, 50.582, 55.231). No clear reference to jewelry was traced, possibly because they were not placed in graves anyway. See Loucatos, "Λαογραφικαί," 75–77.

[74] For similar finds from Philippi, see Antonaras, "Early Christian Glass Finds," 54–55, fig. 9.

[75] James, "Byzantine Glass Mosaic Tesserae," 29–47, esp. 39.

possible exception might be presented by the gold-glass tesserae, which required a certain degree of specialization in their production and might be products of specialized workshops. Such gold-glass tesserae certainly arrived on site either in cakes, or, less probably, in tiny, already-cut cubes.

CONCLUSION

As far as glassmaking and glass products in Late Antiquity are concerned, Thessalonikē presents a quite common case, which is not distinguished at all from other contemporary, major Mediterranean urban centers. Glass was used in Thessalonikē by builders for glazing windows and for decorating the walls of public buildings. Glass was also frequently used in the form of lamps to light the interiors of both public and private spaces. Thessalonians of almost all social strata used glass articles to adorn themselves or their possessions. But most of all, glass in the form of vessels found its place in their households: on the table, not only to pour and to drink, but also to transport and to preserve holy substances, medicaments, cosmetics, and ointments.

Glass, in one or another form, was used by increasingly greater segments of Thessalonikē's society, as its price was quite low and local workshops were active, covering partly the needs of the local market. In Late Antiquity, glass products reached a degree of distribution which was not surpassed until the advent of the eighteenth-century Industrial Revolution or the cataclysmic social and economic changes in the lifestyle of southeastern Europe in the first half of the twentieth century.

To conclude this overview, the most tantalizing fact, at least for archaeologists, should be emphasized. We must be aware that the exact dimensions of the use of glass will never be revealed, as the vast majority of the evidence is lost forever. These were recycled in the form of cheap glass shards, easy to obtain and to melt, which found new life within glassmakers' voracious melting pots.

BIBLIOGRAPHY

Adam-Velenē, Polyxenē. *Μακεδονικοί Βωμοί* (Macedonian Altars). Athens: Tameio Archaiologikōn Porōn kai Apallotriōseōn, Dieuthynsē Dēmosieumatōn, 2002.

Antonaras, Anastassios. "Glass Lamps of the Roman and Early Christian Periods: Evidence from the Thessaloniki Area." In *2nd International Study Congress on Antique Lighting, Zalau, Clui-Napoca, 13–18 May 2006*. International Lynchnological Association, forthcoming.

————. "Glass Vessels from Roman and Early-Christian Thessalonikē and its Surroundings (first century B.C.–sixth century A.D.)." In *Annales du 17ème congrès de l'association international pour l'histoire du verre, Antwerp, 2009*. Edited by Koen Janssens, Patrick Degryse, Peter Cosyns, Joost Caen and Luc Van't Dack. Antwerp: Association International pour l'Histoire du Verre, forthcoming.

————. "Υαλοποιία και υαλουργία στο ρωμαϊκό και παλαιοχριστιανικό κόσμο. Υαλουργική δραστηριότητα στη Θεσσαλονίκη" (Glass-Making and Glass-Working in the Roman and Early Christian World: Glass-Working Activity in Thessalonikē). *ArchDelt*, forthcoming.

————. "Υάλινα και κεραμικά αγγεία 3ου–7ου αι. μ.Χ Δύο όψεις του ίδιου(;) νομίσματος" (Glass and Ceramic Vessels of the Third–Seventh Centuries A.D.: Two Faces of the Same[?] Coin). In *Επιστημονική Συνάντηση Η Κεραμική της Ύστερης Αρχαιότητας στον Ελλαδικό Χώρο (3ος-7ος αι.)* (Scientific Meeting Late Antique Pottery in the Area of Greece [3d–7th C.E.]), *12–16 November 2006*. Edited by Stella Drougou and Demetra Papanikola-Bakirtzi. Thessalonikē: Aristotle University of Thessaloniki and Archaeological Institute of Macedonia and Thrace, forthcoming.

————. *Ρωμαϊκή και παλαιοχριστιανική υαλουργία. 1ος–6ος αι. Παραγωγή και προϊόντα. Τα αγγεία από τη Θεσσαλονίκη και την περιοχή της* (Roman and Early Christian Glassworking. 1st–6th C.E. Production and Products. Vessels from Thessalonikē and its Surroundings). Athens: I. Sideris, 2009.

————. "Early Christian Glass Finds from the Museum's Basilica, Philippi." *JGS* 49 (2007) 47–56.

————. "Υάλινα μεσοβυζαντινά βραχιόλια. Συμβολή σε θέματα διάδοσης, παραγωγής, τυπολογίας και χρήσης" (Middle Byzantine Glass Bracelets. Contribution to Issues of Distribution, Production, Typology and Use). *ArchDelt* 27 (2006) 423–34.

————. "Ενδείξεις δραστηριότητας εργαστηρίων υαλουργίας στη Θεσσαλονίκη" (Indications of Glass-Working Activity in Thessalonikē). Pages 247–53 in *2o Διεθνές Συνέδριο Αρχαία Ελληνική Τεχνολογία, Αθήνα, 17–21 October 2005*. Athens: TEE, 2006.

————. "New Glass Finds with Base Marks from Thessaloniki." Pages 2:413–20 in *Corpus des signatures et marques sur verres antiques*. 2 vols. Edited by Danielle Foy and Marie-Dominique Nenna. Aix-en-Provence-Lyon: Association française de l'archéologie du verre, 2006.

————. "The Use of Glass in Byzantine Jewelry: The Evidence from Northern Greece." Pages 331–34 in *Annales du 16ᵉ congrès de l'association international pour l'histoire du verre*. London: AIHV, 2005.

Antonaras, Anastassios. "Late Antique Gold-Embroidered Silks: New Finds from Thessalonikē." Pages 18–19 in *8th Annual Meeting of European Association of Archaeologists, 24–29 September 2002, Thessalonikē, Hellas, Abstract Book*. Thessaloniki: European Association of Archaeologists, 2002.

_____. *2003–Glass: From the Collections of the Museum of Byzantine Culture, Calendar-Album of the Museum of Byzantine Culture*. Thessaloniki: Association of the Friends of the Museum of Byzantine Culture, 2002.

_____. "Early Christian Gold-Embroidered Silks from Thessalonikē." *MBC* 8 (2001) 45–47.

Auth, Susan Handler. "Drink May You Live! Roman Motto Glasses in the Context of Roman Life and Death." Pages 103–12 in *Annales du 13ème congrès de l'association international pour l'histoire du verre*. Amsterdam: AIHV, 1996.

Barag, Dan. "Recent Important Epigraphic Discoveries Related to the History of Glassmaking in the Roman World." Pages 109–16 in *Annales du 10ème congrès de l'association international pour l'histoire du verre*. Amsterdam/Lochem: AIHV, 1985.

_____. *Glass Vessels of the Roman and Byzantine Periods in Palestine*. Ph.D. diss., Hebrew University, Jerusalem, 1970. [in Hebrew]

Cabrol, Fernard and Henri Leclerq. "Pie zeses." Columns 1023–31 in *Dictionnaire d'archéologie chrétienne et de liturgie* 14. Paris: Letouzey et Ané, 1939.

Daffa-Nikonanou, Alexandra. "Δύο επείσακτα αγγεία από τον τάφο της Νεάπολης Θεσσαλονίκης" (Two Imported Vessels from the Grave of Neapolis, Thessalonikē). Pages 263–76 in *Αμητός, Τιμητικός τόμος για τον καθηγητή Μανώλη Ανδρόνικο 1*. (Amētos, Honorary Volume for Professor Manolis Andronikos). Thessaloniki: Aristoteleio Panepistēmio Thessalonikēs, 1986.

Egeria. *Egeria's Travels*. Translated by John Wilkinson. London: S.P.C.K., 1971.

Feissel, Denis. *Recueil des inscriptions chrétiennes de Macédoine du IIIᵉ au VIᵉ siècle*. BCHsupp. 8. Athens: École française d'Athènes, 1983.

Foy, Danielle, ed. *De transparentes speculations. Vitres de l'antiquité et du Haut Moyen age (Occident-Orient). Exposition temporaire en liaison avec les 20ème rencontres de l'association française de l'archéologie du verre, sur le thème du verre plat, Bavay, 1 octobre 2005/31 décembre 2005*. Bavay-Bagacum: Musée/site d'archéologie de Bavay, 2005.

Fremersdorf, Fritz. *Antikes, islamisches und mittelalterliches Glas, sowie kleinere Arbeiten aus Stein, Gagat und verwandten Stoffen in den vatikanischen Sammlungen Roms. (Museo Sacro, Museo Profano, Museo Egizio, Antiquarium Romanum)*. Vatican City: Biblioteca Apostolica Vaticana, 1975.

_____. *Die Römischen Gläser mit Schliff, Bemalung und Goldauflagen aus Köln*. 2 vols. Die Denkmäler des römischen Köln 8. Cologne: Löwe, 1967.

Giacchero, Marta, ed. *Edictum Diocletiani et Collegarum de pretiis Rerum Venalium in integrum fere restitutum e Latinis Graecisque Fragmentis*. Genoa: Istituto di storia antica & scienze ausiliarie, 1974–.

Grose, David Frederick. *Early Ancient Glass: Core-Formed, Rod-Formed, and Cast Vessels and Objects from the Late Bronze Age to the Early Roman Empire, 1600 B.C. to A.D. 50*. New York: Hudson Hills, 1989.

Haevernick, Thea Elisabeth. *Die Glasarmringe und Ringperlen der Mittel- und Spätlateinezeit auf dem Europäischen Festland*. Bonn: Römisch-Germanische Kommission des Deutschen Archäologischen Instituts zu Frankfurt a.M., 1960.

Iliffe, J. H. "A Tomb at El Bassa c. A.D. 396." *QDAP* 3 (1933) 81–91.

Isings, Clasina. *Roman Glass from Dated Finds*. Groningen: J. B. Wolters, 1957.

Israeli, Yael. "What Did Jerusalem's First-Century B.C.E. Glass Workshop Produce?" Pages 54–58 in *Annales du 16ᵉ congrès de l'association international pour l'histoire du verre*. London: AIHV, 2005.

———. "The Invention of Blowing." Pages 46–55 in *Roman Glass: Two Centuries of Art and Invention*. Edited by Martin Newby and Kenneth Painter. London: The Society of Antiquaries of London, 1991.

James, Liz. "Byzantine Glass Mosaic Tesserae: Some Material Considerations." *BMGS* 30 (2006) 29–47.

Kallinikou, Protopresvyterou Konstantinou. *Ὁ χριστιανικὸς ναὸς καὶ τὰ τελούμενα ἐν αὐτῷ* (The Christian Church and What Takes Place There). 4th ed. Athens: Gregori, 1969.

Kitzinger, Ernst. "A Marble Relief of the Theodosian Period." *DOP* 14 (1960) 17–42.

Koukoules, Phaedon. *Βυζαντινῶν βίος καὶ πολιτισμός* (The Life and Culture of the Byzantines). 6 vols. Collection de l'Institute français d'Athènes 10–13, 43, 73, 76, 90. Athens: Ekdoseis tou Gallikou Institoutou Athenōn, 1951.

———. "Βυζαντινῶν νεκρικὰ ἔθιμα" (The Burial Customs of the Byzantines). *EHBS* 16 (1940) 3–80.

Kourkoutidou-Nikolaidou, Eutuchia. "Vitraux paléochrétiens à Philippes." *Corsi di cultura sull'arte ravennate e bizantina* 31 (1984) 277–96.

Kypraiou, Evangelia, ed. *Greek Jewelry. 6000 years of Tradition. Thessalonikē, Villa Bianca 21 December 1997–21 February 1998*. Translated by David Hardy and Alex Doumas. Athens: TAPA, 1997.

Kyriakakis, James. "Byzantine Burial Customs: Care for the Deceased from Death to the Prothesis." *The Greek Orthodox Theological Review* 19 (1974) 37–72.

Laskaris, Nikolaos G. *Monuments funéraires paléochrétiens (et byzantins) de Grèce*. Athens: Éditions Historiques Stèfanos D. Vasilopoulos, 2000.

Loeschcke, Siegfried and Heinrich Willers. *Beschreibung römischer Altertümer gesammelt von Carl-Anton Niessen*. 2 vols. Cologne: Von Greven und Bechtold, 1911.

Loucatos, Demetrios. "Λαογραφικαὶ περὶ τελευτῆς ἐνδείξεις παρὰ Ἰωάννη τῷ Χρυσοστόμῳ" (Folkloric Indications on Death by John Chrysostom). *Epeteris tou laographikou archeiou* 2 (1940) 30–117.

Makropoulou, Despoina. "Grave Finds and Burial Practices in Thessaloniki (fourth–fifteenth century)." Communication given at the 21st International Congress of Byzantine Studies, London, 21–26 August 2006. Online: http://www.byzantinecongress.org.uk/paper/II/II.4_Makropoulou.pdf.

———. "Παλαιοχριστιανικά κοσμήματα από τη Θεσσαλονίκη" (Early Christian Jewelry from Thessalonikē). Pages 61–62 in *23ο Συμπόσιο Βυζαντινής και Μεταβυζαντινής Αρχαιολογίας και Τέχνης της Χριστιανικής Αρχαιολογικής Εταιρείας, Πρόγραμμα περιλήψεων εισηγήσεων και ανακοινώσεων* (23rd Byzantine and Post-Byzantine Archaeology and Art Symposium of the Christian Archaeological Society). Athens: Christianikē Archaiologikē Etaireia, 2003.

Makropoulou, Despoina. "Ταφικά ευρήματα, νομίσματα και νομισματικοί θησαυροί στα παλαιοχριστιανικά κοιμητήρια της Θεσσαλονίκης" (Burial Finds, Coins, and Coin Hoards of the Early Christian Cemeteries of Thessalonikē). Pages 263–72 in *Αφιέρωμα στη μνήμη του Σωτήρη Κίσσα* (Dedication in Memory of Sōtērēs Kissas). Edited by Anastasia Kalamartzi-Katsarou and Sapho Tampaki. Thessaloniki: Hellēnikē Hetaireia Slavikōn Meletōn/University Studio Press, 2001.

————. "Κοσμήματα από τον 3ο έως τον 6ο αι. μ.Χ. από ανασκαφές της Θεσσαλονίκης. Συμβολή στη μελέτη της παλαιοχριστιανικής αργυροχρυσοχοΐας" (Jewelry from the Third to the Sixth Century A.D., from Excavations in Thessalonikē. Contribution to the Study of Early Christian Silver and Goldsmithery). *ΘΠ* 3 (1997) 56–69.

Markē, Euterpē. *Η νεκρόπολη της Θεσσαλονίκης στους υστερορωμαϊκούς και παλαιοχριστιανικούς χρόνους (μέσα του 3ου έως μέσα του 8ου αι. μ.Χ.)* (The Necropolis of Thessalonikē during the Late Roman and Early Christian Period [mid 3rd – mid 8th century]). Dēmosieumata tou Archaiologikou deltiou 95. Athens: Hellenic Ministry of Culture; Archaeological Receipts Fund, 2006.

Mikou-Karachaliou, Kate, ed. *Greek Jewelry, Five Thousand Years of Tradition*. Athens: ELKA Ltd., 1995.

Nalpantis, Demetrios. *Ανασκαφή στο οικόπεδο του Μουσείου Βυζαντινού Πολιτισμού στη Θεσσαλονίκη* (The Cemetery on the Grounds of the Museum of Byzantine Culture in Thessaloniki). Athens: Tameio Archaiologikōn Porōn kai Apallotriōseōn, Dieuthynsē Dēmosieumatōn, 2003.

Nigdelis, Pantelis Meletiou. *Επιγραφικά Θεσσαλονίκεια. Συμβολή στην πολιτική και κοινωνική ιστορία της αρχαίας Θεσσαλονίκης* (Epigraphica Thessalonicensia. Contribution to the Political and Social History of Ancient Thessalonikē). Thessaloniki: University Studio Press, 2006.

Oppenheim, A. Leo, Robert H. Brill, Dan Barag, and Axel von Saldern. *Glass and Glassmaking in Ancient Mesopotamia*. Corning, N.Y.: The Corning Museum of Glass Monographs 3, 1970.

Pallas, Demetrios. *Les monuments paléochrétiens de Grèce découverts de 1959 à 1973*. Vatican City: Pontifico Istituto di Archeologia Cristiana, 1977.

Paolucci, Fabrizio. *L'arte del vetro inciso a Roma nel IV secolo D.C.* Firenze: All'Insegna del Giglio, 2002.

————. *I vetri incisi dall'Italia settentrionale e dalla Rezia nel periodo Medio e Tardo Imperiale*. Florence: All'Insegna del Giglio, 1997.

Papanikola-Bakirtzi, Demetra, ed. *Everyday Life in Byzantium, Exhibition Catalogue, Thessalonikē, White Tower, October 2001–January 2002*. Athens: Ministry of Culture, 2002. [in Greek]

Pelekanidis, Stylianos. "Ἡ ἔξω τῶν τειχῶν παλαιοχριστιανική βασιλική τῶν Φιλίππων" (The Extra Muros, Early Christian Basilica of Philippi). *ArchEph* 1955 (1961) 114–79. Repr., pages 333–95 in *Studien zur frühchristlichen und byzantinischen Archäologie*. Thessaloniki: Institute for Balkan Studies, 1977.

Petsas, Fōtios. "Ανασκαφή πανεπιστημιουπόλεως Θεσσαλονίκης" (Excavation of the University Campus of Thessaloniki). *ArchDelt* 22 B′ 2, *Chronika* (1967) 391–93.

Philippe, Joseph. *Le monde Byzantine dans l'histoire de la verrerie (Vᵉ-XIVᵉ siècle)*. Bologna: Patron, 1970.

Romiopoulou, Aikaterine. "Νοσοκομείο ΑΧΕΠΑ" (AXEPA Hospital). *ArchDelt* 31 (1976) 241–42.

Ross, Marvin C. *Jewelry, Enamels, and Art of Migration Period*. Vol. 2 of *Catalogue of the Byzantine and Early Mediaeval Antiquities in the Dumbarton Oaks Collection*. Washington, D.C.: The Dumbarton Oaks Research Library and Collection, 1965.

Ružić, Mira. *Rimsko staklo u Srbiji*. Belgrade: Centar za Arheološka Isrtaživanja, 1994.

Saguì, Lucia. "Un piatto di vetro inciso da Roma: contributo ad un inquadramento delle officine vetrarie tardoantiche." Pages 337–58 in *Studi in memoria di Lucia Guerrini*. Edited by Maria Grazia Picozzi and Filippo Carinci. Studi Miscellanei 30. Rome: L'Erma, 1996.

Schäfer, Ernst. "Die Heilige mit dem Kreuz in altchristliche Kunst." *Römische Quartalschrift für christliche Altertumskunde und für Kirchengeschichte* 44 (1936) 67–104.

Spaer, Maud. *Ancient Glass in the Israel Museum, Beads and Other Small Objects*. Jerusalem: The Israel Museum, 2001.

Stern, Eva Marianne. *Roman, Byzantine and Early Medieval Glass; 10 B.C.E.–700 C.E.; Ernesto Wolf Collection*. Ostfildern, Germany: Hatje, 2001.

———. "Roman Glassblowing in a Cultural Context." *AJA* 103 (1999) 441–84.

——— and Birgit Schlick-Nolte. *Early Glass of the Ancient World, 1600 B.C.–A.D. 50*. Ernesto Wolf Collection. Ostfildern, Germany: Hatje, 1994.

Trowbridge, Mary Luella. *Philological Studies in Ancient Glass*. University of Illinois Studies in Language and Literature 13. Urbana, Ill.: University of Illinois, 1930.

Venclová, Natalie. *Prehistoric Glass in Bohemia*. Prague: The Archaeological Institute of the Czechoslovak Academy of Sciences, 1990.

Whitehouse, David. *Roman Glass in the Corning Museum of Glass*. 3 vols. Corning, N.Y.: Corning Museum of Glass, 1997.

Reflections on the Architectural History of the Tetrarchic Palace Complex at Thessalonikē*

Aristoteles Mentzos

The monumental palace complex of the Tetrarchic period evolved at the southeastern end of the city of Thessalonikē. The area was annexed to the city in the third quarter of the third century C.E., on the occasion of the construction of a new wall enclosure. It was divided into two unequal parts, northern and southern, by the main thoroughfare of the city, the Mese or Leophoros, as it was called by the Byzantines (fig. 1).

The earliest identifications of buildings as belonging to the Tetrarchic palace appeared in the early 1950s. At that time Greek archaeologists fought a futile battle against the interests of city developers, as they tried to preserve parts of the ancient city that came occasionally to light during building projects in the 1960s and 1970s. As a consequence, ancient remains were rarely excavated systematically; investigation reports are limited, if not missing altogether. Sometimes finds are described briefly, and a comprehensive presentation of the complex was never attempted. Fortunately, the situation has changed in the last decades, when several published works on the subject appeared.[1]

* I would like to express my thanks to Mariana Karamberi, Fani Athanasiou, and Dr. D. Christodoulou; I owe special thanks to Giannis Kiagias for the drawing of fig. 9.

[1] Mayer, *Rom*; Christodoulou, *Αυτοκρατορικά συγκροτήματα*. From 1994 on, several papers have been published by the archaeologists working on the site, as well as by the team of architects entrusted with the documentation and restoration of the complex; they have appeared in the annual *AEMΘ*, the acts of the annual meetings of archaeologists from Macedonia and Thrace.

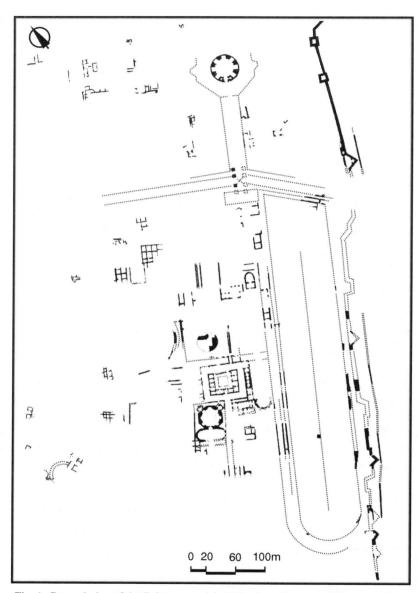

Fig. 1. General plan of the Palace area. After Massimo Vitti, as published by Thea
Stefanidou-Tiveriou.

When it was originally constructed, the palace was squeezed into the far end of the south part of the area annexed to the city. Thus it was not placed in a prominent spot; a probable reason for this is that it was the only unused area inside the city walls that belonged to the city and was therefore available for the palace. This area, according to a local tradition attested already in the sixteenth century C.E., was known as κάμπος; the name has been related by scholars to the Latin *campus*.[2] It is thus probable that in the Roman period, before its annexation to the city, the area had been used as an army camp or exercise field for the city militia, a *campus martius*, and was therefore public property.

The remains of a large second-century C.E. residential quarter were discovered under the foundations of the palace, beneath the south gallery of the north court.[3] They have the same axis as the later palace buildings. The residence was destroyed by fire; coins found beneath the destruction layer go as far back as the third quarter of the third century C.E.[4] The quality of the building decoration[5] and the position of the remains amidst the later palace buildings make it probable that it belonged to the army camp; the possibility that it had been used in the early life of the palace is not excluded by the numismatic evidence.

The southern part of the palace area includes the following (fig. 2): the north peristyle court, the basilica (east of the court), a two-story appendage between the court and the basilica, the bath (south of the latter), and the Octagon complex (west of the bath and south of the north court). It is not the purpose of this paper to satisfy the need for a comprehensive presentation of all buildings in the southern part of the palace area; our discussion will be limited to the buildings that constitute its nucleus: the precinct of the Octagon, the basilica, and the north court.

[2] Chatzi-Ioannou, *Thermais*, 14. The relatedness was accepted by later scholars: Theocharidis, "Ο ναός των Ασωμάτων," 27 n. 3; Vakalopoulos, *History of Thessaloniki*, 229; Vitti, *Η πολεοδομική εξέλιξη*, 57; Bakirtzis, "Η βυζαντινή οχύρωσις," 304. Bakirtzis believes, unjustifiably, that the name applies to the whole lower flat part of the city.

[3] It has been partially excavated and presented by the archaeologists Mariana Karamberi and Eugenia Christodoulidou in the annual volumes of *AEMΘ* of the years 1995, 1996, 1997, and 2003.

[4] Karamberi, "Το Γαλεριανό Οκτάγωνο," 209.

[5] Karamberi and Christodoulidou, "Η διαχρονικότητα της Θεσσαλονίκης," 393–96.

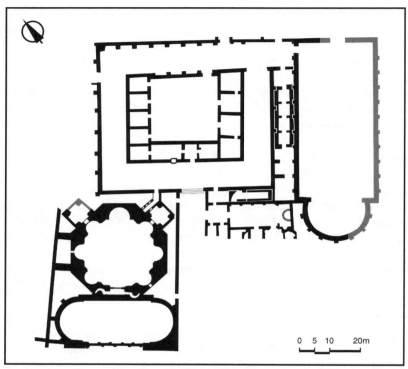

Fig. 2. Palace; schematic drawing of the precinct in its last phase. Drawing by
Nicholas Valassiadis.

THE OCTAGON

The precinct of the Octagon includes the octagonal hall, its vestibule to the
south, and the adjoining peristyle court (fig. 2). The whole complex faces
south[6] toward the seashore and was probably also accessible from the sea.[7]
It is situated at the southwest end of the palace and is set apart from that
area by an enclosure wall, traces of which can still be noticed at the west,
north, and east boundaries of the precinct. The western enclosure wall is
oblique to the axes of the palace; it conforms to the axis of the street grid at

[6] The orientation of both the palace and the city street grid is northwest to southeast
and northeast to southwest; here for reasons of convenience, we shall refer to these axes as
west-east and north-south.

[7] As claimed by several scholars; see Vitti, *Η πολεοδομική εξέλιξη*, 110.

the southeastern part of the Roman city.[8] This fact implies that the western enclosure wall may have served at the same time as the boundary between the palace complex and the city.

The Octagon is built on a circular foundation wall 5.60 m wide, with a total diameter of 32.60 m. It is octagonal internally and externally; on the interior each side contains a semicircular niche 5.22 m across. The south side, which contains the entrance, forms a rectangular niche. Two spiral staircases built in the width of the south wall are accessed through doors opening in the east and west sides of the entrance niche. The north niche, opposite the entrance, is larger than the rest (7.05 m across). A brickwork ornament is found embedded in the middle of the north niche wall; it consists of an equilateral cross in a wreath between two palm branches (fig. 3).[9] Two small domed annexes, externally rectangular and internally cruciform, are attached at the sides adjacent to the north side of the Octagon.

The Octagon vestibule, a large entrance hall, is attached to the south side of the octagonal hall. It is a rectangle of 60 by 22.50 m, its east and west short sides ending in apses. South of the vestibule extended the peristyle court; its north, west, and east porticoes, paved with mosaic floors, have been archaeologically attested.[10] The north portico of the peristyle communicated with the vestibule by a 17.85 m long opening bridged by a *tribelon*, a three-part colonnade. At a later period the vestibule was turned into a water reservoir.

Scholars have discussed at length the architectural history of the Octagon: Charalambos Makaronas, who conducted the first excavations of the monument, placed it in the Tetrarchic period, just a little later than both the Thessalonikē Rotunda and Diocletian's mausoleum at Split.[11] According to Makaronas the cross ornament on the north niche wall was inserted stealthily on the wall of the Octagon by zealous Christian masons during Galerius's reign.[12] Makaronas also suggested that the building was probably used as a church in the early Byzantine period.[13] Michael Vickers adopted Makaronas's dating with the elaboration that, as news of the first Edict of Toleration broke

[8] Vickers, "Towards a Reconstruction," 239–51. This axis was confirmed by excavations in new building constructions of the 1980s and the 1990s; see Markē, "Η Αγία Σοφία," 255.

[9] The ornament, coeval with the niche wall, has frustrated scholars; see Vickers, "Observations on the Octagon," 114–16.

[10] The most recent study is Athanasiou et al., "Οι οικοδομικές φάσεις," 239–55.

[11] Makaronas, "Το Οκτάγωνον," 303–21, esp. 319.

[12] Ibid., 316.

[13] Ibid., 314.

Fig. 3. Octagon; brick ornament on the north niche wall. Photo: Aristoteles Mentzos. By permission of the Thessaloniki Ephoreia of Classical Antiquities.

out in 311 C.E., Christian masons inserted the cross in the wall and then continued their work "according to the design."[14]

In 1975 the architect Giorgios Knithakis suggested that the Octagon and its vestibule were preceded by an earlier rectangular hall.[15] According to this assumption the peristyle court was coeval with the supposed rectangular hall, therefore earlier than the Octagon; this latter was built in the fourth century and was modified (to a church?) in the early Christian period.[16] The vestibule, according to the same scholar, was turned into a water cistern after the abandonment of the palace, in the first half of the seventh century C.E. Knithakis's theory was advanced further in 1980 by the architect Professor Charalambos Bouras, who adopted the idea of a preexisting Galerian rectangular hall and suggested that the Octagon with its vestibule was erected

[14] Vickers, "Observations," 116.

[15] Knithakis, "Το Οκτάγωνον," 90–119.

[16] Ibid., 104–5; the pavement of the Octagon, the narrowing of the south entrance, and the two side annexes belong to this modification.

at the end of the fourth century C.E. by Theodosius I and was destined as that emperor's mausoleum.[17]

These theories have aimed at reconciling the traditional Galerian dating of the Octagon with the following archaeological facts. First, the architectural characteristics of the Octagon, especially the massive dome, are more common in the period after the early fourth century. Second, the Christian ornament in the middle of the wall of the north niche, which is intrinsic to the building, may not be earlier than 317 C.E. when Illyricum was ceded to Constantine by Licinius.[18]

Another theory concerning the Octagon has been put forward by the team of architects entrusted with the architectural documentation and restoration of the palace complex. It has been presented in several papers and in its more recent form goes as follows:[19] The original, Galerian building was initially planned as a perfect Octagon with eight equal sides on the outside and seven equal semicircular niches on the inside plus the rectangular entrance niche. During the course of building, just when the walls of the octagonal hall had attained the height of 1.20 m,[20] a revision of the construction plan led to the enlargement of the north niche opposite the entrance, by prolonging externally the foundation of the north side; this in turn resulted in the shortening of the north exterior face and the elongation of the two adjacent sides.[21] It has been further suggested that the vestibule also underwent a similar change of plan during the early stages of its construction. These changes, according to the team of researchers, took place immediately after 311 C.E.; the beginning of construction work on the Octagon is placed in 308 C.E. when Galerius moved his seat from Serdica to Thessalonikē. The two domed annexes were added to the Octagon in the fifth century C.E. The final destruction of the building occurred, according to the team, in the seventh century C.E.

These claims, although they begin from true premises, are insufficiently documented and lead to erroneous conclusions. To begin with, there is no evidence in the case of the Octagon that any modifications took place when the building was under construction for the following reasons: 1) There is no visible change in the materials used in the supposed two construction phases;

[17] Bouras, "Νέες παρατηρήσεις," 33–42.

[18] Stefanidou-Tiveriou, *Το μικρό Τόξο*, 102.

[19] Athanasiou et al., "Οι οικοδομικές φάσεις," 239–55.

[20] Ibid., 247.

[21] This theory received mixed reactions from contemporary scholars. Stefanidou-Tiveriou, "Το ανακτορικό συγκρότημα," 184–85, has adopted it; Christodoulou, *Αυτοκρατορικά συγκροτήματα*, 434, on the contrary, is reserved toward the notion that the construction of the Octagon had been arrested midway and then was resumed on a revised plan.

even the brick courses along the seam of the supposed addition follow the same lines (fig. 4). 2) No separating layer of mortar appears on the wall of the north side, which would mark the end of the earlier phase and the resumption of construction work. 3) There is no plausible explanation as to why and under what circumstances such a drastic change of the plan of the Octagon would have become necessary.[22]

Before proceeding to a new explanation, it is necessary to reexamine the octagonal building itself. In doing so, we must take into account two things. First, it is remarkable that the plan of the Octagon, as well as that of the vestibule and the peristyle court, present irregularities and inconsistencies in their dimensions; thus the dimensions of both buildings' external and internal sides vary considerably. Second, although the width and diameter of the foundation ring of the Octagon corresponds to an exact number in Roman feet, other dimensions of the building do not follow this rule.

The vestibule follows the same pattern also. The span of the apses at the west and east side varies, and their exterior sides differ in appearance. It seems that the east and west sides of the vestibule were built upon a system of preexisting foundation walls that belonged to the original precinct enclosure (fig. 5). The peristyle also presents irregularities. All three of the archaeologically investigated porticoes vary in width;[23] their mosaic floors also have different decoration.[24] These discrepancies in the plan of the Octagon, the vestibule, and the peristyle would demand an explanation more coherent than that of a sudden, arbitrary change of plan.

The foundation of the Octagon consists of a perfect ring with an outer diameter of 100 Roman feet (32.50 m). In contrast to the regularity of the foundation, the tracing of the Octagon on its foundation is visibly irregular; it stands on it asymmetrically, the corners of the building ending in some instances precariously at the very edge of the foundation structure. A close observation of the way in which the superstructure is joined to the foundation shows that the foundation of lime mortar and rubble was later levelled and sealed with a mortar of liquid lime, before the erection of the Octagon began (fig. 6). The same procedure was applied in the interior, as has been observed beneath the Octagon floor.[25] Furthermore, the mortar used in the foundation

[22] It seems that the reason why the wall above the additional foundation was built independently from the rest was to avoid a possible rift of the wall due to the unequal strength of the foundation.

[23] The north portico is 7 m wide, compared to 5.70 m on the east and 6.25 m on the west portico.

[24] Atzaka, *Τα ψηφιδωτά*, 79–80.

[25] According to information kindly communicated to me by Ms. Mariana Karamberi,

Fig. 4. Octagon; external north wall. Seam of the supposed addition. Photo: Aristoteles
Mentzos. By permission of the Thessaloniki Ephoreia of Classical Antiquities.

differs both in color and composition from that used in the superstructure,
particularly in the quantity and size of tile crumbles in the mortar. All the
above indicate that the Octagon does not belong to the same construction

who conducted archaeological excavations in the area of the Octagon.

Fig. 5. Vestibule foundation from the northwest. Photo: Aristoteles Mentzos. By permission of the Thessaloniki Ephoreia of Classical Antiquities.

period with its circular foundation. It is therefore probable that an older, centrally-planned building of circular form, a rotunda, existed originally upon the foundation. This would explain more adequately why the foundation has such a perfectly circular form when the octagonal superstructure would be better suited with an irregular, polygonal foundation corresponding to the angular outline of the actual building.

Another circular foundation platform, with a slightly smaller diameter of 29.50 m, can be associated with the Octagon.[26] It is coaxial to the Octagon on the main, north-south axis of the palace and lies at a distance of about 76 m north of it (fig. 7). It probably supported a similar circular building; it presents a uniform surface of lime mortar with rubble, similar to that of the Octagon foundation. Since no traces of superstructure were found on it, it seems probable that a projected construction stopped short at the foundation course.

[26] Vitti, *Η πολεοδομική εξέλιξη*, 117; Karamberi, "Το Γαλεριανό Οκτάγωνο," 210.

Fig. 6. Octagon west side; detailed view of foundation and superstructure. Photo: Aristoteles Mentzos. By permission of the Thessaloniki Ephoreia of Classical Antiquities.

This building was set in an enclosure wall too and was probably accessed from the north; traces of a *cardo* that have been spotted further up to the north, if prolonged, would lead straight to the center of the platform.[27] It appears that the two circular buildings stood back-to-back on either side of a street, vestiges of which are shown in plans drawn during the 1970s; the two substructures are equidistant from the street. This street led from the western border of the palace to the palace basilica. Its starting point, together with a gate communicating with the city, was recently discovered to the northwest of the Octagon during the construction of a new apartment building.[28] The details of the archaeological remains point toward a *via colonnata*.

A correlation of the evidence permits the reconstruction of the original, Galerian phase of the palace: Two circular temples, each one inside its own enclosure, stood back-to-back on either side of a ceremonial *via colonnata* that led to the palace basilica (fig. 7). This specific arrangement reminds us of

[27] See Karydas, "Τοπογραφικές παρατηρήσεις," 450.
[28] Karamberi, "Γαλεριανά έργα υποδομής," 307–13.

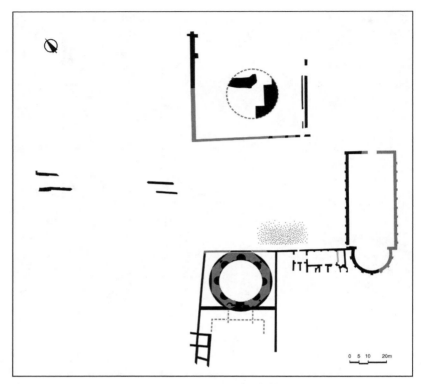

Fig. 7. Schematic drawing of the earlier phase of the Palace. Drawing by
Nicholas Valassiadis.

the twin temples before the *aula* (fore-court) in Diocletian's Palace.[29] There
was therefore symmetry in the plan of the nucleus of the original palace.

The two rotundas in Thessalonikē must have belonged to the early
Tetrarchic, or Galerian, period of the palace and must have functioned as
palace temples. The following isolated finds connected with the excavation of
the Octagon can also be dated in this period: fragments of stucco decoration,
along with a frieze with repeated circus scenes;[30] a small, 0.15 m high, marble
fragment with the torso of a *putto*;[31] and four revetment pilaster capitals that

[29] See McNally, *Architectural Ornament*, 34, III. E in fig. 2.

[30] Vavritsas, "Θεσσαλονίκη, Γαλεριανόν," 502, plate 433. In the frieze the same mold,
showing a *putto* in front of a racing horse with rider, is applied *ad infinitum*.

[31] Makaronas, "Τo Οκτάγωνον," 311, fig. 10. The find reminds us of the *putti* in the
interior frieze of the so called Mausoleum of Diocletian at Split; see McNally, *Architectural
Ornament*, 32, figs. 69–70.

were found on the floor of the octagonal hall.[32] Each of these belonged to the interior decoration of this earlier, Galerian building and are dated to the period of 308 to 311 C.E.[33] The means by which we can arrive at this quite precise dating is offered by a group of marble architectural reliefs associated with the first period of the palace decoration: The above-mentioned four pilaster capitals which probably belong to the original wall decoration of the tetrarchic rotunda and a marble arch that probably crowned a niche in the Octagon precinct have been convincingly dated by Thea Stefanidou-Tiveriou. She dated the arch to between 308 and 311 C.E. and the revetment capitals to the second decade of the fourth century.[34]

Similarly, the existing pavement shows clear signs of repair; the original colored slabs have in some parts been replaced by plain white marble slabs. When the original majestic entrance to the Octagon from the vestibule was walled up for the creation of the cistern, another, narrower entrance was created at the inner face of the south niche, flush with the interior wall of the Octagon.

The two domed annexes also present a complex architectural history. They are structurally independent from the Octagon, but not necessarily of a later date; their floor was originally about 0.40 m higher than the floor of the Octagon. At an even later period the southwest annex was abolished altogether, while the northeast annex was used as an entrance vestibule which connected the Octagon with the north court via a narrow, gamma-shaped, vaulted gangway.[35]

The Octagon itself seems to have existed for a long time, as is indicated by the numerous additions or alterations to the building described above. An important final intervention in the history of the building was the conversion of the vestibule into a cistern. The interventions include the blocking of the south entrance by a wall, the blocking of the original south triple colonnade by a strong buttressed wall, and the lowering of the original floor of the vestibule. It appears that this intervention was the last in the architectural history of the complex of the Octagon. According to the team of architects who have undertaken the study and restoration of the palace, it also signaled the final abandonment of the Octagon.[36] This need not be the necessary

[32] About the circumstances of their discovery see Vickers, "Observations," 116–17. For a detailed approach see Stefanidou-Tiveriou, *Το μικρό Τόξο*, 92–94.

[33] Christodoulou, *Αυτοκρατορικά συγκροτήματα*, 324–74, argues convincingly that Thessaloniki was the seat of Galerius in the period from 308 to 311 C.E.

[34] Stefanidou-Tiveriou, *Το μικρό Τόξo*, 92–94.

[35] Excavation reports also mention the luxurious decoration of the annex in this period.

[36] Athanasiou, "Οι οικοδομικές φάσεις," 253.

course of events, however; on the contrary, the opposite is more probable for two reasons. First, the later door at the inner face of the south niche of the Octagon makes sense only if the Octagon was still functioning after the blocking off of the old entrance. Second, the accessibility of the Octagon from the north peristyle, through the vaulted corridor and the northeast annex, made sense when there was no longer access to the Octagon through the vestibule. Alternatively, the new use of the Octagon vestibule as a cistern was realized only when the south access to the Octagon had lost its purpose and a new one was created from the north peristyle.

Having established that the Octagon continued to exist long beyond the Tetrarchic phase of the palace, let us examine the evidence for its dating. Scholars had originally assumed that the pavement of the Octagon succeeded an older mosaic, 30 cm below the present floor.[37] Trial trenches dug subsequently under the pavement disproved the existence of an earlier mosaic floor;[38] nevertheless, the finds from these trenches—numerous masses of tesserae in mortar found beneath the floor bed together with fragments of marble slabs[39]—show that the pavement of the Octagon was laid upon the demolition debris of an earlier building. Since this debris was contained in the circular foundation, it follows that it must have belonged to the rotunda that preceded the Octagon.

The surviving pavement of the Octagon consists of panels of white and polychrome marble slabs. It is organized along the perpendicular axis of the octagonal hall (north niche–south entrance). Along this axis and near the entrance a panel was set consisting of four *opus sectile emblemata*. According to most scholars, the pavement may be dated to the early Byzantine period.[40] Comparison with similar pavements in Rome indicates a dating around the sixth or seventh centuries C.E.[41]

[37] Vickers, "Observations," 111.

[38] Karamberi, "Ο ρόλος του Οκταγώνου," 122–23.

[39] I owe this information to Ms. Mariana Karamberi, who supervised the excavations.

[40] Siganidou, "Θεσσαλονίκη," 409; Knithakis, "Το Οκτάγωνον," 106; Vickers, "Observations," 118.

[41] Athanasiou, "Η διακόσμηση," 266–67. In spite of the claims of the group of architects, it is highly improbable that pavements with simple, small-scale geometric motifs, like those in the Octagon, can be dated to the early fourth century; see Guidobaldi and Guidobaldi, *Pavimenti marmorei*. Similarities with the Octagon pavements are found in pavements from the eastern part of the Empire in the sixth century and also with pavements of Rome from the sixth to the eighth centuries: the pavement of the presbytery of Santa Maria Antiqua, (ibid., 283–94) (sixth or early seventh centuries); the pavement in Santa Maria in Cosmedin (ibid., 461–66); and the pavement of the entrance hall to the Basilica Emilia. A parallel

The brick ornament on the wall of the north niche also provides us with chronological indications. Any attempt to compare it with the Constantinian *signum crucis* is not convincing.[42] On the contrary, it bears similarities to the brick ornaments on the fifth- or seventh-century west walls of the city.[43] The ornament, a cross in a wreath between palm leaves, can be explained in this respect as symbolizing the triumph of Christianity over paganism, a purifying or apotropaic sign. It would thus be better understood if it is assumed that the previous use of the building was foul and impure. In this respect the brick ornament on the wall of the Octagon had a function similar to that of the crosses engraved on the foreheads of classical statues in Late Antiquity.

The south façade of the vestibule consists of an imposing arch; the lower tier of the arch *tympanum* was occupied by a *tribelon* with an arched lunette window above it. This architectural form presents characteristic traits of early Byzantine palatial architecture: The whole vestibule with *tribelon* façade is very similar in form with the vestibule-narthex of the Lateran Baptistery (432–440 C.E.).[44] Looking further for similarities, we notice that the façade itself has particular analogies with the façade of the Great Mosque at Damascus, built at the end of Late Antiquity (705–708 C.E.).[45] As an architectural form the vestibule with its façade can therefore be placed between the middle of the fifth and the beginning of the eighth century. It is also remarkable that, as Panagiota Atzaka notices in her study of the Thessalonikē mosaic pavements, the mosaic of the east portico of the south peristyle, which is coeval with the vestibule, can be compared with mosaics in the city of the late fifth or early sixth century C.E.[46] Therefore we can sum up the following periods in the history of the Octagon precinct:

1. The original Rotunda was encompassed in an enclosure (*temenos*), which set it apart from the city as well as from the rest of the palace. It was probably preceded by a columnar entrance porch and was accompanied by a spacious four-porticoed *peristylium* inside the enclosure wall (fig. 7).

in central organization is offered in a pavement of a room in front of the entrance to the Basilica Emilia (ibid., 264–75) which was laid after 410 and before the ninth century C.E..

[42] Vickers, "Observations," 114–16.

[43] Equilateral brick crosses inside arches of radially set bricks; see Velenēs, *Τα τείχη της Θεσσαλονίκης*, 113, figs. 19, 22.

[44] Buchowiecki, *Handbuch der Kirchen Roms*, 89–92.

[45] Ceswell and Allan, *Short Account,* 68–69, figs. 29–30. Creswell derives the façade of al-Walid's mosque from a palace façade, probably from the courtyard façade of a palace at Constantinople.

[46] Atzaka, *Τα ψηφιδωτά δάπεδα*, 100. Atzaka assumes that all the palace mosaics are Galerian. This one she compares with the mosaic of the atrium south stoa of the Basilica B at Nikopolis of *Epirus vetus* (end of the fifth century C.E.).

The Rotunda, as well as its symmetric pendant to the north, functioned as a pagan temple and belonged to the initial, early fourth-century Galerian architectural project.

2. After a period of neglect, during which the building may have been seriously damaged by earthquakes and other natural causes, the old Rotunda was demolished and an octagonal building was erected in its place. The new building could not fit in the circular foundation of the rotunda because its outline was not a regular Octagon and its plan provided for an elongated north-south axis. An additional foundation was therefore added at the north end of the existing foundation. A spacious vestibule was added at the south side of the Octagon, in place of the north stoa of the court adjoining the former circular building. An imposing façade dominated the south side of the vestibule; the court was enlarged by building a new portico further to the east, in order to secure access to the Octagon from the north and east areas of the palace complex (fig. 8). Remnants of apsed halls between the Octagon court and the hippodrome were also of immediate proximity to the bath and the hippodrome; they can therefore be interpreted as belonging to the imperial quarters.[47]

The Octagon in its interior arrangement with internal niches bears close analogies with a number of palace halls.[48] The analogies include also the spacious vestibule with apsidal ends and the peristyle. The exact function of the Octagon has been disputed. A banquet hall, a reception hall, or a throne room have all been proposed as candidate functions,[49] but, as Jean-Michel Spieser has suggested, the octagonal hall could have performed all of these functions.[50] Additional information concerning the function of the Octagon is provided by the two spiral staircases: Positioned in the width of the Octagon's south wall, these stairs cannot be interpreted as service access to the roof, as they are too comfortable (1.05 m wide) and are placed in a prominent position immediately beside the main entrance. A plausible explanation for their use is that they provided access to a gallery that ran along the interior of the hall, above the arched tops of the niches (fig. 9).[51] It appears that interior

[47] Vitti, *Η πολεοδομική εξέλιξη*, 115.

[48] Mayer, *Rom*, 46; Bouras, "Νέες παρατηρήσεις," 37. Bouras suggested a mausoleum; still, the spaciousness of the vestibule and the many entrances to the main hall and the forecourt render this theory less probable.

[49] Christodoulou, *Αυτοκρατορικά συγκροτήματα*, 431.

[50] Spieser, *Thessalonique*, 118–20. Speiser argues that the primary usage of the hall was for banqueting, but with time it came to be used as a reception hall.

[51] As suggested by Bouras, "Νέες παρατηρήσεις," 34; the explanation is also adopted by Christodoulou, *Αυτοκρατορικά συγκροτήματα*, 429.

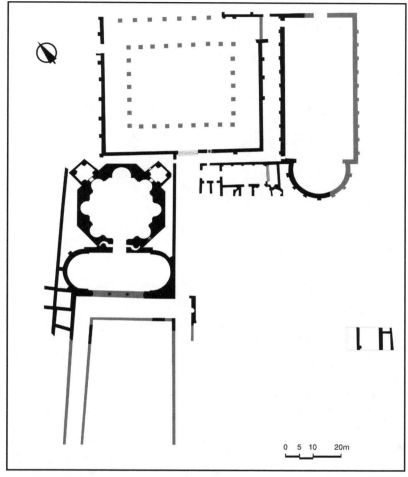

Fig. 8. Schematic drawing of the second phase of the Palace. Drawing by
Nicholas Valassiadis.

galleries played a significant role in the Byzantine imperial court ritual.
There, according to the *Book of Ceremonies*, stood the court dignitaries in
acclamation rites:

> The Emperor stands in the middle of the banquet hall (*triklinos*) called
> Justinianos; the dignitaries bow to him. Then he moves toward the
> exit and as they prepare to go through the gate towards the Heliakos
> porch the chamberlain herald spreads the cloth (*parakyptikon*) upon
> the balustrade of the railing. . . . The king stands before the throne . . .

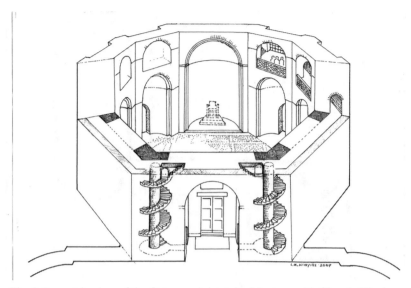

Fig. 9. Isometric view of the Octagon. Aristoteles Mentzos with Giannis Kiagias.

and sits on it. The dignitaries of the imperial chamber . . . take positions on either side near the cloth of the railing without leaning on it, but standing upright.[52]

3. The imperial banquet was originally the principal function of this hall; the two domed annexes that were joined to it at the sides adjacent to the north side were banquet preparation rooms. The niches of the Octagon as a banquet hall hosted banquet couches, *stibadia*, with the exception of the niches at either side of the north niche, which communicated with the annexes/service rooms. Parallels in the palaces of Lausos and Antiochos at Constantinople confirm this explanation.[53] No examples of banquet halls

[52] Ὁ δὲ βασιλεὺς εἰσελθὼν μέχρι τῆς εἰσαγούσης πύλης ἐν τῷ Ἰουστινιανῷ· . . . ἐξέρχεται ἐν τῷ Ἰουστινιανῷ τρικλίνῳ τῆς προελεύσεως. Καὶ στάντων ἁπάντων ἐν τῷ αὐτῷ τρικλίνῳ ἔνθεν κἀκεῖσε τῶν προειρημένων πατρικίων τε καὶ στρατηγῶν μετὰ πάσης τῆς συγκλήτου, ἵσταται ὁ βασιλεὺς ἐν τῷ πρώτῳ ὀμφαλίῳ. Καὶ δηριγευόμενος ὁ βασιλεὺς ὑπ' αὐτῶν πάντων . . . διέρχεται, καὶ μελλόντων αὐτῶν ἐξέρχεσθαι τὴν ἐξάγουσαν ἀπὸ τοῦ Ἰουστινιανοῦ πρὸς τὸ ἡλιακὸν πύλην, εὐθέως ἐφαπλοῖ τὸ παρακυπτικὸν ἔμπροσθεν τοῦ σένζου ἐπάνω τοῦ στηθέου τοῦ καγκέλλου κουβικουλάριος ὁ φωνοβόλος· ὁ δὲ βασιλεὺς ἀνελθὼν ἵσταται ἔμπροσθεν τοῦ σένζου, . . . καὶ παντὸς τοῦ λαοῦ ἀναφωνήσαντος «Ἅγιος», καθέζεται ἐπὶ τοῦ σένζου. Οἱ δὲ ἄρχοντες τοῦ κουβουκλείου ἵστανται ἔνθεν κἀκεῖσε, . . . πλησίον τῶν παρακυπτικῶν τοῦ καγκέλλου, μὴ ἐπερειδόμενοι ἐπ' αὐτοῖς, ἀλλ' ἵστανται ὄρθιοι (Vogt, *Constantin VII Porphyrogénète*, II, 73, 95.31–96.25).

[53] See Krautheimer, *Early Christian*, 71, fig. 30.

from the Great Palace of Constantinople survive, but the seventh-century historian Theophylactus Simocatta provides us with an interesting analogy to the Octagon complex in his narration of the enthronement of emperor Maurice in the Great Palace in August of 586 C.E.:

> When the emperor Tiberius (Tiberius II Constantine) knew he was dying
> . . . he asked to be brought to the open air court of the palace, which
> is indirectly joined to the Hall of many couches by an antechamber,
> which has a magnificent and famous façade and having convoked . . .
> the dignitaries . . . he addressed them.[54]

4. In the middle Byzantine period the function of the banquet receded; therefore another alteration was added to the octagonal hall. The pavement was restored with the use of secondhand material.[55] The annexes had lost their purpose; thus, the northwest annex was torn down and the northeast annex was reconfigured as an entrance vestibule, by lowering its floor in order to attain the same level as the Octagon itself. A new narrow, gamma-shaped gangway now connected the Octagon with the north court. The creation of this passage indicates a need for connecting the Octagon with the northern areas of the palace; it also shows a probable shift of importance to the northern areas of the palace. A secondary entrance opened in the southeast niche served in connecting the Octagon with the southern area of the palace (fig. 3). The creation of a new door at the inner face of the south niche, when the old entrance to the vestibule was shut off, aimed at separating the entrance to the staircases from the rest of the hall in such a way that the use of the upper level did not interfere with the use of the lower level of the octagonal hall.

There is probably one more final period in the use of the octagonal hall. This period is marked by the demolition of the throne furnishings in the north niche and the digging of a barrel-vaulted tomb in the center of the niche.[56] The tomb was built when the hall had lost its use both as a banquet and a throne room; the digging of the tomb destroyed the niche floor, which subsequently

[54] Ὅτε τὸν αὐτοκράτορα Τιβέριον τῆς ἐντεῦθεν ἔδει λοιπὸν μεταβήσεσθαι λήξεως καὶ τῷ κοινῷ ὑπείκειν νόμῳ τῆς φύσεως, . . . ἀνερρήθη Μαυρίκιος καὶ βασιλέως ἀξίᾳ μεγαλαυχεῖται καὶ νεάζων τῇ ἁλουργίδι τῆς μεγάλης τῶν αὐτοκρατόρων δυνάμεως μετελάγχανεν. φοράδην γὰρ ἀχθεὶς ὁ βασιλεὺς Τιβέριος ἐπὶ τὴν ὕπαιθρον τῶν βασιλείων αὐλήν, ἥτις παρήνωται τῇ πολυστιβάδι τῶν ἀνακτόρων οἰκίᾳ προαυλίῳ περιφανεῖ καὶ περιδόξῳ τῷ προσκηνίῳ, τὸν τῆς ἱεραρχικῆς προεστῶτα καθέδρας συγκαλεσάμενος . . . καὶ πρό γε τῆς ἀναρρήσεως τῷ ξυλλόγῳ τάδε παρέθετο (Theophylactus Simocattes, *Historiae I*, 1.31 B 1–3).

[55] Lazzarini, "Pavement and Marbles," 115.

[56] There are traces of yet another tomb in an *arcosolium* dug in the exterior wall of the northwest side of the Octagon.

was not repaired.[57] An attempt to date the tomb on the basis of the painted decoration of its interior is not convincing.[58] Of crucial importance is a bronze coin found inside the tomb issued by Emperor Alexius I,[59] which points toward a dating in the late eleventh century. It is hard to pronounce a judgment about the use of the Octagon in this final period, but it is possible that it was both funerary and ecclesiastical. The condition of the western side of the Octagon offers additional evidence. The demolition of this side appears intentional; it is probable that in the tenth or eleventh century an entrance porch or an antechamber was attached to the west side of the Octagon.

THE PALACE BASILICA AND THE NORTH COURT

Unfortunately the eastern part of the palace basilica still lies under the neighboring apartment buildings. The basilica is a single-aisle apsidal hall, which bears a close resemblance to, and has almost the same dimensions as, the basilica of Trier.[60] The basilica is structurally earlier than the buildings around it. It was built before the bath; it is also earlier than the north court, as demonstrated by the joints of the respective buildings. The basilica is built along the same axes as the rest of the palace. Its direction is parallel with the conventional north-south axis of Thessalonikē. The axis of the building is almost the same, with a deviation of just two to three meters, as the axis created by the Rotunda and the Arch "of Galerius."[61] Originally it was a free-standing building. It had a distance of about seven meters from the eastern outer wall of the north court and about eleven meters from the west wall of the neighboring hippodrome. The basilica faces to the north, toward the Mese; its main entrance lies in the middle of the north wall. This is logical,

[57] Karamberi, "Το Γαλεριανό Οκτάγωνο," 211. Karamberi claims that the tomb was built in the ruins of the Octagon; this, though, is not supported by the excavation finds.

[58] Markē, *Η νεκρόπολη*, 189. Markē's comparisons of the motifs painted on the interior of the tomb point toward a date later than the second half of the fifth century C.E. She further believes that the tomb was decorated at a period later than its first use, unjustifiably, as it appears, since she takes for granted that the Octagon was turned into a church in the time of Theodosius I and that the tomb is contemporary to that event.

[59] Karamberi, "Το Γαλεριανό Οκτάγωνο," 211. Ms. Karamberi kindly informed me that the tomb was opened on 15 August 1964; according to the excavation diaries, reproduced in her notes, inside the tomb were found several skeletons, three vases, and a bronze coin, which was identified by Ms. Karamberi as issued by the emperor Alexius I Komnenus; Wroth, *Catalogue*, 551, plate LXV 19.

[60] Athanasiou, "Η Βασιλική," 114, fig. 2; see also Mayer, *Rom,* 46.

[61] Christodoulou, *Αυτοκρατορικά συγκροτήματα*, 450.

since the audience for royal appearances in the basilica would come from the city through the main street, the Mese, to the north of the palace. The building possessed another narrow entrance at the southernmost end of the western wall, beside the apse, which was connected via a series of corridors with the south peristyle and ultimately with the imperial apartments. Since this entrance was relatively narrow and close to the apse, it is only logical that it was used exclusively by the sovereign and his attendants.

The basilica seems to have also had a long history of architectural interventions. There is a structural difference between the foundation and parts of the basilica walls, which suggests that the basilica was rebuilt.[62] The same phenomenon has been noticed in the palace Octagon, with the difference that in the case of the basilica it did not involve a complete demolition of the earlier superstructure, nor did it affect the original plan of the building, as with the rotunda that preceded the Octagon.[63]

The pavement of the basilica presents evidence of repeated repairs; according to the team of architects entrusted with the architectural documentation of the monument, traces of two successive pavements have been found. However, a more careful interpretation of the evidence provided by a pavement section in a drawing published by the team shows that it is a matter of not just two, but three successive pavements.[64] The latest floor consists of large white marble slabs that are white with bluish hues. These are similar to those found in the vestibule of the bath and also similar to the posterior pavement of the corridors of the north court (see below).

The north court is a slightly irregular rectangle squeezed into a space defined by the following preexisting buildings: the enclosures of the two rotundas from the north and south, the bath from the southeast, and the basilica from the east. The court has a main entrance from the south and also has secondary access points on the north and west sides. As is shown by the wall joints, the court postdates both the bath and the basilica; it is built on the site of the ceremonial road that linked the west gate of the palace with the basilica. This makes the north court later than the two rotundas. The complex in its final form consists of a small peristyle in the middle, surrounded on three sides by flights of single rooms; the whole is enclosed on all four sides by wide corridors, originally paved with mosaics. The pavement of the west and south corridors belongs to two phases. Above the original mosaic, there

[62] Athanasiou, "Η Βασιλική," 120–23.

[63] Ibid., 120–22. Athanasiou claims that part of the west wall belongs to the original construction.

[64] Ibid., 116.

is a later pavement of marble slabs, of the same kind as those in the pavement of the basilica, flanked on either side by bands of *opus segmentatum*.[65]

The architectural organization of the court is exceptional, since it consists of three architectural entities enveloped one inside the other; contrary to what we might expect, the width of the inner rooms is less than the width of the outer corridors. The unusual architectural organization, if combined with the floor repair, renders it probable that the north court was originally an open, four-porticoed peristyle, like the court of the mosaics in the Great Palace of Constantinople. At a later period the hypaethral central space was filled up with rooms and a small peristyle, while the mosaic pavement of the former porticoes was paved over with white-bluish marble slabs. Two coins found in the fill between the two pavements of the court's north corridor were issued by the Emperors Marcian and Leo I. The coins are small, with diameters of 1.1 and 0.9 cm.[66] Since the small denominations of the fifth century continued to be in use well into the sixth century, after the monetary reform introduced by Emperor Anastasius (496–518 C.E.), the repair of the pavement could have been achieved in the sixth century or even beyond.

We can summarize the interventions in the basilica and the north court as follows: The erection of the north court destroyed the original way which led to the basilica, passing between the two round temples. The mosaics of the north court portico are dated in the first half of the fourth century;[67] therefore the court was built before the Octagon. The central open air space of the inner peristyle is paved with the same material, large marble slabs, as the repair of the court corridors; it is the same as the final pavement of the basilica. The use of the marble slabs marks a large-scale reconstruction phase of the complex, which involves a restoration of the official character of the palace appendages. It could, therefore, be contemporary with the last "official" phase of the Octagon.

Conclusion

In a previous article I suggested that the palace was built by stages, advancing from the south toward the Arch; I proposed thus that the north court was later than the basilica and the Octagon and that the building at the junction

[65] Idem, "Ανάκτορα Γαλερίου," 415.

[66] Karamberi, "Ο ρόλος του Οκταγώνου," 126.

[67] Atzaka, *Τα ψηφιδωτά δάπεδα*, 81–85. The comparisons offered by Atzaka vary from the late fourth to the fifth century.

of A. Svolos (formerly Prince Nickolaos) and Gounari Streets was later than each of these.[68] Mayer, in his Ph.D. thesis, also suggested that the palace was built in stages: The Octagon and the basilica are earlier than the bath, and the north court is even later.[69] Thea Stephanidou-Tiveriou has adopted the view that the palace complex was built in several stages, but insists that it was planned as a single enterprise.[70] Still, the basic idea that permeates the writings of the majority of scholars when they refer to the palace is that the whole complex is the result of the activity of a single person, the emperor Galerius, and that construction began in 298/299 C.E. However, as I have tried to prove in this paper, the palace has a significantly longer and more complicated history.

The palace area encloses a number of independent buildings or groups of buildings, some of which are only vaguely known while others are partly excavated. It is probable that the earlier palace buildings developed around a preexisting nucleus, an official residence built in the second century C.E. Although the area occupied by the palace extends from the sea shore to the street that later became the main artery of the Roman city, the Mese, it is clear that the earliest and most important buildings of the palace complex were situated in the southernmost part of the relatively narrow stretch of land which eventually was taken over by the palace. Even though it has been postulated that the whole palace complex retains the basic elements of a unified whole and obeys a given set of general rules,[71] it is equally clear that not all its buildings are coeval. It is also obvious that all the buildings could not have been erected during the limited period of Galerius's sojourn in Thessalonikē.

The earliest buildings in this area included, as far as we know, the monumental gate in the west end of the palace precinct, the ceremonial street that led from the west gate to the basilica, and two round temples symmetrically disposed on either side of this "street." There is no concrete evidence that any of these earlier buildings can be placed before 308 C.E. It has been convincingly argued that the building program was in progress in the period from 308 to 311 C.E.[72]

[68] Mentzos, "Το ανάκτορο," 350–51.

[69] Mayer, *Rom,* 46.

[70] Stefanidou-Tiveriou, "Σχεδιασμός και χρονολόγηση," 185.

[71] Athanasiou et al., "Οι οικοδομικές φάσεις," 239–53.

[72] Christodoulou, *Αυτοκρατορικά συγκροτήματα,* 324–74, argues at length in favor of the fact that Thessalonikē was the seat of Galerius in the period from 308 to 311 C.E.

The palace continued to develop after the death of Galerius; an indication of this fact is provided by literary evidence, according to which several emperors and members of the imperial family either paid visits to or temporarily resided in Thessalonikē, from the early fourth to at least the late seventh century.[73] During this long period of time new buildings were added to the palace while others were modified. The palace expanded toward the north, which was the only direction available for its growth. The building of the Octagon with the vestibule and the modified peristyle is included in a large scale restructuring carried out in the early Byzantine period (the sixth or seventh century C.E.). Even before this restructuring a vast peristyle court was erected in the area between the two, now-demolished pagan temples. The reason for the destruction of the rotundas may have been a strong earthquake. A strong earthquake is also believed to have destroyed the dome of the Rotunda;[74] there exists historical testimony about a strong earthquake that hit Thessalonikē in the first half of the fifth century C.E.[75]

As regards the date of the early Byzantine intervention in the palace, there are clues which point toward the sixth or seventh century. Architectural forms used in the palace were in practice in the area of Byzantine influence. The south façade of the vestibule finds analogies from the mid-fifth to as late as the early eighth century C.E. The emblems in the Octagon pavement are coeval with the emblems in the wall decoration of St. Demetrios basilica, which are dated to the seventh century.[76] The north court was repaired in the sixth century C.E. or later, according to the coins found beneath the second floor. The basilica too was used for a long time, as is demonstrated by the fact its floor was paved three times; its last period of use coincides with that of the north court. The Octagon seems to have been used at an even later period. The conversion of the vestibule to a cistern suggests a *terminus ab quem* in the seventh century C.E.; this and other water cisterns in the palace area were continuously in use throughout the Middle Byzantine period. The latest use of the Octagon as a burial chapel goes as far as the late eleventh century C.E. In this respect it would be more accurate to refer to the palace not as the Galerian, but as the Late Antique or, better, as the early Byzantine palace of Thessalonikē.

[73] Mentzos, "Το ανάκτορο," 350–51.

[74] Mentzos, "Reflections," 63.

[75] Karamberi, "Ο ρόλος του Οκταγώνου," 128; Knithakis, "Το Οκτάγωνον," 106, after Vickers, "Observations," 120 n. 80.

[76] Bakirtzis, *Basilica of St. Demetrius*, 34.

BIBLIOGRAPHY

Athanasiou, Fanē, et al. "Η διακόσμηση του Οκταγώνου των ανακτόρων Γαλερίου" (The Decoration of the Octagon of the Galerian Palace). *AEMΘ* 18 (2004) 255–68.

————. "Οι οικοδομικές φάσεις του Οκταγώνου των ανακτόρων του Γαλερίου στη Θεσσαλονίκη" (The Construction Phases of the Octagon of the Galerius Palace Complex at Thessaloniki). *AEMΘ* 18 (2004) 239–55.

————. "Η Βασιλική του Γαλεριανού συγκροτήματος" (The Basilica of the Galerian Complex). *AEMΘ* 12 (1998) 113–27.

————. "Ανάκτορα Γαλερίου. Η αναστήλωση ως μέθοδος τεκμηρίωσης του μνημείου" (The Galerian Palace: The Restoration as Method of Documentation for the Monument). *AEMΘ* 11 (1997) 401–16.

Atzaka, Panagiota. *Τα ψηφιδωτά δάπεδα της Θεσσαλονίκης* (The Mosaic Floors of Thessaloniki). Byzantine Monuments 9. Thessaloniki: Center of Byzantine Studies, 1998.

Bakirtzis, Charalambos. *The Basilica of St. Demetrius*. Thessaloniki: Institute for Balkan Studies, 1988.

————. "Η βυζαντινή οχύρωσις της Θεσσαλονίκης" (The Byzantine Fortification of Thessaloniki). *Byzantina* 7 (1975) 289–344.

Bouras, Charalambos. "Νέες παρατηρήσεις πάνω στο Οκτάγωνο της Θεσσαλονίκης" (New Observations on the Thessaloniki Octagon). Pages 2:33–42 in *Citta del Vaticano. Acts du Xe Congres international d'archeologie chretienne. Thessalonique, 28 septembre–4 octobre 1980*. Vatican City: Pontificio instituto di archeologia cristiana; Thessaloniki: Society for Macedonian Studies, 1984.

Buchowiecki, Walther. *Handbuch der Kirchen Roms*. Vol. 1. Vienna: Brueder Hollinek, 1967.

Ceswell, Keppel Archibald Cameron and James W. Allan. *A Short Account of Early Muslim Architecture*. Aldershot: Scolar, 1989.

Chatzi-Ioannou, Michael. *Thermais hētoi, Peri Thessalonikēs*. Athens, 1879.

Christodoulou, Dimitrios. *Αυτοκρατορικά συγκροτήματα στα Βαλκάνια την περίοδο της Τετραρχίας* (Imperial Complexes in the Balkans during the Period of the Tetrarchy). Ph.D. diss., Aristotle University of Thessaloniki, 2004.

Guidobaldi, Federico and Alessandra Guiglia Guidobaldi. *Pavimenti marmorei di Roma dal IV al IX secolo*. Studi di antichità cristiana 36. Vatican City: Pontificio instituto di archéologia cristiana, 1983.

Karamberi, Mariana. "Γαλεριανά έργα υποδομής" (Galerian Infrastructure Projects). *AEMΘ* 15 (2001) 307–16.

————. "Το Γαλεριανό Οκτάγωνο και η ανθρώπινη ματαιοδοξία" (The Galerian Octagon and Human Vanity). *AEMΘ* 11 (1997) 205–14.

————. "Ο ρόλος του Οκταγώνου στο Γαλεριανό συγκρότημα και η σχέση του με το μεγάλο περιστύλιο" (The Role of the Octagon in the Galerian Complex and its Relation with the Great Peristyle). *Archaiologika analekta ex Athenon* 23–28 (1990–1996) 121–26.

———— and Eugenia Christodoulidou. "Η διαχρονικότητα της Θεσσαλονίκης μέσα από το Γαλεριανό συγκρότημα" (The Continuity of Thessaloniki through the Galerian Complex). *AEMΘ* 11 (1997) 393–400.

Karydas, Narkissos. "Τοπογραφικές παρατηρήσεις και πολεοδομική οργάνωση της περιοχής νοτιοδυτικά της Ροτόντας με αφορμή τρεις νέες ανασκαφές οικοπέδων" (Observations Regarding the Topography and Urban Organisation of the Area Southwest of the Rotunda on the Basis of Three New Excavations of Building Lots). *ΑΕΜΘ* 11 (1997) 439–54.

Knithakis, Giorgos. "Το Οκτάγωνον της Θεσσαλονίκης" (The Octagon of Thessaloniki). *ArchDelt* 30 (1975) 90–120.

Krautheimer, Richard. *Early Christian and Byzantine Architecture*. 4th ed. Harmondsworth, U.K.: Penguin, 1986.

Lazzarini, Lorenzo, et al. "The Pavement and Marbles of the 'Oktagon' of Galerius' Palace in Thessaloniki." Pages 107–15 in *ASMOSIA VI Proceedings of the Sixth International Conference Venice, 15–18 June 2000*. Interdisciplinary Studies on Ancient Stones. Padua: Bottega d'Erasmo, 2002.

Makaronas, Charalambos. "Το Οκτάγωνον της Θεσσαλονίκης" (The Octagon of Thessaloniki). *PAE* (1950) 303–21.

Markē, Euterpē. *Η νεκρόπολη της Θεσσαλονίκης στους υστερορωμαϊκούς και παλαιοχριστιανικούς χρόνους (μέσα του 3ου έως μέσα του 8ου αι. μ.Χ.)* (The Necropolis of Thessalonikē during the Late Roman and Early Christian Period [mid 3rd – mid 8th century]). Dēmosieumata tou Archaiologikou deltiou 95. Athens: Hellenic Ministry of Culture; Archaeological Receipts Fund, 2006.

———. "Η Αγία Σοφία και τα προσκτίσματά της μέσα από τα αρχαιολογικά δεδομένα" (Hagia Sophia and its Annexes Viewed through the Archaeological Data). *ΘΠ* 1 (1997) 54–61.

Mayer, Emanuel. *Rom ist dort, wo der Kaiser ist. Untersuchungen zu den Staatsdenkmaelern des dezentralisieren Reiches von Diokletian bis zu Theodosius II*. Monographien. Römisch-Germanischen Zentralmuseum, Forschungsinstitut für Vor- und Frühgeschichte 53. Mainz: Römisch-Germanisch Zentralmuseum; Bonn: Habelt, 2002.

McNally, Sheila. *The Architectural Ornament of Diocletian's Palace at Split*. BAR International Series 639. Oxford: Tempus reparatum, 1996.

Mentzos, Aristoteles. "Reflections on the Interpretation and Dating of the Rotunda of Thessaloniki." *Egnatia* 6 (2001–2002) 57–82.

———. "Το ανάκτορο και η Ροτόντα της Θεσσαλονίκης. Νέες προτάσεις για την ιστορία του συγκροτήματος" (The Palace and the Rotunda of Thessaloniki: New Proposals for the History of the Complex). *Byzantina* 18 (1995–1996) 339–64.

Siganidou, Mary. "Θεσσαλονίκη, Ανασκαφαί πλατείας Ναυαρίνου." *ArchDelt* 20 (1965 Β') 408–10.

Spieser, Jean-Michel. *Thessalonique et ses monuments du IVe au Vie siecle*. Paris: de Boccard, 1984.

Stefanidou-Tiveriou, Theodosia. "Το ανακτορικό συγκρότημα του Γαλερίου στη Θεσσαλονίκη. Σχεδιασμός και χρονολόγηση" (The Planning and Dating of the Palace Complex of Galerius in Thessalonikē). *Egnatia* 10 (2006) 163–88.

———. *Το μικρό Τόξο του Γαλερίου στη Θεσσαλονίκη* (The Small Arch of Galerius at Thessalonikē). Bibliothēkē tēs en Athēnais Archaiologikēs Hetaireias 151. Athens: Hē en Athēnais Archaiologikē Hetaireia, 1995.

Theocharidis, Georgios. "Ο ναός των Ασωμάτων και η Rotonda του Αγίου Γεωργίου Θεσσαλονίκης" (The Asomatoi Church and the Rotunda of Saint George of Thessalonikē). *Hellenika* 13 (1954) 24–70.

Vakalopoulos, Apostolos. *History of Thessaloniki*. Thessaloniki: Institute for Balkan Studies, 1983.

Vavritsas, Andreas. "Θεσσαλονίκη, Γαλεριανόν Συγκρότημα (Πλατεία Ναυαρίνου)." *ArchDelt* 27 (1972/ B2) 502.

Velenēs, Giorgos. *Τα τείχη της Θεσσαλονίκης* (The Walls of Thessaloniki). Thessaloniki: University Studio Press, 1998.

Vickers, Michael. "Observations on the Octagon at Thessaloniki." *JRS* 63 (1973) 114–16.

———. "Towards a Reconstruction of the Town Planning of Roman Thessaloniki." Pages 239–51 in *Ancient Macedonia. 1st International Symposium Thessaloniki, 1970*. Thessaloniki: Institute for Balkan Studies, 1973.

Vitti, Massimo. *Η πολεοδομική εξέλιξη της Θεσσαλονίκης. Από την ίδρυσή της έως τον Γαλέριο* (The Urban Development of Thessalonikē from its Foundation to Galerius). Bibliothēkē tēs en Athēnais Archaiologikēs Hetaireias 106. Athens: Hē en Athēnais Archaiologikē Hetaireia, 1996.

Vogt, Albert. *Constantin VII Porphyrogenete. Le livre des cérémonies*. Vol. 2. Paris: Les belles lettres, 1939.

Wroth, Warwick. *Catalogue of the Imperial Byzantine Coins in the British Museum II*. London: British Museum Press, 1908.

Early Christian Interpretation in Image and Word: Canon, Sacred Text, and the Mosaic of Moni Latomou*

Laura Nasrallah

Toward the beginning of his *Adversus haereses*, Irenaeus argues that people who interpret scripture wrongly are like those who dismantle the mosaic tesserae of a likeness of a king to produce instead an image of a dog or fox.[1] The image of the mosaic reappears when Daniel Boyarin states, in developing a theory of midrash, that "the text is always made up of a mosaic of conscious and unconscious citation of earlier discourse."[2] That both the late second-century Christian writer Irenaeus and Daniel Boyarin, a Jewish Talmudist and scholar of religion writing in the late twentieth century, should use the metaphor of a mosaic for the interpretation of sacred texts is a significant coincidence. For both, interpretation of scripture is a matter of piecing together and juxtaposing various authoritative texts like tesserae in order to form an image, a mosaic of meaning. Such a mosaic is literally what we find at Moni Latomou in Thessalonikē, which this paper takes as a

* Thanks to colleagues who have read drafts of this piece and kindly offered advice: Joan Branham, David Frankfurter, Herbert Kessler, AnneMarie Luijendijk, and Larry Wills, among others.

[1] Irenaeus, *Haer.* 1.1.15 in the Greek edition or 1.8.1 in the *Ante-Nicene Fathers* translation; see 1.1.20 (*ANF* 1.9.4) for an extension of the metaphor to correct scriptural interpretation.

[2] Boyarin, *Intertextuality*, 12. The image of biblical interpretation as mosaic and tesserae continues at various points in his book.

test case to explore the interpretation of sacred texts in the literary and visual practices of early Christianity.

The apse mosaic of the church of Moni Latomou or Hosios David in Thessaloniki—either the sanctuary of the Monastery of the Stone Worker or, as it was rededicated in 1921, the church of the Holy David, an ascetic saint of the city[3]—dates to the third quarter of the fifth century (fig. 1).[4] The meaning and the literary and artistic sources of its iconography have been debated ever since it was uncovered in the 1920s, and even much earlier, as we know from the eleventh- or twelfth-century *Narrative of Ignatius*, which recounts legends of the sanctuary's founding, a miracle regarding the original mosaic program, and the rediscovery of the mosaic by an Egyptian monk. The focal point of the mosaic is the beardless Christ sitting on a rainbow, sailing over the *oikoumenē* or inhabited world, shining in a circle of light. This Christ has been interpreted many ways: as an emperor, a philosopher-teacher, an anti-Arian statement that Christ *is* God.[5] The mosaic as a whole has often been interpreted as borrowing from Isaiah, Ezekiel, Habakkuk, Revelation, or a combination of these texts.

This chapter takes up again the question of the interpretation of the mosaic at Hosios David. It does so less to explicate the mosaic itself and more in order to think about what methods we use to interpret early Christian images and how the very making of an image is a hermeneutical process. The early

[3] Regarding Hosios David, see Vasiliev, "Life of David of Thessalonica"; this attribution to Hosios David may date earlier. Tsigarides mentions this title in relation to a 1917 survey of churches in Thessaloniki (*Latomou Monastery*, 8).

[4] The majority of scholars date the original structure (and the mosaics) to the fifth century: Xyngopoulos, "Sanctuary of the Monastery," 151; Diehl, "A propos de la mosaïque," 335–38; Hoddinott, *Early Byzantine Churches*, 175; Grabar, *Martyrium*, 1:146, 2:192; Gerke, "Il mosaico absidale," 179–99. Debates, however, continue over the dating of the mosaic. Diehl suggests a date as early as the fourth century (*Comptes rendus*, 256–61). Morey dates the mosaic to the seventh century, arguing that the image of Christ seated on the *arcus coeli* rather than a throne does not appear before ca. 600 ("Note on the Date," 342–43).

[5] The mosaic of Moni Latomou has most often been interpreted in light of other early Christian apse iconography around the empire. Spieser ("Representation of Christ," 63–73) used the mosaic of Hosios David as one piece of evidence in his diachronic framework of early Christian apse decoration. Mathews, in his controversial *Clash of the Gods* (118–19) uses the mosaic of Hosios David to argue against what he calls the "emperor mystique": the idea, advanced by Grabar (*Christian Iconography*, 44), that iconographic programs like this present Christ as a new emperor over and against the Roman imperial rhetoric of old. Mathews insists instead that we should read the mosaic at Hosios David—along with most early Christian mosaics—as opposing Roman imperial iconography and in light of the Arian controversy. The glowing light at the center of the mosaic responds to the Nicene creed's "light from light, true God from true God" (Mathews, *Clash of the Gods*, 118). Hosios David's beardless Christ for Mathews becomes a god, not an emperor.

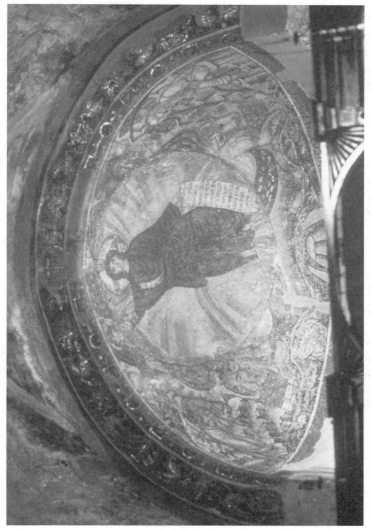

Fig. 1. View of the apse, Moni Latomou, Thessaloniki, Greece. Photo: Holland Hendrix. Harvard New Testament Archaeology Project.

Christian homilist or commentator and the early Christian mosaicist or frescoer (or the person who commissions the image) engaged in similar acts. In bringing together the question of early Christian practices regarding making literature and images, I advance two arguments. First, I argue that an image may reveal that noncanonical texts or even those labeled "heretical" were read and used in a given location, despite arguments to the contrary found in contemporaneous literary sources and even among contemporary scholars. That is, early Christian images may offer evidence about the boundaries of canon at the time of their production. Second, I argue that by analyzing literary and imagistic depictions of authoritative texts together, we deepen our understanding of the hermeneutical principles that underlie the production of texts such as homilies and commentaries as well as of images such as the apse mosaic at Hosios David. Looking simultaneously at how an image and how a literary text engage in interpretation of sacred texts may break down our logocentrism—our tendency to try to pin down an image by indexing aspects of it to a particular passage or verse in scripture—and expand our understanding of intertextual impulses in the ancient world.

The first part of this chapter describes the church and its mosaic, discussing the various links scholars have tried to make between scripture and the iconographic program of the mosaic. I focus particularly on Revelation and its putatively fragile position within the canon of the Greek East. The second part uses John Chrysostom's homily on 1 Thessalonians to show that the production of early Christian images such as the Moni Latomou mosaic is similar to the production of early Christian literature that interprets sacred texts. In addition, I suggest that 1 Thessalonians 4, written to first-century C.E. residents of Thessalonikē, may have been one of the inspirations for the production of the mosaic at Moni Latomou, and that 1 Thessalonians may have been evoked for those who looked at its completed images.

The Mosaic and the Canon

The church of Moni Latomou or Hosios David is located on the winding streets of the *Ano Polis*, above the regular grid of the lower city of Thessaloniki. In the modern period, it was first examined in 1921 by Andreas Xyngopoulos, who also discovered its mosaics in 1927. The majority of scholars concur with Xyngopoulos's conclusion that it dates to the latter

part of the fifth century.[6] The small church, a cross-in-square, originally measured some 4.5 m by 14.75 m in its central bay, with a central dome and four corner chambers with domed ceilings.[7] Today, two-thirds or less of the original structure remains.

The fifth century was a time of a Christian building boom in Thessalonikē. We find roughly contemporaneous building projects in the large basilicas of St. Demetrios and of the Virgin Acheiropoietos.[8] In such churches one moved in a great thrust through the monumental space of the large main aisles toward the apse. The Rotunda, a slightly older Galerian structure that was converted into a church, provides a different kind of space with stunning mosaics that date to perhaps the fifth century.[9] Its dome lifts the eyes upward to the glittering heavens and to a ring of saints who stand in the midst of ecclesiastical or palace architecture.[10] I mention these churches to give a sense of walking the ancient city of Thessalonikē in the fifth century, with its monumental architecture and rich imagery. It was filled with different architectural, iconographic, and literary interpretations and assertions of encounter with the divine and the holy.[11] The church of Moni Latomou in contrast offered its viewer an intimate space in which to "behold our God," as its inscription says.

[6] Xyngopoulos, *Sanctuary of the Monastery*, 142–80. Pelikanides concurred in his 1949 review *Early Christian Monuments of Thessalonikē*.

[7] According to Krautheimer and Ćurčić, the cross-in-square type was fully developed by the last third of the fifth century; because of the style of the mosaics they suggest an early date for Moni Latomou, "shortly before 500" (*Early Christian and Byzantine Architecture*, 240). Its form changed slightly as it was renovated over the years, and some time before the early sixteenth century, it was converted into the Suluca Mosque. Part of it may have fallen into ruins early, as a minaret was built over the southwest corner of the church (Tsigarides, *Latomou Monastery*, 13–14).

[8] Regarding the uses of the basilica of St. Demetrios, see the contribution of Charalambos Bakirtzis in this volume.

[9] For the hypothesis that the Rotunda was a Constantinian building project and church from the start, see Ćurčić, *Some Observations and Questions*, 11–14.

[10] These buildings are carefully constructed to have an aesthetic impact upon the worshiper; for example, the windowsills of the Rotunda are angled perfectly so that the sills' white marble slabs reflect warm light onto the old tesserae (Iliadis, "Natural Lighting," 13). For a discussion of the Rotunda and early Christian literature, see Nasrallah, "Empire and Apocalypse in Thessaloniki."

[11] See the chapter by Ćurčić in this volume. For the idea of walking the city, see Certeau, *Practice of Everyday Life*, 98–99, and Nasrallah, "Empire and Apocalypse in Thessaloniki," 471–72.

Legend and General Description

The church and its mosaic have often been interpreted in light of Ignatius's *Narrative* or, to give the full title, the *Edifying Account of the Theandric Image of Jesus Christ our Lord which Manifested itself in the Monastery of the Stone-Workers at Thessaloniki.* The text dates to the mid-eleventh or twelfth century but contains legends from an earlier date.[12] I recount portions of its legends in some detail because the story of the *Narrative* and its account of the mosaic have influenced subsequent scholarly identification of the mosaic's figures and meaning.

In the story, the monk Senouphios from Egypt is called to Thessalonikē to see God: He had asked God to reveal Godself as in the final judgment[13] and was told to go to the monastery named Latomos in Thessalonikē, dedicated to the prophet Zechariah. When he met the monks, he was told that such a monastery did not exist in the city. He left, having seen nothing at all and thinking the whole trip had been the devil's deceit. Asking God again, he was called to go to Thessalonikē, where he prayed alone in the church of Moni Latomou during a thunderstorm. From the apse ceiling fell a covering of leather, bricks, and lime, and Christ's face appeared.

This apparition was not the only strange revelation at Moni Latomou that Ignatius's *Narrative* records. According to Ignatius, this church was commissioned by Theodora, daughter of the Christian-persecuting emperor Maximian (by which perhaps Galerius Maximianus is meant). One day she wandered by a church and went in during the time for the reading:

> When the time even had come for the reading of the holy sayings—for it was a reading concerning the second coming (ἐπιδημία)[14] of Christ our true God, in which he should lead all creation into judgment and give to each according to his or her works—she received the seeds of

[12] Papadopoulos-Kerameus published the text in 1909, using a vellum manuscript from 1307 (*Varia Graeca sacra*, 102–13). Tsigaridas suggests that Ignatius wrote at the end of the ninth century or in the eleventh century (*Latomou Monastery*, 9) but offers no arguments; Diehl states that he wrote "without a doubt in the twelfth or thirteenth century" but offers no evidence ("La mosaïque," 333). New research understands Ignatius to have been the head of the Akapniou monastery in Thessalonikē; the founding of this monastery dates to the end of the tenth century at the earliest, and so the *Narrative* dates later (Kaltsogianni, *Thessaloniki in Byzantine Literature*, 133).

[13] For an English translation of portions of the *Narrative*, see Hoddinott, *Early Byzantine Churches*, 68–69 and 178–79.

[14] Lampe, s.v. ἐπιδημία. In early Christian writings the word is roughly equivalent to *parousia*, since it signals a visit or stay, or even, as translated here, the second coming (3b).

the word like so much good earth; she fostered the seeds in the warmth
of her heart and they soon began to root in her soul.[15]

She was converted and baptized. Concealing her Christianity, she said that
she was ill and asked for her father to build her a house with a bath near
the quarries in the northern part of the city—the opposite corner, so to
speak, from the pagan imperial palace. This "house" became the church.
She commissioned a mosaic of Christ's mother, which at the last minute
was suddenly transformed into "Christ with a man's features sitting on a
shining cloud." When her Christian identity was discovered, Theodora had
the mosaic covered to protect it. Theodora was killed at the command of
her own father, but, although he ordered that the bath be burned down, the
mosaic somehow survived.

This *Narrative* has informed later scholarly interpretations of the meaning
of the mosaic and the identification of its figures, as well as the history of
the church itself: Tsigarides's idea that the church was built on top of a
Roman bath, for instance, and Hoddinott's and Grabar's conclusions that the
church was dedicated to Zechariah. The *Narrative* names the two figures on
either side of Christ as Ezekiel and Habakkuk, and these identifications too
have influenced scholars. This later legend *interprets* the mosaic, not only
labeling its figures, but also setting it within a story of imperial power and
its destructive forces, on the one hand, and a reading about judgment and
the sudden miraculous appearance of Christ, on the other.

Turning from the legend to the mosaic, we see that it is enclosed by two
framing bands. The outer band, which traces an arch on the flat wall before
the apse, consists of gold swans on a red and blue ground, interspersed with
vessels and plants,[16] a motif similar to one found at the mosaics of the nearby
Rotunda.[17] The second band is folded onto the edge of the curved apse and
depicts on a red background multicolored rectangles and ovals, like jewels,
linked by a golden chain. At the bottom of this band we find an anonymous
donor inscription, the letters in silver tesserae against a red background.[18]

We shall see how the mosaic refers to a variety of literary traditions; it
also draws from a variety of imagistic traditions. The Christ with hand raised
reminds one of scenes of imperial or philosophical address, as with the Prima

[15] Ignatius *Narrative* in Papadopoulos-Kerameus, *Varia graeca sacra*, 104, lines 27–33,
[translation mine].

[16] Tsigaridas, *Latomou Monastery*, 40.

[17] Hoddinott, *Early Byzantine Churches*, 178; Morey, "Note," 34; Spieser, *Thessalon-
ique*, 157.

[18] Feissel, *Recueil des inscriptions chrétiennes*, 98.

Porta Augustus, and Christ's seat upon the rainbow throne draws on imperial enthronement imagery, such as that found nearby in the Arch of Galerius, as well as its Christian articulations in scenes of the *maiestas Domini* and even the *traditio legis* (as on the sarcophagus of Junius Bassus). The rivers of Paradise too appear in a variety of scenes, including that of a youthful Christ seated on the glowing blue orb, holding Revelation's scroll with the seven seals, at San Vitale in Ravenna. Thus the various compositional elements of the Moni Latomou mosaic are themselves a bricolage of motifs that can be applied in a variety of typical scenes.[19]

The central portion of the mosaic depicts a young, beardless man with long, dark hair seated on a rainbow, his right hand raised in the *ad locutio* gesture of imperial or philosophical address, later sometimes interpreted as a gesture of blessing (fig. 2).[20] His clothes are civilian rather than military or imperial: A blue himation covers a red tunic with gold detailing, and he wears gold sandals. He sits on a rainbow and emerges from within a ball of light; behind his head is a golden nimbus. Behind the orb of light, with the eyes on their wings shining through, are four creatures holding closed, jeweled codices: a man or angel (with a halo), an eagle, an ox, and a lion.

At Christ's feet are four streams that lead to rivers full of fish (fig. 3). To the viewer's left, the river contains a figure (perhaps a river god), and a bearded old man at its banks, bent slightly, mirrors that figure with hands on either side of his face, reacting in fear or with an apotropaic gesture (fig. 4). Behind the man are fences on a tall hill, and behind that an unidentified city with five or six buildings with columns rising in the distance. Whether the city is Jerusalem (perhaps hinting at Isaiah's vision of a New Jerusalem) or Thessalonikē or some other city is unclear. Opposite the figure in front of the city, and on the other side of Christ, is another older, bearded man, who sits thoughtfully, hand on chin, in a bucolic setting with a hut in the distance. An open codex lies on his lap and he seems to be reading (fig. 5). Although some have argued that these figures — the two bearded men and the river god — are reacting to Christ, upon closer inspection we see that they are engrossed in their own worlds: the river, on the one hand, and the codex, on the other. This may be a theophany, but it does not seem to come with much thunder, even if, as Ignatius's *Narrative* claims, Theodora's conversion was inspired

[19] This idea, for which I am grateful, was pointed out to me by Herbert Kessler; see also the discussion in Spieser, *Thessalonique*, 158–61.

[20] Hoddinott, drawing on Grabar's earlier connections of this image with Buddhist iconography (e.g., *Martyrium* 2.192), argues for its connection to gestures of reassurance made by the Buddha in Buddhist iconography (*abtaya mudra*) (*Early Byzantine Churches*, 176).

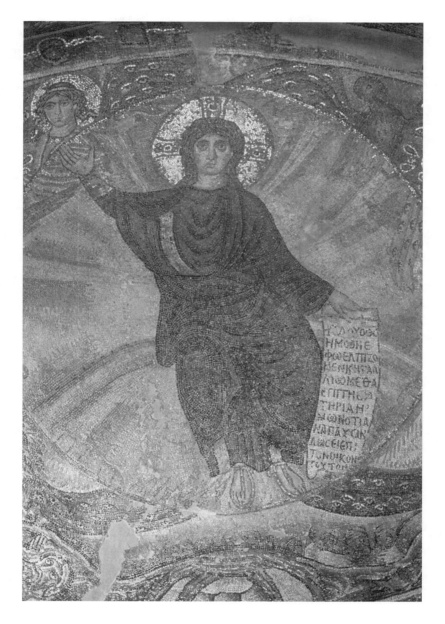

Fig. 2. Detail, central portion of the mosaic. Hosios David, Thessaloniki, Greece.
Photo: Holland Hendrix. Harvard New Testament Archaeology Project.

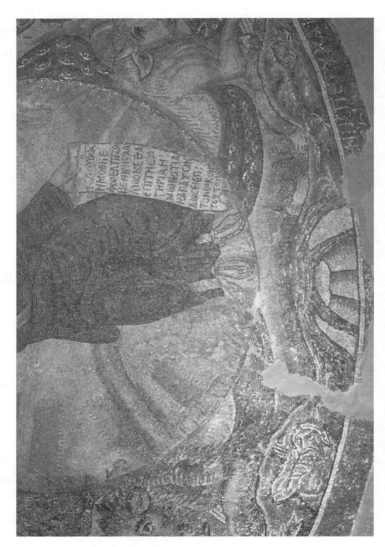

Fig. 3. Detail, central lower portion of the mosaic. Hosios David, Thessaloniki, Greece. Photo: Holland Hendrix, Harvard New Testament Archaeology Project.

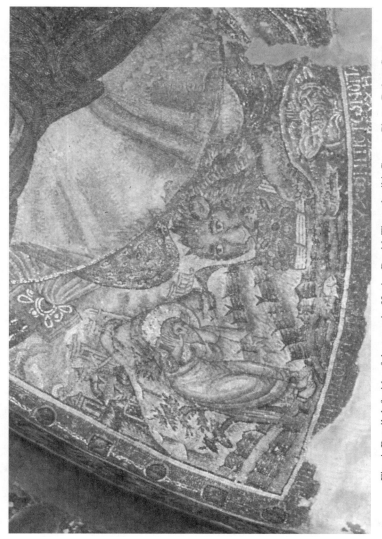

Fig. 4. Detail, left side of the mosaic. Hosios David, Thessaloniki, Greece. Photo: Robert Stoops. Harvard New Testament Archaeology Project.

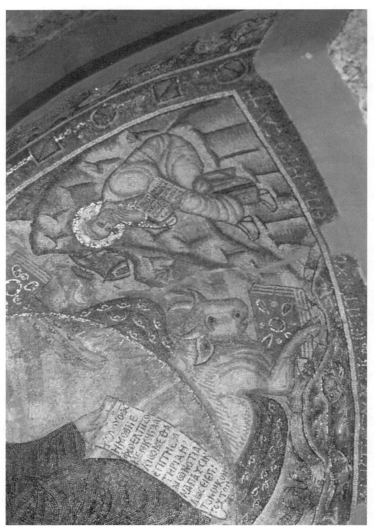

Fig. 5. Detail, right side of the mosaic. Hosios David, Thessaloniki, Greece. Photo: Holland Hendrix. Harvard New Testament Archaeology Project.

by a reading about judgment, and even if a thunderclap shook down the mosaic's covering to reveal it to the monk Ignatius. In Thessalonikē, Christ hovers over a placid scene in the *oikoumenē*; his commanding presence is both imperial and divine—not a surprising combination, given the Roman blurring of the body of the emperor with the body of a god in imperial cult and iconography.

Most scholars who have written about this mosaic have been concerned with one of two things. One group has been concerned with how its depiction of Christ relates to the christological controversies and discussions of the fifth century and with how this Christ is or is not like a Roman emperor.[21] In what follows we shall be concerned with the other conversation about the mosaic, which has attempted to link the mosaic's iconography to certain passages from the Bible—that is, to understand the mosaic by providing source texts for its images.

The Mosaic's Inscriptions

Both art historians and scholars of early Christianity have often turned to biblical texts to decode early Christian images, noting with some surprise when the image "diverges" from the literary text. The mosaic at Moni Latomou resists scholars' attempts to index its images by means of written texts. Yet this mosaic is concerned with books and writing (fig. 6). While finding mosaic inscriptions or books depicted within a monumental iconographical program is not unusual,[22] the mosaic of Hosios David—with its five codices, one scroll,[23] and three inscriptions—calls the viewer's attention not only to images but also to writing and to the connection between image and text.[24]

One inscription lies outside the images of the mosaic itself. At the bottom of the mosaic is the dedicatory inscription, which contains letters written in

[21] See n. 5.

[22] We can picture, to give only two examples, the Latin on the open codex Christ holds at Santa Pudenziana in Rome or the Greek "labels," providing name, profession, and some sort of dating system, of the figures on the bottom register of the Rotunda mosaic in Thessalonikē. We also find books laid carefully on pillowed thrones in various early Christian images.

[23] See discussion of the scroll and of the mosaic as a whole as evidence of "realized eschatology" in Luijendijk, "Behold our God."

[24] Of course, if Weitzmann and Kessler are right, then we must consider too that image and word are already connected in illustrated manuscripts and pattern books to which artisans and patrons referred in planning images and which artisans adjusted to fit the space and medium of production. Moreover, as Kessler argues, the choice of images may signal something about Jewish-Christian relations and competition over scripture in a given location (Weitzmann and Kessler, *Frescoes of the Dura Synagogue*).

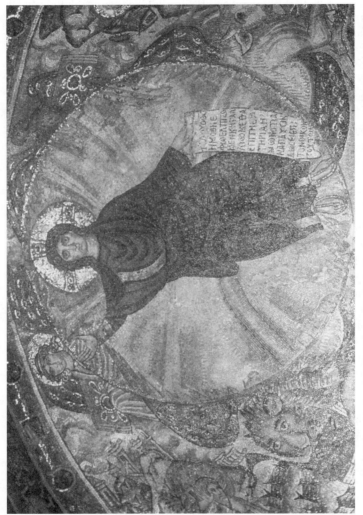

Fig. 6. Detail, central portion of the mosaic. Note the four jeweled codices (one can be seen only partially, on the bottom right) and the scroll. Hosios David, Thessaloniki, Greece. Photo: Holland Hendrix. Harvard New Testament Archaeology Project.

silver tesserae on a deep red background.[25] The inscription is fragmentary, but with the help of Ignatius's *Narrative* and another inscription on the mosaic it has been reconstructed to read:

+ Πηγὴ ζ(ω)τικὴ, δεκτικὴ, θρεπτικὴ ψυχῶν πιστῶν ὁ πα<u>νέντιμος οἶκος</u>
οὗτος. Εὐ<u>ξαμ</u>ένη ἐπέτυχα καὶ ἐπιτυχοῦ<u>σα</u> ἐπλήροσα. +
+ Ὑπὲρ εὐχῆς <u>ἧς οἶδεν ὁ Θεὸς τὸ ὄνομα</u>.[26]

> A life-giving spring, receiving, nourishing faithful souls, is this all-honored house. Having made a vow, I (feminine) attained to it, and having attained to it, I fulfilled it.
> On account of a vow of her whose name God knows.

The fact that the donor was female of course either stimulated the legend of Ignatius's *Narrative*—which relates that Theodora, the emperor's daughter, dedicated the church and mosaic—or is stimulated by it.

The dedicatory inscription expands an inscription contained within the image itself. The figure to the viewer's right and Christ's left sits thoughtfully reading words in an open codex. These words are echoed in the dedicatory inscription at the bottom of the mosaic. The words of the codex are upside down to the viewer, and, in epigrapher Denis Feissel's assessment, are full of mistakes due to the compression of aspects of the dedicatory inscription and due to the small number of tesserae available to form each letter. Feissel offers the following reconstruction:

> On the left:
> + Πη|γὴ ζω|τικὴ, δε | κτ(ικ)ή, θρε|πτικὴ
> On the right:
> ψυ|χῶγ πι|στοῦν (*sic*) | ὁ <π> παν|έν(τι)μος | οἶ(κ)ος ο|(ὗτ)ος +[27]

> Life-giving spring, receiving, nourishing
> faithful souls, is this all-honored house.

Unlike the words on Christ's scroll, discussed below, these inscriptions do not clearly cite an authoritative or scriptural text.

The scroll, rolling downward from Christ's left hand, reads:

+ Ἰδοὺ ὁ Θ(εὸ)ς | ἡμῶν, ἐφ᾽ ᾧ ἐλπίζο|μεν κ(αὶ) ἠγαλλιώμεθα | ἐπὶ τῇ σωτ|ηρίᾳ ἡ|μῶν ὅτι ἀ|νάπαυσιν | δώσει ἐπὶ | τὸν οἶκον | τοῦτον.[28]

[25] Feissel, *Recueil des inscriptions chrétiennes*, 97.

[26] Ibid., 98.

[27] Ibid., 99.

[28] Ibid., 99. Feissel mentions that the initial cross is noted only by Pelikanides and gives

> Behold our God, upon whom we hope; and we rejoice greatly
> in our salvation, that he may give rest in this house.

This text modifies the Septuagint version of Isa 25:9–10a:

καὶ ἐροῦσιν τῇ ἡμέρᾳ ἐκείνῃ Ἰδοὺ ὁ θεὸς ἡμῶν, ἐφ᾽ ᾧ ἠλπίζομεν
καὶ ἠγαλλιώμεθα, καὶ εὐφρανθησόμεθα ἐπὶ τῇ σωτηρίᾳ ἡμῶν.
ὅτι ἀνάπαυσιν δώσει ὁ θεὸς ἐπὶ τὸ ὄρος τοῦτο.

And they will say on that day, "Behold our God, in whom we hope
and rejoiced, and we have delighted in our salvation." God will give
rest upon this mountain.

The inscription on the scroll condenses the Septuagint's redundancies and shifts the end of the verse from "this mountain" to "this house."[29] Thus the church itself, tucked high on the city hill, with its view of the bay below, becomes the hoped-for mountain of God. The rest of the passage in LXX Isaiah[30] describes this mountain as Zion, the eschatological location where the Lord Sabaoth makes a rich feast for all the nations, a mountain where death is swallowed up, tears are wiped away, and the people's shame or disgrace is removed (LXX Isa 25:5–8). This passage from Isaiah is quoted in Rev 21:3–4: The heavenly Jerusalem is a place that is "the dwelling (σκηνή) of God with humans. . . . God himself will be with them and will wipe away every tear from their eyes, and death shall be no more."[31]

The scroll's quotation from Isaiah, together with the imagery of the mosaic, communicates a message that fluidly draws from and evokes a variety of sacred texts. The fact that Christ holds a scroll, rather than an open codex like the figure below, may signal that Christ offers an ancient and venerable proclamation (and a variation of Isaiah) linked with the antiquity and honor given to the Jewish scriptures as compared to the recent texts and still-coalescing canon of the New Testament. The image of Christ holding out a scroll is similar to "portraits" of prophets that predate the Hosios David mosaic, such as that of Jeremiah displaying the "new covenant" (according to Herbert Kessler's interpretation) at Dura Europos[32] or the prophets depicted on either side of the apse at San Vitale in Ravenna. The form of the old covenant as

in the notes variations in Ignatius's *Narrative*.

[29] See LXX (Rahlfs) Isa 25:9–10a. The inscription also skips one phrase found in the Septuagint ("and we have delighted"). (All LXX translations are mine.)

[30] The Septuagint differs from the Hebrew of the Masoretic text.

[31] See also, e.g., Zech 2:14–15, Ezek 37:27, 2 Kgs 6:16, Isa 8:8.

[32] Kessler, Herbert, "Prophetic Portraits in the Dura Synagogue," *JAC* 30 (1987) 149–55.

scroll merges with the meaning of a new covenant and its bringer: Christ (the Messiah) thus offers the words of Isaiah as now his own, a bit revised to fit the "house" of the small church rather than the eschatological mountain to which Isaiah referred. This "house" of Hosios David becomes the location of the *parousia* or appearance of Christ, perhaps the very second coming that Theodora heard about in the reading that inspired her conversion. The "house" of Hosios David is also a place of rest, a life-giving spring (as the dedicatory inscription says), and an evocation of Revelation's promise of an end-time transformation of all humans.

In the center of the mosaic, four closed, jeweled codices are held between the wings, paws, or covered hands of the four creatures described in Ezekiel and Revelation, which are commonly used as signs of the gospel writers or evangelists.[33] While the codex, which looks so much like our books, might seem a commonplace, fifth-century eyes may have seen it as a newer technology that marked Christian identity. Christians of the second century and beyond innovated by elevating the codex to a conveyor of sacred texts, which had earlier usually been inscribed in scrolls.[34] Alongside the open codex held by the figure on the right, Christ's scroll, and the dedicatory inscription, the closed codices speak in their own way of the importance of written texts in relation to the visual image of the mosaic. The mosaic is not only an image, but an image that contains within itself multiple references to literature and writing. These images of writing may in turn encourage the viewer to consider how sacred texts are used in liturgical performances in Hosios David itself. The worshiper may reflect upon the quotation of sacred texts from the Jewish scriptures and from new emerging Christian ones, but also upon the physicality of the texts employed during worship.

Revelation and the Interpretation of the Mosaic

Debate over the meaning of this mosaic has focused not only on Christ, but also on the two figures on either side of him and how these figures might help in better understanding the center of the mosaic. Because Ignatius's *Narrative* describes a chapel dedicated to Zechariah, one or the other of the

[33] But neither Ezekiel nor Revelation has creatures holding books. The conflation of the four creatures with the four gospel writers is a later phenomenon; for the inspiration for these sorts of images in early Christianity we need to move to the late second century and to Gaul, to Irenaeus's *Haer* 3.11.8. Irenaeus does not describe creatures holding books but suggests that the gospels are inevitably four and to be associated with the four animals surrounding the throne in Ezekiel and Revelation.

[34] The codex was more commonly associated with the counting house or the lecture room (Young, *Biblical Exegesis*, 9–16); see also Gamble, *Books and Readers*.

figures has often been interpreted as that prophet.[35] Tsigarides summarizes the many options: "The two figures in the lower corners have been variously identified as Ezekiel and Isaiah, Ezekiel and Zachariah, Ezekiel and St. John the Evangelist, Isaiah and St. John the Evangelist, and also as the Apostles Peter and Paul."[36]

Much work has been done to analyze whether the mosaic inscriptions give clues as to the artist's "sources" for the mosaic and thus clues as to an interpretation of the mosaic as a whole. In the 1940s, Grabar nicely summarized the various possibilities, which have been rehearsed ever since. Grabar shows that the scroll Christ holds echoes Isa 25:9–10. Both Ignatius's *Narrative* and the fourteenth-century icon now in Bulgaria (which probably takes as its source both the mosaic in Thessalonikē and Ignatius's interpretation of it) identify the two figures on either side of Christ as Ezekiel and Habakkuk and thus, according to Grabar, so have scholars thereafter.[37] This identification has some logic to it, as both prophets experienced theophanies.[38] Grabar rejects this identification with Ezekiel and Habakkuk and suggests instead Zechariah and Ezekiel.[39]

Scholars have spent much time trying to identify the two figures on either side of Christ; so too, much attention has been paid to determining the

[35] Diehl ("La mosaïque," 335) states that one is Ezekiel and the other Habakkuk.

[36] Tsigarides, *Latomou Monastery*, 43.

[37] A fourteenth-century icon from the Monastery of St. John the Theologian in Poganovo, Bulgaria, seems to be a copy of the Hosios David mosaic. See Gerasimov, "L'icone bilatérale de Poganovo," 279–88; see also Grabar, "A propos d'une icone."

[38] Ezekiel's "visions of God" happened as "the heavens were opened" beside the river Chobar while he was in exile or captivity (LXX Ezek 1:1 καὶ ἠνοίχθησαν οἱ οὐρανοί, καὶ εἶδον ὁράσεις θεοῦ) and the figure on the left seems particularly interested in the rivers that course from Christ's feet. Habakkuk too speaks of visions at the end times. Hab 2:1 describes the prophet as standing on guard; the Lord says to him: "Write the vision even plainly upon a tablet," and Habakkuk hears from God that "the just shall live by faith" (Hab 2:4 LXX "by my faith"; Grabar, *Martyrium*, 2:198). This phrase, Grabar says, could be linked to the "souls of the faithful" mentioned on the dedicatory inscription and the small codex held by the figure on the right. Although this phrase from Hab 2:4 would indeed become famous in some early Christian communities—perhaps especially because of Paul's use of it in Rom 1:17 where it becomes a key statement of the epistle—a link between the mosaic and Hab 2:4 based only upon the root πιστ- is tenuous indeed, as Grabar himself later mentions.

[39] Grabar, *Martyrium*, 2:199. He finds instead in Zechariah an "evocation of the new Jerusalem" (200) which better fits the figure on the left: "And on that day living water shall issue forth from Jerusalem, half of it to the first sea and half of it to the last sea, and in summer and in spring it will be thus. And the Lord will be king over all the earth; in that day the Lord will be one and his name will be one" (LXX Zech 14:8–9). Grabar considers Zechariah to offer a better textual link because this passage has the motif of living waters and the idea that "Jerusalem shall dwell in security" (Zech 14:11 RSV), a concept that could be echoed in the reference to peace or repose for "this house," found in the scroll of Christ on the mosaic. Grabar concludes that the "author of the mosaic" was guided by Ezek 47:1 and Zech 14:8–9, as well as Isa

meaning of the mosaic as a whole. Since its discovery it has been interpreted as a vision of the glory of God, the *maiestas Domini*, and three biblical texts of theophanies are given as possible sources: Isa 6:1–9, Ezek 1:1–28, and Rev 4:1–11. Certainly, elements of the visions of Ezekiel and Revelation are present in the image. Since the late first-century text of Revelation quotes and draws from Ezekiel, disentangling the two texts is nearly impossible. Both refer to a rainbow. LXX Ezek 1:28 states: "Like a vision of a bow, when it is in a cloud on a rainy day, so was the state of the light all around. This rainbow was a vision of the likeness of the glory of the Lord." Revelation places "around the throne" a rainbow that "looks like an emerald" (Rev 4:3). The four animals are found in Ezekiel in the center of the fire, but with four faces each, and are given a highly complex description (Ezek 1:5f). Revelation simplifies the picture: Around the throne are four living creatures, "full of eyes in front and behind," and their wings too are "full of eyes all round and within" (Rev 4:7–8), just like the creatures in the mosaic. Moreover, Revelation, written in the late first century C.E., co-opts the language and imagery of the Roman Empire in order to resist it and offers an imperial and divine Christ in order to contest the economic and persecutory political order of the day where emperors made claims to be gods.[40] Of course the mosaic does not directly copy from the book of Revelation—with its "one like a son of man" with head and hair "white as white wool, white as snow; his eyes were like a flame of fire, his feet were like burnished bronze" (Rev 1:14–15a)—but we should not expect it to. Images are not indexically related to literary texts but are interpretations of them, rich with associative logic; they are visual examples of intertextuality. The Christ at Hosios David (at least in the legend of Ignatius) hints at a similar interpretation: This mosaic is a theophany that survives all persecutions, whether Roman, iconoclastic, or Muslim.

Yet those writers who interpret early Christian apse mosaics have generally argued that Revelation is not a likely influence on the mosaic at Hosios David. Montague R. James states, for example: "It can be shown then that by the middle of the fifth century the scene of the great Adoration in the Apocalypse had won a central position in the greatest churches of the West. In the East we look for such a thing in vain."[41] James Snyder argues that

25:9, which is found on Christ's scroll. The image thus "offers an eschatological theophany anticipated by the prophets, of which two, Ezekiel and Zachariah, are represented as they witness this vision" (Grabar, *Martyrium*, 2.201). He then bolsters his insight that the seated figure can be identified as Zechariah by referring to the historical legend of the dedication of the church to the prophet Zechariah, which is mentioned in Ignatius's *Narrative*.

[40] See Frilingos, *Spectacles of Empire*; Friesen, *Imperial Cults*.

[41] James, *Apocalypse in Art*, 33. So also Meer, *Maiestas Domini*, 21–24.

the images at Hosios David "have usually been interpreted as the Visions of Ezekiel or Isaiah" precisely because "it is a principle, generally accepted, that the Eastern Christian world rejected John's Apocalyptic vision," although he rightly argues against this conclusion.[42] Art historians' assumptions about Revelation are grounded in comments such as that of James Charlesworth, in his introduction to the Pseudepigrapha: "The Greek Church apparently was not thoroughly convinced about the canonicity of one book, Revelation, until about the tenth century."[43]

It is often assumed that by the end of the second century the canon of the New Testament was closed forever, decided definitively by some church council. The reality was of course much messier.[44] In earliest Christianity, there was no one criterion such as "inspiration" by which books could be collected together; instead, the continued and widespread *use* of certain texts within liturgy and by community determined whether they were considered worthy of inclusion.[45] A closer look at the evidence regarding the book of Revelation reveals that its status in the Greek East was ambiguous.

In the early fourth century, Eusebius in the *History of the Church* (3.25) famously placed Revelation in two categories: the "agreed upon" or recognized texts (ταῦτα μὲν ἐν ὁμολογουμένοις) *and* the books that are

[42] Snyder, "Meaning of the Maiestas," 144. He concludes that "the textual sources that inspired the liturgical *Maiestas domini* in Hosios David included *Revelation*, a book of the Bible rarely accepted in the East" (152). Snyder explains Revelation's impact at Hosios David in light of western influences, which I think is not necessary.

[43] Charlesworth, "Introduction for the General Reader," xxiii; see also Metzger, *Canon*, 16.

[44] Scholars have sometimes argued that the New Testament canon was more or less fixed by the second century C.E. The origin of canon formation is often traced to the anti-Jewish bishop (or bishop manqué) Marcion, who was perhaps the first to develop a Christian canon and a radical one at that: the gospel of Luke, and the letters of Paul expurgated of hints of Paul's Jewish identity or use of Jewish scriptures. Regarding epigraphic evidence and biblical texts, Feissel surveys church inscriptions, house inscriptions (especially lintels), and funerary epitaphs and concludes that "epigraphy . . . can contribute to determining the state of a biblical text in use at a given period in a given part of the Greek world, and to discerning its connection to various manuscript traditions. . . . It is obvious from these all too lacunary pieces of evidence that epigraphy, so varied in time and space, did not even come close to using a uniform biblical text; yet, perhaps in a more modest way, it can be one helpful source in trying to understand the history of the formation and corruptions of the text of the Bible" (Feissel, "Bible in Greek Inscriptions," 294–96).

[45] See, e.g., Koester, "Writings and the Spirit"; McDonald, *Formation*. On Revelation in the New Testament canon in general, see appendix IV: "Early Lists," in Metzger, *Canon of the New Testament*, 305–15. On the use of the Bible in early Christian communal gatherings, see, e.g., Justin *1 Apol.* 66; see discussion of variations in the use of texts from the Old and New Testaments in different regions of the Mediterranean in Rouwhorst, "Readings of Scripture."

"not genuine" (ἐν τοῖς νόθοις). Athanasius's *Thirty-Ninth Festal Letter,* penned in 367 in Egypt, includes Revelation and is the first list to correspond to the books now in the New Testament.[46] But evidence from the late fourth century, especially in Cappadocia, indicates both the inclusion and exclusion of Revelation from the Christian canon.[47] And of course the question of Revelation's value continued for centuries. Martin Luther, for example, said: "I miss more than one thing in this book, and it makes me consider it to be neither apostolic nor prophetic."[48] Revelation even continues to be maligned (offhandedly) by modern-day scholars such as Manlio Simonetti, who says that in the mid-fifth century learning was in decline in both Alexandria and Antioch, and "it is symptomatic that only in this late stage, a period of obvious weariness, do the first Greek commentaries on Revelation appear."[49]

The mosaic of Hosios David is another "manuscript" of this contentious text, another instantiation of the themes of Revelation, with its rainbow, its four creatures, and its depiction of divinity ruling over the *oikoumenē*. Even if Eusebius's canon list is ambivalent about Revelation, we know from other evidence that the text was alive and well in the second and third centuries, at least. 𝔓[47], which Bruce Metzger dates to the mid- or late third century, contains ten codex leaves of Revelation; Revelation is also found in Codex Sinaiticus, which dates to the fourth century.[50] Ideas such as that of the descent

[46] On the politics of developing this list and fixing canon over and against Alexandrian schools, see Brakke, "Canon Formation."

[47] The canon of Gregory Nazianzen, bishop in Cappadocia in the late fourth century, does not count Revelation among the books "of the New Mystery." The canon of Amphilochius of Iconium, again in the late fourth century, expresses ambivalence: "and again the Revelation of John, / Some approve, but the most / Say it is spurious." The canon approved by the third synod of Carthage (397) accepts the book of Revelation (Metzger, *Canon,* 313–15).

[48] In his "Preface to the Revelation of St. John," Martin Luther famously questioned Revelation's authority in the introduction to his translation of the Bible (1522–1527): " 'About this book of the Revelation of John, I leave everyone free to hold his own opinions. I would not have anyone bound to my opinion or judgment. I say what I feel.' Luther marked his evaluation of the book of Revelation even more explicitly in the table of contents, where the twenty-three books of Matthew to 3 John are each assigned a number. Then, below, a blank line precedes the listing of Hebrews, James, Jude, and Revelation, which are all unnumbered" (Metzger, *Canon,* 242). The book of Revelation has long had a strange status in relation to the New Testament canon, from antiquity to our own day. In today's U.S. culture, one rarely hears Revelation read or preached from the pulpit in mainstream Christian churches. Yet the book pervades the national consciousness in many and multifarious forms. The *Left Behind* series of novels, an imaginative retelling of the events of Revelation, is tremendously popular. See Frykholm, *Rapture Culture*; Shuck, *Marks of the Beast.*

[49] Simonetti, *Biblical Interpretation,* 111.

[50] Metzger, *Text of the New Testament,* 38, 42. Revelation may also have been found in Codex Vaticanus, another possibly Constantinian text, but unfortunately that manuscript

of the new Jerusalem are found in sayings attributed to the Montanists, who thrived in the late-second century and originated in Asia Minor.[51] We find rich borrowings from Revelation in so-called apocryphal texts, such as the perhaps mid-second-century C.E. *Epistula Apostolorum*,[52] the perhaps fifth-century *Apocryphal Epistle of Titus*, and especially the second-century *Apocalypse of Peter*, which enjoyed occasional status in the Christian canon. Revelation emerges in apocalypses such as the *Apocalypse of Elijah* (which fleshes out Rev 11:4–12's reference to two prophetic martyrs), the *Apocalypse of Daniel*, the *Apocalypse of Zephaniah*, and the *Sibylline Oracles*, as well as other prophetic or apocalyptic texts.

The iconography of the Moni Latomou mosaic is evidence that Revelation was read and freely interpreted in Thessalonikē in the fifth century.[53] This fact has broader implications. If we acknowledge that the New Testament canon does not begin to close until the fourth century and indeed that our fourth-century evidence indicates an ongoing dispute about the authority and canonicity especially of Revelation, then a mosaic program of the fifth century that *thinks with* Revelation can be an important piece of evidence for the study of canon formation. Such a study cannot be limited to manuscript evidence or canon lists from early Christian writings and church councils. Rather, we must use iconographic evidence in various centuries to investigate the patterns of use of texts and stories that stood on the edge of canonicity.

THE PAROUSIA OF 1 THESSALONIANS, OR, HOW A HOMILY AND A MOSAIC LOOK SIMILAR

Our first illustrated Greek classical texts come from the fourth century C.E., and it is possible that illustrated versions of the Septuagint, for example, predated the mosaic of Hosios David.[54] We should not assume, however, that

breaks off after part of Hebrews (Metzger, *Canon*, 207).

[51] E.g., the saying of either Quintilla or Priscilla found in Epiphanius, *Pan.* 49.1.

[52] See esp. 1.251.

[53] See James, *Apocalypse in Art*, on the popularity of Revelation in early Christian art.

[54] See the work of Weitzmann, *Illustrations in Roll and Codex*. Weitzmann theorizes an evolution in artists' depictions of narrative literary texts. His argument depends, however, upon his assumption that artists were precisely interpreting such texts (see, e.g., p. 23). Weitzmann's thesis is frustrated by what he must assume as artists' "increasing independence from the textual units": "Not very long after the cyclic method was introduced into the representational arts under the influence of literary narration, artists learned to use this method with increasing independence from the textual units, selecting pictures from various texts and mixing them up" (ibid., 27). We should consider instead that versions of the *Iliad*

this mosaic provides a scene or scenes from a literary text. The New Testament canon at this time was fluid; other early Christian texts such as those found in the apocryphal acts of the apostles were also fluid in their variations on beloved stories; early Christian ritual and use of authoritative oral traditions too were in flux.[55] If illustrated manuscripts or pattern books from which artisans drew ideas for their images circulated, yet another level of variety and flux is added to the interpretation of Christian sayings, stories, and ideas.

To understand the mosaic of Hosios David more fully, we must see it as one of many literary and visual texts that interpret authoritative sacred texts to offer their own theological, political, and social messages. As I have indicated above, I agree with scholars like Christa Belting-Ihm and Wayne and Martha Meeks[56] that no one text lies behind the iconography of this mosaic; even the attempt to pin a multitude of texts to certain figures or images within the mosaic is too limited an approach.[57] Instead, this mosaic is evidence of *ongoing practices of early Christian interpretation of sacred or authoritative texts*. I use the awkward locution "sacred or authoritative" because we must keep in mind the fluidity of the canon and Christian predilections for having

and *Odyssey*—two prime texts that Weitzmann argues are illustrated from the archaic period on—were fluid and debated into the Roman period. See Nagy, *Poetry as Performance*. See discussion of the influence of Weitzmann's ideas in Lowden, *Octateuchs*, 4–8; for a critique of the circular reasoning regarding a "lost model," see ibid., 80–83. The Octateuchs that contain illustrations are traditionally dated to the tenth or eleventh century C.E. (ibid., 2); Lowden posits a prototype that dates to the eleventh century (ibid., 83). It is possible, as Weitzmann and Kessler argue, that the third-century C.E. frescoes of the synagogue at Dura Europos may be modeled on manuscript illustrations (*Frescoes of the Dura Synagogue*). The mosaic of Hosios David differs from the Octateuchs and the Dura synagogue in that it does not contain what Weitzmann terms "narrative art" or "cyclic illustration whereby one episode is divided into a number of phases that quickly follow each other" (ibid., 5).

[55] On textual fluidity see Thomas, *Acts of Peter*; for an important study of early Christian ritual that uses Nagy's ideas from *Poetry as Performance*, see Aitken, *Jesus' Death*.

[56] Wayne and Martha Meeks, in their study of the mosaic of Hosios David, sum it up well: "Our survey of biblical passages to which the motifs of the Latomou mosaic might allude amply vindicates Ihm's observation that it does not illustrate a particular text. . . . It is not a pastiche of the three great theophanies Ihm cites, Isa 6:1–5, Ezekiel 1, and Revelation 4. There are more features of the composition that recall Ezekiel's visions than any other, but elements of the Apocalypse are also undeniable, and there are more or less probable allusions to many other texts . . ." (Meeks, "Vision of God," 132). See also Spieser, *Thessalonique*, 159. For a broader discussion, see Barthes, "Rhetoric of the Image," 32–51; Jensen, *Understanding Early Christian Art*, 69–79; eadem, "Early Christian Images and Exegesis."

[57] For an eleventh/twelfth century example of the multiple possible readings of images, consider Bruno of Segni. Kessler states: "Bruno's most important claim, however, is that the patent subjects of church decoration constantly change through the process of interpretation: 'not all of everything is seen at one time,' he insists; some things, in fact, are 'invisible beneath a single image, in some way hidden'" ("Gregorian Reform?" 25–48).

a variety of authoritative texts. We can think of the fifth-century mosaics at Sta. Maria Maggiore in Rome that depict portions of the *Protevangelium of James*, or of the popularity of depictions of Thecla in Egypt and elsewhere in early Christian art, to offer two examples among many.[58] These stories, whether transmitted orally or in a variety of written forms,[59] might or might not become part of a Bible, but they were sacred and authoritative for some communities.[60]

Scholars have tried to shoehorn early Christian biblical interpretation into neat categories such as allegorical and historical, categories that those very interpretations defy.[61] This scholarly attempt to organize early Christian biblical interpretation has also prevented us from seeing how early Christian interpretation, whether in literary text or image, engages in practices similar to contemporaneous or slightly later rabbinic interpretation or midrash. Daniel Boyarin demonstrates that the logic of midrash in the Talmud is that "this is a verse made rich in meaning from many places"; that is, a verse is impoverished if considered only in its own context and is enriched when juxtaposed with other verses. As Boyarin goes on to explain: "the fundamental moment of all of these midrashic forms is precisely the very cocitation of several verses."[62] The nature of midrashic reading "is founded on the idea that gaps and indeterminacies in one part of the canon may be filled and resolved by citing others."[63] The mosaic of Moni Latomou can be read as

[58] Regarding the cult of Thecla especially in Egypt, see Davis, *Cult of Saint Thecla.* Regarding Sta. Maria Maggiore in Rome, see Sieger, "Visual Metaphor as Theology," 84.

[59] On the topic of the fluidity of manuscripts and storytelling in early Christianity, see Thomas, *Acts of Peter*, esp. ch. 4.

[60] On issues of canon and authority, see Koester, "Writings and the Spirit."

[61] Early Christian biblical interpretation is usually characterized as either Antiochene or Alexandrian in nature, as tending toward history or allegory. Young instead explains: "The Fathers were more aware of these complexities ['language and its usage, context, references, background, genre, authorial intention, reader reception, literary structure and so on'] than standard accounts suggest. The traditional categories of 'literal', 'typological' and 'allegorical' are quite simply inadequate as descriptive tools, let alone analytical tools. Nor is the Antiochene reaction against Alexandrian allegory correctly described as an appeal to the 'literal' or 'historical' meaning. A more adequate approach needs to be created" (*Biblical Exegesis*, 2). The question of what constitutes a historical-literal interpretation in contrast to an allegorical one is largely up to scholars' interpretations. Simonetti, for example, will sometimes dismiss a writing because it is too homiletical or moral in focus and insufficiently exegetical; the criterion of what constitutes "exegesis" in the first place, however, is not defined (*Biblical Interpretation in the Early Church*, 53–81, esp. 74 on John Chrysostom and 77 on Athanasius).

[62] Boyarin, *Intertextuality*, 27–29, quotations at 28 and 29.

[63] Ibid., 27.

a fifth-century midrash that brings together various authoritative sacred texts, known through writing or oral performance, in order to offer its own interpretation of the coming of Christ.

I have already argued that Revelation was read in Thessalonikē in the fifth century and should be understood as one influence in the production of the Moni Latomou mosaic. I have also offered in some detail a summary of others' interpretations of how scripture might influence the text of the mosaic inscriptions, the images of the mosaic as a whole, and the identification of the figures to the right and left of Christ. I now wish to suggest another text important to the early viewer's interpretation of the Moni Latomou mosaic, a text that to my knowledge has never been considered as one of the many possible sources for interpreting this mosaic—a curious oversight, since it found its first home and interpreters in the very city where Moni Latomou is.[64] This source is Paul's first letter to the Thessalonians. I suggest 1 Thessalonians for two reasons: First, because it is a local text and among others may have been influential in Thessalonikē, and second, and more importantly, because this source leads us to a late fourth-century homily, a homily that provides a good example of the fluid mixing of sacred and authoritative texts that constituted biblical interpretation at the time.

The first-century city of Thessalonikē, with its imperial cult sites and local honors for Roman benefactors,[65] is the backdrop to Paul's 1 Thessalonians, a letter from the late 40s, addressed to what is likely a community of poor laborers in the city.[66] Language of persecution, opposition, and comfort threads through the letter. Paul is responding to what seems to him a crisis in this community concerning those members who have died:

> For this we declare to you by the word of the Lord, that we who are alive, who are left until the coming of the Lord, shall not precede those who have fallen asleep. For the Lord himself will descend from heaven with a cry of command, with the archangel's call, and with the sound of the trumpet of God. And the dead in Christ will rise first; then we who are alive, who are left, shall be caught up together with them in the clouds to meet the Lord in the air; and so we shall always be with the Lord. (1 Thess 4:15–17)

[64] See Nasrallah, "Empire and Apocalypse in Thessaloniki."

[65] Hendrix, "Thessalonicans Honor Romans."

[66] Friesen, "Poverty in Pauline Studies"; Malherbe, *Letters to the Thessalonians*, 65–66. For an analysis of Paul's language of suffering and space in 1 Thessalonians, see Johnson-DeBaufre, "Extreme Geography," article in draft. I thank the author for allowing me advance access to this research.

This "day of the Lord," Paul continues, "will come like a thief in the night. When people say, 'There is peace and security,' then sudden destruction will come upon them" (1 Thess 5:2–3).[67] Paul describes the coming of the Lord as a *parousia*, a term often used for the appearance of a Roman emperor. As Helmut Koester, James R. Harrison, and others have argued, this passage should be read in light of Roman imperial propaganda. Paul translates the Roman *pax et securitas* into Greek: Those who make claims to offer εἰρήνη καὶ ἀσφάλεια do so falsely. There is no "peace and security" in this present empire; there is no "peace and security" in the face of the "day of the Lord" — a technical term that signals the idea of the coming judgment and the end of the present world.[68]

Later interpreters reading 1 Thessalonians expanded on the connections between Christ's *parousia* and theophany, an imperial *adventus*, and judgment, all themes of the Moni Latomou mosaic and/or its interpretation in Ignatius's *Narrative*.[69] Investigation of one particular homily by John Chrysostom on 1 Thessalonians, especially its comments about Christ's *parousia* or appearance in the sky, allows us to deepen our understanding of the practice of early Christian biblical interpretation — its intertextuality, to use Boyarin's theory of midrash — and so to understand better how the Moni Latomou mosaic engages in the same practice. Many pieces of literature could have demonstrated how early Christians and their Jewish contemporaries weave together various authoritative sacred texts into new ones; Revelation itself, for example, draws from Ezekiel, Daniel, and other traditions of the Jewish Bible. Chrysostom's homily provides a unique example of a sermon about Paul's discussion of the *parousia* of Christ in 1 Thessalonians; although we have commentaries on and references to the Thessalonian correspondence, Chrysostom's writing is the only extant early Christian sermon I know on the topic. I have also chosen Chrysostom's homily because it is a homily and so allows us to imagine better how rhetoric was deployed in church space. Although we do not know how the small church

[67] The translation is RSV.

[68] Later interpreters would explicitly state that Paul in 1 Thessalonians was describing "the day of judgment"; see, e.g., Hippolytus *Comm. in Dan*. 4.21.2. See Koester, "Imperial Ideology," 161–62; Harrison, "Paul and the Imperial Gospel." See also Donfried, "Imperial Cults of Thessalonica." I disagree with Donfried's use of Acts 17 to elucidate 1 Thessalonians and his over-reading of the epistle, where any mention of affliction becomes evidence of Roman persecution of Christians.

[69] "Likewise, when a king enters some city, people in office and of highest station meet him at some distance, while those accused of crimes await the arrival of the judge inside" (Theodoret of Cyrus, *Commentary*, 118).

of Moni Latomou was originally used—it is not a massive public space like the churches of St. Demetrios or Acheiropoietos in the city below—we should imagine the space alive with people who not only saw the mosaic but participated in the liturgy, which included the reading of sacred texts and their interpretation.[70]

John Chrysostom's sermon helps us to understand the mosaic of Moni Latomou in two ways. First, it allows us a new vantage point from which to understand the synthesis of texts and images at Moni Latomou (and potentially in other early Christian images). That is, it helps us to understand concretely the *practices* of interpretation that may have been developing in *both* textual commentary and visual images.[71] Second, one of John Chrysostom's sermons on 1 Thessalonians 4 provides evidence that even in the late third century, the king's appearance and the appearance of Christ are linked and that the concept of theophany is already blurred with 1 Thessalonians 4 and quasi-imperial appearance. Thus, Chrysostom's reading suggests that art historical debates over whether the Moni Latomou mosaic depicts Christ's theophany or Christ as king are moot: Both can be evoked by the image.

In his homilies on 1 Thessalonians, John Chrysostom tends to summarize part of the epistle's text for his congregation. Thus Paul's second-person-plural address to the first-century community in Macedonia mixes with Chrysostom's own address to a fourth-century community in Antioch. This mixing is not a surprise, given Chrysostom's own identification with Paul.[72] Yet not only does Chrysostom identify himself with Paul; he also blurs Paul's audience with his own and in doing so links one civic community

[70] On early Christian liturgy and especially Eucharistic practices, see Dix, *Shape of the Liturgy*.

[71] I am not arguing here that Christian iconographic practices derive from Jewish interpretive practices as might have been found in illuminated manuscripts of the Septuagint (see Weitzmann, "Illustration of the Septuagint," 45–47), but rather that literary and visual processes of interpretation developed alongside each oher and sometimes exhibited similar characteristics. See also Jensen, *Understanding Early Christian Art*, 70.

[72] Mitchell begins her book on Chrysostom's portraits of Paul with this quotation from Chrysostom: "I love all the saints, but I love most the blessed Paul, the chosen vessel, the heavenly trumpet, the friend of the bridegroom, Christ. And I have said this, and brought the love which I have for him out in the public eye so that I might make you, too, partners in this love charm" (Chrysostom, *In illud: Utinam sustineretis modicum*, 28–33 in Migne PG 51.301; quoted and translated in Mitchell, *Heavenly Trumpet*, 1). This phenomenon of identification with Paul extends, as Mitchell discusses, to an eleventh-century manuscript (Vat. Cod. gr. 766, fol. 2ᵛ; plate 1 in Mitchell's book). A small illumination depicts Chrysostom writing; behind and above him hangs a picture of Paul, which is centered near the top of the image; below, Paul himself stands intimately close, looking over Chrysostom's shoulder as he writes (pp. 34–35 and 490; see especially the latter for further bibliography).

(Thessalonian) to another (Antiochene), and one time period (first century) to another (late fourth century).[73] Within the physical walls of the church, identity and time are conflated. This fluid transition between one audience and another, one time period and another, one text and the production of another is a product of the midrashic and intertextual impulses of interpreters of the second to sixth centuries and beyond. So also the hovering Christ of the Moni Latomou mosaic cannot be limited to one time (the judgment) or one text (Revelation or Ezekiel) but evokes a variety of accounts of theophany.

Chrysostom speaks of Paul's praise of the Thessalonian community. In 1 Thess 1:7–10, Paul says, "you became an example to all the believers in Macedonia and in Achaia; for from you the word of the Lord has sounded forth not only in Macedonia and Achaia, but in every place your faith in God has gone forth, so that it is not necessary for us to say anything."[74] John Chrysostom paraphrases, and it is unclear whether he addresses the Thessalonians or his own congregation: "Therefore you have filled all people nearby with learning, it says, and the inhabited world (*oikoumenē*) with wonder" (*Hom. in 1 Thess.* 2). Chrysostom dwells on Paul's use of ἐξηχέω, which, he believes, marks something like the sound of a trumpet. Thus Chrysostom ties Paul's praise of the Thessalonians at the beginning of the letter (immediately following the greeting) with the eschatological message to come in 1 Thessalonians 4–5.[75] The trumpet sounds early, and the noise filling all the world at the *parousia* of Christ is prefigured in the Thessalonians' (or Antiochenes'?) own good report and is evoked, I would argue, in images such as that at Moni Latomou. Of course, as Chrysostom's listeners might recognize, that good report is still filling the world, reaching Antioch and elsewhere.

As we have seen above, New Testament scholars have argued that the message of 1 Thessalonians 4–5, where Christ appears in the clouds, is a political one. Chrysostom confirms the possibility of this reading not only for twentieth- and twenty-first-century scholars, but also for those readers

[73] See Dawson, who borrows the term "figural" from Auerbach, on "the Christian figural reader": "Figural 'meaning' describes the intelligibility discovered in the relation between two events comprising a single divine performance in history. In order to discern the meaningfulness of the relationship, the figural reader cannot allow the description of that relationship to replace the graphic character of the representations being related" (Dawson, *Christian Figural Reading*, 86).

[74] All translations of John Chrysostom's *Hom. in 1 Thess.* are mine. The Greek is taken from the Migne edition available through the TLG.

[75] Chrysostom does the same in *Hom. 1 Thess.* 1, in which he addresses 1 Thess 1:1–7 but still brings in the language of the day of the Lord as a thief from 5:2, 4.

of the fourth century. He frames the fame of the Thessalonian Christians in terms of Macedonian imperial prominence, saying that the Romans were admired for having captured the Macedonians.[76] He reads this straightforward political insight in terms of the vision of the prophet Daniel, who saw Alexander as a winged leopard. The book of Daniel, written in the second century B.C.E. as a critique of Antiochus IV Epiphanes, reaches back to Alexander the Great; John Chrysostom stretches its import forward to the city of Thessalonikē at the time of Paul and perhaps even in the late fourth century. The trumpeting of Thessalonikē (and of the appearance of Christ) in the *oikoumenē* seems to move backward and forward in time, and, as we shall see, visionary builds upon visionary. Here and elsewhere, Chrysostom weaves 1 Thessalonians with ancient prophets and theophanies; this interpretation of one text by means of another results in a mixing of literary sources. The mosaic of Moni Latomou makes a similar interpretive move through its images and texts, mixing phrases that evoke not only Isaiah but also Ezekiel, Revelation, and other texts with images that also evoke such prophetic materials; it produces a visual midrash.

Chrysostom's homily on 1 Thess 4:15–17 insists that Paul experienced a vision and that this vision fits into a larger biblical tradition of theophanies. At the very beginning of the homily, we can observe two things. First, we see the quick pacing and complexity of Chrysostom's quotations and allusions. Second, we note that Chrysostom is interested in bringing together these quotations in order to demonstrate the continuity of Paul's visionary experience and prophetic voice with the great authorities of the past (the Jewish prophets) as well as Paul's difference and greater authority in this visionary realm:

> The prophets, wishing to demonstrate the trustworthiness of [their] sayings, said this before all other things: "The vision, which Isaiah saw," and again, "The word of the Lord, which came to Jeremiah," and again, "The Lord says these things," and other such statements. And many saw God himself seated, as it was possible for them to see. But Paul did not see him seated, but having in himself Christ speaking, instead of this ["The Lord says these things"], he said, "Or do you seek proof of Christ speaking in us?" (2 Cor 13:3) and again, "Paul apostle of Jesus Christ" (Gal 1:1 modified), showing that nothing [he said] is his. For the apostle uttered the word of him who sent him. And again, "I think that even I have the spirit of God." (1 Cor 7:40) (*Hom. 1 Thess.* 8)

[76] Chrysostom, *Hom. 1 Thess.* 2.

In this passage we find structural and conceptual echoes of the mosaic of Moni Latomou. Chrysostom clusters together, fast and furious, a set of authoritative prophets and their means of guaranteeing their visionary experience. In addition, he weaves together the weighty authority of past prophets, who are indubitably canonical scripture in the fourth century, with a newer and more contentious figure, Paul, to whom Chrysostom is particularly attached. Chrysostom lifts Paul up and suggests that his visionary experience of Christ's theophany in 1 Thessalonians 4 is not lesser than ancient forms of prophetic experience gained through vision (the debate over the seated God) or audition (the merging of the prophet's and God's voices, or of Paul's and Christ's voices).

When Chrysostom comes to the quotation and discussion of Paul's statement about the *parousia*, his midrashic moves are no less complex. Thus Chrysostom engages the sacred text point-by-point, explaining it by means of other scripture. I quote at length:

> Therefore let us see now even what he says. "For we say this to you in a word of the Lord, that we who are living, who survive until the *parousia* of the Lord, will not outstrip those who have fallen asleep, because the Lord himself by a word of command, by the voice of an archangel, and by a last trumpet will descend from heaven."[77]

> • Christ also then said this very thing: "The powers of the heavens will be shaken" (Matt 24:29).

> • Why in the world by a trumpet? For also on Mount Sinai we saw this, and there were angels there [see Exod 19:16; 20:18; Acts 7:39 regarding an angel being at Mount Sinai; also Exod 32:34].

> • But what does "the voice of the archangel" mean? Just as he said concerning the virgins: "Rise, the bridegroom has come" (cf. Matt 25:6). Either it says this, or that just as with a king, thus also it will be then, with angels [or messengers] serving at the resurrection. For it says, "Let the dead rise," and the deed is done; the angels are not mighty enough for this work, but his word is. It is as if a king commanded and said: "Let those who have been shut up go forth, and let the servants lead [them] out: They do not now [do this] finally by their own might but by his voice. And Christ said this elsewhere: "He will send his angels with a great trumpet, and they will gather his chosen ones from the four winds, from the edges [i.e., from one end of heaven to the other; Matt 24:31]." (*Hom. 1 Thess.* 8)

[77] Chrysostom offers a slight variation on the now-accepted text of 1 Thess 4:15–16.

This passage demonstrates four interpretive practices in which both Chrysostom and the mosaic of Moni Latomou engage. First, one scripture is explained by another, and catchwords or phrases govern the logic of the explanation. Authoritative texts broadly construed can be concatenated to advance a new meaning. Second, those scholars who are familiar with rabbinic texts of the Mishnah (codified in the third century), for example, will hear the similarities of John Chrysostom's method of arguing with rabbinic modes of thought. In the latter, as Daniel Boyarin puts it, midrash seeks to explain puzzles within the biblical text.[78] The Mishnah offers multiple voices side by side: Rabbis over time and space seek together to puzzle out the meaning of scripture. Here we are reduced to Chrysostom alone; nevertheless, a similar interpretive logic governs. Choices that might puzzle ("Why in the world by a trumpet?") are explained by means of other scriptures. Third, the passage allows us to see a heavenly Lord in action, to experience the *parousia* and to note the differences and similarities between Chrysostom's presentation of it and that at Moni Latomou. Fourth, Chrysostom's treatment of 1 Thessalonians shows that 1 Thessalonians 4 can reasonably be added to the many scriptural allusions or quotations that scholars have attributed to the mosaic of Moni Latomou.

Conclusions

The mosaic of Moni Latomou thus provides a site for thinking about the intersection of literary and visual texts in early Christianity and the hermeneutical processes by which authoritative written and visual texts are combined and recombined. Despite my own training as a scholar of New Testament and early Christian literature, my goal in this essay has been to move away from our impulses—impulses shared even by art historians—to give priority to literature and to find firm literary links to "explain" the images of a mosaic. Instead, the mosaic of Moni Latomou has allowed us to explore the fluidity of the canon of the Christian Testament in the fifth century, on the one hand, and the midrashic interpretive practices of early Christians, on the other. These themes elucidate the early Christian interpretive practices that produced this beautiful mosaic.

This essay has advanced two arguments in relation to the early Christian mosaic of Moni Latomou. Scholars have questioned the links between the mosaic's images and the book of Revelation. Some scholars have argued that

[78] Boyarin, *Intertextuality*, x.

the mosaic represents the "vision of Ezekiel," stating that Revelation was not included in the canon of the Greek East and could not have influenced it. I have argued that this logic is backward, especially because of the fluidity of the New Testament canon in the fourth century and beyond. We should instead see that the mosaic of Moni Latomou provides evidence that Revelation was part of a *local* canon for Thessalonikē; it was *not* marginal but was vibrantly used and interpreted in at least one early Christian community there.[79]

Second, the mosaic of Moni Latomou, as we have seen, is concerned not only with communicating through images but also through written texts: five codices and a scroll, mosaic inscriptions, Revelation, 1 Thessalonians, and the prophets of the Jewish scriptures. The mosaic is self-consciously intertextual, bringing together with its image of the reigning, pacific, teaching Christ writings that would have had meaning to those persons of the fifth century who worshiped there. It is an intertextual response that, like the book of Revelation itself, brings together a variety of texts to produce an entirely new message. The inscriptions point us to Isaiah; the two figures on either side to ancient prophets; the four creatures that came to be understood as stand-ins for the evangelists point us to Revelation; Christ seated on the rainbow, his hand in a gesture of *ad locutio*, brings us to the speaking emperors and the philosophers of Jesus' own time. As John Chrysostom's imaginative catena or chain weaves 1 Thessalonians with prophets and theophanies, with Matthew's four winds and angels, as it confuses and mixes texts together, so we can imagine a similar associative logic operative for those Christians who planned the mosaic of Moni Latomou.

Chrysostom's sermon is thus a literary model of the sort of intertextuality performed at Moni Latomou. It also supports my argument that the ordinary viewer in Thessaloniki in the fifth century may have seen in this mosaic resonances with 1 Thessalonians. John Chrysostom's rhetoric demands that his listeners consider their own righteousness before the judge in the skies at the last trumpet. So also the mosaic at Moni Latomou exerts its own rhetoric on the viewer, demanding that she behold her God, asking that she understand her God in *this* form, hovering over the inhabited world in *this* way.

[79] In fact, earliest Christian iconography is a tool for the study of New Testament canon formation. Images should inform our understanding of how various texts were used in various locations and at various times.

BIBLIOGRAPHY

Aitken, Ellen Bradshaw. *Jesus' Death in Early Christian Memory: The Poetics of the Passion*. Göttingen: Vandenhoeck & Ruprecht; Fribourg: Academic Press, 2004.

Barthes, Roland. "Rhetoric of the Image." Pages 32–51 in *Image—Music—Text*. Translated by Stephen Heath. New York: Hill and Wang, 1977.

Boyarin, Daniel. *Intertextuality and the Reading of Midrash*. Bloomington, Ind.: Indiana University Press, 1990.

Brakke, David. "Canon Formation and Social Conflict in Fourth-Century Egypt: Athanasius of Alexandria's Thirty-Ninth 'Festal Letter.'" *HTR* 87 (1994) 395–419.

Certeau, Michel de. *The Practice of Everyday Life*. Translated by Steven Rendall. Berkeley, Calif.: University of California Press, 1984.

Charlesworth, James. "Introduction for the General Reader." Pages xxi–xxxiv in *Apocalyptic Literature and Testaments*. Vol. 1 of *The Old Testament Pseudepigrapha*. Edited by idem. Garden City, N.Y.: Doubleday, 1983.

Ćurčić, Slobodan. *Some Observations and Questions Regarding Early Christian Architecture in Thessaloniki*. Thessaloniki: Hypourgeio Politismou. Ephoreia Vyzantinōn Archaiotētōn Thessalonikēs, 2000

Davis, Stephen J. *The Cult of Saint Thecla: A Tradition of Women's Piety in Late Antiquity*. New York: Oxford University Press, 2001.

Dawson, John David. *Christian Figural Reading and the Fashioning of Identity*. Berkeley, Calif.: University of California Press, 2002.

Diehl, Charles. "A propos de la mosaïque d'Hosios David à Salonique." *Byzantion* 7 (1932) 335–38.

———. *CRAI* (1927) 256–61.

Dix, Gregory. *The Shape of the Liturgy*. 2d ed. London: Black, 1960.

Donfried, Karl. "The Imperial Cults of Thessalonica and Political Conflict in 1 Thessalonians." Pages 215–23 in *Paul and Empire: Religion and Power in Roman Imperial Society*. Edit-ed by Richard A. Horsley. Harrisburg, Pa.: Trinity Press International, 1997.

Feissel, Denis. "The Bible in Greek Inscriptions." Pages 294–96 in *The Bible in Greek Christian Antiquity*. Edited and translated by Paul M. Blowers. The Bible through the Ages 1. Notre Dame, Ind.: University of Notre Dame Press, 1997.

———. *Recueil des inscriptions chrétiennes de Macédoine du IIIᵉ au VIᵉ siècle*. Athens: École française d'Athènes, 1983.

Friesen, Steven J. "Poverty in Pauline Studies: Beyond the So-Called New Consensus." *JSNT* 26 (2004) 323–61.

———. *Imperial Cults and the Apocalypse of John: Reading Revelation in the Ruins*. New York: Oxford University Press, 2001.

Frilingos, Christopher. *Spectacles of Empire: Monsters, Martyrs, and the Book of Revelation*. Philadelphia: University of Pennsylvania Press, 2004.

Frykholm, Amy. *Rapture Culture: Left Behind in Evangelical America*. New York: Oxford University Press, 2004.

Gamble, Harry. *Books and Readers in the Early Church: A History of Early Christian Texts*. New Haven, Conn.: Yale University Press, 1995.

Gerasimov, Todor. "L'icone bilatérale de Poganovo au Musée archéologique de Sofia." *CA* 10 (1959) 279–88.

Gerke, Friedrich. "Il mosaico absidale di Hosios David di Salonicco." *Corsi di Cultura sull'arte ravennate e bizantina* 11 (1964) 179–99.

Grabar, André. *Martyrium. Recherches sur le culte des reliques et de l'art chrétien antique.* 2 vols. Paris: Collège de France, 1946. Repr., London: Variorum Reprints, 1972.

———. *Christian Iconography: A Study of Its Origins.* Bollingen Ser. 35.10; Princeton, N.J.: Princeton University Press, 1968.

———. "A propos d'une icone Byzantine du XIVᵉ siècle." *CA* 10 (1959) 289–304.

Harrison, James R. "Paul and the Imperial Gospel at Thessaloniki." *JSNT* 25 (2002) 71–96.

Hendrix, Holland. "Thessalonicans Honor Romans." Th.D. diss., Harvard Divinity School, 1984.

Hoddinott, Ralph F. *Early Byzantine Churches in Macedonia and Southern Serbia.* London: MacMillan, 1963.

Iliadis, I. G. "The Natural Lighting of the Mosaics in the Rotunda at Thessaloniki." *Lighting Resource and Technology* 33 (2001) 13–24.

James, Montague Rhodes. *The Apocalypse in Art.* The Schweich Lectures of the British Academy 1927. London: Oxford University Press, 1931.

Jensen, Robin. "Early Christian Images and Exegesis." Pages 65–85 in *Picturing the Bible: The Earliest Christian Art.* Edited by Jeffrey Spier. New Haven, Conn.: Yale University Press, 2007.

———. *Understanding Early Christian Art.* New York: Routledge, 2000.

Johnson-DeBaufre, Melanie. "Extreme Geography: Mapping the Bodies of Believers in 1 Thessalonians." Article in draft.

Kaltsogianni, Heleni, et al., eds. *Thessaloniki in Byzantine Literature: Historical and Hagiographical Texts.* Byzantine Texts and Studies 32. Thessaloniki: Byzantine Research Centre of the University of Thessaloniki, 2002. [in Greek]

Kessler, Herbert. "A Gregorian Reform Theory of Art?" Pages 25–48 in *Rome e la Riforma Gregoriana. Tradizioni e innovazioni.* Edited by Serena Romano and Julie Enckell Julliard. Études lausannois d'histoire de l'art 5. Rome: Viella, 2007.

———. "Prophetic Portraits in the Dura Synagogue." *JAC* 30 (1987) 149–55.

Koester, Helmut. "Imperial Ideology and Paul's Eschatology in 1 Thessalonians." Pages 158–66 in *Paul and Empire: Religion and Power in Roman Imperial Society.* Edited by Richard Horsley. Harrisburg, Pa.: Trinity Press International, 1997.

———. "Writings and the Spirit: Authority and Politics in Ancient Christianity," *HTR* 84 (1991) 353–72.

Krautheimer, Richard and Slobodan Ćurčić. *Early Christian and Byzantine Architecture.* 4th ed. New Haven, Conn.: Yale University Press, 1986.

Lampe, Geoffrey W. H. *A Patristic Greek Lexicon.* Oxford: Clarendon Press, 1961.

Lowden, John. *The Octateuchs: A Study in Byzantine Manuscript Illustration.* University Park, Pa.: Pennsylvania State University Press, 1992.

Luijendijk, AnneMarie. "Behold our God: The Apse Mosaic of Osios David." Unpublished paper. April 1995.

Luther, Martin. "Preface to the Revelation of St. John" (1522). Online: http://www.bible-researcher.com/antilegomena.html.

Malherbe, Abraham. *The Letters to the Thessalonians.* Anchor Bible 32B. New York: Doubleday, 2000.

Mathews, Thomas. *The Clash of the Gods: A Reinterpretation of Early Christian Art.* Princeton, N.J.: Princeton University Press, 1993.

McDonald, Lee. *The Formation of the Christian Biblical Canon.* Rev. ed. Peabody, Mass.: Hendrickson, 1995.

Meeks, Wayne and Martha. "Vision of God and Scripture Interpretation in a Fifth-Century Mosaic." Pages 124–45 in *Reading in Christian Communities: Essays on Interpretation in the Early Church.* Edited by Charles A. Bobertz and David Brakke. Notre Dame, Ind.: University of Notre Dame Press, 2002.

Meer, Frederik van der. *Maiestas Domini: théophanies de l'Apocalypse dans l'art chrétien.* Rome: Pontifical Institute of Christian Archaeology, 1938.

Metzger, Bruce. "Early Lists of the Books of the New Testament." Pages 305–15 in idem, *The Canon of the New Testament: Its Origin, Development, and Significance.* Oxford: Clarendon, 1985.

———. *The Text of the New Testament: Its Transmission, Corruption and Restoration.* New York: Oxford University Press, 1964.

Migne, Jacques-Paul. *Patrologiae Graecae.* Paris: J.-P. Migne, 1857–1866. Online: http://nrs. harvard.edu/urn-3:hul.eresource:patrgrae.

Mitchell, Margaret. *The Heavenly Trumpet: John Chrysostom and the Art of Pauline Interpretation.* Louisville, Ky.: John Knox, 2002.

Nagy, Gregory. *Poetry as Performance: Homer and Beyond.* Cambridge, U.K.: Cambridge University Press, 1996.

Nasrallah, Laura. "Empire and Apocalypse in Thessaloniki: Interpreting the Early Christian Rotunda." *JECS* 13 (2005) 465–508.

Papadopoulos-Kerameus, Athanasios. *Varia Graeca sacra. Sbornik grečeskich neizdannych bogoslovskich tekstov IV-XV vekov.* St. Petersburg: Zapiski of the Historical-Philological Faculty of the University of St. Petersburg, 1909.

Pelikanides, Stylianos. *Early Christian Monuments of Thessalonikē: Acheiropoiētos, Moni Latomou.* Thessaloniki: Pan. Pournara, 1973. [in Greek]

Rahlfs, Alfred, ed. *Septuaginta. Verkleinerte Ausgabe in einem Band.* Stuttgart: Deutsche Bibel-Gesellschaft, 1935, 1979.

Rouwhorst, Gerard A. M. "The Readings of Scripture in Early Christian Liturgy." Pages 305–31 in *What Athens has to do with Jerusalem: Essays on Classical, Jewish, and Early Christian Art and Archaeology in Honor of Gideon Foerster.* Edited by Leonard V. Rutgers. Leuven: Peeters, 2002.

Rufus, Charles. "A Note on the Date of the Mosaic of Hosios David at Salonika." *Byzantion* 7 (1932) 342–43.

Shuck, Glenn. *Marks of the Beast: The Left Behind Novels and the Struggle for Evangelical Identity.* New York: New York University Press, 2005.

Sieger, Joanne Deane. "Visual Metaphor as Theology: Leo the Great's Sermons on the Incarnation and the Arch Mosaics at S. Maria Maggiore." *Gesta* 26 (1987) 83–91.

Simonetti, Manlio. *Biblical Interpretation in the Early Church: An Historical Introduction to Patristic Exegesis.* Translated by John A. Hughes. Edinburgh: T&T Clark, 1994.

Snyder, James. "The Meaning of the 'Maiestas Domini' in Hosios David." *Byzantion* 37 (1967) 143–52.

Spieser, Jean-Michel. "The Representation of Christ in the Apses of Early Christian Churches." *Gesta* 37 (1998) 63–73.

————. *Thessalonique et ses monuments du IV^e au VI^e siècle*. Bibliothèque des écoles françaises d'Athènes et de Rome. Paris: de Boccard, 1984.

Theodoret of Cyrus. *Commentary on the Letters of St. Paul*. 2 vols. Translated by Robert Charles Hill. Brookline, Mass.: Holy Cross Orthodox Press, 2001.

Thomas, Christine M. *The Acts of Peter, Gospel Literature, and the Ancient Novel: Rewriting the Past*. New York: Oxford University Press, 2003.

Tsigarides, Efthymios. *Latomou Monastery (The Church of Hosios David)*. Thessaloniki: Institute for Balkan Studies, 1988.

Vasiliev, A. "Life of David of Thessalonica." *Traditio* 4 (1946) 115–47.

Weitzmann, Kurt. "The Illustration of the Septuagint." Pages 45–47 in *Studies in Classical and Byzantine Manuscript Illumination*. Edited by Herbert Kessler. Chicago: University of Chicago Press, 1971.

————. *Illustrations in Roll and Codex: A Study of the Origin and Method of Text Illustration*. Princeton, N.J.: Princeton University Press, 1947. Repr., 1970.

———— and Herbert Kessler. *The Frescoes of the Dura Synagogue and Christian Art*. Washington, D.C.: Dumbarton Oaks Research Library and Collection, 1990.

Xyngopoulos, Andreas. "The Sanctuary of the Monastery of the Stone-Worker in Thessalonikē and its Mosaics." *ArchDelt* 12 (1929) 142–80. [in Greek]

Young, Frances. *Biblical Exegesis and the Formation of Christian Culture*. Cambridge, U.K.: Cambridge University Press, 1997.

CHAPTER FOURTEEN

Late Antiquity and Christianity in Thessalonikē: Aspects of a Transformation

Charalambos Bakirtzis

The city of Thessaloniki that the visitor encounters today is the result of a series of events and socioeconomic phenomena that occurred during the first quarter of the twentieth century: the surrender of Thessaloniki to Greece by the Turkish authorities in 1912 during the Balkan Wars (1912–1913), the devastating fire in the city in 1917 toward the end of the First World War (1914–1918), and the migration and settlement in the city of Greek refugees from Eastern Romulia in 1918 and from Asia Minor in 1922 after the war between Greece and Turkey (1919–1922). All these events gave the former oriental city, with its distinctly cosmopolitan and Balkan air, a peripherally European orientation.[1] This change became evident in the new town plan, which combined a French colonial style with a neo-Byzantine flavor, and in the new role played by monuments within the urban fabric. Once lost in a labyrinth of alleys and amid the daily life of the city, the monuments were elevated to landmarks by the new plan.[2]

Yet, these events reflect only the most recent of a series of transformations throughout the city's long history. Maybe the most important events that shaped Thessaloniki's complex cultural tradition date back to its early history

[1] Bakirtzis, "Byzantine Thessaloniki," 155–62.
[2] Yerolympos, *Urban Transformations*, 87–125.

and to the city's transformation into one of the important Christian centers of the Byzantine Empire. The title of our volume refers to this event: "From Roman to Early Christian Thessalonikē." Many parameters accompany this transformation, some of which are presented in the Museum of Byzantine Culture in Thessaloniki under the title: "From the Elysian Fields to the Christian Paradise."[3] My contribution will address some other aspects of this phenomenon, focusing on two important institutions in Late Antique Thessalonikē: the hospital in the basilica of St. Demetrios and the theater life in the city.

<p style="text-align:center">* * * * *</p>

Οἱ ὑπηρετοῦντες τοῖς ἐν τῷ ξενοδοχείῳ ἀρρώστοις μετὰ τοιαύτης διαθέσεως ὑπηρετεῖν ὡς ἀδελφοῖς τοῦ κυρίου ὑπηρετοῦντες.

Those who serve the sick in the inn for strangers: let them serve with such a disposition as if they were serving the brothers of the Lord.

<p style="text-align:center">Saint Basil, Bishop of Caesarea</p>

The oldest of the *Miracles of Saint Demetrios*, the kernel of which recount events that occurred in Thessalonikē at the end of the sixth century, make frequent references to medical cases.[4] This fact illustrates the intention of the author of the *Miracles* to stress the real nature of the miraculous interventions of St. Demetrios. As a result, the descriptions of the symptoms of the patients correspond to reality. The Eparch Marianos, for example, sought the aid of St. Demetrios after he had suffered a stroke (§§ 14, 98). The case of the official with bleeding is an instance of a stomach hemorrhage (§ 25). The symptoms of the demoniac soldier who was detained by his comrades in their camp in Thessalonikē are consistent with those of schizophrenia or bipolar disorder (§ 47). From the limited information provided by the *Miracles of Saint Demetrios* on the methods of treatment (§§ 14, 26), we can see that these treatments were modeled on the ancient medical practices of Hippocrates and Galen.

Apart from the cases of illness which afflicted the citizens of Thessalonikē, the narratives of the *Miracles of Saint Demetrios* also include random information about the medical care provided to the sick in Thessalonikē at

[3] Kourkoutidou-Nikolaidou, "From the Elysian Fields," 128–42.

[4] Lemerle, *Les plus anciens recueils*, §§ 14, 25, 38, 47, 98, 246, and 261; Bakirtzis, Ἁγίου Δημητρίου Θαύματα, 361–62, 365, 367, 372, 384, 420, 423.

the end of the sixth century. Collating this information allows us to sketch the hospital regime in the city at that time.

In the first instance, the sick were looked after in their own homes or in the churches of the city (§§ 37, 45). The churches, which were not recorded by name, certainly had space set aside for the provision of health care treatment. A room with special arrangements in the eastern side of the *cryptoporticus* of the Agora in Thessaloniki, with a wall painting of St. Kosmas and St. Damianos dating from the sixth century, served as a surgery (fig. 1).[5] In the basilica of St. Demetrios, the residents of the city received medical services and treatment irrespective of their social standing: the paralyzed eparchs (§§ 14, 98),[6] the hemorrhaging official (§ 25), and a variety of residents of the city with serious illnesses, such as malignant fevers, bubonic swellings, bloody sputum (§ 38), and psychiatric problems (§ 47).[7]

The narratives make no mention of any stretcher service for moving patients; rather, the patients were taken to the church by their families on a stretcher, on an animal, or in their arms (§§ 18, 47). Upon the patients' arrival, the church personnel provided them with a mattress, once they had been told of their admission by the hospital's administrative services (§§ 20, 22, 47). During the time of their stay they did not wear everyday clothes but probably a sort of short tunic provided by the health care service of the basilica (§§ 22, 49).

The doctors, specialists in a variety of fields, followed the progress of the patients, made rounds every day (§ 42), and took case histories (§ 38). Thereafter they would hold a discussion, each contributing knowledge from his own specialty, and agree on the course of treatment to be followed. Specialists with a good reputation would also practice in other towns and be invited to Thessalonikē as circumstances required (§ 14). Apart from a bed, patients were also provided with food and hot baths (§ 39). This means that the patients' ward must have communicated with the food preparation and dining area, as well as with the bathhouse. In other words, they were on the north side of the basilica, where bath installations and other annexes of the basilica have been excavated.[8] Relatives of the patients did not stay overnight (§ 49). This indicates that the basilica had sufficient auxiliary staff for a night

[5] Bakirtzis, "Ἡ Ἀγορὰ τῆς Θεσσαλονίκης," 5–18.

[6] Paralyzed eparchs represent a common medical case. Lascarato and Manduvalos, "Cases of Stroke," 5–10.

[7] We find no reference to any kind of exorcism as curative method. Vakaloudi, "Illnesses," 189–94.

[8] Soteriou, Ἡ βασιλική, 299–302, 317–32.

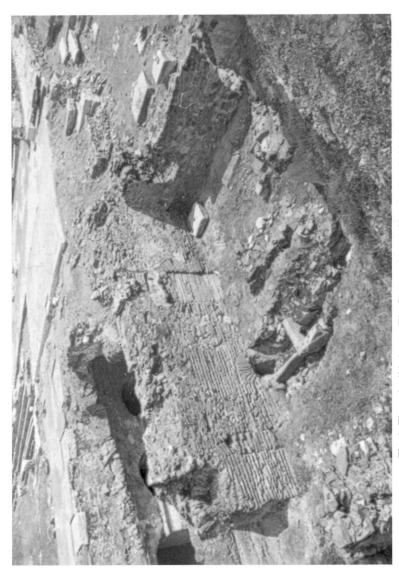

Fig. 1. Thessaloniki. Agora: The Surgery. Photo: Charalambos Bakirtzis.

shift, probably made up of volunteers. Once the patients had recovered their health, they were returned to their families (§ 45).

We have no record of any charge for treatment or of the cost of running the hospital. The wages for the doctors and staff must have been borne exclusively by the church and would have been included as a municipal service in its charitable work.

Apart from the medical and hospital care provided by the basilica of St. Demetrios in the location where patients were treated, miraculous cures occurred during the night with the appearance of St. Demetrios himself in a vision (§§ 39, 42):

> And he, that is the sick man, in a kind of ecstasy, saw the saint at night, dressed in a cloak, with a ruddy and cheerful countenance, as if he were a consul, . . . observing all of those who were in danger. On some he laid his hand and made the sign of the cross; on others he bestowed a troubled look; and a few he passed by frowning, with a heavy heart, as if he could not bear to behold them, in the great sadness he felt for them. Without exception, these latter died at dawn, or soon afterwards. Those he had honored with a visit, but had been troubled to look upon, did not die, but remained ill for a long time, though with hope of being cured. . . . The others, whom he had signed with his grace, showed signs of returning health first thing in the morning. (§ 42)

The location where the saint appeared and where the patients were tended was considered a *locus sanctus* (ἱερὸς τόπος).[9] It also communicated with the food preparation and dining area and the bathhouse. For these reasons, I have formed the view that this space was on the northwest corner of the basilica (fig. 2), where, since the end of the seventh century, the grave of St. Demetrios has been located.[10]

It appears from the above information that at the end of the sixth century the city of Thessalonikē provided its citizens with free hospital care in the church of its patron saint in rather the same way as did the *xenon* (hospital) of Sampson, which was attached to the church of Hagia Sophia in Constantinople, and other hospitals.[11] In the hospital of St. Demetrios, scientific, Hippocratic medicine was practiced, and, at the same time and in the same location, miraculous cures were effected in visions by incubation, in accordance with the Asklepian models of antiquity.[12] The unique nature

[9] For "hierophany" and "hierotopy," see Lidov, "Hierotopy," 33.

[10] Bakirtzis, "Pilgrimage to Thessalonike," 191.

[11] Miller, *Birth of the Hospital*, 84, 121–24.

[12] Steger, *Asklepiosmedizin*, 104–65; Edelstein and Edelstein, *Asklepios,* 181–213; Chaniotis, "Illness and Cures," 323–34; Nutton, "Galen to Alexander," 7.

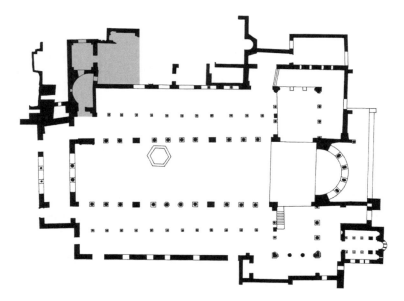

Fig. 2. Thessaloniki. Plan of the basilica of Saint Demetrios.
Charalambos Bakirtzis.

of St. Demetrios's cult emerges from the comparison of his attitude toward the science of Hippocratic medicine with that of other doctor saints, such as Kosmas and Damianos or Artemios, who worked their miraculous cures by incubation in their churches in Constantinople. St. Demetrios was neither hostile toward doctors nor skeptical about their methods of treatment.[13] He did not compete with the doctors by indicating treatment and medication which conflicted with their prescriptions. In addition, he seems to have made a distinction between the healing roles of the saint and the doctors. St. Demetrios did not cure with medication and exercise, but in a miraculous way and left the implementation of Hippocratic medicine to the hospital doctors. The latter accepted his miraculous acts, confirmed the patients' cure, and issued the appropriate discharge documentation (§ 42).

The cult of Asklepios was popular in the Greco-Roman world, and Asklepieia appeared in many cities. Treatment at these centers was performed through the incubation of the patient, to whom the god appeared during the course of sleep. The cure which Asklepios offered was effected by touch but also by the recommendation of medicines and other medical treatment.[14] The

[13] For the hostility toward doctors in early Christian times, see Miller, *Hospital*, 69–71.

[14] Edelstein and Edelstein, *Asklepios*, 145–58.

priests at the Asklepieia were often doctors as well. The cult of Asklepios was not unknown in Roman Thessalonikē,[15] and one of the three clans of the city was called Asklepias. The god's worshipers had their own religious association called Asklepiastai.

Healing by dream was practiced in the famous Sarapeion of Thessalonikē.[16] Not a single one of the sixty-nine inscriptions found in the city and linked to the cult of Egyptian gods refers to any manner of communication between god and patients other than dreams.[17] Nor do we find any recommendation on the part of the god concerning medication or other medical treatment, as was often the case with Asklepios. In other words, we see that St. Demetrios tended to follow the therapeutic practice of Sarapis rather than that of Asklepios, whose arts were closer to those of the doctor saints of Constantinople.

We can therefore understand that the personality of St. Demetrios did not engulf merely the cult of Kabeiros, as has been pointed out by Edson and Touratsoglou,[18] but also those of other popular gods of Roman Thessalonikē, such as Asklepios and Sarapis, the main characteristic of whom he perpetuated. And something else: Just as Sarapis shared a temple and altar with Isis (σύνναος and σύμβωμος), so St. Demetrios was worshiped in the basilica together with the Mother of God, whose characteristics drew upon those of Isis.[19] In the famous ciborium, which was in the central nave of the basilica, St. Demetrios dwelt alongside Lady Eutaxia ("Good Order") (§§ 81–93), who was none other than the goddess Fortune (Tyche) of the city.[20] Indeed, the author of the *Miracles of Saint Demetrios* had no hesitation in declaring that, together with other saints, Demetrios protected the city (§ 220). The author thus allowed correlations to be made with the polytheism that had previously existed in Roman and Late Roman Thessalonikē.

Such an important contribution by the basilica of St. Demetrios should have left a trace. The iconography in the church is of a dedicatory nature and was under the control of the clergy. A recurring theme in the early

[15] Tzanavari, "Worship of Gods," 241–45.

[16] Koester, "Archaeology and Paul," 47–54; Vitti, *H πολεοδομική εξέλιξη*, 174–75; Steimle, "Neue Erkenntnisse zum Heiligtum," 291–306, and, in this volume, Koester, "Egyptian Religion in Thessalonikē," 133–50.

[17] Fraikin, "Note on the Egyptian Gods," 1–6; idem, "Thessalonike: Egyptian Gods."

[18] Edson, "Cults of Thessalonica," 203–4; Touratsoglou, "Τοῦ ἁγιωτάτου πατρῴου," 71–83.

[19] Witt, *Isis in the Ancient World*, 272. For the phrase "σύνοικον δ' ἔλαβες Σέραπιν," see Grandjean, *Une nouvelle arétalogie*, 17, line 17. For Virgin *lactans* and Isis *lactans*, see Corrington, "Milk of Salvation," 402–13.

[20] Bakirtzis, "Lady Eutaxia of Thessaloniki," 18–29.

Christian mosaics in the basilica is children. This point has aroused the interest of scholars, although no convincing interpretation has been given. Robin Cormack expressed the view that the mosaics of the northern, small colonnade depicted the story of a little girl, Maria, who grew up under the protection of St. Demetrios.[21] Recently, Cecily Hennessy has proposed that the faithful communicated with God through children.[22] After the discovery of an inscription which identifies the saint with two children on the northwest pillar of the sanctuary as St. George, the association of the children exclusively with St. Demetrios has ceased to hold true, and it appears that the children are linked to the basilica itself rather than to the saints.[23]

In my view, the iconography of the basilica is linked to the operation of the hospital. The depiction of children in the iconography of the basilica of St. Demetrios in Thessaloniki has to do with its curative properties, and the sarcophagi, ciboria, icon lamps, and gardens represented in the mosaics were involved in the healing process. The cross on little Maria's forehead is related to the healing practice and to the cross that St. Demetrios sketched on the foreheads of the sick (§ 42).[24] The same therapeutic force was exercised by the cross inscribed on the forehead of statues dating from antiquity, the significance of which we explain as the cross's ability to rid them of the evil demons that had possessed them.[25] In this sense, the inscription on the mosaic of the Mother of God and St. Theodore—[. . . π]ᾶσιν ἀνθρόποις ἀπελπισθεὶς παρὰ δὲ τῖς σῆς δυνάμεως ζωοποιηθὴς εὐχαριστῶν ἀνεθέμην[26] ("Despairing of all people, fortified by your life-giving strength, in thankfulness I dedicate this offering")—shows that a sick man, having despaired of doctors, recovered his health through the grace of the Mother of God and in gratitude paid for a wall mosaic icon as an offering.[27]

I would not rule out the possibility that the general hospital of St. Demetrios's may have specialized in pediatric[28] and obstetric cases, which would explain another iconographical oddity in the basilica of St. Demetrios:

[21] Cormack, "Mosaic Decoration of St. Demetrios," 17–52.

[22] Hennessy, "Iconic Images of Children," 163.

[23] Bakirtzis, "Προεικονομαχικὸ ψηφιδωτό," 127–35.

[24] Cormack, "Mosaic Decoration of St. Demetrios," 34.

[25] Delivorrias, "Interpretatio Christiana," 107–23. On statues "sealed in Christ," see Hjort, "Augustus Christianus-Livia Christiana," 99–112.

[26] Soteriou, *Saint Demetrios*, 195, reads "Εν ἀνθρώποις" instead of "[. . . π]ᾶσιν ἀνθρόποις."

[27] Xyngopoulos, *Ἡ βασιλική*, 31.

[28] Bourbou, "Infant Mortality," 187–203. Bourbou has noted an increased infant mortality in the Proto-Byzantine period.

the depiction of the Virgin and a good many female saints in the mosaics (St. Matrona, St. Pelagia, and others) and wall paintings.

Based on the above correlations, I think that the basilica of St. Demetrios, as a Christian healing center, replaced the Asklepieion and the Sarapeion as the main healing centers of Roman and Late Roman Thessalonikē. The hospital of St. Demetrios had room both for doctors trained in the scientific techniques of Greek empirical and rationalist medicine and for the thaumatourgical cures of St. Demetrios. Conditions resembled those seen today in the churches of Panagia at Tenos and Lourdes and elsewhere in the villages where pilgrims still practice incubation.[29]

<p style="text-align:center">* * * * *</p>

Μῖμός ἐστιν μίμησις βίου τά τε συγκεχωρημένα καὶ ἀσυγχώρητα περιέχων.

Mime is imitation of life encompassing both the things that have been agreed upon and the things not agreed upon.

<p style="text-align:right">Diomedes, *Ars Grammatica*</p>

The theater, as an important social institution and part of the life of the city, contributed to the cultural transformation of the city into a Christian metropolis. Hunters, gladiators, wild animals, and other stage professionals are present in the lengthy announcements of the Pythian Games for the years 252 and 260 C.E. in Thessalonikē.[30] Classical theater was obsolete by that time, and its place had been taken in public taste by the lively art of the mimes.[31] The theater of mime brought topicality and biting satire. Dubious morals and the favorite theme of adultery were what the public most enjoyed. In his narrative "Λούκιος ἢ ὄνος" (Lucius or the Ass), Lucian describes the performance of a mime in Thessalonikē with scenic effects involving the transformation of people into animals, animals into people, and the love tangles which occurred between them.[32]

[29] Witt, *Isis*, 190.

[30] Velenēs, "Ἐπιγραφὲς ἀπὸ τὴν ἀρχαία Ἀγορά," 1317–27.

[31] Webb, *Demons and Dancers*; Adam-Velenē, *Θέατρο καὶ θέαμα*, 38–48; Puchner, "Acting in the Byzantine Theater," 312–13; Stephanis, *Διονυειακοὶ τεχνῖται*; Solomos, *Ὁ Ἅγιος Βάκχος*, 15–64; Theocharidis, *Beiträge zur Geschichte*, 67–77.

[32] *Luciani Samosatensis opera*, 333–38.

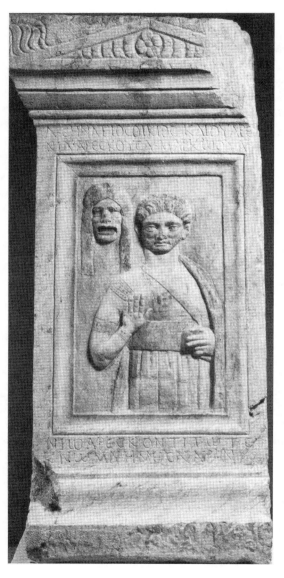

Fig. 3. Thessaloniki. The funeral altar of Marcus Vereinius Arescon. After *Roman Thessaloniki*, 266.

Inscriptions on funeral altars in Thessaloniki bear witness to the theatrical society of the city in Roman times.[33] Marcus Vareinius (150–200 C.E.) was a tragedian, which meant that he acted as both singer and interpreter of tragic roles. On the stone on his altar, he is shown with the mask of a female role in which he won the plaudits of the public (fig. 3). The same public awarded him the nickname Ἀρέσκων (the Beguiler) because he pleased them so much. The mime L. Canuleius Zosimus (145/6 or 261/2 C.E.) was described by his peers in the way that they wished to remember him: lithe, with his supple body and his memorable dance and acrobatic performances. Best of all, Terpnus Attaleus was accompanied by the title of "pantomime." This title, "virtuoso of the art of mime," which refers to one who enthralled audiences in one-man

[33] Adam-Velenē, *Μακεδονικοί βωμοί*, 193, 206; idem, "Entertainment and Arts," 266.

shows, is inscribed on the tombstone of this leading mime from Attaleia, who worked, died, and was buried in Thessalonikē. Identified with his art even after his death, he was still known by the name given to him by his grateful public: Τερπνός (the Captivator).

Our understanding of this folk mime theater which flourished in Roman and Late Roman Thessalonikē is complemented by the clay figurines of mimes, which were found in excavations, and marble statues of the Muses. These statues adorned the proscenium of the theater in the Agora, south of the St. Demetrios basilica.[34] In this theater, and in the open air plaza in front of it, all the performances were given, interwoven with gladiatorial contests involving men and beasts (figs. 4–5).[35] In this theater, at the beginning of the fourth century, the fight between the pagan gladiator Lyaios and the Christian Nestor, which is described in the *Vitae* of St. Demetrios, took place.[36]

We have little evidence for mimes in the form of fragments of scripts used directly by players. Although many papyrus fragments contain a few incomplete lines, the most important is Papyrus Oxyrhynchus 413, found at Oxyrhynchus in Egypt in the late nineteenth century. It contains substantial parts of two theatrical scripts. One is entitled *Moicheutria*. The other has been given the name of its heroine, *Charition*, a Greek woman rescued from captivity in India.[37]

The text from a work in dialogue form by an unknown mime writer from Thessalonikē, which I shall present and analyze, permits a more complete perception of this folk theater. This theatrical text has lively dialogue, theatrical freshness, a conflict of characters drawn clearly in a psychological manner, and it heightens the interest of the spectators through its sharp question-and-answer technique. Moreover, the text is accompanied by detailed staging directions. The dialogue is conducted between the mime, who expresses public opinion, and an elderly man, who kept a mistress and tried to hide the fact, while the audience booed.

[34] Korti-Konti, "Μίμοι τῆς Θεσσαλονίκης," 621–30; Stephanidou-Tiveriou, "Οἱ Μοῦσες," 1419–31.

[35] Papadopoulou, "Chronika," 197–99, figs. 2–6. For pictorial graffiti showing performers found at Aphrodisias and Ephesos, see Roueché, "Images of Performance," 254–81.

[36] Skedros, *Saint Demetrios of Thessaloniki*, 8–11, 149–57; Velenēs and Adam-Velenē, "Ρωμαϊκὸ θέατρο," 241–56. Velenēs and Adam-Velenē place this theater in the area between the church of St. Sophia and Galerius's Palace, away from the basilica of St. Demetrios. In this case the basilica, well identified as the church of St. Demetrios, does not correspond to St. Demetrios, neither is his legend related to Thessalonikē.

[37] Webb, *Demons and Dancers*, 98.

Fig. 4. Thessaloniki. Agora and the Theater. Photo: Charalambos Bakirtzis.

Fig. 5.
Thessaloniki.
Agora: Graffiti
from the Theater.
Drawn by Eirene
Malle after
ArchDelt 18
(1963), Chronika
B'2, 198.

The story runs as follows: By some curious theatrical business, which would have made the audience laugh, the elderly man attempts to evade the mime. When this is no longer possible, he is subjected to the following challenging address: "I've got some songs to sing about you and your daughter," meaning his mistress, who would have been half his age. At first, like all liars, the Thessalonikan treats the mime's challenge with disdain and self-confidence, denying the existence of a daughter: "Don't bother. I haven't got a daughter and there's nothing for you to say about me." The mime refuses to give way, however, and challenges him even further by stating that his daughter is mother to many children and promising to make more revelations. The old man, who is much perturbed at this, presses the mime not to make any revelations, all the while denying that he has a daughter: "For goodness' sake, don't say anything about me or about her you call my daughter." The mime will not budge, however, and indignantly persists. Then the old man shouts even louder and tries to get the mime to swear by all that is holy "to say nothing about me or my daughter." With such lively dialogue, the interest of the audience is maintained until the point where the mime exits and leaves us to guess the extent of his revelations.

This text has not survived in any manuscript of the poetic works of Late Antiquity or any collection of works by writers from Thessalonikē, but was included intact, with its dialogues and stage directions, in a collection of texts

of an entirely different character. It forms the introduction to chapter 14 of Book 1 of the *Miracles of Saint Demetrios,* entitled "On the Tragedian."[38] This chapter contains the story of the siege of Thessalonikē by the Avars and Slavs in 586 or 597 and the intervention by St. Demetrios, which saved the city. The mime play was not altered in any way by the author of the chapter, Archbishop Ioannēs, and was included in full in the *Miracles of Saint Demetrios.*

The story is the same and the words are the same. But in the *Miracles,* it takes on a different meaning: Archbishop Ioannēs of Thessalonikē tells of a dream which his predecessor, Eusebius, had in 586 or 597.[39] In his dream the archbishop saw himself sitting in the city theater, in one of the seats reserved for high officials watching a mime play, the subject of which is not given. The archbishop felt uncomfortable among this crowd of people because he thought his presence in the theater was inappropriate for a man in his position due to the widespread reaction of fanatical Christians against theatrical events.[40] I would mention the public statement by John Chrysostom—"May the stage perish! Blessed are the barbarians who know nothing of the theater!"—and Justinian I's Novella 123 in which bishops and monks were prohibited, to no effect, from frequenting theaters. Just as the archbishop was thinking of getting up and leaving, the leading mime of the company appeared on the stage. There followed exactly the same dialogue that I quoted above with the only difference that in this case the old man was the archbishop and his daughter with many children was the well populated city of Thessalonikē.

Hans-Georg Beck refers to a similar Byzantine text, which is not a religious sermon on the Annunciation under the name of John Chrysostom, but a short story in the form of a dialogue between a young man (an angel) and a young woman (the Virgin) married to an old man (Joseph). The story has clear evidence of its origins in ancient mimes.[41]

Old wine in new bottles—even the most inventive modern writer would envy such a transformation. The text remains exactly the same, but the

[38] For the text, see Lemerle, *Recueils,* §§ 132 and 133. For my comments on the text, see Bakirtzis, Ἁγίου Δημητρίου Θαύματα, 390–93. The mime character of the text is noted by Speck, "Ideologische Ansprüche-historische Realität," 36. For the *tragōdos* in Late Antiquity, see Webb, *Demons and Dancers,* 155.

[39] Lemerle, *Recueils,* § 131.

[40] Theocharidis, *Beiträge zur Geschichte*; Webb, *Demons and Dancers,* 213–16.

[41] Joannis Chrysostomi, "In annuntiationem sanctissime deiparae," Spuria, *PG* 60, 755–60; Beck, *Das byzantinische Jahrtausend,* 113–15; Puchner, "Acting," 311. For another example of "Christian" mime of the fifth or sixth century from Syria, see Link, *Die Geschichte des Schauspieler*; and Vogt, "Études," 623–40. Andrew White, theater historian, informs me that R. Phoenix and Cornelia B. Horn are working on the translation of this Syriac tale.

meaning changes; the satiric dialogue now sounds prophetic. The mime, whose appearance on the theater stage was inexplicable, now becomes a messenger, and his dialogue with the archbishop foretells the imminent siege of the city.

An eloquent comment on this transformation from Late Antiquity to Christianity comes from a marble epistyle from Philippi and its second-century C.E. decoration (fig. 6).[42] To avoid discarding the decorated marble and so that it could be used afresh as building material for the construction of the phiale in the courtyard of the hostel for pilgrims to the Octagon, the decorative motifs on the façade of the epistyle were repeated on its narrow, broken side. At first glance, the difference cannot be seen. Careful comparison, however, reveals that the decorative motifs on the narrow side of the epistyle are repeated mechanically and more freely. They function differently, as *horror vacui*, in a new location where the cross dominates.[43]

I shall now turn to a second theatrical text, which is different in content and is preserved in the *Acta Sanctorum* for the month of April.[44] This text concerns the trial of the Christian martyrs of Thessalonikē—Eirēnē, Agapē, Agathon, Chionē, Filippa, Kassia, and Eutychia—and their consequent sentence to death by fire, imprisonment, incarceration in a public brothel, and the execution of the verdict. The year is 304 C.E.[45] The mime has a large cast, and in order of appearance, we see the leading investigator Duolketios, the prosecutor Artemesios, the accused Christians, and the dumb personae such as the clerks of the market, the slave Zosimos (superintendent of the public brothel), and some soldiers. The work is structured in six scenes, and the main three scenes enjoy the same setting. They take place in a public place where justice is dispensed by the person in authority, while the three other scenes, which are interspersed between the three main ones and at the end, take place alternately on the site where executions by fire were carried out and in the public brothel. None of these minor scenes has dialogue, but they instead consist of singing and dancing. "Λούκιος ἢ ὄνος" (Lucius or the Ass), described by Lucian in the theater of Thessalonikē, is also a scene of singing and dancing with a rich setting and impressive effects.

[42] Pelekanidis, "Ἀνασκαφὴ Φιλίππων," 60.

[43] "No work of art or literary creation can be fashioned without the use of traditional form and materials. Its message is conveyed not through forms and materials themselves, but through the reshaping of the form and the interpretation of the material" (Koester, "First Thessalonians," 20).

[44] *Acta Sanctorum, April (AASS Aprilis I)* 245–50; Musurillo, *Acts*, 281–93; Christou, *Martyrdoms*, 78–80, 304–27.

[45] Christou, *Martyrdoms*, 78.

Fig. 6. Philippi. Pilgrims' Guesthouse: Marble Epistyle. Photo: Charalambos Bakirtzis.

The dialogues in the text are unusually sharp.[46] This is why it is accepted that they were the record of a trial.[47] This sharp dialogue reinforces the naturalness of the theatrical performance. And yet, the interruption of the judicial process by the dramatic insertion of scenes of singing and dancing, which enact the execution of the sentences and the brothel, has more to do with the requirements of production. Stage directions have no place in the record of a trial. Their insertion into the dialogues, however, facilitated the performance. The absence of precise reference to location would be unacceptable in the record of a trial because it would detract from the procedure of proving the case, but it facilitated the mounting of production in any suitable place. The drama *Dulcitius* in fourteen scenes written in Latin by Hrowsvitha, a nun in Gandersheim (tenth century), has as its theme the episode of the martyrs Agapē, Eirēnē, and Chionē.[48] The *Dulcitius* drama, as an adaptation of an earlier theatrical play in Greek and in Latin, reinforces my opinion that the written tradition of the Thessalonikan martyrs has a theatrical origin.

Taken out of the religious context in which it has been transmitted to us, the text is one of the mime parodies (Christological mimes) at the time of the persecutions, which presented the martyrdom of Christians, as well as baptism or crucifixion, as entertaining subjects.[49] In my own view, the third-century Alexamenos graffito in Rome (fig. 7) depicts such a scene of a mime parody in Rome: a crucified mime wearing hose, singlet, and a donkey mask.[50] The inscription "Alexamenos worships God" are words of the mime parody and refer to the second mime, who is depicted before the one being crucified.

On occasion and in the interests of verisimilitude, actual executions of condemned Christians replaced the mock ones performed by the mimes.[51] Lucian states that condemned women were used in Thessalonikē in fights with wild animals or other mime presentations in roles that the mimes

[46] The dialogue form is not unknown in the Acts of Martyrs; see Musurillo, *Acts*, 22–28, 42–46.

[47] Christou, "Κινήσεις χριστιανῶν," 84–89.

[48] *Patrologia Latina* 137, 993–1002; Musurillo, *Acts*, xii–xiii.

[49] Webb, *Demons and Dancers*, 123–28; Puchner, "Acting," 316.

[50] Online: http://en.wikipedia.org/wiki/Alexamenos graffito; Mathews, *Clash of Gods*, 48–51. Mathews has noted that it is one of the venerated representations of Christ with the head of an ass. Tertullian, writing in the late second or early third century, mentions an apostate Jew who carried around Carthage a caricature of a Christian with ass's ears and hooves labeled *Deus Christianorum Onocoetes* ("the God of the Christians begotten of an ass"; Tertullian, *Ad Nationes* 1:14). It is obviously an advertisement of a mime performance with a similar content that was staged at a theater in Carthage. For bear-headed or dog-headed mimes in the Byzantine period, see Maguire and Maguire, *Other Icons,* 118–19.

[51] For the violence on stage, see Webb, *Demons and Dancers*, 121–23.

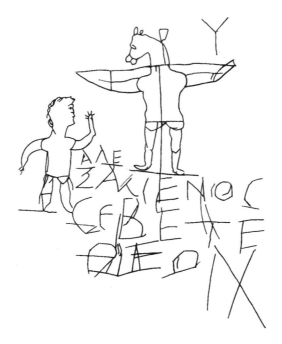

Fig. 7. Rome. The Alexamenos Graffito. Drawn by Eirene Malle after a photo.

themselves declined to perform.[52] We do not know if this specific production of the martyrs Agapē, Eirēnē, and Chionē in Thessalonikē ended with the real death of condemned Christians in flames. Given the slaughter of thousands of Thessalonikans in the hippodrome in 390, however, this possibility cannot be ruled out.

The hospital in the basilica of St. Demetrios and the mime theater in Thessalonikē are only two aspects of a broader cultural phenomenon. Yet, they allow an interesting conclusion since they reflect the interaction of two vital social institutions during the transformation of Roman Thessalonikē into an early Christian city: This was a conservative transformation in a progressive city—conservative because it neither excluded nor absorbed the past and progressive because it renewed itself and survived without undergoing periods of abandonment or desolation.

Transformations of this kind continue to this day. The built environment of Thessaloniki at the end of the twentieth and the beginning of the twenty-

[52] *Luciani Samosatensis opera*, 335, § 52.

first century has radically changed, and the city is expanding as a result of the massive influx of immigrants mainly from the Balkans and the formerly socialist countries. Thessaloniki's inhabitants, both native citizens and foreigners, have increasing needs in their efforts to face the harsh realities of daily life.[53] They seek intellectual strength and emotional security in the city's tradition, as it is preserved in its museums, monuments, history, and myths. Access to this cultural heritage is of vital importance since it sustains communal memory and shapes civic identity. For this reason the protection and preservation of civic monuments receives great financial support from the European Community, as well as from national, municipal, and private sources, with the objective of providing all inhabitants with equal access to the city's tradition and to offer a just distribution of the relevant expense.

APPENDIX 1. ON THE TRAGEDIAN

Ὁ ἀρχιεπίσκοπος . . . ἐβούλετο ἀναστὰς ὑποχωρεῖν, ὁρᾷ τραγῳδὸν εἰσιόντα ἐπὶ τὸ καλούμενον τοῦ θεάτρου λογεῖον καὶ λέγοντα αὐτῷ·
ΤΡΑΓῼΔΟΣ
Μεῖνον ὅτι σὲ καὶ τὴν θυγατέρα σου ἔχω τραγῳδῆσαι.
Ὁ δὲ ΑΡΧΙΕΠΙΣΚΟΠΟΣ λέγει αὐτῷ
Μὴ κοπωθῆς, ἐγὼ γὰρ οὔτε θυγατέρα ἔχω, οὔτε δὲ εἰς ἐμὲ ἔχεις τι τραγῳδῆσαι.
Ἀποκρίνεται ἐκεῖνος ὁ ΤΡΑΓῼΔΟΣ
Ἀληθῶς καὶ θυγατέρα ἔχεις, καὶ πολύτεκνον θυγατέρα, καὶ δεῖ με αὐτὴν ἅμα καὶ σὲ τραγῳδῆσαι.
. . . Ὡς ἔμελλεν ἐκεῖνος (τραγῳδός) ἄρχεσθαι τοῦ τραγῳδεῖν, ἀναστὰς ἐκ τοῦ θρόνου αὐτοῦ ὁ ἀρχιεπίσκοπος κράζει αὐτῷ φωνῇ·
ΑΡΧΙΕΠΙΣΚΟΠΟΣ
Τὸν θεὸν τῶν ὑψωμάτων, μήτε ἐμὲ τραγῳδήσῃς, μήτε ἣν λέγεις θυγατέρα μου.
Ὁ δὲ (τραγῳδός) διαπονηθεὶς ὡς ἐμποδισθεὶς δῆθεν τοῦ ἄρξασθαι λέγει αὐτῷ·
ΤΡΑΓῼΔΟΣ
Οὐκ ἐνδέχεται μὴ τραγῳδῆσαί με καὶ σὲ καὶ τὴν θυγατέρα σου.

[53] The mosaic inscription of the seventh century in the basilica of St. Demetrios—Πανόλβιαι Χριστοῦ μάρτυς φιλόπολις φροντίδα τίθη κ(αὶ) πολιτῶν κ(αὶ) ξένων ("Most happy martyr of Christ, you who love the city, take care of both citizens and foreigners")—reflects the roles of citizens and of strangers in the life of Thessaloniki. See Soteriou, *Saint Demetrios*, 196.

Καὶ ὡς πάλιν ὑποκρίνεται ἄρχεσθαι, ὁ ἀρχιεπίσκοπος γεγονωτέρα τῇ φωνῇ προέφθασε κράζων αὐτῷ καὶ λέγων

ΑΡΧΙΕΠΙΣΚΟΠΟΣ

Τὸν θεὸν τὸν ταχθέντα ἐκ τῆς ἀχράντου θεοτόκου σαρκὶ διὰ τὴν ἡμετέραν σωτηρίαν, μήτε ἐμέ τραγῳδήσῃς, μήτε τὴν θυγατέρα μου. Καὶ οὕτως ἐπὶ πολλάς φησι τὰς ὥρας, ἐκείνου (τοῦ τραγῳδοῦ) ἐνισταμένου καὶ λέγοντος ὅτι· Τραγῳδῆσαι ἔχω, καὶ τοῦ ἀρχιεπισκόπου ἐνορκίζοντος αὐτὸν μὴ τοῦτο ποιῆσαι, ἄφνω ἀνάσπαστος ἐκ τοῦ λογείου γίνεται ὁ τραγῳδὸς καὶ ἀφανής . . .

APPENDIX 2. THE MARTYRDOM OF THE SEVEN MARTYRS OF THESSALONIKĒ

SCENE I. - Court.

Προσκαθίσαντος Δουλκητίου ἡγεμόνος ἐπὶ τοῦ βήματος, Ἀρτεμήσιος κομενταρήσιος εἶπεν·

ΑΡΤΕΜΗΣΙΟΣ

Ὁποίαν νοτωρίαν περὶ τῶν παρεστώτων τούτων ὁ ἐνθάδε στατιωνάριος ἀπέστειλε πρὸς τὴν σὴν τύχην, εἰ κελεύεις, ἀναγινώσκω.

ΔΟΥΛΚΗΤΙΟΣ ΗΓΕΜΩΝ εἶπεν·

Ἀνάγνωθι.

ΑΡΤΕΜΗΣΙΟΣ

Καὶ ἐκ τῆς τάξεως ἀνεγνώσθη.

«Σοὶ τῷ ἐμῷ δεσπότῃ Κάσσανδρος βενεφικιάριος. Γίνωσκε, κύριε, Ἀγάθωνα καὶ Εἰρήνην καὶ Ἀγάπην καὶ Χιόνην καὶ Κασίαν καὶ Φιλίππαν καὶ Εὐτυχίαν μὴ βούλεσθαι ἱερόθυτον φαγεῖν, οὕστινας προσάγω σου τῇ τύχῃ».

ΔΟΥΛΚΗΤΙΟΣ ΗΓΕΜΩΝ εἶπε πρὸς αὐτούς·

Τίς ἡ τοσαύτη μανία τοῦ μὴ πείθεσθαι ὑμᾶς τῇ κελεύσει τῶν θεοφιλεστάτων βασιλέων ἡμῶν καὶ καισάρων;

καὶ πρὸς Ἀγάθωνα εἶπε·

Διατί παραγενόμενος εἰς τὰ ἱερά, καθὼς οἱ καθωσιωμένοι, τοῖς ἱερείοις οὐκ ἐχρήσω;

ΑΓΑΘΩΝ εἶπεν·

Ὅτι χριστιανός εἰμι.

ΔΟΥΛΚΗΤΟΣ ΗΓΕΜΩΝ εἶπεν·

Ἔτι καὶ σήμερον τοῖς αὐτοῖς ἐπιμένεις;

ΑΓΑΘΩΝ εἶπε·

Ναί.
ΔΟΥΛΚΗΤΙΟΣ εἶπε·
Σὺ τί λεγεις, ἡ Ἀγάπη;
ΑΓΑΠΗ εἶπε·
Θεῷ ζῶντι πεπίστευκα καὶ οὐ βούλομαι τὴν συνείδησίν μου ἀπολέσαι.
ΔΟΥΛΚΗΤΙΟΣ ΗΓΕΜΩΝ εἶπε·
Σὺ τί λέγεις, Εἰρήνη; Διὰ τί οὐκ ἐπείσθης τῇ κελεύσει τῶν δεσποτῶν
ἡμῶν, τῶν βασιλέων καὶ καισάρων;
ΕΙΡΗΝΗ εἶπε·
Διὰ φόβον θεοῦ.
Ο ΗΓΕΜΩΝ εἶπε·
Σὺ τί λέγεις Χιόνη;
ΧΙΟΝΗ εἶπε·
Θεῷ ζῶντι πεπίστευκα καὶ οὐ ποιῶ τοῦτο.
Ο ΗΓΕΜΩΝ λέγει·
Σὺ τί λέγεις, Κασία;
ΚΑΣΙΑ εἶπε·
Τὴν ψυχήν μου σῶσαι θέλω.
Ο ΗΓΕΜΩΝ εἶπε·
Τῶν ἱερείων μεταλαβεῖν θέλεις;
ΚΑΣΙΑ εἶπε·
Οὐ θέλω.
Ο ΗΓΕΜΩΝ εἶπε·
Σὺ τί λέγεις, ἡ Φιλίππα;
ΦΙΛΙΠΠΑ εἶπε·
Τὸ αὐτὸ λέγω.
Ο ΗΓΕΜΩΝ εἶπε·
Τί ἐστι τὸ αὐτό;
ΦΙΛΙΠΠΑ εἶπε·
Ἀποθανεῖν θέλω μᾶλλον ἢ φαγεῖν.
Ο ΗΓΕΜΩΝ εἶπε·
Σὺ τί λέγεις, Εὐτυχία;
ΕΥΤΥΧΙΑ εἶπε·
Τὸ αὐτὸ λέγω, ἀποθανεῖν μᾶλλον θέλω.
Ο ΗΓΕΜΩΝ μᾶλλον εἶπεν·
Ἄνδρα ἔχεις;
ΕΥΤΥΧΙΑ εἶπεν·
Ἐτελεύτησεν.

Ο ΗΓΕΜΩΝ εἶπε·
Πότε ἐτελεύτησεν;

ΕΥΤΥΧΙΑ εἶπε·
Πρὸ μηνῶν τάχα ἑπτά.

Ο ΗΓΕΜΩΝ εἶπε·
Πόθεν οὖν ἐγκύμων εἶ;

ΕΥΤΥΧΙΑ εἶπε·
Ἐξ οὗ ἔδωκέ μοι ὁ θεός ἀνδρός.

Ο ΗΓΕΜΩΝ εἶπε·
Πῶς οὖν ἐγκύμων τυγχάνεις, ὁπότε λέγεις τὸν ἄνδρα σου
τετελευτηκέναι;

ΕΥΤΥΧΙΑ εἶπε·
Τὴν βούλησιν τοῦ παντοκράτορος θεοῦ οὐδεὶς δύναται εἰδέναι. Οὕτως
ἠθέλησεν ὁ θεός.

Ο ΗΓΕΜΩΝ εἶπε·
Παύσασθαι τὴν Εὐτυχίαν τῆς μανίας προτρέπομαι μετελθεῖν τε ἐπὶ τὸν
ἀνθρώπινον λογισμόν. Τί λέγεις, πείθῃ τῇ βασιλικῇ κελεύσει;

ΕΥΤΥΧΙΑ εἶπεν·
Οὐ πείθομαι, χριστιανή εἰμι, θεοῦ δούλη παντοκράτορος.

Ο ΗΓΕΜΩΝ εἶπεν·
Εὐτυχία, διὰ τὸ ἐγκύμονα αὐτὴν εἶναι τέως ἀναληφθήσεται εἰς τὸ
δεσμωτήριον.

Καὶ προσέθηκε·
Σὺ τί λέγεις, Ἀγάπη; Ποιεῖς ταῦτα πάντα ὅσα ἡμεῖς οἱ καθωσιωμένοι
τοῖς δεσπόταις ἡμῶν βασιλεῦσι καὶ καίσαρσι ποιοῦμεν;

ΑΓΑΠΗ εἶπεν·
Οὐκ ἔνι καλῶς τῷ σατανᾷ. Οὐκ ἄγει μου τὸν λογισμόν· ἀνίκητος ὁ
λογισμὸς ἡμῶν.

Ο ΗΓΕΜΩΝ εἶπε·
Σὺ τί λέγεις, Χιόνη;

ΧΙΟΝΗ εἶπε·
Τὸν λογισμὸν ἡμῶν οὐδεὶς δύναται μεταγαγεῖν.

Ο ΗΓΕΜΩΝ εἶπε·
Μή τινα ἔστι παρ' ὑμῖν τῶν ἀνοσίων χριστιανῶν ἢ ὑπομνήματα ἢ διφθέραι
ἢ βιβλία;

ΧΙΟΝΗ εἶπεν·
Οὐκ ἔστι, κύριε· ἅπαντα γὰρ οἱ νῦν αὐτοκράτορες ἐξεφόρησαν.

Ο ΗΓΕΜΩΝ εἶπε·
Τίνες ὑμῖν τὴν γνώμην ταύτην ἔδωκαν;

ΧΙΟΝΗ εἶπεν·
Ὁ παντοχράτωρ θεός.

Ο ΗΓΕΜΩΝ εἶπε·
Τίνες οἱ συμβουλεύσαντες ὑμῖν εἰς ταύτην τὴν ἀπόνοιαν ἐλθεῖν;
ΧΙΟΝΗ εἶπεν·
Ὁ θεὸς ὁ παντοκράτωρ καὶ ὁ υἱὸς αὐτοῦ ὁ μονογενής, ὁ κύριος ἡμῶν
Ἰησοῦς Χριστός.

ΔΟΥΛΚΗΤΙΟΣ ΗΓΕΜΩΝ εἶπε·
Πάντας ὑποκεῖσθαι τῇ καθοσιώσει τῶν δεσποτῶν ἡμῶν τῶν
βασιλέων καὶ καισάρων πᾶσι πρόδηλόν ἐστιν. Ἐπειδὴ δὲ ἀπονοίᾳ
τινὶ χρησάμεναι ἀπὸ τοσούτου χρόνου καὶ τοσαύτης παραγγελίας
γενομένης καὶ τοσούτων διαταγμάτων προτεθέτων, τηλικαύτης
ἀπειλῆς ἐπηρτημένης, κατεφρονήσατε τῆς κελεύσεως τῶν δεσποτῶν
ἡμῶν, τῶν βασιλέων καὶ καισάρων, ἐπιμένουσαι τῷ ἀνοσίῳ ὀνόματι
τῶν χριστιανῶν, ἔτι τε μὴν καὶ τήμερον ἀναγκαζόμεναι ὑπό τε τῶν
στατιωνιζόντων καὶ τῶν πρωτευόντων ἀρνήσασθαι καὶ ἐγγράφως
ποιῆσαι τὰ κελευσθέντα, οὐ βούλεσθε, τούτου ἕνεκεν τὴν δέουσαν εἰς
ἑαυτὰς τιμωρίαν ἐκδέξασθε.

Καὶ τὴν ἀπόφασιν ἔγγραφον ἐκ χάρτου ἀνέγνω·
«Ἀγάπην καὶ Χιόνην, ἐπειδὴ ἀκαθοσιώτῳ διανοίᾳ ἐναντία ἐφρόνησαν
τῷ θείῳ θεσπίσματι τῶν δεσποτῶν ἡμῶν αὐγούστων καὶ καισάρων, ἔτι
εἰκαίαν καὶ ἕωλον καὶ στυγητὴν πᾶσι τοῖς καθωσιωμένοις σέβουσαι
τὴν τῶν χριστιανῶν θρησκείαν, πυρὶ ἐκέλευσα παραδοθῆναι».

Καὶ προσέθηκεν·
«Ἀγάθων καὶ Εἰρήνη καὶ Κασία καὶ Φιλίππα καὶ Εὐτυχία διὰ τὸ νέον
τῆς ἡλικίας τέως ἐκβληθήσονται εἰς τὸ δεσμωτήριον».

SCENE II. – Place of execution by fire.
Martyrdom of Agapē and Chionē.

SCENE III. - Court.
Μετὰ δὲ τὸ τελειωθῆναι τὰς ἁγιωτάτας διὰ πυρός, τῇ ἑξῆς
προσαχθείσης πάλιν τῆς ἁγίας Εἰρήνης,
Ο ΗΓΕΜΩΝ ΔΟΥΛΚΗΤΙΟΣ εἶπε πρὸς αὐτήν·
Ἡ πρόθεσις τῆς σῆς μανίας φανερὰ καὶ διὰ τῶν ὁρωμένων, ἥτις
τοσαύτας διφθέρας καὶ βιβλία καὶ πινακίδας καὶ κωδικέλλους
καὶ σελίδας γραφῶν τῶν ποτε γενομένων χριστιανῶν τῶν ἀνοσίων
ἐβουλήθης ἄχρι καὶ τῆς σήμερον φυλάξαι, προσκομισθέντων τε

ἐπέγνως, καθ᾽ ἑκάστην εἰποῦσα ἴδια μὴ εἶναι μήτε ἀρκεσθεῖσα τῇ κολάσει τῶν ἑαυτῆς ἀδελφῶν μήτε τὸν φόβον ἐκείνων τοῦ θανάτου πρὸς ὀφθαλμῶν ἔχουσα. Ὅθεν ἀνάγκη ἐπικεῖσθαι μέν σοι τὰ τῆς τιμωρίας. Ἔστι δὲ ἐνδοῦναί σοι μέρος φιλανθρωπίας οὐκ ἄκαιρον ὥστε, εἰ βουληθείης νῦν γοῦν θεοὺς ἐπιγινώσκειν, εἶναί σε ἀθῷαν κινδύνου παντὸς καὶ κολάσεως. Τί οὖν λέγεις; Ποιεῖς τὴν κέλευσιν τῶν βασιλέων ἡμῶν καὶ καισάρων καὶ ἑτοίμη εἶ ἱερόθυτον φαγεῖν σήμερον καὶ θῦσαι τοῖς θεοῖς;

ΕΙΡΗΝΗ εἶπεν·

Οὐχί, οὐκ εἰμι ἑτοίμη ποιῆσαι διὰ τὸν παντακράτορα θεὸν τὸν κτίσαντα οὐρανόν τε καὶ γῆν καὶ θάλασσαν καὶ πάντα τὰ ἐν αὐτοῖς. Μεγάλη γὰρ δίκη αἰωνίου βασάνου τοῖς παραβαίνουσι τὸν λόγον τοῦ θεοῦ.

ΔΟΥΛΚΗΤΙΟΣ ΗΓΕΜΩΝ εἶπε·

Τίς σοι συνεβούλευσε τὰς διφθέρας ταύτας καὶ τὰς γραφὰς μέχρι τῆς σήμερον ἡμέρας φυλάξαι;

ΕΙΡΗΝΗ εἶπεν·

Ὁ θεὸς ὁ παντοκράτωρ, ὁ εἰπὼν ἕως θανάτου ἀγαπῆσαι αὐτόν. Τούτου ἕνεκεν οὐκ ἐτολμήσαμεν προδοῦναι, ἀλλ᾽ ἡρετισάμεθα ἤ τοι ζῶσαι καίεσθαι ἢ ὅσα ἂν συμβῇ ἡμῖν πάσχειν ἢ προδοῦναι αὐτάς.

Ο ΗΓΕΜΩΝ εἶπε·

Τίς σοι συνῄδει ταύτας εἶναι ἐν τῇ οἰκίᾳ ἐν ᾗ σὺ ᾤκεις;

ΕΙΡΗΝΗ εἶπεν·

Ἕτερος οὐδεὶς βλέπει εἰ μὴ ὁ παντοκράτωρ θεὸς ὁ πάντα εἰδώς· περισσότερος γὰρ οὐδείς. Τοὺς ἰδίους ἐχθρῶν χείρονας ἡγησάμεθα, μήπως κατηγορήσωσιν ἡμῶν, καὶ οὐδενὶ ἐμηνύσαμεν.

Ο ΗΓΕΜΩΝ εἶπε·

Τῷ περυσινῷ ἔτει, ἡνίκα ἡ τηλικαύτη κέλευσις αὐτῶν τῶν δεσποτῶν ἡμῶν, τῶν βασιλέων καὶ καισάρων, πρώτως ἐφοίτησε, ποῦ ἀπεκρύφθητε;

ΕΙΡΗΝΗ εἶπεν·

Ὅπου ἂν ὁ θεὸς ἠθέλησεν, ἐν ὄρεσι, βλέπει ὁ θεός, ὕπαιθροι.

Ο ΗΓΕΜΩΝ εἶπε·

Παρὰ τίνι ἐγίνεσθε;

ΕΙΡΗΝΗ εἶπεν·

Ὕπαιθροι ἐν ἄλλοις καὶ ἄλλοις ὄρεσιν.

Ο ΗΓΕΜΩΝ εἶπε·

Τίνες ἦσαν οἱ τὸν ἄρτον ὑμῖν παρέχοντες;

ΕΙΡΗΝΗ εἶπεν·
Ὁ θεὸς ὁ πᾶσι παρέχων.
Ο ΗΓΕΜΩΝ εἶπε·
Συνέγνω ὑμῖν ὁ πατὴρ ὁ ὑμέτερος;
ΕΙΡΗΝΗ εἶπε·
Μὰ τὸν παντοκράτορα θεόν, οὐ συνέγνω οὔτε ἔγνω ὅλως.
Ο ΗΓΕΜΩΝ εἶπε·
Τίς τῶν γειτόνων ὑμῖν συνῄδει;
ΕΙΡΗΝΗ εἶπεν·
Ἐπερώτα τοὺς γείτονας καὶ τοὺς τόπους, εἴ τις ἔγνω ὅπου ἡμεῖς ἦμεν.
Ο ΗΓΕΜΩΝ εἶπε·
Μετὰ τὸ ἐπανελθεῖν ἐκ τοῦ ὄρους ὑμᾶς, ὡς σὺ φής, τὰ γραμματεῖα
ταῦτα ἀνεγινώσκετε παρόντων τινῶν;
ΕΙΡΗΝΗ εἶπεν·
Ἐν τῷ οἴκῳ ἡμῶν ἦσαν καὶ οὐκ ἐτολμῶμεν αὐτὰ ἐξάγειν ἔξω. Ὅθεν
λοιπὸν καὶ ἐν θλίψει μεγάλῃ ἦμεν μείνασαι, ὅτι οὐκ ἠδυνάμεθα αὐτοῖς
προσέχειν νύκτα καὶ ἡμέραν, καθὼς καὶ ἀπ᾽ ἀρχῆς ἐποιοῦμεν, ἕως τῆς
περυσινῆς ἡμέρας ἧς καὶ ἀπεκρύψαμεν αὐτά.
ΔΟΥΛΚΗΤΙΟΣ ΗΓΕΜΩΝ εἶπεν·
Αἱ μὲν ἀδελφαί, ἐπεὶ ἠρνήσαντο ποιῆσαι κατὰ τὰ προσταχθέντα αὐταῖς
ἀποφάσει περιεβλήθησαν. Σὺ δέ, ἐπεὶ αἰτία γεγένησαι καὶ πρότερον,
ἔτι δὲ καὶ νῦν τῆς φυγῆς καὶ τῆς τῶν γραμμάτων τούτων καὶ διφθερῶν
ἀποκρύψεως, ἀπαλλαγῆναι τοῦ βίου οὐ τῷ αὐτῷ τρόπῳ σε κελεύω
ἀθρόως, ἀλλὰ διὰ τῆς ἐποπτεύσεως τῶν ἀγορανόμων τῆς πόλεως ταύτης
καὶ Ζωσίμου τοῦ δημοσίου εἰς πορνεῖον στῆναι γυμνὴν κελεύω,
λαμβάνουσαν ἐκ τοῦ παλατίου ἕνα ἄρτον μόνον, μὴ ἐπιτρεπόντων τῶν
ἀγορανόμων ἀναχωρεῖν σε.
Εἰσαχθέντων οὖν τῶν ἀγορανόμων καὶ Ζωσίμου δούλου δημοσίου,
Ο ΗΓΕΜΩΝ εἶπεν·
Ὑμεῖς δὲ μὴν οὐκ ἀγνοεῖτε ὡς, ἐὰν μηνυθείη μοι ἐκ τῆς τάξεως
κἂν ἐλαχίστην ὥραν ἀπηλλάχθαι αὐτὴν ἐκ τοῦ τόπου ἐκείνου, ἐν ᾧ
προστέτακται ἑστάναι, τὸ τηνικαῦτα τῇ ἀνωτάτω δίκῃ ὑποβληθήσεσθε.
Τὰ δὲ γραμματεῖα τὰ προσκομισθέντα ἐν τοῖς πυργίσκοις καὶ τοῖς
κιβωτίοις τῆς Εἰρήνης δημοσίᾳ καήτωσαν.

SCENE IV. – Public Brothel.
Καὶ κατὰ τὸ πρόσταγμα τοῦτο τοῦ ἡγεμόνος ἀπαγαγόντων αὐτήν (Εἰρήνη)
τῶν εἰς τοῦτο τεταγμένων ἐπὶ τὸν δημόσιον τόπον τοῦ πορνείου, διὰ τὴν
χάριν τοῦ ἁγίου πνεύματος τὴν φρουροῦσαν αὐτὴν καὶ φυλάττουσαν

καθαρὰν τῷ τῶν ὅλων δεσπότῃ θεῷ, μηδενὸς τολμήσαντος προσελθεῖν μήτε μέχρι ῥήματος ὑβριστικόν τι ἐπιτηδεύσαντος τελέσαι.

SCENE V. - Court.

Ἀνακαλεσάμενος τὴν ἁγιωτάτην (Εἰρήνη) ΔΟΥΛΚΗΤΙΟΣ ΗΓΕΜΩΝ καὶ στήσας ἐπὶ τοῦ βήματος εἶπε πρὸς αὐτήν· Ἐμμένεις ἔτι τῇ αὐτῇ ἀπονοίᾳ;
 ΕΙΡΗΝΗ εἶπε πρὸς αὐτόν·
Οὐχὶ ἀπονοίᾳ, ἀλλὰ θεοσεβείᾳ.
 Ὁ δὲ ΗΓΕΜΩΝ ΔΟΥΛΚΗΤΙΟΣ εἶπε·
Καὶ ἀπὸ τῆς προτέρας σου ἀποκρίσεως φανερῶς ἐδείχθη τὸ μὴ καθωσιωμένως πεπεῖσθαι τῇ κελεύσει τῶν βασιλέων· καὶ νῦν ἔτι ἐμμένουσάν σε τῇ αὐτῇ ἀπονοίᾳ θεωρῶ. Ὅθεν λήψῃ τὴν δέουσαν τιμωρίαν.

Καὶ αἰτήσας χάρτην, πρὸς αὐτὴν ἀπόφασιν ἔγραψεν οὕτως·

«Εἰρήνην, ἐπειδὴ οὐκ ἠθέλησε πεισθῆναι τῇ κελεύσει τῶν βασιλέων καὶ θῦσαι, ἔτι γε μὴν θρησκεύουσαν χριστιανικῇ τινι τάξει, τούτου χάριν, ὡς καὶ τὰς πρότερον δύο ἀδελφὰς αὐτῆς, οὕτω καὶ ταύτην ζῶσαν καῆναι ἐκέλευσα».

SCENE VI. – Place of execution by fire.
Martyrdom of Eirēnē.

Καὶ ταύτης τῆς ἀποφάσεως ἐξελθούσης παρὰ τοῦ ἡγεμόνος, λαβόμενοι οἱ στρατιῶται ἀπήγαγον αὐτὴν ἐπί τινος ὑψηλοῦ τόπου, ἔνθα καὶ αἱ πρότερον αὐτῆς ἀδελφαὶ μεμαρτυρήκασι. Πυρὰν γὰρ ἄψαντες μεγάλην, ἐκέλευσαν αὐτὴν ἀφ᾽ ἑαυτῆς ἀνελθεῖν. Ἡ δὲ ἁγία Εἰρήνη, ψάλλουσα καὶ δοξάζουσα τὸν θεόν, ἔρριψεν ἑαυτὴν κατὰ τῆς πυρᾶς καὶ οὕτως ἐτελειώθη.

BIBLIOGRAPHY

Adam-Velenē, Polyxenē. *Θέατρο καὶ θέαμα στὸν Ρωμαϊκὸ κόσμο* (Theater and Entertainment in the Roman World). Thessaloniki: University Studio, 2006.

———. "Entertainment and Arts in Thessaloniki." Pages 266–81 in *Roman Thessaloniki*. Edited by D. V. Grammenos. Translated by David Hardy. Thessaloniki: Archaeological Museum of Thessaloniki, 2003.

———. *Μακεδονικοί βωμοί* (Macedonian Altars). Athens: Tameio Archaiologikōn Porōn kai Apallotriōseōn, Dieuthynsē Dēmosieumatōn, 2002.

Bakirtzis, Charalambos. "Byzantine Thessaloniki and the Modern Face of the City." Pages 155–62 in *Proceedings of the Seminar "Enhancement and Promotion of Cultural Heritage," Athens-Delphi 17–19 March 2003*. Athens: Hellenic Ministry of Culture; Archaeological Receipts Fund; Greek Presidency of the European Union, 2006.

———. "Προεικονομαχικὸ ψη‵δωτὸ τοῦ Ἁγίου Γεωργίου στὴ Θεσσαλονίκη" (A Pre-Iconoclastic Mosaic of St. George in Thessaloniki). Pages 127–35 in *Doron: Timetikos Tomos ston Kathegete Niko Nikonano*. Thessaloniki: Polytechnical School of the University of Thessaloniki and 10th Ephoreia of Byzantine Antiquities, 2006.

———. "Pilgrimage to Thessalonike: The Tomb of St. Demetrios," *DOP* 56 (2002) 175–92.

———. "Lady Eutaxia of Thessaloniki." *MBC* 6 (1999) 18–29.

———. "Ἡ Ἀγορὰ τῆς Θεσσαλονίκης στὰ παλαιοχριστιανικὰ χρόνια" (The Agora of Thessaloniki in Early Christian Times). Pages 2:5–18 in *Actes du Xe Congrès International d'Archéologie Chrétienne, Thessalonique 1980*. Vatican City: Pontificio istituto di archeologia cristiana, 1984.

Beck, Hans-Georg. *Das byzantinische Jahrtausend*. München: Beck, 1978.

Bourbou, Chryssi. "Infant Mortality: The Complexity of It All." *Eulimene* 2 (2001) 187–203.

Chaniotis, Angelos. "Illness and Cures in the Greek Propitiatory Inscriptions and Dedications of Lydia and Phrygia." Pages 323–34 in *Ancient Medicine in its Socio-Cultural Context, Papers Read at the Congress Held at Leiden University, 13–15 April 1992*. Edited by Philip J. van der Eijk, Herman Frederik Johan Horstmanhoff, and Piet H. Schrijvers. Amsterdam: Rodopi, 1995.

Christou, Panagiotis. "Κινήσεις χριστιανῶν νέων τῆς Θεσσαλονίκης κατὰ τοὺς χρόνους τῶν διωγμῶν" (Movements of Young Christians in Thessalonikē during the Persecutions). Pages 84–89 in *Second Symposium on Christian Thessalonike: From Paul to Constantine, Vlatadon Monastery 31 October–2 November 1988*. Thessaloniki: Kentro Historias Thessalonikes, 1990.

———. *Τὰ μαρτύρια τῶν ἀρχαίων Χριστιανῶν* (The Martyrdoms of the Ancient Christians). Hellenes Pateres tes Ekklesias 30. Thessaloniki: Paterikai Ekdoseis Gregorios ho Palamas, 1978.

Cormack, Robin. "The Mosaic Decoration of St. Demetrios, Thessaloniki: A Re-Examination in the Light of the Drawings of W. S. George." *Annual of the British School at Athens* 64 (1969) 17–52.

Corrington, G. Paterson. "The Milk of Salvation: Redemption by the Mother in Late Antiquity and Early Christianity." *HTR* 82 (1989) 402–13.

Delivorrias, Angelos. "Interpretatio Christiana: Γύρω ἀπὸ τὰ ὅρια τοῦ παγανιστικοῦ καὶ τοῦ χριστιανικοῦ κόσμου" (Interpretatio Christiana: Concerning the Boundaries of the Pagan and Christian Worlds). Pages 107–23 in *Eufrosynon: Afieroma ston Manolis Chatzidakis*. *ArchDelt* 46. Athens: Hellenic Ministry of Culture; Archaeological Receipts Fund, 1991.

Edelstein, Emma J. and Ludwig. *Asklepios: A Collection and Interpretation of the Testimonies*. New Introduction by Gary B. Ferngren. Vol. 2. Baltimore, Md.: The Johns Hopkins University Press, 1998.

Edson, Charles. "Cults of Thessalonica." *HTR* 41 (1948) 153–204.

Fraikin, Daniel. "Thessalonikē: Egyptian Gods." In *Cities of Paul: Images and Interpretations from the Harvard New Testament Archaeology Project*. Edited by Helmut Koester. [CD-ROM]. Minneapolis, Minn.: Fortress, 2005.

————. "Note on the Egyptian Gods in Thessaloniki." *NA* 1 (1974) 1–6.

Grandjean, Yves. *Une nouvelle arétalogie d'Isis à Maronée*. Leiden: Brill, 1975.

Hennessy, Cecily. "Iconic Images of Children in the Church of St. Demetrios, Thessaloniki." Pages 157–72 in *Icon and World: The Power of Images in Byzantium: Studies Presented to Robin Cormack*. Edited by Antony Eastmond and Liz James. Hants: Ashgate, 2003.

Hjort, Øystein. "Augustus Christianus-Livia Christiana: *Sphragis* and Roman Portrait Sculpture." Pages 99–112 in *Aspects of Late Antiquity and Early Byzantium, Papers Read at a Colloquium Held at the Swedish Research Institute in Istanbul, 31 May–5 June 1992*. Edited by Lennart Rydén and Jan O. Rosenquist. Stockholm: Swedish Research Institute in Istanbul, 1993.

Joannis Chrysostomi. Spuria. "In annuntiationem sanctissime deiparae." *PG* 60, 755–60.

Kelermenos, Nikolaos. *Ἡ γένεσις τοῦ νοσοκομείου στὴ Βυζαντινὴ αὐτοκρατορία*. BHTA Medical Art. Athens: Ecclesiastical Metropolis of Thebes and Levadia and The Johns Hopkins University Press, 1998. Translated by Timothy Miller. *The Birth of the Hospital in the Byzantine Empire*. Baltimore, Md.: The Johns Hopkins University Press, 1985.

Koester, Helmut. "Archaeology and Paul in Thessalonikē." Pages 47–54, in idem, *Paul and His World: Interpreting the New Testament in its Context*. Minneapolis, Minn.: Fortress, 2007.

Korti-Konti, Stefi. "Μίμοι τῆς Θεσσαλονίκης" (Mimes of Thessalonike). Pages 1:621–30 in *Ancient Macedonia VI, Papers Read at the Sixth International Symposium Held in Thessaloniki, October 15–19, 1996*. Vol. 1: *Julia Vokotopoulou in Memoriam*. Thessaloniki: Institute for Balkan Studies, 1999.

Kourkoutidou-Nikolaidou, Eutychia. "From the Elysian Fields to the Christian Paradise." Pages 128–42 in *The Transformation of the Roman World AD 400–900*. Edited by Leslie Webster and Michelle Brown. London: British Museum Press for the Trustees of the British Museum in association with the British Library, 1997.

Lascarato, Ioannes and Vasileios Manduvalos. "Cases of Stroke on the Throne of Byzantium." *JHN* 7 (1998) 5–10.

Lemerle, Paul. *Les plus anciens recueils des Miracles de Saint Démétrius et la pénétration des Slavs dans les Balkans*. Vol. 1: *Le texte*. Le Monde Byzantin. Paris: Centre National de la Recherche Scientifique, 1979.

Lidov, Alexei. "Hierotopy. The Creation of Sacred Spaces As a Form of Creativity and Subject of Cultural History." Pages 32–58 in *Hierotopy: The Creation of Sacred Spaces in Byzantium and Medieval Russia*. Edited by idem. Moscow: INDRIK, 2006.

Link, Josef. *Die Geschichte des Schauspieler nach einem syrischen Manuskript der Königlichen Bibliothek*. Berlin: Itzkowski, 1904.

Lucian, of Samosata. "Λούκιος ἢ ὄνος" (Lucius or the Ass). Pages 2:303–38 in *Luciani Samosatensis Opera. Ex recognitione Caroli Iacobitz*. Vol. 2. Leipzig: B.G. Teubner, 1913.

Maguire, Eunice Dauterman and Henry Maguire. *Other Icons: Art and Power in Byzantine Secular Culture*. Princeton, N.J.: Princeton University Press, 2007.

Mathews, Thomas. *The Clash of Gods: A Reinterpretation of Early Christian Art*. Princeton, N.J.: Princeton University Press, 1993.

Miller, Timothy. *The Birth of the Hospital in the Byzantine Empire*. Baltimore, Md.: The Johns Hopkins University Press, 1985. Translated into Greek by Nikolaos Kelermenos. *Ἡ γένεσις τοῦ νοσοκομείου στὴ Βυζαντινὴ αὐτοκρατορία*. BHTA Medical Art. Athens: Ecclesiastical Metropolis of Thebes and Levadia and The Johns Hopkins University Press, 1998.

Musurillo, Herbert. *The Acts of the Christian Martyrs*. Oxford: Oxford University Press, 1972.

Nutton, Vivian. "Galen to Alexander: Aspects of Medicine and Medical Practice in Late Antiquity." Pages 1–14 in *Symposium on Byzantine Medicine*. Edited by John Scarborough. *DOP* 38. Washington, D.C.: Dumbarton Oaks Research Library and Collection, 1984.

Papadopoulou, Foteine. "Chronika." *ArchDelt* 18 (1963) 197–99.

Pelekanidis, Stylianos. *Studien zur frühchristlichen und byzantinischen Archäologie*. Thessaloniki: Institute for Balkan Studies, 1977.

———. "Ἀνασκαφὴ Φιλίππων" (Excavations at Philippi). *PAE* (1973) 55–69.

Puchner, Walter. "Acting in the Byzantine Theater: Evidence and Problems." Pages 304–24 in *Greek and Roman Actors: Aspects of an Ancient Profession*. Edited by Pat Easterling and Edith Hall. Cambridge, U.K.: Cambridge University Press, 2002.

Roueché, Charlotte. "Images of Performance: New Evidence from Ephesus." Pages 254–81 in *Greek and Roman Actors: Aspects of an Ancient Profession*. Edited by Pat Easterling and Edith Hall. Cambridge, U.K.: Cambridge University Press, 2002.

Skedros, James C. *Saint Demetrios of Thessaloniki: Civic Patron and Divine Protector, 4th–7th Centuries CE*. HTS 47. Harrisburg, Pa.: Trinity Press International, 1999.

Solomos, Alexis. *Ὁ Ἅγιος Βάκχος ἢ τὰ ἄγνωστα χρόνια τοῦ ἑλληνικοῦ θεάτρου, 300 π.Χ.–1600 μ.Χ.* (Saint Bakchos or the Unknown Years of the Greek Theater, 300 B.C.E.–1600 C.E.). 2d ed. Athens: Pleias, 1974.

Soteriou, Georgios and Maria. *Ἡ βασιλικὴ τοῦ Ἁγίου Δημητρίου Θεσσαλονίκης* (The Basilica of Saint Demetrios in Thessaloniki). Athens: The Archaeological Society of Athens, 1952.

Speck, Paul. "Ideologische Ansprüche–historische Realität. Zum Problem des Selbstverständlisses der Byzantiner." Pages 19–45 in *Byzanz und seine Nachbarn*. Edited by Armin Holweg. Munich: Südosteuropa-Gesellschaft, 1996.

Steger, Florian. *Asklepiosmedizin. Medizinischer Alltag in der römischen Kaizerzeit*. Medizin, Gesellschaft und Geschichte der Medizin der Robert Bosch Stiftung, Beiheft 22. Stuttgart: Franz Steiner, 2004.

Steimle, Christopher. "Neue Erkenntnisse zum Heiligtum der Agyptischen Götter in Thessaloniki. Ein unveröffentlichtes Tegebuch des Archäologen Hans von Schoenebeck." *AEMΘ* 16 (2002) 291–306.

Stephanidou-Tiveriou, Theodosia. "Οἱ Μοῦσες ἀπὸ τὸ Ὠδεῖο τῆς Θεσσαλονίκης" (Muses from the Odeion of Thessalonikē). Pages 1419–31 in *Ancient Macedonia V, Papers Read at the Fifth International Symposium Held in Thessaloniki, October 10–15, 1989. Vol. 1: Manolis Andronikos in Memoriam.* Hidryma Meleton Chersonesou tou Haimou 240; Thessaloniki: Institute for Balkan Studies, 1993.

Stephanis, I. E. *Διονυειακοὶ τεχνῖται. Συμβολὲς στὴν προσωπογραφία τοῦ θεάτρου καὶ τῆς μουσικῆς τῶν ἀρχαίων Ἑλλήνων* (Contribution to the Prosopography of the Theater and the Music of Ancient Greeks). Herakleion: Panepistemiakes ekdoseis Kretes, 1998.

Theocharidis, Georgios J. *Beiträge zur Geschichte des byzantinischen Profantheaters im IV. und V. Jahrhundert, hauptsächlich auf Grund der Predigten des Johannes Chrysostomos, Patriarchen von Konstantinopel.* Laografia parartema 3. Thessaloniki: Helenike Laografike Etaireia, 1940.

Touratsoglou, Ioannes. "Τοῦ ἁγιωτάτου πατρῴου θεοῦ Καβείρου" (Concerning the Holiest Father God Kabeiros). *He Thessalonike* 1 (1985) 71–83.

Tzanavari, Katerina. "The Worship of Gods and Heroes in Thessaloniki." Pages 177–262 in *Roman Thessaloniki.* Edited by D. V. Grammenos. Translated by David Hardy. Thessaloniki: Archaeological Museum of Thessaloniki, 2003.

Vakaloudi, Anastasia. "Illnesses, Curative Methods and Supernatural Forces in the Early Christian Empire, 4–7 c. A.D." *Byzantion* 73 (2003) 189–94.

Velenēs, Georgios and Polyxenē Adam-Velenē. "Ἐπιγραφὲς ἀπὸ τὴν ἀρχαία Ἀγορὰ τῆς Θεσσαλονίκης" (Inscriptions from the Ancient Agora of Thessaloniki). Pages 1317–27 in *Ancient Macedonia VI, Papers Read at the Sixth International Symposium Held in Thessaloniki, October 15–19, 1996.* Vol. 2: *Julia Vokotopoulou in Memoriam.* Hidryma Meleton Chersonesou tou Haimou 272. Thessaloniki: Institute for Balkan Studies, 1999.

———. "Ρωμαϊκὸ θέατρο τῆς Θεσσαλονίκης" (The Roman Theater in Thessaloniki). *AEMΘ* 3 (1989) 241–56.

Vitti, Massimo. *Η πολεοδομικὴ εξέλιξη της Θεσσαλονίκης. Από την ίδρυσή της έως τον Γαλέριο* (The Urban Development of Thessalonikē from its Foundation to Galerius). Bibliothēkē tēs en Athēnais Archaiologikēs Hetaireias 106. Athens: Hē en Athēnais Archaiologikē Hetaireia, 1996.

Vogt, Albert. "Études sur le théâtre byzantin." *Byzantion* 6 (1931) 623–40.

Webb, Ruth. *Demons and Dancers: Performances in Late Antiquity.* Cambridge, Mass.: Harvard University Press, 2008.

Witt, Reginald E. *Isis in the Ancient World.* Baltimore, Md.: The Johns Hopkins University, 1971.

Xyngopoulos, Andreas. *Ἡ βασιλικὴ τοῦ Ἁγίου Δημητρίου Θεσσαλονίκης* (The Basilica of Saint Demetrios in Thessalonike). Thessaloniki: Society of Friends for Byzantine Macedonia, 1946.

Yerolympos, Alexandra. *Urban Transformations in the Balkan Town Planning and the Remaking of Thessaloniki.* Thessaloniki: University Studio Press, 1996.

Index

Harvard Theological Studies

64. Nasrallah, Laura, Charalambos Bakirtzis, and Steven J. Friesen, eds. *From Roman to Early Christian Thessalonikē: Studies in Religion and Archaeology*, 2010.

63. Short, J. Randall. *The Surprising Election and Confirmation of King David*, 2010.

61. Schifferdecker, Kathryn. *Out of the Whirlwind: Creation Theology in the Book of Job*, 2008.

60. Luijendijk, AnneMarie. *Greetings in the Lord: Early Christians and the Oxyrhynchus Papyri*, 2008.

59. Yip, Francis Ching-Wah. *Capitalism As Religion? A Study of Paul Tillich's Interpretation of Modernity*, 2010.

58. Pearson, Lori. *Beyond Essence: Ernst Troeltsch as Historian and Theorist of Christianity*, 2008.

57. Hills, Julian V. *Tradition and Composition in the* Epistula Apostolorum, 2008.

56. Nickelsburg, George W. E. *Resurrection, Immortality, and Eternal Life in Intertestamental Judaism and Early Christianity*. Expanded Edition, 2006.

55. Johnson-DeBaufre, Melanie. *Jesus Among Her Children: Q, Eschatology, and the Construction of Christian Origins*, 2005.

54. Hall, David D. *The Faithful Shepherd: A History of the New England Ministry in the Seventeenth Century*, 2006.

53. Schowalter, Daniel N., and Steven J. Friesen, eds. *Urban Religion in Roman Corinth: Interdisciplinary Approaches*, 2004.

52. Nasrallah, Laura. *"An Ecstasy of Folly": Prophecy and Authority in Early Christianity*, 2003.

51. Brock, Ann Graham. *Mary Magdalene, The First Apostle: The Struggle for Authority*, 2003.

50. Trost, Theodore Louis. *Douglas Horton and the Ecumenical Impulse in American Religion*, 2002.

49. Huang, Yong. *Religious Goodness and Political Rightness: Beyond the Liberal-Communitarian Debate*, 2001.

48. Rossing, Barbara R. *The Choice between Two Cities: Whore, Bride, and Empire in the Apocalypse*, 1999.

47. Skedros, James Constantine. *Saint Demetrios of Thessaloniki: Civic Patron and Divine Protector, 4th–7th Centuries C.E.*, 1999.

46. Koester, Helmut, ed. *Pergamon, Citadel of the Gods: Archaeological Record, Literary Description, and Religious Development*, 1998.

45. Kittredge, Cynthia Briggs. *Community and Authority: The Rhetoric of Obedience in the Pauline Tradition*, 1998.

44. Lesses, Rebecca Macy. *Ritual Practices to Gain Power: Angels, Incantations, and Revelation in Early Jewish Mysticism*, 1998.

43. Guenther-Gleason, Patricia E. *On Schleiermacher and Gender Politics*, 1997.

42. White, L. Michael. *The Social Origins of Christian Architecture* (2 vols.), 1997.

41. Koester, Helmut, ed. *Ephesos, Metropolis of Asia: An Interdisciplinary Approach to its Archaeology, Religion, and Culture*, 1995.

40. Guider, Margaret Eletta. *Daughters of Rahab: Prostitution and the Church of Liberation in Brazil*, 1995.

39. Schenkel, Albert F. *The Rich Man and the Kingdom: John D. Rockefeller, Jr., and the Protestant Establishment*, 1995.

38. Hutchison, William R. and Hartmut Lehmann, eds. *Many Are Chosen: Divine Election and Western Nationalism*, 1994.

37. Lubieniecki, Stanislas. *History of the Polish Reformation and Nine Related Documents*. Translated and interpreted by George Huntston Williams, 1995.

— Davidovich, Adina. *Religion as a Province of Meaning: The Kantian Foundations of Modern Theology*, 1993.

36. Thiemann, Ronald F., ed. *The Legacy of H. Richard Niebuhr*, 1991.

35. Hobbs, Edward C., ed. *Bultmann, Retrospect and Prospect: The Centenary Symposium at Wellesley*, 1985.

34. Cameron, Ron. *Sayings Traditions in the Apocryphon of James*, 1984. Reprinted, 2004.

33. Blackwell, Albert L. *Schleiermacher's Early Philosophy of Life: Determinism, Freedom, and Phantasy*, 1982.

32. Gibson, Elsa. *The "Christians for Christians" Inscriptions of Phrygia: Greek Texts, Translation and Commentary*, 1978.

31. Bynum, Caroline Walker. Docere Verbo et Exemplo: *An Aspect of Twelfth-Century Spirituality*, 1979.

30. Williams, George Huntston, ed. *The Polish Brethren: Documentation of the History and Thought of Unitarianism in the Polish-Lithuanian Commonwealth and in the Diaspora 1601–1685*, 1980.

29. Attridge, Harold W. *First-Century Cynicism in the Epistles of Heraclitus*, 1976.

28. Williams, George Huntston, Norman Pettit, Winfried Herget, and Sargent Bush, Jr., eds. *Thomas Hooker: Writings in England and Holland, 1626–1633*, 1975.

27. Preus, James Samuel. *Carlstadt's* Ordinaciones *and Luther's Liberty: A Study of the Wittenberg Movement, 1521–22*, 1974.

26. Nickelsburg, George W. E. *Resurrection, Immortality, and Eternal Life in Intertestamental Judaism*, 1972.

25. Worthley, Harold Field. *An Inventory of the Records of the Particular (Congregational) Churches of Massachusetts Gathered 1620–1805*, 1970.

24. Yamauchi, Edwin M. *Gnostic Ethics and Mandaean Origins*, 1970.

23. Yizhar, Michael. *Bibliography of Hebrew Publications on the Dead Sea Scrolls 1948–1964*, 1967.

22. Albright, William Foxwell. *The Proto-Sinaitic Inscriptions and Their Decipherment*, 1966.

21. Dow, Sterling, and Robert F. Healey. *A Sacred Calendar of Eleusis*, 1965.

20. Sundberg, Jr., Albert C. *The Old Testament of the Early Church*, 1964.

19. Cranz, Ferdinand Edward. *An Essay on the Development of Luther's Thought on Justice, Law, and Society*, 1959.

18. Williams, George Huntston, ed. *The Norman Anonymous of 1100 A.D.: Towards the Identification and Evaluation of the So-Called Anonymous of York*, 1951.

17. Lake, Kirsopp, and Silva New, eds. *Six Collations of New Testament Manuscripts*, 1932.

16. Wilbur, Earl Morse, trans. *The Two Treatises of Servetus on the Trinity: On the Errors of the Trinity, 7 Books, A.D. 1531. Dialogues on the Trinity, 2 Books. On the Righteousness of Christ's Kingdom, 4 Chapters, A.D. 1532*, 1932.

15. Casey, Robert Pierce, ed. Serapion of Thmuis's *Against the Manichees*, 1931.

14. Ropes, James Hardy. *The Singular Problem of the Epistles to the Galatians*, 1929.

13. Smith, Preserved. *A Key to the Colloquies of Erasmus*, 1927.

12. Spyridon of the Laura and Sophronios Eustratiades. *Catalogue of the Greek Manuscripts in the Library of the Laura on Mount Athos*, 1925.

11. Sophronios Eustratiades and Arcadios of Vatopedi. *Catalogue of the Greek Manuscripts in the Library of the Monastery of Vatopedi on Mt. Athos*, 1924.

10. Conybeare, Frederick C. *Russian Dissenters*, 1921.

9. Burrage, Champlin, ed. *An Answer to John Robinson of Leyden by a Puritan Friend: Now First Published from a Manuscript of A.D. 1609*, 1920.

8. Emerton, Ephraim. *The* Defensor pacis *of Marsiglio of Padua: A Critical Study*, 1920,

7. Bacon, Benjamin W. *Is Mark a Roman Gospel?* 1919.

6. Cadbury, Henry Joel. 2 vols. *The Style and Literary Method of Luke*, 1920.

5. Marriott, G. L., ed. Macarii Anecdota: *Seven Unpublished Homilies of Macarius*, 1918.

4. Edmunds, Charles Carroll and William Henry Paine Hatch. *The Gospel Manuscripts of the General Theological Seminary*, 1918.

3. Arnold, William Rosenzweig. *Ephod and Ark: A Study in the Records and Religion of the Ancient Hebrews*, 1917.

2. Hatch, William Henry Paine. *The Pauline Idea of Faith in its Relation to Jewish and Hellenistic Religion*, 1917.

1. Torrey, Charles Cutler. *The Composition and Date of Acts*, 1916.

Harvard Dissertations in Religion

In 1993, Harvard Theological Studies absorbed
the Harvard Dissertations in Religion series.

31. Baker-Fletcher, Garth. *Somebodyness: Martin Luther King, Jr. and the Theory of Dignity*, 1993.

30. Soneson, Jerome Paul. *Pragmatism and Pluralism: John Dewey's Significance for Theology*, 1993.

29. Crabtree, Harriet. *The Christian Life: The Traditional Metaphors and Contemporary Theologies*, 1991.

28. Schowalter, Daniel N. *The Emperor and the Gods: Images from the Time of Trajan*, 1993.

27. Valantasis, Richard. *Spiritual Guides of the Third Century: A Semiotic Study of the Guide-Disciple Relationship in Christianity, Neoplatonism, Hermetism, and Gnosticism*, 1991.

26. Wills, Lawrence Mitchell. *The Jews in the Court of the Foreign King: Ancient Jewish Court Legends*, 1990.

25. Massa, Mark Stephen. *Charles Augustus Briggs and the Crisis of Historical Criticism*, 1990.

24. Hills, Julian Victor. *Tradition and Composition in the* Epistula apostolorum, 1990. Reprinted, 2008.

23. Bowe, Barbara Ellen. *A Church in Crisis: Ecclesiology and Paraenesis in Clement of Rome*, 1988.

22. Bisbee, Gary A. *Pre-Decian Acts of Martyrs and* Commentarii, 1988.

21. Ray, Stephen Alan. *The Modern Soul: Michel Foucault and the Theological Discourse of Gordon Kaufman and David Tracy*, 1987.

20. MacDonald, Dennis Ronald. *There Is No Male and Female: The Fate of a Dominical Saying in Paul and Gnosticism*, 1987.

19. Davaney, Sheila Greeve. *Divine Power: A Study of Karl Barth and Charles Hartshorne*, 1986.

18. LaFargue, J. Michael. *Language and Gnosis: The Opening Scenes of the Acts of Thomas*, 1985.

12. Layton, Bentley, ed. *The Gnostic Treatise on Resurrection from Nag Hammadi*, 1979.

11. Ryan, Patrick J. *Imale: Yoruba Participation in the Muslim Tradition: A Study of Clerical Piety*, 1977.

10. Neevel, Jr., Walter G. *Yāmuna's* Vedānta *and* Pāñcarātra: *Integrating the Classical and the Popular*, 1977.

9. Yarbro Collins, Adela. *The Combat Myth in the Book of Revelation*, 1976.

8. Veatch, Robert M. *Value-Freedom in Science and Technology: A Study of the Importance of the Religious, Ethical, and Other Socio-Cultural Factors in Selected Medical Decisions Regarding Birth Control*, 1976.

7. Attridge, Harold W. *The Interpretation of Biblical History in the* Antiquitates judaicae *of Flavius Josephus*, 1976.

6. Trakatellis, Demetrios C. *The Pre-Existence of Christ in the Writings of Justin Martyr*, 1976.

5. Green, Ronald Michael. *Population Growth and Justice: An Examination of Moral Issues Raised by Rapid Population Growth*, 1975.

4. Schrader, Robert W. *The Nature of Theological Argument: A Study of Paul Tillich*, 1976.

3. Christensen, Duane L. *Transformations of the War Oracle in Old Testament Prophecy: Studies in the Oracles Against the Nations*, 1975.

2. Williams, Sam K. *Jesus' Death as Saving Event: The Background and Origin of a Concept*, 1972.

1. Smith, Jane I. *An Historical and Semantic Study of the Term "Islām" as Seen in a Sequence of Qur'an Commentaries*, 1970.